The Queer Encyclopedia of the Visual Arts

Claude J. Summers

Editor

CLEIS
PRESS

Published in the United States by Cleis Press Inc.,
P.O. Box 14684, San Francisco, California 94114.
Printed in the United States.
Cover design: Scott Idleman
Cover photograph: Photograph of Andy Warhol by Ed Kashi / CORBIS
© 2004 Andy Warhol Foundation for the Visual Arts / Artists Rights Society (ARS), New York
Book design: Karen Quigg
Cleis Press logo art: Juana Alicia
First Edition.
10 9 8 7 6 5 4 3 2 1

Archives, libraries, service bureaus, and individuals have been indispensable in providing access to the images that illustrate *The Queer Encyclopedia of the Visual Arts*. These organizations and individuals deserve particular thanks. Archiv für Sexualwissenschaft, Berlin for providing access to the image on page 58. J. Peter Benet for creating and granting permission to use the image on page 283. Cleis Press for providing and granting permission to use the image on page 266. Clipart.com for providing access to its copyrighted material (Copyright © 2003-2004 Clipart.com) and granting permission to use the images on pages 51, 60, 150, 161, 170, 224, 291, and 297. The Library of Congress Prints and Photographs Division for providing access to and duplicating the images on pages 39, 66, 143, 167, 177, 194, 197, 198, 207 (lower left), 215, 227, 289, 330, 330, 341, and 347. McCormick Library of Special Collections, Northwestern University for providing access to the images on pages 46, 48, 49, 102, and 245. The Naval Historical Foundation for access to and duplication of the image on page 320. Northwestern University Library for providing access to the wealth of material contained in its open stacks. Northwestern University Library Art Collection for access to the images on pages 1, 3, 57, 65, 71, 95, 108, 122, 124, 129, 130, 144 (top right and bottom left), 169, 195, 207 (upper right), 212, 219, 230, 243, 263, 279, 286, 291, 292, 301, 303, 306, 318, and 322.

LIBRARY OF CONGRESS CATALOGING-IN-PUBLICATION DATA

The queer encyclopedia of the visual arts / Claude J. Summers, editor.
 p. cm.
 Includes bibliographical references and index.
 ISBN 1-57344-191-0 (pbk.)
1. Homosexuality and art—Encyclopedias. 2. Art—Encyclopedias.
 I. Summers, Claude J.
 N72.H64Q44 2004
 704'.08664'03—dc22 2004004263

For Ted, again;

and for Wik, the "onlie begetter";

and for Linda Rapp, Robert Herndon, and Tim Flemming

CONTENTS

Acknowledgments
viii

Introduction
ix–xii

How to Use *The Queer Encyclopedia of the Visual Arts*
xiii

A-to-Z List of Entries
xiv–xv

Topical Index
xvi–xix

Entries A to Z
1–354

Notes on Contributors
355

Index of Names
361

ACKNOWLEDGMENTS

A collaborative project of the scope of *The Queer Encyclopedia of the Visual Arts* necessarily depends on the kindness and cooperation of numerous individuals, including especially the authors of the articles.

I owe most to Andrew "Wik" Wikholm, President of glbtq, Inc., whose vision and commitment and enthusiasm have made this book possible. Ted-Larry Pebworth has been a supportive partner and collaborator in many ways beyond the indexing and copyediting skills that he has deployed in this project. Linda Rapp, friend and assistant, has generously contributed her time, energy, and expertise.

I am grateful to all those who offered advice and made suggestions, especially as to topics and contributors. Tee Corinne, Patricia Simons, and Patricia Juliana Smith have been especially helpful as members of the www.glbtq.com advisory board. Michael Tanimura, production manager at glbtq, discovered a number of inconsistencies and errors and knew how to correct them. Betsy Greco, glbtq project administrator, has been unfailingly efficient and cheerful.

Work on this project has been sustained by the support of numerous friends, including Diana and Peter Benet, Helen Brooks, Neil Flax, John Edward and Willene Hardy, Raymond Frontain, Robert Herndon and Tim Flemming, George Koschel, and Gary and Mary Ann Stringer.

Finally, we are also grateful to the following: Archiv für Sexualwissenschaft, Berlin; Library of Congress Prints and Photographs Division; McCormick Library of Special Collections, Northwestern University; National Archives and Records Administration; Northwestern University Library Art Collection.

Introduction

THE QUEER ENCYCLOPEDIA OF THE VISUAL ARTS surveys and introduces a remarkable cultural achievement, one that includes both the contributions of gay, lesbian, bisexual, transgender, and queer people to the visual arts and their representation in the visual arts. That is, this work is interested in glbtq individuals not only as makers of art, but also as subjects and objects of art.

Presenting nearly 200 articles on individuals, artistic movements, periods, nations, and topics such as AIDS activism and censorship, *The Queer Encyclopedia of the Visual Arts* offers a revisionist art history, one that places the achievements of gay, lesbian, bisexual, transgender, and queer artists in historical contexts and that privileges the representation of subjects that have traditionally been censored or marginalized.

Celebrating the richness and variety of queer contributions to the visual arts, this book presents that achievement as a significant cultural legacy. This legacy includes accomplishments as diverse as the homoerotic images on Greek vase paintings and the sometimes graphic depictions in ancient Indian temple sculpture; the works of Michelangelo and Caravaggio; the self-portraits of Frida Kahlo and the screaming popes of Francis Bacon; the architecture of Julia Morgan and Philip Johnson; the photography of Claude Cahun, Robert Mapplethorpe, and Tee Corinne; the Pop Art of Andy Warhol and the narrative paintings of George Dureau; and the contemporary art of Bhupen Khakhar, David Hockney, Félix González-Torres, and Janet Cooling. It encompasses the religious expressions of El Greco and the pornographic fantasies of Tom of Finland, no less than the naturalism of Winslow Homer, the Art Deco nudes of Tamara de Lempicka, and the anthropomorphic "graffiti" drawings of Keith Haring.

The queer presence in the visual arts is so various and pervasive that it resists neat summary. Indeed, it is an integral part of humanity's artistic expression, and as diverse as humanity itself. It can scarcely be divorced from "mainstream art," for so many of the world's most prominent artists have in fact been of alternate sexualities. Yet there is real value in seeing queer art in its own terms as an expression of a queer artistic impulse and as a documentation of queer experience.

Queer art has so often been denigrated, suppressed, or robbed of its specificity and roots in efforts to render it "universal" that it has very infrequently been seen whole and in the contexts that gave it life. The aim of *The Queer Encyclopedia of the Visual Arts* is to help remedy the effects of an old but still active, homophobic project of exclusion and denial, by in fact presenting queer art whole and in the multiple contexts that helped shape it. Doing so yields new insight into the creation of art and increases our understanding of a wide range of artistic achievements.

Recovering and Reclaiming Our Artistic Heritage

Recovering our cultural heritage is a crucially important endeavor for everyone, but it is especially significant for gay men, lesbians, and others who have grown up in families and societies in which their sexual identities have been ignored, concealed, or condemned. They often come to a realization of their difference with little or no understanding of alternate sexualities beyond the negative stereotypes that pervade contemporary society, and they usually feel isolated and frightened at the very time they most need reassurance and encouragement.

Not surprisingly, a staple of the gay and lesbian "coming out" story is the trip to the local library, where the young homosexual, desperate for the most basic information, is usually utterly confused or bitterly disappointed by what he or she discovers, for even now our society does not make it easy for young people to find

accurate information about alternate sexualities. Only later is the radical loneliness of young people who have accepted their sexual identity assuaged by the discovery of a large and varied cultural heritage, one that speaks directly to the experience of contemporary men and women in the West but that also reflects other forms of same-sex love and desire in different times and places.

This volume is at once a documentation and reclamation of that cultural legacy and also a contribution to it. It participates in a long endeavor by queer men and women to recover a social and cultural history that has frequently been deliberately distorted and censored.

For centuries, educated and literate homosexuals living in eras that condemned homosexuality have looked to other ages and other societies in order to find cultural permission for homosexual behavior, to experience some relief from the incessant attacks on their self-esteem, and to penetrate the barriers of censorship that precluded open discussion of the love that dared not speak its name. Such attempts range from the ubiquitous lists of famous homosexuals in history to more elaborate and sophisticated historical research, such as that of Jeremy Bentham in the eighteenth century and of Edward Carpenter and John Addington Symonds at the end of the nineteenth century, as well as the recurrent attempts by gay and lesbian artists and writers to discover traditions and languages through which to express themselves.

Too often, however, attempts to document the gay and lesbian cultural legacy paid little attention to historical differences and tended to make few distinctions between different kinds of homosexualities, equating the emergent homosexual of the nineteenth century with the ancient Greek pederast, the medieval sodomite, and the Native North American *berdache*, for example, as though all four phenomena were merely minor variations on the same pattern.

The Queer Encyclopedia of the Visual Arts is motivated by the same impulse to understand the past and to recover the (often suppressed or disguised) artistic expressions of same-sex love that propelled earlier projects. But as the beneficiary of a more open climate and a recent explosion of knowledge about homosexuality in history, it is in a far better position than they were to discover a usable past. The new understanding of sexuality in history and culture that emerged in the 1980s and 1990s has in fact enabled this particular enterprise. Without the gay, lesbian, and queer studies movement, this volume would not have been possible.

Gay, Lesbian, Queer Studies Movement

In entering the academic mainstream, gay, lesbian, and queer studies have enlarged our understanding of the meaning of sexual identities, both in our own culture and in other times and places. They have challenged naive,

uninformed, and prejudiced views, and, perhaps most important, have discovered and recovered significant artifacts and neglected artists.

Queer studies in the visual arts have also reclaimed established and celebrated artists, revealing the pertinence and centrality of (frequently disguised or previously misinterpreted) same-sex relationships and queer experience to understanding canonical works. They have viewed celebrated achievements through a queer lens, in the process discovering aspects of the world's artistic heritage that either had not been noticed or had been suppressed.

But although gay, lesbian, and queer studies have enriched the academic study of history and art, they still tend to be ghettoized in elite universities, often in women's studies programs that are themselves frequently isolated. Meanwhile, standard art histories continue all too often to omit or discount gay and lesbian representations, fail to supply relevant biographical information about gay, lesbian, bisexual, and transgender artists, and foster the grievously mistaken impression that the world's artistic traditions are almost exclusively heterosexual.

The Queer Encyclopedia of the Visual Arts aims to redress these deficiencies. It seeks to place portrayals of same-sex desire in historical context, to provide accurate biographical information about artists who have contributed to queer artistic traditions, and to explore important questions about the presence of homoeroticism in the world's artistic legacy.

How does the homosexuality of an artist affect his or her work even when that work has nothing specifically to do with homosexuality? How does one decipher the "coding" of artworks in which the homosexual import is disguised? Is there such a thing as a gay sensibility? Are some artistic movements more amenable to homoeroticism than others? Is there an iconography of queer art? Why is St. Sebastian an icon of gay male artists? These are some of the questions asked and variously answered in this book.

Theoretical Issues

The study of the representation of alternate sexualities in art must inevitably confront a variety of vexed issues, including basic conceptual questions of definition and identity. Who, exactly, is a homosexual? What constitutes sexual identity? To what extent is sexuality the product of broadly defined social forces? To what degree do sexual object-choices manifest a biological or psychological essence within the desiring individual? These questions not only are problematic for the historical study of homosexuality and of queer art, but also reflect current controversies about contemporary and historical sexual roles and categories, and they resist glib answers.

Although contemporary North Americans and western Europeans typically think in terms of a dichotomy between homosexuality and heterosexuality, and between the homosexual and the heterosexual, with vague compartments for bisexuality and bisexuals, such a conception is a historically contingent cultural construct, more revealing of our own age's sexual ideology than of actual erotic practices even today. The range of human sexual response is considerably less restricted than these artificial classifications suggest, and different ages and cultures have interpreted (and regulated) sexual behavior differently.

Because human sexual behavior and emotions are fluid and various rather than static or exclusive, the sexologist Alfred Kinsey and others have argued that the terms *homosexual* and *heterosexual* should more properly be used as adjectives rather than nouns, referring to acts and emotions but not to people. Moreover, the conception of homosexuality and heterosexuality as essential and exclusive categories has historically operated as a form of social control, defining the person who responds erotically to individuals of his or her own sex as the "Other," or, more particularly, as *queer* or *unnatural*.

But though it may be tempting to conclude that there are no such entities as homosexuals or heterosexuals or bisexuals, this view, which so attractively stresses the commonality of human beings and minimizes the significance of sexual object-choices, poses its own dangers. Human sexuality is simply not as plastic as some theorists assert, and to deny the existence of homosexuals, bisexuals, and heterosexuals—or the pertinence of such categories—is to deny the genuineness of the personal identities and forms of erotic life that exist today. It is, indeed, to engage in a process of denial and erasure, rendering invisible a group that has had to struggle for recognition and visibility.

For most people, sexual orientation is not merely a matter of choice or preference but a classification that reflects a deep-seated internal, as well as social, reality. However arbitrary, subjective, inexact, and culture-bound the labels may be, they are impossible to escape and they affect individuals—especially those in the minority categories—in profound and manifold ways.

The most painful and destructive injustice visited upon people of alternative sexuality has been their separation from the normal and the natural, their stigmatization as *queer*. Yet the internalization of this stigma has also been their greatest strength and, indeed, the core of their identity in societies that regularly assign individuals to ostensibly exclusive categories of sexual desire. The consciousness of difference both spurred and made possible the recent creation of a homosexual minority—a gay and lesbian community—in the Western democracies, a process that involved transforming the conception of homosexuality from a "social problem" and personal failing to an individual and collective identity.

Quite apart from the fact that it facilitates identity politics, however, an acceptance of otherness, whether defined as lesbian, gay, bisexual, transgender, or the umbrella term *queer*, is also often personally empowering. Fostering qualities of introspection and encouraging social analysis, it enables people who feel excluded from some of the core assumptions and rituals of their society to evaluate themselves and their society from an ambiguous and often revealing perspective.

Homoerotic desire and behavior have been documented in every conceivable kind of society. What varies is the meanings that they are accorded from era to era and place to place. In some societies, homosexuality is tolerated and even institutionalized, whereas in others it is vilified and persecuted. In every society, there are undoubtedly individuals who are predominantly attracted to members of their own sex or who do not conform easily to gender expectations, but the extent to which that sexual attraction or gender nonconformity functions as a defining characteristic of these individuals' personal and social identities varies considerably from culture to culture.

Thus, any transhistorical and transcultural exploration of the queer artistic heritage must guard against the risk of anachronism, of inappropriately imposing contemporary culture-bound conceptions of homosexuality on earlier ages and different societies. Sexual categories are always historically and culturally specific rather than universal and invariant.

On the other hand, however, the recognition of cultural specificity in regard to sexual attitudes need not estrange the past or obscure connections and continuities between historical periods and between sexual ideologies. For instance, modern North American and western European male homosexuality, which is predominantly androphiliac (that is, between adults), egalitarian, and socially disdained, is in many crucial respects quite different from ancient Greek male homosexuality, which was predominantly—though by no means exclusively—pederastic, assymetrical in power, and socially valorized; but awareness of those differences does not obviate the similarities that link the two distinct historical constructs.

Neither does the acknowledgment of the distinctions between ancient Greek homosexuality and modern homosexuality entail the dismissal of the enormous influence that classical Greek attitudes toward same-sex love exerted on the formation of modern Western attitudes toward homosexuality. For many individuals in the early modern and modern eras, ancient Greek literature, philosophy, and art helped counter the negative attitudes toward same-sex eroticism fostered by Christian

culture. Ancient Greek literature and art have provided readers, writers, and artists of subsequent centuries a pantheon of heroes, a catalog of images, and a set of references by which same-sex desire could be encoded into their own representations and through which they could interpret their own experiences.

Nor should our sensitivity to the cultural specificity of sexual attitudes cause us to rob individual artists of individual perspectives or to condescend toward the past. All artists exist in relation to their time and must necessarily create from within their worldviews, or, as philosopher Michel Foucault would say, the *epistemes* of their ages. But the fact that artists are embedded in their cultures does not mean that they lack agency and individuality.

Artists tend to be more independent than their contemporaries, not less; and although they may express the tendencies and suppositions of their societies, they also frequently challenge them, even if those challenges are themselves facilitated and contained by societal beliefs. Hence, it is a mistake to assume that artists of earlier ages, before the general emergence of a modern homosexual identity, could not share important aspects of that consciousness, including a subjective awareness of difference and a sense of alienation from society. One of the rewards of studying the queer artistic heritage is, in fact, the discovery of a queer subjectivity in the past and of the affinities as well as differences between earlier and later homosexualities.

A Beginning, Not an End

For all its considerable heft, *The Queer Encyclopedia of the Visual Arts* has no pretensions to comprehensiveness. There are some notable omissions of topics and artists, due variously to lack of space, an absence of available information and research, or a difficulty in finding qualified contributors. Moreover, *The Queer Encyclopedia of the Visual Arts* is undoubtedly biased in favor of European and American artistic traditions, even as it also provides a great deal of information about other traditions and cultures.

The point that needs emphasis, however, is that as the first comprehensive work of its kind, this encyclopedia is an important beginning, not an end. It introduces readers to a wealth of artistic achievement, making accessible the fruits of the intense study that has recently been focused on queer culture. It aspires to be a valuable companion to readers interested in the artistic representation of alternate sexualities from ancient times to the present.

Claude J. Summers
January 2004

How to Use *The Queer Encyclopedia of the Visual Arts*

SIR FRANCIS BACON DIVIDED BOOKS INTO THREE TYPES. "Some books are to be tasted, others to be swallowed, and some few to be chewed and digested: that is, some books are to be read only in parts; others to be read, but cursorily; and some few to be read wholly and with diligence and attention." This book aspires to all three categories.

We certainly believe that *The Queer Encyclopedia of the Visual Arts* is inviting and rewarding enough to entice readers into diligent and attentive study. At the same time, however, we hope that the book will also invite browsers, who will dip into it repeatedly over time for pleasure and enlightenment. In addition, we hope that it will also serve as a valuable reference tool for readers who need to find particular information quickly.

The essays in the *Encyclopedia* are presented alphabetically, an arrangement that should encourage browsing. They are generally of three types: overviews of national or ethnic art or art historical periods, essays on topics or movements of particular significance for the queer visual arts, and essays on individual artists important to the queer arts heritage. The A-to-Z List of Entries provides a convenient, alphabetical guide to the entries.

The overviews of art historical periods or national art sometimes comprise several essays. For example, the entry on European Art includes distinct essays on the following periods: Medieval, Renaissance, Mannerism, Baroque, Eighteenth Century, Neoclassicism, Nineteenth Century, and Twentieth Century. Similarly, the survey of American Art includes multiple essays, "American Art: Gay Male, Nineteenth Century"; "American Art: Lesbian, Nineteenth Century"; "American Art: Gay Male, 1900–1969"; American Art: Lesbian, 1900–1969"; American

Art: Gay Male, Post-Stonewall"; and American Art: Lesbian, Post-Stonewall." Under the rubric "Subjects of the Visual Arts," there are twenty-three distinct essays on subjects ranging from Androgyny to Vampires.

The entries on individual artists are also diverse, varying from succinct accounts to in-depth critical analyses of major figures such as Caravaggio or Michelangelo. The most important criterion in determining whether an artist was assigned an entry is his or her contribution to the queer visual arts. The lack of an individual entry for an artist does not, however, mean that the author is not significant to the glbtq heritage or is not discussed in the volume. For example, there are no entries for Frederic Leighton or Gustave Moreau, but both can be found in the volume. Discussions of artists who are not accorded individual author entries can most conveniently be found via the Index of Names.

The frequent cross-references should be helpful for readers interested in related topics or in finding further discussions of particular artists. At the end of nearly all the articles, readers are urged to "see also" other entries.

Each article is followed by a brief bibliography. With some exceptions, the bibliographies emphasize secondary rather than primary material, pointing the reader to other studies of the topic or artist.

Finally, the volume's two indexes should be of help in maneuvering through this large collection. The Topical Index conveniently groups entries that are related to each other in various ways, including the nationality of artists. The Index of Names should be especially valuable in enabling readers to discover discussions of individual artists, some of whom are discussed in several entries in addition to—or in lieu of—their own entries.

A-to-Z List of Entries

Abbéma, Louise .. 1
Abbott, Berenice .. 2
African Art
 African Art: Contemporary 3
 African Art: Traditional 5
 African American and African Diaspora Art 10
AIDS Activism in the Arts 14
American Art
 American Art: Gay Male, 1900–1969 16
 American Art: Gay Male, Nineteenth Century 18
 American Art: Gay Male, Post-Stonewall 21
 American Art: Lesbian, 1900–1969 24
 American Art: Lesbian, Nineteenth Century 27
 American Art: Lesbian, Post-Stonewall 30
Angus, Patrick ... 33
Architecture ... 34
Arts and Crafts Movement 37
Austen, Alice .. 38
Australian Art ... 40

Bachardy, Don ... 43
Bacon, Francis ... 44
Barthé, James Richmond 45
Bazille, Jean-Frédéric 47
Beardsley, Aubrey 48
Beaton, Cecil .. 50
Bernhard, Ruth .. 52
Biren, Joan Elizabeth (JEB) 53
Bleckner, Ross ... 54
Blunt, Anthony .. 55
Bonheur, Rosa ... 56
Breker, Arno ... 59
Bronzino, Agnolo .. 60
Brooks, Romaine ... 61

Cadmus, Paul .. 65
Cahun, Claude ... 67
Canadian Art .. 68
Caravaggio .. 70
Carrington, Dora .. 73
Cellini, Benvenuto 74
Censorship in the Arts 76
Chicago, Judy ... 79
Classical Art .. 80
Contemporary Art 83
Cooling, Janet .. 89
Corinne, Tee .. 90

Day, F. Holland ... 93
Demuth, Charles ... 95
Dobell, Sir William 96
Donatello ... 97
Duchamp, Marcel .. 99
Duquesnoy, Jérôme 100
Dureau, George ... 100
Dürer, Albrecht ... 102

Eakins, Thomas .. 105
Edison, Laurie Toby 106
El Greco (Domenikos Theotokopoulos) 107
Elbe, Lili ... 109
Erotic and Pornographic Art
 Erotic and Pornographic Art: Gay Male 110
 Erotic and Pornographic Art: Lesbian 114
European Art
 European Art: Baroque 116
 European Art: Eighteenth Century 120
 European Art: Mannerism 123
 European Art: Medieval 125
 European Art: Neoclassicism 127
 European Art: Nineteenth Century 130
 European Art: Renaissance 134
 European Art: Twentieth Century 136

Fani-Kayode, Rotimi 141
Fini, Léonor .. 142
Flandrin, Hippolyte 143
French, Jared ... 144
Friend, Donald .. 145
Fuseli, Henry ... 147

Géricault, Théodore 149
Gilbert & George .. 151
Girodet-Trioson, Anne-Louis 154
Gleeson, James .. 155
Gloeden, Baron Wilhelm von 155
Gluck (Hannah Gluckenstein) 156
Gonzáles-Torres, Félix 158
Goodsir, Agnes Noyes 159
Grace, Della (Del LaGrace Volcano) 160
Grant, Duncan .. 161
Gray, Eileen .. 162

Hammond, Harmony Lynn 165
Haring, Keith ... 166
Hartley, Marsden .. 167
Hepworth, Dorothy, and Patricia Preece 168
Höch, Hannah ... 169
Hockney, David .. 171
Hodgkins, Frances 172
Homer, Winslow ... 173
Homomonument ... 175
Hosmer, Harriet Goodhue 176

Indian Art .. 179
Islamic Art ... 185
Israel, Franklin D. 188

Japanese Art .. 191
Johns, Jasper ... 193
Johnson, Philip ... 194

Kahlo, Frida .. 197
Khakhar, Bhupen .. 198
Klumpke, Anna Elizabeth 199

Latin American Art . 201
Latina/Latino American Art . 204
Laurençin, Marie . 206
Leibovitz, Annie . 208
Lempicka, Tamara de . 210
Leonardo da Vinci . 211
Leslie-Lohman Gay Art Foundation 213
Lewis, Mary Edmonia . 214
Leyendecker, Joseph C. 215
Ligon, Glenn . 216
List, Herbert . 217
Lukacs, Attila Richard . 218
Lynes, George Platt . 219

Mammen, Jeanne . 221
Mapplethorpe, Robert . 222
Marées, Hans von . 223
Meurent, Victorine . 225
Michals, Duane . 226
Michelangelo Buonarroti . 226
Minton, John . 231
Morgan, Julia . 232

Native American Art . 235
New Zealand Art . 237

Ocaña, José Pérez . 239

Pacific Art . 241
Parmigianino (Francesco Mazzola) 242
Parsons, Betty . 243
Percier, Charles, and Pierre Fontaine 244
Photography
 Photography: Gay Male, Post-Stonewall 246
 Photography: Gay Male, Pre-Stonewall 251
 Photography: Lesbian, Post-Stonewall 253
 Photography: Lesbian, Pre-Stonewall 257
Pierre et Gilles . 259
Pisis, Filippo Tibertelli De . 260
Pontormo, Jacopo . 262
Pop Art . 264
Pulp Paperbacks and Their Covers 265

Raffalovich, Marc André . 267
Rainbow Flag . 268
Rauschenberg, Robert . 270
Ricketts, Charles, and Charles Shannon 271
Ritts, Herb . 272
Rudolph, Paul . 274

Salons . 277
Sargent, John Singer . 279
Schwules Museum (Gay Museum) 280
Segal, George . 282
Sipprell, Clara Estelle . 285
Sodoma, Il (Giovanni Antonio Bazzi) 286
Solomon, Simeon . 287
Stebbins, Emma . 289

Subjects of the Visual Arts
 Subjects of the Visual Arts: Androgyny 290
 Subjects of the Visual Arts: Bathing Scenes 291
 Subjects of the Visual Arts: Bicycles 293
 Subjects of the Visual Arts: David and Jonathan . . . 294
 Subjects of the Visual Arts: Diana 296
 Subjects of the Visual Arts: Dildos 297
 Subjects of the Visual Arts: Dionysus 298
 Subjects of the Visual Arts: Endymion 299
 Subjects of the Visual Arts: Ganymede 300
 Subjects of the Visual Arts: Harmodius and
 Aristogeiton . 301
 Subjects of the Visual Arts: Hercules 303
 Subjects of the Visual Arts: Hermaphrodites 303
 Subjects of the Visual Arts: Narcissus 304
 Subjects of the Visual Arts: Nude Females 305
 Subjects of the Visual Arts: Nude Males 309
 Subjects of the Visual Arts: Orpheus 314
 Subjects of the Visual Arts: Priapus 314
 Subjects of the Visual Arts: Prostitution 315
 Subjects of the Visual Arts: Psyche 318
 Subjects of the Visual Arts: Sailors and Soldiers 319
 Subjects of the Visual Arts: Sappho 321
 Subjects of the Visual Arts: St. Sebastian 321
 Subjects of the Visual Arts: Vampires 322
Surrealism . 323
Symbolists . 325

Tchelitchew, Pavel . 329
Tom of Finland (Touko Laaksonen) 330
Tress, Arthur . 331
Tsarouchis, Yannis . 332
Tuke, Henry Scott . 333

Vaughan, Keith . 335
Video Art . 336

Walker, Dame Ethel . 339
Warhol, Andy . 340
Weber, Bruce . 342
White, Minor . 343
Whitney, Anne . 346
Wojnarowicz, David . 347
Wolfe, Elsie de . 349
Wood, Thelma Ellen . 350

Zenil, Nahum B. 353

Topical Index

AFRICAN ART

African American and African Diaspora Art........ 10
African Art: Contemporary.......................... 3
African Art: Traditional............................. 5
Fani-Kayode, Rotimi................................ 141

AFRICAN AMERICAN ART

African American and African Diaspora Art........ 10
American Art: Gay Male, Post-Stonewall............ 21
American Art: Lesbian, Post-Stonewall 30
Barthé, James Richmond........................... 45
Lewis, Mary Edmonia 214
Ligon, Glenn 216
Photography: Lesbian, Post-Stonewall.............. 253

AIDS

AIDS Activism in the Arts........................... 14
American Art: Gay Male, Post-Stonewall............ 21
Bleckner, Ross 54
Canadian Art....................................... 68
Contemporary Art.................................. 83
Fani-Kayode, Rotimi................................ 141
Gonzáles-Torres, Félix 158
Haring, Keith 166
Ritts, Herb .. 272
Wojarnowicz, David 347

AMERICAN ART

Abbott, Berenice 2
African American and African Diaspora Art........ 10
AIDS Activism in the Arts........................... 14
American Art: Gay Male, 1900–1969............... 16
American Art: Gay Male, Nineteenth Century....... 18
American Art: Gay Male, Post-Stonewall............ 21
American Art: Lesbian, 1900–1969................. 24
American Art: Lesbian, Nineteenth Century 27
American Art: Lesbian, Post-Stonewall 30
Angus, Patrick..................................... 33
Architecture 34
Arts and Crafts Movement......................... 37
Austen, Alice 38
Bachardy, Don..................................... 43
Barthé, James Richmond........................... 45
Bernhard, Ruth 52
Biren, Joan Elizabeth (JEB)........................ 53
Bleckner, Ross 54
Brooks, Romaine 61
Cadmus, Paul...................................... 65
Censorship in the Arts.............................. 76
Chicago, Judy 79
Contemporary Art.................................. 83
Cooling, Janet 89
Corinne, Tee....................................... 90
Day, F. Holland.................................... 93
Demuth, Charles 95

AMERICAN ART (continued)

Dureau, George.................................... 100
Eakins, Thomas.................................... 105
Edison, Laurie Toby................................ 106
Erotic and Pornographic Art: Gay Male............ 110
Erotic and Pornographic Art: Lesbian 114
French, Jared...................................... 144
Gonzáles-Torres, Félix 158
Grace, Della (Del LaGrace Volcano)................ 160
Hammond, Harmony Lynn......................... 165
Haring, Keith 166
Hartley, Marsden 167
Homer, Winslow 173
Hosmer, Harriet Goodhue 176
Johns, Jasper 193
Klumpke, Anna Elizabeth.......................... 199
Latina/Latino American Art 204
Leibovitz, Annie................................... 208
Leslie-Lohman Gay Art Foundation 213
Lewis, Mary Edmonia 214
Leyendecker, Joseph C............................. 215
Ligon, Glenn 216
Lynes, George Platt 219
Mapplethorpe, Robert 222
Michals, Duane 226
Native American Art............................... 235
Parsons, Betty..................................... 243
Photography: Gay Male, Post-Stonewall 246
Photography: Gay Male, Pre-Stonewall............. 251
Photography: Lesbian, Post-Stonewall.............. 253
Photography: Lesbian, Pre-Stonewall............... 257
Pop Art.. 264
Pulp Paperbacks and Their Covers 265
Rainbow Flag 268
Rauschenberg, Robert 270
Ritts, Herb .. 272
Salons .. 277
Sargent, John Singer 279
Segal, George...................................... 282
Stebbins, Emma.................................... 289
Subjects of the Visual Arts: Bathing Scenes........ 291
Subjects of the Visual Arts: Bicycles 293
Subjects of the Visual Arts: Endymion............. 299
Subjects of the Visual Arts: Nude Females......... 305
Subjects of the Visual Arts: Nude Males.......... 309
Subjects of the Visual Arts: Prostitution 315
Subjects of the Visual Arts: Sailors and Soldiers....319
Subjects of the Visual Arts: Sappho............... 321
Subjects of the Visual Arts: St. Sebastian 321
Tchelitchew, Pavel 329
Tress, Arthur 331
Video Art... 336
Warhol, Andy 340
Weber, Bruce 342
White, Minor 343
Whitney, Anne 346
Wojnarowicz, David 347
Wood, Thelma Ellen 350

ARCHITECTURE & DESIGN

Architecture . *34*
Arts and Crafts Movement *37*
Gray, Eileen . *162*
Israel, Franklin D. *188*
Johnson, Philip . *194*
Morgan, Julia . *232*
Percier, Charles, and Pierre Fontaine *244*
Rudolph, Paul . *274*
Wolfe, Elsie de . *349*

ARTISTIC MOVEMENTS

Arts and Crafts Movement *37*
European Art: Baroque . *116*
European Art: Eighteenth Century *120*
European Art: Mannerism *123*
European Art: Neoclassicism *127*
Surrealism . *323*
Symbolists . *325*

AUSTRALIAN ART

Australian Art . *40*
Dobell, Sir William . *96*
Friend, Donald . *145*
Gleeson, James . *155*
Goodsir, Agnes Noyes . *159*
Photography: Lesbian, Post-Stonewall *253*
Subjects of the Visual Arts: Nude Males *309*

BISEXUALITY

Bernhard, Ruth . *52*
Cellini, Benvenuto . *74*
Classical Art . *80*
Edison, Laurie Toby . *106*
Fini, Léonor . *142*
Höch, Hannah . *169*
Kahlo, Frida . *197*
Lempicka, Tamara de . *210*
Salons . *277*

CANADIAN ART

Canadian Art . *68*
Erotic and Pornographic Art: Lesbian *114*
Lukacs, Attila Richard . *218*
Native American Art . *235*
Photography: Lesbian, Post-Stonewall *253*
Photography: Lesbian, Pre-Stonewall *257*
Sipprell, Clara Estelle . *285*
Subjects of the Visual Arts: Nude Females *305*

CENSORSHIP

Cadmus, Paul . *65*
Censorship in the Arts . *76*
Corinne, Tee . *90*
Demuth, Charles . *95*
Mapplethorpe, Robert . *222*
Warhol, Andy . *340*
White, Minor . *343*
Wojnarowicz, David . *347*

CLASSICAL ART

Classical Art . *80*
Subjects of the Visual Arts: Androgyny *290*
Subjects of the Visual Arts: Bathing Scenes *291*
Subjects of the Visual Arts: Diana *296*
Subjects of the Visual Arts: Dildos *297*
Subjects of the Visual Arts: Dionysus *298*
Subjects of the Visual Arts: Endymion *299*
Subjects of the Visual Arts: Ganymede *300*
Subjects of the Visual Arts: Harmodius and
 Artistogeiton . *301*
Subjects of the Visual Arts: Hercules *303*
Subjects of the Visual Arts: Hermaphrodites *303*
Subjects of the Visual Arts: Narcissus *304*
Subjects of the Visual Arts: Nude Females *305*
Subjects of the Visual Arts: Nude Males *309*
Subjects of the Visual Arts: Orpheus *314*
Subjects of the Visual Arts: Priapus *314*
Subjects of the Visual Arts: Prostitution *315*
Subjects of the Visual Arts: Psyche *318*
Subjects of the Visual Arts: Sappho *321*

CROSS-DRESSING

African Art: Traditional . *5*
Indian Art . *179*
Kahlo, Frida . *197*
Native American Art . *235*
Subjects of the Visual Arts: Hercules *303*

EROTICA

American Art: Gay Male, 1900–1969 *16*
Beardsley, Aubrey . *48*
Brooks, Romaine . *61*
Cadmus, Paul . *65*
Censorship in the Arts . *76*
Classical Art . *80*
Corinne, Tee . *90*
Demuth, Charles . *95*
Eakins, Thomas . *105*
Erotic and Pornographic Art: Gay Male *110*
Erotic and Pornographic Art: Lesbian *114*
Fini, Léonor . *142*
Gloeden, Baron Wilhelm von *155*
Grace, Della (Del LaGrace Volcano) *160*
Leslie-Lohman Gay Art Foundation *213*
Mapplethorpe, Robert . *222*
Photography: Gay Male, Post-Stonewall *246*
Photography: Gay Male, Pre-Stonewall *251*
Photography: Lesbian, Post-Stonewall *253*
Photography: Lesbian, Pre-Sonewall *257*
Subjects of the Visual Arts: Dildos *297*
Subjects of the Visual Arts: Ganymede *300*
Subjects of the Visual Arts: Nude Females *305*
Subjects of the Visual Arts: Nude Males *309*
Subjects of the Visual Arts: St. Sebastian *321*
Tom of Finland (Touko Laaksonen) *330*

EUROPEAN ART

Abbéma, Louise..1
African American and African Diaspora Art.........10
Arts and Crafts Movement..........................37
Bacon, Francis..........................44
Bazille, Jean-Frédéric..........................47
Beardsley, Aubrey..........................48
Beaton, Cecil..........................50
Blunt, Anthony..........................55
Bonheur, Rosa..........................56
Breker, Arno..........................59
Bronzino, Agnolo..........................60
Cahun, Claude..........................67
Caravaggio..........................70
Carrington, Dora..........................73
Cellini, Benvenuto..........................74
Contemporary Art..........................83
Donatello..........................97
Duchamp, Marcel..........................99
Duquesnoy, Jérôme..........................100
Dürer, Albrecht..........................102
El Greco..........................107
Elbe, Lili..........................109
Erotic and Pornographic Art: Gay Male..........110
Erotic and Pornographic Art: Lesbian..........114
European Art: Baroque..........................116
European Art: Eighteenth Century..........................120
European Art: Mannerism..........................123
European Art: Medieval..........................125
European Art: Neoclassicism..........................127
European Art: Nineteenth Century..........................130
European Art: Renaissance..........................134
European Art: Twentieth Century..........................136
Fani-Kayode, Rotimi..........................141
Fini, Léonor..........................142
Flandrin, Hippolyte..........................143
Fuseli, Henry..........................147
Géricault, Théodore..........................149
Gilbert & George..........................151
Girodet-Trioson, Anne-Louis..........................154
Gloeden, Baron Wilhelm von..........................155
Gluck (Hannah Gluckenstein)..........................156
Grant, Duncan..........................161
Hepworth, Dorothy, and Patricia Preece..........168
Höch, Hannah..........................169
Hockney, David..........................171
Homomonument..........................175
Laurençin, Marie..........................206
Lempicka, Tamara de..........................210
Leonardo da Vinci..........................211
List, Herbert..........................217
Mammen, Jeanne..........................221
Marées, Hans von..........................223
Meurent, Victorine..........................225
Michelangelo Buonarroti..........................226
Minton, John..........................231
Ocaña, José Pérez..........................239
Parmigianino..........................242

EUROPEAN ART (continued)

Photography: Gay Male, Post-Stonewall..........246
Photography: Gay Male, Pre-Stonewall..........251
Photography: Lesbian, Post-Stonewall..........253
Photography: Lesbian, Pre-Stonewall..........257
Pierre et Gilles..........................259
Pisis, Filippo Tibertelli De..........................260
Pontormo, Jacopo..........................262
Raffalovich, Marc André..........................267
Ricketts, Charles, and Charles Shannon..........271
Salons..........................277
Sargent, John Singer..........................279
Schwules Museum (Gay Museum)..........................280
Sodoma, Il..........................286
Solomon, Simeon..........................287
Subjects of the Visual Arts: Androgyny..........290
Subjects of the Visual Arts: Bathing Scenes..........291
Subjects of the Visual Arts: Bicycles..........293
Subjects of the Visual Arts: David and Jonathan...294
Subjects of the Visual Arts: Diana..........296
Subjects of the Visual Arts: Dildos..........297
Subjects of the Visual Arts: Dionysus..........298
Subjects of the Visual Arts: Endymion..........299
Subjects of the Visual Arts: Ganymede..........300
Subjects of the Visual Arts: Hercules..........303
Subjects of the Visual Arts: Hermaphrodites..........303
Subjects of the Visual Arts: Narcissus..........304
Subjects of the Visual Arts: Nude Females..........305
Subjects of the Visual Arts: Nude Males..........309
Subjects of the Visual Arts: Orpheus..........314
Subjects of the Visual Arts: Priapus..........314
Subjects of the Visual Arts: Prostitution..........315
Subjects of the Visual Arts: Psyche..........318
Subjects of the Visual Arts: Sailors and Soldiers....319
Subjects of the Visual Arts: Sappho..........321
Subjects of the Visual Arts: St. Sebastian..........321
Surrealism..........................323
Symbolists..........................325
Tchelitchew, Pavel..........................329
Tom of Finland (Touko Laaksonen)..........................330
Tsarouchis, Yannis..........................332
Tuke, Henry Scott..........................333
Vaughan, Keith..........................335
Walker, Dame Ethel..........................339

INDIAN ART

Indian Art..........................179
Khakhar, Bhupen..........................198
Subjects of the Visual Arts: Androgyny..........290
Subjects of the Visual Arts: Nude Males..........309
Subjects of the Visual Arts: Prostitution..........315

ISLAMIC ART

Islamic Art..........................185

JAPANESE ART

Japanese Art..........................191
Subjects of the Visual Arts: Nude Males..........309
Subjects of the Visual Arts: Prostitution..........315

LATIN AMERICAN ART

Fini, Léonor.................................142
Kahlo, Frida.................................197
Latin American Art............................201
Subjects of the Visual Arts: Nude Females.........305
Zenil, Nahum B................................353

LATINA/LATINO AMERICAN ART

American Art: Gay Male, Post-Stonewall............21
American Art: Lesbian, Post-Stonewall.............30
Contemporary Art.............................83
Gonzáles-Torres, Félix.........................158
Latina/Latino American Art.....................204

NATIVE AMERICAN ART

Native American Art...........................235

NEW ZEALAND ART

Hodgkins, Frances............................172
New Zealand Art..............................237
Photography: Lesbian, Post-Stonewall.............253
Subjects of the Visual Arts: Nude Females.........305

PACIFIC ART

Pacific Art...................................241

PHOTOGRAPHY

Abbott, Berenice................................2
African American and African Diaspora Art........10
American Art: Gay Male, 1900–1969.............16
American Art: Gay Male, Nineteenth Century......18
American Art: Gay Male, Post-Stonewall...........21
American Art: Lesbian, 1900–1960..............24
American Art: Lesbian, Post-Stonewall............30
Austen, Alice.................................38
Beaton, Cecil.................................50
Bernhard, Ruth...............................52
Biren, Joan Elizabeth (JEB)....................53
Cahun, Claude...............................67
Canadian Art................................68
Corinne, Tee.................................90
Day, F. Holland..............................93
Dureau, George.............................100
Eakins, Thomas.............................105
Edison, Laurie Toby.........................106
Erotic and Pornographic Art: Gay Male..........110
Erotic and Pornographic Art: Lesbian............114
European Art: Twentieth Century...............136
Fani-Kayode, Rotimi.........................141
Gloeden, Baron Wilhelm von..................155
Grace, Della (Del LaGrace Volcano)............160
Höch, Hannah...............................169
Hockney, David.............................171
Latina/Latino American Art...................204
Leibovitz, Annie.............................208
Ligon, Glenn................................216

PHOTOGRAPHY *(continued)*

List, Herbert.................................217
Lynes, George Platt...........................219
Mapplethorpe, Robert........................222
Michals, Duane..............................226
Photography: Gay Male, Post-Stonewall..........246
Photography: Gay Male, Pre-Stonewall...........251
Photography: Lesbian, Post-Stonewall...........253
Photography: Lesbian, Pre-Stonewall............257
Pierre et Gilles..............................259
Ritts, Herb..................................272
Sipprell, Clara Estelle........................285
Subjects of the Visual Arts: Bathing Scenes........291
Subjects of the Visual Arts: Bicycles.............293
Subjects of the Visual Arts: David and Jonathan...294
Subjects of the Visual Arts: Endymion...........299
Subjects of the Visual Arts: Nude Females.........305
Subjects of the Visual Arts: Nude Males..........309
Surrealism..................................323
Tress, Arthur................................331
Weber, Bruce................................342
White, Minor................................343

SUBJECTS OF THE VISUAL ARTS

Subjects of the Visual Arts: Androgyny...........290
Subjects of the Visual Arts: Bathing Scenes........291
Subjects of the Visual Arts: Bicycles.............293
Subjects of the Visual Arts: David and Jonathan...294
Subjects of the Visual Arts: Diana...............296
Subjects of the Visual Arts: Dildos..............297
Subjects of the Visual Arts: Dionysus............298
Subjects of the Visual Arts: Endymion...........299
Subjects of the Visual Arts: Ganymede...........300
Subjects of the Visual Arts: Harmodius and
 Aristogeiton..............................301
Subjects of the Visual Arts: Hercules.............303
Subjects of the Visual Arts: Hermaphrodites.......303
Subjects of the Visual Arts: Narcissus............304
Subjects of the Visual Arts: Nude Females.........305
Subjects of the Visual Arts: Nude Males..........309
Subjects of the Visual Arts: Orpheus............314
Subjects of the Visual Arts: Priapus.............314
Subjects of the Visual Arts: Prostitution.........315
Subjects of the Visual Arts: Psyche.............318
Subjects of the Visual Arts: Sailors and Soldiers....319
Subjects of the Visual Arts: Sappho.............321
Subjects of the Visual Arts: St. Sebastian.........321
Subjects of the Visual Arts: Vampires............322

TRANSSEXUALISM

Classical Art.................................80
Elbe, Lili...................................109
Grace, Della (Del LaGrace Volcano)............160
Indian Art..................................179
Subjects of the Visual Arts: Androgyny...........290
Subjects of the Visual Arts: Hermaphrodites.......303

Abbéma, Louise *(1858–1927)*

A PAINTER IN THE IMPRESSIONIST STYLE, AS WELL AS AN engraver, sculptor, and writer, Louise Abbéma was one of the most successful women artists of her day. Her media were etching, pastel, and particularly watercolor; as a writer, she collaborated with the journals *Gazette des Beaux-Arts* and *L'Art*. She is best remembered for her portraits and genre scenes, and for her relationship with Sarah Bernhardt, but Abbéma also painted flowers again and again. They appear throughout her oeuvre—women hold them in bunches, they fill vases, and they are the subjects of her still lifes.

Abbéma was born in Etampes, France, the great-granddaughter of actress Mlle Contat and Comte Louis de Narbonne. Through her aristocratic family, she had an early introduction to the arts. Tellingly, however, in 1903, Abbéma wrote that it was lesbian painter Rosa Bonheur who "…decided me to become an artist."

Abbéma began studying art at an early age. By twelve she had begun to paint, making genre scenes of her hometown. In 1873 she went to Paris to study with painter Charles Chaplin and the following year with Carolus-Duran. At this time it was still somewhat unusual for women to be accepted in the art academies. She later studied with Jean-Jacques Henner.

In 1876, at age 18, Abbéma painted a portrait of her good friend, the lesbian actress Sarah Bernhardt, whom she met five years earlier. The portrait was exhibited at the Paris Salon des Artistes Français of 1876 (at Carolus-Duran's suggestion, she had begun showing work in the Salon the previous year). *Portrait of Sarah Bernhardt* was an immediate success for the young painter, and Abbéma became Bernhardt's official portraitist.

Soon after this success, Abbéma made a bronze medallion of Bernhardt (the only known sculpture by her), which she exhibited at the Salon in 1878. In turn, Bernhardt, herself a sometime sculptor, exhibited a marble bust of Abbéma at the same Salon. Abbéma later made drawings

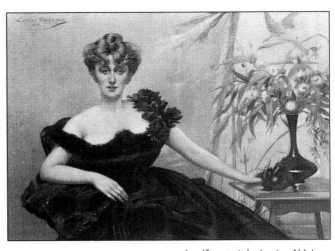

A self portrait by Louise Abbéma.

after both sculptures. Abbéma and Bernhardt maintained a close friendship throughout their lives.

Abbéma's long relationship with Bernhardt, coupled with the fact that she never married, has been the basis for the widespread assumption that she was a lesbian.

In addition to painting Bernhardt, Abbéma also made portraits of her instructor Carolus-Duran; Charles Garnier, architect of the Paris Opéra; and Ferdinand de Lesseps, among many others. One of her most esteemed works is the painting *Déjeuner dans la serre* (owned by the Museum of Pay, France), which may most fully declare her affinities with the Impressionists.

Like many artists, Abbéma enhanced her reputation by regularly exhibiting at the Salon. She received an honorable mention from the Salon in 1881 and continued to show there until 1926. An artist of international reputation, she also exhibited work in the Women's Building at the 1893 World's Columbian Exposition in Chicago.

Among Abbéma's surviving works are mural sketches she made for the Columbian Exposition and large decorative panels for the Town Halls of Paris and the 7th, 10th, and 20th arrondissements; the Hôtel de Ville; the Musée de l'Armée; the Théâtre Sarah Bernhardt; and the French National Horticultural Society. Her international work includes decorative panels for the Palace of the Governor of Dakar in Senegal, Africa.

In 1900, Abbéma exhibited work at the Exposition Universelle in Paris and was awarded a bronze medal. She was nominated as official painter of the Third Republic, and in 1906 she was awarded the Cross of Chevalier de la Légion d'Honneur.

Abbéma died in 1927, aged sixty-nine, having had a long and successful career. — *Carla Williams*

BIBLIOGRAPHY

Bénézit, E. *Dictionnaire critique et documentaire des peintres, sculpteurs dessinateurs et graveurs. Vol. 1.* Paris: Librairie Grund, 1976.

Fusco, Peter, and H.W. Janson, eds. *The Romantics to Rodin: French Nineteenth Century Sculpture from North American Collections.* Los Angeles: Los Angeles County Museum of Art in association with George Braziller, 1980.

Garfinkle, Charlene G. "Louise Abbema and the Transatlantic Nature of Her Columbian Exposition Mural Sketches." Lecture, Ohio State University, 1999.

www.comenosfinearts.com/european/abbema_bio.htm

SEE ALSO

European Art: Nineteenth Century; Bonheur, Rosa

Abbott, Berenice *(1898–1991)*

Accomplished American photographer Berenice Abbott may be best known for her photographs of New York City's changing cityscape, but she also made memorable images of lesbians, bisexuals, and gay men in Paris in the 1920s and in New York from the 1930s through 1965.

Born in Springfield, Ohio, in 1898, Abbott briefly attended Ohio State University before moving to New York City in 1918. In New York, she lived in a semi-communal Greenwich Village apartment shared by Djuna Barnes and others. Man Ray and Marcel Duchamp were part of her social circle.

In 1921, Abbott moved to Europe, where she studied sculpture in Paris and Berlin. Among her lovers in Paris were artists' model Tylia Perlmutter and sculptress and silverpoint artist Thelma Wood. In Paris, between 1923 and 1925, she studied photography while working as Man Ray's assistant. In 1926, she opened her own portrait studio and had a successful one-person exhibition. Two years later, she showed photographs at the Salon des Indépendants.

During Abbott's Paris years, she photographed many figures from the worlds of literature and the arts, including James Joyce, Foujita, Coco Chanel, and Max Ernst. However, her most significant contribution to queer history and aesthetics are her vivid portraits of lesbians and bisexuals. Among these are the younger expatriate lesbian writers Margaret Anderson, Jane Heap, Sylvia Beach, Bryher, Janet Flanner and Flanner's lover Solita Solano, as well as the artist Gwen Le Gallienne, with whom she frequented gay bars.

Another of Abbott's most memorable images is that of a masculine-appearing Thelma Wood, made after she and Abbott were no longer lovers. Abbott also photographed Wood's new love, Djuna Barnes, whose affair with Wood was the inspiration for the novel *Nightwood* (1936). Unlike her image of Wood, Abbott's photograph of her lover, Tylia Perlmutter, is delicate and dreamy.

Abbott also photographed the French bookstore owner Adrienne Monnier, Sylvia Beach's lover; the wealthy Violette Murat (Princess Eugène Murat); and artist Marie Laurençin, a bisexual who may have had an affair with Murat. Abbott made images as well of such gay or bisexual men as André Gide, Robert McAlmon, and the flamboyant Jean Cocteau. Abbott's bisexual Paris clients also included painters Margaret Sargent and Betty Parsons (later of the Betty Parsons Gallery in Manhattan) and architect/designer Eileen Gray.

Returning to New York City in 1929, Abbott photographed the rapidly changing city. She also photographed U.S. Highway 1 from Maine to Florida and

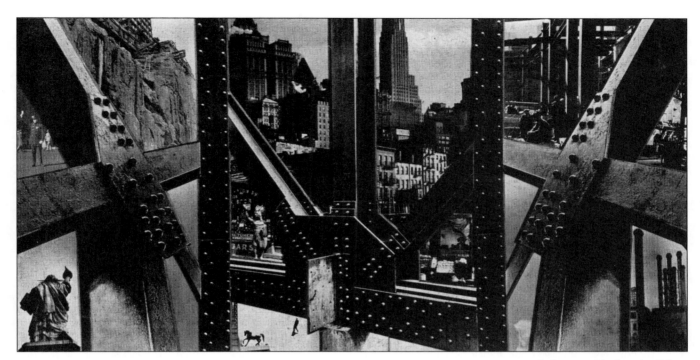

A photomural by Berenice Abbott.

created images to illustrate the laws and processes of physics. But she also continued making images of lesbian and bisexual women. In particular, she photographed such subjects as poet Edna St. Vincent Millay, Harlem Renaissance art patron A'Lelia Walker, and actress/director Eva Le Gallienne, Gwen's stepsister.

In New York, Abbott formed an alliance with critic Elizabeth McCausland, which lasted from the early 1930s until McCausland's death in 1965. Abbott's portraits of McCausland confirm the aptness of the nickname she gave her lover, "Butchy." McCausland wrote early essays about Abbott's work.

Having almost flaunted her love of women early in her life, Abbott later obscured and even lied about her lesbianism, distancing and closeting herself as thoroughly as possible. In 1968, she moved permanently to Maine.

Had her lovers been male and her lesbian and bisexual subjects been heterosexual, Abbott's work—given its quality and the accomplishments of her subjects— would have achieved earlier and greater recognition. Still, her work brought her fame and financial security. Her images of blatantly lesbian-appearing women, such as Jane Heap, for example, have been exhibited in art galleries and museums for decades. As the story of her life and the lives of her subjects become better known, her role in creating memorable images of gay, lesbian, and bisexual people finds greater appreciation.

— *Tee A. Corinne*

BIBLIOGRAPHY

Abbott, Berenice. *Berenice Abbott Photographs*. New York: Horizon Press, 1970. Washington, D.C., and London: Smithsonian Institution Press, 1990.

Mitchell, Margaretta K. *Recollections: Ten Women of Photography*. New York: Viking, 1979.

O'Neal, Hank. *Berenice Abbott: American Photographer*. New York: McGraw-Hill, 1982.

Peters, Susan Dodge. "Elizabeth McCausland On Photography." *Afterimage* 12.10 (1985): 10–15.

SEE ALSO

Photography: Lesbian, Pre-Stonewall; Gray, Eileen; Parsons, Betty; Wood, Thelma Ellen

African Art: Contemporary

B LACK AFRICANS TYPICALLY SHUN MEMBERS OF THEIR communities who are openly gay because they believe Westerners imposed homosexual behavior on their indigenous cultures. Consequently, and unfortunately, intolerance of homosexuality in Africa is frequently urged as an active moral and developmental good, and seen as part of the struggle of African nationalism against Western imperialism. In this difficult climate, only a few openly gay black African artists produce work with homosexual themes.

Bulelwa Madekurozwa

One such artist is the painter Bulelwa Madekurozwa (b. 1972), who lives and works in Harare, Zimbabwe. While studying in Harare in the early 1990s, Madekurozwa discovered that most of the artists in her school were men who painted portraits of stereotypically shy but proud African women tilling fields and toting babies. To challenge this representation, Madekurozwa painted portraits of strong black women with direct gazes.

Early in her career, Madekurozwa grappled with ways to express her thoughts and experiences as an African lesbian through her art. To put it mildly, lesbianism is not accepted in Zimbabwe. Although the country has an active women's rights movement, females are both socially and legally disadvantaged.

Since women traditionally were denied individual sexual identities, lesbians face horrifyingly violent anti-gay sentiments. As the country's gay community slowly takes shape, therefore, women are being left behind. While men who come out in Zimbabwe at least know that male homosexual relationships exist, the inability even to conceive of a lesbian relationship hinders the coming-out process for women.

It is therefore not surprising that Madekurozwa makes only veiled references to lesbianism in her paintings. In one early work, two figures—one clothed and androgynous, the other with the nude body of a black woman—embrace.

When the public did not take Madekurozwa's early paintings seriously, she decided to change her subject matter. She discovered that her work makes more of an impression on Zimbabweans when she addresses homosexuality through images of males. Additionally, painting seminude male figures allows Madekurozwa to counter the frivolous display of half-naked women's bodies on television and in movies, videos, magazines, and paintings. In her works, the male body becomes a commodity since it is objectified for the delight of the viewer.

"Heaven" (1997) depicts a young, uniformed policeman in a state of half undress crouching in an alluring pose. The painting grabs the viewer's attention since it is nearly life-sized and the composition looks like a close-up snapshot, with parts of the figure cut off at the edge of the canvas. The absence of margins around the figure encourages the viewer's eye to travel into the scene and caress the male body.

"Heaven" borrows the pinup idea featured in the logo of a well-known gay club, and the scribbled messages in the upper right-hand corner are reminiscent of lewd bathroom graffiti. Madekurozwa serves the policeman to the viewer like a piece of meat while making the point that figures of authority are as human as the rest of us and, as such, are sexual—sometimes homosexual—beings.

"Sunday Afternoon" (1997) addresses the homosexual nature of two male policemen. The figures, one of them only partially clothed, lovingly embrace while facing the viewer. Madekurozwa's large, flowing, sumptuously colored brushstrokes are so sensuous, the figures' expressions so tender and content, that the viewer is forced to ask: How can anything be wrong with this?

Madekurozwa's paintings of authority figures articulate the conflict between societal expectations, gender stereotyping, and personal needs. Her work encourages viewers to challenge convention so that they may achieve personal fulfillment.

Rotimi Fani-Kayode

Like Madekurozwa, the Nigerian-born, London-based photographer Rotimi Fani-Kayode (1955–1989) used his art to undermine conventional perceptions. His photographs of nude or seminude black males frequently blend African and Western iconography with sexual, sometimes homoerotic, themes. They present an alternate reality, transporting the viewer into unfamiliar worlds that encourage a reconsideration of commonly held ideas and assumptions about racial and sexual identity.

Living in London since adolescence, Fani-Kayode was all too aware of the Western world's misperception and misrepresentation of black Africans. His black-and-white photograph entitled "Mask" (1989) appears, at first glance, to fulfill the Western stereotype of the African "primitive": The male subject wears only a loincloth and crouches in an aggressive pose, seemingly ready to run into the jungle toting a bow and arrow.

Fani-Kayode also knew that, in the Western imagination, the African body is not only exotic but also erotic. Consequently, when the viewer scrutinizes "Mask," she realizes that the loincloth is actually a studded leather jockstrap. Further, the man's "teeth" are metal portions of the studded cock ring that he holds in his mouth. The jockstrap and cock ring parody the Western idea that the black male is nothing more than a sex machine that emits semen and speaks salacious words.

Further, the over-the-top representation found in "Mask" challenges the validity of this stereotype. The two plant fronds that the figure holds in front of his face function as a mask, reminding viewers that they should look beyond stereotypes to discover complex personalities. By creating a brash, in-your-face image, Fani-Kayode forces the viewer to reconsider his understanding of race and sexuality.

Fani-Kayode's black-and-white photograph entitled "White Bouquet" (1987) also shakes the viewer's established worldview. The photo, a reinterpretation of Édouard Manet's famous painting *Olympia* (1863), shows a white man presenting a bouquet of flowers to a black male lounging on a chaise. Both nude figures turn their backs to the viewer. In Manet's work, a clothed black female servant gives flowers to a nude white female prostitute, and both women face the viewer.

"White Bouquet"'s gender and racial reversal is echoed in its compositional inversion; even the presenter of the flowers is on the opposite side from that in *Olympia*. This undoing of the familiar results in an ambiguous image left open to many complex interpretations.

Conclusion

Although a few contemporary black African artists address issues of homosexuality, violent opposition to the gay lifestyle in Africa makes it difficult for them. While Bulelwa Madekurozwa cautiously exhibits her work in Zimbabwean galleries, Rotimi Fani-Kayode once stated that if he exhibited his works in Nigeria, riots would break out. Certainly Fani-Kayode would have been accused of spreading corrupt and decadent Western values.

— *Joyce M. Youmans*

BIBLIOGRAPHY

Bailey, David A. "Photographic Animateur: The Photographs of Rotimi Fani-Kayode in Relation to Black Photographic Practices." *Third Text* 13 (Winter 1997): 57–62.

"Bulelwa Madekurozwa." *Gasworks Gallery.* www.gasworksgallery.org/varts/bul_mad/ (20 July 2001).

Chipunza, Linda. "Looking Closely." *Gallery: The Art Magazine from Gallery Delta* 16 (June 1998): 16–18.

Fani-Kayode, Rotimi. "Traces of Ecstasy." *Ten.8* 2.3 (Spring 1992): 64–71.

Fani-Kayode, Rotimi, et al. "Rotimi Fani-Kayode and A. Hirst." *Revue Noire* 3 (December 1991): 30–50.

Hall, Charles. "Rotimi Fani-Kayode." *Arts Review* 43.1 (January 1991): 42.

Oguibe, Olu. "Finding a Place: Nigerian Artists in the Contemporary Art World." *Art Journal* 58.2 (Summer 1999): 30–41.

Mabanga, Thebe, and Bulelwa Madekurozwa. "The Male Commodity." *Daily Mail and Guardian*, 29 September 2000. www.mg.co.za/mg/art/q_n_a/000929-bulelwa.html (20 July 2001).

Mercer, Kobena. "Mortal Coil: Eros and Diaspora in the Photographs of Rotimi Fani-Kayode." *Overexposed: Essays on Contemporary Photography.* Carol Squiers, ed. New York: The New Press, 1999. 183–210.

Sibanda, Doreen. "Contemporary Maskings: Bulelwa Madekurozwa and Tendai Gumbo." *Gallery: The Art Magazine from Gallery Delta* 13 (September 1997): 12–15.

Taylor, Robert. "Gay Artist, Black Genius." *Body Politic 5: Power Tools.* www.bodypolitic.co.uk/body5/rotimi.html (6 July 2001).

Vera, Yvonne. "Bulelwa Madekurozwa." *Revue Noire* 28 (March–April–May 1998): 10–13.

Wright, Kai. "Lesbians Admonished with 'Sew Them Up': Organizing Challenges for Zimbabwean Women Come from Outside, within Gay Community." *The Washington Blade*, May 5, 2000. www.aegis.com/news/wb/2000/WB000501.html (13 July 2001).

SEE ALSO

African Art: Traditional; African American and African Diaspora Art; Fani-Kayode, Rotimi

African Art: Traditional

MANY FORMS OF AMBIGUOUS SEXUALITY CAN BE found throughout the traditional arts of Africa, including images of androgyny, hermaphroditism, and transvestism. Moreover, much of erotic sculpture and theater can also be seen as homoerotic, although the goals of eroticism may differ greatly in the African context from those of the Western context, having more to do with increase and the veneration of ancestral power than with sexual pleasure. Furthermore, African art is so symbolic and iconic that if homosexual implications do exist, they may be difficult for the outsider to read.

Traditional African art is distinguished here from contemporary African art, but it should be noted that tradition and the contemporary are not mutually exclusive in Africa. If "tradition" is recognized to mean "handed down," then most of what is known as the traditional African arts almost always blends the traditional with the transitional, or the "handed across," to varying degrees. The same can be said of homosexual traditions.

African arts are a holistic form traditionally, consisting of the integration of sculpture, costuming, sound, movement, oral narrative, and theater, which sometimes are indistinguishable. This concept of holism applies not only to the arts, but pervades all of traditional African thinking about the nature of things and of human behavior. Holism does not divide, as in Western compartmentalization and categorization.

Polarities

In Africa, polarities such as "homosexual" and "heterosexual" may function as complementary oppositions generally do, expressing the extremes of human behavior such as the passive and the aggressive, the benevolent and the malevolent, the feminine and the masculine, or the spiritual and the physical.

There are many examples of dual, antithetical masks. Among the Baga of Guinea, for example, the masquerade of D'mba is the epitome of beauty and good comportment, while her antithesis, D'mba-da-Tshol, is the epitome of ugliness and erratic behavior. Among the Dan of Liberia, sleek and gentle female masks are opposed to grotesque and violent male masks.

In social structure, dual entities exist, such as masculine and feminine sides of the village among the Baga, each containing men and women, each side complementing the other in complex alignments of paired oppositions.

Together, these pairings in masking and in social structure suggest the human condition and the need to balance complementary oppositions such as aggression and passivity, order and chaos, care and neglect, the hot and the cool, and masculine and feminine qualities in

both men and women. In much of African culture, the extremes, which are found in all of us, are considered useful and should be channeled situationally.

Homosexual Behavior in African Cultures

Apparently, many cultures in Africa include the range of sexuality in these useful dualities. Quite a few studies have shown that homosexual behavior is accepted in many traditional African societies, even if, like much of African thought, it is not to be discussed openly. Homosexual behavior has its accepted niche, for example, among the Temne of Sierra Leone, where it is associated with the "left hand," as opposed to the "right," the hidden and private as opposed to the open and public.

Public display is governed in Africa differently from the West. Same-sex physical affection such as holding hands, hugging, kissing, and sleeping together is simply the African norm, displayed openly, although not associated with homosexuality. Public display of affection between men and women, however, is considered offensive.

Sexual play and intercourse between men, especially, and, to some extent, between women, has been documented widely in traditional Africa, and in some cases it is practiced openly. Frequently scholars have attributed these activities to economic need of the powerless, sexual voracity of the powerful, or the social prohibition of heterosexual activity before marriage. Sexual preference, however, might also be considered a factor in some cases.

In the ritual arts, some homosexuality seems to have taken place, although this is extremely difficult to document, given the severe secrecy governing most of African ritual. Because of its special status, homosexuality is often accommodated in ritual situations, such as the priesthood, where the special facility of gender mediation suggests special spiritual powers. Ritual contexts have also provided for the acceptance of homosexuality as a stable category, and for some rare cases of homosexual marriage within traditional African societies.

Homosexual Coupling in Art and Ritual

In the material form of the arts, the clear depiction of homosexuality of any type is almost nonexistent. There are, however, two exceptions worth noting.

One ancient Egyptian wall relief from Dynasty V south of Saqqara shows the close embrace of two powerful male court officials, Nyankhkhnum and Khnumhotep, both bearing the title of "king's manicurist." Face to face, with noses touching, one holds the other's wrist, while the other, slightly behind, holds the shoulder of the first.

Although their shared tomb depicts their respective wives and children as well, which is common imagery, this precise embrace is a pose reserved in Egyptian art for spouses, or in representing the king being received by a god, and the embrace of two men is never otherwise seen. The two men have been called brothers, or twins, by scholars, but no written evidence from the tomb supports this.

South of the Sahara, one ivory carving dating to the early twentieth century from the Vili of Congo (Kinshasha), in a private collection in Antwerp, seems to show several homosexual scenes: two men with their hands on the genitals of adjacent men, two men holding a phallic staff, and one man holding his own erection.

Sexuality is clearly an element in some prehistoric South African rock painting, where groups of men are shown with erections, but they are generally hunting scenes, and the intent of this imagery is elusive. Wrestling scenes in Egyptian art, such as those at Beni Hassan, may seem homoerotic to Westerners, but they function in the context of war and Egyptian assertions of power.

To the casual observer, the appearance of homosexuality in African art is often the result of a misunderstanding of complex symbolic codes. Conversely, the seeming absence of clear imagery throughout African art may be due to our inability to interpret more abstract conventions, or due to the inherent "left-handedness" or secrecy of homosexual acts.

Homosexual coupling, both male and female, however, clearly exists in other forms of art, such as theatrical ritual, where it can easily be read because of the direct use of the human body. In the proceedings of male and female initiation into adulthood, the context of some of the most magnificent African art and essentially a theater of symbolic performance ritual, homosexual practices are often reported.

Man–boy sex, or at least the representation of it, is most common. Among the Temne of Sierra Leone, for example, the last boy to be initiated is given the name, Tithkabethi ("vagina initiate"). Boys in initiation often wear women's clothes, as documented among the Temne and among the Nandi of Kenya.

Among the Ndembu of Congo (Kinshasa), the chief instructor of the boys' initiation is called the "husband of the novices" and the novices themselves are called *mwadi*, senior wives, and are said to be "married by" the chief instructor. The novices are said to play with the sexual organs of male visitors to the initiation lodge, a practice considered helpful in the healing of their circumcisions. In a particular ritual, an elder man lies on the ground, exposing his penis, and each of the novices mimes copulation with him.

One must keep in mind that initiation procedure is performance, not real life. Nevertheless, that these practices overlie real man–boy sex within the initiation is not so hard to imagine, as the practice has been documented so thoroughly throughout Africa in daily life apart from ritual. In Sierra Leone, for example, it is rather common for a "big man," who otherwise leads a heterosexual life,

to have sex with an adolescent boy, to whom he gives gifts, as he would to any lover. Enough suggestions have been given of homosexual insertion as a part of African male initiation to give the practice some credibility.

Throughout the male initiation ceremony, the masculinity of the young boy is challenged, whether through beatings by the older men, the ritual mutilation of his penis, or through sexual receptivity. It has been suggested that since initiation procedures are sexually exclusive, and each sex remains independent from the other for a given period of time, heterosexual intercourse itself is rejected in favor of homosexual intercourse.

Nowhere in Africa is man–boy sex explained, as it is in New Guinea, as a means of increasing the sexual potency of the young boy. Rather, it seems to function as a demonstration of power relations, and, to some extent, as sex education as well as gender formation. It is in the rituals of male and female initiation principally that the social construction of gender is negotiated and reinforced.

Among women in initiation proceedings, for example in the Bondo association of Sierra Leone, it is said that the very tight bonds that are developed between the initiates of the same age group often include homosexuality, in the context of an extremely close and lengthy confinement away from the rest of society, and that these relationships often continue into adulthood and heterosexual marriage.

Among the Kaguru of Tanzania, some men claim that women demonstrate sexual intercourse to the girls in initiation, the leaders together, and with the initiates, taking the roles of both men and women, although this has not been confirmed.

Homosexuality in the Artist/Ritual Leader

While homosexuality may not often be the subject of African art, homosexual persons may be more inclined than others to become practitioners of the arts and rituals. In the Sudan, the healing ritual system known as *zaar*, practiced mainly by women, is also joined by men, some of whom become ritual leaders. These men are assumed to be homosexual by the community, and some are overtly homosexual. In Mombasa, Kenya, receptive homosexual men called *mashoga*, dressed in wigs and women's clothes, are active as performers at weddings, playing the *pembe* (a female musical instrument), and doing *chagkacha* (a seductive female dance).

Male ritual leaders called *mugawe* among the Meru of Kenya dress as women routinely and sometimes even marry other men. Coptic monks in the sixth or seventh century, whose work included the painting of sacred manuscripts, apparently were known for their homosexuality, judging by a man's wedding vow on papyrus that promises "never to take another wife, never to fornicate, nor to consort with wandering monks."

Among the Dagara of Burkina Faso, the homosexual man is said to be well integrated into the community, occupying a performance role of intermediacy between this world and the otherworld, as a sort of "gatekeeper." As Somé reports, a Dagara man has testified that such a person "experiences a state of vibrational consciousness which is far higher, and far different from the one the normal person would experience.... So when you arrive here, you begin to vibrate in a way that Elders can detect as meaning that you are connected with a gateway somewhere.... You decide that you will be a gatekeeper before you are born."

Diviners, who manipulate materials to find a spiritual solution to clients' problems, in several areas of Africa have been known to be homosexuals, for example among the Zulu of South Africa and among the Nyoro of Kenya, where they would demonstrate spiritual possession by "becoming a woman."

Carlos Estermann found that among the Ambo of Angola a special order of diviner, called *omasenge*, dressed as women, did women's work, and contracted marriage with other men who might also be married to women. "An *esenge* [sing. of *omasenge*] is essentially a man who has been possessed since childhood by a spirit of female sex, which has been drawing out of him, little by little, the taste for everything that is masculine and virile."

In the case of the Zande of the Central African Republic, sex between a man and a boy was said to benefit the diviner, and would take place before the consultation of oracles, when sex with women would be taboo. But, as Evans-Prichard reported, the Zande went on to allow that the reason was not simply ritual prohibition, but also "just because they like them."

Homoeroticism in Art

Perhaps the most common use of eroticism in African art is the depiction of the phallus. Well-known examples of singular phallic sculpture include columnar earthen shrines, documented among many groups in the Sahel— for example, the Dogon, Batammaliba, and Lobi. The sexual realism of these columns is heightened by the pouring of white meal over the rounded top.

Large, vertical, stone pillars, called *akwanshi*, found along the Cross River in Nigeria, and traced to before the colonial period, are carved quite realistically as an erect penis, with a distinct head and shaft. Generally the height of an adult person, they seem also to represent a truncated human figure.

Male initiates among the Zulu of South Africa carry wooden clubs with a knob on the end resembling the head of a penis. With sometimes several dozen young men initiated at one time, the sea of upraised phalluses is a powerful sight.

The Baga of Guinea revere a great male founding spirit who is manifested by an enormous, vertical shaft of fiber, perhaps twenty meters tall, topped by a wooden bird head, and carried inside by as many as twenty men. The powerful male image is frightening to the community, as it shivers and throbs. Alternatively, a heavy, wooden, vertical shaft in the form of a huge serpent may represent the founding male spirit, and is balanced on top of the dancer's head.

The exaggeration of the phallus as a part of a male figure is almost universal throughout Africa. The Yoruba god, Eshu, the god of confusion, the crossroads, chance, and sex, is depicted with a wooden phallus sprouting from the top of his head. Wooden figures of ancestral chiefs among the Ndengese of Congo (Kinshasa), are carved with enormous phalluses to emphasize the fertile power of the ancestors. The Egyptian god, Amun-Min, he who awoke the sexual potency of the god Osiris, is depicted as a mummy with an erection.

Among the Yaka of Congo (Kinshasa), during the initiation called *nkanda*, young male officials perform with erotic masks known as *kholuka* in the coming-out ceremonies. The masks, constructed by the young men, often are surmounted by human figures in heterosexual intercourse but also frequently by the single male figure with an enormous erection, very realistically formed, and sometimes shown in masturbation. During the dance, including pelvic thrusts, the dancer also carries a wooden phallus, and sometimes sheds his clothing to reveal his own erect sexual organ. During this performance, the men disparage the women and ridicule the women's sexual organs, while extolling their own.

All these phallic representations are made by, made for, and used by, men exclusively. What is one to make of the stimulus for this? If men are the ones who venerate, worship, and manipulate the representation of the male organ, and are energized by it, it cannot be seen as other than same-sex attraction of a sort, and perhaps symbolic mutual masturbation, even as the stated intention is to honor the ancestors, to encourage fertility and increase, or to enliven the dead.

In female homosexuality, the creation of an artificial penis has been documented among the Ovimbundu. Wilfred Hambley mentioned, in 1937, that "A woman has been known to make an artificial penis for use with another woman."

In Zanzibar, the artificial penis was said by M. Haberlandt, in 1899, to have been made by black and Indian craftsmen. "It is a stick of ebony in the shape of a male member of considerable size, sold secretly. Sometimes it is also made from ivory. There exist two different forms. The first has below the end a nick where a cord is fastened, which one of the women ties around her middle in order to imitate the male act with the other. The stick is pierced most of the way and it then pours out warm water in imitation of ejaculation. With the other form, the stick is sculpted with penis heads at both ends so that it can be inserted by both women into their vaginas, for which they assume a sitting position. This kind of stick is also pierced. The sticks are greased for use."

Cross-Dressing in Art

African art history is full of references to cross-dressing, both male-to-female and female-to-male. Throughout Africa, masked dance is almost exclusively performed by men, even when the character represented is female. There are just a few examples of women's costuming, even fewer examples of any type of women's masking, and only one example where a woman exclusively wears a wooden mask representing a woman. So the opportunities for women to represent men are far fewer than the opportunities for men to represent women.

Still, numerous examples have been given of women costumed as men, without masks, in a performance of ridicule and perhaps defiance. Women of the Bondo association in Sierra Leone are seen in the final ceremonies of the girls' initiation dressed as men, frequently with two giant gourds under their pants meant to ridicule herniated men. The women sometimes approach men and imitate active sexual penetration, in a reversal of the norm.

Throughout Africa, it is common to see ceremonies in which some men dress as women, and this has been explained variously as ritual of inversion, ritual of rebellion, and as a means of "making special" or setting apart the event from the routine.

In a particular Bondo ceremony called *e-lukne* ("the transplanting"), men often dress as women in a ritual of total upheaval where the townspeople race around the town carrying rubbish, tree limbs, and old furnishings. Here the meaning seems to be one of overturning the social order, with no reference directly to homosexuality, and ultimately serving as a trope for the discombobulating transfer of the young woman from her clan of birth to the clan of her husband.

Among the Baga of Guinea, almost any masked dance occasions the appearance of one or two men without masks but in women's gowns and jewelry, a phenomenon completely unexplained except to say, "Because they like to."

But an exceptional event is the Baga dance for their great female spirit, a-Bol, in which all the participating men dress as women and imitate their movements erotically, undulating the hips, and sometimes suggesting sexual intercourse with men on the sidelines. The musical instruments used during the dance are those normally reserved exclusively for women: the cittern, *wa-sakumba*, and the small *të-ndëf* drum.

It has been suggested that because the female spirit is the patron of the lower-ranking clans, associated with "the younger," who are, in turn, associated with homosexuality (common before marriage), the men representing her are placed ritually in this class and its sexual reference.

Among the Yoruba of Nigeria, priests of the god Shango, the god of thunder and lightning, are usually female, but male priests are common and they always dress as women, with braided hair. They operate in the ritual context in which the god is said to "mount" the priest in spirit possession, as a male animal mounts a female in intercourse. Some studies have indicated specifically that the male priests do not practice homosexuality, while others have disputed this.

There are hundreds of examples throughout West and Central Africa in which men represent women with masks, sometimes with false breasts and false pregnant bellies—for example, among the Dogon of Mali, the Yoruba of Nigeria, and the Chokwe of Zambia. It is the men, not the women, who represent the spiritual world, in general, and who are authorized to perform masked, with the exceptions noted above.

Explanations for this phenomenon may vary from group to group, but commonly it is simply a function of the male control of the spiritual. Women are often associated with the physical world, the village, and the home, whereas men are often associated with the spiritual world, the world outside the secure domicile.

Men also use masks to control, to honor, to placate, and sometimes, to rebuke women. In the Yoruba *Gelede* dances, for example, men assume the likeness of "the mothers" in order to control their extraordinary powers, which they fear, and which are symbolized, in part, by the woman's unique ability to nurture.

Gender Transformation

There are some examples of permanent gender transformation, which goes beyond occasional cross-dressing, in which men "become" women and women "become" men in African ritual. Among the Gabra of Ethiopia and Kenya, symbolic gender inversion takes place as a function of the gender-specificity of space, as older men are assigned to the inside of the camps, a feminine space, whereas masculinity is constructed among the younger men by assignment to the outside. Whereas the initiation of boys turns them into men, the second initiation, *jilla galaani* ("rites of the return home"), turns the men into women socially, though not sexually.

In Sierra Leone, men are theoretically unable to join the women's Bondo association, but one case has been mentioned in which a man who had violated Bondo secrecy was initiated as a Bondo official and was henceforth regarded as a woman. Likewise, women in Sierra Leone are prohibited from joining the men's Poro association, but every local chapter of Poro is likely to have a few women in official positions who, likewise, are said to have violated Poro law, and are required to live their lives as men.

No one has studied this phenomenon in depth enough to determine exactly what this means sexually. One wonders how "coerced" the transformations are, when every potential violator, even from childhood, knows well the consequences of such a violation.

The accession to leadership sometimes seems to require gender transformation. Two pharaohs of ancient Egypt, Hatshepsut and Smenkhare, who are believed to have been women (the latter being Nefertiti in her later years), are consistently shown wearing false beards and men's clothing, just like the male pharaohs. This is probably not because they functioned as men sexually, but because a male identity was needed to function as a pharaoh. Accompanying texts refer to them exclusively as men.

Women elsewhere in Africa today who take the role of monarchs may be regarded as women sexually but as men socially, and are called not queens, but kings and chiefs, as among the Mende of Sierra Leone, the Chokwe of Zambia, or the Mbundu of Angola. One might argue that this is a convenient mechanism to avoid enfranchising women as a class.

Sexual Duality

Many representations exist showing the human being as Janus, of dual sex. Janus masks of the Ejagham in Nigeria, for example, have one face dark and one light, delineating the oppositions of physical and spiritual, female and male. Human figures of the Lobi of Burkina Faso, the Dogon of Mali, and the Luba of Congo (Kinshasha), among many African ethnic groups, are carved with a male face on one side and a female face on the other. This depiction can represent the bisexual ancestors or other spiritual beings who are both male and female or have attributes of both. It can also represent the ability to work in both the physical and the spiritual worlds, themselves frequently aligned with such dyads as the interior and exterior, the village and the wilderness, and the feminine and the masculine.

Conclusion

Although homosexual activity is widely documented in the history of Africa, and homosexual status is known as a tradition in various areas, the depiction of the homosexual is almost unknown in sculpture and painting for traditional ritual. However, it is well-known in ritual performance. The problem for research is how to interpret this phenomenon, and even more basically, how to decipher it within an artistic system based upon metaphor and hidden meaning.

While there is little evidence of the homosexuality of artists, per se, there is widespread documentation of the homosexuality or gender transformation of the leaders of ritual performance, who function as intermediaries between worlds because of their gender fluidity. In the world of African art and ritual dominated by men, the enormous corpus of phallic objects seems to suggest, if not homosexual preference, then homosexual fascination, celebration, reverence, or titillation. In the exhibition of homosexual activity, gender transformation, cross-dressing, androgyny, and sexual duality, many possibilities of interpretation exist, and the student of African art and communication, which are always highly metaphoric, is cautioned to avoid assuming the obvious.

— *Frederick Lamp*

BIBLIOGRAPHY

Beidelman, Thomas O. *The Cool Knife: Imagery of Gender, Sexuality, and Moral Education in Kaguru Initiation Ritual*. Washington, D.C.: Smithsonian Institution, 1997.

Bourgeois, Arthur P. "Yaka Masks and Sexual Imagery." *African Arts* 15.2 (1982): 47–50, 87.

Drewal, Henry J., and Margaret T. Drewal. *Gelede: Art and Female Power among the Yoruba*. Bloomington: Indiana University Press, 1983.

Dundes, Alan. "A Psychoanalytic Study of the Bullroarer." *Man* n.s. 11.2 (1976): 220–238.

Evans-Prichard, Edward E. "Sexual Inversion among the Azande." *American Anthropologist* 72 (1970): 1428–1434.

Haberlandt, Michael. "Conträre Sexual-Erscheinungen bei der Neger-Bevölkerung Zanzibars." *Zeitschrift für Ethnologie* 31.6 (1899): 668–670.

Hambley, Wilfred D. *Sourcebook for African Anthropology*. Chicago: Field Museum, 1937.

Hollis, Alfred C. *The Nandi*. Oxford: Clarendon Press, 1909.

Lamp, Frederick. "Frogs into Princes: the Temne Rabai Initiation." *African Arts* 11.2 (1978): 34–49, 94.

———. *Art of the Baga: A Drama of Cultural Reinvention*. New York: Museum for African Art; Munich: Prestel, 1996.

———, ed. *See the Music, Hear the Dance: Rethinking African Art at the Baltimore Museum of Art*. Baltimore: Baltimore Museum of Art; Munich: Prestel, 2004.

Matory, J. Lorand. *Sex and the Empire That Is No More: Gender and the Politics of Metaphor in Oyo Yoruba Religion*. Minneapolis: University of Minnesota Press, 1994.

Murray, Stephen O., & Will Roscoe, eds. *Boy-Wives and Female Husbands: Studies of African Homosexualities*. New York: St. Martin's, 1998.

Pierpont Morgan Library. Coptic papyrus, M662 B12 (wedding contract for a cleric), 6th–7th centuries.

Smith, W. Stevenson, and William K. Simpson. *The Art and Architecture of Ancient Egypt*. New York: Penguin Books, 1981.

Somé, Malidoma Patrice. "Gays As Spiritual Gate Keepers." *White Crane Newsletter* 4.9 (1993): 1, 6, 8.

Turner, Victor. *The Forest of Symbols: Aspects of Ndembu Ritual*. Ithaca, N. Y.: Cornell University Press, 1967.

Talbot, P. Amaury. *Some Nigerian Fertility Cults*. London: Oxford University Press, 1927.

Wood, John Colman. *When Men Are Women: Manhood among Gabra Nomads of East Africa*. Madison: University of Wisconsin Press, 1999.

SEE ALSO

African Art: Contemporary; Pacific Art

African American and African Diaspora Art

GAY AND LESBIAN REPRESENTATION IN THE VISUAL arts created by people of the African Diaspora emerged most clearly in the late twentieth century as artists began to explore issues specific to gender and sexuality. Artists attracted to members of their own sex certainly existed all along, but prior to the late twentieth century their visibility was not nearly as apparent and their work did not deal explicitly with themes relating to their sexuality.

For example, the American expatriate nineteenth-century sculptor Mary Edmonia Lewis (1845–1890) was probably a lesbian and Harlem Renaissance–era sculptor James Richmond Barthé (1901–1989) was almost certainly gay, but neither Lewis nor Barthé publicly declared their homosexuality.

Drawing on a long tradition of autobiography in African American history, however, contemporary artists rely heavily on self-portraiture, which almost necessarily involves the exploration of sexual and affectional issues. Perhaps because African American culture has traditionally been unaccepting of homosexuality, many artists of color remain "closeted" longer than their counterparts in the majority white culture. Thus, many of these artists find themselves dealing with issues of external and internal homophobia as well as external and internal racism.

At the same time, however, much of the contemporary work incorporates desire and longing, in both sexual relations and in representing the self, as well as in demanding representation of lives and sexualities that are otherwise ignored or suppressed. As the focus of that desire, the body figures prominently in these representations.

For many artists, the simple act of representing the self in visual form becomes a radical declarative act; photography thus has been a primary medium through which to achieve visibility because the act of photographing validates the subject depicted. For both the artist and the viewer the artmaking process often functions as

a form of therapy as wounds are opened and healed through the power of visualization.

Furthermore, reclaiming the historical imagery that every Diaspora artist shares is also an essential element in the empowerment of the gay or lesbian artist of African descent. In doing so, artists can embrace or reject stereotypes based on their own revaluation of images that have previously been imposed upon them. On the other hand, not every gay or lesbian artist of the African Diaspora addresses sexuality and gender issues in their work.

Early Figures

Mary Edmonia Lewis, an African American expatriate who lived and worked in Rome in the 1860s and 1870s, is noted primarily for her marble busts, executed in a neoclassical style, of American abolitionists and transcendentalists, as well as sculptures of allegorical and literary subjects.

James Richmond Barthé, the only Harlem Renaissance artist to exploit the black male nude for its political and erotic significance, is particularly noted for his images of dancing male and female figures. His work reveals both a mastery of traditional techniques and a deep interest in primitivism.

Also associated with the Harlem Renaissance was a friend and probable lover of Barthé, Richard Bruce Nugent (1906–1987). He was undoubtedly the most openly gay African American artist of his time. In the 1920s and 1930s, he contributed homoerotic artwork and stories to a number of publications. His famous story, "Smoke, Lilies, and Jade" (1926), which may be the first depiction of homosexual and bisexual desire in African American fiction, was accompanied by his illustrations when it appeared in the only published number of the literary quarterly *Fire!!*

Artists of Color in England

In the 1980s, England emerged as a hotbed of artistic activity for artists of color, especially individuals hailing from the West African country of Nigeria, a former British colony that has been self-governing only since 1960. Nigeria has contributed an extraordinary number of curators and artists (some of Nigerian descent rather than Nigerian-born) to the contemporary arts dialogue in England and North America, and many of them deal with gender- and sexuality-related issues.

Among these are artist and art historian Olu Oguibe (b. 1964) and curator and editor Okwui Enwezor (b. 1963), coeditors (with Salah M. Hassan) of *Nka: Journal of Contemporary African Art*; mixed media artist Yinka Shonibare (b. 1962); painter Chris Ofili (b. 1968); photographer and installation artist Oladélé Bamgboyé (b. 1963); and gay photographer Rotimi Fani-Kayode (1955–1989).

Part of the reason for this artistic emergence are the writings of prominent gay male theorists such as Kobena Mercer (b. 1960) and filmmaker Isaac Julien (b. 1960), who, in addition to writing about artists of African descent, have written extensively on the representation of Africans and African Americans by gay white artists such as Robert Mapplethorpe.

Sunil Gupta (b. 1953), a gay Canadian, Indian-born photographer considered "black" in his adopted Britain, focuses both his images and writings on the black, often African, male body. He is a member of Autograph, the Association of Black British Photographers, which was founded in London in 1988 to provide a forum and venue for photographic artists in Britain of Caribbean, African, and South Asian origin.

Among the early (and current) members of Autograph whose work has been heavily promoted and published by the organization are, in addition to Gupta, gay photographers Ajamu (b. 1963) and cofounder Rotimi Fani-Kayode; lesbian photographer Ingrid Pollard (b. 1953); and gay American photographer Lyle Ashton Harris (b. 1965).

Gay British filmmaker Steve McQueen (b. 1969) emerged in the late 1980s with films exploring issues of displacement and exile. The journal *Ten.8*, published in Birmingham, England, has also been a rich source of discussion regarding sexual and gender identity.

Because many black British artists are not native-born or are first generation Britons, their work often addresses questions of both national and sexual identities. Ajamu's work, for example, articulates the dualities that black gay men experience. "Being a black queer photographer in England is akin to surviving in enemy territory," the artist wrote in 1998. "My mission is to create radical, challenging and innovative work that cuts through the bullshit surrounding the unsatisfactory/dishonest way that sex/sexuality and those with culturally forbidden lives/desires are represented (or hidden) within British society."

Rotimi Fani-Kayode, from a family of Yoruba priests, explored his sexuality through intimate self-portraits and portraits of male friends in which the body becomes both icon and metaphor for cultural displacement, spirituality, and sexuality.

Ingrid Pollard's work explores environmental racism, class, gender, and lesbianism in subjects ranging from self-portraits positioning the black woman's body in the traditional English landscape and diaristic tableaux about coming out to architectural details in cyanotype.

Another black lesbian artist in Britain is Jacqui Duckworth, a filmmaker whose work focuses on her battle with multiple sclerosis. She compares her "coming out" as a lesbian with "coming out" as a person living with a disease.

African American Gay Male Artists

Several gay and lesbian African American artists have also achieved recognition; and, as in England, artists incorporating photographic imagery are at the forefront. Some artists employ explicit gay male imagery while others are more subtle in explorations of their sexuality.

Among the best known African American artists is filmmaker Marlon Riggs (1957–1994), whose *Tongues Untied* (1989) is a controversial yet groundbreaking representation of black gay sexuality. Riggs's other films, such as *Ethnic Notions* (1987), *Color Adjustments* (1991), and *Black Is...Black Ain't* (1995), explore the history of race and ethnicity in the United States.

Some artists use self-portraiture to explore issues of the representation of gender and sexuality in the media and popular culture. New York–based Iké Udé is an important black presence as an artist, writer, and publisher of *aRUDE* magazine, which focuses on art, fashion, and culture. He is not gay or bisexual, but his style might be described as "Victorian dandy" and is deeply influenced by African gender-role playing.

For his 1996 "Cover Girl" series, Udé recreated a series of popular magazine covers, from *Town and Country, Time, Ebony, Vogue,* and others, using self-portraits not only to subvert the dominant definitions of male and female roles but also to take shots at specific figures within the culture, such as Michael Jackson and Mike Tyson. In collaboration with Lyle Ashton Harris, Udé has also produced evocative works that challenge gender roles in popular culture and art history.

In his own self-portraits, Harris constructs a gay narrative through fantasy and cross-dressing. Harris's sexually explicit self-portraits are confrontational, calling attention to the exclusion of such images from the dominant media. Harris also collaborates with his brother, gay filmmaker Thomas Allen Harris (b. 1962).

Their 1994 triptych "Brotherhood, Crossroads, Etcetera" depicts the nude brothers embracing while holding guns and kissing while Thomas points a gun at Lyle's chest. The work explores notions of intimacy— not necessarily sexuality—between black males. "The images...speak to the ambivalence around two people who love each other critically," explains Lyle, "yet have dealt with issues of mirroring, envy and competition. This is nothing new for we are all familiar with the Cain and Abel biblical narrative."

Other artists have taken a more documentary approach to represent communities. For example, a portrait series by Vincent Alan W. (1960–1996), "Queens Without a Country: Afro-American Homosexuals Who Have Changed the Face of Berlin" (1986–1987), depicts black expatriate gay men in Europe. Previously, W. worked primarily in New York, where he photographed gay black life. The straightforward and honest Berlin images are coupled with the subjects' own words and shed light on a marginalized group as they speak of their desires, aspirations, and frustrations.

Still other artists have reclaimed their own family images and histories in the quest for identity. Darrel Ellis (1958–1992), a New York–based mixed-media artist, started out making self-portraits until he discovered a cache of photographs his father, Thomas Ellis, had made in the 1950s. Ellis reworked them, using painting and drawing to explore identity within the family dynamic and to rewrite the familial narrative as a kind of self-therapy.

Relatedly, multimedia artist Glenn Ligon (b. 1960) also uses the family album format. In one series, he juxtaposes his own family photographs with amateur gay male pornographic images. He intersperses these disparate images literally to insert the body of the gay male into family history.

For the 1993 Whitney Museum Biennial exhibition, Ligon created "Notes on the Margin of the 'Black Book'" (1991–1993) in direct response to Robert Mapplethorpe's celebrated yet controversial photographs of the black male body.

Like Ellis, photographer Christian Walker (b. 1954), originally from Atlanta, also alters the surface of his photographic prints, made from old family images, using oil, charcoal, and pigments. Walker's work deals with miscegenation, race relations, and the family dynamic rather than his own sexuality.

African American Lesbian Artists

Although black lesbian visual artists are a diverse group, it nevertheless remains difficult to find women artists who identify as both lesbian or bisexual and of African descent. Still, a number of African American lesbian photographers and filmmakers have emerged in the last twenty years. While their work is less well known and well documented than that of their male counterparts, they also explore themes of community, family, and sexuality, often through representations of the self.

Like their male counterparts, lesbian artists have also had articulate writers and critics to advance the discussion surrounding their images. While black lesbian novelist and poet Jewelle Gomez wrote about images of her family and of black women in 1987 without addressing lesbian identity, in 1995 critic Jackie Goldsby located black lesbian desire in Vanessa Williams's *Penthouse* magazine pictorial, which featured her engaging in simulated sex with another woman. Goldsby's essay points out the persistent invisibility of the black lesbian body, as virtually none of the sensationalistic press accounts of the publication of the images actually addressed the lesbian content of the photographs.

Using the documentary approach to break down that invisibility, San Franciscan Jean Weisinger (b. 1954) makes self-portraits as well as portraits of women and the lesbian community. In 1996, Aunt Lute Press published a calendar of her portraits of women authors, many of them women of color, lesbians, or both.

The varied photojournalistic work of photographer and curator Valeria "Mikki" Ferrill (b. 1937) has focused on everything from black cowboys to "Dykes on Bikes" at the Gay Pride parade in San Francisco, giving faces to both racial and sexual communities that are little known in mainstream society.

Using representational imagery but in a much more interpretive vein is H. Lynn Keller (b. 1951), a San Francisco–based photographer and filmmaker whose work addresses identity, politics, and spirituality.

Likewise, Carla Williams (b. 1965), a Santa Fe–based artist, uses self-portraits to investigate representations of the black female body throughout photographic history. She positions herself as both photographer and subject to break down the separation between the object and the viewer's gaze. In addition, Williams's website, www.carlagirl.net, functions as a source of information about black artists (especially women artists) and gay and lesbian artists to help facilitate access to resource materials.

Working in the tradition of British photographer Jo Spence, who, along with lesbian photographer Rosy Martin, pioneered the practice of phototherapy, African/Caribbean/Canadian artist Karen Augustine deals explicitly with sexual abuse and black women's mental health in her photo/text mixed-media works. "Drawing from my own experience, I noticed various dynamics within the abuser/abused relationship," Augustine writes in a self-interview. "I couldn't deny the role my sexuality, class, gender and race played in this straight, white man's need to express his power over me." Augustine also writes about black women's sexuality and art.

African American lesbian filmmakers Jocelyn Taylor, Yvonne Welbon (b. 1962), and Cheryl Dunye (b. 1966) have also garnered much attention in recent years for their work regarding black lesbian identity. Dunye's *Watermelon Woman* (1996), in which a black lesbian is determined to restore not only a name but a lesbian history to a forgotten film actress once billed only as "Watermelon Woman," mirrors the filmmaker's own attempt to give an eloquent cinematic voice to black lesbian lives.

Conclusion

The gay, lesbian, and bisexual artists of the African Diaspora largely work in representational media. Their work explores race and sexuality, although it is by no means limited to such subjects. Indeed, their increased visibility—their openness as gay or lesbian and of African descent—gives them freedom to explore every aspect of their complex lives and worlds.

— *Carla Williams*

BIBLIOGRAPHY

Autograph, the Association of Black British Photographers. www.autograph-abp.co.uk/

Bailey, David A., Stuart Hall, et al., eds. *Ten.8: Critical Decade* 2.3 (Spring 1992).

Bailey, David A., ed. "Black Experiences," *Ten.8* no. 22 (1986).

Blake, Nayland, Lawrence Rinder, and Amy Scholder, eds. *In a Different Light: Visual Culture, Sexual Identity, Queer Practice.* San Francisco: City Lights Books, 1995.

"Bodies of Excess." *Ten.8* 2.1 (Spring 1991).

Boffin, Tessa, and Jean Fraser, eds. *Stolen Glances: Lesbians Take Photographs.* London: Pandora Press, 1991.

Bright, Deborah, ed. *The Passionate Camera: Photography and Bodies of Desire.* London: Routledge, 1998.

Corinne, Tee A. "Lesbian Photography on the U.S. West Coast: 1972–1997." www.sla.purdue.edu/waaw/Corinne/index.html

Dent, Gina, ed. *Black Popular Culture: A Project by Michele Wallace.* Seattle: Bay Press, 1992.

Harris, Thomas Allen. Home Page. www.chimpanzeeproductions.org

Kelley, Caffyn, ed. *Forbidden Subjects: Self-Portraits by Lesbian Artists.* North Vancouver, B.C.: Gallerie Publications, 1992.

Mercer, Kobena. *Welcome to the Jungle: New Positions in Black Cultural Studies.* New York: Routledge, 1994.

McBreen, Ellen. "Biblical Gender Bending in Harlem: The Queer Performance of Nugent's 'Salome.'" *Art Journal* 57.3 (Fall 1998): 22–27.

Read, Alan, ed. *The Fact of Blackness: Frantz Fanon and Visual Representation.* Seattle: Bay Press, 1996.

Weisinger, Jean. *Imagery: Women Writers, Portraits by Jean Weisinger.* San Francisco: Aunt Lute Books, 1996.

Williams, Carla. Home Page. www.carlagirl.net

Willis, Deborah. *Reflections in Black: A History of Black Photographers, 1840 to the Present.* New York: Norton, 2000.

———, et al. "Darrel Ellis." *New York: Art in General,* 1996.

Wilmer, Val, ed. "Evidence: New Light on Afro American Images." *Ten.8* no. 24 (1987).

SEE ALSO

American Art: Gay Male, 1900–1969; American Art: Lesbian, 1900–1969; American Art: Gay Male, Post-Stonewall; American Art: Lesbian, Post-Stonewall; Photography: Lesbian, Post-Stonewall; Barthé, James Richmond; Fani-Kayode, Rotimi; Lewis, Mary Edmonia; Ligon, Glenn; Mapplethorpe, Robert

AIDS Activism in the Arts

THE ACTIVIST MOVEMENT OF THE 1970S THAT GALVA-nized large numbers of gay men and lesbians to protest repression, police entrapment, and other forms of discrimination was transformed by the AIDS epidemic that struck the gay community so devastatingly in the 1980s.

In the early and mid-1980s, the unifying issue among gay activists was government negligence about AIDS. In the early years of the epidemic, AIDS was rarely discussed in the national media or by political officials. As a result, many gay activists were compelled to voice their anger and sorrow through art, producing traditional works that were embraced by the museum and institutional art worlds, as well as a number of anonymous, public graphics, emblems, and memorials.

These political, yet accessible, public artworks reached millions and helped transform AIDS from a syndrome that many were reluctant to speak about to a subject that could be raised sympathetically in popular news magazines and on television programs.

Gran Fury

One of the earliest, and most influential, pioneers of AIDS activism through art was Gran Fury, an artists' collective formed in 1988 as the propaganda office for the gay activist group ACT UP (AIDS Coalition to Unleash Power). Gran Fury, named after the brand of automobile used by the New York City Police Department at the time, sought to create a public, nonmuseum role for art that attempted to inform a broad public and provoke direct action to end the AIDS crisis.

Gran Fury's primary objectives were to render complex issues understandable and to give visual form to the shocking AIDS statistics originating at the time from the National Centers for Disease Control and New York's Department of Health. Gran Fury's artworks merged the simplicity of commercial advertising with the complexity of political argument to arouse a response from the general public. They targeted the streets, rather than the galleries, and determined that images were more compelling when accompanied by words of explanation and elaboration.

An early Gran Fury graphic offered the alarming news that "One In 61 Babies Born In New York Is HIV Positive" and another drolly advised men to "Use Condoms or Beat It." Their first institution-sponsored graphic implored the art world to fight AIDS because "With 47,524 Dead, Art Is Not Enough."

Gran Fury courted controversy throughout the late 1980s and early 1990s, with such projects as their street-spanning banner announcing that "All People With AIDS Are Innocent," which caused an uproar when it was exhibited at New York's Henry Street Settlement in 1989. This sentiment served as a direct counterbalance to the predominant attitude at the time, propelled by representations within the mainstream media, that people with AIDS were either "innocent victims"—that is, hemophiliacs and children—or "guilty sufferers"—that is, gay men and IV drug users.

The collective's image of three interracial homosexual and heterosexual couples kissing above the caption "Kissing Doesn't Kill: Greed and Indifference Do" caused another furor the following year when it appeared on the sides of buses in New York, Los Angeles, and Chicago. The original format of the work included a block of type (which was deleted in some cities for its controversial content) that read "Corporate greed, government inaction, and public indifference make AIDS a political crisis."

Perhaps Gran Fury's most inflammatory work was its contribution to the Venice Biennale in 1990, which nearly got the group arrested. The Venice Biennale is one of the most prestigious of international art exhibitions. Gran Fury seized on this opportunity to export its provocative brand of art activism to Europe. The collective's infamous "Pope Piece" skewered the pope for his anti–safe sex beliefs. The artwork paired two billboard-sized panels: one coupling the image of the pope with a text about the church's anti–safe sex rhetoric, the other a two-foot-high erect penis with texts about women and condom use.

Italian authorities, including Biennale personnel, considered prosecuting the group for blasphemy; only the last-minute intervention of sympathetic magistrates precluded an international incident.

In addition to the work of Gran Fury, several other significant public projects arose as a response to the AIDS crisis, including the SILENCE = DEATH Project, the Red Ribbon Project, and the AIDS Memorial Quilt.

SILENCE = DEATH Project

In 1986, six anonymous gay men formed the SILENCE = DEATH Project and created the graphic emblem that has become synonymous with AIDS activism. This highly visible work incorporated the emblem "SILENCE = DEATH" in white type beneath an inverted pink triangle—the symbol Nazis forced homosexuals to wear in concentration camps, and which gay activists of the 1970s had already appropriated as a symbol of gay liberation.

Similar to many of Gran Fury's works, the SILENCE = DEATH Project attempted to locate the root cause of the AIDS crisis not in HIV infection but in larger social forces—the government, the corporate culture, the mainstream public—that ignored, remained silent about, or profited from the crisis.

The Red Ribbon Project

Another artists' collective, the Visual AIDS Artists' Caucus, founded in 1989, created the Red Ribbon Project. Intended to be anonymous, the Red Ribbon—originally a loop of red silk ribbon fastened on a lapel or pinned to a shirt—was designed as a symbol of commitment to people with AIDS and to the AIDS struggle. Sponsored by the group Broadway Cares/Equity Fights AIDS, the Red Ribbon debuted at the televised 1991 Tony Awards.

Since then, the Red Ribbon has become a widespread symbol throughout the world and has appeared in many different forms and versions. In 1993, for instance, the U.S. Postal Service released a Red Ribbon stamp with the caption "AIDS Awareness." The Red Ribbon Project has also provided the impetus for other groups to designate variously colored ribbons for their own causes, such as the pink ribbon worn for breast cancer awareness.

Over time, a small backlash against the use of the Red Ribbon developed, with some AIDS activists deriding the symbol as more of a politically correct fashion accessory than a meaningful social or political statement. Despite some commercialization, however, the Red Ribbon continues to raise consciousness about the epidemic and demonstrate support for, and solidarity with, those living with HIV and AIDS.

NAMES Project AIDS Memorial Quilt

Activist Cleve Jones conceived the NAMES Project AIDS Memorial Quilt in 1985 as a community artwork to commemorate the lives of those who had died of AIDS. Typically known simply as the AIDS Quilt, as of 2003 it was composed of over 44,000 three-by-six-foot, quilted, appliquéd, and collaged panels of fabric, representing 83,000 names (19 percent of all AIDS deaths in the United States at that time). Since its inception, participants have created these quilt components for friends, lovers, family members, and public figures.

The ever expanding AIDS Quilt—currently measuring approximately 792,000 square feet, or roughly the size of sixteen football fields—is now too large to be exhibited in its entirety. Its national debut took place on the National Mall in Washington, D. C., during the March on Washington for Lesbian and Gay Rights in 1987. At that time it covered a space a little larger than one football field and included 1,920 panels. A year later the Quilt returned to Washington, D. C., this time composed of over 8,000 panels.

Celebrities, politicians, family members, lovers, and friends read aloud the names of the people represented by the quilt panels; this reading of names is now a tradition followed at nearly every Quilt display.

The AIDS Memorial Quilt is the largest public art project in the world. Nominated for a Nobel Peace Prize in 1989, the Quilt has also been the subject of many books, films, scholarly papers, articles, and theatrical performances. *Common Threads: Stories From the Quilt* won the Academy Award for best feature-length documentary film in 1989.

Day Without Art

Another broad-based initiative was Day Without Art, an annual "international day of mourning and action in response to the AIDS crisis," which was launched in 1989. Day Without Art was conceived as an effort to force the art world to confront the effects of the epidemic within its own institutions.

In 1999, marking the tenth anniversary of Day Without Art, an art archive was created. A project of the Estate Project for Artists with AIDS, the Virtual Collection is an expanding database of 3,000 digitized images of artworks created by artists who either have died of AIDS or are living with HIV. The Virtual Collection has been shaped into a scholarly and curatorial resource that is housed in various museums and universities throughout the country.

Performance Artists

AIDS activism also emerged as a potent subject among performance artists. Examples range from the postmodern drag extravaganzas of Lypsinka, to the overtly political parody of the Pomo Afro Homos, to Tim Miller's nude monologue performances. In fact, Miller became the center of national attention in the late 1980s as a preeminent AIDS firebrand and political radical, one of four artists whose National Endowment for the Arts funding was cut off in a censorship campaign spearheaded by then Senator Jesse Helms.

The overall importance of these public, politicized works of art was their ability to focus attention on the AIDS crisis and to serve as a rallying cry for those inside the movement. Many of these projects gained media coverage across the country through wire services and public radio stations, and even spawned a debate on the floor of the Illinois State Senate over the representation of gays and lesbians.

As a result, AIDS awareness has now spread into the mainstream, creating its own sphere of community-based organizations, charitable institutions, and even magazines for those who are HIV positive.

Conclusion

In the new millennium, gay activism has increasingly become less galvanized by the specter of AIDS and has seemingly splintered into dozens of micromovements—focusing on issues ranging from gays in the military to parenting, same-sex marriage, workplace fairness, and so on. However, activists and artists working to effect

change, regardless of the issue, have learned many valuable lessons from their predecessors in the power and efficacy of vocal, public activism through art.

— *Craig Kaczorowski*

BIBLIOGRAPHY

ACT UP—AIDS Coalition to Unleash Power. www.actupny.org

Atkins, Robert. "AIDS: Making Art and Raising Hell." Queer Arts Resource.
 www.queer-arts.org/archive/show4/forum/atkins/atkins.html

Knight, Christopher. "ART REVIEW: Gran Fury's Graphic AIDS Message." *Los Angeles Times,* March 6, 1991.

Meyer, Richard. "This is to Enrage You: Gran Fury and the Graphics of AIDS Activism." *But Is It Art? The Spirit of Art as Activism.* Nina Felshin, ed. Seattle: Bay Press, 1995.

The NAMES Project AIDS Memorial Quilt. www.aidsquilt.org

Román, David. *Acts of Intervention: Performance, Gay Culture, and AIDS.* Bloomington: Indiana University Press, 1998.

SEE ALSO

American Art: Gay Male, Post-Stonewall; Contemporary Art; Haring, Keith; Wojnarowicz, David

American Art: Gay Male, 1900–1969

IN THE DECADES PRIOR TO STONEWALL, HOMOPHOBIA was as prevalent in the art establishment as in other facets of American society. Most gay artists were closeted, and they seldom visualized gay subjects openly and directly. Because the idealized male nude had long been a venerable subject in Western art, subtly erotic images of men could be displayed publicly; but for most of the period, sexually explicit gay works could be created only for a restricted audience. Thus, wealthy patrons played a major role in encouraging the production of gay works.

Gay artists showed inventiveness by developing visual codes understood only by those "in the know." After 1945, however, some adventurous artists abandoned the mainstream art world and developed independent networks for the distribution of gay works.

Pre–World War I

At the beginning of the century, "pictorialism" in photography fostered pastoral images of languid youths, posed with props intended to evoke ancient classical and Christian stories. Among the practitioners of this style, F. Holland Day caused controversy through his intensely sensual photographs of ecstatic youths (such as "Saint Sebastian," 1906). Day enjoyed the support of such wealthy connoisseurs as Edward Perry Warren, who also provided significant resources for the (later) study of gay

history through his donations of ancient Greek and Roman male erotic works to the Boston Museum of Fine Arts.

In the years preceding World War I, young avant-garde artists found inspiration for their lives as well as their art in socially tolerant European capitals, especially Berlin and Paris. Prominent among them was Marsden Hartley, who fell in love with a young German officer, Karl von Freyburg, an early casualty of the war. Returning to New York in 1914, Hartley mourned his loss in a series of geometric compositions, which evoked Freyburg's memory through German military insignia, initials, and other motifs.

When these works were exhibited during the early years of the war, the American press branded Hartley a traitor. It is indicative of the virulence of homophobia in this era that Hartley did not defend himself against this charge and that he never publicly explained the love inspiring these works.

More fortunate in his personal and professional life was Joseph Christian Leyendecker, a commercial artist, who developed one of the most successful advertising campaigns of the century: the Arrow Collar Man. This archetypal image of the clean-cut American male was modeled on his life partner, Charles Beach. Exemplifying ways that gay men could "infiltrate" American society, Leyendecker subtly subverted heterosexist conventions through his popular illustrations, depicting rugged men gazing ambiguously at one another.

Emergence of a Gay Subculture

Gay baths and other institutions that fostered the emergence of a gay subculture in New York and other large American cities between 1914 and 1929 were seldom represented in the visual arts. However, Charles Demuth, famous for his semiabstract modernist still-life compositions, frankly depicted the evolving "gay scene" in watercolors for his closest friends: sexual encounters in baths, sailors fondling one another while urinating, public sex at Coney Island. Historically, these works have great significance, for they visualize the emergence of a culture very differently organized than "straight" society.

During the 1920s, the culturally and socially dynamic Harlem Renaissance fostered acceptance for gay people of all races in New York's largest African American neighborhood. Exemplifying the mood of tolerance are the elegant and dignified portraits of drag queens and kings made by James VanDerZee, a prominent Harlem photographer.

Richard Bruce Nugent, a visual artist as well as a writer, provoked controversy through his very frank depictions of gay sexuality; in his drawings for Wilde's *Salome* and other works, Nugent created powerfully erotic images that fused diverse cultural traditions.

Mainstream exposure of African American artists was limited by white patrons, who fostered only work that both affirmed their social values and catered to their taste for the "primitive." Carl Van Vechten, a vocal white supporter of the Harlem Renaissance, lionized its leaders in dignified photographs and essays. However, in a series of erotic photographs made only for his personal consumption, he depicted white men "servicing" well-endowed black men, posed with theatrical "jungle" props. The racist stereotypes evident in these works would recur in images of men of color by gay white artists.

The 1930s and 1940s
During the 1930s and 1940s, American artists responded to the Great Depression and World War II with heroic images of ordinary people in the Social Realist style. Paul Cadmus was the only artist affiliated with this movement who devoted himself to recording the experiences of gay people. In monumental paintings at once satiric and celebratory, Cadmus depicted men cruising in gyms and parks. His *The Fleet's In!* (1934) provoked such outcry that it was removed from an exhibition at the Corcoran Gallery, Washington, D.C., in a process that foreshadowed the response to Robert Mapplethorpe's work in the 1990s.

Although Cadmus's commitment to gay subjects limited his public exposure, he benefited from the support of Lincoln Kirstein, one of the most important American patrons of art during the mid-twentieth century.

Kirstein also encouraged the homoerotic work of George Platt Lynes, a successful fashion photographer. For a limited circle of wealthy clients, Lynes created elegant, titillating photographs of nude men, usually posed and lit so as to conceal their genitals. In official photographs of the New York City Ballet, produced under Kirstein's patronage, Lynes captured romantic and sensual interactions among male dancers.

Ballet also stimulated the imagination of Hubert Julian Stowitts, whose bold, colorful tempera paintings received international acclaim. However, both poor health and increasing social conservatism contributed to the rapid decline of his career in the postwar period.

The 1950s
In the 1950s, gender and sexual "normalcy" were enforced throughout American society. Jackson Pollock and other leading proponents of Abstract Expressionism, the prevailing avant-garde art movement, asserted that their paintings embodied the heroic emotions of the emphatically heterosexual male.

During the 1950s, Betty Parsons was the only leading New York dealer who deliberately fostered the work of gay men, lesbians, and others who refused to conform to the restrictive conventions of the era. Among the artists promoted by Parsons were Alphonso Ossorio, whose kitschy and opulent abstractions challenged the prevailing style; Forrest Bess, who dealt with gay and transsexual issues in provocatively titled works (for example, *Two Dicks,* 1956); and Walter Murch, who created shimmering, realistic depictions of objects with phallic connotations.

Jasper Johns and Robert Rauschenberg, who lived together from 1954 to 1960, cleverly subverted Abstract Expressionism by utilizing its "hallmark" bold strokes within their assemblages of found and made objects. Although Johns has denied that the work has any gay content, his *Target with Plaster Casts* (1955) seems to articulate the situation of the closeted male homosexual.

Emerging Gay Communities
The repressive mood of postwar America inspired "Beat" writers and artists to reject the mainstream and to advocate sexual and other personal freedoms. Gay men seeking to escape middle-class conformity gravitated to the San Francisco Bay Area and a few other major urban centers.

Amateur photographers recorded many aspects of life in these gay meccas. Through donations to gay historical societies, some of these images have become publicly accessible. The work of Jess (Collins) is especially noteworthy. A nationally recognized Bay Area artist, he created paintings and photographs celebrating gay life in San Francisco and his relationship with poet Robert Duncan.

The emerging gay communities created a market for erotic male images. "Underground" artists such as "Blade" (Neil Blate) produced stories and drawings that are at once tender and bluntly explicit. Blade's images were reproduced and distributed clandestinely through gay bars.

Pretending to fulfill the ideals of the physical culture movement, physique magazines also responded to the demand for gay erotica by publishing photographs of bodybuilders, with the minimum of covering required by postal authorities. In 1952, Bob Mizer founded *Physique Pictorial* (published regularly until 1992), which was directed openly and consistently to gay men. In 1957, Tom of Finland's work was published for the first time in the United States in Mizer's magazine.

George Quaintance was among the artists who regularly created drawings for *Physique Pictorial*. Depicting individuals in fanciful costumes that evoked many different cultural contexts, Quaintance created an appealing gay version of history. The men shown in *Physique Pictorial* were exclusively athletic, "clean-cut," and white. Yet, despite this limitation, these images contributed positively to the formation of community identity by showing individuals happy about their sexuality.

The 1960s

In the comparatively open 1960s, a few leading artists brought gay concerns to the forefront of the art world and thus helped to provide a foundation for the flourishing of queer art after Stonewall.

Andy Warhol, the most famous of these artists, rejected the macho ideals of the Abstract Expressionists and projected a "sissy" public image. Warhol transgressed gender boundaries by producing countless repetitions of icons of American consumer culture, supposedly the domain of women. Although he largely avoided sexual themes in his paintings and sculptures, he incorporated them in offbeat, low-budget films, beginning with *Blow Job* (1963).

David Hockney, who immigrated permanently to America in 1963, painted lyrical portraits of gay couples and individuals. In depictions of incidents from everyday life (such as *Domestic Scene, Los Angeles*, 1963), in portraits of friends such as Christopher Isherwood and Don Bachardy, and in commissioned portraits (such as *The Conversation*, showing Henry Geldzahler and Raymond Foy, 1980), Hockney subtly revealed the intimacies and complexities of committed relationships. In these works, the (homo)sexuality of the subjects is evident, but it is not emphasized.

Settling permanently in California, Hockney enjoyed painting scenes of beautiful youths lounging around and swimming in pools (for example, *Le Plongeur*, 1978, among many other pieces). Although ultimately inspired by homoerotic desire, Hockney managed to infuse these works with a generalized sensuality, which can be enjoyed by viewers of divergent sexual orientations. By creating homoerotic images that could appeal to mainstream audiences, Hockney initiated a new phase of gay art.

— *Richard G. Mann*

BIBLIOGRAPHY

Chauncey, George. *Gay New York: Gender, Urban Culture, and the Making of the Gay Male World, 1890–1940.* New York: Basic Books, 1994.

Cooper, Emmanuel. *Fully Exposed: The Male Nude in Photography.* London and New York: Routledge, 1990.

———. *The Sexual Perspective: Homosexuality and Art in the Last 100 Years in the West.* 2nd ed. London and New York: Routledge, 1994.

Davis, Whitney, ed. *Gay and Lesbian Studies in Art History.* New York: Harrington Park Press, 1994.

Dubin, Steven C. *Arresting Images: Impolitic Art and Uncivil Actions.* London and New York: Routledge, 1992.

Kaiser, Charles. *The Gay Metropolis: 1940–1996.* Boston: Houghton Mifflin, 1997.

Saslow, James M. *Pictures and Passions: A History of Homosexuality in the Visual Arts.* New York: Penguin Putnam, 1999.

Stryker, Susan, and Jim Van Buskirk. *Gay by the Bay: A History of Queer Culture in the San Francisco Bay Area.* With a Foreword by Armistead Maupin. San Francisco: Chronicle Books, 1996.

SEE ALSO

African American and African Diaspora Art; Photography: Gay Male, Pre-Stonewall; Bachardy, Don; Cadmus, Paul; Day, F. Holland; Demuth, Charles; Hartley, Marsden; Hockney, David; Johns, Jasper; Leyendecker, Joseph C.; Lynes, George Platt; Rauschenberg, Robert; Tom of Finland; Warhol, Andy

American Art: Gay Male, Nineteenth Century

ALTHOUGH HOMOSEXUALITY WOULD NOT BE CATEGO-rized as a distinct type of "deviant" personality until the beginning of the twentieth century, heterosexual values were effectively imposed throughout American society during the nineteenth century. Men whose love for other men violated those norms concealed their personal lives from others, and they often suffered from severe feelings of guilt. Nevertheless, Winslow Homer and Thomas Eakins, two of the most prominent American artists of the century, created numerous works celebrating same-sex camaraderie and affection.

Homer and Eakins both liked to depict archetypally "masculine" men, engaged in traditionally male activities such as hunting and fighting. Near the end of the century, John Singer Sargent created definitive visual representations of the dandy, the androgynous figure who embodied the ideals of small, sophisticated urban circles, in which same-sex desire was accepted and even cultivated.

Photographs of friends also provide important visual documentation about same-sex relationships in the nineteenth century.

Guilt and Fear

The life and career of the leading Romantic painter, Washington Allston (1773–1843), reveal the guilt and fear often experienced by gay men in nineteenth-century America. Although his choice of profession disconcerted his aristocratic South Carolina family, Allston otherwise tried to "live up to" their deeply entrenched social and moral ideals. To appease his family, he married twice. However, he never had any children, and he organized his affairs so as to have only minimal contact with his wives.

Allston's disinterest in women is suggested by his remarkably "cool" and aloof treatment of female figures in his paintings of mythological subjects, such as *Dido and Anna* (1805–1808). His desire for other men probably constituted the "propensity to sin," about which he berated himself throughout his life. References in the personal papers of the artist and his acquaintances reveal that the "partiality" he felt for certain of his male friends caused him great anxiety.

While Allston was resident in England between 1811 and 1818, he received numerous threats from blackmailers, who ultimately caused him to leave the country suddenly, without giving any notice to his patrons or friends. Thus, he appears to have been an early victim of the laws, instituted in Britain in 1810, that made sodomy a capital offense. Feelings of guilt deeply affected his productivity and inhibited his completion of many important projects, including major commissions from the United States government.

It has been suggested that Allston's extensive series of paintings of unconventional subjects about the life of Saint Peter (including *The Denial of Saint Peter*, 1811–1818, and *The Angel Liberating Saint Peter from Prison*, 1816) served as a means for him to articulate the conflicts caused by his homosexuality. Earlier artists usually had depicted Peter as weak and bewildered in their representations of these subjects. However, Allston consistently depicted Peter as an uncharacteristically handsome and muscular figure, nobly enduring the torments inflicted upon him by others. Thus, Peter seems to embody the strength and courage that Allston undoubtedly aspired to, but which he sadly was not able to realize in his life.

Male Camaraderie: Homer and Eakins

A prolific artist, Winslow Homer (1836–1910) produced many paintings and prints that represented and celebrated the camaraderie and intimate friendships of soldiers, hunters, and other men engaged in typically "masculine" outdoor occupations. Very unusually for a male artist of the nineteenth century, he also depicted the affection and enjoyment experienced by women together.

A solitary individual, Homer consistently refused to reveal any details about his personal life to biographers and art critics. His contemporaries attributed his "failure" to marry to his "shyness" around women, and most scholars continue to endorse this opinion.

One of Homer's closest friends was Albert Kelsey, with whom he shared a studio in Paris for two years (1867–1868). A posed, studio photograph made in Paris commemorates their relationship; Kelsey stands, with his linked hands and arms resting on the shoulders and back of his friend, who is seated on a tall Greek column. Significantly, on the back of his copy of the photograph, which he preserved for the rest of his life, Kelsey wrote "Damon and Phythias," a reference to the mythological heroes, who were devoted to one another. Later in his life, Homer made a witty drawing of Kelsey, riding nude on the back of a turtle in the Bahamas.

An extensive series of paintings and watercolors of the 1870s (including, among many other pieces, *Waiting for an Answer*, 1872; *Reading*, 1875; and *Shall I Tell Your Fortune*, 1876) often has been interpreted as an expression of Homer's feelings of frustration about the failure of a romance. The mood of tension and restlessness of these works, which greatly disconcerted critics in the 1870s, suggests the intensity of Homer's complex feelings about the ambiguous theme of the series.

The pensive red-haired woman, featured in all these works, usually is considered to be a portrait of a woman whom Homer hoped to marry. However, it has been demonstrated that Homer based this notably "masculine looking" woman upon a young boy whom he occasionally employed as a model during this period. Rather than referring to a specific relationship, these images may constitute an extended contemplation upon the repression of same-sex love by a homophobic society.

Concern about this issue might have helped to provoke Homer's personal and professional crisis of 1881, when he withdrew permanently from the New York art world. After spending two years in a tiny English fishing village on the harsh North Sea coast, he settled in Prout's Neck, Maine, where he largely lived in isolation from others.

Trained as a graphic artist, Homer established his reputation through the illustrations that he produced for the popular magazine *Harper's Weekly*. Commissioned by *Harper's* to record the events of the Civil War, Homer did not produce the heroic, propagandistic images desired by the editors.

Such prints as *War for the Union, A Bayonet Charge* (1862) revealed the chaos and confusion of the battlefront and prominently featured wounded and dead men. Numerous drawings and paintings (for example, *Surgeon's Call*, 1863, and *Soldier Being Given a Drink from a Canteen*, 1864) depict ordinary soldiers trying to help one another deal with the devastating effects of war.

In addition, Homer produced many paintings and drawings of camp life, including *The Briarwood Pipe* (1864) and *Pitching Quoits* (1865). In these quiet scenes of soldiers resting behind the battle lines, Homer subtly revealed the intimate friendships that men developed in the difficult experiences of war.

Many of the images of men hunting and fishing that Homer produced in the post–Civil War era (for example, *Camping out in the Adirondack Mountains*, 1874, and *Two Guides*, 1875) also evoke the spiritual rapport of men engaged in outdoor occupations. However, during this period, he increasingly created contemplative pictures of solitary figures in natural settings (*Playing a Fish*, 1874, among other pieces).

In contrast to most other male American artists active in the nineteenth century, Homer produced dignified images of women that lack any hint of sentimentality or condescension (see, for example, *Noon Recess*, 1873, and *Milking Time*, 1875). Such images as *Promenade on the Beach* (1880) show women enjoying one another's company.

After his personal crisis of 1881, Homer tended to infuse his works with a dark and somber mood. In his late paintings, he often depicted monumental figures engaged in powerful struggles with the forces of nature, as he did most forcefully in *The Life Line* (1884), which was based upon a rescue that he witnessed off the coast of Maine.

Homer's late paintings of fishermen (such as *The Herring Net*, 1885, and *Eight Bells*, 1886) reveal the heroism involved in their daily activities. An unusually romantic painting, *Buffalo Girls* (1890), depicts two women passionately embracing as they dance on a moonlit beach.

Utilizing drawings and watercolors that he made during travels in the American South and the Caribbean, Homer also created powerful images of persons of African descent. These works were virtually unique in the era, when white artists routinely depicted black people with demeaning stereotypes. *The Gulf Stream* (1899) celebrates both the courage and sensual beauty of an African American fisherman who has survived a devastating tropical storm.

As did Homer, Thomas Eakins (1844–1916) created an intensely realistic, distinctly American classicism. Believing that he could not attain an adequate understanding of anatomy through the training conventionally available in art schools, he studied for four years at Jefferson Medical College in his native Philadelphia. His direct, intensely honest depictions of the human figure attest to the impact of this education upon his art.

Eakins refused to incorporate in his works any of the elegant decorative and historical details that greatly appealed to American viewers of the late nineteenth century. As a result, he never attained the degree of success that he merited. Eakins's dedication to studying the world around him is evident even in his occasional treatments of traditional religious and historical themes, such as *The Crucifixion* (1880), which is a remarkably direct and straightforward (albeit dignified) depiction of a naked man strapped to a cross.

Eakins was profoundly influenced by the ideas of Walt Whitman, with whom he became close friends after painting his portrait in 1887–1888. Eakins's carefully composed images of naked youths in Arcadian landscape settings (such as *The Swimming Hole*, 1893–1895) constitute visual equivalents of Whitman's poems, celebrating male beauty and comradeship. Eakins often painted scenes of all-male athletic activities, such as rowing (for example, *The Biglin Brothers Turning the Stake*, 1873) and boxing (for example, *Counting Out*, 1888).

As a teacher at the Pennsylvania Academy of Art, Eakins emphasized to his students the importance of the study of the naked male figure. His insistence that women students draw from unclothed male models caused him to be dismissed from his position at the Academy in 1886. His attempt to establish an independent Art Students League ended in financial disaster. Out of fashion for the rest of his life, he struggled to make a living by painting commissioned portraits.

During his later years, Eakins certainly derived a great deal of emotional support from his wife, Susan Macdowell, a former student whom he married in 1884, shortly before his fortieth birthday. Susan Macdowell shared many of her husband's interests, and, like him, she was an ardent admirer of Whitman's poetry. His austere portrait of her (1899) reveals both her strong personality and her warm affection for the artist.

Eakins also developed a very close relationship with Samuel Murray (1869–1941), a working-class Irishman whom he trained as a sculptor. The two shared a studio for eleven years, and they took extended wilderness trips together. Like Whitman's romantic associations with younger men, this relationship of an older and younger man corresponds with Platonic ideals of male relationships.

There has been much scholarly speculation about the extent to which Eakins was fully aware of the homoerotic implications of his treatment of the male figure. Even though the modern concept of homosexuality had not yet been formulated, it seems very unlikely that this forthright and honest supporter of Whitman's ideals would be entirely naive about this aspect of his work.

In particular, his numerous photographs of his students at the site of *The Swimming Hole* (1883) evoke the erotic appeal of the youths. In these photographic studies, he consistently posed the figures so as to emphasize their genitals and to suggest various physical and emotional interactions among them. In his final painting of this scene, Eakins modestly concealed their genitals, but he subtly revealed his voyeuristic fascination with the youths by portraying himself as a swimming figure (in the lower-right foreground), gazing longingly up at them.

The Dandy: Sargent

In contrast to Homer and Eakins, many American artists active in the late nineteenth century disdained images of their own country and sought inspiration in Europe. Among them was John Singer Sargent (1856–1925), who settled permanently in London in 1884.

Developing a fashionable style, ultimately influenced by such old masters as Velázquez and Frans Hals, Sargent quickly established an international reputation as the leading portraitist of the wealthy elite. Many of his clients included Americans, whom he sketched during their overseas trips or on his occasional visits to the United States.

Most scholars have asserted that Sargent was essentially an asexual individual, devoted only to his career. Eager to be accepted as a member of "high society," the bachelor Sargent maintained an impeccable and restrained public persona. Yet, despite his evident concern with his reputation, Sargent moved freely in the emerging "gay circles" in London and Boston. In his portraits of writers and artists from these groups (for example, W. *Graham Robertson*, 1894), he created archetypal images of the elegant, androgynous figure of the dandy.

Sargent's sensitivity to the beauties of the nude male figure is most evident in an extensive series of studies and watercolors, which he never exhibited and which he kept in his personal possession until his death. One group of sketches depict a mature, notably athletic figure in bold stances; the sketches literally thrust the model's genitals toward the viewer.

Many pieces depict a youthful model, reclining casually and languidly on a bed, with legs spread wide apart, as if to emphasize his genitals. A mood of voyeuristic intimacy is created through such features as the close "cropping" of the bed and the unconventional perspective from immediately above the figure.

Sargent's "finished" watercolors of the clothed figure of his friend Peter Harrison, who is shown reclining on a bed (approximately 1905), are infused with the same intimate and sensual mood as are his studies of the similarly posed nude model. Subtle indications of Sargent's appreciation of the beauties of the male body can be noted in some of his popular exhibited paintings. For example, *On His Holidays* (1901) features an attractive youthful hiker, resting in a sensual pose alongside a mountain stream.

Photographic Portraits of Male Friends

Extensive visual evidence of intimate homosocial, potentially homosexual, relationships are provided by the affectionate portraits of male friends made by both amateur and professional photographers from the mid-1840s onward. In the era before sexual behavior had been rigorously codified into binary categories, young men were allowed to express their friendship through embraces and other gestures and actions that now would be interpreted as exclusively gay.

Most of the photographs of pairs and groups of male friends probably were intended to commemorate friendships without any sexual overtones. Nevertheless, in some instances, explicit gestures, passionate embraces, and even revealing inscriptions forcefully evoke relationships that were celebrated sexually.

By the middle of the second decade of the twentieth century, the conception of homosexuality as a distinct identity category, with implications of mental and physical illness, caused the genre of male friendship photographs to disappear. The twentieth-century conception of homosexuality cannot adequately explain the fluid relationships eloquently revealed in countless nineteenth-century images of male friends.
— *Richard G. Mann*

BIBLIOGRAPHY

Cooper, Emmanuel. *The Sexual Perspective: Homosexuality and Art in the Last 100 Years in the West.* 2nd ed. London and New York: Routledge, 1994.

Deitcher, David. *Dear Friends.* New York: Abrams, 2001.

Saslow, James M. *Pictures and Passions: A History of Homosexuality in the Visual Arts.* New York: Penguin Putnam, 1999.

SEE ALSO

Photography: Gay Male, Pre-Stonewall; Eakins, Thomas; Homer, Winslow; Sargent, John Singer

American Art: Gay Male, Post-Stonewall

DURING THE LAST THREE DECADES OF THE TWENTIETH century, gay male art underwent a radical transformation. Like individuals in many other professions, gay artists came out of the closet after Stonewall, and they began to treat gay themes openly and directly.

Since the mid-1980s, prominent gay artists have been able to take advantage of opportunities for mainstream exhibitions, which would have been inconceivable earlier in the century. However, the highly publicized (and sometimes successful) attempts to suppress exhibitions of Robert Mapplethorpe's *X Portfolio* exemplify the threats of censorship which continue to worry many gay artists.

In the post-Stonewall period, artists of color have challenged the white racist underpinnings of much American gay art before Stonewall. In addition, during the past two decades, queer perspectives have inspired artists to visualize "fluid" constructions of gender and sexuality. Thus, contemporary queer artists integrate sexuality and passion into explorations of other aspects of identity, such as race, ethnicity, spirituality, and family life.

In response to AIDS, artists have created powerful works that help to inspire courage in the face of suffering and loss. Within the limits of this short entry, it is possible to mention only a few representative examples of the many artists active in the later twentieth century.

The 1970s

In the years immediately after Stonewall, a sense of exultation and liberation stimulated artists to create many different types of works recording and celebrating diverse

aspects of gay communities and relationships. *Agit Prop* (1971), a forty-foot-long collage mural created by John Burton and Mario Dubsky in the "Firehouse" (the Gay Artists Alliance Building in New York City) is generally acknowledged to be the first monumental group image of the newly liberated gay community. Combining photographs of gay protests with images of African American political leaders and other cultural heroes, Burton and Dubsky visualized the hope for an egalitarian and just society.

Very different in mood, but equally effective in affirming the solidity of the gay community, are the intimate, domestic portraits of middle-class gay couples by David Alexander. In these colorful paintings, Alexander often includes reminders of gay cultural history that subtly relate his subjects to the long struggle for gay rights.

In his elegantly composed and lit photographic portraits, Peter Hujar (d. 1987) captures the distinct personalities of a wide range of gay and transsexual individuals living in New York, including famous personalities as well as street hustlers and others living "on the fringes" of society. In such characteristic images as "Jerry Rothlein" (1979) and "Nicholas Abdallah Mouffrage" (1980), Hujar defies stereotypical ideas of beauty but, nevertheless, manages to endow his subjects with a sense of great dignity.

A similar sense of dignity and strength imbues the photographs and paintings of New Orleans artist George Dureau, whose portraits of dwarfs, street youths, and amputees are at once erotic and moving.

Mainstream Success and Censorship

By the mid-1980s, the struggle for gay rights had progressed sufficiently far that some openly gay artists attained great success in the mainstream art world. Probably the most prominent of these artists is Keith Haring, who remained active as a "street artist" even after his paintings and sculptures were exhibited at major galleries and museums. His exuberant compositions—densely packed with "comic-book style" figures—had great popular appeal. Thus, he was able to celebrate gay sexuality, advocate safe sex practices, and promote various political causes in widely circulated works.

However, other politically engaged gay artists enjoyed less easy relations with the public than Haring, and many of them became embroiled in controversy. For instance, David Wojnarowicz became absorbed in several censorship battles involving *Tongues of Flame* (1990) and other major works. Combining photographs, paintings, and print techniques, Wojnarowicz created angry and impassioned pieces that linked homophobia to the structures of capitalist society.

Opening in 1975, the Leslie-Lohman Gallery in New York was the first major commercial gallery devoted to the promotion of gay art, including explicit erotic work; by the mid-1980s, similar galleries were opened in several other major cities. However, widespread intolerance for gay erotic imagery was revealed by the intense controversy provoked by two exhibitions of Robert Mapplethorpe's work: a Whitney Museum (NYC) retrospective (1988) and the nationally touring The Perfect Moment (1988–1990).

The Corcoran Gallery in Washington, D.C., canceled The Perfect Moment, and, in 1990, Dennis Barrie, Director of the Contemporary Art Center, Cincinnati, Ohio, was tried on the charge of pandering obscenity because he refused to cancel the exhibit. Although Barrie was eventually cleared of this charge, his long, nationally publicized trial demonstrated the limits still imposed on gay expression.

Barrie's trial was focused primarily on Mapplethorpe's X Portfolio, an extended series of photographs produced largely in the late 1970s, which featured elegantly composed and lit images of fist-fucking and other S/M sexual practices. Expert witnesses, testifying on Barrie's behalf, managed to convince the jury that Mapplethorpe was primarily concerned with aesthetic, rather than sexual, matters.

Sexually Explicit Images

Many of those who publicly condemned Mapplethorpe's exhibitions linked the sexual acts depicted in the X Portfolio to the AIDS epidemic. Confronted with the AIDS hysteria of the late 1980s, numerous gay community leaders called upon artists to avoid explicit depictions of S/M sexuality.

Yet, some artists have continued to create powerful images of the S/M sexual "underground." Prominent among these artists is Mark Chester, who describes himself as a gay radical sex photographer. Although Chester's photographs are often likened to Mapplethorpe's, his work is distinctive in several respects. Although he composes his images as carefully as Mapplethorpe did, Chester avoids the elegant "aloofness" of Mapplethorpe's X Portfolio in order to reveal the intimate feelings linking his subjects to one another and often to himself.

Moreover, Chester seldom depicts individuals who resemble the handsome, athletic young men who predominated in the work of Mapplethorpe. Instead, Chester celebrates the intense masculinity and sensuality of heavyset middle-aged men, wearing glasses; Hassidic leather daddies, clad in the ritual attire of both Orthodox Judaism and the S/M underground; and others who are usually excluded from erotic art.

Racial and Ethnic Issues

The mainstream media, which gave so much attention to the explicit sexual imagery of the X Portfolio, tended to

overlook the racism of such Mapplethorpe images as "Man in a Polyester Suit" (1980) and many of his other photographs of African American men. However, within the gay community, this aspect of Mapplethorpe's work stimulated debate about the dominance of white perspectives in gay erotic art. Prominent cultural critics, such as Kobena Mercer, called attention to the work of gay artists of color and condemned the lack of exposure of their work.

Many recent artists of color have articulated distinctive visions of gay sexualities and communities that challenge the racist ideology evident in much of the erotic imagery created by white gay men. In this respect, their work realizes the goals of unjustly overlooked, earlier twentieth-century artists of color, such as Bruce Nugent.

For instance, in *Tongues Untied* (1989) and other films, Marlon Riggs celebrated the African American gay community and investigated how it was impacted by racism, internalized homophobia, and AIDS. Another African American artist, Glenn Ligon, has created photograph "albums" and multimedia installations, such as *Feast of Scraps* (1995), which reveal the unacknowledged presence of gay men in African American families and visualize histories and dreams of love and desire among black men.

The essays and videos (such as *My Mother's Place*, 1991) produced by activist/artist Richard Fung attack racist conceptions of "rice queens" and present intensely erotic images of gay men within the context of Asian American families and communities. In such paintings as *Intimidades* (2000), Eugene Rodriguez has explored ways in which such factors as social class, geographic location, and ethnic heritage affect the formation of intimate relationships among Latino men.

Queer Artists

By the late 1980s, the essential structure of "gay" culture, focused exclusively upon same-sex desire among men, was challenged by a queer perspective. Queer artists oppose any limits upon sexual expressions and gender constructions, and, most often, they seek to blur other types of boundaries that limit human experience.

In his photographic tableaux, for example, Lyle Ashton Harris represents the interaction of diverse gender, sexual, racial, national, and spiritual "categories." Enacting diverse "masculine" and "feminine" roles in *Brotherhood, Crossroads and Etcetera* (1994), he and his brother, filmmaker and performance artist Thomas Allen Harris, envision the synthesis of Yoruba and Christian religious traditions and reveal the coexistence of violence and love in families and communities.

Queer perspectives have also been articulated vividly by many performance artists. For example, Chicago-based Lawrence Steger, working in collaboration with Iris Moore, has transgressively explored diverse gender roles and sexual identifications in such provocative, surreal pieces as *Rough Trade* (1994).

Martin Wong's career exemplifies the reluctance of queer artists to be confined by any preexisting categories. His paintings of the 1980s, depicting the African and Latino communities of New York's Lower East Side, were originally dismissed by critics because they did not conform to the era's limiting "identity politics," which held that artists should articulate only the perspectives of their own ethnic/racial groups.

Such powerful works as *Little Got Rained On* (1983) and *The Annunciation According to Mikey Pinero: Cupcake and Paco* (1984) visualize spiritually and erotically charged narratives, loosely based on the writings of Miguel Pinero, with whom Wong had an intense, stormy relationship. In *Ms. Chinatown* (1992) and other characteristic paintings of the 1990s, Wong explores multiple gender and sexual possibilities, as he fuses memories of his childhood in San Francisco's Chinatown with the glamorous and decadent representations of that community in Hollywood movies and tourist mementos.

Responses to AIDS

Artists have helped to articulate the diverse responses of the gay and queer communities to the devastation wrought by AIDS, which broke out in 1981. Angry about the seeming indifference of the medical establishment and about the widespread stigmatization of those diagnosed with the disease, some artists resolved to use their work as a tool to organize the affected communities to agitate for change.

Gran Fury, a collective formed by six New York–based artists, created bold and direct poster designs, such as *SILENCE = DEATH* (1986), which depicted the Gay Liberation pink triangle and the title/slogan in white against a black background. Disinterested in monetary rewards, Gran Fury donated most of its works to ACT UP.

Frustrated both by the failure of scientists to develop a cure and by the impact of AIDS on its own members, Gran Fury largely withdrew from the political arena and produced its final (untitled) posters in 1993. Against a plain white background, inscriptions in small black type call upon viewers to contemplate the consequences of AIDS.

Donald Moffett is among the artists who dealt with AIDS-related issues in both street posters (such as his anti-Reagan *He Kills Me*, 1987) and exclusive, carefully made works sold through prestigious galleries (such as the installation piece *You and Your Kind Are Not Wanted Here*, 1990).

Félix González-Torres created an extensive body of work which called attention to the spiritual and emotional impact of AIDS without engaging in simplistic rhetoric. In "Bed" (1991), a photographic image of an unmade bed, and other billboards designed for specific locations in New York, Los Angeles, and Munich, he expressed the conflict between public and private experienced by those under surveillance by the government and the medical establishment because of their HIV/AIDS status and their sexual orientation.

In opposition to mainstream conceptions of persons with HIV/AIDS as isolated and stigmatized, artists have represented the strong families and communities that embraced them. In this vein, San Francisco–based photographer Albert Winn created deeply felt and intimate images recording the experiences of himself and his friends, such as "Brothers" (1991) and "Tony from My Writing Group" (1994).

Duane Michals narrated responses to the deaths of loved ones in photographic tableaux, including "Dream of Flowers" (1986) and "The Father Prepares His Dead Son for Burial" (1991).

In "Untitled (March 5th) #2" (1991), González-Torres utilized two bare lightbulbs and extension cords to develop a complex piece to mourn the death of his partner, Ross Laycock.

Many artists have used traditional religious imagery in innovative ways as they sought to articulate their feelings about the losses caused by AIDS. For instance, Thomas Woodruff memorialized friends, such as *Ruoy Eman* (1992), through paintings of skulls with Crowns of Thorns and other Catholic symbols. For these pieces, Woodruff utilized ornate frames which recall Baroque altarpieces.

Delmas Howe spent six years working on *Stations: A Gay Passion* (completed 2001), an assemblage of sixty monumentally scaled paintings, drawings, and lithographs. Utilizing a figurative language ultimately inspired by the Italian Renaissance and incorporating numerous references to the Passion of Christ, this series celebrates both the intense sexuality of the New York gay community during the 1970s and the heroic suffering of persons with AIDS.

Through such pieces, Howe and other recent artists have fulfilled the traditional function of art to uplift the human spirit in the face of profound crisis.

— *Richard G. Mann*

Bibliography

Bad Object-Choices, eds. *How Do I Look? Queer Film and Video.* Seattle: Bay Press, 1991.

Cooper, Emmanuel. *Fully Exposed: The Male Nude in Photography.* London and New York: Routledge, 1990.

————. *The Sexual Perspective: Homosexuality and Art in the Last 100 Years in the West.* 2nd edition. London and New York: Routledge, 1994.

Dubin, Steven C. *Arresting Images: Impolitic Art and Uncivil Actions.* London and New York: Routledge, 1992.

Gott, Peter, ed. *Don't Leave Me This Way: Art in the Age of AIDS.* London and New York: Thames and Hudson, 1994.

Horne, Peter, and Reina Lewis. *Lesbian and Gay Sexualities and Visual Cultures.* London and New York: Routledge, 1996.

Kaiser, Charles. *The Gay Metropolis: 1940–1996.* Boston: Houghton Mifflin, 1997.

Munoz, Jose Esteban. *Disidentifications.* Minneapolis: University of Minnesota Press, 1999.

Saslow, James M. *Pictures and Passions: A History of Homosexuality in the Visual Arts.* New York: Penguin Putnam, 1999.

See also

American Art: Gay Male, 1900–1969; Photography: Gay Male, Post-Stonewall; African American and African Diaspora Art; AIDS Activism in the Arts; Leslie-Lohman Gay Art Foundation; Dureau, George; González-Torres, Félix; Haring, Keith; Ligon, Glenn; Mapplethorpe, Robert; Michals, Duane; Wojnarowicz, David

American Art: Lesbian, 1900–1969

AMERICAN LESBIAN ART IN THE EARLIER TWENTIETH century was indelibly shaped by the expatriate experience, especially by the salons of Paris, and by the emergence of a more democratic art form, photography, which allowed marginalized communities to document their lives and experiences. After World War II, however, many lesbians felt enormous pressure to retreat into the closet.

Expatriates in Paris

Like the generation that preceded them, American women artists of the early twentieth century went to Europe to seek a less restricted environment in which to develop their art and many went back and forth between the continents.

In Paris, an international group of artists and intellectuals congregated around the literary salons of expatriate American lesbians Gertrude Stein (1874–1946) and her partner, Alice B. Toklas (1877–1967), both writers and art patrons; and that of the publicly lesbian Natalie Clifford Barney (1876–1972), nicknamed "The Amazon" for her love of equestrianism. Barney, a wealthy poet and author from Washington, D.C., hosted her weekly salon for sixty years.

Djuna Barnes (1892–1982) was born in Cornwall-on-Hudson, New York, and later moved to New York City, where her first job was as a reporter and illustrator. A painter, she eventually also became a poet, playwright, and novelist, and illustrated her own books.

In 1921, Barnes went to Paris as a correspondent for *McCall's* magazine; she remained for twenty years. She became part of a circle of writers, including Stein and Barney, who became known as "the Academy of Women" or "the Literary Women of the Left Bank." Her *Ladies Almanack* (1928) is a satire about the group and is infused with lesbian eroticism. *Nightwood* (1932) is based on the breakup of Barnes's love affair in Paris with Thelma Wood (1901–1970), an American sculptor and graphic artist.

Photographer Berenice Abbott (1898–1981) originally moved to New York from Ohio to be a sculptor. There she met and fell in with an artistic crowd that included Barnes. She moved to Paris in 1921, where she changed the spelling of her name from "Bernice" to the more cosmopolitan "Berenice." Working as artist and photographer Man Ray's darkroom assistant, Abbott learned photography and opened her own studio. She also rediscovered and rescued the work of nearly forgotten *vieux Paris* photographer Eugène Atget.

Abbott specialized in portraits of women, many of them lesbian expatriates, though her most famous image is her poignant portrait of author James Joyce (1928). Her study of flamboyantly cross-dressed lesbian author Janet Flanner (1927) is one of her more overtly sapphic subjects; she also photographed lovers Barnes and Wood.

In 1929, Abbott returned to live in the United States; her "Changing New York" documentary project (1935–1939) was her defining work and also defined that era in the city. Although she associated with lesbians throughout her career, Abbott never discussed her sexuality and was closeted throughout her life. In 1985, the artist Kaucyila Brooke wrote to Abbott regarding her lesbianism; Abbott vehemently responded: "I am a photographer, not a lesbian."

One of the most prominent lesbian artists among the expatriates was Romaine Brooks (1874–1970), born Beatrice Romaine Goddard in Rome. By her recollection she had a peripatetic, abusive childhood. Forced as a child to draw clandestinely because her mother forbade it, Brooks emancipated herself at twenty-one and moved to Europe, exploring her creative possibilities in Italy and England before settling in Paris in 1905. She was briefly married in 1902 to a gay musician, John Ellingham Brooks; that same year her mother's death left her independently wealthy.

Brooks was primarily a portraitist who painted mostly women—herself, her friends, and her lovers. Interested in androgyny and gender roles, she exalted a kind of heroic female or "woman warrior" in her depictions. Brooks's paintings have a dominant gray palette, an austerity that extended into her home décor as well.

In 1915, Brooks, then forty-one, met Barney; they would remain together for nearly fifty years. Her portrait of Barney, *The Amazon* (1920, Musée Carnavalet, Paris), is one of Brooks's best-known works. Cross-dressed subjects appear throughout her oeuvre, including her portrait of the British lesbian artist Gluck (Hannah Gluckenstein, 1895–1978) entitled *Peter: A Young English Girl* (1923–1924, National Museum of American Art, Smithsonian Institution), and her study of the lover of novelist Radclyffe Hall, *Una, Lady Troubridge* (1924, National Museum of American Art, Smithsonian Institution).

But her most important work in this genre is her 1923 *Self-Portrait* (National Museum of American Art, Smithsonian Institution). This work boldly establishes a lesbian identity in the visual arts. In her later years Brooks wrote two unpublished memoirs of her life: "No Pleasant Memories" and "A War-Time Interlude."

Photography as Art Form and Document

On the other side of the cultural spectrum of visual production from that cultivated in the salons of Paris is a more democratic art form, photography. This new art form permanently transformed lesbian representation.

The introduction in 1888 of the Kodak box camera revolutionized photography. By having ready access to inexpensive cameras, marginalized communities and their members were able to validate their lives and existences by permanently putting a face to them. The box camera manufacturers began heavily marketing the medium to women, touting the new camera as so easy to operate that even a woman could use it.

Nowhere was amateur photography more embraced than in the United States, a country in love with picturing itself and in need of instant histories to validate its relative youth.

The significance of photography as a documentary tool emerged in the early twentieth century, especially for gay men and lesbians. Anonymous photographs of men or women in loving embraces occasionally appear in archives or antique shops as silent testimonies to lives lived largely in secret.

Some gay and lesbian photographers focused on the world outside, leaving their own lives shadowed in mystery and subject to speculation. Others, however, openly documented their worlds, leaving an important legacy of "proof" where little else survives.

Little-known nineteenth-century lesbian pioneers such as photographer Emma Jane Gay (1830–1919), who photographed Native Americans in Idaho, and Edith S. Watson (1861–1943), who photographed primarily in Canada, paved the way for later, more celebrated practitioners, such as Frances Benjamin Johnston (1864–1952) and Alice Austen (née Munn) (1866–1952).

Frances Benjamin Johnston, born in West Virginia and raised in a socially prominent family in Washington, D.C.,

had a privileged introduction to photography. She studied at the Académie Julian in Paris, and received her first camera as a gift from George Eastman, the inventor of the Kodak camera.

Johnston worked as a freelance photojournalist and opened a studio in Washington in 1895, where as official White House photographer she documented the administrations of Presidents Benjamin Harrison, Grover Cleveland, William McKinley (whom she photographed seconds before his assassination), Theodore Roosevelt, and William H. Taft.

Johnston also photographed Natalie Barney. Her famous self-portrait (ca. 1896), seated with her skirt pulled up, crossed legs exposed, smoking a cigarette, and grasping a beer stein, was her radical take on the concept of the "New Woman" being touted in contemporary literature.

She became a vocal advocate for women in photography. In 1897, *The Ladies' Home Journal* published Johnston's article "What a Woman Can Do With a Camera," and at the Paris Exposition of 1900 she served as curator of an exhibition of photographs by twenty-eight women photographers.

Johnston's one-time business partner and presumed lover, Mattie Edwards Hewitt (d. 1956), was a successful freelance home and garden photographer. In 1913, she and Johnston opened a studio together in New York, and in the 1920s they photographed New York architecture together. Johnston continued to photograph until her death in New Orleans at age eighty-eight. The details of Hewitt's later career are unknown.

Alice Austen, another daughter of privilege, had a very different but no less significant career as a photographer. A native of Staten Island, New York, Austen received her first camera at age ten. For more than fifty years Austen photographed primarily her family and circle of friends in and around Staten Island, amassing more than 9,000 negatives of her work. Austen met teacher Gertrude Amelia Tate in 1899 but Tate did not move in with Austen until 1917; theirs was a fifty-five-year relationship.

Austen was the first lesbian photographer to depict lesbian lifestyles honestly in her work. She photographed herself and her friends (called "the Darned Club" because they excluded men) smoking, bicycling, dressed as men, and in loving embraces. The stock-market crash of 1929 wiped out Austen's fortune, but she and Tate were able to support themselves until 1945. Poverty then caused them to separate; Tate went to live with her sister and Austen ended up at the Staten Island Farm Colony (poorhouse), where she was rediscovered. Sales of her work allowed her to move to a nursing home.

Clear Comfort, the Alice Austen House and Museum, is now open to the public. It has been restored and maintains the photographer's archives. Although Austen and Tate lived their lives rather openly, there have been attempts to force them into the closet posthumously. Barbara Hammer's 1998 documentary, *The Female Closet,* focuses in part on Austen's life and discusses the Austen House board's refusal to allow scholars to use the collection in order to study her sexuality.

Out of or Back to the Closet?

While lesbians were active in all aspects of the art world in the earlier twentieth century, their openness about their sexual orientation varied considerably. Some, such as Natalie Barney and Gertrude Stein, were publicly lesbian, while the lesbianism of others was frequently unknown to all but their intimates. The climate of acceptance in the art world, while perhaps never as full as one would wish, changed considerably after World War II, when enormous pressure was placed on gay men and lesbians to retreat into the closet.

Betty Parsons (1900–1982) was a painter and renowned art dealer in New York for four decades. She was open about her bisexual affairs in the 1920s and 1930s but she withdrew to the closet after World War II, just as she achieved particular prominence as a dealer.

Parsons ran the Wakefield Gallery and Bookshop in New York from 1940 until 1944 and in 1946 opened the Betty Parsons Gallery, which specialized in Abstract Expressionism, a genre predominantly associated with white heterosexual males. At one time her gallery represented the work of Ellsworth Kelly, Barnett Newman, Jackson Pollock, Clyfford Still, Mark Rothko, and others. Seven of these "giants," however, left Parsons in 1951 when she would not focus exclusively on them, even though she had promoted their work more actively than that of her other artists.

Increasingly, she began to show more of her "alternative" artists, such as Swiss lesbian Abstract Expressionist Sonja Sekula (1918–1963), whom Parsons represented from 1948 until 1957. Years later, speaking to her biographer, Parsons explained the need to disavow her lesbianism: "You see, they hate you if you are different; everyone hates you and they will destroy you. I had seen enough of that. I didn't want to be destroyed."

It is no wonder, then, that with such opposition many serious bisexual and lesbian artists who emerged in the first half of the century remained closeted, or at least quiet, about their orientations. But theirs may have been the last generation to subvert their identities in order to further their careers. Increasingly, hand in hand with the burgeoning feminist movement, gay men and lesbians were unwilling to settle for silence and second-best. By the 1960s, they had become increasingly vocal about demanding their equal rights in all aspects of their lives, and with those rights would come visibility.

— *Carla Williams*

BIBLIOGRAPHY

Borzello, Frances. *A World of Our Own: Women Artists Since the Renaissance.* New York: Watson-Guptill Publications, 2000.

Bright, Deborah, ed. *The Passionate Camera: Photography and Bodies of Desire.* London and New York: Routledge, 1998.

Chadwick, Whitney. *Amazons in the Drawing Room: The Art of Romaine Brooks.* Berkeley: University of California Press, 2000.

———. *Women, Art, and Society.* Rev. ed. London: Thames and Hudson, 1997.

Davis, Whitney, ed. *Gay and Lesbian Studies in Art History.* Binghamton, N. Y.: The Haworth Press, 1994.

Duberman, Martin, ed. *Queer Representations: Reading Lives, Reading Cultures.* New York: New York University Press, 1997.

Hall, Lee. *Betty Parsons.* New York: Harry N. Abrams, Inc., 1991.

Novotny, Ann. *Alice's World: The Life and Photography of an American Original, Alice Austen, 1866–1952.* Old Greenwich, Conn.: The Chatham Press, 1976.

Saslow, James M. *Pictures and Passions: A History of Homosexuality in the Visual Arts.* New York: Viking, 1999.

Secrest, Meryle. *Between Me and Life: A Biography of Romaine Brooks.* New York: Doubleday, 1972.

www.natalie-barney.com

www.loc.gov/rr/print/coll/131.html

www.sla.purdue.edu/WAAW/Palmquist/Photographers/Gay.htm

SEE ALSO

American Art: Lesbian, Nineteenth Century; Photography: Lesbian, Pre-Stonewall; Salons; Abbott, Berenice; Austen, Alice; Brooks, Romaine; Gluck (Hannah Gluckenstein); Parsons, Betty; Wood, Thelma Ellen

American Art: Lesbian, Nineteenth Century

ACCORDING TO CULTURAL AND ART HISTORIANS, THE notions of "lesbian art" and "lesbian artist" did not exist prior to 1970. However, lesbian artists certainly existed and worked in the nineteenth century, their accomplishments all the more remarkable for the obstacles they faced both as women and as homosexuals. The reasons for their relative obscurity are easily apparent—serious women artists of any stripe were an anomaly in the nineteenth century, and sexism and homophobia in the arts mirrored that of the rest of the culture.

In order to have careers many women artists resorted to simple deceptions, such as signing their works with a first initial and surname in order to avoid obvious gender identification, just as many women writers used male pen names in order to get their works published.

Their fears were well-founded—lesbian sculptor Anne Whitney (1821–1915), for example, won a commission in 1875 for a sculpture of the abolitionist Clark Sumner, only to be denied the job when it was realized she was a woman. Likewise, disbelieving critics accused lesbian sculptor Harriet Hosmer (1830–1908) of exhibiting her male teacher's work as her own.

Mary Ann Willson

Little definitive information survives about early-nineteenth-century lesbian artists and their lives. Although not much is known about her, one exception is Mary Ann Willson (active 1810–1825), a New York–based folk artist who is considered to be one of the first American watercolorists. Her paintings, made with natural pigments derived from berry juice, brick dust, and vegetable dyes, ranged in subject matter from biblical narratives to a colorful, fanciful mermaid holding an arrow in one hand (*Marimaid*, ca. 1815).

The self-taught Willson settled around 1810 on Red Mill Road, Greenville Town, Greene County, New York, with a Miss Brundage, with whom she bought land and built a log cabin home. Willson painted and sold her pictures, mainly to her farmer neighbors, while Brundage farmed their land.

American Expatriates in Europe

Many lesbian artists found a receptive climate in Europe, where more training opportunities were open to them. Financial freedom was often a determining factor—most of the women who studied in Europe came from wealthy families, which afforded them the freedom to travel and pay for their private educations. Of the best-known American lesbian artists of the nineteenth century, nearly all spent time in France or Italy in creative and intellectual communities that nurtured their talents. For painters, the destination was Paris; for sculptors, Rome.

The establishment throughout Europe in the late 1700s of separate art academies for women had transformed their opportunities to study from original works and develop their talents. European women artists who emerged in the eighteenth century, many from established artistic families, also began to take pupils informally. It would be the first time that women were able to study with women, demonstrating that an artistic career was reasonable and within reach. By the end of the century many of these women would even become instructors in the traditional male-only academies.

Women Sculptors in Rome

The women sculptors who went to Rome to tackle their recalcitrant medium were in the forefront of a burgeoning feminism that would not accept a lesser status for women's work. They were already radical, since sculpture was not considered an art form appropriate for women.

"[T]hat strange sisterhood of American 'lady sculptors' who at one time settled upon the seven hills [of Rome] in a white, marmorean flock" is how novelist Henry James, referring to their preference for the fine white marble quarried near Rome, famously dubbed lesbian sculptors Hosmer, Whitney, Mary Edmonia Lewis (1844–1909), and Emma Stebbins (1815–1882)—along with nonlesbians Louisa Lander, Margaret Foley, Florence Freeman, and Vinnie Ream Hoxie (the only "sister" to marry).

These artists worked primarily in the Neoclassical style, producing monumental sculptures of historical and allegorical female subjects including Cleopatra; Beatrice Cenci; Hagar, the biblical servant of Sarah; and Zenobia, the Queen of Palmyra.

Harriet Hosmer

Harriet Goodhue Hosmer, from a liberal Unitarian family in Watertown, Massachusetts, became the first American woman to heed the call to Rome. She knew from an early age that she wanted to be a sculptor and would not be dissuaded because of her gender. In 1852 Hosmer carved her first full-size marble work, *Hesper, the Evening Star*, and that same year moved to Rome to take an apprenticeship.

Within four years of her arrival Hosmer became financially independent through sales of her work. Her monumental work *Zenobia in Chains* (1859, Wadsworth Atheneum, Hartford, Connecticut) met with tremendous acclaim when exhibited in the United States, drawing 15,000 visitors to its exhibition in Boston. Its success allowed her to establish her Roman studio and she quickly became the "star" of the Roman art world, frequently compared to her male counterpart, the celebrated sculptor William Wetmore Story.

Anne Whitney

Anne Whitney, also from a Massachusetts Unitarian family and a friend of Hosmer's, was a published poet before turning to the visual arts. Whitney was politically active and her work reflected her political and social beliefs. She worked in Boston as a sculptor, where she met with success. In 1866 she, too, went to Rome, and upon her return in 1871 she received a commission for the Capitol Building in Washington, D.C., for a sculpture of Revolutionary War hero Samuel Adams.

Whitney completed more than 100 works, including a portrait bust of her friend Lucy Stone (Boston Public Library), an early feminist who was the first Massachusetts woman to earn a college degree and who kept her name when she married, inspiring later feminists to dub themselves "Lucy Stoners."

Whitney established her studio at 92 Mount Vernon Street on Beacon Hill in Boston. She is said to have had a "Boston marriage" with the painter Abby Adeline Manning (dates unknown), whose work has fallen into obscurity and who is remembered now only as Whitney's longtime companion.

Mary Edmonia Lewis

Unique among the sisterhood was Mary Edmonia Lewis (1844–1909). The only daughter of an Ojibwa (Chippewa) Indian mother and an African American father, she was the most remarkable of the American expatriates because of her humble beginnings and mixed-race heritage. Born in upstate New York in 1844 and orphaned at an early age, Lewis attended Oberlin College but left amidst a scandal and never graduated.

In 1863, Lewis went to Boston to study with the sculptor Edward A. Brackett, and it was there that she met and befriended Hosmer and Whitney. For a time Lewis and Whitney maintained studios in the same building. Aside from the scant tutelage she received from Brackett and later from Whitney, Lewis was largely self-taught as a sculptor. Like Hosmer, she was wary of having her work attributed to her teachers so she chose not to continue with any formal education in art.

Lewis sailed for Rome in 1865. Her studio near the Spanish Steps was a popular destination for tourists and a gathering place for other expatriate artists and intellectuals, many of them women, and she supported herself from the sale of her work.

In Rome Lewis turned to African American and Native American subjects that reflected her heritage, including at least three works about emancipation depicting freed men and women, and *The Old Indian Arrow Maker and His Daughter* (1872, National Museum of American Art, Smithsonian Institution).

"Masculine" Clothing and Appearance

"Wearer of masculine clothing" soon became a euphemism for the lesbian artist. Some, such as the French lesbian painter Rosa Bonheur (1822–1899), had to request special permission from the police to wear men's clothing to attend classes or to simply go about in public. Although any practical-minded woman artist in the nineteenth century would prefer the simple maneuverability of men's garments to the voluminous skirts of women's fashion, the habit is most famously associated with Bonheur, Lewis, and Hosmer.

Lewis wore so-called "mannish" attire, and Hosmer was sometimes called "mannish" in her appearance. Nathaniel Hawthorne, whose controversial novel *The Marble Faun* (1859) included the characters of two women sculptors in Rome, derisively described Hosmer's dress: "She [wore] a sort of man's sack of purple broadcloth, into the side pockets of which her hands were thrust as she came forward to greet us.... She had on a

male shirt, collar and cravat, with a brooch of Etruscan gold." The attention to their dress made each of these famous lesbians popular with both tourists and the contemporary press because they defiantly went against the societal norm.

Lesbian Patron Charlotte Cushman

Patronage was an important factor for the nineteenth-century lesbian artist. Just as there were lesbian artists, so, too, were there lesbian patrons who bought and supported the work.

Boston-born actress Charlotte Saunders Cushman (1816–1876), famous for her gender-defying roles on the stage, was a kind of guardian and patron to many artists including Lewis and Hosmer and hosted a salon that they all frequented.

Cushman was instrumental in encouraging Hosmer to relocate to Rome and made the initial journey with her. She provided Hosmer with free housing for her first seven years in Rome and arranged for her apprenticeship with sculptor John Gibson.

Eventually Cushman took the artist Emma Stebbins as her partner, introducing her to the sculpture medium. Stebbins, originally from New York, arrived in Rome at age forty-one, a mature woman but novice artist. Cushman helped Stebbins receive some of her more important public commissions, and her works now stand in Brooklyn, Boston, and New York's Central Park (*Angel of the Waters*, ca. 1862). After Cushman's death, Stebbins edited the actress's letters and published her biography.

Recognition

As the times changed, lesbian artists became more prominent and their successes more frequent, although some achieved recognition only posthumously in the twentieth century.

In 1864, Hosmer wrote letters to the press successfully defending her work as her own, thereby gaining her rightful recognition and establishing the "masculine" medium as one that women could master. Hosmer, who was called "the most famous female sculptor of the century," was consequently influential to generations of women artists.

Lewis's monumental masterpiece, *The Death of Cleopatra* (National Museum of American Art, Smithsonian Institution), was exhibited at the Centennial Expositions in Philadelphia in 1876 and in Chicago in 1878, where it generated a tremendous amount of excitement and interest.

Whitney later taught at Wellesley College in Massachusetts; her sculpture of Clark Sumner was eventually executed and erected in Harvard Square, in Cambridge, Massachusetts, in 1902. Her Mount Vernon

Street studio is now a featured stop on a walking tour of Beacon Hill in Boston.

In 1940, Bonheur's partner, the American painter Anna Elizabeth Klumpke (1856–1942), published a combination of her own memoirs and a biography of her lover. She is best known for her portraits of famous women such as Bonheur and women's rights advocate *Elizabeth Cady Stanton* (1889, National Portrait Gallery, Smithsonian Institution).

Mary Ann Willson, who apparently stopped painting upon Brundage's death, was rediscovered in 1943 and her *Prodigal Son* watercolor series is now in the collection of the National Gallery of Art. In 1969, Willson's and Brundage's life together became the inspiration for Isabel Miller's popular novel *Patience and Sarah* (1972, originally self-published in 1969 as *A Place for Us*).

— *Carla Williams*

BIBLIOGRAPHY

Borzello, Frances. *A World of Our Own: Women Artists Since the Renaissance*. New York: Watson-Guptill Publications, 2000.

Chadwick, Whitney. *Women, Art, and Society*. Rev. ed. London: Thames and Hudson, 1997.

Dwyer, Britta C. *Anna Klumpke: A Turn-of-the-Century Painter and Her World*. Boston: Northeastern University Press, 1999.

Klumpke, Anna Elizabeth. *Memoirs of an Artist*. Boston: Wright and Potter, 1940.

———. *Rosa Bonheur: The Artist's (Auto)Biography*. Gretchen Van Slyck, trans. Ann Arbor: University of Michigan Press, 1997.

Miller, Isabel. *Patience and Sarah*. New York: McGraw Hill, 1972.

Saslow, James M. *Pictures and Passions: A History of Homosexuality in the Visual Arts*. New York: Viking, 1999.

Sherwood, Dolly. *Harriet Hosmer, American Sculptor 1830–1908*. Columbia: University of Missouri Press, 1991.

Stebbins, Emma, ed. *Charlotte Cushman: Her Letters and Memories Of Her Life*. Boston: Houghton, Osgood and Company, 1879.

Wolfe, Rinna Evelyn. *Edmonia Lewis: Wildfire in Marble*. Englewood Cliffs, N.J.: Silver Burdett Press, 1998.

www.altladies.com/Notable_Womyn.htm

www.uuwhs.org/Mar2000Exhibit/3-WalkingTour/SBU3_template.html

www.nga.gov/cgi-bin/pbio?204770

www.patienceandsarah.com/

SEE ALSO

American Art: Gay Male, Nineteenth Century; Bonheur, Rosa; Hosmer, Harriet Goodhue; Klumpke, Anna Elizabeth; Lewis, Mary Edmonia; Stebbins, Emma; Whitney, Anne

American Art: Lesbian, Post-Stonewall

SINCE STONEWALL, LESBIAN ARTISTS IN AMERICA, from installation artists to filmmakers and photographers to performance artists and painters, have become increasingly diverse and visible.

Lesbians in the 1950s and 1960s benefited from both the feminist and the civil rights movements. Within the feminist movement emerged lesbian feminism, which gave rise to groups and experiences that galvanized the lesbian movement and gave many middle-class women the freedom in which to "come out" and embrace their sexuality.

During this time, however, there were few venues and outlets for women's art, let alone lesbian art. One exception was *The Ladder*, the newsletter from 1956 until 1972 of the San Francisco–based Daughters of Bilitis (DOB), the first lesbian rights organization, which regularly included artwork.

The 1960s: Feminism and Abstraction

Explicitly "lesbian" imagery did not emerge until the 1960s. The reasons for this are varied. Many lesbians shied away from sexual content for fear that explicit depictions of their sexuality would be misunderstood within a patriarchal, heterosexual society that was unable or unwilling to understand the nature of those images. Consequently, some lesbian artists made work with "ghetto content"—imagery that was understood only within the community. This strategy made it less likely for their work to be welcomed into a mainstream dialogue.

As the feminist and civil rights movements progressed and women artists persisted, woman-based content began to emerge in the visual arts. The ideas that art might validate women's lives, that previously devalued craft traditions were significant, and that women's bodies were biological vessels of creation and change—these were not concepts that had been previously welcome in the canon, but they increasingly became the impetus for women's art.

However, some lesbian artists who emerged during that decade, particularly New York–based artists such as Louise Fishman (b. 1939) and Joan Snyder (b. 1940), favored a more abstract style consistent with the dominant art movement of the time. For them, the lack of narrative or reference in Abstract Expressionism proved an apt metaphor for their inability to be open regarding their homosexuality elsewhere.

On June 3, 1968, a galvanizing incident occurred in the art world involving the radical lesbian feminist Valerie Solanas (1936–1988), founder of SCUM (Society for Cutting Up Men) and author of the *SCUM Manifesto*. Solanas tried to assassinate gay Pop artist Andy Warhol because she believed he had stolen her ideas. While Solanas was certainly mentally disturbed, her claim of stolen authorship and subsequent action, however radical, was keenly understood by women artists whose own groundbreaking works had frequently been overlooked while their male, sometimes gay, counterparts found fame and acceptance.

One year later, the Stonewall uprising on June 28, 1969, at the Stonewall Inn, a gay bar in New York's Greenwich Village, became the watershed moment in gay and lesbian history and forever changed lesbian visibility in the art world.

The 1970s: Agitation and Change

In the 1970s, both New York and Los Angeles became important centers for lesbian artists. However, there were differences in the art produced in the two places. East Coast lesbians were more likely to shy away from explicitly lesbian imagery, while this was less true on the West Coast, where the influence of the dominant art world was not as immediate or as pervasive.

The first Gay Pride parade was staged in New York in 1970, on the anniversary of the Stonewall uprising. Significantly, Fran Winant (b. 1944), a poet, painter, and member of the Feminist Lesbian Art Collective (FLAC), was pictured on the Gay Liberation Front's poster for the march.

As gays and lesbians began to organize and agitate for their civil rights, the necessity for documentation became paramount, and lesbian photographers actively chronicled their communities. Artists such as Joan E. Biren (JEB) (b. 1944) in Washington, D.C., and Tee A. Corinne (b. 1943), Jean Weisinger (b. 1954), and Cathy Cade (b. 1942) in the San Francisco Bay Area photographed the assemblies, marches, meetings, and other events within their communities.

In doing so, they both validated the existence of the lesbian and gay communities at the time and preserved a record for the future. The proliferation of postcards, posters, journals, and other alternative publications indicated a developing and expanding audience for their work.

As their imagery developed, each of the photographers mentioned above also explored a more expressive or artistic side of the medium. Self-representation was both literal, as photographers pictured their own bodies, and metaphorical, as they depicted their friends and lovers. Still, with the feminist agenda governing much of their work's content, many lesbian artists shied away from explicitly sexual depictions of their lifestyles, the end result of which was nearly to neuter themselves in the service of political correctness.

One exception was Corinne, whose close-cropped imagery of women's genitalia combined the erotic and

the clinical and both reclaimed desire and demystified the female body.

In 1970, New York–based artist Kate Millett (b. 1934) published *Sexual Politics* and overnight became the spokeswoman for the women's movement. The book sold half a million copies in paperback and landed its author on the cover of *Time* magazine. The bisexual Millett was not only a writer, however, but also a sculptor and mixed-media installation artist whose work featured found objects. From the beginning Millett's work was political, addressing U.S. policy in Vietnam as well as domestic issues such as violence against women.

Although Millett saw sales of her publications fall dramatically after she came out as a lesbian, the relationship between the feminist movement and the lesbian movement remained strong. Many lesbians, for instance, participated in *Womanhouse* (1972), an installation and performances that were part of the Feminist Art Program at the California Institute of the Arts (CalArts), directed by feminist artists Judy Chicago and Miriam Schapiro.

Womanspace, which was founded in 1973 at the new Woman's Building in Los Angeles, hosted a Lesbian Week. The third issue of the New York–based journal *Heresies: A Feminist Publication on Art and Politics* (1977–1993), was entitled *Heresies: Lesbian Art and Artists*. It was the first nonlesbian journal issue to focus on lesbian work exclusively. Not surprisingly, the editor found it difficult to secure work from lesbian artists, who were reluctant to be identified and segregated.

Lesbian critic and historian Arlene Raven was cofounder of the Feminist Studio Workshop, the educational division of the Los Angeles Woman's Building, which published *Chrysalis: A Magazine of Women's Culture* (1977–1980). She also sponsored the Natalie Barney Collective, which researched and documented lesbian artists.

Through the Collective, Raven also founded The Lesbian Art Project (1977–1979), which hosted art and writing groups and regular salons. In 1979, the Project produced *The Oral Herstory of Lesbianism*, directed by Terry Wolverton, a performance for women only which explored the hidden history of lesbianism and called for lesbians to record their stories.

In 1978, New York–based Harmony Hammond (b. 1944), whose abstract work referenced women's histories, bodies, and emotions, curated A Lesbian Show at 112 Greene Street Workshop in New York. Including the work of eighteen artists—Hammond, Louise Fishman, Kate Millett, Fran Winant, Barbara Asch, Suzanne Bevier, Betsy Damon, Maxine Fine, Jessie Falstein, Mary Ann King, Gloria Klein, Dona Nelson, Flavia Rando, Sandra de Sando, Amy Sillman, Ellen Turner, Janey Washburn, and Ann Wilson (with Amy Scarola, Etana Dreamer, and Yvonne Lindsay adding their work to the walls during the exhibition)—A Lesbian Show is generally considered to be the first important lesbian art exhibition.

While it included readings, videos, films, performances, and discussions organized by Damon (b. 1940), it did not include photographs or erotic art. It focused mainly on abstract work like Hammond's. As with the lesbian issue of *Heresies* the previous year, which Hammond cofounded and on which she had also worked, there was some difficulty in getting artists to be "out" in a "ghettoized" context.

The 1980s: Presence and Recognition

Just two years later, in 1980, The Great American Lesbian Art Show (GALAS), organized by six lesbian artists, along with the members of the Feminist Studio Workshop, opened. Its purpose was to highlight the state of lesbian art at the beginning of the new decade. In addition to an invitational exhibition at the Woman's Building in Los Angeles, the exhibition included more than 200 regional "sister" events and exhibitions in fifty communities and the establishment of the GALAS Archives. GALAS was a rousing success, receiving coverage in the Los Angeles mainstream art press.

The exhibition also marked the first time that work by lesbians of color—African American Lula Mae Blockton and Cuban American Gloria Longval—were included in a lesbian art exhibition. Lesbians of color had previously either been overlooked by the majority white, middle-class lesbians, or declined to participate because of particular homophobia within their communities; even Blockton had turned down the invitation to participate in 1978's A Lesbian Show.

Other significant exhibitions of the time included The Third Wave, mounted as an anniversary exhibition of A Lesbian Show, featuring about half of the artists who participated in the earlier show.

In 1982, Extended Sensibilities: Homosexual Presence in Contemporary Art, featuring works of painting, drawing, and sculpture, took place at the New Museum in New York. It was the first exhibition to address homosexuality as a subject in art. Eight of the eighteen artists were lesbians: Betsy Damon, Nancy Fried, Janet Cooling, Lili Lakich, Jody Pinto, Carla Tardi, Fran Winant, and Harmony Hammond.

The curator, Daniel J. Cameron, put forth three categories of gay art content: homosexual content, or stereotyped images; ghetto content, or work that is easily recognized only by the gay community; and sensibility content, "work which is created from the personal experience of homosexuality which need not have anything to do with sexuality or even lifestyle." The latter

category was further subdivided into three types: "the homosexual self," "the homosexual other," and "the world transformed."

Although overall the exhibition failed conceptually and was criticized for not being "political or gay enough," it became the best-attended show to that date at the New Museum and generated a necessary dialogue regarding gay and lesbian representation in art.

As postmodernism with its antifeminist rhetoric redefined aesthetics and fueled the 1980s art boom, lesbian artists redefined their content to be less abstract, more political, and more sexually explicit.

An important element of this shift was the emergence of working-class artists and artists of color such as Chicanas Judith F. Baca (b. 1946) and Yolanda Lopez (b. 1942), and Hulleah Tsinhnahjinnie (b. 1954), a Seminole, Muskogee, and Diné "two-spirited" person—a term she prefers to the more white cultural term "lesbian." Their work deals primarily with issues of self-identity and representation.

Photographers such as Jill Posener (b. 1953), Zoe Leonard (b. 1961), Laura Aguilar (b. 1959), Kaucyila Brooke (b. 1952), and Gay Block (b. 1942) found the medium ideal for investigations of race, gender, and representation. As the most democratic art form, photography could easily incorporate both "high art" and popular culture references, frequently inserting the lesbian body into mainstream scenarios, as in Deborah Bright's (b. 1950) "Dream Girls" series (1990), in which she deftly replaces the leading men in famous film stills with photographs of her butch self getting the girl.

Millie Wilson's (b. 1948) 1989 installation "Fauve Semblant: Peter (A Young English Girl)," based on a Romaine Brooks portrait of lesbian painter Gluck (née Hannah Gluckenstein, British, 1895–1978), imagines a museum retrospective exhibition for a fictional lesbian painter while paying homage to those two real, largely forgotten predecessors.

Lesbian sexuality, in particular the sexual outlaw, is explored in the work of Della Grace (b. 1957; now known as Del LaGrace Volcano), an American artist working in London, whose images incorporate S/M and gay male iconography. It is also an important subject of the work of Catherine Opie (b. 1961), whose portraits of her own S/M community and transgendered and drag friends claimed the traditional genre of portraiture for these marginalized—and previously unseen—subjects. Self-representation, including portraits of community, had become crucial.

The 1990s and 2000s: Queer is Here
After 1980's GALAS, there was not another major lesbian-themed exhibition until lesbian curator Pam Gregg's All but the Obvious: A Program of Lesbian Art

at Los Angeles Contemporary Exhibitions (LACE) in 1990. ABO established a queer lesbian sensibility and consisted of performances, readings, film, and video in addition to the visual art exhibition, with works by Laura Aguilar, Janet Cooling, Catherine Opie, Millie Wilson, Kaucyila Brooke, Della Grace, Nancy Rosenblum, Tracy Mostovoy, Collier Schorr, Laurel Beckman, Beverly Rhoads, Catherine Saalfield, Jacqueline Woodson, Gaye Chan, and Monica Majoli.

Gregg's Situation: Perspectives on Work by Lesbian and Gay Artists (1991), cocurated with Nayland Blake, followed in San Francisco, and the decade saw numerous exhibitions and spaces devoted to lesbian art from California to Houston (Out! Voices from a Queer Nation, 1991) to Boulder, Colorado (2 Much: The Gay & Lesbian Experience, 1993).

In 1991, British-born lesbian artist Nicola Tyson opened Trial Balloon in a section of her New York studio loft, an all-woman, semicommercial gallery that highlighted the work of lesbian artists and was the first in more than twenty years to focus on women artists.

At the end of the 1980s and beginning of the 1990s, gay and lesbian artists found themselves at the forefront of arts funding controversies. In 1990, lesbian performance artist Holly Hughes (b. 1955) became one of the NEA Four, along with Tim Miller, Karen Finley, and John Fleck. These artists, all of whom had been awarded individual grants by the National Endowment for the Arts (and all of whom, except Finley, are gay), were charged with indecency and their grants rescinded.

They sued and their grants were reinstated, but the climate for government support had shifted and the decade was marked by conservative reaction and controversies regarding artistic representation, particularly when it related to gays and lesbians and people of color.

However, despite the controversies, by the 1990s lesbians no longer restricted themselves in terms of sexual or political content. New generations of artists, while owing—and acknowledging—a debt to the lesbian feminist work of the 1970s, constructed work based on their own experiences in a more pluralistic culture. Lesbian exhibitions such as Seattle's Gender, fucked (1996) blurred the distinctions between masculine/male and feminine/female in work dealing with transgender politics through representations of drag, passing, tomboys, etc.

Lesbian artists in the 1990s found drawing and painting once again viable media for lesbian expression, as they used appropriation to recontextualize art history. Trial Balloon's 1992 exhibition Part FANTASY: the sexual imagination of seven lesbian artists explored through the medium of drawing was perhaps the first lesbian show to focus on the significance of media as well as content.

In her continuing work, artist Deborah Kass (b. 1952) smartly appropriates the work of Andy Warhol, replacing his gay Pop icons with her own lesbian ones. Nicole Eisenman (b. 1968) draws, paints, and constructs Amazons, flipping the script on men and art history in lesbian scenes and castration fantasies. Zoe Leonard, Mary Patten, Judith Bamber, and others create work using "cunt" imagery to reclaim art and the female body for lesbian audiences.

Artists such as Tammy Rae Carland and G.B. Jones go even further in referencing lesbian popular culture to reassert lesbian sexuality. They derive imagery from pulp novels, women-in-prison films, and lesbian porn. Carland is also cofounder with musician Kaia Wilson of Mr. Lady records, an independent label that distributes lesbian videos and films. Mr. Lady is also home to lesbian performance-art band Le Tigre, composed of Kathleen Hanna, Johanna Fateman, and JD Samson. (Founding member and filmmaker Sadie Benning, no longer with the group, was a pioneering video artist as a teenager in the 1980s.)

Performance, a mainstay of early feminist art, has become an important element in lesbian culture through the work of Le Tigre, Phranc, The Butchies (Wilson's band), Jocelyn Taylor, Shu Lea Chang, and others. Queer activists such as Dyke Action Machine (DAM; Carrie Moyer and Sue Schaffner), The Lesbian Avengers, and fierce pussy (Carrie Yamaoka, Joy Episalla, Pam Brandt, and Alison Froling) incorporate elements of performance in their "actions."

At century's end a conservative backlash began: in 1998 the NEA Four lost an appeal by the government to the Supreme Court and eventually lost their grant funding. At the start of the new millennium, however, lesbian art is experiencing a pluralism and visibility it has never previously enjoyed. The proliferation of alternative venues from lesbian sex journals to zines to cartoons to websites to concerts is an important development for the future of lesbian art. Lesbian artists in America, from installation artists to filmmakers and photographers to performance artists and painters, are increasingly diverse and visible.

— *Carla Williams*

BIBLIOGRAPHY

Blake, Nayland, Lawrence Rinder, and Amy Scholder, eds. *In a Different Light: Visual Culture, Sexual Identity, Queer Practice.* San Francisco: City Lights Books, 1995.

Boffin, Tessa, and Jean Fraser, eds. *Stolen Glances: Lesbians Take Photographs.* London: Pandora Press, 1991.

Boffin, Tessa, and Sunil Gupta, eds. *Ecstatic Antibodies: Resisting the AIDS Mythology.* London: Rivers Owen Press, 1990.

Bright, Deborah, ed. *The Passionate Camera: Photography and Bodies of Desire.* London and New York: Routledge, 1998.

Bright, Susie, and Jill Posener, eds. *Nothing but the Girl: The Blatant Lesbian Image: A Portfolio and Exploration of Lesbian Erotic Photography.* New York: Freedom Editions, 1996.

Davis, Whitney, ed. *Gay and Lesbian Studies in Art History.* New York: Harrington Park Press, 1994.

Duberman, Martin, ed. *Queer Representations: Reading Lives, Reading Cultures.* New York: New York University Press, 1997.

Gates, Beatrix. *The Wild Good: Lesbian Photographs & Writings on Love.* New York: Anchor Books, Doubleday, 1996.

Horne, Peter, and Reina Lewis, eds. *Outlooks: Lesbian and Gay Sexualities and Visual Cultures.* London and New York: Routledge, 1996.

Kelley, Caffyn, ed. *Forbidden Subjects: Self-Portraits by Lesbian Artists.* North Vancouver, B.C.: Gallerie Publications, 1992.

Hammond, Harmony. *Lesbian Art in America.* New York: Rizzoli International Publications, 2000.

Jones, Amelia, ed. *Sexual Politics: Judy Chicago's Dinner Party in Feminist Art History.* Berkeley and Los Angeles: UCLA at the Armand Hammer Museum of Art and Cultural Center in association with University of California Press, 1996.

Kiss & Tell: Persimmon Blackbridge, Lizard Jones, Susan Stewart. *Her Tongue on My Theory: Images, Essays, and Fantasies.* Vancouver: Press Gang Publishers, 1994.

Lord, Catherine, ed. *Pervert.* Irvine: The Art Gallery, University of California at Irvine, 1995.

Saslow, James M. *Pictures and Passions: A History of Homosexuality in the Visual Arts.* New York: Viking Penguin, 1999.

Smyth, Cherry. *Damn Fine Art by New Lesbian Artists.* London: Cassell, 1996.

Vicinus, Martha, ed. *Lesbian Subjects: A Feminist Studies Reader.* Bloomington: Indiana University Press, 1998.

Mr. Lady Records: www.mrlady.com

www.disgrace.dircon.co.uk

Lesbian photographers: www-lib.usc.edu/~retter/photolist.html

Queer Arts Resources: www.queer-arts.org

SEE ALSO

Photography: Lesbian, Post-Stonewall; Pop Art; Biren, Joan Elizabeth (JEB); Brooks, Romaine; Chicago, Judy; Cooling, Janet; Corinne, Tee; Gluck (Hannah Gluckenstein); Grace, Della (Del LaGrace Volcano); Hammond, Harmony Lynn; Warhol, Andy

Angus, Patrick (1953–1992)

AMERICAN REALIST ARTIST PATRICK ANGUS PRODUCED keenly observed and compassionate depictions of the 1980s gay demimonde. His work captures, with sympathy, understanding, and wit, the longing and loneliness of many urban gay men of the era.

Born on December 3, 1953, in North Hollywood, California, and raised in Santa Barbara, Patrick Angus was a shy boy who wanted to be an artist. With no guidance and only misinformation for reference, he floundered.

Although a kind high-school art teacher mentored him and even let him use his studio, Angus was afraid to broach the subject of his sexual angst with a heterosexual man.

In 1974, a scholarship to the Santa Barbara Art Institute led him to discover the book *72 Drawings by David Hockney* (1971). Here he found an artist who celebrated his sexual persona in his work and who glamorized the "good" gay life in Los Angeles, only 100 miles away. However, when Angus moved to Hollywood in 1975, he discovered that the good gay life does not exist for poor people, "unless, of course," as he bitterly noted, "they are beautiful." Angus, believing that he was sexually unattractive, was hopelessly lonely for the affection of an objectified beautiful boy.

Growing up when figurative painting was anathema to the art establishment, Angus had his aesthetic preference strengthened through his friendship with other "realist" artists who agreed with his view that an art dependent on observation was more interesting than the usual "concept art-product of that dreary Minimalist age." A superb draftsman, with a keen eye for gestural detail, Angus made portraits of friends and recorded with Hockney-like wit the Los Angeles scene around him, evading, however, overtly gay subject matter.

In 1980, in New York City to see the Picasso Retrospective at the Museum of Modern Art, Angus made a crucial observation of the sexual autobiography inherent in Picasso's work. He declared that "Picasso demonstrated that *anything* [including orgasm] can be depicted—Picasso is the ultimate realist."

Thereafter, Angus began to paint large canvases based on his personal obsession with erotic loneliness. Three major paintings define his milieu: *Boys Do Fall in Love* (1984), which depicts a strip show; *Flame Steaks* (1985), which is set in a hustler bar; and *The Mysterious Baths* (1985), which portrays a gay bathhouse. On the basis of work such as these canvases, playwright Robert Patrick described Angus as "the Toulouse-Lautrec of Times Square."

However, his subject matter closed off the commercial art market to Angus; and the bourgeois gay establishment disapproved of his depictions of the politically incorrect "bad" gay life, the demimonde of cruising, hustling, and loneliness. All attempts to exhibit Angus's work were rebuffed. (One of these humiliating efforts can be seen in the film *Resident Alien*, a documentary of the life of Quentin Crisp, one of Angus's first vocal supporters.)

In despair that his work would never be accepted by the art establishment, Angus resigned himself to obscurity and poverty. He found a room in a New York welfare hotel, where he could paint, but he refused to risk more humiliation by attempting to exhibit his work. This reluctance prompted Robert Patrick to introduce

this "Emily Dickinson of Painting" through the pages of *Christopher Street* magazine, the most literate of gay publications in the 1980s. As a result, Angus's work began to sell. The artist was particularly gratified that David Hockney bought five major paintings.

In the early 1990s, however, still poor and unable to afford a doctor, Angus collapsed and was diagnosed with AIDS. Facing imminent death, he worried that his life's work would die with him. But in the last months of his life, three one-man shows of his work were mounted. On his deathbed in 1992, when he saw the proofs for a book of his paintings, he said, "This is the happiest day of my life."

Patrick Angus's keenly observed images of the gay underclass of the 1980s are a major contribution to the legacy of American social realism as embodied in the work of such artists as Thomas Eakins, Winslow Homer, Edward Hopper, Reginald Marsh, and Paul Cadmus. Moreover, they are unique in the history of art for their compassionate depiction of the longing and loneliness of some urban gay men. — *Douglas Blair Turnbaugh*

BIBLIOGRAPHY

Goodbye to Berlin? 100 Jahre Schwulenbewegung. Eine Ausstellung des Schwules Museums und der Akademie der Künste. Berlin: Rosa Winkel, 1997.

Patrick, Robert. "Patrick Angus, Painter." *Christopher Street* No. 126 (1988): 44–51.

Trent, Robert. "The Portraits of Patrick Angus: Love, Pain, and the Whole Damn Thing." *Christopher Street* No. 147 (1990): cover, 18–25.

Turnbaugh, Douglas Blair. *Strip Show: Paintings by Patrick Angus.* London: Editions Aubrey Walter, 1992.

SEE ALSO

American Art: Gay Male, Post-Stonewall; Cadmus, Paul; Censorship in the Arts; Eakins, Thomas; Hockney, David; Homer, Winslow

Architecture

DURING THE 1990S, SEXUALITY ENTERED THE FIELD of architecture. Scholars began researching the sexuality of architects from the past; activists addressed workplace discrimination; and practitioners used sexual identity as an inspirational tool in design.

The American Institute of Architects (AIA) began sponsoring an annual diversity conference focusing on the links between gender, sexuality, and cultural experience. Archivists from the Avery Architectural and Fine Arts Library at Columbia University and the Frances Loeb Library at Harvard University began examining their collections from gay, lesbian, and gender perspectives.

Groups such as BGLAD (Boston Gay and Lesbian Architects and Designers) and OLGAD (Organization of Lesbian and Gay Architects and Designers) formed to build community by organizing meetings, hosting lectures, and publishing newsletters. Consumer magazines such as the *New York Times Magazine* and *Architectural Digest* featured same-sex couples, and gay and lesbian magazines such as *The Advocate* and *Genre* incorporated design columns.

The effects of HIV and AIDS also brought gay architects into the media. Many who died, such as Alan Buchsbaum (1935–1987), Frank Israel (1945–1996), Roger Ferri (1949–1991), Mel Hamilton (1949–1992), and Mark Kaminski (1953–1993), were in the prime of their careers. The profession began to recognize the lost potential of these gifted designers.

When Philip Johnson, one of the most famous architects in the United States, appeared on the cover of *Out* in 1996, the profession's "coming out" reached its apex. Gay, lesbian, bisexual, and transgender people were all undeniably part of architecture's family.

Gay and Lesbian Architects

Looking into the sexual orientation of architects and designers can lead readers to make assumptions about its impact on design decisions, which must perforce remain speculative. Some architectural critics and historians caution against forming conclusions about such matters, for too little is known about the effect of sexuality on creativity. Moreover, the process of identification and speculation can close down readings of ambiguous work.

Still, there is a long association of gay men and lesbians with building and design, whether it be the constructions on a grand scale by figures such as William Beckford and Ludwig of Bavaria or the interior designs of Elsie de Wolfe. While any list of gay and lesbian architects is both incomplete and limiting, its inclusion here highlights the diversity and wealth of talent these somewhat arbitrarily selected individuals have brought to the field.

In his biography of Louis H. Sullivan (1856–1924), Robert Twombly writes, "There is a good deal of evidence—some personal, some architectural—to suggest that Louis Sullivan may have been homosexual." Sullivan, who coined the phrase "form follows function," began to strip down the classical influence that was popular in his time. His designs featured both organic ornamentation (intricate patterning based on natural forms) and structural innovations (multistory steel structures with elevators). His work includes landmark buildings in Buffalo, Chicago, New York, and St. Louis.

In *Boston Bohemia*, Douglass Shand-Tucci implies that Ralph Adams Cram (1863–1942) was homosexual at a time when the term was just being recognized. Focused on the relationship of art and religion and using

architecture to communicate his beliefs and passions, Cram is best known for his American Gothic churches such as All Saints in Ashmont, Boston and University Chapel at Princeton. As Shand-Tucci remarks, "Anglo-Catholicism became for Cram the principal expression or carrier of his sexual orientation—and in a most characteristically Platonic way."

Elsie de Wolfe (1865–1950), Julia Morgan (1872–1957), and Eleanor Raymond (1887–1989) are three probable lesbians whose work has recently been studied. de Wolfe, considered to be the first professional interior designer, brought light colors and casual decor into formerly dark, heavy Victorian-era settings.

Morgan, the first woman architect registered in California, was eclectic. Many of her residential-scaled churches and girls clubs carried on the local traditions of wood construction. Her best known work, San Simeon, or Hearst Castle, is a varied mix of European and American elements. Sara Boutelle observes that "Morgan had a special knack for swimming pools, using color, light, and shape to create sumptuous designs that flaunted a hedonism startling for so modest an architect."

Raymond, an innovator interested in solar power and new structural technologies, focused on small modern homes in New England. "I like the personal contact with whoever is going to use what I design," she said. "Houses are so important in the background of children that I feel important [doing them]."

Philip Johnson (b. 1906) is often credited with popularizing the International Style. As the first Director of the Department of Architecture at New York's Museum of Modern Art, a professor at many universities including Harvard and Yale, the first Pritzker Prize winner (1979), and *Time* magazine cover boy (1984), Johnson is both famous and influential. His "Glass House" in New Canaan, Connecticut, modernist office buildings, postmodernist skyscrapers, and deconstructivist structures are well-documented. His chameleon-like attachment to changing design trends have kept him fashionable and controversial.

Bruce Alonzo Goff (1904–1982), Paul Rudolph (1918–1997), and Charles Moore (1925–1993) were educators and innovators. Known mostly for his residences, Goff rejected the strict geometries of modernism. His houses strongly respond to their sites: the circular forms, abstract shapes, and natural contours found in land, rock, and sea. As a visionary, he tried not to follow what came before but to look for design solutions outside the mainstream. Many of his designs are playful and experimental, blurring the distinction between inside and outside with gardens, pools, and rough textures.

Rudolph was at the forefront of a style known as Brutalism, using poured and textured concrete to make aggressive and massive forms. Towers and beams, ramps

and windows overlap, penetrate, and integrate in strikingly sculptural ways; mechanical and structural systems are often complex. His large-scale government, commercial, and residential buildings around the world are often imaginative and memorable while sometimes disorienting and "in-your-face." As he once said of his designs, "You overdo it in order to make it visible."

Moore's work helped found the postmodern movement. Rebellious and fun, Moore quoted equally from classical structures and pop culture. He argued that architectural forms have meanings and associations and worked with their symbolism. Turning familiar forms into brightly colored icons made a connection to the past while pointing out their current use as appliqué. Moore's scenographic, populist tendencies are best represented in the Piazza d'Italia in New Orleans and museums at Williams College and Dartmouth College.

Alan Buchsbaum is one of the creators of the High Tech style. Bringing off-the-shelf, industrial materials into commercial interiors, juxtaposing open, metal shelving with old English office chairs in New York lofts, Buchsbaum created contemporary, informal spaces for adventurous individuals. He disliked the banality and pretension of formal interiors and worked with clients such as Bette Midler, Diane Keaton, and Christie Brinkley, who appreciated his alternative approach. He died from AIDS complications in 1987.

Franklin D. Israel is well known for his work in Los Angeles. Taking his cues from the riots, fires, floods, and earthquakes of the city, Israel's work embodies both the tension of the city and the need to find a place to rest. His homes for Hollywood figures and offices for film companies challenge notions of comfort and order. When he learned about his HIV-positive status, Israel became more open about his sexuality. Knowing that his time might be limited, he worked hard to make his designs innovative, tough, and visually attractive.

Jed Johnson (1949–1996) designed interiors, sometimes in association with his life partner, architect Alan Wanzenberg. Johnson began editing and directing films at Andy Warhol's Factory and designed the artist's townhouse. By 1980, he had opened his own office and developed an eclectic style that included the contemporary and classic. With clients such as Richard Gere, Mick Jagger, and Barbra Streisand, Johnson decorated by "looking at the personality of the client and taking your clues from it…. You get an image of a room that would suit them," he remarked. Johnson died in the 1996 TWA Flight 800 explosion.

Currently active gay and lesbian architects include, in addition to Philip Johnson, such prominent figures as Rodolfo Machado, Mark Robbins, Stanley Saitowitz, David Schwarz, Jorge Silvetti, and Robert A. M. Stern. In addition, writers who focus on architecture and space include such authors as Stanley Abercrombie, Aaron Betsky, Jonathan Boorstein, Arthur Drexler, Herbert Muschamp, Meyer Rus, Jim Russell, Joel Sanders, Henry Urbach, and Wayne Attoe.

Queer Space

While the listings above acknowledge the accomplishments of gay and lesbian writers, curators, designers, and architects, architectural contributions are also made by those outside the profession of architecture. Many North American and western European cities have large concentrations of gay men and lesbians. Because the relationship between people and places is always reciprocal, cities that have large queer populations become spaces for possibility, sites of pleasure, containment, visibility, and escape.

Affording the opportunity for both community and anonymity, the city thus comes to embody "queer space." This is particularly so of areas where gay, lesbian, and transgender people live and gather, the so-called "gay ghettos," which have been crucial to the modern gay and lesbian political and social movements. The ghettos have not only provided protective space for queer people, but also served as the centers of gay, lesbian, bisexual, and transgender communities—even for people who do not actually live in them.

The appropriation, formation, and transformation of neighborhoods by gay and lesbian residents often have significant civic and economic impact, insofar as this process leads to the rejuvenation of neglected areas. Sometimes known as "urban pioneers," gay men and lesbians have been in the forefront of the gentrification of neighborhoods in most major cities of the United States.

However, gay neighborhoods may be more transitory than permanent. After these enclaves are fully developed, their character tends to shift again. Once "cleaned up," the neighborhoods often depend less on a particular subculture and more on broader economic considerations. Moreover, as tolerance and acceptance of gay, lesbian, and transgender people increase, these groups have less need and desire to develop specific neighborhoods.

Government agencies have begun to acknowledge the considerable contributions of gay and lesbian residents to urban areas. Some cities, such as, for example, New Orleans, have launched campaigns to attract gay and lesbian residents as a means of revitalizing urban areas. Others have recognized that sites of commerce, socializing, and political life have cultural and historical significance.

Thus, the main street in Chicago's New Town is now lined with rainbow-topped pylons. In New York, the site of the 1969 Stonewall riots has been designated a National Historic Landmark. Books such as Martinac's *The Queerest Places* and Higgs's *Queer Sites* help docu-

ment places of particular significance for gay, lesbian, bisexual, transgender, and queer people.

The practice of marking sites of gay and lesbian significance is sometimes controversial, however. Arguments develop about how to interpret the queer past and build a queer future. The question of what makes a space queer or queer friendly can be contentious. The conflicting agendas of "assimilationists" campaigning for human rights and "resistors" opposing sexual hegemony complicate our thinking about public space.

Still, there is no denying that the concept of queer space, a conscious and activist recognition of the role sexual difference plays in architectural projects and places, is an important one. At its most basic, the phrase describes the physical location where queer people conduct their lives.

While it is very difficult for anyone to act outside the heteronormativity of most public and private space, queer space offers the promise of a place where members of sexual minorities can act freely and independently, a place where mainstream values that determine "appropriate" conduct can be resisted and restructured. Architecture and space are such crucial elements to human relationships that it is not surprising that the connections between sexuality, identity, and place-making have recently become an important topic of queer studies.

— Ira Tattelman

BIBLIOGRAPHY

Bell, David, and Gill Valentine, eds. *Mapping Desire*. London: Routledge, 1995.

Betsky, Aaron. *Queer Space: Architecture and Same Sex Desire*. New York: William Morrow, 1997.

Boone, Joseph A., et al., eds. *Queer Frontiers: Millennial Geographies, Genders, and Generations*. Madison: University of Wisconsin Press, 2000.

Boutelle, Sara Holmes. *Julia Morgan, Architect*. New York: Abbeville Press, 1988.

Cook, John W., and Heinrich Klotz. *Conversations with Architects*. New York: Praeger, 1973.

Higgs, David, ed. *Queer Sites: Gay Urban Histories Since 1600*. London: Routledge, 1999.

Ingram, Gordon Brent, Anne-Marie Bouthillette, and Yolanda Retter, eds. *Queers in Space: Communities, Public Places, Sites of Resistance*. Seattle: Bay Press, 1997.

Leap, William L., ed. *Public Sex/Gay Space*. New York: Columbia University Press, 1999.

Martinac, Paula. *The Queerest Places: A National Guide to Gay and Lesbian Historic Sites*. New York: Henry Holt, 1997.

Schifter, Jacobo. *Public Sex in a Latin Society*. Binghamton, N.Y.: Hayworth Press, 2000.

Shand-Tucci, Douglass. *Boston Bohemia 1881–1900; Ralph Adams Cram: Life and Architecture*. Amherst: University of Massachusetts Press, 1995.

Taylor, Jerry. "Obituary—Eleanor Raymond." *The Boston Globe* (July 28, 1989): 18.

Twombly, Robert. *Louis Sullivan: His Life and Work*. New York: Viking, 1986.

Vilades, Pilar. "The Education of Jed Johnson." *Home* 37.7 (July 1991): 120–25.

SEE ALSO

Israel, Franklin D.; Johnson, Philip; Morgan, Julia; Rudolph, Paul; Wolfe, Elsie de

Arts and Crafts Movement

A S PART OF ITS REACTION AGAINST THE INDUSTRIALISM of the nineteenth century, the Arts and Crafts movement, which emphasized handcrafted decorative works of art and architecture, created medieval-type artists' guilds, which have been seen as homosocial.

The Arts and Crafts movement began in England in the 1860s and ended around 1920, having spread its influence throughout Europe and the United States. Famous Arts and Crafts artists and artisans include men as varied as Gustav Stickley, Louis Sullivan, Charles Rennie Mackintosh, Louis Comfort Tiffany, and Frank Lloyd Wright. Gay and bisexual figures such as C. R. Ashbee and Edward Carpenter were also associated with the movement.

The Arts and Crafts Movement was a reaction to the overtly industrial society that was flourishing by the 1850s. The Great Exhibition of 1851 in London had demonstrated that England was the industrial leader of Europe. However, many observers, including art critic John Ruskin, believed that quality art and design were sorely lacking. In *The Stones of Venice* (1851–1853), Ruskin railed against the industrial construction of furniture and everyday decorative objects because they lacked spirit and artistry.

The movement also had its origins in the love of Gothic and medieval culture that was part of Romanticism. The Pre-Raphaelite poets and painters looked back to Camelot and Chaucer for inspiration. Architects such as A. W. N. Pugin brought the Gothic revival to a new prominence in English architecture with his design for the Houses of Parliament. So inspired was the Arts and Crafts movement by the Gothic revival that it sponsored the creation of medieval-type artists' guilds to create works of decorative art.

At the heart of the movement was its reverence for handcrafted decorative works of art. It took as its chief artistic inspiration the world of medieval and Tudor England, and encompassed everything from furniture and wallpaper to tapestries and silverware. The focus was on

simplicity of design with ornamentation for specific purposes only, as opposed to the random or excessive ornamentation typical of industrial objects. Furniture was streamlined, but wallpaper and fabrics were decorative.

Morris, Ashbee, and Artists' Guilds

Although its ideology was often socialist, the Arts and Crafts movement was in many ways an upper-class trend, as few could afford one-of-a-kind decorative objects. Still, the socialist views of leaders such as William Morris, who established Morris, Marshall, Faulkner & Co. in 1861, were expressed in their desire for art by the people and for the people.

Morris's company was one of the first to specialize in handcrafted decorative objects such as furniture, stained glass, and wallpaper. It was followed by numerous guilds and art societies that produced handcrafted arts. The two most famous London guilds were the Art Workers' Guild (1884) and the Arts and Crafts Exhibition Society (1888). These particular guilds were dominated by men, but there arose other guilds that not only employed women but were exclusively female-based.

Morris employed his female family members; and his daughter May eventually became head of his embroidery division. The Leek Embroidery Society (ca. 1880) was an example of a guild of salaried women. These guilds today have been seen as homosocial, especially because the guilds involved workers in activities that went beyond work, including performing plays and holding social dances.

Such was the case of the Guild and School of Handicraft established in 1888 by C. R. (Charles Robert) Ashbee. Ashbee was heavily influenced by both Ruskin and Morris and is best known today for his designs in furniture, silver, and jewelry, as well as his Queen Anne domestic architecture.

Ashbee's interest in the men of his guild was personal as well as professional. He encouraged homosocial activities among the men. Although he was married and had children, he also had affairs with men. He was a friend and associate of the gay rights pioneer Edward Carpenter, who was also an apostle of the natural life.

The Arts and Crafts movement owes its success in many ways to two other nineteenth-century trends: Aestheticism and Art Nouveau. Aestheticism, which rose in popularity during the 1860s, encouraged the belief that one should surround oneself with beautiful art in order to become more refined. Art Nouveau was the French version of the Arts and Crafts movement in its celebration of purposeful decorative motifs for everyday household objects. In contrast to its British cousin, however, Art Nouveau was the first international commercial artistic fad, ultimately negating the Arts and Crafts movement because these works were often mass-produced.

The Arts and Crafts movement had a great influence on interior design, the aesthetics of home furnishings, and the production and conception of decorative objects as art even in an industrial age. — *Roberto C. Ferrari*

BIBLIOGRAPHY

Callen, Anthea. *Angel in the Studio: Women in the Arts and Crafts Movement 1870–1914.* London: Astragal Books, 1979.

Crawford, Alan. *C. R. Ashbee: Architect, Designer & Romantic Socialist.* New Haven: Yale University Press, 1985.

Cumming, Elizabeth, and Wendy Kaplan. *The Arts and Crafts Movement.* London: Thames and Hudson, 1991.

Davey, Peter J. *Arts and Crafts Architecture.* London: Phaidon, 1995.

Harvey, Charles. *Art, Enterprise, and Ethics: The Life and Works of William Morris.* London: Frank Cass, 1996.

Hitchmough, Wendy. *The Arts & Crafts Lifestyle and Design.* New York: Watson-Guptill, 2000.

Lambourne, Lionel. *Utopian Craftsmen: The Arts and Crafts Movement from the Cotswolds to Chicago.* Salt Lake City: Peregrine Smith, 1980.

MacCarthy, Fiona. *The Simple Life: C. R. Ashbee in the Cotswolds.* Berkeley: University of California Press, 1981.

Stansky, Peter. *Redesigning the World: William Morris, the 1880s, and the Arts and Crafts.* Princeton: Princeton University Press, 1985.

SEE ALSO

Architecture

Austen, Alice *(1866–1952)*

ALICE AUSTEN, ONE OF THE FIRST AMERICAN WOMEN to become a photographer, lived the life of an independent, genteel woman during the Victorian age. She also defied conventions and challenged stereotypes in nearly every aspect of her life.

She was born Elizabeth Alice Munn on March 17, 1866, to Alice Cornell Austen and Edward Stopford Munn, who married in 1863. The future photographer's father abandoned her and her mother around 1869. Her mother then reclaimed the surname of her birth and, with Elizabeth Alice, moved into her upper-class family's Staten Island home, called Clear Comfort.

The house, originally built in 1700, had been enlarged into a Carpenter Gothic country home during the mid-nineteenth century by Austen's grandparents, John Haggerty Austen and Elizabeth Alice Townsend. Residing among some of the country's wealthiest families, such as the Vanderbilts, Cunards, and Roosevelts, the Austens lived in genteel circumstances.

In 1876, when Austen was only ten years old and photography was a new medium, her uncle Oswald Mueller,

a shipper, gave her a large-format camera. Austen mastered it, including its bulky dry-glass plates, by the time she was eighteen. Later she developed her prints inside her family's home.

Since Austen was of independent means, she had enough time to become a splendid photographer, championship tennis player, skilled sailor, avid swimmer, golfer, and bicyclist at an early age. Her wealth allowed her to create images without relying on the sale of her work. It also allowed her the freedom to challenge gender stereotypes.

Alice Austen captured a visual record of elegant family life during the Gilded Age. While wonderful images of friends and family at home, in private clubs, on picnics, sailing, lounging in gardens, and living the refined life resulted, Austen was not satisfied with documenting her life of privilege. She also captured sweeping views of New York Harbor, recorded some of the earliest automobile trips, traveled into Manhattan to take photographs of commuters, immigrants and laborers, and recorded historic events.

In addition, she documented her own trips throughout the northeastern United States, to the World's Columbian Exposition in Chicago (1893), and across Europe. Austen's photographic forte was capturing people and places as they appeared. Unlike much photography of the day, Austen's photography utilized a sharp focus. In technique and subject matter, Austen anticipated the genre of documentary photography.

Herself a woman-identified woman, Austen included women in her photographs and recorded the private world she shared with her women friends, including Gertrude Eccleston, Julia Marsh, Sue Ripley, Violet Ward, and Daisy Elliott. Much of Austen's photographic work recorded the life she lived on her own terms with her women friends—all of whom lived as independent "new women."

Austen's images of her women friends provide evidence of homoeroticism. Such photographs as those entitled "Mrs. Snivley" and "Julia and I in Bed" (both from 1890), "Julia Martin, Julia Bredt, and Self Dressed Up as Men" (1891), and "The Darned Club" make manifest Austen's homoerotic feelings and her ability to alter the stereotypical vision of women.

In 1899, Austen met Gertrude Amelia Tate (ca. 1871–1962) of Brooklyn, who was to be her longtime companion. Tate moved into Clear Comfort during 1917. The two women lived together and supported each other for thirty years.

Austen's life ended on a sad note because, although talented and renowned, she invested her family inheritance in the stock market shortly before its crash in 1929. She unwisely mortgaged the family home so that she and Gertrude could travel to Europe one last time.

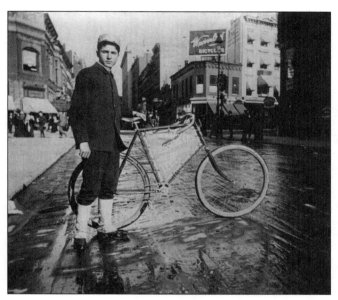

Untitled photograph by Alice Austen.

Upon returning home to Staten Island, they ran a tea room in Clear Comfort and Gertrude taught ballroom dancing lessons in an attempt to meet their financial obligations.

The plan did not work, however, and Austen lost the house in 1945 when she was evicted at the age of 79. She signed her possessions over to Gertrude, who moved in with her own family members, and Austen spent the next few years in a small apartment.

Austen spent her remaining years in nursing homes, entering the Staten Island Farm Colony (a home for paupers) on June 24, 1950, when she was 84.

The following year, however, Austen's fortunes changed. The art historian Oliver Jensen discovered the negatives of her photographic plates and saw to their purchase by the Staten Island Historical society in 1951. Jensen secured publishing rights to the plates and arranged for an exhibition and sale of prints of Austen's work. Austen earned enough money to live in a comfortable residence for one more year. She died on June 9, 1952.

Gertrude Tate lived another ten years with her family and then moved to a nursing home. Upon Gertrude's death the Tate family learned that Austen and Gertrude had wanted to be buried together. The Tate family, however, refused to honor the women's wishes.

Alice Austen created more than 8,000 images over a period of five decades. More than 3,000 of her photographs survive and are housed at Clear Comfort. The house was dedicated as a National Historic Landmark on April 8, 1976, one month after the 110th anniversary of Austen's birth.

Clear Comfort is decorated in the manner of the late nineteenth century and includes Austen's darkroom.

Young women of today can visit and learn of an important role model who defied the limitations and expectations of her day. However, as Barbara Hammer's documentary *The Female Closet* (1998) discloses, the board of Austen House discourages the use of the collection in order to study sexuality. — *Ray Anne Lockard*

BIBLIOGRAPHY

Khoudari, Amy S. "Looking in the Shadows: The Life and Photography of Alice Austen." Master's thesis, Sarah Lawrence College, 1993.

Novotny, A. *Alice's World: The Life and Photography of an American Original: Alice Austen, 1866–1952.* Old Greenwich, Conn.: Chatham Press, 1976.

Peimer, Laura. "Alice's Identity Crisis: A Critical Look at the Alice Austen House Museum." *History of Photography* 24.2 (Summer 2000): 175–179.

Rittelmann, Leesa. "The Private and Public Worlds of Nineteenth Century American Photographer Alice Austen." M.A. paper, University of Pittsburgh, 1993.

SEE ALSO

Photography: Lesbian, Pre-Stonewall; American Art: Lesbian, 1900–1969; Subjects of the Visual Arts: Bicycles

Australian Art

HISTORICALLY, AUSTRALIA HAS PRODUCED SOME important gay and lesbian artists and is currently home to many others. These artists work with a wide variety of materials and explore a broad range of topics. Their art encompasses portraits, figure studies, jewelry, paintings, interactive videos, and other genres, while embracing styles as distinct as surrealism, camp, and the abject.

Earlier Artists

Although she lived most of her life in Paris and London, Agnes Noyes Goodsir (1864–1939) was born in Victoria, Australia. She became part of the legendary lesbian scene in Paris in the 1920s and 1930s, and is best known for her portraits of sophisticated women.

Another prominent portrait painter is Sir William Dobell (1899–1970), who is regarded by many as one of Australia's greatest painters. Although his paintings are often homoerotic, particularly his idealized and sexualized portraits of construction workers, he spent much of his life hiding his homosexuality from a conservative Sydney society.

Far more open was Donald Friend (1915–1989), who specialized in nude male figure studies. Although he spent much of his life abroad (including many years in Bali), he returned to Australia near the end of his life. Friend's richly illustrated book *Bumbooziana* (1979) shocked a prudish Australian public with its eroticism and satire.

Another Australian expatriate artist was Leigh Bowery (1961–1994). He was born in the Melbourne suburb of Sunshine, but earned fame in London as a fashion model and performance artist. The centerpiece of his art was his transformed (and often disfigured) body.

Contemporary Artists

Contemporary gay and lesbian artists find Australia more hospitable than earlier artists did. Hence Australia is now home to a vital gay and lesbian artistic community. Some of the most interesting of the contemporary artists are discussed below, but the listing is necessarily highly selective.

Deborah Kelly and Tina Fiveash

The Gay and Lesbian Mardi Gras Festival in Sydney provides an annual forum for Australian artists to showcase their work. For the 2001 festival, writer/artist Deborah Kelly and photographer Tina Fiveash (b. 1970) collaborated to produce a series of six photographs entitled "Hey, hetero!" Beginning in February 2001, these photos appeared on illuminated public advertising spaces, billboards, magazine pages, street posters, and postcards.

The "Hey, hetero!" series forces viewers to consider the hidden advantages of being straight. "Hey, hetero!" proclaims one photograph with a nuclear family picnicking in a park, "When they say family, they mean you!" Another, which features an infant lying on its back on a rug, is emblazoned with the statement: "Hey, hetero! Have a baby: no national debate." A third work encourages heterosexuals to get married "because you can!"

Produced to look like slick, sophisticated advertisements, the "Hey, hetero!" photographs are unsettling, and even alarming. The viewer might become unbearably uncomfortable if not for the element of camp and humor incorporated into the works; the people in the photographs often display artificial poses and goofy grins that suggest that the works are spoofs, but the message is ultimately too serious to ignore.

Since heterosexuality generally is understood as the "norm," it is never deconstructed, questioned, or challenged. By pointing it out, even advertising it, Kelly and Fiveash reveal that heterosexuality, like homosexuality, is socially constructed; it is its own culture, and its members share common beliefs, privileges, and fashion sensibilities.

Timothy Horn

In contrast to Kelly and Fiveash, who emphasize the constructedness of heterosexual society, Timothy Horn (b. 1964) sculpts magnificent objects that belong in a make-believe world. One of his most recent series includes

works inspired by the Cinderella story (1999–2001). Crowns, brooches, a slipper, and other items are made from relatively common, inexpensive materials such as nickel-plated bronze, cast crystal, and Easter-egg foil.

Lavish and beautiful, Horn's creations are also over-the-top and tacky. The artist accentuates the latter two qualities by giving his works trashy, lewd titles such as *Pink Bits*, *Love Muscle*, *Bearded Clam*, *I Want Candy*, and *Boy Pussy*. His name for the sumptuous, down-scaled carriage central to the Cinderella story is *Bump n' Grind*. This title emphasizes the crude, sexual aspect inherent in any romantic fantasy.

Horn's works insult good taste. The artist deems his celebration of the fake and the ornamental a queer sensibility, and he calls his reinterpretation of the Cinderella myth a queer rewriting. Indeed, the flashy, glitzy, ridiculously feminine *Glass Slipper (Ugly Blister)* could be part of a costume from an upscale drag show.

While Horn's fashion accessories are for the brash, the shameless, and the proud, they are also for the outcast and the different. For example, a brooch titled *Big Girl* incorporates the word "butch" above three teardrop pearls. The work could be a medal for a tormented outcast or a badge of honor for someone who is different.

Big Girl also raises issues related to gender construction. The word "butch" brings masculine associations to mind; yet jewelry is quintessentially feminine. The combination of these two elements reminds the viewer that identity is complex and unstable. Since the person who wears *Big Girl* does not fit into accepted gender roles, the accuracy of these roles is called into question.

Vanessa Buemi and Karen Coull

Works by artists Vanessa Buemi and Karen Coull address these same issues, with a feminist spin. Both artists use handcrafted objects to explore stereotypes of femininity. Buemi's *Femme with Butch Tendencies*, for example, consists of an exquisite length of crocheted pink yarn, to which steel crampons are attached.

Similarly, a thorn-encrusted pillow by Karen Coull is designed to unsettle. A commonly held belief is that females are supposed to be soft, yielding, and manageable like a pillow; they are not supposed to harm others, or to be capable of violence and rage.

Linda Dement

Linda Dement (b.1959) uses her artwork to break the stereotype of the passive, yielding female. In her electronic videos, she positions female subjects in a culture of pain, abuse, and abandonment as a means to give them both salvation and ammunition.

For the interactive CD-ROM *Cyberflesh Girlmonster* (1995), around thirty women scanned parts of their bodies and digitally recorded a sentence or another sound, such as a dog barking. Dement then animated conglomerate bodies culled from this information and created interactive monsters. When the viewer/participant clicks on one of the monsters, words may be heard or seen, sounds may be heard, another monster may appear, or a digital video may play.

Cyberflesh Girlmonster reveals the various attributes of a male-dominated society, such as rape, that spawn monstrous responses in women. The work treats women as powerful individuals who have revenge fantasies that they act out. For example, in one part of the work, text that reads "If only a woman could kill just one of the men who has raped her" is followed with several video clips that demonstrate bloody scenarios by which a woman might physically act out revenge.

James Gleeson

James Gleeson (b. 1915) is perhaps the most famous Australian artist who addresses homosexual themes in his work. He began painting in the Surrealist style in the 1930s. Since that time, he has created a multitude of works that explore the subconscious. Psychoanalytic theory informs his paintings, which are as elusive to the mind as they are seductive to the eye; their meanings seem just beyond conscious understanding.

Some of Gleeson's paintings have homoerotic undertones. In these works, nude men populate strange, colorful landscapes that may suggest the artist's mind. Perhaps these works illustrate the unconscious as it entices the conscious mind to take pleasure in male flesh. If so, these works may represent the universal struggle of the liberation of the individual will from one stronger than its own, such as that of society.

Conclusion

Australian artists play an important role in the gay/lesbian/transgender community. Their bold, innovative works increase awareness and understanding about alternate genders and lifestyles.

— *Joyce M. Youmans*

BIBLIOGRAPHY

"Decoding the Secrets of Surrealist James Gleeson." *University of Technology, Sydney, News,* October 16, 2001: www.uts.edu.au/new/archives/2001/July/04/html.

Dement, Linda. "Cyberflesh Girlmonster." *Digimatter.* www.digimatter.com/monster.html.

———. "In My Gash." *Digimatter.* www.digimatter.com/gash.html.

Dow, Steve. "Posting Teasing Messages." *The Age,* December 18, 2001: www.theage.com.au/entertainment/2001/12/18/FFXWUEP4BVC.html.

Kelley, Deborah, and Tina Fiveash. "Hey, Hetero!" *ABC Online,* 2001. abc.net.au/arts/news/hetero/heterocover.htm.

Riley, Vickie. "Singing the Body Electric: Cyberporn and Art in Linda Dement's Work." *Creative Camera* 336 (October–November 1995): 30–33.

Sydney Gay and Lesbian Mardi Gras Webcast. www.mardigras.com.au/webcast/events.asp?genre=look.

"The 2002 Anne and Gordon Samstag International Visual Arts Scholarships." University of South Australia. www.unisa.edu.au/samstag/scholars/scholars2002/horn.htm.

SEE ALSO

Dobell, Sir William; Friend, Donald; Gleeson, James; Goodsir, Agnes Noyes

Bachardy, Don (b. 1934)

MUCH OF THE PUBLIC ATTENTION GARNERED BY American painter and draftsman Don Bachardy has been the result of his long relationship with the late novelist and memoirist Christopher Isherwood. But Bachardy is an accomplished artist in his own right, and his talent has earned him considerable success on his own, as evidenced by his frequent solo exhibits, inclusion in many museum collections, and numerous reproductions and collections of his work.

Nonetheless, Bachardy has forthrightly acknowledged that the encouragement and support of Isherwood—the most frequent subject of his drawings and paintings—helped him gain the confidence to become a full-time artist. Moreover, Isherwood's distinguished reputation as a writer and his contacts in the film industry gained Bachardy access to many of the celebrities whom he was to draw.

Born in Los Angeles on May 18, 1934, Bachardy began drawing as a child. By his early teenage years, he was specializing in portraits rendered in ink and acrylics. Bachardy attributes his interest in looking at people to his childhood obsession with movies, a passion carried into his adult life. The close-ups of screen actors upon which he gazed as an impressionable child are at least partially responsible for his lifelong interest in portraiture.

Bachardy was only eighteen years old when he met Isherwood, who was thirty years his senior. The discrepancy in their ages shocked many of their friends; but in his memoir *My Guru and His Disciple* (1980), Isherwood observes that "I myself didn't feel guilty about it, but I did feel awed by the emotional intensity of our relationship, right from its beginning; the strange sense of a fated, mutual discovery. I knew that, this time, I had really committed myself."

In another memoir, *Christopher and His Kind* (1976), Isherwood describes Bachardy as "the ideal companion to whom you can reveal yourself totally and yet be loved for what you are, not what you pretend to be."

Bachardy was a student of languages and theater arts at UCLA when he met Isherwood in 1952 and began a relationship that lasted until Isherwood's death in 1986. The novelist was Bachardy's first live model, and his initial sitting in 1953 marked the beginning of a series of portraits that, to Bachardy, "encompass[es] the full range of my work as an artist and . . . represent[s] my best effort."

Bachardy was still drawing Isherwood—along with several of Isherwood's friends, many of them celebrities—when he enrolled at the Chouinard Art Institute in 1956. In 1961, he began study at London's Slade School of Art; that same year heralded his first solo exhibition, held at the Redfern Gallery in London.

Bachardy's drawings and paintings are included in the permanent collections of the Metropolitan Museum of Art, the Smithsonian, the National Portrait Gallery in London, Princeton University, the Fogg Art Museum of

Harvard University, and the University of California at Los Angeles, among many others.

His published works include *October* (with Isherwood, 1980), *One Hundred Drawings* (1983), and *Drawings of the Male Nude* (1985), all published by Twelve Trees Press, along with a collection called *70 X 1* (Illuminati, 1983) and *Last Drawings of Christopher Isherwood* (Faber and Faber, 1990).

Bachardy also collaborated with Isherwood on a television script, *Frankenstein: The True Story* (1973) and on a dramatization of Isherwood's 1967 novel *A Meeting by the River*, which failed on Broadway in 1979.

Most recently, University of Wisconsin Press published Bachardy's book *Stars in My Eyes* (2000), a richly illustrated account of numerous sittings with various actors, writers, composers, and directors whom Bachardy and Isherwood knew. The book's prose is culled from a journal Bachardy kept at Isherwood's urging, and validates the novelist's precept that art is often a record of the artist's own experiences, even when the focus is on the subject.

The fascinating comments on the sitters also vividly attest that Bachardy's acuity of observation and insight is by no means limited to his drawings, as when he shrewdly remarks of Peter Pears, "With his long, beaky face, he's like a hefty egret. His cold, blue, passionless bird-eyes are the darkest spots in their surrounding expanse of pink. His big clumsy hands are fleshy, like hunks of swollen pink dough."

Always preferring to draw live models rather than work from photographs, which dilutes the artmaking experience for him, Bachardy insists to this day upon completing every portrait in a single sitting. He describes a sitting as a "true collaboration" in which he receives energy from his subject.

Bachardy is probably best known for his nudes, which are at once erotic and dispassionately observed, and for his celebrity portraits. While his drawings and paintings of noncelebrities far outnumber the likenesses he has rendered of famous people, he has completed sittings with such well-known and diverse subjects as Myrna Loy, Ginger Rogers, Anaïs Nin, Gore Vidal, Jane Fonda, Katharine Hepburn, James Merrill, Ellsworth Kelly, Robert Mapplethorpe, and Aldous Huxley, among many others. (He has also been the subject of works by artists such as David Hockney, whose masterful double portrait of Isherwood and Bachardy is justly famous.)

In the late 1980s, Bruce Voeller of the Mariposa Education and Research Foundation commissioned Bachardy to create a series of portraits of a dozen gay rights leaders. The series includes studies of Elaine Noble, Frank Kameny, Phyllis Lyon, Del Martin, Morris Kight, Charles Bryden, James Foster, Bruce Voeller, David B. Goodstein, Jean O'Leary, Reverend Troy Perry, and Barbara Gittings. In 1995, after the death of Voeller

and the closure of the Mariposa Foundation, the series was donated to the Human Sexuality Collection at Cornell University Library.

Among Bachardy's best-known works are the frequently reproduced drawings and paintings of Isherwood that span some thirty years and capture the novelist in an amazing variety of moods; the famous likeness of W. H. Auden—his forehead a mass of wrinkles—that hangs in the National Portrait Gallery, London; the haunting image of a haggard, aged Bette Davis, her downturned mouth held as though set in stone; and the intense and controversial painting of former California governor Jerry Brown that hangs in the California State House.

Bachardy's portraits are not flattering—in fact, they occasionally seem cruel in their honesty—but in sure lines and deft strokes they convey with authenticity and accuracy the personalities of his sitters. Indeed, they are psychological portraits as much as they are physical likenesses. Almost Oriental in their economy of line, Bachardy's drawings distill the essences of his subjects, even as they also constitute a record of his own experience.

— *Teresa Theophano*

BIBLIOGRAPHY

Bachardy, Don. *Stars In My Eyes*. Madison: University of Wisconsin Press, 2000.
 www.americanartists.org

SEE ALSO

American Art: Gay Male, Post-Stonewall; Contemporary Art; Hockney, David; Mapplethorpe, Robert; Subjects of the Visual Arts: Nude Males

Bacon, Francis (1909–1992)

FRANCIS BACON IS WIDELY RECOGNIZED AS BRITAIN'S most important twentieth-century painter. Through beautifully composed works featuring screaming faces and beaten bodies, Bacon marked the violent trauma characterizing Europe's past century. On this basis his painting was celebrated in Britain's post–World War II society.

As well as reflecting a universal preoccupation with violence, however, Bacon's paintings draw from the artist's own fascination with gay male masochism and the manner with which such desire can be represented.

An openly gay man who refused to censor his art, Bacon produced one of the few bodies of work characterized by radical sexuality yet praised by a broad and largely conservative art public.

Bacon was born on October 28, 1909, in Dublin, Ireland, the son of a British horse breeder and trainer. He passed a relatively happy youth disturbed only by the

outbreak of Ireland's civil war, a conflict in which Irish rebels perceived all English, including Bacon's family, as the enemy. He later claimed that this experience initiated his fascination with violence.

At the age of sixteen, in 1927, Bacon was evicted from his family home for sleeping with his father's horse grooms. Bag in hand, he resolved to travel in Europe. After nearly two years in Paris and Berlin, Bacon eventually settled in London, where he realized his plans to become a furniture and interior designer. He quickly found success in 1930 with his widely published, Bauhaus-inspired interiors. Bacon's memory of Picasso's work in Paris, however, inspired him to become a painter.

In a patron–apprentice arrangement quite common at the time, Bacon moved in with an older established painter named Roy de Maistre and became the elder's student and lover. Bacon concentrated his efforts on semiabstracted crucifixions through the 1930s, before finally arriving, in 1944, at his *Three Figures at the Base of a Crucifixion*, the painting that initiated his brilliant career as an artist.

Soon thereafter he introduced the themes for which he is most noted: screaming popes (for example, *Study after Velázquez's Portrait of Pope Innocent X*, 1953), bleeding figures surrounded by sides of beef (*Painting 1946*, 1946), and bludgeoned men in blue business suits (*Three Studies of the Human Head*, 1953).

In 1953, he exposed the sexual desire behind these works with his *Two Figures*, a painting featuring photographer Eadweard Muybridge's famous wrestlers taken from the mat to the bed. The result was an unmistakable representation of one man raping another.

Remarkably, postwar Britain acclaimed this work and others as profound reflections on the century's trauma. Bacon's work was touted as England's enlightened alternative to American Abstract Expressionism.

Bacon continued to paint openly from his gay desire. He made his lover, George Dyer, his favorite subject throughout the 1960s and early 1970s, including most movingly *Triptych May–June 1973* (1973). In these paintings and others featuring friends, Bacon characteristically smudged his subjects' faces nearly beyond recognition, using his fine skill with paint both to represent and to deform his subjects.

Although the violence of this work bears a clear sexual significance, particularly when used to represent sex between men or to render portraits of Dyer, Bacon de-emphasized this linkage. Instead, he stressed the more abstract nature of his fascination with violence.

Bacon provocatively declared his need to paint from photographs rather than perform a deforming representation before sitting models. Similarly, he also exclaimed his ecstatic inspiration from slaughterhouses and medical books on diseases without actually discussing the radical gay desire that inspired these works.

Critics also found it difficult to discuss the almost unspeakable same-sex violence of Bacon's painting, choosing instead to focus inordinate attention on his studio, where a fantastic mess seemed the more appropriate signifier for the artist's disturbing painted content.

Bacon was offered both a knighthood and the Order of Merit, but refused them. At the end of a long and productive life, Bacon died on April 28, 1992, in Madrid, in the arms of a Spanish banker with whom he had been having an affair.

Bacon's turbulent relationship with Dyer, which ended with the latter's suicide in 1971, is the subject of John Mayberry's film *Love Is the Devil* (1998).

— *Andres Mario Zervigon*

BIBLIOGRAPHY

Ades, Dawn. *Francis Bacon.* Exhibition Catalog, Tate Gallery. London: Thames and Hudson, 1985.

Russell, John. *Francis Bacon.* London: Thames and Hudson, 1993.

Sinclair, Andrew. *Francis Bacon: His Life and Violent Times.* New York: Crown, 1993.

Sylvester, David. *The Brutality of Fact: Interviews with Francis Bacon.* New York: Thames and Hudson, 1988.

van Alphen, Ernst. *Francis Bacon and the Loss of Self.* Cambridge, Mass: Harvard University Press, 1992.

SEE ALSO

European Art: Twentieth Century

Barthé, James Richmond (1901–1989)

JAMES RICHMOND BARTHÉ WAS A POPULAR African American sculptor associated with the Harlem Renaissance. He used his art as a means of working out internal conflicts related to race and sexuality.

Born on January 28, 1901, in Bay St. Louis, Mississippi, into a family of devout Roman Catholic Creoles, Barthé left home at sixteen to work as a houseboy for a wealthy and socially prominent New Orleans family.

In 1924, he moved to Chicago, where he took evening art classes at the Art Institute of Chicago and discovered his talent for sculpture. Only months before the stock-market crash in 1929, Barthé moved to New York City. There he quickly made the acquaintance of many important artists, writers, patrons, and other intellectuals of the Harlem Renaissance.

Although he became renowned as a portraitist of celebrities in the worlds of art, theater, and dance, Barthé produced a variety of sculptures throughout his career.

His three major themes are racial politics, religion, and eroticism.

Barthé's life and art were devoted to resolving internal conflicts resulting from the political pressures he felt as a black artist in New York, as a deeply spiritual person, and as a homosexual. His sculptures became the means through which he attempted to work out and work through these conflicts.

Although he has been labeled a New Negro Artist, Barthé did not fit in well with the New Negro philosophy as articulated by Alain Locke, the chief intellectual of the Harlem Renaissance. Barthé saw himself as set apart from those common black folk described so passionately in the writings of Langston Hughes and Zora Neale Hurston. Unlike many of his artistic and literary contemporaries, Barthé was not overtly political or activist in his promotion of the race, though racial issues frequently surface in his work.

In 1931, Barthé's solo exhibition in a New York gallery brought him to the attention of critics. His work expresses a range of emotions and experiences, from lynching as a social reality for blacks to the ephemerality and eroticism of dance.

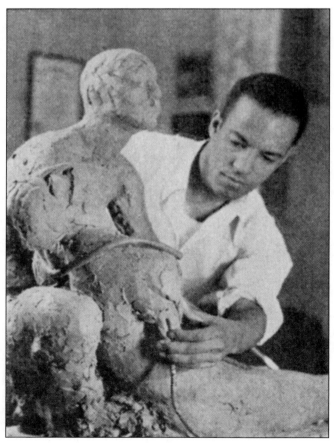

James Richmond Barthé.

Artistically, Barthé preferred traditional styles and methods. He was particularly inspired by Western classical notions of beauty and Michelangelo's idealization of the male nude. He coupled this interest with Rodinesque expressive compositions and a fascination with primitivism.

These qualities are particularly noticeable in his many images of dancing men and women. For Barthé, dance was an inexhaustible theme; he even took dance lessons with Mary Radin of the Martha Graham group soon after arriving in New York as a way to authenticate movement in his figures.

In his images of males and females engaged in dance Barthé confronts and attempts to resolve his preoccupations with race, spirituality, and homoerotic desire. Many of the dancing figures suggest the sculptor's ritualistic and erotic involvement with the single male or female subject in motion.

In 1937, Barthé exhibited six dance figures at the Dance International 1900–1937 exhibition held at Rockefeller Center: *African Boy Dancing*; *Feral Benga*; *Kolombuan*; *The Lindy Hoppers*; *African Dancer*; and *Wetta*. The exhibition was a critical triumph for the artist and all of his works were immensely popular with the public, especially his statue of Feral Benga, which was widely publicized.

African Dancer is especially interesting for its androgynous features: a masculinized face combined with large breasts and narrow hips. By using modern dance as a theme for his sculptures, Barthé hoped to engage contemporary ideas of expression, primitivism, and modernity.

Barthé was unique among African American artists during the Harlem Renaissance in that he was the only one to exploit fully the black male nude for its political, racial, aesthetic, and erotic significance, as in *Feral Benga* and *Stevedore*. His homoeroticism is expressed in both Western mythological themes and in notions of the Africanized primitive.

Although Barthé remained closeted all his life, he entered an established network of gay men and women soon after his arrival in Harlem in 1929. His penchant for homoerotic themes was encouraged by his friends in New York's gay and artistic communities, which stretched across barriers of race, gender, and class.

Among his black friends and associates were Wallace Thurman, Claude McKay, Langston Hughes, Jimmie Daniels, Countee Cullen, and Harold Jackman. His white allies included Carl Van Vechten, Noel Sullivan, Charles Cullen, Lincoln Kirstein, Paul Cadmus, and Jared French.

The majority of Barthé's patrons were white and gay. They included notables such as Winifred Ellerman (who published under the pseudonym Bryher), Van Vechten, Lyle Saxon, and Edgar Kaufmann Jr. His most important African American supporters included his friend and

one-time lover, Richard Bruce Nugent, as well as Alain Locke.

— *James Smalls*

BIBLIOGRAPHY

Margaret Rose Vendryes. "Expression and Repression of Identity: Race, Religion, and Sexuality in the Art of American Sculptor Richmond Barthé." Ph.D. diss., Princeton University, June, 1997.

SEE ALSO

African American and African Diaspora Art; American Art: Gay Male, 1900–1969; Cadmus, Paul; French, Jared; Michelangelo Buonarroti; Subjects of the Visual Arts: Nude Males

Bazille, Jean-Frédéric *(1841–1870)*

A MEMBER OF THE CIRCLE OF YOUNG PAINTERS THAT included such luminaries of Impressionism as Claude Monet and Auguste Renoir, Jean-Frédéric Bazille is remembered as an artist of great talent whose full potential was never realized because of his early death. His work includes plein-air scenes, portraits, and multi-figure compositions. Among his best-known paintings is a bucolic (and homoerotic) scene of male bathers, *Scène d'été* (*Summer Scene,* 1869).

Bazille, who was born on December 6, 1841, came from a well-to-do Protestant family in Montpellier, France. His father, Gaston Bazille, was a city councillor and president of the Society of Agriculture. As a youth Frédéric enjoyed the outdoor life at the family's country house and was an avid duck-hunter.

The Bazille family and their circle had an interest in art, and young Frédéric became familiar with the work of painters such as Courbet and Delacroix. He also began studying painting himself.

In 1860, he took up the study of medicine in accordance with his father's wishes. Two years later he moved to Paris to pursue his medical education but also continued his study of art. It was not long before he abandoned medicine to devote himself to painting, a decision his father reluctantly accepted.

In November 1862, Bazille began studying at the studio of Swiss artist Charles Gleyre, where he met and became friends with Monet, Renoir, and Alfred Sisley. In 1863, when the studio temporarily closed because of Gleyre's health problems, Bazille and his friends went to Chailly near Fontainebleau to paint from nature.

The next year, Bazille and Monet, along with Eugène Boudin and Johan Barthold Jongkind, spent the summer in Normandy, again painting in the outdoors. In 1865, Bazille returned to Chailly, where he painted a landscape, *Paysage à Chailly,* and posed for Monet's *Déjeuner sur l'herbe.*

The young artists often worked side by side and also served as models for each other. Monet painted Bazille and his cousin Camille des Hours-Farel as *The Strollers* (*Les promeneurs*) in 1865, and Renoir did a portrait of Bazille at his easel (*Bazille peignant à son chevalet*) in 1867.

Bazille depicted Monet in *The Improvised Sickbed* (*L'Ambulance improvisée*) in 1865 after the latter suffered a leg injury. In 1867 he painted portraits of Sisley and Renoir.

The friends shared housing and studio space in Paris as well. Bazille was more fortunate than some of the others since he enjoyed the support of his prosperous family. Indeed, Bazille was able to help the financially struggling Monet by buying his *Femmes au jardin* (*Women in the Garden,* 1867) for a generous sum.

Bazille submitted two paintings to each of the annual Paris salons from 1866 to 1870. In every year except 1867, one was accepted.

Bazille could have avoided military service since his father had paid for a substitute for him, but he volunteered for the army in 1870. Sent to the front lines of the Franco–Prussian War, he died in battle at Beaune-la-Rolande on November 28 of the same year, at the age of twenty-eight.

The question of Bazille's homosexuality remains somewhat speculative. Todd Porterfield points to the "urbane homosociality of [Bazille's] Paris milieu," where he associated with writers and musicians including Charles Baudelaire, Émile Zola, Paul Verlaine, Arthur Rimbaud, and Edmond Maître, some of whom he painted.

Other commentators discuss evidence from the paintings themselves, in particular two, *Scène d'été* (*Summer Scene,* 1869) and *Pêcheur à l'épervier* (*Fisherman with a Net,* 1868). The former, which may have inspired some of Thomas Eakins's better-known nude bathing scenes, shows eight young men in and around a pond, variously swimming, lounging, wrestling, and disrobing.

The figures wear bathing suits in the painting, but most are nude in the preparatory sketches, and Kermit S. Champa has expressed the opinion that the suits were added as "late retouches." Champa refers to the all-male group of bathers in a naturalistic setting as "personal fantasy purporting to be external fact."

The same might be said of *Pêcheur à l'épervier,* a curious picture of a nude man, viewed from the back as he prepares to cast a net into a pond in a wooded area. In the near background his companion is in the final stage of undressing. Farther away but still clearly visible is a large country house.

The central figure is caught in a pose reminiscent of classical Greek statuary, yet he is obviously modern. The cast-off clothing of his friend and the architecture of the distant building also establish the contemporaneity of the scene.

Bazille had high hopes for the acceptance of this painting at the Paris salon, writing about it, "Mes amis ont été fort contents de mes études, surtout de mon homme nu. J'en suis bien aise parce que c'est la toile que je préférais." ("My friends have been very happy with my studies, especially of my nude man. I am delighted because it is the canvas that I preferred.") Its rejection was a great disappointment to him.

Karen Wilkin notes that Bazille was "better at the male nude than the female." Among Bazille's female nude subjects was *La toilette* (1870), in which an unclad white woman is attended by a black female servant wearing only a skirt of foreign design and a turban. The mistress's hand rests lightly on the servant's shoulder.

To their side, another female servant, this one white and in modern dress, holds a shawl. Her presence situates an otherwise exotic scene in contemporary culture. Porterfield sees in this composition "a concentration of Orientalist clichés that connoted a lesbian encounter."

Because Bazille's career was so short and since he did not leave a large body of work—some sixty-five oil paintings dating from 1862 to 1870—it is somewhat difficult to assess his place in art history. Wilkin describes him as "a serious man...struggl[ing] to find an individual voice and method when possibilities were enlarging."

His work shows the influence of painters from the past, in particular the Venetian old masters, Delacroix, and Courbet, but also shares characteristics with the work of his contemporaries such as Monet and Renoir. He is generally considered a pre-Impressionist or early Impressionist and is remembered as a talented participant in the inner circle of the nascent movement.

— *Linda Rapp*

BIBLIOGRAPHY

Bajou, Valerie M.C. "Bazille, (Jean-)Frédéric." *The Dictionary of Art.* Jane Turner, ed. New York: Grove's Dictionaries, 1996. 3:434–436.

Champa, Kermit S. "Frédéric Bazille: The 1978 Retrospective Exhibition." *Arts Magazine* 52.10 (June 1978): 108–110.

Jourdan, Aleth, et al. *Frédéric Bazille: Prophet of Impressionism.* Brooklyn, NY: The Brooklyn Museum, 1992.

Porterfield, Todd. "Bazille, Jean-Frédéric." *Gay Histories and Cultures: An Encyclopedia.* George E. Haggerty, ed. New York and London: Garland Publishing, Inc., 2000. 103–105.

Schulman, Michel. *Frédéric Bazillle 1841–1870: Catalogue raisonnée.* Paris: Éditions de l'Amateur, 1995.

Wilkin, Karen. "Forever Young: Frédéric Bazille." *The New Criterion* (February 1993): 28–32.

SEE ALSO

European Art: Nineteenth Century; Subjects of the Visual Arts: Nude Males; Eakins, Thomas

Beardsley, Aubrey (1872–1898)

ENGLISH DECADENT ARTIST AUBREY BEARDSLEY WAS A precocious talent who made a lasting contribution to the art of illustration. One of the greatest of the Symbolists and a master of pen and ink, Beardsley developed a highly original, formally elegant style, inspired in part by Greek vase painting, in which ornamental rhythm of line combines with a perverse and wickedly satiric imagination to create unforgettable images, often hilarious, frequently erotic, and sometimes deeply moving.

Beardsley was born on August 21, 1872, in Brighton, England, into a genteel family, but one rendered nearly destitute by the incompetence of his businessman father. He was a musical and artistic prodigy, so his talent was obvious very early, but so was his ill health. He had his first attack of tuberculosis, the disease that would eventually kill him, at the age of nine. For the rest of his brief life, he was plagued by numerous illnesses and relapses.

He was educated at the Bristol Grammar School and later, with the encouragement of Pre-Raphaelite painter Sir Edward Burne-Jones, attended night classes at the Westminster School of Art. Although he absorbed a number of influences, including that of the Pre-Raphaelites, Beardsley was largely self-taught.

Aubrey Beardsley.

In 1892, the young artist received his first commission, an invitation to illustrate an edition of Thomas Malory's *Morte d'Arthur* for the publisher J. M. Dent. The assignment entailed over 300 illustrations and chapter heads, which the artist executed in a mock-medieval, Pre-Raphaelite style.

In 1893, as he was working on the Dent commission, he met Oscar Wilde, with whom he would be associated for the rest of his life, at least in the public's imagination. Wilde's *Salome* had just been published in French. Later that year, a new journal, *The Studio*, published an article on Beardsley by Joseph Pennell, accompanied by eight of the artist's drawings, including one inspired by *Salome*.

Wilde's publisher John Lane invited Beardsley to illustrate the English edition of the drama. When it was published in 1894, both the play and the witty, provocative—blatantly erotic—illustrations created a sensation.

That same year, Beardsley became famous as the art editor of *The Yellow Book*, a new arts and letters periodical that Lane inaugurated. Although Wilde never actually contributed to the magazine, it was widely assumed to be an organ for the aesthetic ideas that the playwright espoused. Beardsley's stunning black-and-white drawings, title-pages, and covers helped make the new quarterly a great success.

But *The Yellow Book* also quickly became a site of the *fin de siècle* culture wars, a target of moralists concerned about the influence of the decadent movement on English society and art. One detractor described Beardsley's designs for the periodical as "Diseased, weird, macabre, and sinister."

In the context of the growing notoriety of Wilde and his circle, these descriptions may be seen as an attack on the newly visible homosexual subculture that emerged at the end of the nineteenth century. The culture wars culminated in Wilde's prosecution and conviction for gross indecency in 1895 and his sentence to two years' imprisonment at hard labor.

One casualty of the spirit of reaction precipitated by the Wilde trials of 1895 was Beardsley himself. He was summarily fired from his job as art editor of *The Yellow Book*. He had been too closely associated with Wilde for the publisher's comfort and his art too erotic and perverse for the new mood of conformity prompted by Wilde's conviction.

Ill and in financial straits, Beardsley accepted a job as a draftsman for Leonard Smithers's new quarterly, *The Savoy*. Smithers, a publisher of somewhat dubious reputation who dabbled in erotica, lacked the prestige of John Lane, but he proved to be a good friend to Beardsley.

The Savoy soon folded, but not until Beardsley had published in it both some extraordinarily intricate illustrations to Pope's mock-epic "The Rape of the Lock" and also his own highly erotic (but incomplete) tale "The

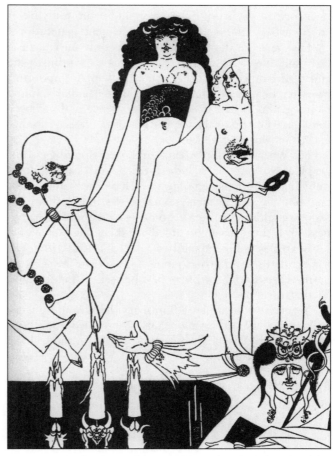

An illustration of Oscar Wilde's *Salomé* by Aubrey Beardsley.

Story of Venus and Tannhauser," probably inspired by the opera by Richard Wagner, whom Beardsley admired.

In his last years, despite his serious illness, Beardsley continued to work. He produced illustrations for Théophile Gautier's decadent novel *Mademoiselle de Maupin* and for Aristophanes' sexual comedy *Lysistrata* and a set of initials for an edition of Ben Jonson's *Volpone*. These designs are distinguished by the delicacy of their patterns. They comment less on the texts they purportedly illustrate than they satirize the foibles of Beardsley's own time.

In 1896, Smithers published a collection of Beardsley's pen-and-ink designs, *A Book of Fifty Drawings*, the first collection of the artist's work.

In his last months, Beardsley was sustained by the patronage of Smithers and the support of his friend Marc André Raffalovich, a Russian-born poet and theorist of homosexuality.

In search of a better climate, Beardsley traveled to the south of France in 1898. After converting to Roman Catholicism, he died in Mentone on March 16, 1898, at the age of twenty-five.

Considering the brevity of his life, Beardsley's achievement is astonishing. A highly original creator, he

transformed the art of illustration and profoundly influenced artists of his own and subsequent generations.

His expert draftsmanship made his drawings particularly suitable to the technical advances in printing at the end of the nineteenth century. Perhaps most important, however, he came to maturity at a time peculiarly suited to his genius, when theories of decadence and aestheticism gave license to the expression of perverse sexuality and to fetishism of all kinds.

His work is sexually frank and, occasionally, pornographic. Not only does he draw erect penises and stylized pubic hair and fetishize objects such as shoes and feathers, but he also depicts sexual obsession, lesbianism, sadomoaschism, and male homosexuality with a frankness and enthusiasm intended to shock and provoke.

Beardsley is preeminently a satirical artist, with a gift for caricature and grotesquerie. He deforms even as he aestheticizes and his art may best be seen as an attack on Victorian values.

Yet he also created revolutionary designs and images and patterns of surpassing beauty. His influence has been immense, and can be discerned especially in the stylized lines of Art Nouveau. — *Claude J. Summers*

BIBLIOGRAPHY

Brophy, Brigid. *Beardsley and His World.* New York: Harmony Books, 1976.

Nelson, James G. *Publisher to the Decadents: Leonard Smithers in the Careers of Beardsley, Wilde, Dowson.* With an Appendix on Smithers and the Erotic Book Trade by Peter Mendes and a Checklist of Smithers's Publications by James G. Nelson and Peter Mendes. University Park: Pennsylvania State University Press, 2000.

Pease, Allison. *Modernism, Mass Culture, and the Aesthetics of Obscenity.* Cambridge: Cambridge University Press, 2000.

Snodgrass, Chris. *Aubrey Beardsley: Dandy of the Grotesque.* New York: Oxford University Press, 1995.

Sturgis, Matthew. *Aubrey Beardsley: A Biography.* Woodstock, N. Y.: Overlook Press, 1999.

Zatlin, Linda Gertner. *Aubrey Beardsley and Victorian Sexual Politics.* Oxford: Clarendon Press, 1990.

SEE ALSO

European Art: Nineteenth Century; Symbolists; Erotic and Pornographic Art: Gay Male; Day, F. Holland; Demuth, Charles; Raffalovich, Marc André; Ricketts, Charles, and Charles Shannon

Beaton, Cecil *(1904–1980)*

SIR CECIL WALTER HARDY BEATON, THE CELEBRATED photographer of cultural icons and royalty, was born in Hampstead, London, on January 14, 1904, the eldest son of a prosperous timber merchant. He was educated at Harrow and Cambridge, where he excelled in art and first became involved with photography as a hobby.

Beaton left Cambridge, where his interests had been more social than academic, without a degree in 1921, and set about making a career in photography while working as a clerk in London.

His photography came to the attention of Edith Sitwell, one of his first sitters, and through her patronage and that of her brothers Sacheverell and Osbert, he found an entry into the world of the modernist *illuminati*, the social and artistic figures he so greatly admired.

Beaton gained public notice with his innovative portrait photos of glamorous individuals placed in unusual poses with theatrical props or costumes, as well as for his use of double and triple exposures for unique effects.

Some early critics found his work fragile, precious, and chichi, but, at the same time, provocative and witty. In retrospect, his often facile portraits might be considered manifestations of camp.

In 1928, in hopes of making a fast fortune, he traveled to New York, where he was befriended by lesbian socialite Elsie de Wolfe and soon had many American film and stage stars among his clientele.

During this period, much of his time and energy was devoted to travel and an extravagant social life, yet he found time for drawings, photographs, and articles for publication in such glossy magazines as *Vanity Fair, Vogue, Life,* and *Harper's Bazaar.*

Moreover, he began a simultaneous career as a theatrical stage designer when his longtime fascination with ballet was realized in commissions for the Cochran Revue, an English company, and the noted Ballets Russes de Monte Carlo.

Collections of Beaton's photographs, which would eventually become numerous, began to appear in the 1930s, most notably *The Book of Beauty* (1930), *Cecil Beaton's Scrapbook* (1937), and *Cecil Beaton's New York* (1938).

The 1930s culminated for Beaton with a commission for a series of photographs of Queen Elizabeth, the late Queen Mother. He would subsequently become the Royal Family's official portraitist.

Through the years of World War II, however, Beaton's work took a more serious turn. He became the official photographer for various British government and military agencies, and his work created a permanent historical record of the overwhelming devastation inflicted on London by German bombings during the Battle of Britain.

After the war, Beaton returned to his stage interests, designing lush and extravagant stage sets and costumes for Broadway and London theater as well as opera and film. He won a Tony Award (1957) for his costumes for

the Broadway production of *My Fair Lady*, and an Academy Award (1958) for sets and costumes for the film *Gigi*.

These honors, along with his widely circulated images of the Royal Family, brought him the financial security and social status he had long craved, and, in 1972, a knighthood.

Beaton was noted for his effeminate demeanor—he wore lipstick and painted his nails as a schoolboy and was drawn to drag attire for much of his life—and he realized quite early in his life that he was, as he recorded in his diary, "a terrible, terrible homosexualist." His relationships with men were usually emotionally painful, as his love went unrequited.

He nonetheless persisted, at certain junctures in his life, in what his biographer Hugo Vickers terms "excursions into heterosexuality," conceivably out of fear of persecution and a sense of internalized homophobia.

The most noted of these "excursions" was his relationship with Greta Garbo, who was herself most likely a lesbian or bisexual, but inclined at times to similar "excursions." Beaton became obsessed with Garbo in 1932, while on a visit to Hollywood, and persisted in importuning her for decades. According to Beaton's accounts, the relationship was consummated in the late 1940s, and rumors of their impending marriage were rampant.

Garbo, however, was emotionally distant and detached, and ultimately she rejected him, ironically, in a manner following the pattern of most of his gay relationships. She was, moreover, offended by his revelations about their relationship in *The Happy Years: Diaries 1944–48* (1972), the third volume of his published diaries. While these revelations were based, at least subconsciously, on a desire for retribution, Beaton retained his Garbo fixation until his death.

A portrait of artist Pavel Tchelitchew by Cecil Beaton.

In 1974, Beaton suffered a severe cerebral hemorrhage that left him partially paralyzed, although he managed to learn to draw, write, and take photographs with his left hand. His health remained fragile, however, and he died at Reddish House, his home in Broadchalke, Salisbury, on January 18, 1980. — *Patricia Juliana Smith*

BIBLIOGRAPHY

Beaton, Cecil. *Beaton.* James Danziger, ed. London: Secker and Warburg, 1980.

————. *Cecil Beaton: A Retrospective.* David Mellor, ed. Boston: Little, Brown, 1986.

————. *The Happy Years: Diaries 1944–48.* London: Weidenfeld and Nicolson, 1972.

————. *The Parting Years: Diaries 1963–74.* London: Weidenfeld and Nicolson, 1978.

————. *The Restless Years: Diaries 1955–63.* London: Weidenfeld and Nicolson, 1976.

————. *The Strenuous Years: Diaries 1948–55.* London: Weidenfeld and Nicolson, 1973.

————. *The Wandering Years: Diaries 1922–1939.* London: Weidenfeld and Nicolson, 1961.

Garner, Phillipe. *Cecil Beaton.* London: Collins, 1983.

Ross, Josephine. *Beaton in Vogue.* London: Thames and Hudson, 1986.

Souhami, Diana. *Greta and Cecil.* London: Jonathan Cape, 1994.

Spencer, Charles. *Cecil Beaton: Stage and Film Designs.* New York: St. Martin's Press, 1975.

Strong, Roy C. *Cecil Beaton: The Royal Portraits.* London: Thames and Hudson, 1988.

Vickers, Hugo. *Cecil Beaton: The Authorized Biography.* London: Weidenfeld and Nicolson, 1985.

————. *Loving Garbo: The Story of Greta Garbo, Cecil Beaton and Mercedes de Acosta.* London: Jonathan Cape, 1994.

SEE ALSO

Photography: Gay Male, Pre-Stonewall; El Greco; Wolfe, Elsie de

Bernhard, Ruth (b. 1905)

Ruth Bernhard, one of the preeminent twentieth-century photographers of the nude female, was born Ruth-Maria Bernhard on October 14, 1905, in Germany. Her father was an artist who specialized in posters and elegant typeface design.

Bernhard studied art in Berlin before following her father to New York City in 1927.

In New York, she worked as a magazine photographer's assistant and began to make personal photographs. During the 1930s, she photographed for her father and for industrial designers.

Bernhard met many lesbians in Manhattan, including photographer Berenice Abbott and Abbott's lover, critic Elizabeth McCausland. Around 1934, she began making images of women in the nude.

In 1935, Bernhard met photographer Edward Weston. His work and personality had a major influence on her life. Although they exchanged passionate letters, Bernhard decided against a physical relationship because she did not want to become another of his conquests.

Bernhard moved to Los Angeles in 1936, but returned to New York City during World War II. Around 1943, she met Eveline (Evelyn) Phimister (1908–1996), an artist who designed fabric, wallpaper, window displays, and sets for Broadway shows. They lived together in New York, San Francisco, and Los Angeles for about ten years.

Although Bernhard had many love relationships, Phimister was the only one with whom she ever lived.

In 1953, Ruth Bernhard moved from Los Angeles to San Francisco, where she became part of an influential group of photographers that included Ansel Adams and Imogen Cunningham. She made her living by photographing a variety of subjects, including the dogs of the rich.

She also began to teach, inspiring several generations of photographers through her emphasis on personal vision and the qualities of light. Public knowledge of her work spread through exhibitions and books of her images.

Her most significant lesbian-themed photograph is "Two Forms," made around 1963. In it, a black woman and a white woman—who were lovers—are shown pressed against one another. The photograph strikingly distills passion. Other works that resonate with lesbian audiences include images of nude women in boxes and studies of sea shells.

In 1967, Bernhard met Colonel Price Rice of the United States Air Force, an African American ten years her junior. He courted her for a decade before they became lovers. Although they maintained separate residences, their relationship continued until his death in 1999.

In the early 1970s, Bernhard was poisoned by fumes from a faulty heater. The poisoning cost her the ability to concentrate for extended periods. After that event, she made no new negatives.

Bernhard lived the actively lesbian part of her life during a time of widespread social oppression of homosexuals in the United States. Perhaps understandably, just as the lesbian liberation movement sought to embrace her, Bernhard chose to privilege the bisexual side of her nature.

However, in her nineties, Bernhard cooperated with biographer Margaretta K. Mitchell in revealing publicly her many relationships with women, her unconsummated affair with Edward Weston, and her long

involvement with a younger man. Her willingness to discuss her life openly attests to a bravery beyond that of many contemporary lesbian and bisexual artists.

— *Tee A. Corinne*

BIBLIOGRAPHY

Bernhard, Ruth. *Collecting Light: The Photographs of Ruth Bernhard.* Carmel, Calif.: The Friends of Photography, 1979.

———. *Gift of the Commonplace.* Carmel, Calif.: Center for Photographic Art, 1996.

Mitchell, Margaretta K. *Recollections: Ten Women of Photography.* New York: Viking, 1979.

———. *Ruth Bernhard: Between Art and Life.* San Francisco: Chronicle Books, 2000.

SEE ALSO

Photography: Lesbian, Pre-Stonewall; Abbott, Berenice; Subjects of the Visual Arts: Nude Females

Biren, Joan Elizabeth (JEB) (b. 1944)

DURING THE 1970S AND 1980S, THE PHOTOGRAPHS OF Joan Elizabeth Biren, better known as JEB, defined and set the standard for lesbian feminist imagemaking in the United States. They are broadly inclusive, showing women of various ages, different racial and ethnic groups, able-bodied and differently abled, mothers and children, bearded women, country and city dykes, and those involved in traditional and innovative spiritual practices.

The eldest daughter of civil servants, JEB was born and raised in Washington, D.C. Given her background, it is not surprising that she considered a career in politics or the law. After receiving a B.A. from Mount Holyoke College in 1966, she studied political science and sociology at Oxford University. Upon returning to Washington in 1969, she became active in the women's liberation movement and came out publicly.

JEB cofounded (along with others including Rita Mae Brown and Charlotte Bunch) The Furies, a short-lived but influential lesbian separatist collective that flourished in 1971 and 1972. She published many of her early images in the collective's newspaper, *The Furies.*

At a time of intense activism in the United States—during the period of anti–Vietnam War protests, Black Power, feminism, and the gay and lesbian liberation movements—JEB chose photography as a way to make lesbians more visible. She took a correspondence course in photography and worked in a camera store, in the audiovisual division of a large trade association, and on a small-town weekly newspaper in order to develop her talent and technique.

Between 1971 and 1991, JEB concentrated on making photographs of lesbians. Her images reached a national—and sometimes international—audience through periodicals such as *off our backs*, *The Washington Blade*, and Boston's *Gay Community News.* Many of her photographs were used on book covers and in books and films. She produced record album images for Meg Christian, Maxine Feldman, Margie Adam, Casse Culver, and Willie Tyson.

At Moonforce Media, which she cofounded, JEB also helped organize a national women's film circuit and the first feminist film festivals in Washington, D.C. In the midst of her political and photographic activism, she completed an M.A. in Communication at American University in 1974.

JEB self-published two calendars illustrated with photographs of known lesbians—such as Rita Mae Brown—and images of women together (1974 and 1976). The publications were followed by books of photographic images, *Eye to Eye: Portraits of Lesbians* (1979) and *Making A Way: Lesbians Out Front* (1987). During the 1980s, she crisscrossed the United States giving slide lectures and photography workshops.

Since the early 1990s, JEB has created videos. Her work in this medium includes *For Love and For Life* (1990), about the 1987 March on Washington; several videos about lesbian health issues; and *No Secret Anymore: The Times of Del Martin and Phyllis Lyon* (2002). She was video producer for the 1993 March on Washington for Lesbian, Gay and Bi Equal Rights and Liberation and produced the event's official video, *A Simple Matter of Justice* (1993).

In Cheatham and Powell's *This Way Daybreak Comes* (1986), JEB is quoted as follows: "Lesbians are not just women who are like everybody else, only we do something else in bed. We are different. We are women figuring out how to be 'other than' in a society that has no tolerance for deviance. Therefore if we can see what we look like, have a visual image of lesbians, we can more easily be ourselves." In so justifying her work, JEB makes clear that her art is linked with her activism.

— *Tee A. Corinne*

BIBLIOGRAPHY

Cheatham, Annie, and Mary Clare Powell. *This Way Daybreak Comes: Women's Values and the Future.* 2nd ed. Gabriola Island, B.C.: New Society Publishers, 1986.

Graham, Trey. "JEB (Joan E. Biren)." *Uncommon Heroes: A Celebration of Heroes and Role Models for Gay and Lesbian Americans.* Phillip Sherman, ed. New York: Fletcher Press, 1994. 198–199.

JEB (Joan E. Biren). *Eye to Eye: Portraits of Lesbians.* Washington, D.C.: Glad Hag Books, 1979.

———. *Making A Way: Lesbians Out Front.* Washington, D.C.: Glad Hag Books, 1987.

———. "That's Funny, You Don't Look Like a Jewish Lesbian." *Nice Jewish Girls.* Evelyn Torton Beck, ed. Watertown, Mass.: Persephone Press, 1982. Revised edition, Boston: Beacon Press, 1989. 122–129.

Kaser, James A., ed. *Queerly Visible: The Work of JEB (Joan E. Biren), A Washington, D.C., Photographer.* Washington, D.C.: The Gelman Library, George Washington University, 1997.

SEE ALSO

Photography: Lesbian, Post-Stonewall; American Art: Lesbian, Post-Stonewall; Contemporary Art; Subjects of the Visual Arts: Nude Females

Bleckner, Ross (b. 1949)

AMERICAN NEO-ABSTRACTIONIST ARTIST ROSS BLECKNER typically draws upon and plays with earlier traditions of abstraction, frequently by integrating his private experience as a gay man with public concerns surrounding gay identity and, especially, the AIDS crisis.

Born in New York City and raised in Hewlett, a prosperous Long Island suburb, Bleckner received his B.F.A. from New York University (1971) and his M.F.A. from the California Institute of the Arts (1973). He gained early recognition with his inclusion in the 1975 Whitney Biennial at the Whitney Museum of American Art in New York.

When he was invited back for participation in the 1987 and 1989 Whitney Biennials, Bleckner had since received critical acclaim and was associated with avant-garde currents of the early 1980s. These developments included a revival of figurative art, earlier modernist styles, including abstraction, and a return to importance of painting, all of which carried a retrograde quality given the pluralism and rise of experimental media during the 1970s.

A rash of "neo" movements appeared: for example, neo-Expressionism, neo-Surrealism, neo-Pop, and neo-Minimalism. Critics also coined a new descriptive term, "appropriation," to refer to artists who borrowed media and styles deemed outmoded with which to make contemporary social critiques. Bleckner's art was at the center of these events.

Although Bleckner makes prints and works as a photographer, his primary medium is large-scale oil painting. His paintings draw and play upon earlier traditions of abstraction, particularly the high modernist styles of postwar Abstract Expressionism and 1960s formalist abstraction.

Into these styles, which had been read by critics at their time of ascendancy as pure form without extrapic-

torial meaning, Bleckner incorporates representational elements that allude to the personal and political. In his blend of abstraction and the social, Bleckner stands among an important group of contemporary artists of the 1980s known as neo-abstractionists.

His ironic use of traditional oil painting and styles linked to the heroic period of American abstraction (1950–1970), which was dominated by heterosexual male artists, lies in his integration of gay issues. As was the case for another contemporary gay artist, Félix González-Torres, Bleckner weds his private experience as a gay man to public concerns surrounding gay identity, most especially the AIDS crisis.

A painting from 1986 typifies the tone of Bleckner's art, which continues to the present. *8,122+ As of January 1986* is characteristic of the "image paintings" or "nocturnes" of the early 1980s. Cutting through a darkened atmospheric ground, points of light suggest a celestial sky dotted with constellations and shooting stars. A horizontal cut rose hovers above the illuminated outline of an urn.

Flowers, urns, doves, fruits, chandeliers, and streaks of radiant light figure prominently in Bleckner's elegiac use of an iconography of death and mourning. Borrowing from the past, Bleckner evokes the Dutch tradition of still-life paintings that served as memento mori, a reminder of life's brevity and the inevitability of death.

Bleckner conceived the paintings in this group as "memorials" commemorating the loss of life, most hauntingly in their allusion to the tragedy of AIDS. In *8,122+ As of January 1986*, the numerals 8, 1, 2, and 2+ each appear respectively in the four corners of the painting. The reference is to the count of those who had died of AIDS at that point in a history that, horribly, has continued to number the deaths of thousands more in the subsequent years.

— *Richard H. Axsom*

BIBLIOGRAPHY

Audiello, Massimo. "Ross Bleckner: The Joyful and Gloomy Side of Being Alive." *Flash Art* 183 (Summer 1995): 112–115.

Dennison, Lisa, Tom Crow, Simon Watney, and Lisa Liebermann. *Ross Bleckner.* New York: Harry N. Abrams, 1995.

Schwabsky, Barry. "Memories of Light." *Art in America* 83 (December 1995): 80–85.

Wakefield, Neville. "Mourning Glory: Ross Bleckner in Retrospect." *Artforum* 33 (February 1995): 69–74.

SEE ALSO

Contemporary Art; American Art: Gay Male, Post-Stonewall; González-Torres, Félix

Blunt, Anthony (1907–1983)

ANTHONY FREDERICK BLUNT ENJOYED A PRESTIGIOUS career as one of Britain's most notable art historians. His last years, however, were marked by shame and ostracism after public revelations that he had been a spy for the Soviet Union and had been the unnamed "fourth man" in the 1950s Cambridge spy scandal.

Blunt was born September 26, 1907, in Bournemouth, England, into an affluent family of Anglican clergymen. His grandfather was a bishop, and his father was eventually appointed chaplain to the British ambassador to France. He spent his childhood and adolescence in Paris, where he was introduced to the French Renaissance art that would later be the focus of his academic career.

Blunt returned to England to attend Marlborough School and, subsequently, Trinity College, Cambridge, from which he graduated in 1932. He was appointed to a fellowship at Trinity upon receiving his degree, and thus he remained at Cambridge throughout the 1930s.

During this period, Blunt, despite his privileged background, became an ardent Communist. In 1934, he traveled to Moscow, where he made his first connections with the KGB, the Soviet Union's intelligence agency. Upon his return to Cambridge, he began to recruit a number of his finest students (many of whom were homosexuals) for the Communist cause. Among these were Guy Burgess (who was for a time Blunt's lover), Donald Maclean, and Harold "Kim" Philby.

With the onset of World War II, Blunt enlisted in the British army and was commissioned as an officer. In 1940, he volunteered for service with MI5, the British counter-intelligence agency. His purpose was to collect military secrets and pass them on to his KGB connections.

Apparently even after the end of the war in 1945, he continued to act as a double agent. Burgess, Maclean, and Philby were also strategically placed in various government positions that gave them access to secret information, and the four men worked in collaboration.

After the war, Blunt embarked on a brilliant career as an art historian and seemed to live a charmed life for the next three decades, during which he became one of the world's foremost art critics and authorities. In 1945, he was named Surveyor of the King's (later Queen's) Pictures, in which capacity he administered the Royal Family's extensive collections and had considerable access to the monarchy. He held this position until 1979.

He was appointed director of the Courtauld Institute of Art in 1947, became a Fellow of the British Academy in 1950, was knighted by the queen in 1956, and became professor of art history at the University of London in 1960. All the while he continued his contacts with the KGB.

His fellow conspirators, however, were unable to avoid detection. In 1951, Blunt learned from his contacts that Maclean was about to be arrested for espionage. Accordingly, Blunt and Philby, with help from the KGB, facilitated an escape for Maclean and Burgess, who defected to the Soviet Union, where they remained for the rest of their lives. Philby's involvement was subsequently discovered, and he likewise defected.

Because of the homosexual element of this scandal, British law enforcement found "justification" for increasing its surveillance and prosecution of gay men throughout the 1950s and early 1960s; and gay men in the United States and the United Kingdom were, as a rule, banned from sensitive government posts as they were assumed to be security risks.

Although British intelligence had long believed there was a fourth man involved in the spy ring, Blunt remained undetected until 1963, when an American art critic being scrutinized by the FBI revealed his connections to the Cambridge spies. The MI5 confronted Blunt with this evidence, but granted him immunity in return for his testimony.

Blunt's crimes were not made public, and he was allowed to retain all his posts and honors because the British government did not want a scandal concerning one so closely connected to the Royal Family, particularly in the wake of the Profumo sex and espionage case only months before.

Thus, in spite of acts that had severely damaged his country's military security throughout the Cold War, Blunt remained unscathed until publication of Andrew Boyle's *The Climate of Treason* (1979), which documented Blunt's culpability, but which, because of British libel laws, did not identify him by name.

Margaret Thatcher's government was quick to act on this revelation, however, and the Prime Minister herself divulged Blunt's identity in a speech before the House of Commons. Consequently, Blunt was stripped of his knighthood, his honors, and his appointments. He retreated from public life and died in disgrace on March 26, 1983.

The deeds of Blunt and the other Cambridge spies have become the basis for a variety of works, including Marek Kanievska's film *Another Country* (1984) and Alan Bennett's play *A Question of Attribution* (1991).

— *Patricia Juliana Smith*

BIBLIOGRAPHY

Boyle, Andrew. *The Climate of Treason*. London: Hodder and Stoughton, 1980.

Carter, Miranda. *Anthony Blunt: His Lives*. New York: Farrar, Straus & Giroux, 2002.

Costello, John. *Mask of Treachery*. London: Collins, 1988.

Gunn, Rufus. *A Friendship of Convenience*. London: Gay Men's Press, 1997.

Modin, Yuri. *My Five Cambridge Friends*. Trans. Anthony Roberts. London: Headline Press, 1994.

Penrose, Barrie. *Conspiracy of Silence: The Secret Life of Anthony Blunt*. London: Grafton, 1986.

Sinclair, Andrew. *The Red and the Blue: Cambridge, Treason, and Intelligence*. Boston: Little, Brown, 1986.

Sutherland, Douglas. *The Fourth Man: The Story of Blunt, Philby, Burgess, and Maclean*. London: Secker & Warburg, 1980.

Bonheur, Rosa (1822–1899)

THE MOST POPULAR ARTIST OF NINETEENTH-CENTURY France, Rosa Bonheur was also one of the first renowned painters of animals and the first woman awarded the Grand Cross by the French Legion of Honor. A professional artist with a successful career, Bonheur lived in two consecutive committed relationships with women.

Born on March 16, 1822, in Bordeaux, Marie Rosalie Bonheur was the oldest of the four children of Raimond Oscar Bonheur (1796–1849) and Sophie Marquis. Bonheur's father was an art teacher who came from a poor family, while her mother, a musician, had descended from a middle-class family and had been her husband's art student.

Bonheur's father, who taught drawing and landscape painting, was an ardent member of the utopian Saint Simeon society. The group held idealistic beliefs about the reform of work, property, marriage, and the role of women in society. Most importantly, for the artist's future, the Saint Simeons questioned traditional gender norms and firmly believed in the equality of women. While teaching artistic techniques to his oldest daughter, Raimond Bonheur also encouraged her independence and taught her to consider art as a career.

In 1828, Raimond Bonheur joined the Saint Simeons at their retreat outside Paris. Sophie and the children joined him in Paris the following year. Four years later, however, Raimond abandoned his family to live in isolation with his fellow Saint Simeons.

Sophie Bonheur died in 1833 at the age of thirty-six. Rosa was only eleven years old when her mother died, but she was aware of the heavy price her mother paid for married life with a man who was more dedicated to his own ideals than to meeting his family's needs. Rosa also saw that her mother's marriage led to poverty and her death from exhaustion.

After her mother's death, Bonheur was taken in by the Micas family, who resided nearby. Mme Micas and Bonheur's mother had been friends. When Mme Bonheur died, the Micas family paid Raimond Bonheur's debts and cared for Rosa. Their daughter, Nathalie, who would later become an amateur inventor and unschooled veterinarian, and Rosa became enamored with each other.

When Rosa Bonheur began her career as a professional artist, she had already been trained by her father, who had allowed her to study in all-male classes. Rosa also learned by sketching masterworks at the Louvre from the age of fourteen, and later, by studying with Léon Cogniet.

From the very beginning, Bonheur's favorite subject was animals. She learned their anatomy completely by dissecting them in local slaughterhouses. She also visited the horse market two times a week. Study of animals by direct observation led to the formation of the realist style in which Bonheur worked.

It was for such work that Bonheur obtained written permission from the French government to wear men's slacks. Her working attire also consisted of a loose smock and heavy boots that protected her feet from the dangerous environment in which she painted. The style of dress that the artist adopted for work and home may well have been influenced by her father's attire, which was based on Saint Simeonian clothing experiments. Bonheur also cropped her hair, perhaps to facilitate her work. She did, however, always wear dresses for social occasions because she knew that appropriate dress would further her career.

Bonheur earned a successful living as a painter of animals. She exhibited at the annual Paris Salon regularly from the age of nineteen in 1841 through 1853, when she was thirty-one. She won the salon's gold medal at the age of twenty-six in 1848 and was commissioned by the French government to paint *Plowing on the Nivernais* in 1849. In the same year, Bonheur and her sister Juliette became directors of l'École gratuite de dessin pour les jeunes filles, a post their father had once held.

Bonheur completed her most renowned work, *The Horse Fair*, in 1855. This successful representation of Percherons (a breed native to Normandy) was purchased by Ernest Gambart, a London art dealer whose gallery specialized in work by French artists. He exhibited *The Horse Fair* in London, where Bonheur visited with Nathalie. Queen Victoria requested a private viewing of the painting at Windsor Castle. It would later be purchased in 1887 by Cornelius Vanderbilt and donated to the new Metropolitan Museum of Art in New York City.

Bonheur's trip to England allowed her to meet Charles Eastlake, then President of the Royal Academy, John Ruskin, the English writer and critic, and Edwin Landseer, the British animalier. She also toured the English and Scottish countrysides and executed some paintings based on her observations of new breeds of animals found there.

Gambart made engravings of Bonheur's work, including *The Horse Fair*, and sold them in England,

Europe, and the United States. Bonheur became one of the most renowned painters of the time. Little girls, such as Anna Klumpke in the United States, even had dolls in her likeness, much as American girls played with Shirley Temple dolls during the 1940s and 1950s.

In 1855, the same year in which Bonheur completed *The Horse Fair,* she also finished *Haymaking at Auvergne.* It was shown in the Paris Exposition Universelle that year, hung as a pendant to *Plowing on the Nivernais,* and won the gold medal.

The monetary success Bonheur achieved allowed her to purchase Château By, a house and farm near the Fontainebleau Forest, in 1860. She retired there with Nathalie and Mme Micas during the same year. The three women divided the labor so that Mme Micas was the housekeeper, Nathalie prepared Bonheur's canvases and negotiated with art dealers, and Bonheur was the professional artist who provided income for the household.

During the years that Bonheur lived at By, she painted steadily and entertained celebrities. In 1865 she received a visit from Empress Eugénie, who awarded the artist the Grand Cross of the Legion of Honor. Bonheur was the first woman to be singled out for the distinguished award established by Napoleon to recognize the achievements of French citizens.

During the last decade of Bonheur's life, she continued to paint. The most famous work of this period is the portrait she painted of Col. William F. Cody astride his horse. Bonheur had seen his Wild West show at the Paris Exposition of 1889 and at that time made sketches for his portrait. The sketches became the basis for her paint-

ing entitled *The Buffalo Hunt* (1889) and the image became the center of Cody's publicity campaign.

Great sadness enveloped Bonheur's life when Nathalie died during the same year. Her partner's ashes were buried along with those of her mother in the tomb Bonheur had purchased on the death of Mme Micas in 1875. Bonheur's grief overtook her to such a degree that it was very difficult for her to work or see friends. When the young artist Anna Klumpke first met her in 1895, Bonheur was not able to visit with her.

By 1893, however, Bonheur had recovered sufficiently to visit the United States to see the Women's Building at the World's Columbian Exposition in Chicago. When she returned to France, she was better able to talk with Anna Klumpke, the portrait painter from Boston, who had earned recognition for her work in France.

When the two women renewed acquaintance at By in 1895, Bonheur was seventy-seven and Klumpke was forty-three. Over a brief time, the two women became captivated with each other and Bonheur offered Klumpke a living agreement that they both signed on August 11, 1898. Bonheur agreed to build a studio for Klumpke at By and Klumpke agreed to paint portraits of Bonheur and to write the older artist's biography. Klumpke completed three portraits before Bonheur's death on May 25, 1899.

Bonheur, as she had planned, was interred in the tomb she had purchased at Père Lachaise cemetery in Paris. The artist's career was celebrated with a retrospective exhibition at Galerie Georges Petit during 1900.

Although opposed by both her family and Bonheur's, Anna Klumpke managed Bonheur's estate the rest of her

Plowing the Nivernais by Rosa Bonheur.

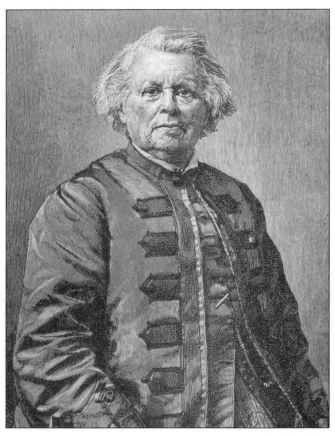

Rosa Bonheur.

her work, Bonheur remains important as an extraordinarily successful artist who rejected the patriarchal model of life and lived with the women she loved.

— *Ray Anne Lockard*

BIBLIOGRAPHY

Ashton, Dora, and Denise Browne Hare. *Rosa Bonheur: A Life and a Legend.* New York: Viking Press, 1981.

Boime, Albert. "The Case of Rosa Bonheur: Why Should a Woman Want to be More Like a Man?" *Art History* 4 (1981): 384–409.

Bonheur, Rosa. *Reminiscences of Rosa Bonheur.* Theodore Stanton, ed. New York: D. Appleton, 1910; reprint, New York: Hacker Art Books, 1976.

Chadwyck, Whitney. "The Fine Art of Gentling Horses and Women and Rosa Bonheur in Victorian England." *The Body Imaged: The Human Form and Visual Culture Since the Renaissance.* Kathlenne Alder and Marcia Pointon, eds. New York: Cambridge University Press, 1993. 89–107.

Digne, Danielle. *Rosa Bonheur ou l'insolence: L'Histoire d'une vie, 1822–1899.* Paris: Denol/Gonthier, 1980.

Klumpke, Anna. *Memoirs of an Artist.* Lilian Whiting, ed. Boston: Wright and Potter, 1940.

———. *Rosa Bonheur, sa vie, son oeuvre.* Paris: Flammarion, 1908. Translated as *The Artist's (Auto)biography: Rosa Bonheur by Anna Klumpke.* Gretchen Van Slyke, trans. Amherst: University of Massachusetts Press, 1997.

Ribemont, Francis. *Rosa Bonheur (1822–1899).* Exhibition catalog. Bordeaux: Musée des Beaux-Arts de Bordeaux, 1997.

Saslow, James M. "Disagreeably Hidden Construction and Constriction of the Lesbian Body in Rosa Bonheur's Horse Fair." *The Expanding Discourse: Feminism and Art History.* Norma Broude and Mary D. Garrard, eds. New York: HarperCollins, 1992. 187–206.

Van Slyke, Gretchen. "Addressing the Self: Cost, Gender and Autobiographical Discourse in l'Abbé de Choisy and Rosa Bonheur." *Autobiography, Historiography, Rhetoric: A Festschrift in Honor of Frank Paul Bowman.* Mary Donaldson-Evans, Lucienne Frappier-Mazur, and Gerald Prince, eds. Amsterdam: Rodopi, 1994. 287–302.

———. "L'Autobiographie de Rosa Bonheur: Un testament matrimonial." *Romanticisme* 85.3 (1994): 37–45.

———. "Does Genius Have a Sex? Rosa Bonheur's Reply." *French-American Review* 63. 21 (Winter 1992): 12–23.

———. "Reinventing Matrimony: Rosa Bonheur, Her Mother, and Her Friends." *Womens Studies Quarterly* 19. 3–4 (Fall–Winter 1991): 59–77.

Weisberg, Gabriel. *Rosa Bonheur: All Nature's Children.* New York: Dahesh Museum, 1998.

SEE ALSO

European Art: Nineteenth Century; Abbéma, Louise; Klumpke, Anna Elizabeth; Stebbins, Emma

life. Klumpke painted a final portrait of Bonheur in 1902 and published *Rosa Bonheur, sa vie, son oeuvre* in 1908. In 1924, Klumpke dedicated the Musée Rosa Bonheur at By and established the Rosa Bonheur Memorial Art School to offer instruction to women. Two decades later, in 1940, Klumpke published *Memoirs of an Artist.* She died in 1942 and her ashes were entombed alongside Bonheur's in Père Lachaise Cemetery three years later.

During the nineteenth century, art was considered a lady's pastime to be pursued at home, but thanks to her father's influence, Bonheur understood her calling as a profession and made her livelihood from it. While Bonheur never referred to herself as a lesbian, she certainly understood her relationships with Nathalie Micas and Anna Klumpke to be a subversive form of matrimony. These liaisons rejected the patriarchal institution of marriage in favor of a matriarchal life in partnership. Bonheur used her last will and testament to force legal recognition of her right to transfer her property to another woman.

Despite Bonheur's popularity, her work was not universally acclaimed by contemporary critics. This was, no doubt, due, at least in part, to her lifestyle and her feminism. Quite apart from the considerable quality of

Breker, Arno (1900–1991)

STATE-COMMISSIONED Nazi sculpture is perhaps one of the last places one might expect to encounter homoeroticism. Given the status of homosexuality as degenerate in Hitler's vision of a new Germany and his subsequent "social purification" schemes, which actively sought to eliminate lesbians and gay men, among a host of other "deviants," the homoeroticism of public artwork designed to advance Nazi ideology is a puzzling contradiction that demands critical attention.

Arno Breker was born on July 19, 1900, in Düsseldorf, the son of a sculptor and stonemason. He studied art in Düsseldorf; then, after a brief stint in Rome, he lived in Paris from 1927 until 1933, when he returned to Germany.

Soon Breker became the best-known sculptor of the Nazi era, receiving numerous commissions to make large-scale public works for the German state. These ranged from sculptures of athletes that decorated the Berlin stadium built for the 1936 Olympic games to programmatic works celebrating Nazi ideals. In 1937, he was named "Official State Sculptor" and soon employed hundreds of assistants.

Considered emblematic of the Nazis' program of public art, Breker's work repeatedly featured representations of nude male athletes, soldiers, and workers—central and complex lodestones of fascist ideals of masculinity. While Breker depicted a variety of subjects both before his state commissions and afterward, his most (in)famous sculptures are his Nazi-era male nudes, imbued with the mythos of Aryan purity and entrenched in the political rhetoric of the Nazi Party.

Hitler, an artist himself, was keen on the role art could and should play in suggesting the superiority and invincibility of German culture. Through its emphasis on athletics, the building of monuments, a glorification of the German landscape, a focus on technological achievement, and deliberate grandstanding like the 1936 Berlin Olympics, the Third Reich consciously aligned itself with the famed virtuosity of ancient Greece.

Deliberately evoking comparisons between Germany and ancient Greece, Breker's neoclassical sculptures cast muscular, naked men as national symbols of Nazi Germany's valor and supremacy. Breker's muscular nudes are meant to signify the virile but highly civilized German male: strong yet restrained, brutal yet pure, nude yet decent. At the same time, these Aryan musclemen serve as ready foils to the weak and corrupt Jew and homosexual, holding out the German male as racially and culturally superior.

Several of Breker's works, whether multipart, freestanding sculpture programs or individual reliefs, feature all-male, all-nude scenes that conjure a homosocial narrative verging on the homoerotic. Despite its attendant homoerotic trappings, the idealized depiction of a community of men—strong, close to nature, and devoted to each other—was central to many Nazi social programs.

Nazi Party officials took steps to counter homosexual activity within the Hitler Youth Movement and other organizations, but Breker's work elucidates the striking proximity between Nazi visions of a platonic fascist utopia and gay fantasies of a steamy wonderland in which the male body is always on view.

Poised for battle, holding their wounded comrades, bonding in sport, or toiling together at hard labor, Breker's male figures are easily readable as gay superheroes, their hard bodies and inner-directed physicality supplanting their official decency.

For contemporary gay audiences, Breker's sculpture is important because it represents a place where politics and desire collide; the salient values of racial and physical desirability in his work are disturbingly grounded in both Nazi and gay cultures. Even a cursory survey of gay visual culture suggests the prominence of men who fit the Aryan ideal. In this sense, gay culture is fixated on the paramount desirability of the white, blond, muscular, youthful (and, to some degree, "straight-acting") man, much as Nazi culture was.

While these two cultures are hardly comparable (and it would be obscene to equate the two), the idol status of this mythic type within each suggests the degree to which these longstanding icons of purity, power, and supremacy carry diverse meaning—and the degree to which they do not.

More pointedly, while gay male desire is generally considered to overturn hegemonic notions of sexual and social normality, the worship of these Aryan emblems suggests that homosexual desire is neither so simple nor so politically correct.

In this sense, Breker's sculptures are challenging reminders of the political nature of desire, pushing us toward new ways of reconciling desire with politics, guilt, and the right to pleasure. They also lead us to ask how effectively and toward what end we can subvert and reclaim even the most egregious elements of modern history.

After the war, Breker's work was denounced as cold and propagandistic, but he continued to work as a sculptor. Among his postwar works are heads of such prominent gay figures as Jean Cocteau, Jean Marais, and Henri de Montherlant. He died on February 13, 1991.

— *Jason Goldman*

BIBLIOGRAPHY

Adam, Peter. *Art of the Third Reich.* New York: Harry N. Abrams, 1992.

Kasher, Steven. "The Art of Hitler." *October* 59 (Winter 1992): 48–85.

Mosse, George L. *Nationalism and Sexuality: Middle-Class Morality and Sexual Norms in Modern Europe.* Madison: University of Wisconsin Press, 1988.

Weinberg, Jonathan. *Speaking for Vice: Homosexuality in the Art of Charles Demuth, Marsden Hartley, and the First American Avant-Garde.* New Haven: Yale University Press, 1993.

SEE ALSO

Subjects of the Visual Arts: Nude Males

Bronzino, Agnolo (1503–1572)

AGNOLO BRONZINO WAS ONE OF THE LEADING PAINTERS of the Florentine School in mid-sixteenth-century Italy. He eventually became court painter to Cosimo de' Medici.

Born in Monticelli in 1503, Bronzino studied with Mannerist painter and portraitist Jacopo Pontormo (1494–1557), whose style the young artist soon adapted for himself. Mannerism involves the adjustment of volume and spatial boundaries and the alteration of figures to create a harmonious unity in art and architecture. Bronzino softened and lengthened his master's brushstrokes, and in so doing he created a style unique to himself.

Most scholars conclude, based on a series of sonnets Bronzino wrote upon Pontormo's death, that the two

Agnolo Bronzino.

men enjoyed a more intimate relationship than that of master and pupil. Later in his life, in 1552, Bronzino also adopted one of his own pupils, Alessandro Allori (1535–1607), as his son.

In sixteenth-century Florence, this type of arrangement often signaled a sexual relationship between two men; an older man adopting his younger lover was quite common. The two artists lived together until Bronzino's death in 1572.

Famous mainly for his portraits, such as the *Portrait of Eleanor of Toledo with her Son Giovanni* (1545–1546), and noted particularly for the softness that illuminates his figures, Bronzino also painted biblical and mythological scenes, designed tapestries and frescoes, and composed poetry.

While some of Bronzino's poetry consists of rather conventional lyric verse, as well as the sonnets upon Pontormo's death, he also wrote a considerable body of burlesque verse. Often obscene and erotic, burlesque verse circulated among Florentine intellectual and aristocratic circles, whose members would have detected obscure allusions and subtexts beneath the bawdy wordplay. Bronzino's burlesque poetry is distinguished by its large number of homoerotic references and allusions.

Mannerism is often considered an artistic movement devoid of sexual expression. While mythological or biblical depictions often feature nude or partially nude figures, such as in Bronzino's own *Venus, Cupid, Folly, and Time* (ca. 1540–1545), there is a reticence to the nudity; bodily parts are strategically covered up, and the subject matter (in this case, mother and son) cautions the viewer against a sexual reading. Even the visual depiction of nude bodies entwined resists a sexual reading, since the bodies are placed at abstract angles to ensure and suggest modesty.

Despite these generalizations, however, there is an undeniable homoerotic subtext to several of Bronzino's famous portraits, including *Andrea Doria as Neptune* (ca. 1545) and *Cosimo I de' Medici as Orpheus* (ca. 1538–1540). Especially interesting in this regard is his *Portrait of a Young Man* (ca. 1535–1540).

A simple portrait of a handsome youth holding two books and wearing a pinky ring, *Portrait of a Young Man* nevertheless possesses a charged eroticism, seen both in the loving depiction the artist has created as well as in the handsome and anonymous (uncommon in Bronzino's work) model. The books may very well represent Bronzino's own Petrarchan poems, love sonnets sometimes addressed to other men. Moreover, parts of the young man's garb, especially his ring and sash, may act as symbols suggesting his sexuality.

Bronzino's work now hangs in the world's most famous museums, including, for example, the J. Paul Getty Museum (Los Angeles), the Metropolitan Museum

of Art (New York), the National Gallery of Art (Washington, D.C.), and the National Gallery (London).

In both his writing and painting, Bronzino contributes significant insights into same-sex desire and relationships in sixteenth-century Florentine society.

— *Michael G. Cornelius*

BIBLIOGRAPHY

Cecchi, Alessandro. *Bronzino*. Los Angeles: Riverside Book Company, 1997.

DiAddario, John. "Bronzino's 'Portrait of a Young Man': Notes Towards a Queer Semiotic." Master's thesis, Columbia University, 1994–1996. Excerpted at www.jonno.com/bronzino/indexB.html.

McComb, Charles. *Agnolo Bronzino: His Life and Works*. Cambridge, Mass.: Harvard University Press, 1928.

Parker, Deborah. *Bronzino: Renaissance Painter as Poet*. Cambridge: Cambridge University Press, 2000.

———. "Towards a Reading of Bronzino's Burlesque Poetry." *Renaissance Quarterly* 50.4 (1997): 1011–1044.

SEE ALSO

European Art: Mannerism; European Art: Renaissance; Pontormo, Jacopo

Brooks, Romaine (1874–1970)

AMERICAN ARTIST ROMAINE BROOKS CREATED A BODY of work unique to the history of modern art. Her life-sized female nudes and portraits of cross-dressed women made her lesbian identity and desire visible to the world.

The third and youngest child of Major Henry Goddard and Ella Mary Waterman, Beatrice Romaine Goddard was born on May 1, 1874, while her mother was traveling in Rome. She was the newest addition to a wealthy but severely dysfunctional family from Philadelphia. The child's father abandoned the family shortly after her birth.

The artist's mother was a cruel narcissist and an erratic parent who left her infant daughter with a family laundress in the United States while she traveled throughout Europe with her other children. The oldest child, St. Mar, suffered from a debilitating mental illness that caused him to exhibit disruptive and violent behavior. Very little is known about Brooks's sister, Mary Aimée (Maya), the middle child.

Brooks was finally allowed to join her mother, brother, and sister in Europe when she was twelve years old. She was, however, educated in private girls' schools while her mother continued her travels. Such an early life experience would lead any child to feel that she was a mere inconvenience.

Brooks's adolescent years consisted of attempts to appease both the needs of her ill brother and her emotionally unstable mother. She was, however, finally able to convince Ella to allow her to study voice near Paris from 1896 to 1898. Although she was given only a tiny allowance and suffered financial hardships, she was highly motivated and dedicated to the voice lessons. But she ultimately decided that her true calling was to the visual arts.

Brooks traveled to Rome in 1898 and began to take free painting classes at La Scuola Nazionale during the day while also studying at Circolo Artistico at night. In 1899, she vacationed in Capri, where she met a cadre of expatriate American and English artists and writers, many of whom were involved in same-sex relationships.

Brooks later described that first trip to Capri as the happiest time of her life. During the following year, Brooks continued to study painting at Académie Colarossi in Paris.

Soon after the turn of the century, Brooks's fortune improved. St. Mar died in 1901 and her mother died of diabetes the following year. Much to her surprise, the artist had inherited, at the age of twenty-eight, the entire family fortune. Her new financial independence allowed her artistic freedom and provided entrée to the salons and homes of the European social and intellectual elite.

The artist moved to London in 1902 and agreed to a marriage of convenience with John Ellingham Brooks, an impoverished, but socially prominent, gay pianist. They separated after three months, and Brooks continued to support him the rest of his life. She further reinvented her identity by dropping the feminine name Beatrice and keeping her married surname. She was now known by the androgynous name of Romaine Brooks.

Having gained social status and artistic respectability through her marriage, Brooks rented a studio in Chelsea across Tite Street from the studio in which James McNeil Whistler (1834–1903) had worked. Whistler's subdued palette would soon influence Brooks's work.

By 1905, when she was thirty-one, Brooks had resettled in Paris, acquired a large studio on the Left Bank, and briefly studied art with Gustave Courtois.

During 1910, Brooks began to paint the works for which she became renowned—life-sized nudes and portraits of Parisian *illuminati*. Her first female nude was *The Red Jacket,* painted in that same year, soon followed by an erotic odalisque entitled *White Azaleas.*

Brooks's first one-woman exhibition was shown from May 2 to May 18, 1910, at the prestigious Galeries Durand-Ruel in Paris. It was a breakthrough exhibition in which Brooks exhibited thirteen portraits and nudes that made her lesbian identity public.

She received critical acclaim from Robert de Montesquiou (1855–1921), the aristocratic dandy on whom Proust based the character of the homosexual

Baron de Charlus in *Remembrance of Things Past*. He was to serve as the artist's principal mentor. Brooks sent the entire exhibition plus additional works to the Goupil Gallery in London the following year.

In 1911, in addition to creating numerous artistic works, Brooks met Ida Rubenstein (1885–1960), a Russian ballerina who performed with the Ballets Russes. The dancer quickly became Brooks's lover and the subject of her most important early portraits and nudes, such as *The Crossing* (1911).

Brooks soon earned a reputation as an accomplished portraitist. Wealthy and renowned individuals began to request sittings. She first painted the influential Italian poet Gabriele D'Annunzio (1863–1938) as *Gabriel D'Annunzio, the Poet in Exile*, in 1912. After he had become a national hero in World War I, she painted a second portrait of him entitled *Gabriel D'Annunzio, Il Commandante* (1916).

Brooks also painted a portrait of Jean Cocteau (1889–1963) before his rise to fame as a poet, novelist, critic, playwright, and artist.

The Cross of France, a portrait of Ida Rubenstein, was executed near the beginning of World War I and exhibited at Georges Bernheim's gallery in 1915 as part of a benefit that D'Annunzio and Brooks organized for the Red Cross. In 1920, the artist received the Chevalier medal from the French Legion of Honor for this and other efforts on behalf of France.

Brooks met the woman who would soon become most important in her life in 1915, when she was forty-one. Natalie Clifford Barney (1876–1972), an American expatriate writer who had moved to Paris in 1902, was thirty-nine when the two women met. The daughter of painter Alice Pike Barney, she was already a brilliant conversationalist and would soon become the muse of a weekly literary salon that lasted from 1919 until 1968.

Even though Brooks did not enjoy such salons and Barney had numerous sexual relationships with other women, the women's relationship lasted for nearly fifty years.

Brooks benefited from Barney's salons in that she painted many of the people who frequented them. Her famous portrait *Natalie Barney, L'Amazone* (1915) depicts the author in feminine attire. A porcelain horse is included in the portrait as a reference to Barney's riding skills.

The author is described in the portrait's title as an Amazon, or woman warrior, for her efforts to reestablish the cult of Sappho in Paris during the first decade of the twentieth century. The painting is a daring declaration of Barney's sexual interests and a bold attempt to link the subject with lesbian history.

Brooks painted one more nude of Ida Rubenstein during 1916 and 1917. Entitled *Weeping Venus*, it appears to be a commentary on the loss of their relationship. Within three years Brooks painted a cross-dressed woman for the first time. In *Renata Borgatti at the Piano* (ca. 1920), one of Brooks's lovers is shown as an androgynous person who deliberately invokes the cultural signs of "deviant" sexuality.

Three years later, Brooks painted her two most famous works. In her *Self-Portrait* (1923) she is cross-dressed, wearing a top hat that is too large and equestrian attire, with the emblem of the Legion of Honor flashing on her lapel. She blatantly and subversively appears as an aristocratic male dandy. In making this portrait the centerpiece of her 1925 exhibition, Brooks demonstrated her refusal to become an object of the heterosexual male gaze.

Her *Self-Portrait* was followed in the same year by her portrait entitled simply *Una, Lady Troubridge* (1923). Una Vincenzo Troubridge (1887–1963) had recently left her husband for Radclyffe Hall, who was to become the author of the most famous lesbian novel of the twentieth century, *The Well of Loneliness* (1928).

In this portrait, another depiction of a cross-dressed woman, Brooks uses the model of the male dandy, including bobbed hair and a large monocle. The pose and eyepiece offer a humorous commentary on gender roles and also allude to a lesbian bar in Paris named "L'Monocle."

Both Brooks's *Self-Portrait* and her portrait of Lady Troubridge were created as three-quarter-length portraits. Visually, one assumes that the two women who are portrayed in the paintings are wearing men's slacks, but in reality they usually wore tailored skirts. Exactly what the two women wore in their portraits is left to the viewer's imagination.

From 1923 to 1924, while Brooks was in England, she and the British artist Gluck (1895–1978) painted each other's portraits. Gluck, only twenty-eight at the time and still experimenting with her own identity, painted the older artist's portrait first.

Brooks did not care for the younger artist's work so it was never exhibited. Her portrait of Gluck, entitled *Peter, a Young English Girl (1923–1924)*, however, was a success. The younger artist, who went by the name Peter before she used the name Gluck, cropped her hair and wore men's clothing. Brooks's portrait of "Peter" depicts a fine-looking young person of indeterminate gender who sports a handsome suit, smart cravat, crisp white collar, and holds a man's hat in her right hand.

After painting Peter's portrait, Brooks built a house with Natalie Barney at Beauvallon, France, near St. Tropez. To preserve their independence, the structure consisted of two wings that were united by a dining room.

Brooks's career reached its zenith in 1925 with three exhibitions of her work. The first was in Paris at the Galerie Jean Charpentier from March through April.

The show traveled to the R. B. L'Alpine Club Gallery in London during June and ended in December at the Wildenstein Galleries in New York.

While the exhibitions of 1925 were successful, Brooks painted few works after this time. She did, however, create two illustrations for Barney's book entitled *The One Who Is Legion; or, A. D.'s After-Life*. The book, about one person who had several different identities, was privately published in a limited edition of 450 copies in London during 1930.

During the same time, the artist began an autobiographical manuscript entitled *No Pleasant Memories* that, although composed over the next twenty years, was never published. One exhibition of Brooks's oeuvre was held at Galerie Théodore Briant in Paris during May 1931.

In the early 1930s, Brooks was haunted by childhood memories that led her to draw more than 100 pen-and-ink works. These curious pieces consist of an intertwined single line that seems to symbolize Brooks's dependency and separation issues.

In the drawing *Caught* (1930), for example, all the figures are entangled. Another drawing entitled *The Impeders* (1930) depicts a figure attempting to escape from enmeshed individuals. *What the Saint Heard and Saw* (1930) appears to illustrate the voices heard and visions seen by the artist's mentally ill brother.

A series of Brooks's drawings were exhibited at the Arts Club of Chicago in January 1935. Brooks traveled to America for the show and in 1936 rented a studio in Carnegie Hall, New York City, where she executed a portrait of the bisexual novelist and photographer *Carl Van Vechten* (1880–1964). A portrait of the internationally known society hostess, lecturer, and writer *Muriel Draper* (b. 1886) followed two years later.

In 1939, as World War II began in Europe, Brooks returned to France to live with Barney in Villa Beauvallon. When the house burned in 1940, Brooks retreated to Italy, where she purchased Villa Sant'Agnes outside Florence. She wrote another unpublished memoir about these years entitled *A War Interlude, or On the Hills of Florence during the War*.

After World War II, Brooks faded from public life. Her artistic output ceased and she lived in isolation. She purchased the smaller Villa Gaia in Fiesole, where she remained until 1967. Amazingly, Brooks took up her brush again at the age of eighty-seven to paint a portrait of Umberto Strozzi (1961), a descendant of the famous Renaissance family.

In 1967, Brooks took a studio apartment in Nice. Within two years, Natalie Barney confessed that she had had an affair with another woman for the past seven years. This confession devastated Brooks, who could no longer cope with the hurt and jealousy she felt toward Barney, so she ended their long relationship.

Having grown increasingly eccentric while living in isolation, Brooks died alone at the age of ninety-six on December 7, 1970. Natalie Barney died two years later in Paris, having also reached the age of ninety-six.

Brooks's artistic legacy was honored with a retrospective exhibition entitled Romaine Brooks, Thief of Souls in 1971 at the National Collection of Fine Arts (now the National Museum of American Art). She had given her collection and private papers to the museum before her death. The same exhibition traveled again in 1980 under the title Romaine Brooks, 1874–1970. Individual works by Romaine Brooks were also included in numerous group exhibitions as art began to be studied through a feminist lens in the 1980s.

Most recently, in 2001, the National Museum of Women in the Arts in Washington, D.C., devoted a one-woman exhibition to Brooks's work entitled Amazons in the Drawing Room. It was the first time that a museum publication examined Brooks's lesbianism in relation to her art. At last, scholars are willing to see what Brooks made visible in life-sized paintings as long ago as the turn of the last century.

— *Ray Anne Lockard*

BIBLIOGRAPHY

Breeskin, Adelyn Dohme. *Romaine Brooks*. 2nd ed. Washington, D.C.: Distributed for the National Museum of American Art by the Smithsonian Institution Press, 1986.

Chadwyck, Whitney. *Amazons in the Drawing Room*. Essay by Joe Lucchesi. [Exhibition: June 29–September 24, 2000, National Museum of Women in the Arts; October 11, 2000–January 21, 2001, Berkeley Art Museum/Pacific Film Archive, University of California at Berkeley.] Chesterfield, MA: Chameleon Books; Berkeley: University of California Press, 2000.

Elliott, Bridget. "Performing the Picture or Painting the Other: Romaine Brooks, Gluck and the Question of Decadence in 1923." *Women Artists and Modernism*. Katie Deepwell, ed. New York: Manchester University Press, 1998. 70–82.

Langer, Cassandra. "Transgressing Le droit du seigneur: The Lesbian Feminist Defining Herself in Art History." *New Feminist Criticism: Art-Identity-Action*. Joanna Frueh, Cassandra Langer, and Arlene Raven, eds. New York: HarperCollins, 1994. 306–326.

Lucchesi, Joseph Edward "'The Dandy in Me': Romaine Brooks's 1923 Portraits." *Dandies: Fashion and Finesse in Art and Culture*. Susan Fillin-Yeh, ed. New York: New York University Press, 2001. 153–184.

Secrest, Meryle. *Between Me and Life: A Biography of Romaine Brooks*. New York: Doubleday, 1974; London: Macdonald and Jane's, 1976.

Werner, Françoise. *Romaine Brooks*. Paris: Plon, 1994.

SEE ALSO

American Art: Lesbian, 1900–1969; Photography: Lesbian, Pre-Stonewall; Erotic and Pornographic Art: Lesbian; Photography: Lesbian, Post-Stonewall; Gluck (Hannah Gluckenstein); Gray, Eileen; Parsons, Betty; Subjects of the Visual Arts: Nude Females

Cadmus, Paul

(1904–1999)

AMERICAN PAINTER PAUL CADMUS IS BEST KNOWN FOR the satiric innocence of his frequently censored paintings of burly men in skintight clothes and curvaceous women in provocative poses, but he also created works that celebrate same-sex domesticity.

Born in New York City on December 17, 1904, into a family of commercial artists, Cadmus studied at the National Academy of Design and the Art Students League. He lived in Europe from 1931 to 1933, where he traveled with artist Jared French and where he produced his first mature canvases.

In the 1930s, Cadmus became the center of a circle of gay men who were prominent within the arts in New York City. This circle included his brother-in-law, Lincoln Kirstein, who helped found the American School of Ballet, and the photographer George Platt Lynes, for whom Cadmus frequently modeled.

Along with fellow painters Bernard Perlin, Jared French, and George Tooker, Cadmus became known as a "Magical Realist," though none of the artists truly accepted the term.

In the early 1930s, Cadmus worked for the Public Works of Art Project, which was later incorporated into the WPA. This experience was to help shape his style for the rest of his long career. Nearly illustrative, his paintings remained linked to a realist style found in many WPA works of the 1930s.

During the 1930s, Cadmus used caricature, satire, and innuendo to veil the homoeroticism of his subjects,

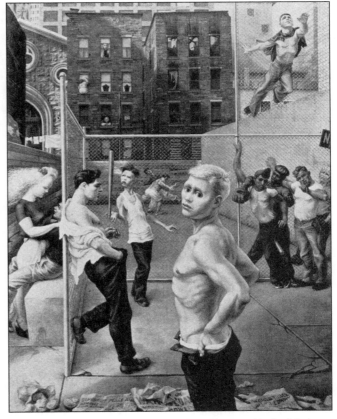

Playground by Paul Cadmus.

which radically pushed at the boundaries of acceptability. Cadmus's 1933 painting *The Fleet's In!* was selected by the WPA for inclusion in a show of the PWAP art at the Corcoran Gallery of Art in Washington, and in 1934 it placed him at the center of a public controversy.

Like many of his early works, the painting is ostensibly heterosexual in its depiction of sailors flirting with young women, who may be prostitutes, but it nevertheless manages to suggest a homosexual exchange between a well-dressed civilian, who sports a red tie, a widely recognized signal of homosexuality from the turn of the twentieth century, and a sailor to whom he offers a cigarette.

The painting's homoerotic subtext led to its removal after the opening of the exhibition. Frequently cited as one of the earliest incidents of government censorship, the removal of the painting was almost certainly motivated by homophobia.

The navy maintains that based on public outcry the Secretary of the Navy, Claude A. Swanson, ordered Assistant Secretary of the Navy Henry Latrobe Roosevelt to exclude the painting from the show.

However, several Cadmus biographers maintain that the picture was removed by Roosevelt on his own behest. Given his relationship to President Roosevelt, the answer may never be known. In 1935 or 1936, after the controversy had subsided, Assistant Secretary Roosevelt sent the painting to the Alibi Club in Washington, D. C., where it remained until the early 1980s.

Cadmus's painting *Coney Island* (1935) also became the subject of controversy. Its portrayal of local residents engaged in provocative (heterosexual) antics enraged Brooklyn realtors, who threatened to file a civil suit against the Whitney Museum of American Art.

Similarly, his commission for the Port Washington post office was also scandalous and was cancelled: The mural he produced, *Pocahontas and John Smith* (1938), so emphasizes the buttocks and genitals of the Native Americans that it obscures the subject, which is the rescue of John Smith.

As a result of Cadmus's notoriety, his 1937 exhibition at Midtown Galleries in New York attracted more than 7,000 visitors.

Other early works of particular interest for their homoeroticism are *YMCA. Locker Room* (1933), *Shore Leave* (1933), and *Greenwich Village Cafeteria* (1934). Like *The Fleet's In!*, these works also document homosexual cruising and seduction.

In Cadmus's paintings, significant exchanges of glances signal sexual longing and availability, often in the very midst of mundane activities. His work documents the surreptitious cruising rituals of an urban, gay male subculture in the 1930s.

A portrait of Paul Cadmus by Carl van Vechten.

Cadmus's painting *What I Believe* (1947–1948) was inspired by E.M. Forster's essay of the same name, in which the novelist expresses his faith in personal relations and his concept of a spiritual aristocracy "of the sensitive, the considerate, and the plucky. Its members are to be found in all nations and classes, and all through the ages, and there is a secret understanding between them when they meet. They represent the true human condition, the one permanent victory of our queer race over cruelty and chaos."

Cadmus's allegorical painting, which depicts such figures as Forster and Christopher Isherwood in Socratic poses, makes clear his intellectual allegiance to the humanism that Forster depicted as gravely threatened by fascism, as well as his own membership in the Forsterian aristocracy.

Cadmus's later works include a series of paintings inspired by Italian Renaissance masters. In these canvases, such as *The Shower* (1943) and *Night in Bologna* (1958), the artist illustrates the polymorphous nature of desire.

In still other later works, such as *The Bath* (1951) and *The Haircut* (1986), Cadmus explores the joys of his

long-term relationship with his partner and model, Jon Andersson. These paintings are particularly touching in their illustration of an entirely ordinary but rarely depicted subject: the domesticity of a same-sex couple.

Although the "Magical Realism" with which Cadmus was identified fell out of favor in the 1950s and Cadmus's reputation went into decline, near the end of his life there was a renewed interest in his work, sparked at least in part by the success of the gay and lesbian liberation movement, as well as by a resurgence of interest in representational art.

The revival of interest in Cadmus was given impetus by the first edition of Lincoln Kirstein's illustrated biography of the artist in 1984. In 1985, Cadmus's life and career was the subject of a PBS documentary, "Paul Cadmus, Enfant Terrible at 80."

In 1989, *The Drawings of Paul Cadmus*, with an introduction by Guy Davenport, was published. In 1996, Cadmus had two exhibitions in New York, one at the Whitney Museum of American Art and the other at D.C. Moore Gallery.

Although he stopped painting toward the end of his life, Cadmus continued to draw at his home in Weston, Connecticut, particularly portraits and figure studies of Andersson, his favorite model and companion of thirty-five years.

Cadmus died on December 12, 1999, five days shy of his 95th birthday.

— *Ken Gonzales-Day*

BIBLIOGRAPHY

Cadmus, Paul, Margaret French, and Jared French. *Collaboration: The Photographs of Paul Cadmus, Margaret French, and Jared French.* Santa Fe: Twelve Trees Press, 1992.

Glueck, Grace. "Paul Cadmus, A Mapplethorpe for His Time." *The New York Times on the Web* (June 7, 1996).

Leddick, David. *Intimate Companions: A Triography of George Platt Lynes, Paul Cadmus, Lincoln Kirstein, and Their Circle.* New York: St. Martin's Press, 2000.

Weinberg, Jonathan. *Speaking for Vice: Homosexuality in the Art of Charles Demuth, Marsden Hartley, and the First American Avant-Garde.* New Haven: Yale University Press, 1993.

SEE ALSO

American Art: Gay Male, 1900–1969; Censorship in the Arts; Photography: Gay Male, Pre-Stonewall; Erotic and Pornographic Art: Gay Male; Contemporary Art; Angus, Patrick; French, Jared; Lynes, George Platt; Subjects of the Visual Arts: Bathing Scenes; Subjects of the Visual Arts: David and Jonathan; Subjects of the Visual Arts: Nude Males; Subjects of the Visual Arts: Prostitution; Subjects of the Visual Arts: Sailors and Soldiers

Cahun, Claude (1894–1954)

PHOTOGRAPHER, PHOTO COLLAGIST, WRITER, AND translator Claude Cahun is known today primarily for creating images, including self-portraits, that play with concepts of gender.

Cahun was born Lucy Renée Mathilde Schwob on October 25, 1894, in Nantes, France, into a prominent French Jewish literary family. She studied at Oxford (1907–1908) and the Sorbonne (1914).

Intensely literary, Cahun wrote about Oscar Wilde and in 1929 translated into French the writing of sexologist Havelock Ellis. Ellis entertained the theory of homosexuals as a third sex, neither masculine nor feminine, but uniting characteristics of both. This theory has been thought by some to have influenced Cahun's photographic imagemaking.

When Cahun was twelve, her divorced father married a woman whose daughter, Suzanne Malherbe, would become Cahun's lover, cocreator, and lifelong companion. They lived in Paris during the 1920s and most of the 1930s.

Cahun wrote for a number of publications including *L'Amitié*, a homosexual review magazine. Her feminism can be seen in a 1925 manuscript (not published until 1999) entitled "Heroines" in which she writes of Sappho, of Ulysses as a cuckold, and of Cinderella's prince as a foot fetishist.

Cahun was independently wealthy and never had to seek employment. Hence, she was able to pursue her photography independent of economic considerations.

Cahun photographed, among others, Sylvia Beach, prominent lesbian expatriate and owner of the English-language Paris bookstore Shakespeare and Company. She also produced self-portraits from 1912 until her death in 1954, many playing with, bending, or distorting gender and sometimes race. Her images were printed scrapbook size and circulated among friends. Most were not exhibited in her lifetime.

In some of her self-portraits Cahun appears as a man, in others as an androgyne, as Buddha, as a figure with shaved head, and sometimes in a dress and wig. In one she sleeps on a shelf in a cupboard. Cahun was active in avant-garde theater and some of her self-portraits show her in roles she played. Later, she recycled her self-portraits into collages.

Collaborating with Malherbe (who used the pseudonym Marcel Moore), Cahun created *Aveux non avenus* (sometimes translated as *Canceled Confessions*): meditations, aphorisms, personal philosophical ideas, and collaged images published as a book under the imprint of Editions du Carrefour in Paris in 1930.

In the late 1930s, Cahun was active in the Surrealist movement, published in Surrealist journals, and contributed

sculptural-objects to Surrealist exhibitions. Her photographs also illustrated Lise Deharme's poems for children in *Le Coeur de pic* (*The Pick-Axe Heart*, 1937).

Cahun and Malherbe moved to the British Isle of Jersey in 1937. The Germans occupied the island in 1940, and the couple, who had worked with anti-fascist political groups in the period between the world wars, practiced covert forms of resistance.

In 1944, the Gestapo raided their home, finding and destroying nude self-portraits and erotic photographs that Cahun had made of herself with Malherbe. They were sentenced to death. However, in February 1945, they were rescued by Allied forces. Cahun remained on the Isle of Jersey until her death on December 8, 1954.

Cahun's work was rediscovered in the 1990s, when it gained immediate popularity because of its relevance to current discussions about the fluidity of gender and the construction of identity.

— *Tee A. Corinne*

BIBLIOGRAPHY

Kline, Katy. "In or Out of the Picture: Claude Cahun and Cindy Sherman." *Mirror Images: Women, Surrealism, and Self-Representation.* Whitney Chadwick, ed. Cambridge, Mass.: MIT Press, 1998. 66–81.

Krauss, Rosalind. *Bachelors.* Cambridge, Mass.: MIT Press, 1999.

Leperlier, François. *Claude Cahun: l'écart et la métamorphose.* Paris: Jean-Michel Place, 1992.

Lichtenstein, Therese. "A Mutable Mirror: Claude Cahun." *Artforum* 30.8 (1992): 64–67.

Rice, Shelley, ed. *Inverted Odysseys: Claude Cahun, Maya Deren, Cindy Sherman.* Cambridge, Mass.: MIT Press, 1999.

SEE ALSO

Photography: Lesbian, Pre-Stonewall; European Art: Twentieth Century; Surrealism; Subjects of the Visual Arts: Nude Females

Canadian Art

VERY FEW SCHOLARS HAVE DEVOTED THEIR ATTENTION to the subject of homosexuality in historical Canadian art, but scholarship on the contemporary period is somewhat fuller. The term "Canadian Art" embraces a conglomeration of heterogeneous styles and subject matters, reflecting the foundation of Canada by First Nations people, French and English colonizers, and numerous immigrant populations. The majority of art produced from the early seventeenth to the twentieth century relies heavily upon imported or traditional means of representation.

Since the rise of the homosexual emancipation movement three decades ago, a handful of Canadian artists have confronted issues of gay and lesbian sexuality in their work. In matters of law—often considered to hold substantial authority over the representation of desire—Canada is liberal in its conception of what is permissible between two consenting adults.

The promulgation of the federal omnibus bill C-150, which passed into law in August 1969, effectively decriminalized most homosexual relations between consenting adults in private. Currently, many provincial statutes protect against discrimination on the basis of sexual orientation; and, as a result of recent rulings by the Supreme Court of Canada, the rights of same-sex couples are also legally recognized.

Historical Canadian Art

The earliest artistic representations created by European settlers were either anthropological sketches, documenting existing populations and natural features of the land, as in cartography, or, especially in New France, religious art for the decoration of churches and related structures.

Until well into the nineteenth century, the two main patrons of the arts were the Church and the few wealthy and ruling families. Many artists, such as Cornelius Krieghoff (1815–1872), were itinerant, accepting commissions for portraits, but often relying upon the sale of scenic pictures for daily sustenance. The effect of sexual identity on the work of these early artists is almost impossible to assess.

It is not until the second half of the nineteenth century, with the founding of art leagues and schools and a National Gallery (1866), that a committed cultivation of the arts in Canada appeared.

An undeniably homoerotic body of work to emerge from this period is by the sculptor Robert Tait McKenzie (1867–1938), a doctor and early defender of physical education. McKenzie's bronze statue *The Sprinter* (1902) reveals the sculptor's accurate observations of the athletic male form and his fine handling of his medium, even as it also recalls the ancient classical world's love and admiration for the physically robust male figure.

While artists such as McKenzie achieved refined works in the context of academic institutions located principally in North America, artists such as James Wilson Morrice (1865–1924) sought an artistic training based on worldly experience and travel. From 1890 until the beginning of the Great War, Morrice trained and worked in Paris.

While details regarding his sexuality remain sketchy, it may be significant that he was acquainted with such homosexual or bisexual figures as Oscar Wilde, Aubrey Beardsley, and Roger Fry. He maintained close friendships with Maurice Brazil Prendergast (1854–1928) and Charles Condor (1868–1909).

In the majority of his panel paintings, executed in a Postimpressionist and Symbolist style, Morrice tends to

distance himself from the various outdoor genre scenes he executes and he imbues his figures with a certain anonymity and melancholia. This sense of separation and detachment may be interpreted as a means of concealing certain sentiments from public knowledge, even as it also raises questions about why the artist is so detached and melancholy.

Morrice's delicately executed pictures contrast sharply with the monumental works of Florence Wyle (1881–1968) and Frances Loring (1887–1968). The two women met in 1905 at the Art Institute of Chicago. They later shared a studio in New York from 1909 to 1912. In the following year they reunited and settled in Toronto, living and working together for the next fifty-five years.

Honoring women workers of World War I in an unsentimental way, Loring's *Girls with a Rail* (1919) has been interpreted as an attack on conventional models of femininity. This particular sculpture may be contrasted with Wyle's delicate *Study of a Girl* (1931). Whereas Loring's statue represents women as unidealized, with pronounced musculature, Wyle's study of a nude female depicts femininity more traditionally.

Another artist to be mentioned during this period is the portraitist and genre painter Florence Carlyle (1864–1923), who in 1890 traveled to Paris for artistic training. In the summer of 1911, she met Judith Hastings, and together they formed a "Romantic Friendship." Although Carlyle's painting is rather academic, she did not shy away from depicting the women close to her. Particularly interesting is *The Threshold* (1913), which depicts a woman standing in an interior dressed in a wedding gown and is thought to represent Hastings.

Post–World War II Canada

The period after World War II is often demarcated in gay history by major campaigns of persecution against gays and lesbians. Research by Gary Kinsman shows that Canada was not immune to witch-hunts by law enforcement agencies, which considered homosexuality and homosexuals in the civil service to be a threat to national security. During the 1950s and 1960s many Canadian public service and military personnel were systematically purged from their positions.

Nonetheless, the 1950s and 1960s saw the rise of a particularly "gay" representational mode in the form of physique and bodybuilding magazines. Of note is the Montreal-born gay photographer Alan B. Stone (1928–1992). Under the pseudonym "Marc Deauville," Stone created a variety of "beefcake" images, including depictions of rugged sportsmen and fine studies of the male torso.

While photography and the development of video would eventually have important reverberations for later art movements, nonreferential painting during the 1950s and 1960s reigned supreme. The terms of that practice, however, considered the inclusion of personal subject matter, such as homosexuality, anathema.

The reaction against nonrepresentational painting mounted slowly and came to fruition in the late 1960s and 1970s. Formed in 1968 by A.A. Bronson (b. 1946), Felix Partz (1945–1994), and Jorge Zontal (1944–1994), the collective known as General Idea approached art from a conceptualist point of view, as seen in their use of film, video, performance, and installation art. Their campy *Miss General Idea* project (1970–1978), which asked invited participants to vie for the pageant's title, questioned the nature of such popular cultural events.

Other artists whose careers began in the 1970s include the video artist Colin Campbell (b. 1942) and the photographer Evergon (b. 1946), whose work deals with issues of sexuality as well as of social and cultural identity.

The late 1970s and early 1980s witnessed a flourishing of multimedia artists who focused on issues of homosexuality, including Paul Wong (b. 1954), Richard Fung (b. 1954), Mike Hoolboom (b. 1958), and John Greyson (b. 1960). Both the painter Pierre Dorion (b. 1959) and the installation artist Micah Lexier (b. 1960) also deserve recognition in this context.

As the 1980s wore on, and as the full impact of the AIDS crisis was felt in the arts community, many artists throughout Canada confronted the subject directly. General Idea, for example, may be known best for their *AIDS Project* (1987–1991), a critical response to society's apathy toward the disease.

Other artists to approach and politicize issues related to AIDS are Andy Fabo (b. 1953) and Stephan Andrews (b. 1956). Further, a number of art institutions in Canada have participated in the AIDS awareness project Day Without Art.

Not all gay artists who matured in the 1980s focused on AIDS, however. The painter Attila Richard Lukacs (b. 1962) and the videographer Bruce LaBruce (b. 1964) are the most notable exceptions. Their often-controversial work forms a substantial attack against the conservative mores held by many members of the gay male community. In their depictions of skinheads, for example, they present unconventional and sometimes disturbing images of same-sex desire.

The 1970s and 1980s were crucial for lesbian artists in Canada, as well. Whether individually or as a group, the Vancouver collective Kiss & Tell, consisting of Persimmon Blackbridge (b. 1951), Susan Stewart (b. 1952), and Lizard Jones (b. 1961), produced photo-based and multimedia performance art that questioned the nature of lesbian representation.

Other lesbian artists to work with photography include Cyndra MacDowall (b. 1953), Nina Levitt

(b. 1955), and Shonagh Adelman (b. 1961). A fifteen-year collaborative enterprise (formed in 1981) between Martha Fleming (b. 1958) and Lyne Lapointe (b. 1957), actualized many site-specific installations, revolving around notions of memory and architecture.

Although Canada may have progressive laws regarding sexual orientation, many gay and lesbian establishments in major urban centers have nevertheless been subject to police harassment. Seizures of art and books alleged to be pornographic—often simply because of their gay or lesbian content—by Canada Customs has also been used as a means to harass the gay and lesbian community.

In addition, the reception of gay and lesbian art has sometimes been impeded by an exceptionally conservative art community. The work of such artists as Paul Wong, Evergon, and Marc Paradis has sometimes been censored or greeted with derision as a result of its same-sex eroticism. In an unfortunate case, the painter Eli Langer was even charged with creating obscene materials, though the case against him was eventually dropped.

Still, the possibility of controversy has not prevented galleries, including artist-run centers such as A Space and Mercer Union in Toronto, from displaying art dealing with gay or lesbian subject matter. Also located in Toronto is the O'Connor Gallery, established in 1995, which hosts an exclusively gay and lesbian roster of lesser-known artists.

Finally, a number of exhibitions devoted exclusively to gay or lesbian themes have been held across Canada, including Sight Specific: Lesbians and Representation (A Space, Toronto, 1988), Homogenius (Mercer Union, Toronto, 1989), 100 Years of Homosexuality (The Photographers Gallery, Saskatoon, 1992), and Queer Looking, Queer Acting (Mount Saint Vincent University Art Gallery, Halifax, 1997). — *Eugenio Filice*

BIBLIOGRAPHY

Boyanoski, Christine. *Loring and Wyle: Sculptors' Legacy*. Toronto: Art Gallery of Ontario, 1987.

Buchanan, Donald. *James Wilson Morrice*. Toronto: The Ryerson Press, 1936.

Fleming, Martha. *Studiolo: The Collaborative Work of Martha Fleming & Lyne Lapointe*. Montreal and Windsor: Artexte Editions and Art Gallery of Windsor, 1992.

General Idea. *Fin de siècle*. Toronto: Power Plant Gallery, 1992.

Gonick, Noam. *Ride, Queer, Ride! Bruce LaBruce*. Winnipeg: Plug-In Gallery, n.d.

Hanna, Martha. *Evergon 1971–1987*. Ottawa: Canadian Museum of Contemporary Photography, 1988.

Johnson, Lorraine, ed. *Suggestive Poses: Artists and Critics Respond to Censorship*. Toronto: Toronto Photographers Workshop and Riverbank Press, 1997.

Kinsman, Gary. *The Regulation of Desire: Sexuality in Canada*. Montreal: Black Rose Books, 1987.

Klusacek, Allan, and Ken Morrison, eds. *A Leap in the Dark: AIDS, Art & Contemporary Cultures*. Montreal: Véhicule Press, 1992.

Lee, Robert. "AIDS, Art and Activism in Canada: Contextualizing the Work of Steven Andrews and Andy Fabo." M.A. thesis, Concordia University, 1995.

Leiss McKellar, Elisabeth. "Out of Order: Florence Carlyle and the Challenge of Identity." M.A. thesis, University of Western Ontario, 1995.

Metcalfe, Robin. *Queer Looking, Queer Acting*. Halifax: Mount Saint Vincent University Art Gallery, 1997.

Miller, James. *Fluid Exchanges: Artists and Critics in the AIDS Crisis*. Toronto: University of Toronto Press, 1992.

Reid, Dennis. *A Concise History of Canadian Painting*. 2nd ed. Toronto: Oxford University Press, 1988.

Reinke, Steve, and Tom Taylor, eds. *Lux: A Decade of Artists' Film and Video*. Toronto: YYZ Books/Pleasure Dome, 2000.

Townsend, Doug, curator. *100 Years of Homosexuality*. Saskatoon: The Photographers Gallery, 1992.

SEE ALSO

AIDS Activism in the Arts; Beardsley, Aubrey; Censorship in the Arts; Lukacs, Attila Richard; Photography: Gay Male, Pre-Stonewall; Photography: Gay Male, Post-Stonewall; Photography: Lesbian, Pre-Stonewall; Photography: Lesbian, Post-Stonewall; Symbolists; Video Art

Caravaggio *(1571–1610)*

ALTHOUGH NO CONCLUSIVE EVIDENCE OF CARAVAGGIO's sexuality has survived, derogatory accusations made by contemporaries, coupled with the aggressive representation of male eroticism in his paintings, suggest that the most original painter of early-seventeenth-century Europe was actively bisexual, if not primarily homosexual.

A poet of dramatic stimulation, Caravaggio was fascinated by the intrusion of the divine into the mundane world; in canvas after canvas he used shifting planes of light and dark to fashion a moment of spiritual *anagnorisis*, that moment of perception that precipitates the reversal of the action in Greek drama.

The divine, however, can manifest itself erotically for Caravaggio, whose earliest paintings (insofar as his paintings can be dated) depict in the most quotidian scenes male youths whose curls, musculature, and luminescent skin tones made Caravaggio the wonder of his age.

Most significantly, in Caravaggio's works the erotic is invariably a part of the scene even when the subject is spiritual intrusion. His religious scenes are often framed in terms of homosexual opposition or homoerotic comfort. Caravaggio, like his English contemporary John Donne, is a poet of erotic spirituality, but, unlike Donne's, Caravaggio's spirituality is invariably homoerotic.

Life

Born Michelangelo Merisi in 1571, but better known to posterity by the name of the town outside Milan where his family owned property, Caravaggio apprenticed with Simone Peterzano before moving to Rome, where he found work in the studio of Cavalier d'Arpino.

The artist's early works won him the support of Cardinal Francesco del Monte, one of the period's most influential arbiters of taste, and a patron who seemed especially appreciative of—or whose own tastes encouraged—the homoerotic elements of Caravaggio's style. Caravaggio's other patrons were as much fascinated by his realism as they were offended by his refusal to idealize his religious subjects.

The artist quickly became the most important—and controversial—painter in Counter-Reformation Rome. His personal life proved as unorthodox as his work. His involvement in a series of street fights and legal wrangles culminated in a brawl during which he killed a man.

He was forced to flee to Genoa, then Naples, and eventually seek refuge on the island of Malta. There he was inducted into the politically powerful Order of the Knights of Saint John of Jerusalem, which protected him until a scandal, possibly involving a sexual liaison with a nobly born male page, forced him once again to flee the execution of a legal sentence.

Caravaggio died in 1610 under mysterious circumstances while on a return journey to Rome, possibly the victim of malarial fever, but just as possibly the victim of a Machiavellian revenge plot by the family of the man whom he had killed in Rome several years before, whose forgiveness he may have been duped into thinking he had finally won.

Caravaggio's Realism and Psychological Drama

To the amazement of his contemporaries, Caravaggio delivered on canvas the energy and realism of daily life. In his still lifes (a genre that Caravaggio is credited with inaugurating), one can see the spots and bruises on each piece of fruit.

His representations of saints, and even of the Holy Family, reject the conventional use of clouds and putti to mark a sacred scene, but instead depict everyday figures in the most common settings rather than the static, idealized figures mandated by Counter-Reformation church edicts.

Thus, in *The Madonna of Loretto*, Caravaggio ignores the famous house that legend holds was miraculously delivered by angels to the Italian city, and focuses instead upon the Virgin and Child standing in a shadowed doorway to greet two pilgrims with dirty feet and gnarled fingers. No space divides the divine figures from the coarse yet spiritually earnest pilgrims who crowd the scene with them, suggesting the immediacy and accessibility of the divine in common life.

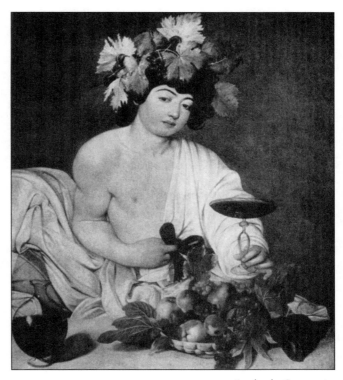

Bacchus by Caravaggio.

Likewise, when commissioned to paint *The Seven Acts of Mercy*, which were traditionally depicted separately in images of noble self-sacrifice, Caravaggio painted a single crowded street scene in which realistic persons can be singled out behaving charitably under the oppressive circumstances of daily life.

Again and again Caravaggio brought religion to life. He refused to promote idealized behaviors beyond the reach of the average person. Instead, he produced church paintings with which the multitudes could identify.

Caravaggio's brand of realism was extended by his experiments with light and darkness to represent psychological drama: the moment in a card game when sharpsters cheat, the slyness of a gypsy fortune teller stealing the ring of the young man whose palm she reads, or the surprise and pain on the face of a boy being bitten by a lizard.

In *The Calling of Saint Matthew*, Jesus is almost obscured in the bustle of the tax gatherer's quotidian existence, suggesting how difficult it is for anyone to hear the word of God.

The hindquarters of the horse from which the saint has fallen dominate the tableau of *The Conversion of Saint Paul*, forcing the viewer to make sense of the convoluted and confusing scene, even as the blinded disciple is depicted as straining to understand the immensity of what is happening to him.

The psychological realism matches the physical drama of *Judith Beheading Holofernes*, in which the determined

crone who glowers over the straining girl's shoulder, ready to wrap the severed head in a bag, appears as much to be a hard-working, emotionally hardened servant as an implacable, avenging Fate.

Caravaggio's Sexual Energy

Most disturbing to many of Caravaggio's viewers is the sexual, primarily homoerotic, energy that radiates from his canvases. The adolescent males whose tight musculature and radiant skin tones are so lovingly rendered in his paintings bespeak Caravaggio's fascination with the *ragazzi di vita*—those adolescent street boys, none of them handsome in the classical sense, who radiate a sexual energy that Caravaggio takes to be the very energy of life.

Unlike Pier Paolo Pasolini's later reworking of the type, there is nothing ominous attached to the viewer's engagement with Caravaggio's boys, who transgress—not through danger—but through unbridled sensual joy.

Victorious Amor, for example, depicts full-frontally a nude prepubescent boy who rises from his couch to gaze directly at the viewer, engaging him in sexual exuberance and maybe even mischief. The picture offers such a powerful homoerotic invitation that its initial owner kept it secured behind a green velvet drapery in his gallery, drawing the curtain only for select viewers.

Homoerotic celebration and homosexual tension dominate Caravaggio's religious scenes as well. In Caravaggio's several representations of St. John the Baptist in the wilderness, for example, the figure is invariably a naked, postpubescent boy who gazes directly at the viewer, engaging him in a way that is anything but ascetic.

Similarly, the rapture depicted in *The Ecstasy of Saint Francis* is as much sexual as it is spiritual, the saint (to whom Caravaggio gave the features of his patron, the pleasure-loving Cardinal del Monte, a reputed pederast) reclining in the arms of a nearly naked teenaged male angel.

Conversely, *The Sacrifice of Isaac* is rendered from such an angle that the boy, forcibly bent over a stone altar by a knife-wielding patriarch and crying out in fear and pain, appears more the victim of homosexual rape than the willing victim that, as a type of the self-sacrificing Christ, he was traditionally represented as being.

Finally, in the most famous of his several variations on the theme of *David with the Head of Goliath*, Caravaggio painted his assistant and probable lover, Francesco Boneri, as David and himself as the decapitated giant, making the painting a somber meditation upon a deeply personal frustration.

Caravaggio's Sexuality

The painter's sexuality remains a contested issue in portions of Caravaggio criticism. Creighton Gilbert, for example, argues that all of the supposedly homoerotic traits of Caravaggio's paintings can be explained by inherited traditions. And biographer Helen Langdon expresses difficulty accepting the tradition that Caravaggio slept with Boneri, the servant boy who modeled for *Victorious Amor*, when the painter was also reputedly involved with female prostitutes.

Langdon apparently assumes that it was impossible for a man of Caravaggio's passion to be sexually involved with a woman even though primarily involved with other men, or for a man primarily attracted to pubescent and barely postpubescent boys to bond emotionally with an intelligent courtesan. Such arguments are poorly informed about the history and psychology of sexuality.

In the absence of clear biographical evidence concerning Caravaggio's sexuality, the decisive evidence must be his work. The female body is rarely eroticized in Caravaggio's paintings, whereas the male body invariably is. Teenaged boys and young men are represented with luscious curls, vibrant skin tones, and muscular legs and buttocks; their gaze directly engages the (presumably male) viewer.

Caravaggio and Post-Stonewall Gay Culture

Little wonder that post-Stonewall gay popular culture has responded so warmly to Caravaggio's work. An in-your-face male sexuality that refuses to apologize for itself has made paintings such as *Boy with a Basket of Fruit, The Musicians, Bacchus*, and especially *Victorious Amor* increasingly popular in gay design.

In one of the most illuminating examples of historical gay intertextuality, poet Thom Gunn has fashioned several poems as responses to specific Caravaggio paintings. And in his film-meditation upon Caravaggio's life and creative processes (*Caravaggio*, 1986), director Derek Jarman presents the painter as the quintessential gay artist, the cursed poet whose brilliant yet unconventional artistic vision and intense personal life unsettle his contemporaries, making him a source of unease as well as fascination.

When filming Caravaggio's painting *David with the Head of Goliath*, Jarman—in a gesture of gay and artistic identification—placed his own face on the head of the defeated giant, as Caravaggio had earlier placed his own.

— *Raymond-Jean Frontain*

Bibliography

Bersani, Leo, and Ulysse Dutoit. *Caravaggio's Secrets*. Cambridge, Mass.: MIT Press, 1998.

Gilbert, Creighton E. *Caravaggio and His Two Cardinals*. University Park: Pennsylvania State University Press, 1995.

Jarman, Derek. *Derek Jarman's "Caravaggio": The Complete Film Script and Commentaries*. London: Thames and Hudson, 1986.

Hammill, Graham L. "History and the Flesh: Caravaggio's Queer Aesthetic." *Sexuality and Form: Caravaggio, Marlowe, and Bacon*. Chicago: University of Chicago Press, 2000. 63–96.

Langdon, Helen. *Caravaggio: A Life*. London: Chatto and Windus, 1998.

Moir, Alfred. *Caravaggio*. 1982. Reprint, New York: Abrams, 1989.

Posner, Donald. "Caravaggio's Homo-Erotic Early Works." *Art Quarterly* 34 (1971): 301–324.

Puglisi, Catherine. *Caravaggio*. London: Phaidon, 1998.

Robb, Peter. M: *The Man Who Became Caravaggio*. 1998. Reprint, New York: Picador, 2001.

SEE ALSO

European Art: Baroque; Lukacs, Attila Richard; Michelangelo Buonarroti; Subjects of the Visual Arts: David and Jonathan; Subjects of the Visual Arts: Dionysus; Subjects of the Visual Arts: Narcissus; Subjects of the Visual Arts: Nude Males; Subjects of the Visual Arts: Prostitution; Subjects of the Visual Arts: Psyche

Carrington, Dora *(1893–1932)*

DORA DE HOUGHTON CARRINGTON WAS AN ENGLISH painter, designer, and decorative artist whose life and relationships were complex. She is best known for her deep attachment to the homosexual writer Lytton Strachey, but she had affairs with both men and women.

Carrington painted only for her own pleasure, did not sign her works, and rarely exhibited them, hence she was not well known as a painter during her lifetime. Even though she was a founding member of the Omega Workshop with Roger Fry, her decorative art also remained unknown to the public until the late 1960s.

Born in Hereford, England, on March 29, 1893, Dora Carrington was the fourth child of Samuel Carrington and Charlotte Houghton. When Dora was ten years old the family moved to Bedford, where she attended a girls' high school and took extra art classes. Seven years later, in 1910, Dora won a scholarship to the Slade School of Art in London, where she studied with Henry Tonks and Fred Brown until 1914.

During her years at Slade, the artist dropped her first name, becoming known simply as Carrington, and cut her hair into a bowl cut. She was a successful student at the Slade School and was awarded several prizes during her years there.

When Carrington was eighteen, she met Mark Gertler (1897–1939), a fellow artist who had the most influence on her early years. Thus began the first of several complex and tense friendships or love affairs that Carrington was to have during her life. She enjoyed Gertler's friendship and a brief affair, but she rebelled against the prevailing standard that a woman be subservient to a man. Carrington painted Gertler's portrait in 1911.

Through Gertler, Carrington became friends with several members of the Bloomsbury group. She met celebrated writer Lytton Strachey (1880–1932) at one of the Bloomsbury gatherings. They became great friends and, even though Strachey was unabashedly homosexual, vowed to share their lives.

One of Carrington's most famous paintings is the *Portrait of Lytton Strachey* (1916). During 1917, Strachey rented the mill house near Tidmarsh Mill in Panbourne, Berkshire. Carrington shared the lodging with him. The same year, the artist created woodcuts for Leonard and Virginia Woolf's *Two Stories,* published by the Hogarth Press.

Carrington's father died in 1918, leaving her a small inheritance that allowed her to feel more independent. In the same year she met Ralph Partridge, an Oxford friend of her brother Noel, who assisted Leonard Woolf at the Hogarth Press. Both Strachey and Carrington fell in love with the heterosexual Partridge, who accepted the fact that she would never leave Strachey.

Carrington and Partridge married in 1921. They honeymooned in Venice with Strachey, and the three lived together in a *ménage à trois.* The following year Carrington had the first of her two extramarital love affairs with men.

Carrington's first lover was Gerald Brenan, an army officer and friend of Partridge's who was a writer and critic. He had moved to Yegen, Spain, in 1919. Partridge, Carrington, and Strachey visited him there in 1920, after which Carrington developed a lengthy correspondence with him and painted his portrait. They had a brief affair in 1922, and Carrington's oil painting *Mountain Range at Yegen, Andalusia* was painted in 1924.

Carrington's sexual feelings toward women were awakened in 1923 when she met Henrietta Bingham, the daughter of the American Ambassador to the Court of St. James. Carrington actively pursued Henrietta and they became lovers.

Carrington privately began to identify herself as a lesbian. During her brief time with Henrietta, she created a pen-and-ink drawing of her lover, the artist's first erotic drawing of a woman. The relationship was also another *ménage à trois.* Henrietta had been Strachey's lover and was a comrade of Carrington's friend Stephen Tomlin.

The following year, Strachey and Partridge purchased the lease to Ham Spray House near Hungerford in Wiltshire. Carrington, Strachey, and Partridge lived there from 1924 until 1932.

Carrington's role at Ham Spray House was to take care of the domestic chores, care for Strachey, and execute a decorative scheme. Her decision to devote her life to Strachey and to be responsible for household chores is ironic given her early rebellion against traditional roles for women in her day. The decision also robbed her of time for her own art.

During 1925, Carrington met Julia Strachey, Lytton's niece and a novelist who had once been a Parisian model

and an art student at the Slade. Julia, who frequently visited Ham Spray, was married to Stephen Tomlin but briefly became one of Carrington's lovers. The artist painted an oil *Portrait of Julia Strachey* (1925). The artist's more private pencil drawing of Julia illustrated the sexual passion Carrington felt toward her.

The year 1926 marked the beginning of mounting sadness in Carrington's brief life. Partridge had begun to live openly in London with Frances Marshall while spending only weekends at Ham Spray.

In 1928 Carrington met Bernard Penrose, a sailor and Partridge's best friend. She experienced renewed creativity while she was with "Beakus" and her letters from that period are profusely illustrated. Penrose, however, wanted Carrington to make an exclusive commitment to him, a demand Carrington refused because she could not end her relationship with Strachey. The affair, her last one with a man, ended badly when Carrington became pregnant and had an abortion.

Strachey became violently ill in November 1931 with what doctors thought was either typhoid fever or ulcerative colitis. He grew worse by the day, and Carrington, who suffered from depressive episodes, attempted to asphyxiate herself in the garage at Ham Spray the following month, but was rescued by Partridge.

Strachey, who had been Carrington's companion for seventeen years, died at the age of 52 on January 21, 1932. Carrington's depression increased even as friends tried to keep her occupied. Six weeks after Strachey's death she borrowed a gun from a neighbor to shoot rabbits in the garden. She shot herself on March 11, 1932 and died shortly before her 39th birthday.

Dora Carrington painted the people and places she loved the most during her life. Her paintings include *The Mill at Tidmarsh* (1918), a *Portrait of Jane Maria Grant, Lady Strachey* (1920), a *Portrait of Annie Stiles* (1921), as well as the others mentioned previously.

Carrington's decorative arts projects included fireplace tiles, bookplates, and inn signs such as that for the Black Swan (1917). She also made quilts, marbled papers for bookbinding, discovered a new technique for patterning on leather, and even ventured into filmmaking.

Much of Carrington's creative energy went into decorative treatments for her friends as well as at Tidmarsh and Ham Spray. Her last painting was a trompe l'oeil work on the front of her neighbors Brian and Diana Guinness's house in May 1931.

Carrington lacked confidence in her own work and undervalued it. She was a perfectionist whose work never met her expectations. While some people in her life criticized Carrington for spending too much time illustrating her correspondence, the illustrations were themselves an art form, as became apparent when her letters were published in 1970. The people who denigrated her

decorative projects during her lifetime failed to recognize her talent as a designer.

There were no exhibitions of Carrington's work during her lifetime. The first exhibition was held at the Upper Grosvenor Galleries in London in 1970. A second exhibition was held at the Christ Church Picture Gallery, Oxford, in 1978. Curated by Noel, Carrington's brother, it was more comprehensive in coverage and included Carrington's paintings, drawings, and decorative works.

Most recently, there was a retrospective of Carrington's work at the Barbican Art Gallery in London during 1995. Despite the posthumous recognition that she has gained, she remains the most neglected serious painter of her generation.

— *Ray Anne Lockard*

BIBLIOGRAPHY

Blythe, Ronald. *First Friends: Paul and Bunty, John and Christine—and Carrington.* London: Viking Press, 1999.

Bradshaw, Tony. *The Bloomsbury Artists: Prints and Book Design.* Introduction by James Beechey. Foreword by Angelica Garnett. Aldershot: Scolar, 1999.

Carrington, Dora. *Carrington: Letters and Extracts from Her Diaries.* David Garnett, ed. Noel Carrington, biographical note. New York: Oxford University Press, 1979. Rev. ed., London: Thames and Hudson, 1980.

Carrington, Noel. *Carrington: Paintings, Drawings, and Decorations.* Foreword by Sir John Rothenstein. New York: Thames and Hudson, 1980.

Caws, Mary Ann. *Carrington and Lytton: Alone Together.* London: Cecil Woolf, 1996.

——. *Women of Bloomsbury: Virginia, Vanessa and Carrington.* New York: Routledge, 1990.

Gerzina, Gretchen Holbrook. *Carrington: A Life.* New York: Norton, 1989.

Hill, Jane. *The Art of Dora Carrington.* New York: Thames and Hudson, 1994.

SEE ALSO

European Art: Twentieth Century; Salons

Cellini, Benvenuto *(1500–1571)*

SCULPTOR, GOLDSMITH, MEMOIRIST, AND FLAMBOYANT pederast, Benvenuto Cellini is one of the greatest artists in the history of Western art. He was the ultimate—that is to say, the last—Renaissance artist, for the free exploration and celebration of the sensual (particularly the homoeroticism) that inspired his genius and was a hallmark of Renaissance Florentine culture were soon aborted.

Benvenuto Cellini was born in Florence at the peak of the Italian Renaissance. Apprenticed to a goldsmith, he excelled in that art. In fact, he was so successful that he was called upon to fulfill major commissions throughout

Italy and France. Indeed, he traveled so much that until he was forty-five years old, he never lived longer than five years in any one place.

The reasons for his sometimes abrupt departures ranged from political upheavals and plague to outbursts of temperament, including murder. His contemporary Vasari described him as "spirited, proud, vigorous, most resolute, and truly terrible."

At nineteen, Cellini went to Rome, where over the years he worked for Popes Clement VII and Paul III, for whom he made jeweled ornaments, coins, and medallions. In 1536, he traveled to France, where he made the famous saltcellar for King François I and sculpted decorations for the palace at Fontainebleau.

In 1545, Cellini returned to Florence, where he lived the rest of his life. Florence was notorious in the Renaissance as "Sodom City": in German slang, "Florenzer" meant "sodomite." In the late fifteenth century, one in two Florentine men had come to the attention of the authorities on suspicion of sodomy by the time they were thirty.

In 1432, the "Office of the Night" was created to eliminate sodomy, but after seventy years it was disbanded as the task was deemed hopeless. About ninety percent of the cases reported involved boys under the age of eighteen. Sexual activity between men and boys was an integral feature of Florentine culture in the sixteenth century.

Cellini himself was convicted of homosexual sodomy in Florence in 1523 and in 1557. He was prosecuted but absolved of charges of heterosexual sodomy in France.

In Florence, Cellini was supported by his appreciative patron Duke Cosimo I de' Medici. Cosimo's first commission was for a large bronze *Perseus* holding Medusa's severed head. This magnificent nude figure in the Piazza della Signoria is a gay icon for its depiction of a beautiful young man.

Cellini's subsequent works, including the marble statues of *Ganymede and the Eagle, Narcissus,* and *Apollo and Hyacinth,* are particularly appealing to men who love boys. In *Ganymede and the Eagle,* the young Trojan boy lovingly ruffles the neck feathers of his seducer, while in *Apollo and Hyacinth* the mature Apollo ruffles the tousled curls of an expectantly receptive Hyacinth, on his knees at the god's feet.

The homoerotic spirit that nourished Cellini's art was soon to be crushed in Florence. In response to the Protestant Reformation, the Roman Catholic Church at the Council of Trent (1545–1563) adopted policies designed to make the Church even more austere than the Protestants. It also embarked on a campaign to crush heresy.

It established the Index of Prohibited Books and it proscribed carnality in art. In 1559, Pope Paul IV ordered draperies painted on the nudes in Michelangelo's *Last Judgment.* The Council's decrees were enthusiastically enforced through the sadistic power of the Inquisition.

In this context, Cellini was convicted of sexual relations with a young man in 1557 and sentenced to four years in prison. Thanks to the intervention of Duke Cosimo, the sentence was commuted to four years' house arrest.

During his years of house arrest, Cellini attempted to rehabilitate his reputation. Not only did he devote himself to religious art (including a deeply religious marble crucifix), but he also took minor holy orders and fathered a son in 1560 by his servant Piera, whom he married in 1563. They subsequently produced three more children.

Most importantly, however, during his period of house arrest, Cellini began his celebrated *Vita.* In this autobiography, the artist recounts his acquaintanceships with princes and popes and his great achievements as sculptor and goldsmith, while disavowing, with wounded innocence, his reputation as a pederast.

He implies that he is a ladies' man, but cannot resist bragging that once he took his apprentice Diego in drag to a party of artists and their whores. The boy was voted the most beautiful prostitute in Florence, which nearly caused a riot when one of the girls groped Diego and discovered the truth of his sex.

Although the *Vita* attempts to present an appearance of orthodox morality and fails to mention Cellini's gay affairs or his convictions for sodomy, it nevertheless repays interest for its homosexual content. Especially significant in this context is Chapter 71 of Book Two, which may be read as a defense of sodomy, that "noble practice" indulged in by "the greatest emperors and the greatest kings of the world."

Cellini says that he lacks the knowledge or means to meddle in the "noble practice," but he nevertheless commends it as "a marvelous matter." Whether these passages can be taken seriously or in jest is a matter of debate; certainly the context in which he was writing— under house arrest for having had sex with a young man—is an important consideration in interpreting the autobiography.

— *Douglas Blair Turnbaugh*

Bibliography

Cellini, Benvenuto. *The Life of Benvenuto Cellini Written by Himself.* John Addington Symonds, trans. Introduction and illustrations by John Pope Hennessy. London: Phaidon Press, 1949.

Rocke, Michael. *Forbidden Friendships: Homosexuality and Male Culture in Renaissance Florence.* New York: Oxford University Press, 1996.

Saslow, James. *Ganymede in the Renaissance: Homosexuality in Art and Society.* New Haven: Yale University Press, 1986.

See also

European Art: Renaissance; Michelangelo Buonarroti; Subjects of the Visual Arts: Ganymede; Subjects of the Visual Arts: Narcissus

Censorship in the Arts

THROUGHOUT RECORDED HISTORY, GOVERNMENTS, religious authorities, and self-appointed arbiters of morality have attempted to regulate what individuals think and believe, read and write, see and depict. Sexuality of all kinds has been a prime subject of regulation and censorship, and homosexuality, the "crime not to be named among Christians" and "the Love that dare not speak its name," has been particularly so.

Censorship and Its Consequences

The history of censorship in the arts includes such incidents as the placing of fig leaves over the genitalia of Renaissance masterpieces, the confiscation by governmental agencies of artworks such as the homoerotic paintings of D. H. Lawrence, the destruction of "degenerate art" by the Nazis in Hitler-era Germany, the banning of books such as Radclyffe Hall's *The Well of Loneliness* (1928) in England and Allen Ginsberg's *Howl* (1956) in the United States, and the denial of public funds to "promote homosexuality" or public space to exhibit sympathetic depictions of gay male and lesbian art and theater.

It includes both the criminalization of particular sexual images and the introduction of informal codes of censorship, such as the Motion Picture Production Code that restricted positive depictions of homosexuality by Hollywood from the 1930s through the 1960s.

Until 1958, when the United States Supreme Court ruled that the homophile magazine *One* was not "obscene, lewd, lascivious and filthy" simply because it discussed homosexuality, the distribution of work with homosexual content, even when it was not sexually explicit, was dangerous, even in the Western democracies.

Photographic images of nude men and women, whether or not they were engaged in erotic activities, were routinely confiscated and destroyed, and the creators and distributors often prosecuted.

Perhaps even more insidious than the official censorship enforced by governments is the self-censorship performed by gay and lesbian writers and artists themselves as a consequence of a pervasive climate of censorship and homophobia.

Realizing the danger of open homosexual expression, many gay and lesbian artists have in effect placed their artistic imaginations in the closet. They have sometimes destroyed their "private" art out of well-justified fear, and they have frequently made decisions to avoid homosexual subject matter in their art.

Many gay and lesbian artists who have defied the legal and social prohibitions against explicit depictions of sexuality have seen their art censored or suppressed, especially if it deals sympathetically with homosexuality or conveys positive images of glbtq people and culture.

Although censorship is by no means a thing of the past, in general the climate of censorship has lightened since the 1960s. Consequently, there is a great deal of difference in the level of explicitness in gay and lesbian artwork created before the lessening of censorship as a consequence of the (hetero)sexual revolution of the 1960s compared with art that was created afterward.

Pre-Stonewall art (work produced prior to the 1969 Stonewall uprising that inaugurated the more militant phase of the gay rights movement) dealing with homosexual subject matter is typically covert or indirect. Artists were forced to adopt strategies of concealment in order to avoid controversy or possibly even imprisonment. The meaning of their work is often discernible only through a decoding of signs and signals, or by reading the art in terms of the artists' biographies.

Conversely, an overt, even confrontational stance is much more common for post-Stonewall gay and lesbian artists. The imagery they employ is more often explicit and unguarded. They increasingly are likely to create openly homosexual work, just as they increasingly are able to conduct their lives openly.

In many parts of the world, censorship continues to be a major impediment to gay and lesbian artistic expression. In the United States and the Western democracies, however, efforts at censorship have become somewhat more subtle, often centering on questions of the public support for art and on the protection of the innocence of children rather than involving outright bans against the creation or distribution of gay or lesbian art.

It is important to note that sometimes censorship obtains the desired effect: the art is destroyed and the artist is reduced to silence or his or her vision is inhibited. But in other instances censorship backfires, causing an image to attract wider attention than it would ever have attained had it been ignored. Thus, sometimes attempts at censorship only encourage additional subversive art.

Pre-Stonewall Censorship in the Arts

There are some striking examples of the suppression and censorship of pre-Stonewall artists' work with homoerotic content. One involves the painter Charles Demuth (1883–1935), who is perhaps best known for his landscapes of industrial America, featuring bridges, grain silos, factories, and so on. These landscapes earned him a reputation as an important artist.

However, early in his career, Demuth painted a series of watercolors of sailors with their genitals uncovered. He was unable to exhibit these works. He also painted flowers, fruits, and vegetables in a way that suggests

human sexuality without directly portraying it. In 1950, officials of New York's Museum of Modern Art excluded the still life *A Distinguished Air* from a major Demuth retrospective because they considered its sexual theme too controversial.

The work of gay photographer Minor White (1908–1976) is also marked by a similar indirectness. In his work, rocks and cracks in stones often substitute for parts of human bodies. White learned to be cautious with his imagery early in his career when an exhibition of his work was canceled in San Francisco on the ground of "public taste."

One of the most famous incidents of suppression of pre-Stonewall art due to breaches of public morality and taste was the case of Paul Cadmus and his painting *The Fleet's In!* In 1933, Cadmus was hired by the PWAP (the Public Works Art Program, a forerunner to the better-known WPA projects) to produce paintings that dealt with American themes. Cadmus produced *The Fleet's In!*, a painting that depicts drunken sailors on shore leave carousing in New York's Riverside Park with a group of women—some of whom may be men in drag—and at least one flamboyantly effeminate man.

When *The Fleet's In!* appeared in 1934 in an exhibition of federally financed work at the Corcoran Gallery of Art in Washington, D.C., naval officials were outraged, and the painting was immediately pulled from the show. Cadmus expressed surprise at the response, and disavowed any scandalous intent; but the painting was not returned to public view until 1981.

Once out of sight, however, *The Fleet's In!* became sensationally visible. It was reproduced in newspapers and magazines across the country. Consequently, Cadmus became an art star who got considerable mileage out of inviting and evading questions about the homoerotic tenor of his work.

Five years later, in 1939, Cadmus was hesitantly commissioned, under the auspices of the Treasury Section of Fine Arts, to execute a mural for the Parcel Post Building in Richmond, Virginia. His subject—*Pocahontas Saving the Life of Captain John Smith*—seemed relatively safe. However, when a design of the mural was publicly exhibited at Vassar College, controversy erupted.

The fact that one of Pocahontas's breasts was fully exposed met with little concern or unease, but a male warrior's bared buttocks in the center of the mural provoked an outcry of protest, as did the rendering of another warrior with an animal pelt dangling between his legs. Given the way Cadmus had positioned the fox skin, it bore a remarkable resemblance to male genitalia. Government officials ordered Cadmus to paint out the fox's snout, which resembled a penis.

In 1964, Andy Warhol (1928–1987) was commissioned to create a piece for the facade of the New York State pavilion at the World's Fair in Flushing Meadow, New York. The work, *Thirteen Most Wanted Men*, was a mural-size composite of enlarged police mug shots, mainly of young and handsome accused felons. Almost immediately after the work was installed on the pavilion, however, World's Fair officials had the piece painted over and destroyed.

Fair officials said that Warhol had been disappointed with his work and wanted to replace it. Others said that Governor Nelson A. Rockefeller had found the mug shots not in keeping with the fair's "Olympics of Progress" theme. What no one dared mention, including the artist, was the implicit homoeroticism of the work.

By whom were these thirteen handsome men really "most wanted"? On one level, it could be surmised, they were wanted by Warhol himself, whose homosexuality was widely presumed, but who chose not to acknowledge it overtly while he was shaping his art career.

Post-Stonewall Censorship in the Arts

In direct opposition to such pre-Stonewall artists as White, Cadmus, and others, the photographer Robert Mapplethorpe (1946–1989) built a reputation on the explicitly gay content of his work, which came under aggressive political attack during the late 1980s and early 1990s, when it became a rallying cry in the era's "culture wars."

But here, as with Cadmus, censorship brought its own recognition and rewards. When the Corcoran Gallery (the same gallery that had come under attack in 1934 for the Cadmus painting) abruptly canceled a Mapplethorpe show in 1989, the story was widely reported in the media as a scandal, and the artist became a household name.

Mapplethorpe had his first gallery show in 1976; his association with many well-connected art world personalities accelerated his successful career as a "bad boy" in the art world. He quickly became known for his photographs in three classic genres: still lifes, celebrity portraits, and male and female nudes.

A strong current of sexuality runs through much of Mapplethorpe's work (including his still lifes of flowers often anthropomorphized into figures teeming with erotic power), but mortality, the fragility of beauty, and even innocence are also recurring motifs throughout his work.

In early 1989, a retrospective of Mapplethorpe's work was organized by the University of Pennsylvania's Institute of Contemporary Art, which had received $30,000 for the show from the National Endowment for the Arts (NEA). The retrospective, Robert Mapplethorpe: The Perfect Moment, included 150 of Mapplethorpe's images: formal portraiture, flowers, children, and carefully posed, sexually explicit, erotic scenes, some of which were sadomasochistic. The exhibit was scheduled to tour seven cities throughout the United States.

As the show traveled, there were widely disparate responses to the same material. For example, in Philadelphia and Chicago, early in the tour, the show went largely unremarked and generally received positive reviews. In Chicago, the show attracted record-breaking crowds at the city's Museum of Contemporary Art.

By the summer of 1989, however, with the show heading to the Corcoran Gallery of Art in Washington, D.C., outrage over Mapplethorpe's work and the use of federal money to fund the exhibit grew to a fever pitch. Although most of the controversy focused on the gay sexual content of several of the photographs, many conservative leaders and critics also purported to find Mapplethorpe's portraits of black men racist and branded the nude studies of young children (both male and female) child pornography.

The outrage over Mapplethorpe's work was fueled mainly by such conservative politicians as Jesse Helms, Dick Armey, and Alfonse D'Amato. Conservative cultural critic Richard Grenier, writing in the *Washington Times*, labeled Mapplethorpe "the great catamite" and fantasized about dousing the body of the photographer with kerosene and burning it.

But it was columnist Patrick Buchanan who launched the most sustained attack, through a series of virulent syndicated newspaper columns. Declaring a cultural war, Buchanan detected a struggle for the soul of America in the battle over the arts.

Ultimately, a letter signed by over 100 congressmen was sent to the chair of the NEA denouncing the use of federal money to fund the Mapplethorpe exhibit (as well as other federally funded and so-called "obscene" work, such as Andres Serrano's photograph "Piss Christ," which depicts a crucifix submerged in a vat of the artist's own urine; it is important to note, however, that Serrano is not gay and his photograph was denounced for religious, rather than sexual, reasons).

The letter threatened to seek cuts in the agency's $170 million budget that was up for approval, and demanded that the NEA end its sponsorship of "morally reprehensible trash," and provide new grant guidelines that would "clearly pay respect to public standards of taste and decency."

Amid these attacks on the NEA, the director of the Corcoran Gallery announced that it would be unwise for the gallery to go forward with its commitment to host the Mapplethorpe retrospective. The Corcoran's director felt that the appearance of such controversial images could jeopardize the future of the NEA. The Corcoran itself was also vulnerable since it has no endowment of its own and is dependent on federal funds for a significant portion of its yearly budget.

The artistic community, both gay and straight, reacted with outrage. Three days after the cancellation was announced, up to 100 protesters demonstrated outside the gallery. Later that week, close to 1,000 demonstrators viewed slides of Mapplethorpe's work projected on the facade of the Corcoran. Students at Corcoran's school of art demonstrated several times. Several artists also boycotted the gallery, withdrawing from scheduled group and solo shows.

The Mapplethorpe retrospective continued to generate heated debate, and legal action, when it moved to Cincinnati's Contemporary Art Center. Within days of the exhibition's opening, the Center and its director were indicted on charges of pandering, obscenity, and the illegal use of a child in nudity-related material.

The arrest and subsequent trial were a first in the history of American art museums. The director of the Center faced up to one year in jail and a fine of $2,000, and the Center itself could have been fined $10,000. Several months of legal wrangling followed, during which time the exhibit was allowed to remain open. The Center and its director were ultimately acquitted of all charges, but only after a humiliating spectacle.

The NEA was again under attack in 1990, when, after sustained politicking from conservatives in Congress and the media, the government agency revoked federal grants that had been awarded to four performance artists—Karen Finley, John Fleck, Holly Hughes, and Tim Miller. Their individual work involved the body and sexuality, and often included strong language and nudity. All but Karen Finley were gay.

The NEA Four, as they came to be known, protested this suppression of their art, as well as a new "decency clause" enacted by Congress that grantees were required to sign, pledging that their work would not contain, among other subject matter, "homoerotic content," which was labeled as "obscene."

Lawyers from the Center for Constitutional Rights argued the case of the four, who sued the NEA and challenged the constitutionality of the decency clause. They won their case in 1993. However, the Clinton administration appealed the decision, wishing to let the decency clause stand, and moved the case to the Supreme Court, where, in 1998, the NEA Four lost to the government.

The widely publicized cancellation of the Mapplethorpe exhibition and the revocation of grants to the NEA Four are only the best-known recent instances of censorship in the arts. A more comprehensive account would mention the mid-1980s confiscation of gay and lesbian art, including the work of photographer Tee Corinne and the lesbian magazine *Bad Attitude,* by Canadian Customs agents; the 1992 conviction of the owner and manager of Glad Day Bookshop (Toronto) for the possession and sale of "obscenity"; the closing of exhibits of artists such as Patrick Angus and David Wojnarowicz; and numerous other attempts to silence the

voices and cloak the images of gay men and lesbians, often in the guise of protecting children and public morality.

Luckily, however, these attempts often succeed only in generating more interest in the very images the censors would like to destroy.
　　　　　　　　　　　　　　　　　　— *Craig Kaczorowski*

BIBLIOGRAPHY

Dubin, Steven C. *Arresting Images: Impolite Art and Uncivil Actions.* New York: Rutledge, Chapman and Hall, 1992.

Meyer, Richard. *Outlaw Representation: Censorship and Homosexuality in Twentieth-Century American Art.* London: Oxford University Press, 2002.

Wallis, Brian, Marianne Weems, and Philip Yenawine, eds. *Art Matters: How the Culture Wars Changed America.* New York: New York University Press, 1999.

SEE ALSO

Angus, Patrick; Cadmus, Paul; Cooling, Janet; Corinne, Tee; Demuth, Charles; Mapplethorpe, Robert; Warhol, Andy; White, Minor; Wojnarowicz, David

Chicago, Judy　　　　　　　　　　　　　(b. 1939)

JUDY CHICAGO, NÉE COHEN, THE ARDENT FEMINIST painter and sculptor who changed her name to reflect her birthplace, was born into a Jewish family in 1939. She graduated from the University of California, Los Angeles, in 1964 and developed the first feminist art program, the Female Art Class, at Fresno State College in 1970.

In 1971, Chicago cofounded, with painter Miriam Schapiro, the Feminist Art Program at the California Institute of the Arts, Valencia. The program's primary project—to restore a Los Angeles mansion—culminated in the groundbreaking installation *Womanhouse*, in 1972. Her subsequent best-known projects include *The Dinner Party* (1974–1979), *Birth Project* (1980), *PowerPlay* (1983–1986), and *Holocaust Project* (1993).

By going beyond traditional painting techniques and exploring embroidery and ceramics, and by utilizing a workshop of women, Chicago has critiqued Western misogynistic beliefs about the production of art versus craft. She has also sought to create new female-centered themes and imagery by developing what she calls "central core," or vaginal, imagery.

Although she does not identify as a lesbian or a bisexual, Chicago has contributed to gay and lesbian culture through her feminist critique of heterosexuality and patriarchy.

Chicago received wide recognition, praise, and criticism for *The Dinner Party.* Conceived as a method of teaching women's history through art and designed by Chicago as a triangular *Last Supper,* this multimedia piece was executed by hundreds of volunteers who wove and embroidered place settings, sculpted and painted ceramic plates, and created tiles that included the names of historical and mythological women.

The ceramic plates and settings representing women from history clearly evoke vaginal imagery and were criticized by conservatives as pornographic and by feminists as essentialist (that is, defining women's experience as purely biological). The piece, although widely accepted as a significant work of late-twentieth-century art, has been offered to and refused by major art institutions and is in need of conservation.

In *Birth Project*, Chicago continued to work collaboratively with female needleworkers. The series portrays a variety of approaches to birth, from symbolic and mythological themes to physical realities such as pain and lactation. The embroidered pieces mark a shift in Chicago's designs from the abstract to the figurative.

In her next series, *PowerPlay*, Chicago stopped working collaboratively, in part because of criticism that she was not a "real" artist. *PowerPlay* includes drawings and paintings and, instead of focusing on women, explores the construction of masculinity and how this construction has affected the world, including men themselves.

While working on *PowerPlay*, Chicago was also studying the Holocaust; in 1993 she exhibited the *Holocaust Project: From Darkness into Light*, which she had worked on with her husband, photographer Donald Woodman.

This mixed-media project, which includes tapestries, drawings, paintings, and photographs, takes a specifically feminist approach to understanding the Holocaust as the result of a systemic Western, patriarchal, Christian, heterosexual hierarchy of power that sought to destroy the "other"—Jews and homosexuals, in particular.

Two of the panels deal specifically with the persecution of homosexuals: *Pansy Crucifixion*, which subverts the derogative use of the word "pansy" and refers to the contemporary AIDS crisis; and *Lesbian Triangle*, which depicts lesbian culture before World War II, the cruelty of the concentration camps, and women comforting each other.
　　　　　　　　　　　　　　　　　　— *Kelly A. Wacker*

BIBLIOGRAPHY

Chicago, Judy. *Beyond the Flower: the Autobiography of a Feminist Artist.* New York: Viking, 1996.

————. *The Birth Project.* New York: Doubleday, 1985.

————. *The Dinner Party.* New York: Viking, 1996.

————. *Through the Flower: My Struggle as a Woman Artist.* Garden City, N. Y.: Anchor, 1977.

Lippard, Lucy R. "Judy Chicago, talking to Lucy R. Lippard." *Artforum* 13 (September 1974): 60–65.

———. "Uninvited Guests: How Washington Lost 'The Dinner Party.'" *Art in America* 79 (December 1991): 39ff.

Lucie-Smith, Edward. *Judy Chicago: An American Vision.* New York: Watson Guptill, 2000.

Molesworth, Helen. "House Work and Art Work." *October* 92 (Spring 2000): 71–97.

Wylder, Vikki Thompson. *Judy Chicago: Trials and Tributes.* Tallahassee, Fla.: Museum of Fine Arts & Dance, 1999.

SEE ALSO

American Art: Lesbian, Post-Stonewall; Contemporary Art; Subjects of the Visual Arts: Sappho

Classical Art

HOMOEROTIC EXPERIENCE IS REPRESENTED IN CLAS-sical Greek and Roman art in several ways.

Some images of same-sex courtship, pursuit, and sexual intercourse survive, especially on Greek vases. These images invariably focus on the activities and responses of men, and they seem to have been made for male patrons.

There are as well a large number of statues that can be understood in relation to ancient literary texts and inscriptions about same-sex desire and desiring gazes, again, male.

In addition, ancient art offers some interesting representations of transvestism, and it provides images both of androgyny and of the category known as the hermaphrodite.

These bits of evidence, though they all are very different from one another, reveal various aspects of ancient Greek and Roman men's experiences of gender and sexuality at the point where these categories diverge from our own.

For example, as modern viewers, we might expect to find examples that we can be certain show us lesbians or that speak to lesbian desire, but we will not find such unambiguous images.

We might also expect to find representations of the *cinaedus*, that Roman figure attested to in literature as a man who prefers to play the passive role in a homoerotic system that is never admitted to be fully reciprocal; but, again, such images do not exist.

The current debates in the field of classics about whether there was a "gay" subculture in Rome to which some *cinaedi* belonged cannot be resolved so far with the aid of visual or archaeological evidence, for there simply is none. What can be said is that certain categories of people could be talked about by male authors in their writings but were apparently considered out of bounds for depiction in visual form.

Greek Vases

The richest source of evidence both for homoerotic sexual activity and for viewers' apparent desire to look at such activity comes from the vases of the later sixth and fifth century B.C.E. in Athens. At the time, Athens dominated the vase making and exporting market, so their decorated vases are found all over the Mediterranean, and Etruscan buyers in central Italy seem to have bought them in substantial quantities.

The vases show everything from Zeus running along one side of a vase in pursuit of the charming boy Ganymede, who rolls a hoop on the other side (*Berlin Painter*), to a young man fondling the genitals of a smaller and clearly younger boy before him, to "inter-crural" sex where the man's penis is clearly placed between the boy's thighs.

All these vases circulated within the culture of pederasty that held an honored place in later sixth-and-fifth-century elite Athenian society. As represented in literature, affairs between youths in their not-yet-married older teens and prepubescent boys (both freeborn citizens) were understood to be thoroughly respectable. The older partner acted as a mentor as well as lover of the younger, teaching him the ways of manhood in the culture and preparing him for a life of citizenship and responsibility.

Penetrative sex is not illustrated in these relationships because of the stigma attached in Greek elite culture to being penetrated; the penetrator can, in effect, have sex with almost anyone as long as he remains the active party.

The vases may in some cases have been used at drinking parties attended by men and youths who were entertained by boy and girl slaves and prostitutes; but some of them were gifts given in the process of wooing boys, and the vases often bear the name of a boy and the word *kalos*, or beautiful.

That the vases formed part of a culture of institutionalized and socially regulated pederastic sex in exchange for gifts is visible from the scenes on the vases as well as from the writings of men such as Plato.

The vases occasionally show us scenes of homoerotic (and heteroerotic) sex that involve people looking on, watching at doors, and even masturbating as they watch. Many of these scenes have as their protagonists the ever cheerful, ever ready satyrs, half man and half goat. The satyrs delight in sex with anything, living or inanimate, and looking on also gives them very obvious pleasure.

That men felt desire at the sight of sexual activity is one aspect of the scenes, whether with satyrs or humans, but another important aspect is that the vases themselves seem to have been meant as incitements to desire.

This suggests, as do some literary texts, that visual stimulation was assumed to be part of men's desire for both women and boys. A second-century C.E. satiric travelogue written by a man now known as pseudo-Lucian

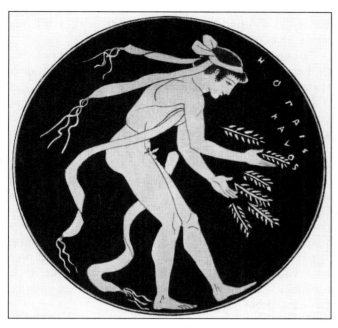

An Ancient Greek vase bearing the inscription "KALOS."

tells, for example, of a group of men visiting the famous nude statue of Aphrodite at her sanctuary in Knidos, on the coast of Asia Minor.

Granted, they go as tourists rather than worshippers, but what is most interesting is the way one viewer expresses his desire for the female beauty of the front of the statue while a second man exclaims over the boyish glory of the back of the figure.

Thinking about these texts, one sees the great and serene statues of nude athletes, warriors, and gods of the Greek past with different eyes, sees them increasingly as objects of visual desire with a strongly homoerotic component.

Whether nude statues of Aphrodite evoked a similar homoerotic response among female viewers is hard to know given that women left so little writing or other evidence of their feelings, but the possibility is there in spite of their being so deeply silenced. Only Sappho's fragmentary poems speak of delight in seeing beautiful girls; and women's motives in giving statues of beautiful goddesses to sanctuaries, although homoerotic visual pleasure may well have played a part, remain unknown beyond their expressions of piety and devotion.

Although both Greek and Roman art show men in homoerotic sexual situations, the few scenes depicting women together are extremely hard to interpret. One vase shows a group of women reclining on banqueting couches and drinking together, some as couples under one blanket, but they use none of the sexual gestures common on vases depicting men.

A second vase represents two nude women, one standing, the other crouching before her and examining the standing woman's crotch. One cannot tell whether the scene concerns sex or depilation, who the women are (probably prostitutes because of their short hair), and who the intended viewers were.

The Roman images of sexual activity provide no equivalents to even these mysterious images, although tombstones with pairs of women in traditional familial poses may indicate the existence of lesbian couples. Again, there is no confirming evidence.

Roman Art

Because the Romans had no equivalent to institutionalized pederasty and did have laws on the books that penalized sex between adult men and citizen boys, they seem never to have had a strong tradition of representing homoerotic sex in the arts.

Their Italian neighbors, the Etruscans, left no literary evidence about attitudes to sexuality, but some of their paintings and decorative objects do show men having anal sex; some scholars assert that these men must be slaves to have been shown in this form.

Among the few exceptions to the Roman reticence about showing homoerotic sex is a famous and problematic silver cup (London, British Museum: *Warren Cup*), believed by some to be modern rather than ancient. It shows two young men about to have anal sex in an elegant interior; on one side of the cup a figure peeks at them through a doorway.

Group heterosexual activity, as shown in the wall paintings of the Suburban Baths in Pompeii, includes at least one scene in which a man anally penetrates a man who is penetrating a woman.

These are exceptions to the rule that, despite the plentiful graffiti and literary texts about homoerotic activity between men (and the rarer ones about lesbian sex, also written by men), the visual arts of Rome avoid the subject except in idealized and mythicized forms, as when Ganymede and other mythological figures are shown on the walls of Pompeian houses.

Gender Instability: Hermaphroditism, Transvestism, Androgyny

In later Greek and Roman art, images appear that question the notion of stable sexual and gender identities. The most famous of these is the hermaphrodite, the youth with a penis and breasts. The Greeks (and Roman copyists) depicted the figure lying down asleep in a pose that suggests a woman from the back but from the front reveals the confusing attributes and shocks the viewer.

This notion of the shocking joke emerges in Pompeian paintings that combine the hermaphrodite with a satyr or faun who recoils in horror at the sight of the "truth" about the object of his lust. For the Romans,

the ambivalence about "prodigies," whose characteristics confused ideas about the natural, revealed itself in the fact that along with the jokes went old stories about burning or burying alive real hermaphrodites.

Along with the hermaphrodite's challenge to nature came images of mythological figures of hypermasculine men in women's clothing. Hercules appears in statues and paintings wearing the feminine garments of Queen Omphale, who had such control over the hero that she could exchange clothes with him and make him sit spinning with her female courtiers.

Omphale always appears nude with the lion skin and club of Hercules, and the nature of her cross-dressing is always confused by her nudity and presentation as feminine.

The same problem attaches to depictions of the Amazons, whose femininity is always asserted through pose, exposure of breasts and legs, and the deeper fact of their invariably being defeated by Greek men.

By contrast, Achilles dresses in women's clothing but is nevertheless always clearly a youth because of his athletic pose and the gesture of reaching for a sword, a gesture that reveals him to Odysseus, who has come to find him. Achilles appears cross-dressed on decorative objects, paintings, and even funerary sarcophagi, because his mother attempted to save him from death in the Trojan War by hiding him among girls at the court of a friendly king.

For mythological heroes to appear in women's clothing does nothing to challenge the gender system as it was practiced; rather, the point of the stories is the reassertion of the system. So too with Omphale in her Venus-style body and the ever dying Amazons. Both male heroes go on to deeds of superhuman strength and bravery, and these cross-dressing episodes seem merely to cast into relief the power of their masculinity.

Why these episodes should appear on funerary monuments remains an open question. Part of the answer may have to do with death's power of change, but perhaps there is as well an element of fascination with the instability of gender and even of sex in a world where mythological figures can and do change sex as well as gender.

Finally, androgyny as a feature of young men (but not of girls) is an important element in both later Greek and Roman art. Gods such as Bacchus and Apollo were regularly represented as silky, longhaired youths, their poses sinuous and their musculature undefined. Although they are both powerful gods, capable of slaughter as well as joy and art, their boyish bodies were clearly meant to evoke the sexiness of pederasty's boy lovers.

This model seems to have held no attraction for those Romans who, commissioning statues or reliefs for the tombs of their beloved relatives and friends, asked the artists to combine a portrait head with a famous statue body.

For girls, the figure of Diana was the most popular of all, but here the boyishness of the goddess of the hunt is obviated by the emphasis in myth and religion on Diana's chastity and her avoidance of men. Nevertheless, if there is a faint sense of female androgyny and of a world of girls without or prior to men, it remained submerged under the normative, assumed heterosexuality of virgin girls who would inevitably marry.

Young Roman men appear in commemorative and honorific statues with the athletic bodies of classical Greek heroes—except for the beloved of the emperor Hadrian, Antinous. The youth is known from about a hundred portraits made after his mysterious drowning in the Nile (in 129–130 C.E.), and his image almost always stresses the sensual, unmuscular body, the thick curly hair, the soft smooth face, and the curving lips of the beloved boy.

Antinous's portraits regularly stress his resemblance to Bacchus and Apollo, to Hermes and the woodland god Sylvanus, all of whom are young and a bit androgynous. Even when he appears in the guise of a pharaoh to stress his identity as Osiris, one of the gods the emperor associated with the dead youth whom he declared a god, his body never evokes muscular adult male power.

Antinous is in some sense the pivotal figure in a sexual system built out of paradoxes and ambivalences, a system that made all things possible to the discreet but actively penetrative elite man, while pretending that such a man would never lose his head over the wrong person. To see Antinous (and the ancient Greek and Roman sexual system) in this light is to understand why the lesbian and the *cinaedus* must remain invisible and why the hermaphrodite must be a joke or be murdered.

— *Natalie Boymel Kampen*

BIBLIOGRAPHY

Ajootian, Aileen. "The Only Happy Couple: Hermaphrodites and Gender." *Naked Truths: Sexuality and Gender in Classical Art and Archaeology.* A. Koloski-Ostrow and C. L. Lyons, eds. New York and London: Routledge, 1997. 220–242.

Clarke, John R. *Looking at Lovemaking: Constructions of Sexuality in Roman Art: 100 BC–AD 250.* Berkeley: University of California Press, 1998.

Dover, Kenneth J. *Greek Homosexuality.* New York: Vintage, 1978.

Gleason. Maud W. *Making Men: Sophists and Self-Presentation in Ancient Rome.* Princeton, N.J.: Princeton University Press, 1995.

Hawley, Richard. "The Dynamics of Beauty in Classical Greece." *Changing Bodies, Changing Meanings: Studies on the Human Body in Antiquity.* D. Montserrat, ed. London and New York: Routledge, 1998. 37–54.

Kampen, Natalie Boymel. "Omphale, or the Instability of Gender." *Sexuality in Ancient Art.* N.B. Kampen, ed. Cambridge: Cambridge University Press, 1996. 233–246.

Kilmer, Martin. *Greek Erotica on Attic Red-figure Vases.* London: Duckworth, 1993.

Meyer, Hugo. *Antinoos.* Mainz: Philipp von Zabern Verlag, 1991.

Stewart, Andrew. *Art, Desire and the Body in Ancient Greece.* Cambridge: Cambridge University Press, 1997.

Williams, Craig. *Roman Homosexuality.* Oxford and New York: Oxford University Press, 1999.

See Also

Subjects of the Visual Arts: Androgyny; Subjects of the Visual Arts: Diana; Subjects of the Visual Arts: Dionysus; Subjects of the Visual Arts: Endymion; Subjects of the Visual Arts: Ganymede; Subjects of the Visual Arts: Harmodius and Aristogeiton; Subjects of the Visual Arts: Hercules; Subjects of the Visual Arts: Hermaphrodites; Subjects of the Visual Arts: Narcissus; Subjects of the Visual Arts: Orpheus; Subjects of the Visual Arts: Priapus; Subjects of the Visual Arts: Psyche; Subjects of the Visual Arts: Sappho

Contemporary Art

FROM ONE PERSPECTIVE, CONTEMPORARY ART IS THE art of the immediate present. However, in the institutional settings of the museum, the art market, and academia, contemporary art designates new currents in art since 1970. Its history is identified with postmodernism, a later phase of modern art. During this period, an art addressing gay and lesbian identity emerged.

Modernism versus Postmodernism

Literary and art criticism has set postmodernism in theoretical opposition to twentieth-century modernism, a tradition dominated by white and heterosexual men. For modernism, oil painting was the preferred medium in the fine arts. It carried the history of modern art. Writers framed modernist art theory in terms of formalism, a critical approach that prized the visual or formal elements of style over content. They conceptualized art history as linear and progressive and, by mid-century, declared abstraction to be modernism's consummate form.

Political protest and the call for social reforms in the United States and France in the 1960s had a tremendous impact on Western culture, including notions of what art should be. The challenges to authority in America made by the civil rights, antiwar, and feminist movements, and in Paris by the 1968 May riots, contributed to a climate of opinion in which modernism in the arts could no longer survive. Modernism, as the standard for twentieth-century art, was discredited by new voices.

Although the term *postmodernism* did not become current until the early 1980s, it is descriptive of the course contemporary art has taken from the early 1970s to the present. Although postmodern critics acknowledged the achievements of modernist artists, they undermined the exclusivist nature of modernism by recognizing and championing a plurality of interests.

In postmodern art, women, nonwhite, and homosexual artists gained fresh authority. Race, ethnicity, and gender were seen as legitimate foundations for art. Figurative and narrative art, which best served these concerns, became viable alternatives to abstraction. The hegemony of oil painting gave way to equal respect for photography, sculpture, installation art, video, and electronic-based media. All of these developments were the crucible in which a gay and lesbian art took its distinctive forms.

The inclusiveness of contemporary art enabled art to become a significant forum for artists who wished to speak to gay and lesbian identity. Following the formation of the feminist and gay liberation movements, the latter in the wake of the Stonewall riots of 1969, the doors opened for the creation and institutionalization of gay and lesbian art. Although frequently controversial with the general public, gay and lesbian art ultimately entered the mainstream of high culture.

The 1970s

Modernist critics saw the history of modern art as a sequence of exclusive art movements. They marginalized all other directions, notably realism, social activism, and untutored art. This exclusivity changed during the 1970s, primarily in the United States. The decade was dense with the preoccupations of a younger generation of artists who investigated a wide variety of subjects with traditional and innovative media.

The pluralism of the period included new formats (conceptualism, performance art, and installation art); realist styles (photorealism); expressionist styles (traditional figuration, Pattern and Decoration, New Image); and new media (earthworks and video art).

Lesbian Artists

In this environment of change, American lesbian artists began to assert themselves in a rich history of exhibitions and public manifestations: for example, the Feminist Lesbian Art Collective (FLAC), a support group and exhibiting society for lesbians living on the Lower East Side of New York that was active in the early 1970s; the Great American Lesbian Art Show—a series of exhibitions that appeared nationwide (Los Angeles, 1980); A Lesbian Show, organized by Harmony Hammond for the Green Street Workshop in New York (1978); and, in literary form, a special issue of *Heresies*, a leading American feminist journal, that was devoted to lesbian art and artists (New York, 1980).

Lesbian art of the 1970s was inseparable from the women's movement and was allied in expression to the work of nonlesbian women artists who pursued feminist

agendas. The most important cities for the advancement of lesbian art were New York and Los Angeles. The inseparability of lesbianism and feminism in the 1970s may be illustrated in the dual career of Kate Millett. As a literary critic, she wrote one of the most important feminist studies, *Sexual Politics* (1970); as a lesbian artist, she expressed herself in sculpture and mixed-media installations.

Harmony Hammond, a prominent feminist writer, was also an abstract sculptor. (In 2000, she published *Lesbian Art in America: A Contemporary History*, the first survey of the subject ever written.)

In lesbian art of the 1970s, there was very little specifically lesbian subject matter, with the exception of works of photographers such as Joan E. Biren (JEB) and Tee Corinne. Photography emerged in the decade as the medium most preferred by lesbian artists, a preference that resulted in some striking work throughout the period.

Generally, however, in the 1970s lesbian experience was coded in feminist imagery and the intimate experiences of women apart from men. This was the case for Hollis Sigler, whose bittersweet art gathered women's clothes and household furniture as proxies for the artist. Louise Fishman, an active lesbian and feminist in her politics, was neither explicitly lesbian or feminist in her art—although her bravura expressionist abstraction can be linked to an assertive "masculine sensibility" in modern art.

Joan Snyder combined words and expressionist style in her lyrical paintings and works on paper to track private memories and relationships. In the 1980s, she began to honor the fate of women in history in a more polemical spirit. Snyder is arguably the most important feminist artist of the period. She has figured significantly in the history of contemporary art to the present.

Judy Chicago's *The Dinner Party* (1974–1979) is a paradigm of lesbian art for the decade. It is a mixed-media installation that consists of a triangle of joined banquet tables that rest upon a tile floor base. The triangular format represents what some artists and writers saw as the centralized and vaginal imagery of a true feminist abstraction.

Calling upon crafts associated with women's history—needlework and porcelain painting—*The Dinner Party* presents thirty-nine stitched and embroidered table settings dedicated to famous women writers, artists, and reformers, with 999 women's names inscribed in gold on the white porcelain tiles below.

Judy Chicago's roster of famous women included lesbian, bisexual, and heterosexual women. This mix was also reflected in the women she gathered to help implement her design. She thus created an ecumenical community effort that suggested the traditional collaborative nature of women's work.

As an important representative of the Pattern and Decoration movement, Judy Chicago's *Dinner Party* was also symptomatic of a new feminist point of view in which decorative forms, previously marginalized in their association with home crafts, took on a new cultural significance as artists absorbed them into the realm of high art. The feminist questioning of traditional gender roles was also posed by the inclusion of male artists in the fabrication of *The Dinner Party*.

Gay Male Artists

In contrast to a vital tradition of lesbian art during the 1970s, there was no counterpart for gay male artists. This is ironic in light of the gay sensibility that was a hallmark of Pop Art during the preceding decade. Of the most influential artists associated with Pop Art, the majority were gay men: the Americans Jasper Johns, Robert Rauschenberg, Andy Warhol, Robert Indiana, and the Englishman David Hockney.

Joining the heterosexual Pop artists in ambivalent critiques that both celebrated and questioned the American Dream, these men could also draw gay identity into their art. However, they veiled their gay identity in the indirect language and idiom of camp.

The exception to this generalization is David Hockney, who was explicit in portraying same-sex love and sensuality, particularly in his prints. Yet, Hockney and the other gay Pop artists never gave their art the polemical edge that would come to mark gay and lesbian art of the postmodern period.

Within the younger generation, the only gay male artists of the 1970s to gain important recognition were Gilbert & George, a British performance team. Their most significant work was large-scale color photography in the form of screens of multiple backlit photographs and text panels. Later, this work became more frank in its explorations of lower-class youth, boy-sex, and the AIDS epidemic.

One explanation for the dearth of gay male art as compared with the efflorescence of lesbian art during the 1970s may be that gay male artists lacked the kind of support that lesbian artists received from their affiliation with an active feminist movement. The emergent Gay Liberation movement was less public and less accepted than the feminist movement. Benefiting from the feminist movement, women artists entered the art market's mainstream for the first time, an economic reality that encouraged lesbian artists.

The 1980s

By the end of the 1970s, modernist aesthetics and theory still dominated discussions of contemporary art. A decisive break, however, came in the 1980s, spurred by French critical theory and the poststructuralist and deconstruc-

tivist writings of Jacques Derrida, Michel Foucault, and Roland Barthes. The term *postmodernist* came to describe the shift. Henceforth, it would be interchangeable with the word *contemporary* to characterize current developments in the visual arts since 1970.

At the core of postmodernist criticism was the rejection of modernism's assumptions concerning subject, style, and media, and its domination by male artists. In postmodernist criticism, writers attempted to explain why specific groups and works of art had been marginalized. They made intense efforts to elucidate and to value "difference" and the "Other."

The most important strategy for correcting past inequities was "naming": identifying and giving voice and image to what had been dismissed. The full impact of these ideas would not be felt in contemporary art until the early 1990s.

In the meantime, postmodernist art of the early 1980s was manifested in a series of revival styles that appropriated the high styles of modernism for personal and ironic commentary: neo-Expressionism, neo-Pop (graffiti and cartoon art), neo-Surrealism, and neo-abstraction.

One clue to the fact that these revival styles were essentially conservative was that large-scale painting was their primary medium. This phenomenon was made obvious in A New Spirit in Painting, an important exhibition in London at the Royal Academy of Art in 1981. The "retro" movements were linked to the cultural conservatism of President Ronald Reagan, Prime Minister Margaret Thatcher, and the bull market and rush of new money associated with investment banking and market speculation. Moreover, despite their links to postmodernist theory, the retro movements were dominated by male artists.

Mostly personal, the new art in revival styles carried little polemical edge or analysis of difference. There were notable exceptions, including, in terms of gay identity, the German neo-Expressionist Rainer Fetting and the neo-abstractionist Ross Bleckner and neo-Pop artist Keith Haring, both American.

Extended Sensibilities: Homosexual Presence in Contemporary Art

The exhibition Extended Sensibilities: Homosexual Presence in Contemporary Art, organized by Daniel Cameron for the New Museum of Contemporary Art in New York in 1982, was of great historical importance. It was the first exhibition in the United States to examine issues raised by contemporary gay art and homosexual identity. It was also the first exhibition to bring gay and lesbian artists together.

Although conservative in subject matter and in the prominence of traditional media (with no photography,

video, or installation art, which would become the primary vehicle for gay and lesbian art in the next decade), the exhibition did attempt to identify the nature of gay and lesbian art in regard to content and sensibility from both personal and political perspectives.

Reactions in the gay community to this major exhibition were mixed. Some artists were ambivalent about coming out in their art and others questioned the validity of any universal gay sensibility. For many, these attitudes would dramatically change with the AIDS crisis, which became acute by mid-decade. Society's repression of its realities galvanized the gay artistic community.

The Impact of AIDS

In 1987, a group of gay artists and critics founded ACT UP/New York (AIDS Coalition to Unleash Power). Although it organized public demonstrations, its first gesture was a shop-window display at the New Museum of Contemporary Art that featured AIDS activist posters and broadsheets. Reviving the Pop Art styles of Andy Warhol and Robert Indiana, these materials, especially their typography and layout, became immediately associated with gay activism, public declarations of gay identity, and proactive campaigns to gain access to political power.

Gay art came of age in the late 1980s. Keith Haring, who until this time had avoided his gay identity in his colorful cartoon caricatures, stepped forward to be counted. One of his most moving works of art is a screenprint he made in 1989 for an ACT UP fundraiser. Its title, *SILENCE = DEATH*, was the organization's motto. On a square black field, dozens of intermingled figures, outlined in silver, sob and grieve. Over this image, Haring centered a large pink triangle in defiant and elegiac protest against indifference.

ACT UP and other gay and lesbian groups adopted the pink triangle to reclaim the symbol used by the Nazis to identify homosexuals in the death camps during World War II. Haring, who was HIV positive, died in 1990.

In addition to ACT UP/New York, this period saw the organization of other artists' collaboratives that functioned as activist organizations, such as Group Material and Gran Fury, which wished to initiate social reform through art.

In 1989, Gran Fury produced a special side panel for New York City buses. Appropriating the graphics and photography of commercial advertising, Gran Fury presented three racially intermixed couples kissing: boy and girl, girl and girl, boy and boy. Admonishing the public's irrational fear of the AIDS virus, the simple caption under the young and attractive couples read: "Kissing Doesn't Kill."

In 1990, at the Venice Biennale, an international venue for modern art since the early twentieth century,

Gran Fury erected billboards lambasting the Catholic Church's condemnation of homosexuality.

The 1987 and 1989 Whitney Biennials

The Whitney Biennials of 1987 and 1989 in New York were significant indications of the increasingly more open stance of gay art. Since 1935, the prestigious annuals and biennials organized by the Whitney Museum of American Art have been curatorial summaries of what was considered to be the best in American art. Not without their controversy, given the authority of a major museum to establish the historical importance and market value of artists, these exhibitions have always been keenly awaited and discussed.

The 1987 Whitney Biennial was striking for the inclusion of gay artists whose works of art were explicitly gay in content. The exhibition included a large-scale painting by David McDermott and Peter McGough, *A Friend of Dorothy, 1943* (1986), a whimsical and chilling study in postmodernist "naming." In a florid and delicate black script, the artists wrote slur words for gay men in a graffiti-like fashion: *faggot, homo, fairy, cocksucker, queer, pansy, Nellie,* and *fem.*

The name *Mary*, painted in red, and the title "Friend of Dorothy" distinguished themselves from the other terms as positive references for gay men. Shocking to see in an oil painting in a major museum, the invectives made public the hushed language of hate. With affectionate wit, the painting checked the foul words with the gay community's own terms.

Among the other gay artists represented in this turning-point exhibition was Ross Bleckner, a painter whose earlier work in the decade borrowed and personalized 1960s minimalist abstraction. The more recent paintings on view at the Biennial were from the artist's series of "trophy paintings." Under densely clear-varnished and reflective surfaces, Bleckner scattered colorful emblems of love, death, and redemption on dark grounds, among which were flowers, funeral urns, and radiant streaks of light. Although universal in their lamentations, these paintings were conceived by Bleckner as personal memorials to the casualties of AIDS.

The 1989 Whitney Biennial would again include Bleckner and also Robert Gober, who, invited back for the 1991, 1993, and 2000 Biennials, would become one of the most honored of living American artists at the end of the final decade of the twentieth century.

Culture Wars

With gay artists more willing to declare their sexual identity in their art, a conservative reaction was probably inevitable. Gay identity art contributed to polarizing certain segments of the general population into what became the "culture wars."

On one side stood the religious right, given license by the conservative presidency of Ronald Reagan. To the other side were the social minorities of gays, African Americans, Native Americans, and Hispanics who became all the more defiant and determined to defeat conservative agendas of exclusion and hate.

The National Endowment for the Arts (NEA) was the target of such conservative and homophobic activists as U.S. Senator Jesse Helms and fundamentalist evangelist Rev. Donald Wildmon. In the name of the Christian Right's morality, they attacked federal funding of what they labeled pornography and obscenity.

These activists determined to destroy the NEA, whose budget President Reagan had attempted to diminish earlier in the decade in the wake of growing contempt for contemporary art, particularly public sculpture that the government was asked to subsidize.

The focus of Helms and Wildmon's ire was the Cuban American Andres Serrano and the gay American artist Robert Mapplethorpe, both photographers whom the religious right made scapegoats in their crusade against "degenerate art." Other artists eventually caught up in the culture wars included performance artists Holly Hughes and John Fleck.

The largely successful efforts to curtail the activities of the NEA and demonize contemporary art were thinly veiled reactions, in the name of "family values," against growing ethnic populations, demands for gay rights, and an increasing social tolerance of Americans toward minorities.

The undermining of contemporary art by religious and political conservatives was countered in important ways by institutional endorsements in the late 1980s, notably those of the Whitney Museum of American Art.

But the stock-market crash of October 1987, which brought the economic juggernaut of the decade to an abrupt end, had an enormous impact on the art market. It further demoralized the art community. Many artists who had gained initial recognition during the decade all but disappeared.

Despite these reverses, however, younger artists gained additional resolve to make racial, ethnic, and gender identities the basis of their art.

For all the advances of the 1980s, there was much to be done and many more voices to be heard. In 1992, with economic recovery at hand and Bill Clinton in office as the new president, the climate for gay men and lesbians in contemporary art was becoming more hospitable. With two major exhibitions as overtures for the new decade, The Decade Show (1990) and the 1991 Whitney Biennial, the last years of the century were auspicious for continuing a tradition of art based on gay identity.

The 1990s

As was the case in the 1970s and 1980s, no single style or medium characterized contemporary art at the end of the twentieth century. Photography and video art were in the ascendancy, aided by technological advances and an increasing emphasis on their importance in commercial art galleries and museum exhibitions and permanent collections. Pluralism thrived, permitting a gamut of art that ranged from traditional realist styles to electronic-based art.

Realism, which underwent a revival of interest in the 1970s as a bona fide contemporary style, had been the established basis for earlier twentieth-century art depicting homoerotic subject matter. For example, a "gay realism" characterized the art of the American Paul Cadmus and the sexualized drawings of Tom of Finland and gay comic-book illustrations.

In contemporary art of the 1980s and 1990s, a resurgent gay realism ran parallel to more innovative styles and media that addressed gay themes. Even within this category, which mostly addressed the male nude, there was a considerable range of expression, from the sadomasochistic essays on love, hate, and sexuality in the work of the Canadian Attila Richard Lukacs to the studio-based neoclassicism of Michael Leonard (Britain) and Luis Caballero (Colombia).

There were two developments that gave coherence to the decade: the dominance of installation art (site-specific, multimedia works); and the preoccupation of artists with race, ethnicity, and gender.

Many artists still felt that cultural and social identity had not been sufficiently endorsed by the art world. This neglect had its initial correction in a landmark exhibition of 1990: The Decade Show, which, organized by the New Museum of Contemporary Art, the Studio Museum in Harlem, and the Museum of Contemporary Hispanic Art in New York, provided a stage for black, Hispanic, Asian American, and feminist artists. It set the tone for the decade, one in which gay art would reach new heights of exposure and acknowledgment.

Gay and lesbian art thrived in the United States during this period, in contrast to Europe, which had no counterpart in terms of exhibition histories, critical attention, and market viability. A number of factors contributed to this disparity, including the more conservative nature of European culture and its persistent nationalism, which in many countries inhibited cultural diversity.

The sustained history in the United States of social reform and struggles for enfranchisement, although not without its complexities, contributed to a multicultural society. Moreover, major American institutions, especially the New Museum of Contemporary Art and the Whitney Museum of American Art, played central roles in validating a contemporary art of gay identity.

The 1991 Whitney Biennial

The multiculturalism of American art was nowhere clearer than in the 1991 Whitney Biennial. In a review of the best of contemporary American art, the curators made a generational selection—early, mid, and late-career artists. Of the seventy-five painters, sculptors, photographers, installation artists, and artists' collaboratives represented, seventeen were gay male artists, the majority of whom focused on gay themes.

Although lesbian artists were not represented in the 1991 Whitney Biennial, lesbian artists did have renewed and important exhibition exposure during the decade. All but the Obvious: A Program of Lesbian Art opened in 1992 in Los Angeles. It was the first exhibition devoted to lesbian art in over ten years. In 1996, Gender, fucked, one of the most significant exhibitions of lesbian artists during the 1990s, was curated by Harmony Hammond and Catherine Lord for the Center of Contemporary Art in Seattle.

In a joint show, reminiscent of the Extended Sensibilities exhibition of 1982, lesbian and gay artists joined forces in Situations: Perspective on Work by Lesbian and Gay Artists in San Francisco in 1991. They joined forces again in 2 Much: The Gay and Lesbian Experience at the University of Colorado at Boulder in 1993—in reaction to a state constitutional amendment that denied lesbians and gay men protection from discrimination.

In the 1991 Whitney Biennial, Jasper Johns and Robert Rauschenberg, now among the most celebrated of American artists, were included. Lovers in the 1950s, they number among the most famous artist couples in twentieth-century art. McDermott and McGough returned with platinum prints of staged recreations of nineteenth-century scientific experiments.

Glenn Ligon made his first appearance in this Whitney Biennial with oblong paintings of stenciled lines of repeated text that chanted his alienation as an African American. Although Ligon made his debut as a black artist, he was candid about his sexual orientation. In Notes on the Margin of the "Black Book," a mixed-media installation in the 1993 Whitney Biennial, he paired family photographs with gay pornography and Robert Mapplethorpe's nude photographs of black men.

Thomas Lanigan Schmidt, also new to the Biennial but with a long history of exhibition at the Whitney and elsewhere, offered commentary in his decorative mixed-media paintings on his Catholic and gay identities.

Haring had died the year before, but was remembered in the Biennial with two large-scale paintings depicting an engorged penis, a Minotaur, an impaled globe, and a foot, invoking violence and bodily harm in an emphasis on the human body and its vulnerability.

The Body's Vulnerability

A concern for the body's vulnerability became almost a fixation in contemporary art at the end of the twentieth century. The obsession has been variously attributed to the anxieties of a dominant and aging baby-boomer generation, to a traditional preoccupation with mortality by Western artists at the ends of centuries (exacerbated now by the approach of the millennium), and to the AIDS crisis, which deeply affected the art community.

The AIDS crisis is a particularly trenchant factor in the character of gay art during the early 1990s. The theme of physical frailty informed some of the most plaintive works of the decade. They were created by both gay and straight artists, many of whom were represented at the 1991 Whitney Biennial.

Group Material, an artists' collaborative of four gay artists, active since the early 1980s, installed an AIDS Timeline in the lobby of the Whitney that traced a history in images and words of society's obliviousness to the plague of the century. Nayland Blake assembled nonfunctional steel contraptions, one with hanging meat cleavers that conveyed imminent threat.

David Wojnarowicz, who died of AIDS in 1992, worked in a wide range of media including painting, installation art, video, film, and the written word. He was vocal in his condemnation of such homophobic figures as John Cardinal O'Connor, Senator Jesse Helms, and the Rev. Donald Wildmon.

In a gelatin silver print of human skeletons, whose arrangement suggests an ancient burial ground, Wojnarowicz lamented the loss of physical intimacy between human beings and the wasting away of the physical self. In his own text, overprinted on the photographic image, he wrote: "All these moments will be lost in time like tears in the rain."

Robert Gober, sculptor and installation artist, began his career in the 1980s. He received critical acclaim for his handcrafted facsimiles of dollhouses, baby cribs, and porcelain sinks—objects, often distorted in shape, that sprang from his childhood memories. As Gober's work evolved, it took on more specific reference to his Catholicism, gender ambiguities, gay identity, and mortality.

In *Untitled, 1990*, included in the 1991 Whitney Biennial, a wax effigy of a naked male figure, still wearing shoes and socks, lies prone on its stomach, truncated at the waist to appear as though it is half-embedded in the wall. A musical staff with the rising and falling notes of a melody is imprinted across his exposed buttocks. The effigy is Gober's body, the hair on its legs his own.

Félix González-Torres, a Cuban American artist who died of AIDS in 1996, was also represented in the 1991 Biennial. He was an installation artist and maker of mysterious objects. He is perhaps best known for the strings of naked lightbulbs with which he would festoon gallery spaces. Electrified, the lightbulbs were allowed to burn out during exhibitions. Recalling Bleckner's "trophy paintings," these draped light strings became lyrical memorials. They played upon the symbolism of the low-burning or extinguished candle, which in traditional Western art served as a reminder of the brevity of life and the inevitability of death.

The theme of human vulnerability and mortality also figured prominently in the 1991 Whitney Biennial in the art of Kiki Smith, John Coplans, Jennifer Bartlett, and the artists' collective known as Tim Rollins + K.O.S., as it had figured in the art of other established artists not included, notably Andres Serrano and the English painter Lucien Freud. All of these artists are heterosexual, suggesting the universality of the theme, which may have been inspired or made urgent by the AIDS crisis, but which also stemmed from an irrefutable fact of human existence.

The Retreat of Gay Identity Art

The 1991 Whitney Biennial may mark the apogee, in terms of exhibition exposure, of a contemporary art speaking to gay identity. The early 1990s were exceedingly important for letting informed general audiences know that gay artists could make great art deriving from gay experience. And yet, after this moment there would be little representation. The Whitney Biennials of the rest of the decade do not have a notable gay presence. Of the artists preoccupied with gay identity, only Gober appears in the 2000 Biennial. What happened?

The retreat of gay identity art raises some interesting questions. After a first generation of concerted and successful efforts to declare social and sexual self-worth in their art, are gay artists now free to go their own way, without obligatory pressures to be combative and make sexual orientation the center of their creativity? Has Western society's relative acceptance of homosexuals made gay identity art unnecessary? What about non-Western cultures where homosexuality is persecuted and punished?

Perhaps the most profound question for glbtq artists at this stage of art history is whether the label of gay and lesbian art is limiting. What about gay artists who express themselves in abstraction? Is gay and lesbian identity art a historical phase similar to the social realist and activist art of the 1930s? What comes next? Will it be a period that the African American installation artist Adrian Piper refers to as "post-ethnicity?"

One of the great achievements of gay and lesbian art was to free sexual energies, to unfetter the self to make art that does not deny sexual integrity. The art of Peter Paul Rubens and Pablo Picasso is unimaginable without its intense heterosexual charge. Yet this art speaks to all

humanity, including glbtq individuals. Many of the artists who have figured in the history of contemporary gay and lesbian art have similarly created works of art that are at once individual and universal. While grounded in sexual identity, it ultimately speaks to people of all sexual orientations who are able to see and experience what is human in all of us.

Robert Gober, Joan Snyder, David Wojnarowicz, Judy Chicago, Félix González-Torres, Keith Haring, Glenn Ligon, and Ross Bleckner, among others, are now entrenched in the history of art. Grounded in personal identity, their art reaches out to move us all in its sensuousness and resonance. — *Richard H. Axsom*

BIBLIOGRAPHY

Atkins, Robert, and Thomas W. Sokolowski. *From Media to Metaphor: Art about AIDS*. New York: Independent Curators, 1991.

Arnason, H. Harvard, and Marla Prather, revising author. *History of Modern Art: Painting, Sculpture, Architecture, Photography*. 4th ed. New York: Harry N. Abrams, 1998.

Auping, Michael. *Jess: Grand Collage, 1951–1993*. Buffalo: Albright–Knox Art Gallery, 1993.

Blake, Nayland, Lawrence Rinder, and Amy Scholder, eds. *In a Different Light: Visual Culture, Sexual Identity, Queer Practice*. San Francisco: City Lights Books, 1995.

Cameron, Daniel, ed. *Extended Sensibilities: Homosexual Presence in Contemporary Art*. New York: New Museum of Contemporary Art, 1982.

Cotter, Holland. "Art after Stonewall: 12 Artists Interviewed." *Art in America* 82.6 (June 1994): 56–65.

Gay and Lesbian Caucus of the College Art Association. *Bibliography of Gay and Lesbian Art*. New York: Gay and Lesbian Caucus of the College Art Association, 1994.

Hammond, Harmony. *Lesbian Art in America: A Contemporary History*. New York: Rizzoli, 2000.

Harrison, Charles, and Paul Wood, eds. *Art In Theory 1900–1990: An Anthology of Changing Ideas*. Malden, Mass.: Blackwell Publishers, 1992.

Horne, Peter, and Reina Lewis, eds. *Outlooks: Lesbian and Gay Sensibilities and Visual Culture*. London and New York: Routledge, 1996.

Hunter, Sam, John Jacobus, and Daniel Wheeler. *Modern Art: Painting, Sculpture, Architecture*. 3rd ed., rev. New York: Harry N. Abrams, 2000.

Lippard, Lucy R. "Naming." *Writings about Art*. Carole Gold Calo, ed. Englewood Cliffs, N.J.: Prentice-Hall, 1994. 262–75.

Lucie-Smith, Edward. *Race, Sex, and Gender: In Contemporary Art*. New York: Harry N. Abrams, 1994.

———. *Ars Erotica: An Arousing History of Erotic Art*. New York: Rizzoli, 1997.

Meyer, Richard. *Outlaw Representation: Censorship and Homosexuality in Twentieth-Century American Art*. New York: Oxford University Press, 2001.

Miller, James, ed. *Fluid Exchanges: Artists and Critics in the AIDS Crisis*. Toronto: University of Toronto Press, 1992.

Phillips, Lisa. "Culture Under Siege." *1991 Biennial Exhibition*. New York: Whitney Museum of American Art, 1991. 15–21

Reed, Christopher. "Gay and Lesbian Art." *Grove Dictionary of Art*. Joan Shoaf Turner, ed. New York: Grove's Dictionaries, 1996. 12:213–220; Grove Dictionary of Art Online: (January 1, 2002).

Whitney Museum of American Art. *1987 Biennial Exhibition*. New York: Whitney Museum of American Art, 1987.

SEE ALSO

AIDS Activism in the Arts; American Art: Gay Male, Post-Stonewall; American Art: Lesbian, Post-Stonewall; Biren, Joan Elizabeth (JEB); Bleckner, Ross; Cadmus, Paul; Censorship in the Arts; Chicago, Judy; Corinne, Tee; European Art: Twentieth Century; Gilbert & George; González-Torres, Félix; Hammond, Harmony Lynn; Haring, Keith; Hockney, David; Johns, Jasper; Ligon, Glenn; Lukacs, Attila Richard; Mapplethorpe, Robert; Photography: Gay Male, Post-Stonewall; Photography: Lesbian, Post-Stonewall; Pop Art; Rauschenberg, Robert; Tom of Finland; Video Art; Warhol, Andy; Wojnarowicz, David

Cooling, Janet (b. 1951)

AN AUDACIOUSLY PIONEERING ARTIST, JANET COOLING has become recognized as a significant contemporary American painter. The recognition of her work has helped bring lesbian imagery into mainstream art.

Cooling was born on October 14, 1951, in Chester, Pennsylvania. She was educated at Pratt Institute (B.F.A., 1973) and the Art School of the Art Institute of Chicago (M.F.A., 1975).

Cooling began her career in the late 1970s and early 1980s exhibiting lesbian erotic paintings: portraits of lovers, self-portraits with her lover, and double portraits of gay and lesbian couples. This work is lyrical, evocative, intimate, and explicit. Cooling abandoned her erotic work in 1986 because of difficulties in exhibiting the paintings.

The sheer joy of sensuality continues to infuse her work, however, which is distinguished by the vibrant and visceral use of color and a complex interplay of abstraction and realism. In this work, urban landscapes, floating figures, empty dress forms reminiscent of shop windows with elegant evening gowns, androgynous suited figures, jazz musicians, and shoes are painted in surreal juxtapositions as if on a stage, framed by curtains that contain the action. It is as if the energy of the imagery and color would explode without the containment of the curtains.

Cooling's personal iconography includes animals that range from whimsical and playful to totemic, powerful, and seductive. Art historical references abound in her paintings, which allude to female forms in earlier compositions but reinterpret them.

For example, Cooling's empty dress forms populate landscapes that echo Renaissance compositions, which

assume the female form is viewed by a male painter, but which are given a new spin when seen through lesbian eyes.

In the mid-1990s, as a tenured professor in the Fine Art Department at San Diego State University, Cooling returned to her roots and again began painting works with overtly lesbian erotic content. The lesbian content in these new paintings is presented in an even stronger and more powerfully sophisticated way than was the case in the earlier work.

On the basis of her powerful series *Paintings from Hell's Kitchen*, Cooling was awarded the highly coveted Marie Walsh Foundation Space Grant for 1998.

Able to paint uninterruptedly in New York City, Cooling has expanded and deepened her exploration of the female form by using female bodybuilders as models. Always inspired by art history, Cooling in her new work plays with Renaissance techniques of figure painting and explores underpainting and glazes, which add a new depth, texture, and glow to her already vibrant color. The sensual interplay between figuration, abstraction, and surrealism is heightened.

In both large-scale and smaller paintings, panel series as well as prolific figure studies, an evocative poetic narrative emerges to which the viewer contributes his or her own meaning. In the new work, the image of Bunny Man, a trickster character, suggests Cooling's personal myth.

Cooling's mature work continues to bring her recognition as a major contemporary painter and bridges lesbian art further with the mainstream. Never one to shy away from radical territory, she has chosen to be a pioneering trailblazer, a lesbian artist inventing new imagery.

She and her partner of many years, Jackie Corlin, have formed a foundation to collect underrecognized and undercollected women painters, particularly lesbians and women of color, thus creating a legacy on many levels. Her work can be seen at http://www.daltonprives.com.

— *Susan Richards*

BIBLIOGRAPHY

Andrea, I., Robert Perine, and Bram Dijkstra. *San Diego Artists*. San Diego: Artra Publishing, 1988.

Frueh, Joanna, Laurie Fierstein, and Judith Stein. *Picturing the Modern Amazon*. New York: Rizzoli International and The New Museum of Contemporary Art, 2000.

Gaines, Malik. "The Heat's on Cooling." *The Advocate* No. 812 (May 23, 2000): 92–93.

Hammond, Harmony. *Lesbian Art In America: A Contemporary History*. New York: Rizzoli International, 2000.

Klein, Jennie. "Janet Cooling." *The New Art Examiner* 23.3 (November 1996): 34–35.

SEE ALSO

American Art: Lesbian, Post-Stonewall; Contemporary Art

Corinne, Tee (b. 1943)

A GIFTED AND VERSATILE ARTIST, TEE CORINNE works with photography, line drawing, paint, sculpture, ceramics, and printing, and she has also published erotic fiction and poetry and reviews. Favorite cover artist for lesbian publisher Naiad, and author of the famous *Cunt Coloring Book* (first version published in 1975, reissued as *Labiaflowers* in 1981), Corinne's work is found on bookshelves across the lesbian nation.

Born Linda Tee Cutchin on November 3, 1943, in St. Petersburg, Florida, Tee Corinne attended Newcomb College of Tulane University before obtaining her B.A. from the University of South Florida (1965) and her Master of Fine Arts from the Pratt Institute (1968). After a seven-year heterosexual marriage, she became the shy superstar of lesbian erotica.

Corinne's courage in insisting that the frank and erotic representation of lesbian sex empowers women gained her the respect of different "schools" of lesbian thought, even those that usually regard one another with hostility. Thus, her work may be found in Pat Califia's *Sapphistry* (1988) but also in *Lesbian Culture* (1993), to whose editors, Julia Penelope and Susan Wolfe, Califia is the lesbian Antichrist.

Corinne is sometimes accused of romanticizing lesbian sex. Close analysis, however, tells a different story. The sex scenes that now saturate lesbian culture, complete with leather, toys, and lipstick, are highly staged, use models (albeit often friends of the photographer), and aim to shock as much as titillate.

Corinne's work is very different. Showing real sex between real-life lovers, she is "interested in loving, beautiful, sexy images.... I also want the images to be a turn-on, create an adrenaline high, a rush of desire so intense that the act of looking is sexual." Stripped of the distancing effect of routine pornographic signifiers, Corinne's work becomes *more* challenging and takes more risks.

Yantras of Womanlove (1982) was the first book of lesbian erotic photographs ever published, and Corinne has been at the forefront of the fight against censorship. Printers have refused to handle her work, and community art galleries have declined to show it. The inclusiveness of her sex photographs also broke new ground. Fat women, women of color, and disabled women are presented to be gazed at with desire, lust, and pleasure. In the era before political correctness, this diversity was genuinely revolutionary.

Partly to protect the privacy of her models and partly to express the beauty and complexity of lesbian sex, Corinne's photographs often use solarization and repeat/reverse printing to produce kaleidoscopic images. At first glance these images are merely pretty, but closer study

reveals astonishingly explicit sexual activity. Their complexity and attractiveness take these blatant images of lesbian sex into places that staged S/M photographs cannot reach.

In 1985, *Yantras* was seized by New Zealand customs, but released by the Indecent Publications Tribunal on the ground that the abstractness of the photographs meant that even young children could glance at the book and not be corrupted! This "open hiddenness" is also a rich metaphor for lesbian sexuality itself—invisible unless you know what to look for, and then, suddenly, it has been there all along.

Combining technical skill in a variety of media, aesthetic inventiveness, and a sexual openness absent from much "bad girl" lesbian pornography, Tee Corinne invented a new language for lesbian sexual power.

In addition to her own original contributions to lesbian art and photography, Corinne has been tireless in supporting other lesbian artists. She writes about art for a variety of publications. A cofounder and past co-chair of the Gay & Lesbian Caucus (an affiliated society of the College Art Association), she is also a cofounder of the Lesbian & Bisexual Caucus of the Women's Caucus for Art. In 1991, she was chosen by *Lambda Book Report* as one of the fifty most influential lesbians and gay men of the decade.

— *Tamsin Wilton*

BIBLIOGRAPHY

Boffin, Tessa, and Jean Fraser, eds. *Stolen Glances: Lesbians Take Photographs*. London: Pandora, 1991.

Califia, Pat. *Sapphistry: The Book of Lesbian Sexuality*. Tallahassee: Naiad Press, 1988.

Corinne, Tee. *Labiaflowers: A Coloring Book*. Tallahassee: Naiad Press, 1981; also published as *The Cunt Coloring Book*. San Francisco: Last Gasp Press, 1988.

———, with Jacqueline Lapidus. *Yantras of Womanlove: Diagrams of Energy*. Tallahassee: Naiad Press, 1982.

———, et al. *Intimacies*. San Francisco: Last Gasp Press, 2001.

Penelope, Julia, and Susan Wolfe, eds. *Lesbian Culture: An Anthology*. Freedom, Calif.: The Crossing Press, 1993.

Wilton, Tamsin. *Finger-Licking Good: The Ins and Outs of Lesbian Sex*. London: Cassell, 1996.

SEE ALSO

American Art: Lesbian, Post-Stonewall; Censorship in the Arts; Contemporary Art; Erotic and Pornographic Art: Lesbian; Photography: Lesbian, Post-Stonewall

Day, F. Holland (1864–1933)

A<small>N AMERICAN INTELLECTUAL, PUBLISHER, AND AESTHETE,</small> Fred Holland Day belonged to a small, international group of early gay photographers of the male nude.

While Day's oeuvre is reasonably diverse, he is perhaps best known for two specific types of photograph, both of which center on the male body: pseudoreligious images, in which he and his male models reenact the suffering of Christ; and pictorial images, in which modernist visions of antiquity and preindustrial cultures play out in nature.

These photographs locate Day's work both within important turn-of-the-century intellectual movements and within the kindling of a photographic homoeroticism. In addition to their poetic composition and exquisite technical execution, Day's photographs are notable for how their erotic male subjects relate to *fin de siècle* cultural interests, Day's homosexuality, and the then-burgeoning medium of photography.

Day was born on July 23, 1864, the son of a wealthy Massachusetts merchant, and enjoyed a life of privilege. He was schooled privately, was well established in aristocratic, intellectual, and Decadent circles, and traveled abroad extensively.

Day's fortune allowed him to pursue a number of endeavors, including the obsessive collection of ephemera relating to his idol, the poet John Keats, and the founding of a Boston publishing house, which, under Day's direction, published the works of other early gay figureheads Oscar Wilde and Aubrey Beardsley.

While Day's first amateur picture may have been made as early as 1885, the first works to suggest his artistic proficiency in the medium do not appear before 1895. His commitment to the advancement of photography as a fine art and his enduring interest in form and composition allowed Day to excel as one of the great early American photographers. His signature soft focus and keen attention to light and shadow suggest a modernist approach and give his pictures a rich, dreamy texture, which gained the attention of his preeminent colleague Alfred Stieglitz.

Day belonged to the pictorial generation of photographers. In the midst of increasing industrialization, the proliferation of science, and turn-of-the-century morality, the pictorial photographers were interested in turning back to the pure beauty of nature and romanticized the simplicity of antiquity and what they perceived to be "less-civilized"—that is, nonwhite—cultures.

Ironically, until the pictorial photographers pushed for the medium's acceptance as an art form, the photograph was largely considered a novelty or a scientific tool of the very machine age they sought to deny. Through their ethnographic portraits of "primitive" peoples and their "pagan" depiction of the adolescent nude in nature, the pictorial photographers sought to capture a world that was aesthetically and materially antithetical, but of great interest to the white urban bourgeoisie.

While homoeroticism was not a defining aspect of the pictorial tradition, per se, the glorification of the young male body was particularly compatible with heady visions of pastoral life and dramatic throwbacks to an imagined, supple antiquity.

Similarly, Day's ethnographic portraits, such as "An Ethiopian Chief" or "Ebony and Ivory" (both 1897), in which he posed his black chauffeur in skimpy, pseudo-African costume, expressed both Day's interest in the male body and a mainstream discourse of colonial exoticism.

A related dynamic is at work in Day's series of 250 photographs of himself portraying "The Passions of Christ" (ca. 1898). The pictures in this series were hardly conceived as devotional emblems of faith; to the contrary, Day's images of a writhing, near-nude Christ, some of which actually depict the artist on the cross, and his equally suggestive St. Sebastian pictures of 1906,

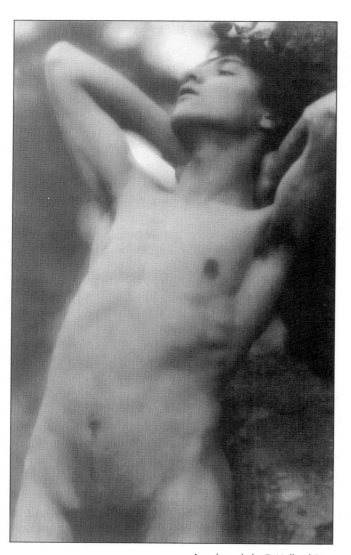

A male nude by F. Holland Day.

advance a wry, subversive homoeroticism with allusions to sadomasochism.

For Day and the members of his circle, the pictures were also a Decadent approach to the concept of suffering and a daring, sublime take on the Christ-figure. Nonetheless, the depiction of the sacred, much like the depiction of the classical, allowed the pictures to register also within mainstream bounds of acceptability.

At the same time, Day's Christian subject matter helped to promote photography as a fine art; his sacred images were praised as the photographic versions of great religious paintings, some works even being lent to an exhibition at a Boston church around 1900.

Accordingly, Day and other gay photographers working within these idioms, such as Baron Wilhelm von Gloeden, whose pictures Day published, produced homoerotic images in a complex social niche.

Their pictures of the exposed male body—whether in the context of Arcadian allegory or ethnic window-shopping—spoke mutually to different, but oddly compatible fantasies: homoerotic desire, spiritual abandon, and cultural otherness. Moreover, their potential for scandal placed them at the center of Victorian consciousness, which at once careened away from and thrived upon the existence of the profane.

Thus, while the impetus behind Day's work was largely homoerotic, it is impossible neatly to divorce the artist's sexuality from or totally reconcile it with the intellectual, cultural, and moral attitudes that characterize the *fin de siècle*.

In 1912, Day built a large house, which he called "The Chateau," on Little Good Harbor, Five Islands, Maine. Day conceived of Little Good Harbor as his own Arcadia, where he made many images of nude youths lounging amidst its picturesque landscape. Along with a cadre of other photographers, Day—white, affluent, educated, and well-connected—hosted there a number of impoverished boys, many of them immigrant workers from the urban slums of Boston. In addition to being Day's guests and enjoying a kind of summer camp, these boys modeled for Day's pagan compositions.

While Day is known to have taken philanthropic pride in mentoring many of the boys, training them in the craft of photography and preening them for social mobility, it is equally conceivable that his interest in poor immigrant boys and boys of color had to do with their social docility as well as their "exotic" beauty.

The conditions of his production are thus not without implications for the slanted power dynamics that often characterize erotic imagemaking and are further testimony to how the political climate of Day's time is manifest in his work.

— *Jason Goldman*

BIBLIOGRAPHY

Berman, Patricia G. "F. Holland Day and His 'Classical' Models: Summer Camp." *History of Photography* 18.4 (Winter 1994): 348–367.

Clattenburg, Ellen Fritz. *The Photographic Work of F. Holland Day.* Wellesley, Mass.: Wellesley College Museum, 1975.

Crump, James. "F. Holland Day: 'Sacred' Subjects and 'Greek Love.'" *History of Photography* 18.4 (Winter 1994): 322–333.

Curtis, Verna Posever, and Jane Van Nimmen, eds. *F. Holland Day, Selected Texts and Bibliography.* New York: G. K. Hall, 1995.

Jussim, Estelle. *Slave to Beauty: The Eccentric Life and Controversial Career of F. Holland Day, Photographer, Publisher, Aesthete.* Boston: David R. Godine, 1981.

Waugh, Thomas. *Hard to Imagine: Gay Male Eroticism in Photography and Film from Their Beginnings to Stonewall.* New York: Columbia, 1996.

SEE ALSO

American Art: Gay Male, 1900–1969; Beardsley, Aubrey; Erotic and Pornographic Art: Gay Male; Gloeden, Baron Wilhelm von; Photography: Gay Male, Pre-Stonewall; Subjects of the Visual Arts: St. Sebastian

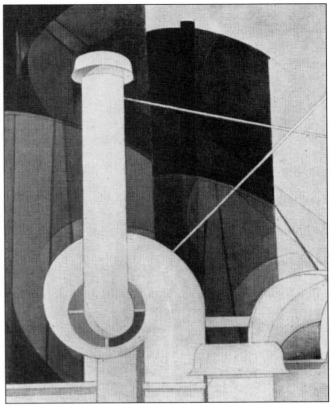

Pacquebot Paris by Charles Demuth.

Demuth, Charles *(1883–1935)*

ONE OF AMERICA'S FIRST MODERNIST PAINTERS, Charles Demuth was also one of the earliest artists in this country to expose his gay identity through forthright, positive depictions of homosexual desire. Demuth, the son of a successful merchant, had the financial freedom to pursue his artistic vision without debilitating regard for public opinion—concerning either aesthetics or sexuality—while his talent ensured that even the most provocative works were of unassailable quality.

Demuth was born on November 8, 1883, in Lancaster, Pennsylvania. From an early age, he suffered from frail health. He graduated from Franklin and Marshall Academy and studied painting at the Pennsylvania Academy of Fine Arts, where the realist tradition of former faculty member Thomas Eakins (himself a painter of major works of homoerotic content) prevailed.

Accordingly, Demuth began working in a realistic manner, but his early admiration for the Aestheticism of Aubrey Beardsley and Oscar Wilde predisposed him to a certain expressive stylization (not to mention liberal attitudes about sexual identity).

Demuth was exposed to Cubism and other pictorial innovations during a 1907 trip to Paris, lessons that were reinforced by subsequent visits to Alfred Steiglitz's New York City gallery, "291," a beachhead of modernism. In that context, Auguste Rodin's erotic figure studies and John Marin's expressionistic watercolors were particularly inspiring, and by 1912 Demuth's own work began to exhibit modernist characteristics.

In 1912, he commenced a relationship with fellow Lancasterian Robert Locher, who was to be his life partner.

A second trip to Paris, also in 1912, occasioned his lifelong friendship with Marsden Hartley, a gay painter slightly his senior, who introduced Demuth to expatriate American intellectuals and artists, among them Gertrude Stein, as well as gay European colleagues. Hartley also served as a stylistic mentor when Demuth began exploring abstraction later in the decade.

After returning to the United States in 1914, Demuth felt fully at home in New York's Greenwich Village bohemia and the summer artist colony of Provincetown, Massachusetts. When in the city, he attended salon gatherings in which Freudian psychoanalytic theories of sexuality were avidly debated, and he frequented Harlem nightclubs where prevailing racial and sexual boundaries were transgressed, often accompanied by his friend Marcel Duchamp, a Dadaist whose own artistic persona confused binary gender roles. In Provincetown, Demuth associated with leftist writers and artists committed to sexual liberation.

Little surprise, then, that his artwork began showing evidence of these unfettered environments. A watercolor series titled *Turkish Bath* (1916–1918), inspired by Manhattan's Lafayette Baths, insinuated the possibility of homosexual contact, the men's virile, mostly nude

bodies suggestively arranged together amidst phallic plumbing fixtures.

Moreover, one work from the series underscored Demuth's personal stake in such matters, showing himself naked and posed ambiguously before another bathhouse patron. Other series, such as those devoted to vaudeville and the circus (1917–1919), contained symbolic references to gay sexuality, while a work such as *Dancing Sailors* (1918) clearly shows latent erotic desire between men, even as they dance with women.

Demuth is best known for his many Precisionist paintings of the 1920s, works inspired by Cézanne's landscapes, Constructivist compositions and—closer to home—Hartley's abstractions, but his more significant historical contribution may be the audacious manner in which he responded to the homophobia that greeted his work *Distinguished Air* (1930).

Loosely interpreting Robert McAlmon's story of the same title, a story set in a Berlin "queer café," Demuth portrayed a situation at an exhibition opening, in which a male couple admires Constantin Brancusi's notoriously priapic sculpture, *Princess X*, while an ostensibly straight male gallery-goer admires the crotch of one of the gay men.

When several exhibitions refused to include *Distinguished Air*, Demuth responded by creating overtly homoerotic watercolors of sailors disrobing, fondling themselves, and even urinating in each other's company.

These works were executed during a two-year period near the end of his life, when a lifelong illness forced Demuth to leave his cosmopolitan surroundings and return to his conservative, small-town Pennsylvania birthplace. These works constitute a display of courage and self-respect that would not soon be repeated by other gay artists.

Demuth died on October 23, 1935, of complications from diabetes. He bequeathed his watercolors to Locher and his paintings to fellow artist and friend Georgia O'Keeffe.

— *Mark Allen Svede*

BIBLIOGRAPHY

Haskill, Barbara. *Charles Demuth.* New York: Whitney Museum of American Art with Harry N. Abrams, 1988.

Weinberg, Jonathan. "'Some Unknown Thing': The Illustrations of Charles Demuth." *Arts Magazine* 61 (December 1986): 14–21.

———. *Speaking for Vice: Homosexuality in the Art of Charles Demuth, Marsden Hartley, and the First American Avant-garde.* New Haven: Yale University Press, 1993.

SEE ALSO

American Art: Gay Male, 1900–1969; Beardsley, Aubrey; Censorship in the Arts; Duchamp, Marcel; Erotic and Pornographic Art: Gay Male; Hartley, Marsden; Subjects of the Visual Arts: Nude Males; Subjects of the Visual Arts: Prostitution; Subjects of the Visual Arts: Sailors and Soldiers

Dobell, Sir William (1899–1970)

WILLIAM DOBELL IS REGARDED BY MANY AS ONE OF Australia's greatest portrait painters. After a modest beginning to his artistic career, Dobell achieved legendary status in Australian art history with his controversial awarding of the 1944 Archibald prize, Australia's premier award for portraiture.

While Dobell's oeuvre is replete with homosexual subtexts, the artist spent his life hiding his sexuality from what was then a very conservative Sydney society, wary of the potential harm to his career that an open display of homosexuality could cause.

Born in New South Wales on September 24, 1899, Dobell grew up in a large family in a working-class suburb of Newcastle, two hours north of Sydney. As an adolescent he spent much of his time in pursuit of art, rather than young women. At the age of fourteen, he left Cooks Hill School, where art training was limited, to pursue a freehand drawing course at a local technical college. After taking up an apprenticeship with an architect in Newcastle, Dobell went to Sydney in 1924, where he worked as a draftsman and attended evening art classes at Julian Ashton's Sydney Art School.

Dobell's receipt of the Society of Artists Travelling Scholarship in 1929 allowed him to further his training at the Slade School of Art in London. Perhaps more importantly, from the perspective of his development as an artist, Dobell used London as a base from which he traveled to museums in Holland, Belgium, and Paris.

Dobell's painting *Boy at the Basin* (1932) is indicative of the influence of seventeenth-century Dutch painting on the young artist, especially the tight brushwork and sensitive use of light evinced in Vermeer's interiors. Many of Dobell's most important life studies of the male nude, including *Study, Boy on Beach* (1933), were also produced at this time, and suggest Dobell's delight in the physicality and sexuality of his male models.

On returning to Sydney in 1939, the still relatively unknown Dobell taught at East Sydney Technical College. With the outbreak of war, he took up a position with the Civil Construction Corps, becoming an unofficial war artist.

It was during this time that Dobell produced some of his most famous portraits. These include *The Cypriot* (1940), *The Strapper* (1941), and *The Billy Boy* (1943), the latter providing one of Dobell's most iconic references to homosexuality. The painting depicts the weighty torso of laborer Joseph Westcott, his flabby, pink flesh barely covered by a diaphanous, loose, white singlet.

In other paintings produced during the war, such as *Emergency Loading at Night, Perth* (1944), *Barrowman, Perth* (1944), and *Concrete Consolidation*

Workers, Sydney Graving Dock (1944), Dobell also idealized the masculinity of fellow Construction Corps workers. His paintings glorify the men's physical prowess, casting them as sexualized, heroic workers.

Dobell's receipt of the 1944 Archibald Prize for his *Portrait of Joshua Smith* made him an Australian household name. Even mainstream society, ordinarily uninterested in the politics of Australia's small artistic community, was intrigued by the often viciously personal debate initiated by the awarding of the prize to Dobell.

Trouble began when a cabal of conservative artists alleged that *Portrait of Joshua Smith* was a caricature, and therefore in breach of the stipulations of the Archibald Prize. The debate was finally settled, in Dobell's favor, by the courts. But the incident was pivotal in Australian art history, provoking a long overdue debate over questions of aesthetics.

The incident was also noteworthy because beneath a thin veneer of high-minded aesthetic discussion lurked a voyeuristic curiosity about the true nature of the relationship between Dobell and his sitter, Joshua Smith, a friend and fellow artist.

Traumatized by the intense public scrutiny of his personal life, in late 1944 Dobell retreated to the relative isolation of Wangi Wangi on the New South Wales central coast. He won the Archibald Prize two more times, in 1948 for his portrait of Margaret Olley and in 1959 for his portrait of Dr. E. G. MacMahon.

Recognition of Dobell's achievements came in 1964 when the Art Gallery of New South Wales presented a retrospective of his work. He was knighted in 1966, and died four years later on May 13, 1970. In accordance with the artist's wishes, much of his estate was used to establish The Sir William Dobell Foundation, an institution that continues to benefit and promote art in New South Wales.

— *Michelle Antoinette*

BIBLIOGRAPHY

Adams, Brian. *Portrait of an Artist: A Biography of William Dobell.* Melbourne: Hutchinson Group of Australia, 1983.

Gleeson, James. *William Dobell.* London: Thames and Hudson, 1964; revised ed., London: World of Art Library, Thames and Hudson, 1969.

Pearce, Barry. *William Dobell, 1899–1970: The Painter's Progress.* Sydney: Art Gallery of New South Wales, 1997.

SEE ALSO

Australian Art; Subjects of the Visual Arts: Nude Males

Donatello (1386 or 1387–1466)

THE MOST INVENTIVE, PROLIFIC SCULPTOR OF THE early Renaissance, Donatello was both technically versatile and adept at powerfully expressive effects. His varied oeuvre includes figures of beautiful male youths imbued with homoerotic sensuality.

Son of a wool-carder, Donatello was born Donato di Niccolò di Betto Bardi in 1386 or 1387. He moved up through the ranks of artisans working at the Florentine cathedral complex so that by 1408 he was carving full-size statues. Soon thereafter, guilds commissioned statues for another civic monument, the granary of Orsanmichele.

Florence's leading citizen Cosimo de' Medici became a patron and friend, enabling Donatello to make contacts with humanists and Italian courts. His renown spread and over a long life he catered to a variety of patrons, chiefly in Florence, Siena, and Padua.

Contemporaries praised Donatello for equaling the ancients and also singled out the vivacity and "lifelike" qualities of his figures. Much of the work was religious, and most figures were male, though he produced reliefs of an affectionate Madonna with the Christ child and carved in wood a harrowed, penitent Magdalene.

Whatever the subject, Donatello endowed narratives with great drama, and his figures were charged with a strong sense of presence as well as intense character. Many are introspective, brooding figures, put to mental and spiritual tests, though Donatello also produced groups of boyish spirits fervently engaged in music-playing and dancing.

While contemporaries noted that Donatello was unmarried and childless, paid no attention to his appearance, and spurned overly showy clothing, such comments were made in the conventional context of establishing the sculptor's single-minded devotion to his artistic practice.

Evidence about Donatello's sexuality comes from the sculptures themselves and from anecdotes collected around 1480, sometimes attributed to Poliziano. Seven of these anecdotes concern Donatello, who was renowned for a sharp wit and called "very tricky" (*intricato*) by the Duke of Mantua.

Three anecdotes eroticize Donatello's relations with apprentices. He hired especially beautiful boys, and "stained" them so that no one else would find them pleasing; when one assistant left after a quarrel, they made up by "laughing" at each other, a slang term for sex. Two of these anecdotes were omitted from some sixteenth-century editions, and the one on laughter was glossed as *licenzioso*.

H. W. Janson was the first scholar to relate these quips to the artist's sculpture. In 1957, he suggested that they illuminated the "strangely androgynous" bronze *David*.

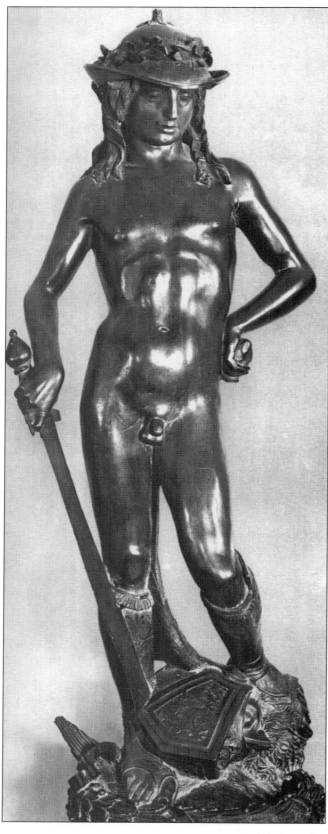

David by Donatello.

The first life-size nude statue of the Renaissance, the *David* is today often considered a homosexual icon. Whereas James Saslow in 1999 called it "a milestone in gay culture—a pederastic hymn to pagan ideals of bodily beauty and grace," fifteen years earlier another gay scholar, John Pope-Hennessy, wrote that homosexual interpretations left a "trail of slime on a great work of art."

Such extreme, anachronistic views are often applied to the statue, whether informed by notions of Freudian perversion or post-Stonewall identity politics. Homophobic and gay-friendly readings alike tend to regard the youth as cruelly punishing an aging, sodomitical Goliath.

Mainstream opinion focuses on the work's political valence, seeing it as celebrating republican liberty opposed to external tyranny, or proclaiming the Medicis' patriotic virtue. Others regard it as a syncretistic combination of Mercury with David, a Neoplatonic allegory of divine love, an epicurean statement about pleasure, or a purely spiritual and aesthetic object. First documented in the courtyard of the Medici palace during a wedding in 1469, even its dating remains uncertain, ranging between the late 1420s and the mid-1460s.

The bronze *David* is not isolated from Donatello's other work, nor is its eroticism unusual. Donatello's characteristic merging of classicism with naturalism is evident in the statue, as is an emphatic interior life. The youth luxuriates in a triumph equally seductive, religious, and political. The nudity, signifying divinely ordained victory against the armored foe, is accentuated by sensual use of bronze and by such elements as a large wing rising from Goliath's helmet, caressing David's thigh and ending at his buttocks.

In his *David* Donatello created a creature aware of his erotic power. A near-contemporary intimated uneasy recognition of this effect in 1504, calling the leg with the teasing feather "awkward" or "silly." Rather than any one aspect being exclusive of other possibilities, the statue is a multivalent mix of civic, dynastic, pious, philosophical, and erotic themes, ones that many female viewers could also appreciate.

More attention should be paid to sensuality in Donatello's other works, such as his exuberant putti, and the so-called *Atys/Amorino* (ca. 1440), a laughing boy-faun with exposed genitals. Clothed youths with a sensual appeal include the marble *David* (1408–1416), *St. George* (ca. 1415–1417), and *St. Louis of Toulouse* (ca. 1418–1422). In the mid-sixteenth century, the Florentine poet Lasca praised the *St. George* as an ideal substitute for a living boyfriend, providing constant amorous pleasure to his gaze.

— *Patricia Simons*

BIBLIOGRAPHY

Avery, Charles. "Donatello." *The Dictionary of Art.* Jane Turner, ed. New York: Grove, 1996. 9:122–132.

Janson, H. W. *The Sculpture of Donatello.* Princeton: Princeton University Press, 1963.

Kent, Dale. *Cosimo de' Medici and the Florentine Renaissance. The Patron's Oeuvre.* New Haven: Yale University Press, 2000.

Poliziano, Angelo. *Detti piacevoli.* Tiziano Zanato, ed. Rome: Istituto della Enciclopedia Italiana, 1983.

Saslow, James M. *Pictures and Passions: A History of Homosexuality in the Visual Arts.* New York: Viking, 1999.

SEE ALSO

European Art: Renaissance; Michelangelo Buonarroti; Subjects of the Visual Arts: David and Jonathan; Subjects of the Visual Arts: Nude Males

Duchamp, Marcel (1887–1968)

CONSIDERED A GENIUS BY SOME, AN IRREVERENT prankster by others, Marcel Duchamp was one of the most influential artists of the twentieth century.

Born on July 28, 1887, near Blainville, France, Henri-Robert-Marcel Duchamp revolutionized how modern art is conceived, made, and interpreted. Above all, his life and art reflect a desire to turn things upside down and to break down all linguistic, sexual, and social restraints.

Closely associated with many of the major artistic movements of his time (Futurism, Cubism, Surrealism, Dadaism), Duchamp never worked within a single aesthetic. He prized creative independence and developed a distinctive anti-art stance, believing that artistic standards of any kind are meaningless.

His best known works, the "ready-mades," challenge the definition of art itself. By displaying ordinary, mass-produced articles, such as a bicycle wheel or snow shovel (titled *In Advance of the Broken Arm*, 1915), Duchamp dissolved the boundaries between life and art. Stripped of their functional and commercial value, these mundane, everyday products when labeled and titled as art assumed a new, often sinister aura.

For Duchamp, a piece of art is its own reality, not a mere imitation of an existing one. His most notorious ready-made, *The Fountain* (a urinal, 1917), was originally rejected for exhibition by the Society of Independent Artists, an organization he helped to found, because of its indecency.

In the Dadaist spirit of revolt against art, morality, and society, Duchamp added a moustache and goatee to a photograph of Leonardo da Vinci's canonical *Mona Lisa*. Titled *L.H.O.O.Q.* (when read aloud in French, the letters suggest words that translate into "she has a hot ass"), this 1919 work epitomizes Duchamp's break with tradition.

Duchamp's artistic theories have been very influential on other artists and are sometimes seen as anticipating postmodernism. Pop artists, such as Andy Warhol, have been particularly influenced by Duchamp's provocative questioning of the nature of art, particularly the relationships between an original and a copy and between utilitarian objects and works labeled art.

Much of Duchamp's work challenges concepts of identity, gender, and sexuality. Later work is often signed "Rrose Sélavy," the name of his feminine alter-ego. Unsatisfied with one identity, Duchamp desired two. He went so far as to be photographed by his friend Man Ray in women's clothing.

Paintings such as his controversial *Nude Descending Staircase* (1912) or his large work on glass *The Bride Stripped Bare by her Bachelors, Even* (1915–1923), comment on the complex, possibly mechanistic, nature of sexual desire.

His final work is the culmination of this obsession. Although after 1923 Duchamp dedicated most of his time to chess, he spent the last twenty years of his life working on *Étant donnés* (1947–1968). In this piece, viewed by spying through peepholes in a wooden door, a nude woman with exposed privates is splayed on the ground. The peeping viewer is immediately complicit in the mysterious circumstances responsible for this questionably erotic pose.

Despite the provocative and explicit nature of his work, Duchamp valued the "beauty of indifference" in his private life. His enormous personal charm and easygoing nature attracted many female lovers but few passionate attachments. A brief marriage in 1927 shocked his friends and ended quickly in divorce. A second marriage to Alexina (Teeny) Sattler in 1954 lasted the rest of his life.

Although he lived much of his life in New York City (and became a United States citizen in 1955), Duchamp died in his homeland of France on October 1, 1968. Much of his work is now housed at the Philadelphia Museum of Art.

— *Julia Pastore*

BIBLIOGRAPHY

Hamilton, George Heard. *The Pelican History of Art: Painting and Sculpture in Europe 1880–1940.* New York: Viking Penguin, 1967.

Paz, Octavio. *Marcel Duchamp: Appearance Stripped Bare.* Rachel Phillips and Donald Gardner, trans. New York: Arcade, 1990.

Tomkins, Calvin. *Duchamp: A Biography.* New York: Henry Holt, 1996.

The Writing of Marcel Duchamp. Michael Sanouillet and Elmer Peterson, eds. New York: Da Capo Press, 1973.

SEE ALSO

European Art: Twentieth Century; Leonardo da Vinci; Pop Art; Subjects of the Visual Arts: Bicycles; Warhol, Andy

Duquesnoy, Jérôme (1602–1654)

FLEMISH ARTIST JÉRÔME (HIERONYMUS) DUQUESNOY was one of the most renowned sculptors of the seventeenth century, but for decades after his death he was better known for his conviction and execution on charges of sodomy than for his impish yet polished style of sculpture.

Born into a Brussels family of artists at the beginning of the seventeenth century, Jérôme Duquesnoy lived his first twenty years in the shadow of his famous father, Jérôme Duquesnoy the Elder (who recast the famous *Mannekin Pis*, 1619, the urinating boy that still stands as Brussels's signature fountain) and his brother François, who showed artistic promise at an early age.

Jérôme the Younger began his career as an apprentice in his father's workshop, but buoyed by both burgeoning talent and youthful enthusiasm, at the age of nineteen he joined his brother in Rome to study with some of the greatest artistic masters the Eternal City had to offer. Jérôme and François spent some time together studying and honing their craft, but the two brothers separated for reasons unknown soon after Antwerp painter Anton Van Dyck, Rubens's most celebrated pupil, visited them in Rome.

Duquesnoy reemerged in Spain, under the auspices of King Philip IV, who granted the young sculptor several important commissions. In 1642, news reached Jérôme that his brother was dying, and Jérôme hurried to his side. The two returned north, but François died en route, and for the rest of his life, ill-founded rumors plagued Duquesnoy that, in a jealous fit, he had poisoned his brother.

Returning to Brussels, Jérôme settled into life as an impulsive and incomparable talent, working not only as a sculptor but also as an engraver, goldsmith, and architect. This period marked the greatest activity of Jérôme's career, when he produced such famous works as *Ganymede and the Eagle of Jupiter* (ca. 1540–1545) and *Children and the Young Faun* (ca. 1542–1547). Many of Duquesnoy's works depict strong, muscled male figures in the Hellenic tradition, the polished bronze often seeming to mirror the sculptor's innate fondness for the form he was creating.

In 1654, Duquesnoy went to Ghent to fulfill several commissions, including what he hoped might be his masterpiece, the mausoleum of Antoine Triest, bishop of Ghent. According to Edmond de Busscher, a contemporary of Duquesnoy's: "He [Duquesnoy] set himself up with his assistants in one of the cathedral's chapels, to lay out and prepare the sections of this tomb, which could have been for the master the finest jewel in a new sculptural crown, had he not come to a sad end."

That end came on the heels of a persistent rumor circulating through conservative Ghent that Duquesnoy was "misusing" two young boys in the chapel where he was working. Incarcerated on accusations of sodomy, Duquesnoy vigorously denied the charges brought against him, but the two boys confirmed the rumors. Duquesnoy's family petitioned Archduke Leopold William for his release, and Duquesnoy himself wrote to his friend the King of Spain.

It was all for naught; the lords of the Privy Council of Ghent, on September 28, 1654, convicted Duquesnoy of sodomy and sentenced him to death. Bound to a stake in the Grain Market in the center of the city, Duquesnoy was strangled, his body reduced to ashes.

For centuries after his death, Duquesnoy's reputation was both tarnished and repressed, and it is only recently that his works have enjoyed critical attention. A sculptor of remarkable talent, Duquesnoy's vigorous body of work finally serves to celebrate that talent rather than stand as a reminder of the sad end to a very promising career.

— *Michael G. Cornelius*

BIBLIOGRAPHY

De Busscher, Edmond. "Les sculpteurs De Quesnoy, Delvaux, Calloigne." *Annales de la Société Royale des Beaux-Arts*. Ghent: 1877.

Dynes, Wayne R., and Stephen Donaldson, eds. "Jerome Duquesnoy the Younger: Two Studies." *Studies in Homosexuality: Homosexuality and Homosexuals in the Arts*. New York: Garland Publishing, 1992. 180–244.

SEE ALSO

European Art: Baroque; Subjects of the Visual Arts: Ganymede

Dureau, George (b. 1930)

ARTIST GEORGE DUREAU IS BEST KNOWN FOR HIS male figure studies and narrative paintings in oil and charcoal, and for his black-and-white photographs, which often feature street youths, dwarfs, and amputees.

He has had solo exhibitions of his work at galleries and museums in Paris, London, Houston, Los Angeles, Portland, Atlanta, and Washington, D.C., among other places. He even lived in New York for several months in 1966. But he is quintessentially a New Orleanian. He was born in the city and, except for brief hiatuses, has lived there his entire life.

As critic Kenneth Holditch observed some time ago, Dureau's art is "entwined with that mixture of contradictory elements that constitutes the carnal atmosphere of his native city. Perhaps this accounts to some extent for the paradoxes so distinctly a part of his best work: the joyful and painful, the beautiful and ugly, the spiritual and sensual, and most significant of all the real in

sharp juxtaposition to that which is vividly imagined. Dureau looks at life in its grandeur and grossness and his keen eye and sure hand do not wink or tremble at either extreme."

Dureau was born on December 28, 1930, to Clara Rosella Legett and George Valentine Dureau and was reared by his mother, grandmother, and aunts, one of whom taught him to paint. He attended Louisiana State University, where he received a B.A. in fine arts in 1952. After serving in the United States Army, he briefly attended Tulane University, where he studied architecture. He worked as an advertising and display manager for New Orleans department stores until he was able to support himself as an artist.

Dureau is notably versatile and works in a number of media. However, he has always been a representational artist. He acknowledges the influence of such Abstract Expressionists as Robert Motherwell, especially in the use of color, but he has steadfastly—even stubbornly—insisted on creating narrative and representational art, even when representationalism was unfashionable.

Dureau's versatility is evident in the variety of his creations, which range from major sculptural pieces such as the gates at the New Orleans Museum of Art and the pediment sculpture for Harrah's Casino in New Orleans to elegant posters for the Tennessee Williams Literary Festival and the New Orleans Jazz and Heritage Festival. He has also executed accomplished still lifes and landscapes. But his most persistent subject is the human figure, whether presented in narrative contexts, mythological fantasies, portraits and self-portraits, clothed or nude, painted or photographed.

One important part of Dureau's oeuvre is his canvases inspired by mythological figures and stories, such as *Doing the Pollaiolo at the New Firenze* (1997) or *Three Maenads and a Centaur* (1997). In these works, usually very large paintings, the figures are intricately posed, fully inhabiting the picture plane, rhythmically interacting with each other.

Many of these paintings, such as *The Poseurs Illuminate the Eighth Deadly Sin* (1997), are frankly homoerotic. All of them tell, or at least imply, interesting, often provocative, stories. Yet they are also slyly humorous, partly because the mythology is often potted and partly because they are presented whimsically. They might be sketches for a Mardi Gras *bal masqué*.

Because the mythological paintings often use the very same models Dureau uses in his portraits and photographs, the classical figures are anything but remote. Indeed, in these paintings, the heroic and the grotesque, the stereotypically beautiful and the deformed easily intermingle, with the real often interrogating or challenging the idealized. The mythological figures are never only symbols of the past. While they function to connect the present to the long ago, they are always also about the here and now.

Many of the nonmythological paintings, such as *Nude Beach* (1965) or *Reception with a Waiter* (1962), also imply provocative narratives. Even a portrait such as *Black Tie to Petronius* (1970), which depicts a handsome, long-haired, languid-eyed, sensuous-lipped young man in a tuxedo, becomes a narrative by virtue of its title, which alludes to a gay Mardi Gras krewe.

Dureau's charcoal drawings and black-and-white photographs are significant contributions to homoerotic art. While they often celebrate the obvious delights of the male body with a disarming frankness, they are also able to discover beauty and dignity in unexpected places. Dureau's subjects are a motley crew, including young street people, poor white and African American hustlers and athletes, dwarfs, and amputees.

In some cases, the series featuring Tony Brown or Otis Baptiste, for example, Dureau lovingly limns a young man's perfect physique, reveling in the heroic beauty and geometrical planes of the male figure. In others, however, such as his portraits of dwarfs or of legless young men, Dureau with the same unsentimental straightforwardness discovers dignity and beauty in them as well.

Dureau's photographs have often been compared with those of Robert Mapplethorpe. But the influence runs not from Mapplethorpe to Dureau but from Dureau to Mapplethorpe. The photographers were friends in the early 1970s. Mapplethorpe was greatly moved by Dureau's photographs, even to the point of restaging many of Dureau's earlier compositions.

For all their similarities, however, the photographs of Dureau and Mapplethorpe are quite different. Whereas Mapplethorpe exhibits his subjects as cool and objective, self-contained and remote icons, Dureau presents his as exposed and vulnerable, playful and needy, complex and entirely human individuals. The difference is foremost a matter of empathy.

In his photographs, as in his paintings, Dureau is not a detached observer. He conveys a deep artistic and psychological involvement with his subjects not merely as objects but also as human beings. Consequently, the photographs induce the viewer's involvement, evoking emotional as well as intellectual and aesthetic responses.

— *Claude J. Summers*

BIBLIOGRAPHY

Calas, Terrington. "George Dureau: The Figure in Excelsis." *George Dureau: Selected Works 1960–1977*. New Orleans: Contemporary Arts Center, 1977. 15–18.

Davis, Melody D. *The Male Nude in Contemporary Photography*. Philadelphia: Temple University Press, 1991.

Dureau, George. *George Dureau: New Orleans, Fifty Photographs*. Edward Lucie-Smith, ed. London: Gay Men's Press, 1985.

Ellenzweig, Allen. *The Homoerotic Photograph*. New York: Columbia University Press, 1992.

Gregg, Randy. "Before Mapplethorpe—Dureau Prefers Playing with Reality to Creating Perfection." *The Oregonian*, January 25, 1991. www.artroger.com/artists/dureau/review.htm

Holditch, W. Kenneth. "The World of George Dureau." *George Dureau: Selected Works 1960–1977*. New Orleans: Contemporary Arts Center, 1977. 3–5.

Lucie-Smith, Edward. *Sexuality in Western Art*. London: Thames and Hudson, 1991.

Pennington, Estill Curtis. "Out of the Past: The Figurative Dureau." *George Dureau*. New Orleans: Arthur Roger Gallery, 1997. 2–4.

SEE ALSO

American Art: Gay Male, Post-Stonewall; Mapplethorpe, Robert; Photography: Gay Male, Post-Stonewall; Subjects of the Visual Arts: Nude Males

Dürer, Albrecht (1471–1528)

C ONSIDERED ONE OF THE GREATEST GRAPHIC ARTISTS in history, Dürer elevated printmaking to the level of painting through his unprecedented use of line and value. His works frequently express sexual themes and homoeroticism.

Dürer was born on May 21, 1471, in the Imperial Free City of Nuremberg, the third of his parents' eighteen children. His father was a jeweler and goldsmith. He was educated at the Lateinschule in St. Lorenz and also trained as a goldsmith by his father.

In 1486, Dürer was apprenticed to the well-known Nuremberg artist Michael Wolgemut, from whom he learned the fundamentals of painting and printmaking. Dürer possessed an insatiable intellectual curiosity and traveled around Europe to broaden his artistic knowledge.

He toured northern Europe between 1490 and 1494 to acquaint himself with German and Flemish art, and in late 1494 and again between 1505 and 1507 he journeyed to Venice. Before his first trip to Venice, Dürer married Agnes Frey, with whom he had a childless and unhappy relationship.

In Venice Dürer absorbed Renaissance ideas and forms and developed his lifelong concern with the figure and its placement in space. Returning to Nuremberg from his first Venetian trip in 1495, Dürer synthesized German, Flemish, and Italian influences and laid the foundation for the northern Renaissance in his first major print series, the *Apocalypse* (1498).

For the next several decades, Dürer built his reputation with graphic works such as the *Large Passion* and *Small Passion* and the *Life of the Virgin*, which were published in 1511, as well as by accepting painting commissions.

During his final years, the artist became preoccupied with theoretical interests and published a book on mathematics for young artists, as well as the first of four books on human proportion. The other three books in the series were published after his death on April 6, 1528, in the city of Nuremberg.

While scholars have noted sexual themes in Dürer's canon, for example in *Large Horse* and *Small Horse*, both from 1505, none have explored the homoeroticism in his work in any depth.

Two letters, however, reveal that Dürer was aware of male–male sexual attraction and may have had a homosexual relationship. In a letter from Venice to his best friend, Willibald Pirckheimer, Dürer wittily comments that Pirckheimer would find pleasure in the beautiful Venetian soldiers running about. A few months later the Canon Lorenz Beham of Bamberg humorously writes to Pirckheimer that Dürer's "boy" surely does not like his beard. Unfortunately, Dürer and Beham do not

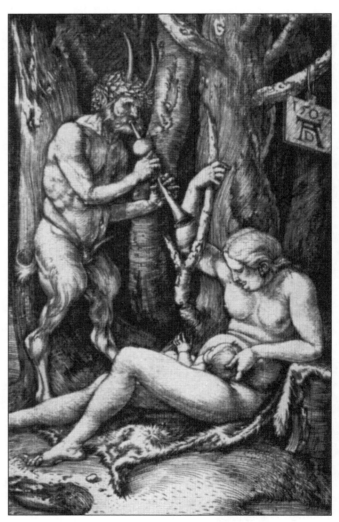

Die Satyrfamilie by Albrecht Dürer.

comment further or make any other homoerotic remarks in their respective letters.

Although written evidence regarding Dürer's sexual interests is limited to these two letters, Dürer's work substantiates the artist's interest in male–male sexual relations. In the *Men's Bath* (1497), for instance, Dürer depicts a group of men in a public bath suggestively grouped together and watched over by a male voyeur.

Dürer also treats homosexuality in the *Death of Orpheus* (1494), which portrays the musician's murder in a woodland by a group of Thracian women. The artist announces Orpheus's crime in a banderole, or scroll bearing an inscription, placed in a tree above the musician's head: "Orpheus, the first pederast." Dürer may have been influenced by contemporary Italian events that made homosexuality and its punishment popular topics of discussion.

Dürer also eroticizes Christ's last days on earth in his *Green Passion* series. In the *Betrayal of Christ* (1503?) from the *Green Passion*, Dürer portrays Christ and Judas preparing for an intimate kiss; while in *Christ Before Caiaphas* (1504) from the same series Caiaphas and a soldier gesticulate to the Savior's exaggerated groin. For these scenes Dürer may have found inspiration in other contemporary sexualized images of Christ, or he may have been motivated by mystical ideas in which a spiritual union with Christ was expressed in physical terms.

In addition to these three images, Dürer also produced other works with a variety of sexual themes and homoerotic content throughout his career, demonstrating that while he may or may not have had a homosexual relationship, he was certainly drawn to the idea of intimate male contact. — *Peter R. Griffith*

BIBLIOGRAPHY

Hutchison, Jane Campbell. *Albrecht Dürer.* Princeton, N.J.: Princeton University Press, 1990.

Panofsky, Erwin. *The Life and Art of Albrecht Dürer.* Princeton, N.J.: Princeton University Press, 1955.

Rupprich, Hans, ed. *Dürer Schriftlicher Nachlass.* Berlin: Deutscher Verein für Kunstwissenschaft, 1956.

Strauss, Walter L.. *The Complete Drawings of Albrecht Dürer.* 6 vols. New York: Abaris Books, 1974.

Strieder, Peter. "Dürer." *Dictionary of Art.* Jane S. Turner, ed. New York: Grove, 1993. 427–445.

SEE ALSO

European Art: Renaissance; Subjects of the Visual Arts: Nude Males; Subjects of the Visual Arts: Orpheus

Eakins, Thomas (1844–1916)

ALTHOUGH HIS PERSONAL SEXUAL PREFERENCE IS AN ongoing matter of discussion, painter and teacher Thomas Eakins is solidly aligned in the history of art with a homophile sensibility. Throughout his career Eakins sought to evoke a realistic classicism in his depictions and thus produced works that celebrated ideals of form, particularly the male figure.

Born on July 25, 1844, in Philadelphia and educated there, Eakins attended the École des Beaux-Arts in Paris from 1866 until 1870. It was there that the artist broadened his worldview and was introduced to photographic *académies*, or academic nude studies. He, in turn, introduced the genre to Philadelphia when he began teaching in 1873 at his alma mater, the Pennsylvania Academy of the Fine Arts.

Primarily a painter, Eakins soon also became an active maker of photographic nude studies to use as drawing aids in the classroom, a radically open policy that engendered loyalty from his students but harsh criticism from his academy colleagues.

In 1884, Eakins married Susan Macdowell (1851–1938), a musician and painter who would become his frequent model and photographer.

Nearly 40 percent of Eakins's photographic production was devoted to nude studies, and the images are classified into three groups: the "Naked Series," consisting of sequences of anatomical poses; the art historical

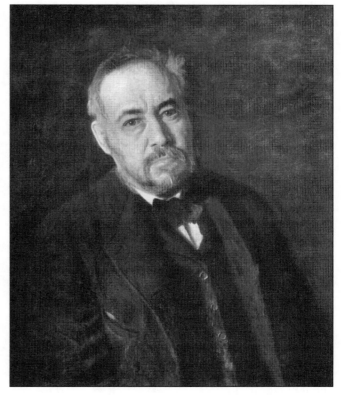

A self portrait by Thomas Eakins.

académies; and motion studies after the work of Eadweard Muybridge.

Eakins never intended his photographs to be viewed as works of art; they are thus, perhaps, more intimate than his paintings. Like many artists who used photography as a visual aid, Eakins was uninhibited in the kinds of images he made for this private consumption.

In his paintings and photographs, Eakins approached the body with classical ideals of male form and friendship, "beauty, fitness, and camaraderie," derived from Greek antiquity. During one outdoor excursion to Mill Creek, Pennsylvania, Eakins and his students made numerous photographic studies of one another, which would eventually be used to create one of Eakins's most famous paintings, *The Swimming Hole* (ca. 1883; Amon Carter Museum, Fort Worth). Photographic images from this excursion were also translated into his "Arcadia" series.

The Swimming Hole, which art historians believe to be a recreation of Plato's Academy, is widely cited as a prime example of homoeroticism in American art. In this seminal work, inspired by a section of Walt Whitman's "Song of Myself," Eakins pictures himself submerged in the water observing from the fringes a group of nude young males frolicking in the water.

That his most famous work should be inspired by Whitman is not coincidental, for Eakins's response to Whitman's work and, later, his relationship with the poet, were significant to his art. Eakins met Whitman in 1887; just weeks later, he painted his portrait (1888, Pennsylvania Academy of the Fine Arts). What Eakins shared with Whitman was an exuberant celebration of the human body and the beauty of nature.

A photographic figure study Eakins made in 1891 of the elderly Whitman relates directly to the painted portrait of 1888. Legend maintains that an infamous "Naked Series" group of a nude, elderly man depicts Whitman, but scholars still debate the claim.

According to Eakins, a naked woman "is the most beautiful thing there is—except a naked man." When he was promoted in 1876 to Director of Instruction at the Pennsylvania Academy of the Fine Arts, he gained control of the school's teaching curriculum and promptly based it on the nude figure, male and female. However, in 1886 Eakins lost his position because he promoted the nude image. More specifically, he was fired for allowing female students to view a nude male model in their life drawing classes.

Embittered by this devastating professional setback, but of independent means, Eakins continued to produce honest, uncompromising work and to teach in various institutions. However, he was not fully appreciated or understood. In his later years, he became somewhat withdrawn, and his work failed to achieve its proper recognition during his lifetime. — *Carla Williams*

BIBLIOGRAPHY

Berger, Martin A. *Man Made: Thomas Eakins and the Construction of Gilded Age Manhood.* Berkeley: University of California Press, 2000.

Bulger, Doreen, and Sarah Cash, eds. *Thomas Eakins and the Swimming Picture.* Fort Worth: Amon Carter Museum, 1996.

Danly, Susan, and Cheryl Leibold. *Eakins and the Photograph: Works by Thomas Eakins and His Circle in the Collection of the Pennsylvania Academy of the Fine Arts.* Washington and London: Smithsonian Institution Press, 1994.

Saslow, James M. *Pictures and Passions: A History of Homosexuality in the Visual Arts.* New York: Viking, 1999.

Sewell, Darrel. *Thomas Eakins.* New Haven: Yale University Press, 2001.

SEE ALSO

American Art: Gay Male, Nineteenth Century; Bazille, Jean-Frédéric; Erotic and Pornographic Art: Gay Male; Photography: Gay Male, Pre-Stonewall; Subjects of the Visual Arts: Bathing Scenes; Subjects of the Visual Arts: Nude Males

Edison, Laurie Toby *(b. 1942)*

L AURIE TOBY EDISON IS BEST KNOWN FOR THREE collections of photographic work featuring, respectively, fat nude women, nude men, and women in Japan. Each collection is characterized by the diversity of individuals pictured. Identifying as a bisexual, she has been active with queer activist organizations, including Queer Nation, and queer history groups.

Born on March 5, 1942, into an upper-middle-class Jewish family in New York City, she grew up in Manhattan and Queens. During her childhood, her father was a businessman, her mother a dress designer, and her grandmother a Greenwich Village jeweler.

Edison grew up among people who had concentration camp numbers tattooed on their arms and remembers being deeply affected by newspaper and magazine photographs of the piled-up naked bodies of Holocaust dead.

In her teens, Edison was influenced by her involvement in the Beat world in New York City, by Abstract Expressionist art, and by jazz music. She attended Wellesley College for one year (1958–1959).

Edison married twice and has a daughter from each marriage. During the 1960s, Edison co-owned The Waverly Shops in Provincetown and Sarasota, selling handcrafted jewelry. Since 1969, she has concentrated on crafting sculptural jewelry (for example, tide pools of precious stones surrounded by tiny ocean creatures). This work is especially prized by science fiction aficionados and continues to be her primary source of income.

Edison became involved in feminism in the 1970s and moved to San Francisco in 1980. Self-taught as a

photographer, she chose this medium as a way to produce work that would combine art and social activism.

In 1989, inspired by her involvement in the Fat Acceptance/Size movement, she began making black-and-white photographs of unclothed fat women. This series circulated in slide shows and exhibitions and was self-published in 1994 as *Women En Large: Images of Fat Nudes*.

In 1996, Edison began working on photographs for an exhibition and book of male nudes entitled *Familiar Men*, which was published in 2003. (Her images of nude men have a comfortable naturalness reminiscent of Diane Arbus's photos of nudists, but with a lyrical quality instead of the biting negativity of Arbus's work.

Edison's nudes need to be seen in the context of her early reaction to the images of the Holocaust dead. She attempts to transform those images into work that honors the living body. All of Edison's nudes are intimate, informative, and sensual without being sexual.

Text—in the form of commentary and narrative by the photographic subjects—is an integral part of both series of nudes.

In 1996, Edison's participation in Gender: Beyond Memory at the Tokyo Metropolitan Museum of Photography led to one-person exhibits in Japan and to another project, *Women of Japan*—a photographic essay of Japanese women from a wide variety of backgrounds and cultures.

Interviews with and essays about Edison's work have appeared in publications in the United States, Japan, Australia, the United Kingdom, and Canada. Her photographs are discussed in three Canadian and U.S. video documentaries and have been featured in exhibits in New York City, San Francisco, Seattle, Canada, Denmark, the United Kingdom, and Japan. In 2001, her photographs were the subject of a solo exhibition at the National Museum of Art, Osaka, Japan. — *Tee A. Corinne*

BIBLIOGRAPHY

Andrews, Donna. "Laurie Edison: Respecting the Beauty of Diversity." *Crescent Blues* 3.5 (2000): www.crescentblues.com/3_5issue/edison.shtml, 2000.

Corinne, Tee A. "A Weight Lifted." *Afterimage* 22.5 (1994): 10–11.

Edison, Laurie Toby, and Debbie Notkin. *Women En Large: Images of Fat Nudes.* San Francisco: Books in Focus, 1994.

Engley, Hollis L. "Plus Size Nudes Raise Eyebrows, 'Deep Fears.'" *The Denver Post*, September 28, 1994.

Notkin, Debbie. "Fat, Feminism, and Discarding the Unattainable Ideal." *The Future of the Body.* Takayuki Tatsumi, ed. Tokyo: Treville, 1998. 210–227. English translation available at www.candydarling.com/lte.

———. "Good Exposure." *Radiance, The Magazine for Large Women* (1994): 24–27, 34–35.

SEE ALSO

Photography: Lesbian, Post-Stonewall; Subjects of the Visual Arts: Nude Females

El Greco
(Domenikos Theotokopoulos) (1541–1614)

DOMENIKOS THEOTOKOPOULOS HAD ONE OF THE MOST unusual "career paths" of any Renaissance artist. In less than a decade, he transformed himself from a Byzantine icon painter into one of the most innovative artists of the western European Renaissance. His Spanish contemporaries readily acknowledged his diverse experiences by nicknaming him El Greco.

El—the Spanish word for "the"—recognized the circumstance that he became established as a prominent artist in Spain. *Greco*—the Italian word for "Greek"—indicated both his origins and the inspiration he drew from his study of Renaissance art in Italy.

Born in 1541 in Heraklion, Crete, Theotokopoulos was trained there in the Byzantine tradition. Before his twenty-fifth birthday, he had become the head of a highly successful workshop for the production of icons. His early paintings, such as *Saint Luke Painting the Virgin Mary* (early 1560s), closely correspond to standard Byzantine formulae.

In late 1567, El Greco emigrated to Venice, where he taught himself how to paint in the "modern" Italian Renaissance style through the independent study of major works by Titian, Tintoretto, and other leading artists. The *Pietà* (1575) and other works executed in Italy show his mastery of the bold, roughly textured brushwork characteristic of the Venetian school of painting.

Like other artists active in sixteenth-century Italy, El Greco sought to distinguish himself by inventing new and unusual interpretations of traditional religious subjects, as he did, for example, in the *Glorification of the Name of Jesus* (ca. 1576).

Unable to obtain prestigious, large-scale commissions in Italy, El Greco permanently emigrated to Spain at the end of 1576. Shortly after he arrived there, he undertook a series of nine altarpieces for the church of Santo Domingo el Antiguo in Toledo, including *Assumption of the Virgin* (1577), which is still recognized as one of his masterpieces. These works helped to establish his reputation as one of the leading artists in Spain.

Until his death in 1614, Theotokopoulos remained active in Toledo, where a supportive group of church officials gave him a steady stream of commissions. The spiritually charged atmosphere of this city is evoked in his dramatic *View of Toledo* (ca. 1610).

In his later years, Theotokopoulos devised a highly original manner by synthesizing Venetian methods of handling paint and Renaissance mastery of anatomy with elements inspired by his training as a Byzantine icon painter (flattened space, stylized gestures, and elongated proportions). The resulting altarpieces, such as *Virgin of the Immaculate Conception* (1607), ideally

responded to his patrons' need for emotionally powerful and distinctive treatments of important religious themes.

From statements recorded by his contemporaries and from his own writings, it is clear that Theotocoupolos fully subscribed to the Italian Renaissance conception of the artist as a genius, an exceptional individual whose life would inherently be of great interest to others. However, in contrast to most other adherents of this belief, Theotokopoulos rigorously concealed virtually all aspects of his personal life from the public gaze.

The one exception to the "closeting" of his affairs is the pride which he took in his son, Jorge Manuel Theotokopoli. In the *Burial of the Count of Orgaz* (1586), one of his most famous works, he included a portrait of his eight-year-old son, from whose pocket protrudes a handkerchief inscribed "Domenikos Theotokopoulos created me 1578" (the year of Jorge Manuel's birth).

Virtually all scholars have asserted that Theotokopoulos must have been heterosexual because he fathered Jorge Manuel, and they have invented all sorts of fantastic explanations to account for the fact that no information about Jorge Manuel's mother has ever come to light.

Thus, for example, it is maintained that the artist hid Jorge Manuel's mother in his house for her own protection because she was Jewish, a "crime" punishable by death in sixteenth-century Spain. More commonly, it is

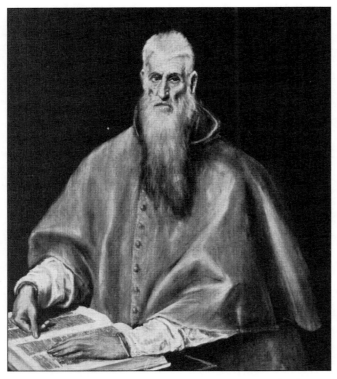

St. Jerome by El Greco.

asserted that the mother must have been the wife of a powerful aristocrat, from whom she sought to conceal her affair with the artist.

However, now that queer families are widely (if reluctantly) acknowledged by many people, it seems time to recognize that Jorge Manuel was raised by two fathers. Theotokopoulos never established a permanent relationship with Jorge Manuel's mother because he already had a life partner: Francesco Preboste (1554–1607).

Born in Italy, where he met Theotokopoulos, Preboste traveled with the artist to Spain and lived with him for the rest of his life. Numerous documents indicate that Theotokopoulos showed a remarkable degree of confidence in Preboste, entrusting him with a wide variety of artistic and financial matters. Preboste's legal authority to act in all matters on behalf of the artist has puzzled scholars who have insisted that he must have been "merely" a studio assistant.

Several subtle references in documents relating to El Greco's affairs hint at the closeness of their relationship, although we, of course, have no firm proof about what they did in the "matrimonial bed" listed in the detailed inventory of El Greco's estate. Because sodomy was routinely punished by execution in Counter-Reformation Spain, it is unlikely that any complete details of their relationship will be forthcoming.

El Greco's depictions of the nude male figure are infused with intense sensual energy, as one can note in examining his many paintings of such religious subjects as Saint Sebastian and Christ on the Cross, as well his occasional representations of mythological themes, such as *Laocoön* (1610).

In contrast, he depicted women with restraint and dignity, unusual among male Renaissance artists. In this regard, one can consider, in particular, his numerous images of Mary Magdalene, who was normally characterized as an object of erotic desire.

Although academic scholars have continued to insist on Theotokopoulos's strict heterosexuality, several avant-garde artists and writers, active in the mid-twentieth century, asserted that he was gay. Even the often homophobic Ernest Hemingway insisted that El Greco's homosexuality was the primary source of his great creative energy.

Jean Cocteau wrote a lavishly illustrated monograph on El Greco, in which he eloquently and passionately explained the homoerotic implications of his altarpieces. Cocteau later modeled his illustrations for Jean Genet's *Querelle* on paintings by Theotokopoulos.

Among other works inspired by this interpretation of the artist, one can note several of Cecil Beaton's homoerotic photographs, which are directly based upon the Renaissance artist's compositions.

— *Richard G. Mann*

BIBLIOGRAPHY

Brown, Jonathan, and Richard G. Mann. *Spanish Paintings of the Fifteenth through Nineteenth Centuries.* Cambridge: Cambridge University Press, 1992.

Cocteau, Jean. *Le Greco.* Paris: Au Divan, 1943.

Hemingway, Ernest. *Death in the Afternoon.* New York: Scribner's, 1932.

Mann, Richard G. *El Greco and His Patrons.* Cambridge: Cambridge University Press, 1989.

San Roman, Francisco de Borja. *El Greco en Toledo.* 1910. Reprint, Toledo: Zocodover, 1982.

Wethey, Harold. *El Greco and His School.* 2 volumes. Princeton, N. J.: Princeton University Press, 1962.

SEE ALSO

European Art: Renaissance; Subjects of the Visual Arts: Nude Males; Subjects of the Visual Arts: St. Sebastian; Beaton, Cecil

Elbe, Lili (1886–1931)

FOR MOST OF HER LIFE, LILI ELBE WAS BETTER KNOWN as Einar Wegener, a male Danish painter of some renown who specialized in landscapes and paintings of Paris. Indeed, it was not until well into adulthood, after she was both a successful artist and husband, that she began her transition to living full-time as female. Her series of sexual reassignment surgeries in the early twentieth century was a remarkable and pioneering feat, making her one of the world's first postoperative male-to-female transsexuals.

Einar was born in Denmark in 1886. He first met Gerda Wegener at art school in Copenhagen. The two budding artists fell in love at first sight. They married when Elbe was approximately twenty years old, and before she had any inkling of her true gender identity. Lili Elbe was "born" one day while filling in for Gerda's absentee model; Gerda asked Einar to wear stockings and heels so that she could substitute Einar's legs for those of her model. Einar felt surprisingly comfortable in the getup.

Later, the intended model showed up unexpectedly and dubbed Einar "Lili." Elbe, who later decided on her last name in tribute to the river she loved, continued to model for Gerda on a regular basis, and Gerda's numerous paintings of Elbe gained quite a bit of popularity in Copenhagen. Gerda was later invited to Paris to exhibit her works featuring Elbe, whom she introduced as Einar's sister. Gerda is still recognized as a significant Art Deco artist.

After Elbe's series of surgeries—she traveled from Copenhagen to Berlin and Dresden for four operations—she was able to obtain a passport issued under her female name and to have her marriage annulled by the King of Denmark himself. Two doctors had diagnosed Elbe as a homosexual before her surgeon in Dresden, a well-known German doctor who had suspected Elbe of being intersexed, claimed to discern the presence of rudimentary ovaries. Elbe's male sex organs were removed and then an ovarian tissue transplant was performed. The surgeries took their toll on Elbe, whose health began to decline.

Because Elbe felt that she and Einar were entirely different entities, she stopped painting altogether once she began her transition. Soon after the annulment of her marriage to Elbe, Gerda Wegener married a man who had been a mutual friend of hers and Einar's; Elbe herself accepted a proposal of marriage from another male friend of the former couple.

Elbe had intended to get married after undergoing a final operation to complete her transition; she hoped to become a mother at some point, and it appears that her doctor believed this was biologically possible through surgery. However, Elbe died of heart problems before the intended surgery and wedding, though not before her case had become a sensation in the pages of German and Danish newspapers in 1931.

Following Elbe's death, Ernst Ludwig Hathorn Jacobson, under the pseudonym Niels Hoyer, compiled a book, *Man Into Woman* (1933), based on the painter's life, using her letters and diary entries. The work is important as one of the earliest popular works to make a distinction between homosexuality and transsexuality, or, in contemporary theory, between sexual orientation and gender identity. It brought to the attention of many transsexuals the possibility of gender reassignment surgery, a process that was then in its infancy.

Elbe is also the subject of the award-winning novel *The Danish Girl*, by David Ebershoff, which was published in early 2000; a screen adaptation is in the works.

— *Teresa Theophano*

BIBLIOGRAPHY

Heidenreich, Linda. "Elbe, Lili." *Who's Who in Contemporary Gay and Lesbian History: From Antiquity to World War II.* Robert Aldrich and Garry Wotherspoon, eds. London: Routledge, 2001. 146–147.

Hoyer, Niels, ed. *Man Into Woman.* New York: Dutton, 1955.

SEE ALSO

European Art: Twentieth Century

Erotic and Pornographic Art: Gay Male

Given the historic stigma around making, circulating, and possessing overtly homoerotic images, the visual arts have been especially important for providing a socially sanctioned arena for the depiction of the naked male body. They have even allowed the suggestion of homoerotic desire and physical affection within acceptable cultural and moral boundaries. Even so, much of the history of homoerotic imagemaking may be characterized by calculated ambiguity, coding, denial, and underground circulation.

Although recent controversies and attempts at censorship may seem to suggest that the visual depiction of homoeroticism is a new phenomenon, the existence of numerous premodern (prior to ca. 1700) artworks that address homosexuality, either in the affirmative, as erotic records of homosexual delight and existence, or in the negative, as rhetorical blights against the love that dare not speak its name, suggests a long, complex, and variable relationship between homosexuality and the arts.

The Impact of Modernity on Visual Expressions of Homosexuality

As modernity brought colossal changes to the ways in which sexuality, and homosexuality in particular, is understood and experienced, so too did it severely impact visual expressions of homoeroticism. Although sex between men had been generally vilified and punished for centuries, the decades between 1890 and 1960 both found renewed disdain for homosexuality and witnessed the proliferation of coherent gay cultures, mindful of both gay pleasures and their policing by the larger society. The visual expressions of these cultures were either kept from the mainstream or engineered to circumvent its suspicions.

The broad, ideological shift away from sexual subterfuge and toward erotic openness, epitomized by the Stonewall riots of 1969 but underway well before and still in progress today, can be charted in the increasing sexual explicitness of homoerotic images as well as in advancements in their mass distribution.

Whereas the visual arts long served as a solitary, if inadequate and somewhat inaccessible, source of homoerotic imagery up until the mid-twentieth century, the increasing availability and commercialization of gay pornography in recent decades have made it the main cultural fount of explicit homoerotic pictures. Although the same may be said about the proliferation of heterosexual pornography, gay pornography plays a much more complex cultural role, given the stigma attached to homoerotic imagery of any sort.

Although contemporary gay artists have by no means abandoned eroticism altogether, many contemporary homoerotic artworks tend to comment on or complicate—rather than merely serve up—depictions of sex between men. By calling into question previously unchallenged constructions of race, desire, gender, and sexual identity, and by challenging conventional distinctions between "art," "erotica," and "porn," many contemporary queer artists articulate the postmodern pleasures of revision and subversion.

Reclaiming Homoerotic Art

Michelangelo's sculpture *David* (1501–1504) and Hippolyte Flandrin's *Figure d'Etude* (ca. 1835) are two prominent examples of artworks that present a complex issue in the study of homoerotic art: the reclaiming of artworks and artists from a presumed heterosexual context or existence.

Each work depicts a solitary male figure, naked, muscular, and youthful. David stands in a strong but elegant contrapposto pose, completely revealing his muscled body to the viewer, while the boy in Flandrin's picture sits, tucking his head between his folded legs and concealing his genitals from view.

Although both images are sensual, there is no concrete visual information contained in either artwork to suggest that either figure, the biblical hero David awaiting his enemy Goliath, or the boy posing in the artifice of the studio, is inclined specifically to or on display expressly for the erotic gratification of other men.

Yet, both of these artworks resonate throughout contemporary gay culture as icons of homoerotic desire—the monumental *David* has been often kitschified as a lofty ideal while the crouching pose of Flandrin's boy has been adapted by several gay artists and is reincarnated in countless gay-themed commercial images.

As these artworks and others like them began to be reproduced and widely published in the early 1900s, they became ideal masturbatory fodder for gay men during a time when illicit gay erotica was not readily available and risky to own or produce. That is, in addition to being visually stimulating, pictures of artworks like these also came with a ready alibi: the cultural auspices of high art could veil lustful interests with aesthetic ones.

Given the active erasure of homosexuality from popular historical awareness, contemporary queer art history can be characterized in part by an impulse to uncover, or reclaim, homosexual artworks and artists (among the latter, Michelangelo). The project of literally "looking for" gay bodies, gay stories, and gay sex in the art of bygone cultures is central to repairing a visual history in which homosexuality has been largely scrubbed away.

While it is important to unearth these artists and artworks from a presumed or enforced heterosexual context, and although it is clear that many early-modern

works are related to contemporary queer artworks and can themselves carry erotic significance in contemporary gay culture, it is also important to be mindful that they hail from times and societies very different from our own.

The visual depiction of homoeroticism exists at various points and in various cultures throughout history, but the cultural significance of that eroticism, the means by which it is communicated, and the social consequences of its depiction are vastly diverse. Scenes of men having sex and homoerotic narratives appear in the art of ancient Greece, the Persian Empire, the Renaissance, and many places in between, long before the arrival of modern ideas about what it means to be gay. These early depictions of sexual experiences shared between men are essential records of homosexuality's longevity, but also of its social mutability.

The Greek Precedent

The homoerotic art of ancient Greece is central to the visual history of homosexuality in the West. As a culture whose upper-class adult male citizens engaged in socially sanctioned pederastic relationships with younger boys, the ancient Greeks stand out as early makers of homoerotic artworks.

A number of surviving artifacts—mainly painted vessels—expound on the pleasures and rituals surrounding the older mentor's seduction of his nubile young muse, while a number of sculptures reveal a broad cultural admiration of the athletic male body.

Homoeroticism is also a prominent theme in artworks about mythology: images of Bacchus, the wine god, and his bisexual trysts; the rape of young Ganymede by Jupiter; and the hedonistic orgies of male satyrs all depict same-sex lust with varying degrees of explicitness.

In addition to being among the earliest artworks to depict elaborate homosexual practices and relationships, these works are also important for how their narratives and formal values have inspired, and in many cases legitimized, subsequent homoerotic artworks.

During the Renaissance, classical themes were employed by many artists, but the classical idolization of the nude male and certain homoerotic fables from classical mythology were especially suited to the erotic tastes of the nascent homosexual (or, in the parlance of the day, sodomite) subcultures in cities such as Florence.

Centuries later, gay photographers and painters would similarly look to Greek culture for a romanticized example of tolerated homosexuality, and to Greek artistic traditions to rationalize their own homoerotic expressions.

Starting in the mid-nineteenth century, compositions of scenes from mythology, and more generalized renditions of men in wholesome Arcadian activities, including bathing, lounging in nature, or playing a sport, garnered cultural cachet with vague, nostalgic references

to ancient ideals while also leaving room for homoerotic possibility.

For example, the work of the American realist painter Thomas Eakins (1844–1916) exhibits a strong, yet culturally acceptable interest in nude boys and virile male athletes. Eakins's *The Swimming Hole* (1893–1895) is a particularly good example of how the pseudo-Grecian pretext could be adapted to current artistic and social concerns (in this case, Realism), but retain homoerotic appeal, allowing for two disparate narratives to be rendered in the same visual terms.

The painting depicts two men and four boys (plus the requisite dog) bathing in the great outdoors, reveling in their unashamed, supple nudity. The work simultaneously evokes forthright ideals of nature, democracy, cleanliness, and platonic camaraderie, as well as the homoerotic promise of a cadre of naked male subjects, one of whom represents the painter.

Other artists, such as the German photographer Baron Wilhelm von Gloeden (1856–1931), employed the Grecian pretext more literally, staging nude boy models in "classic" poses and with garlands or skimpy togas.

While allusions to ancient Greece in the homoerotic art of the *fin de siècle* by no means completely safeguarded it from the censorious morality of the mainstream, it is clear that Grecian themes provided for both considerable social allowance and homoerotic potential.

A similar double-edged effect was also achieved with religious subjects such as Christ and St. Sebastian.

Homoerotic Greek art is also important for how it documents a number of ideals for gay male beauty and desirability that persist to this day. For example, the unparalleled attractiveness of the smooth youth first rendered here has become a standard visual convention and telling psychological emblem in several subsequent generations of homoerotic art.

For the ancient Greeks, the centrality of the younger subject was in part a matter of social decorum: homosexual relationships between adult men were less acceptable. However, it is clear that this emphasis on youth is still entrenched in contemporary hierarchies of gay desire.

Similarly, as ideas and images of "Greek love" were adapted to modern homosexual sensibilities, so too were they co-opted by modern notions of race and history, which tend to classify the ancient Greeks as white but also think of them as culturally exotic; their civilized (that is, white) virtue coexists with traces of pagan indulgence.

Accordingly, visual allusions to Greek homoeroticism often simultaneously promote a myth about the paramount desirability of white bodies, but find "darker" pleasures in their pagan hedonism—a construct that reveals the Anglocentric and racist underpinnings often at work in homoerotic art.

Veiling, Coding, Pretext, and Ambiguity

While the pictorial conventions and subjects of homo-erotic Greek art have been widely adopted, its prolific, aboveboard existence in the first place constitutes a major exception in the history of homoerotic art. The usually deviant status of homosexuality has largely required that any affirmative depiction of it be carefully handled.

If art was to be made that expressed homoerotic interest in the male body, or worse, suggested sexual acts or sexual attraction between two or more male subjects, that art would either have to remain private, circulating only among gay men and their cohorts, or artists would have to employ several tactics to code their work, making its erotic content legible to other gay viewers but passable in the mainstream.

Much as people with deviant sexual interests have historically had to hide their erotic lives from the oppressive mainstream, so did artists have to employ strategies of veiling, coding, deliberate ambiguity, and false pretexts.

These tactics are especially prominent in the early decades of the twentieth century, as small European and American homosexual subcultures, which had been forming in urban centers in some capacity since the eighteenth century, continued to develop.

Public openness about homosexuality, to say nothing of making pictures of men engaged in homosexual activity, was cause for scandal or imprisonment. Nevertheless, the erotic possibilities facilitated by these emerging pockets of urban homosexuality became the topic of a handful of artists.

The works of American painters Charles Demuth (1883–1935) and Paul Cadmus (1904–1999) are particularly good examples.

Some of Demuth's works (such as *Three Sailors on the Beach*, 1930) show men having sex outright and were not exhibited publicly in the artist's lifetime, while others, such as those in his *Eight O'Clock* series (1917), can be read as either platonic pictures of urban homosocial domesticity or, for those who are able to read their erotic nuances, windows onto the lives of male lovers.

The coy title of Demuth's *Three Sailors Urinating* (1930) reveals the flimsy double narratives often at work in his pictures; *On "That" Street* (1932), whose title serves as a euphemism for a gay cruising area, depicts an outwardly innocent scene of a homosexual dandy in the midst of two boyish sailors.

Sailors and gaunt dandies—the latter characterized as the fashionable, swishy, and effeminate homosexual of these new gay ghettos—also appear in Paul Cadmus's early paintings. Although these works may outwardly seem to depict only drunken, debauched, straight sailors and wanton women, the subtle presence of the dandy at the margins of Cadmus's pictures indicates a submerged erotic narrative.

The dandy (or fairy), with his dapper suits and tell-all red tie, which was then a street symbol of homosexuality, subtly signifies for what audience the muscled sailors are really on display.

The use of insider knowledge in artworks such as these signals both an increasingly codified gay culture and continued vigilance at once to reveal and to hide its very existence. Accordingly, although illicit same-sex pornography had been made by the 1930s in small, risk-laden underground networks, erotic openness in emerging art, which was subject to scrutiny by patrons and the public, remained limited.

These tactics for simultaneously displaying and refuting homoeroticism would be epitomized—and eventually worn thin—by the physique magazines of the 1950s and 1960s, whose G-stringed beefcake models were supposedly on display for the wholesome appreciation of fitness enthusiasts or, not insignificantly, as anatomical references for figurative artists.

Over time, certain titles became more explicit, revealing their homoerotic motivations, while others continued to capitalize on the mystifying lingo of the "physique enthusiast" to veil (however thinly) their brawny eye candy.

Featuring both photographs and highly stylized drawings, the physique magazines conveyed an interest in what would soon become two distinct breeds of gay erotica: the photochemical media, which are thought to capture the raw authenticity of bodies and sexual acts, and handmade renderings, which can exaggerate and fetishize more freely.

Moreover, unlike painting or sculpture, which (reproductions notwithstanding) are relatively inaccessible media, photography and illustration are more conceptually geared toward the masses—fitting media for the newly emerging gay consumer who could purchase physique paraphernalia through the mail or at the newsstand.

Tom of Finland (Touko Laaksonen, 1920–1991), arguably the most widely celebrated maker of homoerotic art to date, would come to popularize the hand-drawn dirty picture. At first adhering to the soft-core ambiguity of the physique genre, Tom of Finland later brought new "girth" to homoerotic explicitness with his raunchy pictures of impossibly muscled and colossally endowed subjects: domineering soldiers, randy sailors, mischievous cops, and leather-clad bikers. Gone are the heavy-handed allusions to bygone Greek ephebes, ambiguous sensuality, platonic friendship, or old-world tropes of any kind.

No matter how physically reproportioned, Tom's men reign from contemporary life and employ twentieth-century narratives, locating gay lust not in a hazy, imagined past, but in an accessible (if highly exaggerated) present.

While Tom of Finland may not uniformly represent the interests of gay artists of his time, his work is emblematic of a number of major shifts—from ambiguous to explicit, from historical allegory to contemporary narrative, from delicate youths to virile hunks, from high art to popular smut—that prefigure a new era of explicitness, capped by the rise of commercial gay pornography and its imminent detachment from gay artistic production.

Contemporary Issues

Starting in the 1970s, gay and lesbian civil rights groups began to make inroads against oppression and homophobia, pushing for visibility and working to lessen the stigma long associated with homosexuality and images of it.

Within the last decade, as a number of lesbian, gay, bisexual, and transgendered political groups have turned away from more radical politics to seek out the acceptance of the mainstream, the most tolerated images of homosexuality are those that adhere to heterosexual models for normative gender, monogamy, family, domesticity, and decency, and that downplay the carnal pleasures of their subjects.

But this mainstreaming of homosexuality does not account for the entire picture: "Less palatable" homoerotic cultural products (including art, but also television shows, films, and the like) are still often held to higher levels of moral scrutiny than their heterosexual counterparts and encounter a disproportionate amount of censorship and backlash.

Even contemporary homoerotic artworks whose subjects or motivations are not overtly political can generate considerable political shockwaves when exhibited publicly—such is the case of Robert Mapplethorpe (1946–1986), whose explicit photographs of S/M scenes incited public outcry and fueled tremendous backlash from conservative legislators and religious leaders in the 1970s and 1980s.

Also beginning in the 1970s, gay commercial pornography began to proliferate, first in magazines and adult theaters and eventually into its present multimedia ubiquity, taking over much of the erotic functionality that homoerotic artworks had long quietly performed for those with access to them.

Although there always may have been an invisible audience for homoerotic images, a commercially lucrative demographic of gay men was identified in the 1970s, and emerging technologies of mass distribution and shifting social mores made possible its targeting by an emerging porn industry. The allure of bona fide pornography easily surpassed the erotic table scraps that artworks had previously made available.

The seemingly endless supply and increasing accessibility of gay pornography has dramatically altered the landscape in which gay artists work. Indeed, in postmodern style, it is not uncommon for gay artists to create a dialogue with the gay pornography industry by employing its aesthetic vocabulary in their own work.

Much as AIDS deeply impacted the public and private erotic lives of gay men in a diversity of ways, it also wrought a number of changes in visual expressions of homoeroticism. In the midst of great suffering, loss, and mainstream complacency, many gay artists directed their work toward activism and the public while others focused on personal lamentations of friends and lovers.

Generally, the randy, sexually charged tone that characterized a good deal of homoerotic art in the decades before the 1980s was now greatly complicated by widely felt emotional turmoil around the consequences of sex between men. Loathe to accept that the emergence of AIDS meant the end of taking pleasure in male bodies or pictures of them, many artists adopted a meditative tone, trying to reconcile enthusiasm for gay sex with its new risks, necessary precautions, and various emotional entanglements.

— *Jason Goldman*

BIBLIOGRAPHY

Camille, Michael. "The Abject Gaze and the Homosexual Body: Flandrin's Figure d'Etude." *Gay and Lesbian Studies in Art History*. Whitney Davis, ed. Binghamton, N.Y.: Harrington Park Press, 1994. 161–188.

Chauncey, George. *Gay New York: Gender, Urban Culture, and the Making of the Gay Male World, 1890–1940*. New York: Basic Books, 1994.

Cooper, Emmanuel. *The Sexual Perspective: Homosexuality and Art in the Last 100 Years in the West*. New York: Routledge, 1994.

Harris, Daniel. *The Rise and Fall of Gay Culture*. New York: Ballantine Books, 1997.

Horne, Peter, and Reina Lewis, eds. *Outlooks: Lesbian and Gay Sexualities and Visual Cultures*. New York: Routledge, 1996.

Saslow, James M. *Pictures and Passions: A History of Homosexuality in the Visual Arts*. New York: Penguin, 1999.

Waugh, Thomas. *Hard to Imagine: Gay Male Eroticism in Photography and Film from Their Beginnings to Stonewall*. New York: Columbia University Press, 1996.

Weinberg, Jonathan. *Speaking for Vice: Homosexuality in the Art of Charles Demuth, Marsden Hartley and the First American Avant-Garde*. New Haven: Yale University Press, 1993.

SEE ALSO

American Art: Gay Male, 1900–1969; Censorship in the Arts; Classical Art; Photography: Gay Male, Pre-Stonewall; Photography: Gay Male, Post-Stonewall; Cadmus, Paul; Demuth, Charles; Eakins, Thomas; Flandrin, Hippolyte; Gloeden, Baron Wilhelm von; Mapplethorpe, Robert; Michelangelo Buonarroti; Subjects of the Visual Arts: Ganymede; Subjects of the Visual Arts: Nude Males; Subjects of the Visual Arts: St. Sebastian; Tom of Finland

Erotic and Pornographic Art: Lesbian

LESBIANS WHO WANT TO PRODUCE EROTIC ART FOR THE enjoyment of other lesbians face a unique set of problems. Until very recently the world of European "high" art was the exclusive preserve of men, both as producers and as consumers, and this was especially so for erotic imagery.

The exclusion of women artists and the lack of female patrons continue to shape the fine arts today, and lesbian erotic art in particular. For example, the continuing male domination of art schools means, simply, that there are fewer gifted lesbian artists. This may be one reason why lesbian erotic art is dominated by photography, where a set of technical skills may be easily mastered without admission to art school.

The Mystery of Female Desire

For centuries, female sexuality in European culture was policed and repressed with extraordinary rigor. Inevitably the imagery, codes, and signifying systems of erotic art were developed by men (whatever their sexual preference) to arouse other men. One legacy of this repression is that far less is known about the history of female desire than about male desire; another is that women's desire remains relatively mysterious even today.

The commercial failure of soft porn magazines aimed at heterosexual women suggests that there is widespread ignorance about what arouses women, and a substantial body of sexological research suggests that this ignorance extends to women themselves.

Considering that lesbians are subject to even more severe sexual suppression than nonlesbian women, it is remarkable that so much lesbian erotica has been produced in so brief a time.

The Male Gaze

Many influential commentators follow John Berger in arguing that centuries of gender inequality in wealth, status, and sexual autonomy mean that while men are free to look, evaluate, and choose sexual partners, women's sexuality is restricted to narcissistic *self*-evaluation in order to attract men.

In the shorthand of cultural studies, "the gaze is male." This belief makes it difficult to conceive of pornography for anything other than a male audience, of whatever sexuality. Moreover, the routine use of girl-on-girl imagery for male titillation, whether in old-master oil paintings of classical mythology or "lesbo" centerfolds in top-shelf men's magazines, makes it particularly difficult for lesbians to achieve a sense of ownership of sexually explicit lesbian art.

Before the development of photography only a minority of wealthy men had access to intentionally arousing images, but rapid developments in the reproduction and dissemination of visual material, especially via the Internet, means that most individuals in industrialized nations will be familiar with the semiotic codes of male sexuality.

Lesbian erotic art, therefore, has to choose whether to adopt these codes or to construct some kind of alternative erotic language.

Production of Erotic Art by Lesbians for Lesbians

The production of erotic art by lesbians for lesbians is relatively recent, and depended on women achieving some kind of economic independence. The wealthy lesbians of the Left Bank in Paris, for example, were only able to live as they chose because of their class privilege.

Although the conventions of the time meant that they produced little that may be thought of as erotica, the lesbian artists who flocked to Paris in the 1920s and 1930s did begin to develop an iconography that reflected their own sexual culture. The paintings and drawings of Romaine Brooks and Djuna Barnes's ink drawings in the style of Beardsley, for example, breathe a self-consciously "perverse" eroticism that fitted in well with contemporary notions of what it meant to be a lesbian.

Thirty years later, the Argentine-born lesbian surrealist Léonor Fini painted a world from which men are excluded (although their body parts sometimes appear in parcels or glass cauldrons) and in which lesbian sex is presented with electric intensity. Hers are among the earliest images that may appropriately be termed lesbian erotic art, and her 1966 painting of women making love in a train, *Le Long du Chemin*, remains probably the most widely known erotic image painted by a lesbian.

Lesbian Feminist Art

The "second wave" of feminism after World War II gave rise to a trenchant critique of the sexual objectification of women. Many lesbian artists went to great lengths to produce images that would celebrate the naked female body without recourse to the conventions of male pornography.

Monica Sjoo in England and Sudie Rakusin in the United States are in this tradition. Both celebrate lesbian identity by producing stylized images of female archetypes. Although some feminist critics argue that artistic ability is a patriarchal concept that should be ignored, the work produced by Sjoo and Rakusin is so weak aesthetically that it never made much of an impact outside small lesbian feminist communities.

Frank sexuality begins to appear in the 1970s in the work of lesbian feminist photographers, such as Cynthia MacAdams, whose "Rising Goddess" series of nudes manages to express both sensuality and desire. However, MacAdams's work is often (not always) derivative, and her nude studies of young girls, innocent in the context of the time, would cause outrage if published today.

The undoubted star of lesbian feminist erotic art is Tee Corinne, whose defiant insistence that lesbian liberation must include sexual liberation broke new ground.

Corinne's detailed and loving visual exploration of women's genitals, genuinely shocking at the time, made a powerful statement in a context where such images were taboo, and offered lesbians an unfamiliar opportunity to enjoy the desiring "gaze" in freedom. Corinne's *Yantras of Womanlove*, published by Naiad Press in 1982, was the first-ever book of lesbian sex photographs, predating Della Grace's *Love Bites* by nine years.

Lesbian Erotic Iconography

In contrast to such attempts to devise a uniquely lesbian erotic iconography free from patriarchal contamination, some lesbians responded to the pornography debate by consciously reworking established pornographic codes.

Since these "sex-radical dykes" largely identified with the sadomasochistic community, the codes used depended heavily on S/M iconography, including leather, basques, stilettos, suspenders, and bondage paraphernalia. Critics insisted that such imagery could not be divorced from its sexist, often racist, origins. Nevertheless, whether because it "works" politically or sexually, or because it appeals to heterosexual white men, this genre has recently become the dominant one in lesbian pornography.

Adopting Established Codes

Artists who adopt the established codes from either gay or straight men's pornography may do so in ways that strive to wrest control of the gaze from men.

Photographer Della Grace, for example, conscious of the exploitation of women in heterosexual pornography, has explored different ways of confronting this problem in her work. One exhibition of her staged sex photographs featured audiotapes of the models talking about their feelings during the shoot, and she went on to photograph herself in explicit sexual scenarios, shutter-release bulb visibly in shot.

Others may parody the traditional codes of male pornography, may use them ironically, or may attempt to subvert them by incorporating them into butch–femme role play. For example, English photographer Tessa Boffin reworks the classic tale of the sex-hungry sailor and the tart by reversing the gender of the protagonists. Morgan Gwenwald's photographic sequence of a lesbian couple in butch–femme drag, playing out staged sex scenes in New York's Central Park, exploits the iconography of sleazy heterosexuality. Similarly, her shot of a femme in lacy bra unzipping the fly of her butch to reveal a disconcertingly lifelike silicone penis is both an ironic comment on the "lesbian phallus" and a knowing reference to lesbian sexual pleasures.

Politics and the Sex Wars

The contextual problems of lesbian erotica mean that it seldom attains the unselfconscious raunchiness of gay men's pornography. Much sexually explicit lesbian art is intellectual, ironic, or overtly political in a way that is not the case for other pornographic traditions.

Lesbian erotica must also be seen in the context of the "sex wars," which split feminists into two groups: those who believe sexually explicit imagery to be irrevocably contaminated by sexism and others who insist that sexual exploration is central to women's liberation. This conflict led to the development of a unique phenomenon that might best be described as "agitporn," whereby lesbians used painting, photography, and performance to push the boundaries of representation of lesbian sexuality and challenge pro-censorship feminists.

The best example of this phenomenon is the Canadian collective Kiss & Tell. This trio of lesbians, Susan Stewart, Persimmon Blackbridge, and Lizard Jones, set out deliberately to challenge both feminist and state-sponsored censorship by producing explicit photographic images exploring lesbian sexuality.

For their participatory exhibition Drawing the Line, which toured Canada, the United States, and Australia in 1988, Kiss & Tell asked viewers to write comments on the walls alongside the images (men wrote theirs in a book in the center of the gallery), and these comments were then published with a selection of the photographs in a pull-out postcard book.

The last card in the book was self-addressed to the collective, and encouraged readers to contribute their own comments. This combination of encouraging sexual arousal along with democratic participation in political debate is unique to lesbian sex art.

The Power of Lesbian Sexuality

Many argue that lesbian sexuality has been so effectively erased from cultural production that any image of women arousing or pleasuring each other is radical. The appropriation of fetish-chic by the mainstream in the 1990s brought the dildo-wielding, shaved, and pierced dyke into the fast lane of popular culture and even onto the catwalk. But such images compose the minority of lesbian erotica, the bulk of which is far simpler and more straightforward.

Stripped of all pornographic signifiers, "real life" lesbians of all shapes, sizes, colors, ethnicities, and (dis)abilities enjoy the ordinary pleasures of lesbian sex. The power of such images is deceptive. To show a woman clearly getting off on rimming her partner, as Jill Posener does in *1988: Untitled* (1988), or two young black women kissing with obvious passion, as in Katie Niles's *1978: Untitled* (1978), is to show what the heterosexual mainstream wishes to keep secret—the simple

fact that women, whatever their cultural background, do not need men for sex.

Lesbian Sex Magazines

The growth of a self-confident lesbian identity, partly post-Stonewall and partly as a result of second-wave feminism, gave rise to a small explosion of lesbian sex-magazines. Because very few women have access to capital, and because many feminist bookshops continue to exclude publications they believe to be pornographic, lesbian sex-magazines struggle to survive.

The longest-lived is the U.S. title *On Our Backs* (an outright challenge to the feminist publication *off our backs*), while Australia has *Wicked Women*, and even England managed to support, for a tantalizing five issues, the beautifully produced *Quim*.

These pioneering publications offer work to lesbian photographers and illustrators producing explicit erotic imagery, thus providing the essential economic foundation that is so taken for granted by producers and consumers of men's pornography.

Diversity in Lesbian Erotica

Many forms of social exclusion operate within lesbian communities, and acknowledging this fact has been influential in lesbian erotica. Sexualized images of individuals who are fat, disabled, or beyond middle age occur far more frequently (and with more positive intent) in lesbian porn than in pornography aimed at any other group.

The challenge of producing arousing images of black and minority ethnic women, without falling into racist stereotypes, has led to some particularly interesting work from photographers such as Jacqui Duckworth, Laurence Jangey-Paget, and Mumtaz Karimjee.

Lesbian erotic art cannot be detached from the social and political context in which it is produced. It is, perhaps, ironic that the legacy of the "sex wars" that divided feminists in the 1970s and 1980s should be a vibrant, rich, and diverse body of lesbian erotic art. It is also worthy of note that no comparable body of work produced by heterosexual women exists.

The appropriation by the mainstream of fetish imagery from dyke porn may be problematic—this debate continues—but the fact that there is a substantial body of work that may be plundered in this way is undeniable evidence that lesbian sexuality is visible now to an extent that it has never been before. — *Tamsin Wilton*

Bibliography

Berger, John. *Ways of Seeing.* Harmondsworth: Penguin Books/British Broadcasting Corporation, 1972.

Boffin, Tessa, and Jean Fraser, eds. *Stolen Glances: Lesbians Take Photographs.* London: Pandora, 1991.

Bright, Susie, and Jill Posener, eds. *Nothing but the Girl: The Blatant Lesbian Image.* New York: Freedom Editions, 1996.

Cooper, Emmanuel. *The Sexual Perspective: Homosexuality and Art in the Last 100 Years in the West.* London: Routledge, 1986.

Corrine, Tee, with Jacqueline Lapidus. *Yantras of Womanlove: Diagrams of Energy.* Tallahassee, Fla.: Naiad Press, 1982.

Kiss & Tell. *Drawing the Line: Lesbian Sexual Politics on the Wall.* Vancouver, B. C.: Press Gang, 1991.

Kiss & Tell. *Her Tongue on My Theory: Images, Essays and Fantasies.* Vancouver, B. C.: Press Gang, 1994.

MacAdams, Cynthia. *Rising Goddess.* New York: Morgan and Morgan, 1983.

Penelope, Julia, and Susan Wolfe, eds. *Lesbian Culture: An Anthology.* Freedom, Calif.: The Crossing Press, 1993.

Weiss, Andrea. *Paris Was a Woman: Portraits from the Left Bank.* London: Harper Collins, 1995.

Wilton, Tamsin. *Finger-Licking Good: The Ins and Outs of Lesbian Sex.* London: Cassell, 1996.

See Also

Photography: Lesbian, Post-Stonewall; Photography; Lesbian, Pre-Stonewall; Beardsley, Aubrey; Brooks, Romaine; Corinne, Tee; Fini, Léonor; Grace, Della (Del LaGrace Volcano)

European Art: Baroque

THE BAROQUE STYLE PREDOMINATED IN EUROPEAN art beginning about 1590 and lasting through the first decades of the eighteenth century (surviving variously until 1710 or 1740 in different countries).

Although the art of this period encompasses significant national variations, certain common qualities can be noted in most Baroque works. Seeking to involve viewers both physically and emotionally with the illusory realms which they depicted, Baroque artists utilized diverse means to challenge the "decorum" and restraint of the Renaissance period.

Intensely dramatic expressions and gestures that seem to demand a response from the viewer; strongly foreshortened objects, which appear to extend beyond the confines of the artwork; and sudden shifts of light and dark are among the hallmark features of the Baroque.

Intolerance

Caravaggio, who created an extensive body of work with homoerotic implications, played a major role in formulating the Baroque style. However, because the Baroque era in Europe was a period of growing intolerance of any type of "deviance" (sexual or otherwise), most of the artists who were influenced by Caravaggio's stylistic innovations sought to avoid any overt indication of moral impropriety in their works or lifestyles.

The execution of Jérôme Duquesnoy, an internationally prominent Belgian sculptor accused of sodomy, exemplifies the brutality that political and religious leaders exhibited as they combated same-sex love and all other manifestations of "deviance."

Unfortunately, for most of the twentieth century, scholars effectively endorsed the goals of European leaders of the Baroque era by insisting that art of this period contained no indications of queer desire. Only recently have art historians begun to acknowledge the subtle, but effective, means that some artists and patrons utilized to articulate queer identities. Hopefully, future generations of scholars will continue to expand our understanding of this aspect of Baroque culture.

Although the terms *gay*, *lesbian*, and *queer* were not devised until a later period, I have employed them here to denote manifestations of love, desire, and identity that might be described by those terms today.

Caravaggio and the Baroque

Michelangelo Merisi da Caravaggio (1571–1610) formulated many of the quintessential features of the Baroque style in a series of bold paintings, infused with homoerotic desire, such as *Bacchus* (ca. 1595) and *The Musicians* (ca. 1596). In these works, Caravaggio appropriated the standard formulae that Renaissance artists employed in erotic images of women for male patrons. Thus, he clad the youths in vaguely classical robes and depicted them with attributes of prominent figures in ancient Roman mythology.

Flaunting the rigorous gender conventions of the era, Caravaggio's muscular youths tilt their heads coyly and allow their draperies to fall seductively off their shoulders. Furthermore, Caravaggio broke with the Renaissance practice of depicting objects of desire in an exalted realm, aloof from the viewer. With large, moist eyes, the youths gaze out at the spectator and stick out their tongues provocatively between their full, sensuous lips. Naturalistically depicted objects with erotic implications (including glasses of wine and musical instruments) also seem to extend into the viewer's space.

Highly distinctive facial features, dirty fingernails, and rumpled hair distinguish the youths in Caravaggio's paintings from the idealized types common in Renaissance art. It is easy to imagine that they are street hustlers, whom Caravaggio is known to have employed as models.

Rivals attempted to discredit Caravaggio by circulating rumors about his involvement with "low life," but, in testimony during a libel suit brought against him by a rival painter (1603), he willingly acknowledged a hustler and petty criminal named Giovanni Battista as his sexual partner.

The facial features of some of the youths in the early paintings (including one of the figures in *The Musicians*)

closely correspond with documented portraits of Caravaggio by other artists. However, most art historians have insisted that Caravaggio did not represent his own sexuality in these scenes, and a surprisingly large number of scholars still insist that his paintings provide no indication whatsoever of homoerotic desire. (It is maintained that youths are shown with their tongues sticking out simply to demonstrate what one can do with the grapes and other fruit shown in the paintings.)

Many of Caravaggio's early works were commissioned by discerning, wealthy Roman collectors, including Vincenzo Giustiniani and Cardinal Francesco del Monte, who held lavish parties at which they entertained street youths, dressed in togas (and little else). Because of their strong encouragement of Caravaggio's work, Giustiniani and del Monte deserve acknowledgment as the first major European art patrons of the early modern era to foster in a systematic way the visualization of queer desire.

The politically influential Giustiniani and del Monte helped Caravaggio to obtain prestigious commissions for large religious narrative scenes. In such paintings as *The Ecstasy of Saint Francis* (ca. 1597) and his first version of *Saint Matthew Inspired by an Angel* (1602), Caravaggio visualized spiritual rapture with queer erotic imagery; both these paintings show beautiful angels tenderly embracing the saints.

Caravaggio's religious paintings frequently provoked controversy and censorship. In the later part of his career, Caravaggio painted fewer mythological themes, but he did produce *Victorious Love* (1603) as a tribute to Giustiniani. In a scene at once playful and profound, an adolescent Cupid (clearly based on a famous work of another subject by an earlier gay artist, Michelangelo) tramples on books, instruments, and other symbols of human achievement.

Ambiguous feelings about sexuality may be expressed both here and in *David with the Head of Goliath* (ca. 1610). In the latter painting, the youthful hero extends out to the viewer the decapitated head of the artist. By revealing both the problems and joys of love, Caravaggio succeeded in representing queer sexualities with the emotional complexity and richness that was otherwise reserved in the Baroque era for depictions of heterosexual desire.

Caravaggio's great stylistic innovations influenced the work of many later Baroque painters. However, his followers consistently painted scenes without any overt indications of homoerotic desire. Thus, for example, the Dutch artist Hendrick Ter Brugghen (1588–1629), who had been deeply impressed by the works of Caravaggio that he studied in Rome, changed the gender of Caravaggio's *Bacchus* in order to produce the "heterosexualized" *Bacchanate and the Ape* (1627).

The Execution of Duquesnoy

The execution of the Belgian sculptor Jérôme Duquesnoy the Younger (1602–1654) must have served as a warning to other artists about the consequences of any "improprieties" in their lifestyles or their works. Although his reputation is today eclipsed by that of his elder brother, François, Jérôme Duquesnoy was widely regarded as a prominent sculptor during his lifetime.

Having worked since 1621 in various cities in Italy and Spain, Jérôme Duquesnoy returned to his homeland in 1642, and he quickly obtained many prestigious commissions there. On August 31, 1654, he was arrested for sodomizing repeatedly over a period of several weeks two boys whom he had employed as models: Constant de Somere, aged eight, and Jacobus de Sterck, aged eleven.

Today, the artist undoubtedly would be accused of pedophilia, but the ages of the boys do not seem to have been a factor in his trial, as there were no laws prohibiting adult sexual interaction with children.

After being tortured, Duquesnoy confessed to having intercourse with the boys. Antonius Triest, bishop of Ghent, and other prominent patrons unsuccessfully sought to have his sentence commuted from death to life imprisonment.

On September 1, however, Duquesnoy was killed by strangling, and his body was burned immediately afterward, in accord with usual practices at the time. As a result of his "crimes," his name was removed from many of his works, and his career literally was forgotten until recovered by dedicated twentieth-century scholars.

Duquesnoy's exuberant and appealing statues of young boys, such as *Hercules Fighting with Serpents* (ca. 1650), attest to his sexual proclivities, which led to his downfall. In the *Pietà* (ca. 1640), he envisioned a beautiful young angel, passionately kissing the arm of a sensual Christ.

In contrast to most male artists of the Baroque, Duquesnoy depicted female figures with notable restraint and dignity; his meditative statues of Mary Magdalene, such as *The Magdalene Reading* (ca. 1650) evoke sympathy for a woman who had been condemned because of her sensuality.

Persecution and Negative Representations

Unfortunately, Duquesnoy's fate was not unusual. In 1570, even the comparatively tolerant States of Holland instituted laws that required that anyone convicted of sodomy be executed in truly comprehensive fashion by being (successively) strangled, burned, and drowned with a 200-pound weight attached to the neck.

During the seventeenth century, these laws were only sporadically enforced, but in the early 1730s, men sus-

pected of having committed sodomy were systematically hunted down and punished throughout the United Provinces of the Netherlands. In 1730 and 1731 alone, over 250 cases of sodomy were tried in Dutch courts; virtually all of these involved more than one man (eighteen in one proceeding).

From the perspective of gay art history, these highly publicized trials are very significant because numerous prints represented the "crimes" that supposedly threatened the stability of the Netherlands. As a group, these images provide the fullest visual documentation that we have of the circumstances of gay life in the early modern era.

For example, B. de Bakker's engraving *Timely Punishment* (1731; reissued 1732) presents six vignettes, concerning two men who are shown leaving a tavern together, abandoning their wives and children, being arrested, suffering in prison, and being burned at the stake. In the final image, their ashes are scattered to the jubilation of a large crowd.

Similarly, an anonymous engraving, *Justice Triumphant* (1731), depicts the Netherlands being destroyed by fire and water as an "orgy" of drunken sodomites is revealed by allegorical figures of Truth and Virtue.

Popular prints provide valuable evidence of nascent gay and lesbian communities in other countries, even though they are consistently represented from a negative point of view. Typical are the woodcuts in *The Women-Hater's Lamentation* (a tract published in London, 1720); an image of two fashionable men kissing is framed by scenes of men who have committed suicide.

The woodcuts in an anonymous English broadsheet entitled *Hic-Mulier or The Man-Woman* (1620) are particularly interesting because the "problems" posed by lesbians generally were given less attention than the actions of male "sodomites."

The illustrations in *Hic-Mulier* show women cutting their hair to imitate male styles and dressing themselves in men's clothes. The text accompanying these images explains that "men-women" threatened the moral fiber and the economic vitality of England by living together as spouses and by taking jobs that rightfully should be given to men.

"Heterosexualization"

Baroque artists contributed to the "heterosexualization" of society by eradicating erotic connotations from their depictions of Ganymede, the youthful cupbearer of Jupiter, whose image had often served as a coded reference to same-sex love during the medieval and Renaissance periods.

Rembrandt (*Rape of Ganymede*, 1630) and several other Dutch artists mocked the Ganymede myth by rep-

resenting the cupbearer as a baby, who cries and urinates in terror as he is carried up to the heavens by Jupiter in the guise of an eagle. Peter Paul Rubens sought to infuse the myth with heterosexual "family values" by inventing, in *Ganymede and Hebe* (1611), a scene depicting the boy being entrusted with Jupiter's cup by Hebe.

Guido Reni and Anthony Van Dyck

Given the fierce homophobia prevailing in Europe during the Baroque era, historians seeking to reconstruct the lifestyles and works of queer artists often have to depend upon undocumented anecdotes and innuendos.

Utilizing this type of evidence (including rumors about his supposed disdain of women, his possible romantic involvement with his longtime assistant, his interest in cross-dressing, and his "delicate" mannerisms), recent scholars interpret Guido Reni (1575–1642) as a gay artist.

Their analysis of Reni's career constitutes a belated scholarly acknowledgment of the insights of numerous modern gay writers (ranging from Oscar Wilde to Yukio Mishima), who were deeply moved by the visualization of homoerotic desire in his paintings.

Reni's life-sized *Saint Sebastian* (ca. 1620) is more physically and sensually palpable than are most representations by Baroque artists (such as those of Lodovico Carracci, 1599, and Giuseppe Cesari d'Arpino, 1617), who reduced the erotic potential of the theme of a naked man tied to a tree by depicting the saint with a bony physique and directing his gaze away from the spectator.

Throughout his long career, Reni endowed images of violent interaction among men (for example, *Samson Slaying the Philistines*, 1608, and *Apollo Flaying Marsyas*, ca. 1620) with a languid but intense sensuality, which greatly appealed to the Marquis de Sade, who collected his works.

Much of the work of the Belgian painter Anthony van Dyck (1599–1641) also seems to be infused with homoerotic sensuality. Van Dyck was a bachelor (a suspect status in Baroque Europe), but his consistently impeccable behavior prevented any rumors about his personal life.

Van Dyck visualized the harmonious rapport among beautiful male figures in numerous "friendship portraits," commissioned by aristocrats at the English court. These portraits (such as that of George, Lord Digby, later 2nd Earl of Bristol, and William, Lord Russell, later 5th Earl and 1st Duke of Bedford, ca. 1633) provide no overt indications of "immoral" behavior. However, the elegant men in his paintings are posed so that their bodies echo one another, and their delicate expressions and gestures eloquently convey their tender feelings for one another.

The Patronage of Queen Christina

Through their patronage, a few wealthy and influential individuals were able to foster the visualization of queer ideals. Particularly notable in this regard is Queen Christina of Sweden (1618–1689), one of the most prominent patrons and collectors of the Baroque era, when women were allowed very few opportunities to influence the visual arts.

Abdicating her throne in 1654, Christina moved to Rome, where she devoted herself to the patronage of the arts. Her collection prominently featured an exceptionally large number of erotic paintings of women, including Correggio's sexually explicit *Leda* (1520) and Annibale Carracci's *Danae* (1605), as well as many pieces by Titian (for example, *Venus Crowned by Amor with a Lute Player*, 1545) and Veronese (*Mars and Venus*, 1570, among other works). The display of these paintings in the public rooms of the Casino Riario was strongly condemned by many commentators throughout her years in Rome.

Christina further challenged the gender norms of her era by wearing men's clothing; she was often portrayed in attire that combined "male" and "female" elements (as by Wolfgang Heimbach, 1656). Rumors circulated by opponents maintained that she had affairs with her lady-in-waiting and other women, although firm documentation for these suppositions is lacking.

Mainstream scholars generally insist that Christina cannot be regarded as a lesbian. Nevertheless, her extensive collection of intensely erotic images of women provides compelling evidence that she sought to define an identity that we can recognize as queer. As is often the case, art provides significant and compelling insights into sexuality and other aspects of personality that may not be explicitly stated in written documentation.

— *Richard G. Mann*

BIBLIOGRAPHY

Davis, Whitney, ed. *Gay and Lesbian Studies in Art History.* New York: Harrington Park Press, 1994.

Dynes, Wayne R., and Stephen Donaldson, eds. *Homosexuality and Homosexuals in the Arts.* New York: Garland Publishing, 1992.

Hammill, Graham L. *Sexuality and Form.* Chicago: University of Chicago Press, 2000.

Saslow, James M. *Pictures and Passions: A History of Homosexuality in the Visual Arts.* New York: Penguin Putnam, 1999.

Spear, Richard E. *The "Divine" Guido: Religion, Sex, Money and Art in the World of Guido Reni.* New Haven: Yale University Press, 1997.

SEE ALSO

European Art: Renaissance; Caravaggio; Duquesnoy, Jérôme; Michelangelo Buonarroti; Subjects of the Visual Arts: Ganymede; Subjects of the Visual Arts: St. Sebastian

European Art: Eighteenth Century

NEAT DIVISIONS DO LITTLE JUSTICE TO THE DIVERSITY of styles, artists, and characters that fermented during the eighteenth century in Europe. During this period, men whom we would now call homosexuals, such as Johann Winckelmann, Horace Walpole, and William Beckford, were at the forefront of public taste, championing respectively the fresh interest in Classical, Gothic, and Oriental styles.

In the early decades of the eighteenth century, the Baroque style dominated. Tastes shifted from Baroque's depersonalizing spaces and grandiosity to the more light-hearted, warmer, and more intimate Rococo style. This shift in taste was accompanied by a growing interest in interior decoration, especially the elaboration of the boudoir, not least at the Court of Versailles.

In the second half of the century, innovations in interior décor, spearheaded by Robert Adam and Thomas Chippendale, established a popular Neoclassical revival. The century also saw the triumph of Enlightenment values and of scientific knowledge, as well as growing secularism and feminism, which culminated in the fervor of the French revolution and a new spirit of democracy.

Connoisseur Personalities

From the gay point of view, one of the most fascinating aspects of eighteenth-century art is the crucial positioning of great "connoisseur" personalities, many of whom were homosexual. These men, especially Winckelmann, Walpole, and Beckford, managed to influence public taste in a way not seen before, despite the fact that they had difficulty concealing their homosexuality.

Although the heterosexual Lords Burlington and Chesterfield established the taste for Italian art, they were easily trumped by Johann Winckelmann, whose influence was such that he was dubbed the father of both art history and archaeology. In addition, however, Horace Walpole reclaimed Gothic as an artistic and literary style; and later, William Beckford championed the interest in Orientalism that was initially given impetus by multilingual translator William Jones.

Beckford, England's wealthiest man, whose affair with his younger cousin William Courtenay caused him to be outcast from English society, established a mania for collecting from Europe's vast treasure-house of art, to which he had privileged access.

Winckelmann's case is especially noteworthy since his idealized love of young men fundamentally changed the way art was subsequently conceived. He and his followers placed the young male nude at the absolute pinnacle of beauty.

Antoine Watteau

The ascendancy in the early decades of the century of painters such as Antoine Watteau, originally Flemish but working in France, is important as evidence of the trend away from the Baroque toward a more scaled-down, intimate, individual style full of charm, sensuousness, and grace.

At this time, painters felt a new sense of freedom to pursue their individual interests, outside of any school or party line. Hence, Watteau's style tends to elude categorization. His paintings complemented the frivolous, intimate "boudoir" style. He specialized in the *fêtes galantes* (scenes of gallantry) with graceful settings and consummate draftsmanship, which exerted a charm that was not always fully appreciated until a century later.

Art historian Michael Levey characterizes Watteau as the tubercular artist of the bittersweet, comparable to Mozart in music and Keats in poetry. His work has a melancholy mood, as he was fond of painting sad clowns, or the *commedia dell' arte*, which suggests his affinity with society's rejects and misfits. His *Embarkation for Cythera* (1717) best exemplifies this languorous, nostalgic mood, where the passage of time seems inexorable.

Walter Pater, perhaps sensing a parallel sensibility to his own, one that we would now read as gay, described Watteau as "always a seeker after something in the world that is there in no satisfying measure or not at all."

Rococo Style

During the century, the frivolous roseate style of the Rococo became popular, particularly in France. Above all, Rococo emphasized grace, color, lightheartedness, and gaiety—as in a studied lack of seriousness that might now be interpreted by gay audiences as unashamedly "camp." The style was provocative and sometimes so excessive as to become merely "chic" and superficial.

In décor, rococo was characterized by numerous mirrors, gilt-edged panels, ribbon framing, elaborate scrolls, and cornucopias, with a flowing movement. As a decorating style, it flourished especially in Bavaria; and the Schloss Nymphenburg in Munich (1734–1739) by François Cuvillies is a perfect example.

Rococo reached its zenith of frivolity with Jean-Honoré Fragonard's *The Happy Accidents of The Swing* (1776), with its cunning eroticism where the man seated on the left points into the girl's billowing skirts as she gaily swings upwards. Even the foliage in this painting looks like frilly underwear.

In the Rococo, classical subjects were treated with a daring, witty playfulness. The sight of flesh, female in particular, was applauded, even by female audiences and patrons. It was in many ways a subversive style that mocked what artists had come to see as the empty heroics of the Baroque.

François Boucher, under the patronage of Madame de Pompadour, painted with less finesse than Watteau but with an element of fantasy that enshrined the arts of love. He continued Watteau's eroticizing of the space between the viewer and viewed. Showing subjects face on and up close, Boucher's *Reclining Girl* (1752) is notable for its daring treatment of the female nude. Diderot observed that Boucher's pupils had a penchant for rather too hastily painting "chubby pink bottoms."

Italian and Spanish Artists

During the eighteenth century, art from Venice was in great demand, especially in England, where panoramas of the Grand Canal were particularly prized. Giovanni Antonio Canaletto and Francesco Guardi were masters of these ceremonial and festive scenes of regattas. Guardi's brushwork in some ways foreshadowed the Impressionists.

Other Venetian artists of the period included Giambattista Tiepolo, whose technique many believed unsurpassed. His painting *The Death of Hyacinthus* (1782) is said to be modeled on a real death in a homosexual affair. Paolo Veronese also worked very much in the Baroque mode, but with substantial individual flair. Their massive, lush, opulent canvases and altar pieces were greatly admired.

It was Giovanni Battista Piranesi, however, who heralded a strikingly new approach. His etching series entitled *Imaginary Prisons* (1745) contained almost violent chiaroscuro effects that immediately captured the public imagination. He depicted architecture in ruins, but in an emotional way, somewhat like opera scenery. Some etchings suggest a nightmare reality.

His work satisfied the growing taste for accurate archaeological details, but added a questing, nostalgic, romantic spirit. The influence of Piranesi's work was to be a continued inspiration even on interior designer Robert Adam, causing people to reevaluate the antique.

Francisco de Goya, working in Spain, also produced paintings of exceptional verve and intensity, particularly in his etchings. Although his work is not easily classified, it presages the deeper, darker feelings unearthed by Romanticism.

Johann Winckelmann and the Neoclassical Revival

The Grand Tour to the archaeological ruins of Italy and Greece became *de rigueur* for a gentleman hoping for a complete education. New discoveries at the sites of Herculaneum and Pompeii in Italy were significant enough to warrant a detailed examination of Greek and Roman art.

First there, and eager to study the artifacts, was Johann Winckelmann, a humble teacher and son of a cobbler from Germany. He eventually managed to be elected in charge of the Antiquities in Rome. Once Winckelmann was established in Rome, he almost single-handedly formulated a new system of thinking about Greek art, one that clearly drew on his personal taste for adolescent male nudes with slim hips and underdeveloped pectorals.

Winckelmann's monumental study of Greek statuary, *The History of the Art of Antiquity* (1764), had a profound effect and was recognized immediately as setting a new standard of art criticism and art history. His notion of "noble simplicity and calm grandeur" gained currency in what emerged as a new aesthetic throughout Europe. Central to this notion was the male nude, classed as the highest and most esteemed pinnacle of art.

Winckelmann formulated, sometimes in unashamedly ecstatic prose, an almost measurable system that privileged the ideals of beauty and the sublime. While not denying female beauty, his ideas were clearly rather than ambiguously homoerotic. This favoring of a slim, toned, youthful male body represented a shift from what had previously been the acme of beauty, a mature, tortured frame. The Apollo Belvedere became one of the most admired Greek statues because of Winckelmann's ecstatic criticism.

Winckelmann's work was more than art history or art criticism. It was fundamentally a plea for a homosocial ideal that asserted the primacy of art for a healthy culture. Central to his vision was his sheer delight in male—and some female—physiques.

Even Hegel acknowledged Winckelmann's contribution to European culture as lending force to establishing both art history and archaeology as serious scholarly studies. The murder of Winckelmann in Trieste in 1768 shocked not only Goethe, who lamented the news, but the whole of Europe.

English Neoclassicism

In England, Robert Adam, working with a variety of artists such as Angelica Kauffmann, achieved a Neoclassical revolution in interior decoration in the eighteenth century. At Syon House, Middlesex, and Harewood House, Yorkshire, he utilized fresh tints and color combinations, artful settings, integrated schemes, and bas-reliefs based on Greek models.

While the early decades of the century still upheld the legacy of Baroque architecture, the Italian influence was soon manifested in a quieter, simpler, Palladian style for villas, and for the imaginative leap represented in Piranesi. William Kent invented the garden landscape based on notions of picturesque ruins from sketches of Greek and Roman ruins. Lancelot "Capability" Brown made this style fashionable and declared that "nature abhors a straight line."

In palaces and stately homes, patrons indulged new notions of the wild and picturesque based on the idealized landscapes of painter Claude Lorrain. They wanted undulating surfaces, informal layouts, winding paths

with miniature classical temples and grottoes or Chinese summer houses casually dotted around large estates. This landscaping heralded the broad canvases and storm-ridden sentiments of the later Romantics.

Frederick the Great of Prussia, whose homosexual tendencies failed to diminish even after harsh treatment by his father, commissioned his own designs for the palace at Sans Souci. The house there imitated that of Roman Emperor Hadrian at Tivoli. The busts of Antinous, Hadrian's lover, at Sans Souci functioned as code for desires that could not otherwise declare themselves. Frederick also had a Chinese summer house, which reflected an increasing eclecticism in taste.

William Hogarth

In England, William Hogarth, though influenced by French painting, often produced paintings of a highly original quality. In *Harlot's Progress* (1732), *Marriage à la Mode* (1745), *The Rake's Progress* (1735), and other series, Hogarth produced satirically observed narrative paintings in which he used humor for moral ends. His satirical targets included fops, who may be read as gay in contemporary terminology.

These paintings, reproduced as prints, were hugely popular and continue to be so. *The Harlot's Progress* inspired Hofmannsthal's libretto for Richard Strauss's opera *Der Rosenkavalier* (1911), while *The Rake's Progress* inspired a less-than-action-filled libretto by W. H. Auden and Chester Kallman for Igor Stravinsky's 1951 opera of the same name. Later in the twentieth century, David Hockney, in his own designs based on Hogarth, personalized the theme of the Rake, identifying him as the gay artist, an outsider in an uncomprehending society.

The Rake's Progress: The Levee by William Hogarth.

Horace Walpole

Horace Walpole—youngest son of Sir Robert Walpole, generally regarded as England's first prime minister—became an amateur architect, an art historian, and great chronicler of gossip. He was also the man who coined the word "serendipity." Known as an eccentric, he was the author of *The Castle of Otranto* (1764), the first Gothic novel, to which many subsequent horror stories owe a huge debt. This novel almost single-handedly made fashionable the taste for the bizarre, for love of doom and gloom. It also helped establish the Gothic as a site of sexual paranoia, especially the conflict between homosexuality and homophobia.

In his mock-Gothic mansion at Strawberry Hill, Twickenham, to which he continually added traceries, turrets, and tombs, Walpole expressed his own architectural tastes, while also presiding over a literary circle that included not only gay men (such as the poet Thomas Gray) but also the lesbian sculptor Anne Damer and her lover Mary Berry.

Although Walpole regarded the Gothic as a decorative style, rather than an integrated design, Twickenham nevertheless was an important forerunner of the High Church Gothic style that characterized public buildings in the nineteenth century.

William Beckford

William Beckford was handsome, erudite, homosexual, and, at one time, the wealthiest but least appreciated man in England. His father's fortune was based on estates in Jamaica and on slavery, to which Beckford never referred. Beckford was hounded out of England after the exposure of his relationship with his younger male cousin, "Kitty" Courtenay.

Beckford lived in splendor in Portugal and traveled restlessly across Europe, even witnessing the storming of the Bastille on his travels. But upon his return to England he was shunned by society and became an eccentric recluse, a virtual exile in his own country.

From youth, Beckford was obsessed with the *Tales of One Thousand and One Nights* and sought to recreate that feeling in fantasy Oriental interiors, especially at the extraordinary palace he built on his country estate, Fonthill Abbey (1796).

Beckford pioneered a more eclectic range in tastes than was previously thought admirable and built a treasure trove of decorative items in his collections. He retreated into his own Aladdin's fantasy world, reputedly maintaining a harem of boys. He even identified himself as a relation of Caliph Haroun al Rashid.

Beckford's vast resources allowed him to set the tone for collectors. His novel *Vathek* (1786) is a decadent romance that was admired by Lord Byron, and, a hundred years later, by the Symbolists. Beckford not only

awakened the world to the rich beauty of Oriental designs, but he was also one of the world's great art collectors.

Romanticism

Eighteenth-century art finally gave way to Romanticism, which is usually dated as encompassing the period 1785 to 1825.

While eighteenth-century Neoclassicism valued generalities and public expression, Romantics prized the particular and the private. Yet these interests sometimes fused, as in the extremely pared-down linear drawings of Homeric subjects by John Flaxman.

Flaxman's drawings were reproduced in his book illustrations and on Wedgwood pottery. He paralleled the work of French painter Jacques-Louis David and helped embody the homosocial ideals given new impetus by the French Revolution.

Romanticism's cult of the bizarre found expression not only in such literary movements as Gothicism, but also in art. Henry Fuseli, a Swiss artist thought by some to have homosexual leanings—he was known to depict lesbian scenes and females seducing men—believed that his friend William Blake "was damned good to steal from." Blake, however, rejected Academic art in favor of a private mysticism.

Horace Walpole called Fuseli's work "shockingly mad," with the emphasis on the mad, a characteristic that may be said to apply to Blake's work also. The appreciation of the weird, the sublime, and the picturesque became a cornerstone of Romantic individualism. — *Kieron Devlin*

BIBLIOGRAPHY

Bleiler, E.F., ed. *The Castle of Otranto, Vathek, The Vampyre: Three Gothic Novels.* New York: Dover Publications, 1966.

Boyd, Alexander. *England's Wealthiest Son: A Study of William Beckford.* London: Centaur Press, 1962.

Eitner, Lorenz, compiler. *Romanticism and Classicism, 1750–1850: Sources and Documents.* Englewood Cliffs, N. J.: Prentice-Hall, 1970.

Lepmann, Wolfgang. *Winckelmann.* New York: Knopf, 1970.

Levey, Michael. *From Giotto to Cezanne: A Concise History of Painting.* London: Thames and Hudson, 1985.

Park, William. *The Idea of Rococo.* Newark: University of Delaware Press, 1992.

Potts, Alex. *Flesh and the Ideal: Winckelmann and the Origins of Art History.* New Haven: Yale University Press, 1994.

Rosenblum, Robert. *Transformations in Late Eighteenth Century Art.* Princeton, N. J.: Princeton University Press, 1967.

Saslow, James M. *Pictures and Passions: A History of Homosexuality in the Visual Arts.* New York: Viking, 1999.

SEE ALSO

Classical Art; European Art: Baroque; European Art: Neoclassicism; Symbolists; Fuseli, Henry; Hockney, David; Subjects of the Visual Arts: Nude Females; Subjects of the Visual Arts: Nude Males

European Art: Mannerism

IN THE VISUAL ARTS, MANNERISM REFERS TO THE DOMinant style of painting, sculpture, and architecture in Europe from around 1520 to around 1600, particularly in Italy.

Characterized by exaggeration, artifice, and purposeful complexity, this "stylish style"—as John Shearman has described it—was an artistic expression of the highly refined courtly culture of the sixteenth century, while it simultaneously represented the changing status of the artist from mere artisan to educated creative spirit. It has proven to be a great favorite of gay audiences, who developed a camp appreciation for its frequent excesses.

The Term *Mannerism*

The term *Mannerism* derives from the Italian *maniera*, meaning style or manner. The exact usage and meaning of the term have been the subject of highly contentious debate within the field of art history, with some art historians such as Sydney Freedberg applying it to only a small group of artists from the first half of the century, and using alternative terms such as *maniera* and *countermaniera* to describe other groups.

In its most common usage, however, Mannerism refers more generally to the prevalent style of European art and architecture between the High Renaissance and the Baroque. Exaggerated or elongated proportions, extreme idealization, spatial confusion, *horror vacuii* (literally "fear of vacuum," a visual composition with virtually no negative space, in which every square inch is covered with something), and multiple layers of meaning are just some of Mannerism's notable characteristics.

Early Mannerists

Mannerism was most prevalent in Italy, where it was born, and among the most important and influential early Mannerists were the Italian artists Rosso Fiorentino, Jacopo Pontormo, and Parmigianino. (Interestingly, scholars have had reason to speculate on the sexual orientation of Pontormo and Parmigianino, both lifelong bachelors, as well as that of the later Mannerist Agnolo Bronzino.)

Their works moved away from the highly stable and harmonious compositions of High Renaissance artists such as Raphael or Fra Bartolommeo and toward more visually daring and expressively experimental works. In Pontormo's famous *Deposition* (ca. 1528), for example, the space the figures occupy, as well as the very subject itself, are indeterminate and confusing, while simultaneously displaying extreme grace and elegance.

Giulio Romano, the pupil of the High Renaissance artist Raphael, designed the Palazzo del Tè (1526–1535) for the Duke of Mantua in a Mannerist style. His playful

Rape of the Sabines by Giovanni da Bologna.

distortion and exaggeration of well-established High Renaissance classical architectural motifs is an important counterpart to the similar experiments taking place in painting and sculpture.

Bronzino, Vasari, and Bologna

Later important Mannerists included Agnolo Bronzino, court painter to Duke Cosimo I of Florence and his contemporary Giorgio Vasari. Vasari not only established one of the first formal art schools in the liberal arts tradition, but also was the first art historian, writing his *Lives of the Artists* for Duke Cosimo, which appeared in two editions at midcentury.

Bronzino's famous *Allegory* (from ca. 1545) epitomizes the complexities of Mannerism; its allegory is so intricate and obscure as to be the subject of ongoing debate almost five centuries later.

Giovanni Bologna was the most prominent Mannerist sculptor working in the second half of the century. His *Rape of the Sabines* (1581–1583) not only displays the twisting, elongated figures and complex, tortuous compositions favored by Mannerists, but also was originally created purely as an artistic exercise, with no specific subject in mind.

The Status of Artists

Vasari's art school and Giovanni Bologna's creation of "art for art's sake" are both evidence of Mannerism's crucial role in the history of art. Artists were no longer considered artisans, but educated, creative intellectuals on a par with poets and writers, a change of status that had already begun in the High Renaissance.

While artists had long imbued their work with meaning and expression far beyond the limitations of particular commissions, during the Mannerist period the aesthetic and intellectual connotations of art came to the fore in a way not seen since classical antiquity. The highly theorized art of Mannerism set an important precedent for later art and artists.

Internationalism

Mannerism was one of the first truly international styles of Western art. Italian Mannerist artistic ideals spread across Europe, both through the medium of prints and through Italian artists working in other countries.

Primaticcio helped to establish a French variant of Mannerism known as the School of Fontainebleau. Centered on the court of Francis I, it was characterized by further exaggerations of proportions, an emphasis on gracefulness, and frequent eroticism.

Northern European artists such as the Fleming Frans Floris were also heavily influenced by contemporaneous Italian styles.

The Reputation of Mannerism

Oddly enough, from the decline of Mannerism until the late nineteenth century, art historians viewed Mannerism negatively as a revolt against the much-revered art of the High Renaissance. This alleged revolt represented to many art historians an ominous creative decline in the development of art, since the idealism and harmony of the High Renaissance had for centuries provided a hallmark of artistic perfection, and Mannerism seemed so contrary to these ideals.

Even revisionist views in the twentieth century initially perpetuated this notion: the example of modern art allowed Mannerism to be seen with new eyes, but scholars such as Walter Friedländer persisted in viewing the work of the Mannerists as a highly irrational reaction against the idealized beauty and rationality of the High Renaissance. They even referred to Mannerism as "anticlassical."

However, as later scholars such as John Shearman have explained, Mannerism was the product of a highly refined court society that valued artifice, elegance, and erudition in all aspects of culture. It was a natural outgrowth of the idealization of the High Renaissance rather than a revolt against it—that is, it was the extreme application of the goals and principles of the earlier period.

The Appeal to Gay Viewers

Mannerism in art and architecture has often appealed to gay viewers and collectors because of its exquisite refinement and frequent extravagance—tastes often ascribed (stereotypically) to male homosexuals. Certainly Mannerism's exaggerations and extremes of taste lend themselves to appreciation by viewers with a camp sensibility, and the uncertain sexual orientations of some of its practitioners is an added attraction.

Indeed, Mannerism's long rejection by mainstream art history has probably broadened its appeal to gays and lesbians, who likely identify with Mannerism's cultural marginalization.

— *Joe A. Thomas*

BIBLIOGRAPHY

Arasse, Daniel. *La renaissance maniériste*. Paris: Gallimard, 1997.

Freedberg, Sydney. *Painting in Italy, 1500–1600*. 3rd ed. New Haven: Yale University Press, 1993.

Friedländer, Walter J. *Mannerism and Anti-Mannerism in Italian Painting*. New York: Schocken, 1965.

Hauser, Arnold. *Mannerism: The Crisis of the Renaissance and the Origin of Modern Art*. New York: Knopf, 1965.

Shearman, John. *Mannerism*. Harmondsworth: Penguin Books, 1967.

Würtenberger, Franzsepp. *Mannerism: The European Style of the Sixteenth Century*. Trans. Michael Heron. New York: Holt, Rinehart, Winston, 1963.

SEE ALSO

European Art: Renaissance; European Art: Baroque; Bronzino, Agnolo; Parmigianino (Francesco Mazzola); Pontormo, Jacopo

European Art: Medieval

TO STUDY QUEER MEDIEVAL ART IS TO LEAVE THE mainstream of contemporary thinking about the Middle Ages: to reflect, instead, on coded messages of gender and sexuality in the visual culture of a remote civilization.

Only in the past generation have medievalists begun to explore this unfamiliar territory, thanks to which four or five key problems of visual representation can now be identified: the depiction of acts "against nature," the portrayal of "homosexuality" in the Bible and in mythology, the representation of sexual ambiguity, and the marginalization or destruction of images.

Despite their apparent diversity, all of these issues intersect in the desire to construct an iconography—or subject matter—of medieval art, a period of European art that extends from about 300 to about 1400.

Sodomy and Acts "Against Nature"

The very definition of our subject is problematical once we accept the notion that sexuality has its own history. As historians such as John Boswell, James Brundage, Michel Foucault, Bernd-Ulrich Hergemöller, Helmut Puff, and others have pointed out, even the vocabulary we use to analyze medieval experience carries an anachronistic burden, as *homosexual*, *queer*, and *gay* are all modern terms without equivalents in the terminology of the time.

The closest medieval analogue would be *sodomy*, a word whose connotations ranged from same-sex sexual acts to bestiality, heresy, treason, and Judaism. At the same time, behaviors now associated with homoeroticism, such as men holding hands or kissing on the lips, were often asexual in the Middle Ages (at least, when these acts connoted friendship or feudal obligations).

Medieval categories were clearly different from our own, and the visual evidence is equally problematical. A corbel (or sculptured bracket) from the French church of La Sauve Majeure, now at the Cloisters Museum in New York, provides a case in point. Depicting two men locked together in a complicated pose, the corbel is sometimes interpreted as a scene of dual penetration, although it just as likely represents a fight: the interpretation depends in great measure on the assumptions each viewer brings to the image.

Or again, depictions of men playing chess may actually be intended to suggest that the men have other things on their mind, as Silke Tammen has suggested, since chess typically symbolizes seduction in medieval art and literature.

In other words, we may read sexual behavior in an image where there is none and fail to see it in cases where there is.

Key to the medieval rejection of same-sex sexual acts was the belief that such behavior violated nature. In art this idea is especially clear in the illustrated bestiary, a popular text on zoology whose readers would learn, among other things, that hyenas unnaturally change sex several times during their lives.

A twelfth-century English bestiary drew the logical inference by showing a homosexual encounter between two hyenas standing on their haunches to embrace (an image examined by Michael Camille and James Saslow). The point of the illustration was not the physical act alone, but the spiritual transgression "against nature" implicit in the comparison of unclean beasts, Jews, and idolaters. Perhaps the animal imagery also allowed artists to portray acts too shocking to associate with humans.

The Bible and Mythology

Medieval interpretations of scripture provided a particularly important source of attacks on homoeroticism. In the *Bible Moralisée*, a vast picture Bible first produced in Paris ca. 1225, several miniatures have homosexual themes, linked by the supporting sequence of images referring to lust, greed, simony, heresy, blasphemy, idolatry, and the like.

One roundel depicts kissing women and copulating men below another roundel of Adam and Eve, in an opposition that draws attention to natural and unnatural couples (this is also one of the few known images of lesbianism from the period).

Tammen has suggested that, on another level, such imagery may reflect the increasingly repressive attitudes of the Church following the Fourth Lateran Council of 1215.

Sometimes we also find sodomites cowering in Hell, as in the Danish wall painting of Birkeroed and illuminated manuscripts of Guido da Pisa's *Commentary on Dante*, even though the Bible itself never puts sodomites there.

Classical mythology offered a more ambivalent reading of same-sex sexuality. In medieval interpretations of classical mythology homoeroticism could suggest damnation or salvation, according to the symbolic guise it assumed.

Particularly suggestive was the tale of a shepherd named Ganymede, whose beauty so captivated Zeus that, disguised as an eagle, the king of gods carried off the youth to rape or seduce him. If today we read the story as a tale of same-sex desire, in the Middle Ages writers often detected a veiled message about the love of God. The anonymous fourteenth-century author of the *Moralized Ovid* even turned Zeus and Ganymede into symbols of Christ and John the Evangelist.

Shorn of uplifting sentiment, however, the tale became a virulent condemnation of homoerotic yearnings, as seen, for instance, in a Romanesque capital at Vézelay, where a devil stares directly at the viewer while making a hideous grimace.

Sexual Ambiguity

Equally disturbing for medieval audiences was the depiction of sexual ambiguity, though here again the broader symbolic context colored the interpretation. In her study of early-fifteenth-century manuscripts produced for the Valois court, Diane Wolfthal brings to light several instances of cross-dressing and gender uncertainty.

The most colorful example of transgendering from our period, however, is the legend of St. Wilgefortis, a woman who escaped the unwelcome advances of a male suitor only after growing a beard. Crucified for her noble resolve, she inspired a cult that lasted 400 years (from the fourteenth century to the eighteenth century), as a result of which images of bearded ladies on the cross spread across Europe well into the modern age.

Christ's sexuality has also encouraged a certain amount of speculation, largely in response to Leo Steinberg's reading of the eroticized Jesus in Renaissance art. In a reevaluation of Early Christian and Byzantine art, Thomas Mathews proposes that several sarcophagi and mosaics depicted an androgynous Christ, not to celebrate the libido, but to neutralize it; while on the contrary, Richard Trexler sees the lightly clad Christ in late-medieval Crucifixions as a challenge to male arousal.

For Karma Lochrie, images of Christ's wound suggest a vulva or vagina, giving a sexual charge to female mysticism, while for Caroline Walker Bynum, the critical issue is gender roles, not "genitality." As an example she cites a Swabian altarpiece of ca. 1440 where Christ's feeding the apostles and washing their feet at the Last Supper casts him in a "female role."

Marginality and Censorship

Thus far we have surveyed types of scenes depicted by medieval artists. Where these scenes appeared is of equal interest. Not surprisingly, representations of sodomy often occurred in zones outside the main field of vision, paralleling the marginalization of "homosexuality" in medieval society.

In her pathbreaking study of Gothic miniatures, Lillian Randall finds a number of sexually charged motifs in the margins of manuscript pages, including men handling each others' genitals or shooting arrows up each others' hindquarters (interestingly enough, the most graphic descriptions from her list are not illustrated in the plates).

Misericords (or the carved undersides of wooden choir stalls) offered another opportunity for depicting lewd scenes, designed to be crushed by the clerics sitting on them, though the fact that these seats were sometimes displayed in the upright position raises interesting questions about conflicting goals of punishment and delight.

The uneven geographic distribution of such motifs may also be relevant. For instance, while several misericords

in Spain (at Astorga, León, Seville, and elsewhere) portray homosexual acts, nothing comparable is known in England. Whether this regional difference reflects cultural attitudes, or the subsequent, postmedieval destruction of such material in England, is a question which further research will need to address.

It is clear, however, that some works were intentionally destroyed because of their homosexual content, providing a chilling parallel to the actual burning of sodomites in medieval Europe.

Examples of destroyed and censored images include Gerald of Wales's *Topography of Ireland* (ca. 1200), which purportedly showed a same-sex union scandalous enough to be ripped from the book, and an Icelandic law prohibiting the representation of conquerors sexually penetrating their male enemies.

Sometimes images simply omitted offensive material, as in Nardo di Cione's fresco of Hell in a Florentine church, which portrays every torment described by Dante except that for sodomites.

In each of these cases, we find a different connotation for homosexuality. The *Topography of Ireland* preserves the response of an antagonistic viewer; the Icelandic law equates sodomy with humiliation; and Nardo's fresco suggests a fear of contaminating images. As James Saslow has noted, homosexual themes were particularly dangerous in art (as opposed to literature) because the representation of homoeroticism could promote the very behavior it sought to suppress.

Conclusion

The no-man's-land of queer medieval art may be considerably richer than is generally recognized. In terms of coverage alone, the examples cited here embrace several media, extend from one end of the Middle Ages to the other, and cover a broad geographic area.

The scholarship suggests, further, that notions of sexual identity prevalent today had limited relevance a thousand years ago; more important was the idea that sexual behavior outside marriage and procreation violated a moral principle, although the principle in question varied widely, allowing medieval artists to link same-sex sexual acts to idolatry, heresy, greed, and the like.

Given this diversity, the depiction of homosexuality never hardened into a formula: hyenas, kissing women, copulating men, sufferers in Hell, and possibly chess-players represent many different ways of evoking the sin. Well-known themes such as Ganymede and Zeus also accommodated various readings according to the degree, or absence, of Christian allegory.

Much work remains to be done. Early medieval art, secular art, lesbianism, patronage, and reception are areas in particular need of study. The gradual opening of modern society to homosexuality, however, has also opened a window onto medieval art that previous generations had shut tight. As scholarship has come out of the closet, a new way of looking at the past has become possible.

—*William J. Travis*

BIBLIOGRAPHY

Bynum, Caroline Walker. *Holy Feast and Holy Fast: The Religious Significance of Food to Medieval Women.* Berkeley: University of California Press, 1987.

Camille, Michael. *The Gothic Idol: Ideology and Image-making in Medieval Art.* Cambridge: Cambridge University Press, 1989.

———. *Image on the Edge: The Margins of Medieval Art.* Cambridge, Mass.: Harvard University Press, 1992.

———. *The Medieval Art of Love: Objects and Subjects of Desire.* New York: Abrams, 1998.

Forsyth, Ilene. "The Ganymede Capital at Vézelay." *Gesta* 15.1–2 (1976): 241–246.

Foucault, Michel. *Histoire de la sexualité.* Vol. 1. Paris: Gallimard, 1976.

Hergemöller, Bernd-Ulrich. "Homosexuelles Alltagsleben im Mittelalter." *Zeitschrift für Sexualforschung* 5.2 (1992): 111–127.

Kempter, Gerda. *Ganymed: Studien zur Typologie, Ikonologie und Ikonographie.* Cologne and Vienna: Böhlau, 1980.

Lochrie, Karma. "Mystical Arts, Queer Tendencies." *Constructing Medieval Sexuality.* Karma Lochrie et al., eds. Minneapolis: University of Minnesota Press, 1997. 180–200.

Mathews, Thomas F. *The Clash of Gods: A Reinterpretation of Early Christian Art.* Princeton, N.J.: Princeton University Press, 1993.

Randall, Lillian. *Images in the Margins of Gothic Manuscripts.* Berkeley: University of California Press, 1966.

Saslow, James. *Pictures and Passions: A History of Homosexuality in the Visual Arts.* New York: Viking, 1999.

Steinberg, Leo. *The Sexuality of Christ in Renaissance Art and in Modern Oblivion.* New York: Pantheon, 1983.

Tammen, Silke. "Bilder der Sodomie in der Bible Moralisée." *Frauen Kunst Wissenschaft* 21 (1996): 30–48.

Trexler, Richard C. "Gendering Jesus Crucified." *Iconography at the Crossroads.* Brendan Cassiday, ed. Princeton, N.J.: Index of Christian Art, 1993. 107–120.

Wolfthal, Diane. *Images of Rape: The "Heroic" Tradition and Its Alternatives.* Cambridge: Cambridge University Press, 1999.

SEE ALSO

Subjects of the Visual Arts: Ganymede

European Art: Neoclassicism

NEOCLASSICISM REFERS TO THE CLASSICAL REVIVAL movement in European art, architecture, and interior design from the mid-eighteenth to the early nineteenth century. The movement was inspired by the discovery of artifacts excavated from the ancient Italian

ruins of Herculaneum (first excavated in 1709) and Pompeii (first excavation in 1748).

Each country in western Europe contributed a unique aspect to the interest in classical revival, but France and England were the most prolific in terms of producing art and architecture in the Neoclassical style.

In England, Neoclassicism was associated with the aristocratic and industrial ruling classes and became useful to their aims of building an empire.

In France, the new interest in classical revival was linked to political concerns and moral issues associated with the ideals of the French Revolution of 1789. In French art, Jacques-Louis David (1748–1825) created and led an entire school of painting based on Neoclassical principles.

Male–Female Roles

Neoclassical themes often centered on classical stories of heroic male deeds and virtues. The activities and expectations of men and women were strictly divided. Males are shown in public roles and depicted as heroic and stoic. Conversely, women and femininity were confined to the realm of the private and domestic spheres.

The sharp division between the sexes was also reflected in the Neoclassical style itself. Neoclassical paintings are characterized by a severe linearity, rational compositions, direct lighting, and strong acidic colors. Male figures are usually given angular and sculptural qualities, while females are typically rendered in soft, curvilinear forms.

Because of the dominant position of males in both art and society, the Neoclassical style is often referred to as masculine and is set in distinct opposition to the period and stylistic sensibility that preceded it, the Rococo. In Neoclassicism, the male body is burdened with a range of political, social, and sexual meaning.

Male Homosexuality and Neoclassicism

Male homosexuality and its erotic undercurrents played a major role in the aesthetic formation and content of Neoclassicism. The artist's studio became the primary site for understanding, developing, and disseminating Neoclassicism as politics and as erotics.

The pedagogical and erotic intimations of man–boy coupling as had been practiced in ancient Greece were transplanted to and imitated in the artist's studio. The all-male environment of David's studio, for example, fostered a complex relationship among the young male students and elevated the master to the status of father figure.

The environment was competitive and the neophytes constantly vied for David's attention and favor. The homoerotic overtones of the patriarchal male figure surrounded by younger male disciples can best be seen in

David's 1787 *Death of Socrates* (New York, Metropolitan Museum), a painting in which homoeroticism and pederasty are part of the story being told.

Winckelmann

An important influence in developing the homoerotic aesthetic in Neoclassicism was the noted scholar Johann Joachim Winckelmann (1717–1768), who, in his mid-eighteenth-century writings on ancient art, gave intellectual justification to the erotics of Neoclassicism.

Winckelmann sublimated his homosexuality into intense sensual descriptions of male Greek sculptures. His description of the corporeal splendor of the Apollo Beleveedere (Vatican Museums, Rome, ca. fourth century B.C.) is perhaps the most notorious example of this practice: "...a mouth shaped like that whose touch stirred with delight the loved Branchus. The soft hair plays about the divine head as if agitated by a gentle breeze, like the slender waving tendrils of the noble vine; it seems to be anointed with the oil of the gods, and tied by Graces with pleasing display on the crown of the head."

Neoclassical Sculpture

Neoclassical style and subject matter were not confined to painting. In sculpture, the most famous exponents of Neoclassicism were the Italian sculptor Antonio Canova (1757–1822) and the Danish sculptor Bertel Thorvaldsen (1770–1844). Both artists created works of male beauty and sensuality based on classical sources.

Canova's *Theseus and the Centaur* (Kunsthistorisches Museum, Vienna, 1804–1819) and Thorvaldsen's *Jason* (Thorvaldsen Museum, Copenhagen, 1802–1803) are just two examples of marble works portraying Greek gods and heroes that convey the sensuousness of the male form.

The suspension of heroic action and the frozen contemplation of male bodily beauty are underscored by the smooth and polished marble surfaces that heighten the sensual quality of the figures. Both works are based on the *beau idéal* (beautiful ideal)—a tenet of Neoclassical sculpture that sought to combine the most beautiful parts of antique statuary and the most beautiful aspects of living models. The beautiful ideal attempted to satisfy a need, at once intellectual and erotic, to forge in art a representation of the beautiful male body.

Other Subjects

Neoclassicism as a style and movement was also applied to artworks in which the beauty of the male form played very little or no part at all. The French painter J. A. D. Ingres (1780–1867), for example, applied the characteristics of Neoclassical line, voluptuous form, and grace to women.

Landscape painter Pierre-Henri de Valenciennes (1750–1819) used Neoclassical principles of line and rational form to depict the pure landscape, while Claude-Nicolas Ledoux (1736–1806) and Étienne-Louis Boullée (1728–1799) did the same for architecture.

In interior design and the decorative arts, François Honoré-Georges Jacob (1770–1841) triumphed by combining the formal elements of Neoclassicism with the fad for things Egyptian in the early nineteenth century.

In the graphic arts, the drawings and illustrations of the Englishman John Flaxman (1755–1826) made use of a purified linear contour that, although derived from designs on Greek vases, was applied to representations of both women and men.

In its emphasis on rationality and recovery of tradition, Neoclassicism may seem antithetical to the anarchic spirit sometimes associated with our modern understanding of gay, lesbian, bisexual, and queer culture.

Nevertheless, homoeroticism is a prominent presence in Neoclassicism. It could hardly be otherwise given the movement's development of a masculine style, its appreciation of male beauty, and its privileging of ancient Greece and Rome as civilizations to be emulated.

— *James Smalls*

BIBLIOGRAPHY

Crow, Thomas. *Emulation: Making Artists for Revolutionary France.* New Haven: Yale University Press, 1995.

Honour, Hugh. *Neo-Classicism.* New York: Penguin, 1977.

SEE ALSO

Classical Art; European Art: Eighteenth Century; European Art: Nineteenth Century

J. A. D. Ingres' study for the neoclassical *L'Odalisque et l'Esclave.*

European Art: Nineteenth Century

EXAMINING HOMOSEXUAL CONTENT AND INDIVIDUALS in European art of the nineteenth century is problematic. The contemporary terms *gay, lesbian,* and *bisexual* are anachronistic when applied too easily to earlier periods. Still, nineteenth-century European art is particularly important because during the nineteenth century the homosexual as an individual in the contemporary sense was first acknowledged and the seeds of modern gay consciousness may be discerned.

Some artists and art critics of the nineteenth century, such as Simeon Solomon and Oscar Wilde, among others, achieved a self-aware homosexual identity, which is expressed in both their lives and their works.

Lesbianism in nineteenth-century art, however, is only rarely depicted in terms of identity. More commonly, lesbians were depicted as sexual objects, with only a few artists such as Rosa Bonheur emerging as lesbians themselves.

European art of the nineteenth century encompasses a variety of movements and has been the subject of a great deal of scholarship, though only rarely does this scholarship emphasize gay issues.

Robert Rosenblum and H. W. Janson, for example, have written a superb overview of nineteenth-century European art, but their exclusion of artists such as Solomon can be seen as evidence of their reluctance to recognize gay contributions to art history.

Similarly, in his survey of modernism, Richard Brettel focuses in one chapter on gender and sexuality, but he discusses only briefly the development of a homosexual identity or its contribution to modern art. Conversely, the best overviews of gay art history, such as those by Emmanuel Cooper and James Saslow, tend to neglect nineteenth-century art.

Neoclassicism

Nineteenth-century art in Europe began with two movements that both originated in the latter half of the prior century: Neoclassicism and Romanticism. Encompassing literature and music as well as visual art, both movements were broadly conceived.

Neoclassicism was inspired by a revival of interest in Greco-Roman art and culture. Also influential on Neoclassical visual art was the art historian Johann Joachim Winckelmann (1717–1768), who infused his critical appreciation of ancient Greek art with homoeroticism, most noticeably in his rapturous descriptions of the Apollo Belvedere.

The impact of Neoclassical visual art was most apparent in France, where the earlier fantasy-based Rococo style of Watteau and Boucher was identified with the aristocracy. Neoclassicism was particularly associated with the ideals of the French Revolution and was seen as anti-aristocratic.

Jacques-Louis David (1748–1825) is credited with the first Neoclassical painting, *The Oath of the Horatii* (1785), because its layout and framing are balanced and harmonized, and the subject was Roman-based, emphasizing allegiance to the state.

Neoclassical art is frequently homoerotic because it is "masculine" in contrast to the more "feminine" Rococo style. Subjects are often male-oriented classical myths and history, reinterpreted to emphasize their application to the revolutionary politics of the day. Men are often depicted nude, their sculpted physiques emphasizing idealized masculinity.

David's painting *Leonidas at Thermopylae* (1800–1814) is blatantly homoerotic not only because of the nude youths, but also because of the erect scabbard over the central figure's penis and the obvious affection of the men toward one another.

Other nineteenth-century artists who depicted homoeroticism in a Neoclassical style were Jean-Auguste-Dominique Ingres (1780–1867) and his mentee Hippolyte Flandrin (1809–1864).

Oedipus and the Sphinx by J. A. D. Ingres.

Ingres was famous in his day as a Neoclassicist, and critics often positioned him against the Romantic artist Delacroix. Ingres, however, was not a strict Neoclassicist in that he introduced sensuality in his figures. His nudes, such as *Oedipus and the Sphinx* (1808) and *The Turkish Bath* (1859–1862), occasionally incite same-sex desire in their sensual depiction.

Much of Flandrin's art is homoerotic. It typically emphasizes male sexuality or glorifies the male form as a sensual, spiritual figure. His painting *Figure d'Étude* (1835–1836) has become a gay icon.

Romanticism

Because of its connection with revolution, Neoclassicism is perceived by art critics today as an offshoot of Romanticism, the movement that truly defined early-nineteenth-century culture.

Romanticism was based on emotional representation and response. Romantic artists painted works that challenged the bourgeois mindset of the day, often featuring controversial subjects and focusing on the emotionally intense. It frequently attempted to shock. Romanticism generated the stereotype of the artist as a bad influence, an adventurer, often bisexual, who scandalized his audiences.

Théodore Géricault (1791–1824) is often described as the prototype for the Romantic artist in the early nineteenth century. He lived a brief life, yet produced some of the most important European art. His work reflects a male homosocial world. He painted numerous images of soldiers on horseback.

Géricault's most famous painting, *The Raft of the Medusa* (1819), epitomizes Romanticism in its depiction on an immense canvas of a shocking contemporary news story (a shipwrecked crew forced into cannibalism to survive). The male figures, despite their dying state, have idealized physiques, and their physical prowess is arranged in a fluid motion toward the erect black man who waves down a passing ship.

Neoclassicism and Romanticism as art movements died out by the 1840s, although many of the new trends in art that followed can be perceived as offshoots of these movements. The two countries where these new movements flourished were France and England, their capital cities sharing in importance as major art centers. As these new "modern" art trends thrived, so too did the cultural development of same-sex desire.

France

From the rubble of the revolutions and the rise of the lower classes, a respect and admiration for simplicity and everyday living became popular in art. Called Realism, this new trend in art originated in the works of artists such as Géricault and Delacroix in France and Constable and Turner in England. The trend of French Realism took a new turn with the work of Gustave Courbet (1819–1877).

Courbet's approach to Realism was based on his view of the world. His most famous painting, *The Studio of the Painter: A Real Allegory Concerning Seven Years of My Artistic Life* (1854–1855), objectified the artist and his view of the world as the center of the universe.

The physical manifestation of the nude woman, Muse or model, behind Courbet in this painting is balanced by the nude Christlike figure hanging behind the canvas. While the erotic presence of each is not uncommon, the centrality on Courbet's canvas of both figures surrounding the artist makes their erotic depiction especially suggestive.

Depictions of Lesbianism

Courbet's paintings are typically homosocial, often representing the world of the artist and his male friends. However, Courbet is among the few artists of the century whose depiction of lesbianism is noteworthy. For example, in his painting *Sleep* (1866), he depicts two women, one brunette and one blonde, asleep. Both are nude and their limbs are intertwined.

Courbet was no doubt painting the heterosexual male fantasy of two women together, which some would argue is not lesbianism in the truest sense. Nevertheless, its depiction of same-gender sex is clearly homoerotic.

Other lesbian-themed works, not uncommon in nineteenth-century France, were produced during the Impressionist movement by artists such as Renoir and Toulouse-Lautrec.

In addition to lesbian scenes, the Impressionist Jean-Frédéric Bazille (1841–1870) painted homoerotic works depicting nude men, such as *Summer Scene* (1869). Interestingly, two of Bazille's contributions to the Salon, the male homoerotic *Fisherman with a Net* and the lesbian *La Toilette*, were both rejected the same year.

Rosa Bonheur

Lesbianism as an artistic trend arguably has its origins in nineteenth-century France. Rosa Bonheur (1822–1899) was famous as both an artist and a lesbian in her day. Encouraged at an early age to pursue art by her father, the artist Raimond Bonheur, she favored the Realist school, and painted landscapes and animals in works such as *The Horse Fair* (1887).

Bonheur never seems to have painted lesbian-themed work, but she lived as a bohemian artist. She wore men's clothing like the French author George Sand. She had obtained governmental permission to don masculine garb in order to be a better Realist painter by examining nature (for example, farm animals) more closely.

Bonheur never married, but instead maintained a forty-five-year live-in relationship with Nathalie Micas.

After Micas's death, she had a relationship with the American artist Anna Elizabeth Klumpke, whom she lovingly and publicly referred to as her wife. Bonheur left her entire estate to Klumpke upon her death. All three women were buried together in Père Lachaise Cemetery.

England

In 1848, a group of rebellious young artists decided to break away from the traditions of the Royal Academy; they created the Pre-Raphaelite Brotherhood. Their credo was that all art since the time of Raphael was poor. They favored instead the art of the Italian quattrocento, including the work of early Renaissance masters such as Masaccio and Botticelli.

The PRB, as it became known, did not last many years, but by the late 1860s, their attempts to celebrate this part-Gothic, part-Renaissance mindset was revitalized with new subjects, themes, and artists. It became known as the Aesthetic Movement, and included the artists Dante Gabriel Rossetti, Edward Burne-Jones, and Simeon Solomon.

Aestheticism reflected a trend popular among the rising middle class to enhance their lives with beautiful works of art and to refine themselves culturally. Many of the Aesthetic works were commissions by middle-class industrial barons who had earned their wealth from the Industrial Revolution. They requested images of languorous, beautiful women to enhance the decorative appeal of their homes.

Some of these female-dominated works, such as Rossetti's *The Beloved* (1865–1866) and Burne-Jones's *The Golden Stairs* (1872–1880), could be seen as lesbian-based with their mirrored female sensuality, though none were as clearly sexual as those of Courbet and Toulouse-Lautrec.

The androgyne also became a popular image among the Aesthetes. In their depictions, the figurative merging of the two sexes in the androgyne may be a statement on homosexuality, the "intermediate sex" or "third sex" as theorized by such writers as John Addington Symonds and Edward Carpenter.

Simeon Solomon

Among the Aesthetes, only Simeon Solomon (1840–1905) converted the subject of languorous women into that of languorous men. Solomon, born into a middle-class Jewish family of artists, found popularity among his colleagues with his Greco-Roman images. He ultimately used the god Eros as his symbol for same-sex desire. He often depicted the youthful Eros nude, as in his painting *Dawn* (1871).

Solomon was also one of the few British artists to depict the lesbian poet Sappho in visual art. In the painting *Sappho and Erinna in a Garden at Mytelene*

(1864), Sappho's passion for her lover is quite apparent. In 1873, Solomon was arrested and charged with homosexual crimes, and his public career as an artist ended.

Frederic Leighton

The Aesthetic Movement also produced the artist Frederic Leighton (1830–1896). Leighton was educated in Continental art schools and returned to England with a new interpretation of Hellenism for the Aesthetes. His paintings are erotic, if not homoerotic, in both the choice of mythological subjects and presentation of the nude. His work gave rise to the concept of "supersensuality," spiritual eroticism that surpasses physical sensuality.

His numerous nude Venuses and women bathing are highly erotic. His painting *Daedalus and Icarus* (1869) reveals a soft, if not androgynous, nude Icarus waiting to fly to the heavens. His bronze sculpture *An Athlete Wresting with a Python* (1874–1877) is a life-sized study of the idealized nude male form.

Leighton never married and kept his personal life very private, even from those who were his close friends. He kept company with known homosexuals of the day. His home in London, much of it decorated and designed by Leighton himself, is a museum, a shrine to Aestheticism.

Pater, Wilde, and Symonds

Three art critics are important equally for their contributions to nineteenth-century European art and to the history of homosexuality.

Walter Pater (1839–1894), the doyen of Aestheticism, taught classical studies at Oxford and wrote extensively on art appreciation. His conclusion to the first edition of *The Renaissance* (1877) became a gay manifesto for his followers.

Oscar Wilde (1856–1900), a master of publicity, was the most successful popularizer of Aestheticism in the 1880s. Wilde's conviction on charges of gross indecency in 1895 did more to make homosexuality visible in the nineteenth century than any other single event.

Like Wilde, John Addington Symonds (1840–1894) was an active homosexual despite being married. Symonds wrote numerous works on artists such as Michelangelo and Cellini, often commenting on their homosexual liaisons, and in 1883 published a pamphlet on Greek homosexuality.

Symbolism and the *Fin de Siècle*

By the late 1860s, Paris had begun to surpass London as an art center, and artists flocked to Paris either for inspiration or camaraderie. The French capital gave birth to modernism with the Impressionists and exerted a profound influence on art throughout Europe and North America.

Toward the end of the nineteenth century there emerged one of the great queer art movements, Symbolism. The

movement had its origins in France, starting in many ways as a literary movement by the poets and lovers Paul Verlaine and Arthur Rimbaud. Symbolism, however, was not limited to France, and many of its greatest adherents and practitioners were non-French Europeans.

Symbolism, by definition, is based on the idea of the symbol, either the artist's personal symbol or a universal symbol known to all. Symbolist paintings are very visually based, and are considered modern for what they represent rather than for the way they are painted. Symbolic sources ranged from classical mythology and poetics to obscure authors.

Critics have noted that the problem with Symbolism has been the difficulty of identifying the artists' symbolic language, as it is often obscure. However, Symbolism offered homosexual artists an opportunity to explore their sexual identity in a veiled language.

Gustave Moreau

One of the most famous Symbolist artists was Gustave Moreau (1826–1898). Moreau enters the canon of nineteenth-century European art as an academic painter in technique, but his subjects were noteworthy. Obsessed with painting recurring motifs, he chose as his favorite subjects mythological or biblical themes, often interpreted today as queer in their construct. His numerous paintings of the biblical Salome as a femme fatale conjure suggestions of incest and necrophilia.

Moreau also painted androgynous images of Narcissus and Saint Sebastian, both longstanding icons of same-sex desire. His paintings of Orpheus, also considered a homosexual symbol because of his rejection of women after losing his wife, reveal homoerotic desire in the softness and beauty of the figure.

Aubrey Beardsley

In England, the artists Simeon Solomon and Aubrey Beardsley (1872–1898) are considered by critics today to be Symbolists. Solomon's recurring motifs of youthful Eros figures or androgynous angels are homoerotic symbols for same-sex passion. His later works often depict disembodied heads such as Orpheus, Medusa, and others.

Beardsley established a career for himself by illustrating black-and-white hypersexual figures, ranging from sex-starved soldiers with enlarged phalluses in Aristophanes' *Lysistrata* to androgynous figures in Wilde's *Salome*. Beardsley socialized with many known homosexuals of the day, including Wilde's former lover and friend Robert Ross, but notably not Wilde himself.

Other Symbolists

Throughout Europe, Symbolist artists depicted queer subjects. Charles Filiger (1863–1928) painted cartoon-like depictions of saints, often paired in homosocial couplings. Like Solomon, he endured a homosexual scandal and spent much of his life working in private in the French countryside.

The Flemish artist Fernand Khnopff (1858–1921) incorporated lesbian-based themes in many of his works. The artist Jean Delville (1867–1953), also from Belgium, painted homoerotic, androgynous disembodied heads like those of Moreau and Solomon. Delville also painted one of the gayest paintings of the *fin de siècle*. His *School of Plato* (1898) depicts a Christlike philosopher in pink garments lecturing to his pupils, all nude or scantily dressed youths who listen to his every word while reclining in sexual poses alone or with other young men.

Male Nudes

The posing of youthful male nudes as in Delville's painting was not new, and the veiled homoerotic message it sent became popular for a time. The English artist Henry Scott Tuke (1858–1929) painted nude boys frolicking in natural settings. The German Baron Wilhelm von Gloeden (1856–1931) settled in Taormina, Sicily, and established an artistic career for himself by taking staged photographs of nude or partially nude boys among the classical ruins of southern Italy.

Critics note that these paintings and photographs by Tuke and von Gloeden were widely popular throughout Europe because they depicted a "natural" setting. Furthermore, von Gloeden attempted to recapture the days of classical Greece and Rome by depicting the descendants of the ancients. However, for all the respectable naturalness and classicism of these works, there is little doubt that these images were also meant to be erotically charged and geared toward a male homosexual audience.

Conclusion

Homosexuality served as both an inspiration and a way of life for many European artists during the nineteenth century. As the century progressed, new artistic trends and social theories worked together to give rise to a gay artistic sensibility. The flourishing of gay art and gay artists such as Bonheur and Solomon seems to be a part of the modernism that began at midcentury. However, Aestheticism and Symbolism met their premature demise due in part to their association with homosexuality, particularly as a result of the trials of Oscar Wilde.

— *Roberto C. Ferrari*

BIBLIOGRAPHY

Ashton, Dore. *Rosa Bonheur: A Life and a Legend.* New York: Viking Press, 1981.

Brettell, Richard R. *Modern Art 1851–1929: Capitalism and Representation.* Oxford: Oxford University Press, 1999.

Cooper, Emmanuel. *The Sexual Perspective: Homosexuality and Art in the Last 100 Years in the West.* 2nd ed. London: Routledge, 1994.

Dellamora, Richard. *Masculine Desire: The Sexual Politics of Victorian Aestheticism*. Chapel Hill: University of North Carolina Press, 1990.

Dijkstra, Bram. *Idols of Perversity: Fantasies of Feminine Evil in Fin-de-siècle Culture*. New York: Oxford University Press, 1986.

Honour, Hugh. *Neo-Classicism*. Rev. ed. Harmondsworth: Penguin, 1977.

———. *Romanticism*. New York: Harper & Row, 1979.

Lambourne, Lionel. *The Aesthetic Movement*. London: Phaidon Press, 1996.

Lucie-Smith, Edward. *Symbolist Art*. London: Thames and Hudson, 1972.

Newall, Christopher. *The Art of Lord Leighton*. London: Phaidon Press, 1990.

Nochlin, Linda. *Realism*. Harmondsworth: Penguin, 1971.

Reynolds, Simon. *The Vision of Simeon Solomon*. Stroud: Catalpa Press, 1984.

Rosenblum, Robert, and H. W. Janson. *19th-Century Art*. New York: Harry N. Abrams, 1984.

Saslow, James M. *Pictures and Passions: A History of Homosexuality in the Visual Arts*. New York: Viking, 1999.

SEE ALSO

European Art: Neoclassicism; Symbolists; Bazille, Jean-Frédéric; Bonheur, Rosa; Cellini, Benvenuto; Flandrin, Hippolyte; Géricault, Théodore; Gloeden, Baron Wilhelm von; Klumpke, Anna Elizabeth; Michelangelo Buonarroti; Solomon, Simeon; Subjects of the Visual Arts: Narcissus; Subjects of the Visual Arts: Nude Males; Subjects of the Visual Arts: Nude Females; Subjects of the Visual Arts: Orpheus; Subjects of the Visual Arts: St. Sebastian; Subjects of the Visual Arts: Sappho; Tuke, Henry Scott

European Art: Renaissance

A GREAT DEAL OF EVIDENCE ABOUT SEXUALITY SURVIVES from the Renaissance; its interpretation, however, varies. People did not conceive of themselves in terms of having a sexual identity, so a purely biographical approach to the period is not very illuminating. Instead, one can consider various cultural patterns, especially the conditions of artistic production and the types of subjects and themes represented.

Conditions of Artistic Production and Evidence of Same-Sex Activities

Although it was once believed that there was a paucity of evidence about same-sex activities in Renaissance Europe, it is now possible to emphasize the virtual ubiquity of same-sex *conditions* during the period.

The genders were frequently segregated, especially among the upper classes, in educational and religious institutions, and in most work environments, all sites important to the production and consumption of art. Women were largely enclosed; men consorted with other men in a range of homosocial spaces.

Evidence about actual sexual practice varies, but there is often no proof of an artist's "heterosexual" interest. Social historians note the coexistence of various erotic experiences and observe that, as Michael Rocke comments, "males were in general rather flexible about the biological sex of the objects of their desire." Rocke's study of fifteenth-century Florence estimates that two of every three males left some legal record of sodomitical experience.

Even condemnations of an "unspeakable, unnatural vice" gave it a discursive existence and spread intimations of what was erotically possible. Attempted censorship increased the piquancy and desirability of overtly sexual imagery.

The issue is not so much the quantity of evidence as the types, and the ways in which it is read for sexual content. Besides straightforwardly positive or negative representations of same-sex activity, scholars are beginning to notice such modalities as satire, burlesque, irony, nuance, and equivocation.

Whether or not various documented practices began in the Renaissance, new kinds of evidence survive. The advent of print culture codified and disseminated forms of oral culture, such as sexual invective, pasquinades (or lampoons), and obscene jokes. Print technology also enabled the wider marketing of erotic imagery, which in turn increased demand. The Reformation sharpened polemic accusing opponents of same-sex sins.

Homoeroticism is also evident in artists' writings, including poetry by Michelangelo and Bronzino. Cellini's autobiography, written during house arrest for sodomy, noted sexual encounters with women and, less explicitly, erotic attraction to youths. Offices established to regulate sexual activities received denunciations of artists for sodomy with apprentices or models (Leonardo in 1476, Botticelli in 1502, and Cellini in 1523 and 1557, for example).

Conditions of production in a workshop system favored all-male sociability and erotic contact. Trainees were advised to avoid women; many artists did not marry. Several anecdotes record Donatello's erotic relations with apprentices. A succession of attractive models and pupils enthralled Leonardo. For twenty-six years he endured the antics of his favorite (*suo creato*) "Salai" ("Satan") who entered his service as a ten-year-old in 1490 and was his model for depictions of youthful, curly-headed male beauty.

Botticelli, described by Vasari as "extraordinarily fond of those he knew to be students of the arts," was renowned for having nightmares about being married. A poet described the married Giovanni Bellini in bed with a boy. Married with two children, the painter Il Sodoma nevertheless openly adopted the daring nickname by which he is still known. Cellini pled guilty to

the charge of keeping an apprentice for five years "as though he were a wife" (a common expression).

Social gatherings in workshops provided sexual opportunities, and such occasions multiplied in the sixteenth century when artist clubs staged fancy-dress parties or theatrical entertainments. Cellini described a Roman dinner party for artists that was attended by female prostitutes and a seductively cross-dressed youth.

Official disapproval and punitive measures coexisted with a fair degree of tolerance among many patrons and humanists. Bonds between patrons and dependent artists were sometimes eroticized. Particularly in restricted circles, such as a poetic coterie, a courtly elite, or a so-called academy (reading group), homoerotic imagery and wit was appreciated.

Bronzino's double-sided painting of the front and rear of a naked dwarf in the Medici court, for instance, makes several homoerotic allusions. The humanist Willibald Pirckheimer wrote a Greek inscription on his portrait sketched by his friend Dürer: "With erect penis, into the man's rectum."

The interests of certain collectors are telling. For example, Antonio Pérez, Philip II's Secretary of State until accused of sodomy in 1579, owned Correggio's *Ganymede* and Parmigianino's *Cupid Carving His Bow*.

Particularly obscene, overt imagery circulated in prints, which reached a wider market. Today they are sometimes extant in only one or a few copies, suggesting their overuse and deliberate destruction, both voluntary and through institutional censorship.

Hans Sebald Beham and his brother Barthel issued and reissued engravings of naked women touching each other with lewd gestures of genital contact. In the first three decades of the sixteenth century, Marcantonio Raimondi's erotic oeuvre included several suggestive male couples, and an engraving of a woman masturbating with a dildo. Variants and a copy in reverse exist of a School of Fontainebleau print showing aristocratic women erotically engaged while at the baths.

The Rebirth of Classicism
"Renaissance" refers to the "rebirth" of classicism. New energy devoted to archaeology, antiquarianism, humanist scholarship in the secular world, and the appropriation and adaptation of classical form had a fundamental impact on erotic culture.

Art historians debate the precise influence of Neoplatonism on the visual arts, yet little attention is paid to the central element of male–male desire in the writings of Marsilio Ficino, a key proponent of the syncretistic philosophy. More generally, the revitalization of classicism greatly expanded the vocabulary and framework of fantasy.

Mythological narratives, for example, provided avenues for the depiction of same-sex desire. Two of the most popular were the tale of the shepherd boy Ganymede swept into the heavens by amorous Jupiter and the seduction of the nymph Callisto seemingly by her beloved mistress, Diana.

Desire was coded in classicized terms: a poet praised Donatello's *St. George* as "my beautiful Ganymede"; Cellini likened a model to Antinous, the beloved of the Roman emperor Hadrian.

Since ancient myths dealt with transforming metamorphoses, and were situated in timeless realms, they were apt vehicles for erotic dreams and for giving visual form to what was ostensibly taboo. Generic classical allusions justified the representation of idealized naked bodies in motion and intimate contact, seen in outright erotica but also in more mainstream formats such as allegory and pastoral.

The ancient heritage of same-sex desire was frequently invoked, sometimes as an explanation for corruption and sometimes as a model to be emulated. Accused by a rival of being a "dirty sodomite" in the presence of Duke Cosimo I de' Medici, Cellini cleverly retorted that he had neither the power nor knowledge "to meddle in such a marvelous matter," for the "noble practice" was the affair of the god Jupiter with Ganymede and "the greatest emperors and the greatest kings."

During the years he worked at Cosimo's court, Cellini produced three marble sculptures of what he called Greek "fables" when referring to his own love for youths. Each statue represented a beautiful youth with his male lover (Apollo and Hyacinth, Ganymede with Jupiter's eagle, Narcissus captivated by his reflection).

These subjects were generally recognized as being inflected with homoeroticism, as were, in certain manifestations, such figures as Eros/Cupid and Orpheus. Beefy Hercules was feminized under Omphale's sway, or enjoyed genital contact while wrestling with Antaeus.

Religious Representations
An erotic component in any image did not exclude other effects and themes. Religious representations included Christ's adored body, ephebic St. Sebastian penetrated by arrows, same-sex kissing in Paradise, pious women bonding intensely, or witches seducing women. In some of Michelangelo's drawings men grapple in close embrace, eroticizing the soul's struggle between opposing forces.

Renaissance imagery might appear to condemn nonnormative sex or treat a nonerotic subject such as the feminine personification of Virtues, but it was possible for viewers to take the works in other, imaginative directions. The issues of multivalence and alternative reception require more study, and are especially important in relation to female viewers.

Women as Viewers of Art

Many images representing erotic activities between women were made for a presumptively male audience. Nevertheless, in palace interiors (such as one at Fontanellato frescoed by Parmigianino, or the French king's villa at Fontainebleau decorated by Primaticcio and others) women were expected to see scenes of naked women bathing together and touching each other during their toilette, usually in the context of propounding chastity (not having sex with any man other than one's husband).

Women were understood to find sensual pleasure from looking. Titian's close friend Pietro Aretino published in 1534 an obscene scenario in which nuns at an orgy were aroused by pornographic illustrations and had sex with each other. Around 1585 the minor French aristocrat Brantôme described noblewomen enjoying erotic books and paintings, and another chapter concentrated on "woman with woman" (*donna con donna*) sex.

Liminal Masculinity

The most conventional object of homoerotic desire was the adolescent youth, usually imagined as beardless. Attraction to liminal masculinity was also evident in the popularity of angels (officially sexless, yet pictured as boyish) and androgynes. For many influential writers and artists, the erotic and the beautiful were male, or anybody imbued with qualities perceived to have a crucial element of masculinity.

Thus, in 1542, Aretino praised Michelangelo's painting of Venus because it depicted a goddess whose female body had "the male's musculature, such that she is moved by virile and womanly feelings."

Toward the end of the next decade, Lodovico Dolce's paean to Titian's painting of *Venus and Adonis* included the comment that Adonis's face had "a certain fine beauty which could participate in the feminine yet not be remote from virility—an amalgam (*mistura*) which is hard to achieve and agreeable."

In 1550, Vasari singled out Michelangelo's statue of Bacchus for similar reasons. Carved in 1496–1497, the tipsy youth was said to show "a certain fusion (*mistione*) in the members that is marvelous, and in particular—both the youthful slenderness of the male and the fullness and roundness of the female."

In a patriarchal, androcentric culture, polymorphous sexuality was primarily a male privilege, but same-sex erotic fantasies and experiences were available to women too.

— *Patricia Simons*

Bibliography

Brantôme (Pierre de Bourdeille, Seigneur de Brantùme). *The Lives of Gallant Ladies*. Alec Brown, trans. London: Elek, 1961.

Bray, Alan. *The Friend*. Chicago: University of Chicago Press, forthcoming.

———. *Homosexuality in Renaissance England*. London: Gay Men's Press, 1982.

Bronzino, Agnolo. *Rime in burla*. Franca Petrucci Nardelli, ed. Rome: Istituto della Enciclopedia Italiana, 1988.

Brown, Judith C. *Immodest Acts. The Life of a Lesbian Nun in Renaissance Italy*. New York: Oxford University Press, 1986.

Cellini, Benvenuto. *Autobiography*. George Bull, trans. Harmondsworth: Penguin, 1956.

Goldberg, Jonathan, ed. *Queering the Renaissance*. Durham, N. C.: Duke University Press, 1994.

Michelangelo. *The Poetry of Michelangelo*. James Saslow, ed. and trans. New Haven: Yale University Press, 1991.

Rocke, Michael. *Forbidden Friendships. Homosexuality and Male Culture in Renaissance Florence*. New York: Oxford University Press, 1996.

Ruggiero, Guido. *The Boundaries of Eros. Sex Crime and Sexuality in Renaissance Venice*. New York: Oxford University Press, 1985.

Saslow, James M. *Ganymede in the Renaissance: Homosexuality in Art and Society*. New Haven: Yale University Press, 1986.

———. *Pictures and Passions: A History of Homosexuality in the Visual Arts*. New York: Viking, 1999.

Simons, Patricia. "Lesbian (In)Visibility in Italian Renaissance Culture: Diana and Other Cases of donna con donna." *Gay and Lesbian Studies in Art History*. Whitney Davis, ed. New York: Haworth Press, 1994. 81–122.

Sternweiler, Andreas. *Die Lust der Götter. Homosexualität in der italienischen Kunst von Donatello zu Caravaggio*. Berlin: Verlag Rosa Winkel, 1993.

Vasari, Giorgio. *Lives of the Most Eminent Painters Sculptors and Architects*. Gaston Du C. de Vere, trans. 3 vols. New York: Harry N. Abrams, 1979.

Weigert, Laura. "Autonomy as Deviance: Sixteenth-Century Images of Witches and Prostitutes." *Solitary Pleasures: The Historical, Literary, and Artistic Discourses of Autoeroticism*. Paula Bennett and Vernon A. Rosario II, eds. New York: Routledge, 1995. 19–47.

Wittkower, Rudolf and Margot. *Born Under Saturn. The Character and Conduct of Artists: A Documented History from Antiquity to the French Revolution*. New York: W. W. Norton, 1969.

SEE ALSO

Bronzino, Agnolo; Cellini, Benvenuto; Donatello; Dürer, Albrecht; Leonardo da Vinci; Michelangelo Buonarroti; Parmigianino (Francesco Mazzola); Il Sodoma (Giovanni Antonio Bazzi); Subjects of the Visual Arts: Diana; Subjects of the Visual Arts: Ganymede; Subjects of the Visual Arts: Hercules; Subjects of the Visual Arts: Narcissus; Subjects of the Visual Arts: St. Sebastian

European Art: Twentieth Century

A LARGE NUMBER OF SIGNIFICANT TWENTIETH-CENTURY European artists focused on gay, lesbian, bisexual, and transgender themes, making such concerns crucial to the understanding of twentieth-century art.

These artists span all the major art movements and are too numerous for inclusion in a condensed essay. By

necessity, the individuals discussed here constitute only a representative sample of the diverse range of twentieth-century artistic production in Europe of particular interest to glbtq people.

Henry Tuke and Ethel Walker

The careers of two British painters, Henry Scott Tuke (1859–1929) and Dame Ethel Walker (1861–1951), peaked during the early part of the century.

Tuke belonged to a circle of poets and writers who discussed and wrote about the beauty of male youth. His paintings of male nudes are notably sensual. The oil painting *Noonday Heat* (1903), for example, presents two youths who, relaxing on the beach, are completely engrossed in their own private world. Since neither of them addresses the viewer, their relationship seems intimate, exclusive, and ambiguous.

Dame Ethel Walker produced her major works late in her life: from the time she was in her fifties until her death at the age of ninety. She did not demonstrate any special interest in art until she formed a close friendship with Clara Christian in the 1880s; thereafter, the two women lived, studied, and worked together as fellow artists.

Walker is perhaps best known for her portraits of women. She captures her sitters' individual temperaments and expressions. Her obvious, tactile brushstrokes obscure unnecessary detail, thereby allowing the artist to emphasize the compositional aspects that capture the mood of her sitter.

Léonor Fini and the Surrealists

While artists such as Walker and Tuke represented the natural world in their artworks, individuals influenced by the Surrealist movement sought to discover, or even to be liberated into, an alternate reality. According to the Surrealists, this "new" reality necessitated the freeing of the unconscious and included outward manifestations of sexual desire.

The Surrealist attitude toward sexuality was revolutionary. The Surrealists celebrated and concretized desire in their theories, writings, and artworks. Some of them manifested their beliefs in sexually open lifestyles.

Painter Léonor Fini (1907–1996) never officially joined the Surrealists but she displayed her works in many of their exhibitions. She had many lovers of both sexes. She never married but eventually settled with three individuals: two men, one mostly a friend, the other mostly a lover (Stanislao Lepri, a diplomat turned highly successful painter), and one female lover (Constanine Jelenski, a celebrated Polish poet and writer).

A child prodigy, Fini was born in Buenos Aires to an Argentine father and an Italian mother. When she was a young child, her mother fled Fini's "overly macho"

father to her hometown of Trieste, Italy. Since Fini's father repeatedly hired kidnappers to abduct his daughter and bring her to Argentina, her mother disguised Fini as a boy until she reached puberty. After many failed attempts to retrieve his daughter, Fini's father finally gave up and had minimal, if any, contact with her for the rest of his life.

Perhaps the unusual circumstances of Fini's early life contributed to her development into a fiercely independent young woman. Fini, who rebelled against formal education, taught herself to draw and paint through self-discipline and perseverance. She learned anatomy by making detailed drawings of corpses that she found in Trieste morgues.

The intricate sketches of Fini's youth later developed into increasingly simpler and more gestural drawings, usually of women. Shortly after her first exhibition in Milan at the age of seventeen, she moved to Paris, where she remained for the rest of her life.

Most of Fini's paintings are infused with a sensuality that is both beautiful and ominous. The oil painting *Le Lac* (1991), for example, depicts busts of women with full, rounded breasts submerged in water. The hair on top of their heads forms phallic-like structures. The women glow ghostly white, an effect that is enhanced by their ambiguous, lush, and dark environment. These incredible beings dominate their surroundings and seem to function as icons of female sexuality.

The oil painting *The Ends of the Earth* (1949) features a single nude woman who is immersed in dark liquid from the breasts down. Around her float animal skulls said by the artist to represent the extinct male race, which she thought was too brutal and cruel to survive. Like *Le Lac*, *The Ends of the Earth* is a stark, haunting image that presents woman as an icon.

The Ends of the Earth illustrates Fini's refusal to accept the world as defined by men and her consequent creation of a pictorial world defined by female desires. Although erotic connotations infuse her works, the female body is never objectified; the women Fini creates are always powerful and self-possessed.

The lithograph *Armine* (1976), for example, features a nude male figure in profile literally chewing his fingers in desire as he gazes at the beautiful woman who is presented frontally to the viewer. Seemingly aware of her unattainable status, the woman confronts the viewer with a full-on gaze beneath raised eyebrows.

Marcel Duchamp and Claude Cahun

Some artists who worked in the Surrealist tradition, including Marcel Duchamp (1887–1968) and Claude Cahun (1894–1954), experimented with the fluidity of gender roles. Frequently understood as the creator of conceptual art, Duchamp eschewed art that appeals only to the eye in favor of art made for the mind. Ideas

became the focus of his work, and androgyny was a concept that interested him.

The combination of male and female elements in Duchamp's art symbolizes duality and, by extension, the larger truth of nonduality—or the unity of all reality. In other words, twoness actually is oneness when understood from a higher, perhaps surreal, level of perception.

Perhaps the best example of Duchamp's experimentation with gender roles is the creation in 1920 of his female alter ego, Rrose Sélavy ("Eros, c'est la vie," or "Eros, that's life"). Works that present Duchamp as a female include *Belle Haleine (Beautiful Breath,* 1921), a perfume bottle with a photograph of Rrose taken by Man Ray. In addition to appearing in various works of art, Rrose "signed" a number of them, as well as most of Duchamp's literary works, between 1920 and 1940.

Duchamp, a heterosexual, intended Rrose to be amusing, but he also wanted to propagate androgyny as a concept to ponder seriously. The artist also experimented with androgyny outside of his alter ego. In 1938, for example, Duchamp presented a female mannequin half-dressed in his own male clothing for the Exposition Internationale du Surréalisme in Paris. The torso, chest, and arms of the figure wore a suit while the pelvis, legs, and feet remained alarmingly bare.

A contemporary of Duchamp, the French lesbian artist born Lucy Schwob lived her life under the androgynous pseudonym Claude Cahun (1894–1954). Throughout her writings and photography, Cahun explored the idea that gender is a masquerade. Her photographs, which convincingly present her as either male or female, suggest that gender is a construct.

In a 1929 self-portrait, for example, Cahun wears a blond wig and heavy makeup in an obviously elaborate charade of doll-like femininity. In a 1919 self-portrait, however, Cahun looks like a male as she sits in profile.

Cahun's photographs that present her as a mixture of male and female components are shocking, outlandish, and ingenious. In a dramatic self-portrait from 1928, Cahun is a sexy, glamorously made-up female with a scarf draped around her neck. In a twist that makes the viewer unfamiliar with Cahun's work wonder whether the sitter is male or female, the artist wears a shirt that looks like bare skin in the black-and-white photograph. Since the garment makes the artist's chest seem completely flat, the two nipples painted onto the fabric look male.

In another thought-provoking self-portrait from 1928, the artist, with characteristically cropped hair, presents herself as an androgynous being with her left cheek next to a mirror. Most intriguing is the fact that the unaltered mirror reflection of the artist, presented within the same image, highlights the fact that the human face is not bilaterally symmetrical.

With this photograph, Cahun suggests that the existence of "two faces" within a single individual has gender implications. She holds the jacket she is wearing to her neck with her right hand, concealing her neck from the viewer. In the mirror reflection, she appears to hold the collar open with her left hand. Thus, Cahun is able to contrast her feminine neckline, or a more feminine version of herself, with a more masculine portrayal. Within a single image, then, the artist reveals that neither identity nor the perception of identity is fixed or stable.

Cahun's photographs challenge the notion of two distinct, polar-opposite genders, and they do so in an unabashed manner. In almost every self-portrait, Cahun gazes directly, unapologetically at the viewer.

While Cahun was alive, her questioning of gender roles did not end with her artworks. In everyday life, Cahun dressed alternately as a male or a female and sometimes as a combination of both. She was known to make grand entrances wearing the suit of a man, monocle over one eye, on the arm of her lifelong companion, Suzanne Malherbe.

Hannah Höch

Like Cahun and Duchamp, the German artist Hannah Höch (1889–1978) also experimented with androgyny in her artistic production. While Cahun created seamless, believable images, however, Höch worked with the collage, frequently emphasizing its constructedness.

Affiliated with the Dada movement, Höch's works are characteristically nonsensical; Dada artists frequently poked fun at the art world. The very nature of the collage, made from preexisting, or found, materials, challenges the definition of art as an original creative production.

In the photomontage (collage of photographs) titled "Dompteuse" ("Tamer," ca. 1930), Höch leaves the ripped edges of the photographs exposed to reinforce the point that the fantastical being created in the work is constructed. This seated, slim-bodied figure wears a woman's skirt and shirt, sports hairy, muscular arms, and possesses the demure, black-and-white face of a mannequin (the rest of the photograph is in color).

By combining stereotypical male and female imagery, Höch forces the viewer to consider what characterizes specific gender traits, and perhaps also why. "Dompteuse" could also be viewed as a joke about which combination of qualities constitutes a "third sex," since some theorists at the time ascribed bisexuality to a visible, physical combination of masculine and feminine attributes. This investigation may have been of particular interest to Höch since she was bisexual.

Höch sometimes addresses the objectification of women in her work. In the photomontage "Marlene," for example, two male viewers gaze at a pair of gigantic

legs adorned with stockings and high heels that are mounted upside down on a pedestal.

This image is not a simple illustration of male desire for the female form, however. The bright red mouth positioned in the upper right-hand corner is outside of the males' sight lines, and so is presented to the viewer, whether male or female, as an object of desire.

Adding another layer to the work, the name "Marlene" is scribbled across the center of the image. This is probably an allusion to Marlene Dietrich, an actress well known for her androgynous image and her ambiguous sexual identity.

Keith Vaughan

Different in style and in content from Dada and Surrealist works is the art of the openly gay British painter Keith Vaughan (1912–1977). Untaught as an artist, though tutored at Christ's Hospital in London, Vaughan developed his skill through unrelenting practice.

From his early twenties until the end of his life, taken through a suicide that resulted from Vaughan's struggle with cancer, the artist portrayed the male form within the landscape. As his works demonstrate, he conceptualized man as integrated into nature.

The oil painting *Head with Raised Arm* (1948) features a blocky torso and head surrounded by patches of color. The repetition of forms and tones creates an ambiguity between figure and ground. The male figure, in fact, is so much a part of the surroundings that his body seems to become part of the landscape, with only the mouth and an ear fully articulated.

Vaughan's mixed-media work *Ochre Figure* (1952) features a sinewy, linear male form that, like the figure in *Head with Raised Arm*, blends into its surroundings. The face, sketchily articulated, is set into a small head that ultimately functions as a design element.

As Vaughan's career progressed, his work became more abstract. In the 1963 oil painting *Group of Dinkas*, for example, the artist uses a minimum of brushstrokes to suggest three human forms.

Francis Bacon

Widely recognized as Britain's most important twentieth-century painter, Francis Bacon (1909–1996) is best known for his elegantly composed works featuring ugly and disturbing subject matter, especially crucifixions, screaming faces, and beaten bodies. His work has been seen as reflecting the violence and trauma that has characterized twentieth-century Europe, but it also reflects the artist's interest in gay male sadomasochism.

Although Bacon was openly gay and his work presents uncensored radical sexuality, he has nevertheless enjoyed wide praise from mainstream critics. Even works such as *Two Figures* (1953), which depicts male–male rape, have been acclaimed for their symbolic significance and beauty of composition.

Indebted to the old masters, but strongly influenced by modern psychological insights and awareness, Bacon produces deeply disturbing works that nevertheless appeal even as they repel. What has not been sufficiently recognized by mainstream critics is the autobiographical roots of Bacon's paintings, especially its origins in his psychosexual makeup.

David Hockney

Another openly gay British artist, David Hockney (b. 1937) sometimes treats the male form in a funky, even whimsical manner. Hockney developed a distinct style during his studies at the Royal College of Art in London in the late 1950s. Representational but deliberately naive, his style was influenced by both abstract art and children's drawings.

Hockney has deemed a work that dates from this early period, *We Two Boys Together Clinging* (1961), propaganda for homosexuality. In the painting, two scribbled, simplistic human forms embrace and kiss one another. Alluding to the poem by Walt Whitman, the artist incorporated the words "we two boys together clinging" into the composition.

Hockney moved to Los Angeles in 1964, perhaps in part drawn by California's more relaxed attitude toward homosexuality. In Los Angeles, blue skies, swimming pools, and homoerotic images of tanned young men became the most common themes of his increasingly naturalistic work. The voyeuristic *Man Taking Shower in Beverly Hills* (1964), for example, features a nude male seen from the side bending over in the shower.

Rotimi Fani-Kayode

Toward the end of the twentieth century, many artists working in Europe reflected the increasing internationalization of the art world. For example, the Nigerian-born photographer Rotimi Fani-Kayode (1955–1989) moved to London during his adolescence. His work is at once African and European.

One of Fani-Kayode's goals was to use art to undermine the Western world's misperception and misrepresentation of black Africans. His photographs of nude or seminude black males frequently blend African and Western iconography with sexual, sometimes homoerotic, themes. They present an alternate reality, transporting the viewer into unfamiliar worlds that encourage a reconsideration of commonly held ideas and assumptions about racial and sexual identity.

The black-and-white photograph entitled "White Bouquet" (1987) is a reinterpretation of Édouard Manet's famous painting *Olympia* (1863). It depicts a white man presenting a bouquet of flowers to a black

male lounging on a chaise. Both nude figures turn their
backs to the viewer. In Manet's work, a clothed black
female servant gives flowers to a nude white female pros-
titute, and both women face the viewer.

"White Bouquet"'s gender and racial reversal is
echoed in its compositional inversion; even the presenter
of the flowers is on the opposite side than in *Olympia*.
This undoing of the familiar results in an ambiguous
image left open to many complex interpretations.

Conclusion

Many European artists explored gender-related and homo-
sexual themes during the twentieth century. The breadth
of this output is immense and continues to influence
artists working today. The figures mentioned above were
chosen not only because of their distinctive achievements,
but also because their interests are both representative
and diverse.
— *Joyce M. Youmans*

BIBLIOGRAPHY

Bailey, David A. "Photographic Animateur: The Photographs of Rotimi Fani-Kayode in Relation to Black Photographic Practices." *Third Text* 13 (Winter 1997): 57–62.

Byrd, Julie. Excerpt from the paper "Les Femmes Surrealistes." Interdisciplinary Cross-Cultural Conference, University of Illinois. March 3, 1995. www.ed.uiuc.edu/courses/EdPsy387-Sp95/Steven-Clark/project/Fini/Fini.html.

Cooper, Emmanuel. *The Life and Work of Henry Scott Tuke, 1858–1929.* London: GMP Publishers, 1987.

"David Hockney: Artist." *h2g2.* www.bbc.co.uk/dna/h2g2/alabaster/A710821.

Earp, T. W., et al. *Ethel Walker, Frances Hodgkins, and Gwen John: A Memorial Exhibition.* London: Arts Council of Great Britain, 1952.

Fani-Kayode, Rotimi. "Traces of Ecstasy." *Ten-8* 2.3 (Spring 1992): 64–71.

Fani-Kayode, Rotimi, et al. "Rotimi Fani-Kayode and A. Hirst." *Revue Noire* 3 (December 1991): 30–50.

Frey, Raman. *Léonor Fini.* Weinstein Gallery. www.weinstein.com/fini/bio.html (15 April 2002).

Graham, Lanier. "Duchamp and Androgyny: The Concept and its Context." *tout-fait: The Marcel Duchamp Studies Online Journal* 2.4 (January 2002): www.toutfait.com/issues/volume2/issue_4/articles/Graham/graham1.html.

Hall, Charles. "Rotimi Fani-Kayode." *Arts Review* 43.1 (January 1991): 42.

Lavin, Maud. *Cut with the Kitchen Knife: The Weimar Photomontages of Hannah Höch.* New Haven: Yale University Press, 1993.

Mercer, Kobena. "Mortal Coil: Eros and Diaspora in the Photographs of Rotimi Fani-Kayode." *Overexposed: Essays on Contemporary Photography.* Carol Squiers, ed. New York: The New Press, 1999. 183–210.

Oguibe, Olu. "Finding a Place: Nigerian Artists in the Contemporary Art World." *Art Journal* 58.2 (Summer 1999): 30–41.

"Outspoken: David Hockney." *OutUK: The UK Gay Men's Guide* www.outuk.com/outspoken/outguys/hockney.html.

Pearce, Brian Louis. *Dame Ethel Walker: An Essay in Reassessment.* Exeter, Devon, England: Stride Publications, 1997.

Saville, Julia. "The Romance of Boys Bathing: Poetic Precedents and Respondents to the Paintings of Henry Scott Tuke." *Victorian Sexual Dissidence.* Richard Dellamora, ed. Chicago: The University of Chicago Press, 1999. 253–277.

Stewart, Angus. "About Keith Vaughan." www.keith-vaughan.co.uk/akv.htm.

Talley, M. Kirby, Jr. "Henry Scott Tuke: August Blue." *Art News* 93.10 (December 1994): 103–104.

SEE ALSO

Surrealism; Bacon, Francis; Cahun, Claude; Duchamp, Marcel; Fani-Kayode, Rotimi; Fini, Léonor; Höch, Hannah; Hockney, David; Tuke, Henry Scott; Vaughan, Keith; Walker, Dame Ethel

Fani-Kayode, Rotimi *(1955–1989)*

Oluwarotimi (Rotimi) Adebiyi Wahab Fani-Kayode became one of the most important black photographers of the late twentieth century, exploring in his work themes of racial and sexual identity.

He was born in Lagos, Nigeria, in 1955. Fani-Kayode's family came from Ife, the Yoruba spiritual center. The Fani-Kayodes were of the family of the Akire, keepers of the shrine of Ife, the Yoruba oracle. His father was both a high-ranking politician and a Yoruba high priest.

Although he was born into a family of privilege in both political and religious circles, he was dispossessed at a young age. Following a military coup in Nigeria when he was eleven years old, Fani-Kayode fled with his family to England, where they sought political asylum. Although he hoped to return to his homeland, Fani-Kayode was never able to go back to Nigeria. Nonetheless, the iconography of the Yoruba culture figures heavily in his photographs.

In 1976, Fani-Kayode traveled to the United States to study fine art and economics, the latter at his parents' insistence. He received a B.A. from Georgetown University in 1980 and an M.F.A. from Pratt Institute in 1983. By this time he was already making photographs of other black men in Yoruba garb, attempting to reconcile in exile his heritage with his homosexuality. He returned to England soon after his graduation from Pratt in 1983.

Race, sexuality, and nationality are inextricably linked in Fani-Kayode's photographs and writings about his work. In an often-cited essay, "Traces of Ecstasy," he explained, "It is photography, therefore—Black, African, homosexual photography—which I must use not just as an instrument, but as a weapon if I am to resist attacks on my integrity and indeed, my existence on my own terms."

His photographs are lyrical, sensual, sexual, and mythical self-portraits and portraits of other black and white men. They reflect an ongoing exploration of cultural, sexual, and racial identity and pride.

As a black man exiled in England from his African homeland, Fani-Kayode longed for his Yoruba culture, which, however, was not accepting of his homosexuality. This triangle of conflicts defines his work. He never exhibited his images in Africa, fearing that their explicit homoerotic content would damage his family's standing.

Fani-Kayode was also the rare African photographer whose work was purely artistic rather than documentary or commercial. Both his life and art were a dichotomy of revelation and suppression.

Fani-Kayode became a founding member of Autograph, the influential association of black photographers established in London in 1987, and was active in the Black Audio Film Collective.

Fani-Kayode provided the photographs and his partner, British photographer and filmmaker Alex Hirst (who died in 1994), provided the text for the publication *Black Male/White Male* (1988). The book includes Fani-Kayode's most straightforward images exploring masculinity and race, as well as tender portraits of men loving men,

including the writer Essex Hemphill. Fani-Kayode and Hirst also collaborated on at least one photographic series entitled "Bodies of Experience."

Like many artists living with HIV/AIDS, Fani-Kayode addressed his illness directly. Particularly important in this regard is his photographic series "Ecstatic Antibodies."

Fani-Kayode died of AIDS on December 21, 1989. His influential career as an artist had lasted a brief seven years.

Following his death, Hirst signed both artists' names to works previously attributed to Fani-Kayode alone; hence, there is a persistent debate surrounding authorship of Fani-Kayode's photographs. A posthumous publication, *Rotimi Fani-Kayode and Alex Hirst: Photographs* (1996), further extended the debate. — *Carla Williams*

BIBLIOGRAPHY

Anthologie de la Photographie africaine et de l'Océan Indien XIXe & XXe siècles. Paris: Editions Revue Noire, 1998. 290–293.

Fani-Kayode, Rotimi. "Traces of Ecstasy." *Reading the Contemporary: African Art from Theory to the Marketplace*. London: Institute of International Visual Arts; Cambridge, Mass.: MIT Press, 1999. 276–281.

Hirst, Alex. "Introduction." *Black Male/White Male: Photographs by Rotimi Fani-Kayode*. London, Gay Men's Press: 1988. 3.

Mercer, Kobena. "Mortal Coil: Eros and Diaspora in the Photographs of Rotimi Fani-Kayode." *Over Exposed: Essays on Contemporary Photography*. Carol Squiers, ed. New York: New Press, 1999.

Oguibe, Olu. "Finding a Place: Nigerian Artists in the Contemporary Art World." *Art Journal* 58.2 (Summer 1999): 30–41.

Reid, Mark A. "Postnegritude Reappropriation and the Black Male Nude: The Photography of Rotimi Fani-Kayode." *The Passionate Camera: Photography and Bodies of Desire*. Deborah Bright, ed. London and New York: Routledge, 1998. 216–228.

Zaya, Octavio. "On Three Counts I Am an Outsider." *Nka: Journal of Contemporary African Art* No. 4 (Spring–Summer 1996): 24–29.

———. "Rotimi Fani-Kayode." *In/sight: African Photographers, 1940 to the Present*. Clare Bell et al., eds. New York: Guggenheim Museum, 1962. 262.

SEE ALSO

African American and African Diaspora Art; African Art: Contemporary; European Art: Twentieth Century; Photography: Gay Male, Post-Stonewall; Subjects of the Visual Arts: Nude Males

Fini, Léonor (1908–1996)

THE WORK OF BISEXUAL ARTIST LÉONOR FINI RESISTS classification. Although often associated with Surrealism, it is highly personal. It presents a mysterious and evocative world dominated by women.

Born in Buenos Aires in 1908 to parents of Italian, Spanish, and Argentinean descent, Léonor Fini was reared in Trieste, Italy. A largely self-taught artist, as a teenager

she studied Renaissance and Mannerist painting in European museums and anatomy at the Trieste morgue.

In her visits to the morgue at the age of thirteen or so, she became intensely interested in the phenomena of life and death, decay and regeneration that were to influence her art profoundly. In her paintings, images of skulls and bones mark the tension between the transitory and the eternal.

Fini's independence and reliance on personal instinct link her with other women artists associated with Surrealism, including her close friend Leonora Carrington and Frida Kahlo.

In her life and art Fini advanced an ideal of the "autonomous, absolute woman," who was beautiful, domineering, and "governed by passion." Although she had numerous suitors, she refused to marry. She preferred to live communally, often with two men, and demanded a sexual freedom that included bisexuality.

But she made a clear distinction between choosing a lesbian lifestyle and the desire to experience the love of another woman. In an interview with Whitney Chadwick in 1982, Fini freely acknowledged her experience of same-sex love, but refused to accept a lesbian identity, remarking, "I am a woman and have had the 'feminine experience' but I am not a lesbian."

Fini's strong commitment to sexuality as the connection between internal and external realities aligned her with Surrealists such as Salvador Dalí, André Masson, and Hans Bellmer. In 1936, she exhibited with the Surrealists in Paris and was subsequently associated with them.

Fini shared some of the Surrealists' ideas and a similar interest in shocking behavior and dramatic gestures. For example, when several Surrealists first saw her paintings and asked to meet her in a café, she arrived dressed in a cardinal's red robes and explained that she liked the sacrilege of a woman wearing clothes of a man who would never know a woman's body.

However, her association with these male artists was largely social rather than substantive. She was hostile toward André Breton's puritanism and the Surrealists' failure to respect the autonomy of women while they "pretended" to liberate men. Moreover, as Chadwick points out, Fini is distinguished from them by her refusal to subjugate her female images to male desire.

Fini's work may in fact be seen as a response to the patriarchal assumptions of Surrealism. Fini places herself, or other women, at the center of her paintings as images of female power and autonomy. Her works touch on issues of matriarchy, lesbianism, and androgyny. She typically combines carefully rendered reality and an invented theatrical space dominated by fantasy.

Fini frequently includes in her paintings her personal totem, the cat; and she often depicts women who have magical—often sexual—powers. However, her figures

A portrait of Léonor Fini by Carl van Vechten.

are not necessarily intended to be read as abstract principles of dominant women and submissive men, since she based the paintings on images of specific individuals in her life.

Fini's first solo exhibition was at the Julian Levy Gallery in New York, in 1939. During World War II, she lived in Monte Carlo and Rome and continued to work as an illustrator, theater designer, and painter, achieving a considerable reputation in Europe. She died in Paris in 1996.

— *Elizabeth Ashburn*

BIBLIOGRAPHY

Chadwick, Whitney. *Women Artists and the Surrealist Movement*. Boston: Little, Brown, 1972.

Jelenski, Constantin. *Léonor Fini*. Lausanne: Clairefontaine, 1968.

Léonor Fini. Exhibition Catalog, with an essay by Luigi Carluccio. Turin: Galatea-Galleria d'Arte Contemporanea, 1966.

Léonor Fini. Exhibition Catalog, with an introduction by Léonor Fini. Ferrara: Galleria Civica d'Arte Moderna, 1983.

SEE ALSO

European Art: Twentieth Century; Surrealism; Latin American Art; Erotic and Pornographic Art: Lesbian; Kahlo, Frida; Subjects of the Visual Arts: Nude Females

Flandrin, Hippolyte (1809–1864)

I N ART HISTORY, THE CONSIDERABLE ACCOMPLISHMENTS of Hippolyte Flandrin are often overshadowed by those of his mentor, J. A. D. Ingres (1780–1867). Flandrin adhered closely to Ingres's focus on purity and perfection of line. He also followed Ingres in expressing a reverence for the past and for classical themes and subjects. Both artists had an unusual way of mixing tradition with innovation.

However, Flandrin's studies of male youth distinguish him from his master, especially insofar as these works are richly and suggestively homoerotic.

Flandrin came from an artistic family in Lyons. After moving to Paris, where he studied with Ingres, and following a five-year stint in Rome for further study, he quickly gained a reputation as a painter of mythological and religious scenes.

Later in the nineteenth century, art critic Théophile Gautier (1811–1872) equated Flandrin's purity of line and color with purity of emotion and spirituality. Flandrin himself was devotedly religious and approached his art from a spiritual rather than secular point of view. Many of his most ambitious projects were commissioned by churches such as Saint-Germain-des-Prés and Saint-Vincent-de-Paul in Paris.

Nothing about Flandrin allows us to identify him as homosexual. He was married and had several children. He apparently did not consciously conceive of his work as homoerotic.

Many of his mythological scenes, however, concentrate on the youthful male nude as aesthetic object. Flandrin himself claimed that the classical beauty of his work was born out of his knowledge of Homer, Plutarch, Tacitus, and Virgil. The majority of his mythological scenes, produced between 1833 and 1836, feature secluded youthful nude males situated in calm and still environments.

Most of his figures express "a perfect peace" and mix Virgilian lyricism with a striking realism in the detailing of head, hands, and feet. In some of his works, he exploits compositional devices that cover the genital area but also focus attention on it. The homoerotic overtones of these works are profound.

One of these, *Polytes, Son of Priam Observing the Movements of the Greeks Near Troy* (1833–1834; Saint-Étienne, Musée d'Art et d'Histoire) shows a nude male youth sitting in profile atop a classically decorated pedestal. He looks out of the picture and into the distance. The prominent curve of the youth's back and the formal focus on the interplay between form and line communicate a quality of hushed beauty and frozen purity.

The work is implicitly erotic and imbued with a quality of meditative spirituality. One outstanding detail

Hippolyte Flandrin.

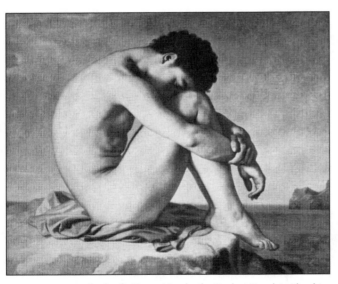

Study of a Young Man by the Sea by Hippolyte Flandrin.

the nude male figure as a showcase for the stylistic purity of line, modeling, chiaroscuro, and color. These features are underscored by a mysterious, meditative calm provoked by a moonlit seascape. The youth's body and the environment work together to evoke an aura of poetic lyricism.

The work has been hailed as an exquisite example of visualized spirituality and beauty. The painting is distinguished not only by a hyperreal rendering of the boy's arms, hands, and feet, but also by its geometric composition, which consists of an equilateral triangle within a circle, which may have mystical significance.

The curled-up, fetal pose was a unique compositional invention and has subsequently been repeated by artists ranging from Edgar Degas to Baron von Gloeden to Robert Mapplethorpe. The pose is perfect for highlighting the male body as an object of spiritual and erotic contemplation. — *James Smalls*

BIBLIOGRAPHY

Camille, Michael. "The Abject Gaze and the Homosexual Body: Flandrin's Figure d'Étude I." *Gay and Lesbian Studies in Art History*. Whitney Davis, ed. New York: Haworth Press, 1994. 161–188.

SEE ALSO

European Art: Twentieth Century; Erotic and Pornographic Art: Gay Male; Subjects of the Visual Arts: Nude Males

French, Jared *(1905–1988)*

DISSATISFIED WITH MERELY DESCRIBING THE MATERIAL world, American painter Jared French devised a pictorial language to explore human unconsciousness and its relation to sexuality.

Most of his works consist of strange, statuelike, somnambulant figures with eerily blank facial expressions positioned in austere landscapes and plazas. Rendered in a technique so precise that they seem more real than real, French's paintings capture and maintain the viewer's interest and imagination.

At Amherst College in 1926, French met artist Paul Cadmus, who was briefly his lover and who became a lifelong friend. After leaving Amherst, French took a job on Wall Street and then toured Europe with Cadmus between 1931 and 1933.

During the 1930s and 1940s, French was a member of the Cadmus circle that included such gay literary and artistic figures as George Platt Lynes, Lincoln Kirstein, George Tooker, Glenway Westcott, and Monroe Wheeler.

In 1937, French married artist Margaret Hoening, his and Cadmus's mutual friend. Cadmus did not seem

is the hyperreal rendering of the young boy's exposed pubic hairs. This detail seems to be at odds with the idealized quality of the rest of the painting. Flandrin thus blends the real and the ideal, the erotic and the contemplative, a poeticized romanticism and an incongruous realism, and classicized form and pious emotion.

Flandrin's most popular and recognizable work is his *Figure d'Étude* (Nude Youth Seated on a Rock, 1835–1836; Paris, Louvre). Typical of Flandrin, this work uses

upset with the marriage and the three were soon collaborating as members of the PAJAMA photographic group (its name composed of the first two letters of each of their given names).

The photographs taken by French, Hoening, and Cadmus are particularly important for documenting the gay and artistic community coalescing at Fire Island in the period from 1937 to 1945. The Fire Island pictures influenced French's painting during the 1940s and 1950s.

Carl Jung's *Archetypes of the Collective Unconscious* also heavily influenced French's artistic output. In this book, Jung proposes the existence of a collective unconscious, defined as an ancient memory inherent in the human mind. According to Jung, each individual inherits the combined knowledge and experience of the entire human species throughout its millennia of existence.

Appropriately, then, archaic art from Ancient Egypt and Greece inspired French's visually repetitive human figures, which represent the whole of humanity and, by extension, its mental state.

An analysis of French's paintings reveals the central role sexuality plays in the artist's conception of humanity. In the tempera painting entitled *Washing the White Blood from Daniel Boone* (1939), American Indians symbolically wash away Boone's European ancestry to make him part of the collective unconscious, here represented by the Indians' culture, which, compared to that of the Western world, is archaic.

Boone's metamorphosis includes a sexual awakening. Surrounded by incredibly muscular, nearly nude male Indians, he stands in the middle of the canvas, arms outstretched, wearing obtrusively feminine underwear: tight, light-pink hip-huggers laced up the center with a dark blue ribbon. This scenario suggests that the painting is an exploration of Jung's concept of the anima, or man's repressed feminine aspect.

French addresses the anima in other works, including the tempera painting *Woman* (1947). In this work, a female figure appears to rise magically from the sea, a symbol of the unconscious, in the background. After her strange birth, she physically multiplies. French evokes the mysterious power of the anima by seamlessly weaving four different views of the figure into a single composition.

During the 1960s, French radically altered his imagery. He began drawing fantastic biomorphic creatures that, at first glance, look like weird rock formations. On closer inspection, however, fragments of human torsos, heads, pelvises, and genitalia emerge. These later works create the impression that primordial energy heaves on anthropomorphic landscapes.

French made paintings out of only a few of these arresting drawings. In one such work, entitled *Nest* (1968–1969), a mass of fleshy, cartilaginous forms appears to mutate atop a seaside cliff. Somewhat horrifically, this hermaphroditic creature, made up of orifices, buttocks, faces, and spines, seems to have impregnated itself and is hatching its egg on a nest of flesh and bone.

Throughout his career, Jared French produced a fascinating body of imaginative art. His artistic development is palpable; while his earlier works capture psychological states of being, his later drawings and paintings seem to transform the human body into a symbol of spirit.

Strange and sometimes eerie, his works probe into a deep, subhuman layer of the psyche. They seem just beyond reason and understanding, and consequently, prove incredibly engaging to the viewer.

However, in the latter part of his career, French fell out of favor with art critics and art collectors. At the end of his life, he was living in Rome, virtually in seclusion.

— *Joyce M. Youmans*

BIBLIOGRAPHY

Grau, Rawley. "Who Was Paul Cadmus?" *Q* (6 February 2001). http//www.q.co.za/01features/010206-cadmus.htm.

Grimes, Nancy. "French's Symbolic Figuration." *Art in America* 80.11 (November 1992): 111–115.

———. *Jared French's Myths*. San Francisco: Pomegranate Artbooks, 1993.

Murphy, Michael J. "French, Jared Blandford." *Gay Histories and Cultures: An Encyclopedia*. George E. Haggerty, ed. New York: Garland, 2000. 341–342.

Wechsler, Jeffrey. *The Rediscovery of Jared French*. New York: Midtown Payson Galleries, Inc., 1992.

SEE ALSO

American Art: Gay Male, 1900–1969; Photography: Gay Male, Pre-Stonewall; Barthé, James Richmond; Cadmus, Paul; Lynes, George Platt

Friend, Donald (1915–1989)

DONALD STUART LESLIE FRIEND WAS AN ECCENTRIC man of wide-ranging creative talents: a great painter, an exceptional figure draftsman, and a gifted satirical writer. Exhibiting widely in Australia during the 1950s and 1960s, Friend also produced many books, stories, and diaries, including the controversial and erotic *Bumbooziana*, which was published in 1979.

Born in Warialda, northwest New South Wales, on February 6, 1915, into an aristocratic sheep-ranching family, Friend defied his family's wishes that he follow in his father's footsteps. Openly homosexual, he left school at the age of sixteen to become an itinerant artist. Friend worked in many different parts of the world, his meandering reflecting an existential search for exoticism and romance.

Friend began his nomadic life by jumping freight trains to Cairns in north Queensland, traveling further north to Thursday Island, and then living with the island people of the beautiful Torres Strait. However, no one place ever completely satisfied Friend's aesthetic and spiritual needs, and it was not long before he was once again on the move.

Friend began his art training in Sydney under the guidance of Sydney Long in 1930, and then with Datillo Rubbo from 1933 to 1935. Assisted by a £100 gift from his grandmother, he traveled to England in 1936 to further his art studies under Mark Gertler and Bernard Meninsky at the Westminster School of Art in London.

In London, Friend met a Nigerian, Lapido, who became his model and lover. Inspired by Lapido, he traveled in 1937 to West Africa, where he found work as the financial adviser to the Ogoga (ruler) of Ikerre. Here, Friend refined his love for the exotic and developed a special interest in ancient African bronze-casting.

With the outbreak of World War II, Friend returned to Sydney and enlisted in the Australian army. For four years he served mainly as an artillery gunner, but in early 1945 he was appointed an Official War Artist. During the last phase of the war in the Pacific, Friend worked in New Guinea and Borneo, two of the bloodiest theaters of Australia's Pacific campaign.

Many of Friend's official wartime works provide rare glimpses of male intimacy and closeness, such as in his figure studies for *The Showers Balikpapan 13 August 1945,* which depict the bare and brawny physiques of young soldiers engaged in the communal showering ritual.

Other works record rare moments of "solitude" and "privacy," such as in *The Mosquito Net* (1945), in which a seemingly unsuspecting naked soldier dozes under the thin veil of a net, his legs apart and groin exposed, oblivious to Friend's voyeuristic gaze.

For the most part, Friend found army life tedious, which encouraged him to produce two fascinating illustrated memoirs of his wartime experiences, *Gunner's Diary* (1943) and *Painter's Journal* (1946). As if to escape the tragedy and torment of the war, the drawings in these journals convey an overall sense of detachment from reality. They are often parodic, witty, and satirical in their depictions of daily duties and general life in the army.

Significantly, Friend's diaries also record the beginning of his long friendship with fellow Australian artist Russell Drysdale, whom he met during the war and whose influence had a profound impact on Friend's creative and personal life.

After the war, Friend joined the bohemian "Merioola" group of artists in Sydney for a brief period, before moving to the old New South Wales mining town of Hill End. His departure was prompted partly by unrequited love for handsome sculpture student Colin Brown.

Colin (1946), *The Young Sculptor* (1946), and *(Study of Colin)* (1946) form part of a series of richly textured paintings and sensitively etched drawings that reveal Friend's awe for the beautiful young Colin. Friend confessed in his diary, "My whole life is Colin. Not particularly Colin himself, but my love and appreciation and desire for the Colins of this world and my life."

During the two years Friend spent at Hill End, he painted often with Drysdale and other artists. However, while Drysdale produced some of his most memorable landscape paintings during this period, Friend found himself cut off from his principal inspiration, the male nude.

In contrast, the female form is noticeably rare in Friend's art, a phenomenon he explained once by saying "[w]omen are just not interesting to me to paint; I suppose it's because I'm homosexual." Indeed, as Friend's art developed, it became more difficult to separate his preoccupation with the young male form as an object of artistic inquiry from its attraction as an object of intuitive desire.

Beginning in March 1949, Friend made several trips to Italy, where he fell in love with another model turned lover, a good-looking Italian peasant named Attilio Guarracino, whom he brought back to Australia. However, the pattern of short but intense romance repeated itself and the relationship did not last.

Friend then returned to London, where some of his most beautiful figure drawings were executed, many of the young Ibaden boy Omu, an acquaintance of the Nigerian Lapido. *Omu Wearing Harlequin Trousers* (1953) and *Negroes with a Lute* (1953) show not only Friend's extraordinary ability to delineate the human form with almost calligraphic precision, but also a camp delight in casting Omu in the comic role of Harlequin.

In the former work, Friend accentuates the slender lines of his model's physique, with Omu shown standing with one hand leaning against the back of a chair, the other placed elegantly on his hip, and dressed in the brightly colored, diamond-patterned pants of Harlequin's costume.

Between 1957 and 1961, Friend settled in Ceylon, now Sri Lanka, before returning to Sydney in 1962. Six years later, he moved again, this time to tropical Bali. Although Friend produced better works at other periods in his life, his fame as an expatriate artist was at its height during his time in Bali, where he lived an eccentric and promiscuous lifestyle. Friend considered these to be his "paradise years." He seemed to have found the exotic existence for which he had always yearned.

In 1979, Richard Griffin published Friend's salacious book *Bumbooziana*, an "investigation into the private habits of elephants, camels, zebras, leopards, etc. and the equally strange customs of men...." Perhaps the most famous of Friend's publications, *Bumbooziana* generated much sensation when introduced to a prudish Australian

public because of its erotic imagery and sexually explicit nature, and its cover page illustrating the sexualized bodies of half-human, half-zebra creations of Friend's wild imagination.

Also in 1979, declining health and difficulty in gaining visa extensions forced Friend back to Australia permanently. He moved first to Melbourne and then returned to Sydney, where he spent the end of his life in a modest rented cottage in Woollahra.

After a lifetime in which the male nude was the centerpiece of his art, in his final years Friend turned mainly to still lifes. He grew increasingly embittered toward the end of his career, frustrated especially by the loss of his fine motor skills after a stroke that left him half-paralyzed and annoyed at the lack of recognition he felt he deserved for his artistic achievements.

Sadly, it was a year after his death on August 17, 1989, that Friend's contribution to Australian art was finally acknowledged by mainstream society, when the Art Gallery of New South Wales mounted a major retrospective of his work, celebrating what truly was an extraordinary life and an exceptional Australian talent.

— *Michelle Antoinette*

BIBLIOGRAPHY

Friend, Donald. *Bumbooziana*. Melbourne: Gryphon Books, 1979.

Fry, Gavin, and Colleen Fry. *Donald Friend: Australian War Artist, 1945*. Melbourne: John Currey O'Neil Publishers, 1982.

Hawley, Janet. *Encounters with Australian Artists*. St. Lucia: University of Queensland Press, 1993.

Hughes, Robert. *Donald Friend*. Sydney: Edwards & Shaw, 1965.

Pearce, Barry. *Donald Friend, 1915–1989: Retrospective*. Sydney: Art Gallery of New South Wales, 1990.

SEE ALSO

Australian Art; Subjects of the Visual Arts: Nude Males

Fuseli, Henry *(1741–1825)*

S WISS-BORN HENRY FUSELI SPENT MOST OF HIS LIFE IN England, where he established a reputation as an artist of great originality. Best known for *The Nightmare* (1781), he also painted scenes from the works of Shakespeare and Milton, as well as pictures of both heterosexual and homosexual subjects.

Born Johann Heinrich Füssli on February 6, 1741, in Zurich, the artist adopted an anglicized version of his name when he settled permanently in England.

Fuseli's father, Johann Caspar Füssli, was a portrait painter and a collector of sixteenth- and seventeenth-century Swiss art. Füssli imparted to his son an appreciation of the Neoclassical ideas of Johann Joachim Winckelmann and Anton Raphael Mengs.

Fuseli took an avid interest in his father's art collection and began making sketches of the drawings when he was eight. His father, however, had decided that his son should be a Zwinglian minister. Consequently, Fuseli studied theology and was ordained in 1761.

The next year, he and his close friend and fellow theology student Johann Lavater published a pamphlet attacking a corrupt Zurich official. As a result of this action, the two found it expedient to leave the city. In 1763 they went to Berlin, and the following year Fuseli continued on to London.

By the time he settled in England, Fuseli had given up the ministry. His primary professional interest had been in writing, but in London he began to think of a career as an artist. In 1767 or 1768 he met Sir Joshua Reynolds, who encouraged him to become a painter.

Fuseli drew some illustrations for Tobias Smollett's *Peregrine Pickle* (1769) and Dr. Willoughby's *Practical Family Bible* (1766–1770), but he wanted to study high art. In 1770 he went to Rome, where he remained for most of the next eight years.

In Rome, Fuseli became intrigued by classical sculpture and the art of Michelangelo, as well as Mannerist artists Parmigianino and Rosso Fiorentino. The style that Fuseli developed at this time and that would remain largely unchanged throughout his life owed much to these sources.

Many of the subjects that Fuseli chose to paint were highly dramatic, often violent or psychologically disturbing. He also executed paintings and drawings of nude men in stances based on classical statuary. His figures were strong, muscular men, often standing with feet planted apart and genitals exposed.

Ian Maidment states that Fuseli's "frank celebration of maleness has appealed to many gay men." When doing paintings for public display, however, Fuseli often added drapery or tights to make the composition acceptable to general audiences.

Fuseli also created drawings with erotic or obscene content. These were intended for private collectors. They included scenes of lesbian encounters and many pictures of women taunting or dominating men. In part because of these images, he gained a reputation as a misogynist.

In 1778, Fuseli returned to Zurich, where he again saw his lifelong friend Lavater. He also supposedly fell in love with Lavater's niece, Anna Landolt. Since she was already engaged at the time, it is unclear if Fuseli ever considered marriage to her a realistic possibility.

Upon returning to England, Fuseli created his most famous painting, *The Nightmare*. Often interpreted as a "punishment" of Landolt for her rejection of him, it shows a young woman sprawled on her back on a bed,

with a gargoyle-like creature sitting on her torso and an ominous-looking horse peering through the bed curtains.

This disturbing picture, which was shown at the Royal Academy exhibition in 1781, soon became well known throughout Europe. Other artists painted variations on its theme, and cartoonists created versions of it illustrating political "nightmares."

Fuseli married in 1788 at the age of forty-seven. His wife, Sophia Rawlins, who had been an artist's model, has been described as his social and intellectual inferior.

A year later, Mary Wollstonecraft met and became infatuated with Fuseli. When she proposed a *ménage à trois*, Sophia Fuseli banned her from the house. Peter Tomory describes Henry Fuseli as "immensely relieved" by that development, and Ruthven Todd calls Fuseli's relationship with Wollstonecraft "a peculiar and sexless intrigue."

Fuseli completed numerous paintings for John Boydell's Shakespeare Gallery, a small museum devoted to depictions of scenes from Shakespeare's work, but, disappointed by the remuneration that he received, decided to start his own Milton Gallery, which was a critical success but a financial failure. He also collaborated with William Blake until the two had a falling-out in 1810.

Fuseli became an Associate of the Royal Academy in 1788 and a full member in 1790. From 1799 he served as Professor of Painting at the Academy. In his later years he was influential because of his writings and lectures on art history and theory.

Fuseli died at Putney Hill near London on April 16, 1825, at the age of eighty-four. After his death, his work was somewhat neglected until Freudian art critics and psychoanalysts revived interest in it because of its images of sexuality in dreams.

— *Linda Rapp*

BIBLIOGRAPHY

Brown, David Blayney. "Henry Fuseli." *The Dictionary of Art*. Jane Turner, ed. New York: Grove's Dictionaries, 1996. 11:857–862.

Maidment, Ian. "Fuseli, Henry." *Who's Who in Gay and Lesbian History from Antiquity to World War II*. Robert Aldrich and Garry Wotherspoon, eds. London and New York: Routledge, 2001. 172–173.

Todd, Ruthven. *Tracks in the Snow*. London: The Grey Walls Press Limited, 1946.

Tomory, Peter. *The Life and Art of Henry Fuseli*. New York and Washington: Praeger Publishers, 1972.

SEE ALSO

European Art: Eighteenth Century; European Art: Mannerism; Michelangelo Buonarroti; Parmigianino (Francesco Mazzola); Subjects of the Visual Arts: Psyche

g

Géricault, Théodore (1791–1824)

THÉODORE GÉRICAULT MAY BE THE BEST-KNOWN nineteenth-century visual artist associated with Romanticism. His art glorifies the irrational, the subjective, the morbid, the overly emotional, the unpredictable, and the bizarre.

Although Géricault produced an impressive number of works in a variety of media, he is identified particularly with one signature creation, a gigantic 1819 oil painting entitled *Raft of the Medusa* (Paris, Musée du Louvre). This work deviated from the established rules of Neoclassical content and style in that it challenged the kinds of subject matter deemed worthy of grand history painting.

Instead of choosing a theme from classical Greek or Roman history, as was customary in art of the early nineteenth century, Géricault chose a topical theme—an event that, according to a published eyewitness account by two survivors, actually happened—and presented it on a grand scale.

The painting measures approximately 16 feet by 23 feet, and each figure is twice life-size, giving dramatic impact to the tragic shipwreck that took place in 1816 off the coast of Senegal. Out of the 150 or so original passengers aboard the makeshift raft, only fifteen survived after spending a horrifying week lost at sea with no food and very little water.

Reported instances of madness, violence, murder, cannibalism, and other unspeakable horrors became public knowledge and the calamity became a national scandal in France. The event called into question the competence and ethics of the conservative Bourbon Restoration government (1815–1830) that had awarded command of the frigate Medusa to an inexperienced and incompetent aristocrat.

In *Raft of the Medusa*, men share experiences of pain and desire within a confined space. The image consists of several male bodies arranged in erotically suggestive positions, suffering physical and psychological distress and torment. A tension is established by juxtaposing the living and the dead, the muscular and the limp, the alert and the unconscious. Acts of frenetic desperation are depicted alongside poses of willful torpor.

At the pinnacle of the composition is a muscular black man whose back faces us. His physique not only evokes Michelangelo's heroic male nudes, but his presence is socially significant. He signals not only the barely visible rescue ship on the distant horizon, but also the resistance of the oppressed and victimized against the destructive odds of nature and disasters created by man.

Moreover, the chain of intermingled male bodies is palpably erotic. As one man circles an arm around the black man's waist, others strain from below to give him support. In this forced comradeship, flesh presses against flesh (one unconscious figure is shown pressing his face against the buttocks of another). The combining of the morbid, erotic, and social is typical of Romanticism.

Although we do not know much about Géricault's sexual orientation, we do know that the labels *gay* or *queer* cannot be applied to him in the modern sense of those terms. Nevertheless, there is a discernible homoerotic

sensibility throughout his work, notable in his choice of themes as well as in their presentation.

Géricault's art highlights masculinity and heroic action. Throughout his career, Géricault remained master of the heroic male nude figure and produced many studio studies in which muscular models are shown in strenuous physical activities (for example, *Study of a Nude Man Pulling on a Rope,* ca. 1816, Musée Bonnat, Bayonne).

He produced several works during the Napoleonic period that depict soldiers both on and off the battlefield (for example, *Wounded Cuirassier,* Musée du Louvre, Paris, Salon of 1814, and *The Chasseur of the Imperial Guard,* Musée du Louvre, Paris, Salon of 1812).

Underscoring the world of men and the tense, erotic charge between them in the artist's work is the fact that Géricault's oeuvre is marked by an almost utter absence of women. His compositions are nearly always of brawny males who confront the harsh elements of nature, animals, and one another.

The struggle between men and animals is a favorite theme. The artist produced many watercolors and drawings of muscular men attempting to control horses and bulls (for example, *The Bull Market,* 1817–1818, Fogg Art Museum, Harvard University, and *Race of the Barbieri Horses,* 1817, Musée du Louvre, Paris).

Works like these are intended to symbolize man's destiny and his attempt to harness uncontrollable and potentially destructive forces. These forces include the physical, emotional, psychological, and sexual energies both in himself and in nature itself. — *James Smalls*

BIBLIOGRAPHY

Bryson, Norman. "Géricault and Masculinity." *Visual Culture: Images and Interpretations.* Norman Bryson, Michael Ann Holly, and Keith Moxey, eds. Hanover, N. H.: Wesleyan University Press, 1994. 228–259.

Eitner, Lorenz. Géricault: *His Life and Work.* London: Orbis, 1983.

Nochlin, Linda. "Géricault, or the Absence of Women." *October* 68 (Spring 1994): 46–59.

SEE ALSO

European Art: Nineteenth Century; European Art: Neoclassicism; Michelangelo Buonarroti; Subjects of the Visual Arts: Nude Males

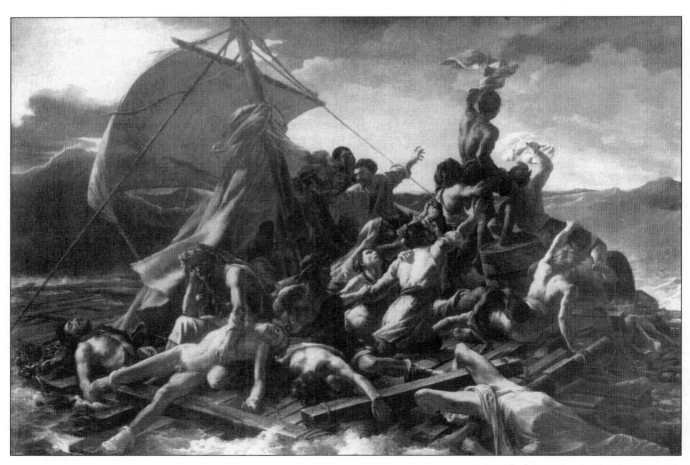

The Raft of the Medusa by Théodore Géricault.

Gilbert & George

Gilbert Proesch (b. 1943)
and George Passmore (b. 1942)

GILBERT & GEORGE ARE TWO OF THE MOST IMPORTANT avant-garde artists on the international art scene of the late twentieth and early twenty-first centuries. Their work explores themes ranging from city life, with all its frailties, to religion, scatology, and homosexuality. As a result, their work is controversial and challenging.

In writing their early art manifesto *What Our Art Means*, the duo stated their intent to break social taboos and express contempt for established norms in an effort to open debate, alter people's opinions, and effect change in society. The frequently negative reaction to their work—especially to its scatological and sexual imagery—may be an indication that they have succeeded.

Early Years and Education

Gilbert Proesch was born in San Marino, Italy, in 1943. His father was a shoemaker, and he trained as a woodcarver in his father's workshop. Gilbert later went on to study at the Wolkenstein School of Art, the Hallein School of Art in Austria, and the Akademie der Kunst in Munich.

George Passmore also comes from a working-class family. Born in Plymouth, Devon, in 1942, he was raised in Tiverton. He left school to work in a shop when he was fifteen years old and eventually studied at the Darlington Adult Education Center in Devon and the Darlington Hall College of Art.

An adventuresome youth, George hitchhiked to London, found a day job in the china section of Selfridge's department store and worked an evening job as a barman at the Player's Club in the city's Strand district. He eventually studied for a year at the Oxford School of Art.

Collaborators in Life and Art

The two artists met in 1967 when they both earned a place in the Advanced Sculpture course at St. Martin's School of Art in London. They have worked together since that time, sharing a home, called Art for All, on Fournier Street in the working-class neighborhood of Spitalfields, in London's East End.

Proesch and Passmore have always worked as an artistic collaborative and dropped their family names to become known as "Gilbert & George." In adopting a collective name, the artists refused individualization and reinforced the point that their art is their life together.

The artists purposefully created an image of themselves as elegantly clothed, well-groomed, and conservative men in order to revolt against the elitism of the art world from a position of normalcy.

First Works

The first works created by Gilbert & George centered on performance.

In 1968, after small shows in Frank's Sandwich Bar and other locales, they felt slighted when they were not invited to participate in London's exhibition of new minimalist and conceptual art entitled When Attitude Becomes Form.

They responded to this snub by painting their heads and standing motionless in the center of the gallery on opening night. German dealer Konrad Fischer saw the audacious performance and immediately offered the duo a show at the Düsseldorf Kunsthalle. The artists became an overnight success and soon had exhibitions in the Netherlands, Belgium, Italy, New York, and London.

The following year, Gilbert & George gained fame with the now-famous performance piece they eventually entitled *The Singing Sculpture*.

In this work, the duo stood on a table wearing identical gray worsted, three-button suits, faces decorated in bronze makeup, one holding a cane, the other holding a glove. The performance was accompanied by the English music-hall song, "Underneath the Arches," played on a tape recorder located underneath the pedestal on which they stood. When the pre–World War II popular song ended, the artists exchanged cane and glove; then one of them stepped down from the table, reset the equipment, and stepped back up onto the table.

The piece was performed in different locations over several years, sometimes in eight-hour marathons. In this performance, Gilbert and George themselves literally became their art. The work, which appealed to viewers of all ages and classes, was also notable for its accessibility.

In 1989, in honor of its twentieth anniversary, *The Singing Sculpture* was exhibited again at the Sonnabend Gallery in New York.

Other early series of works created by Gilbert & George included postcard sculptures addressed to collectors and gallery owners in which they detailed their daily lives, and magazine sculptures published in selected periodicals. In *The Meal*, a performance piece given in a hall in Ripley, Gilbert & George served dinner to David Hockney in front of an invited audience.

Other early series that were not performance pieces included *Drinking Sculptures* (1974), a series exploring drunkenness, and *Bloody Life* (1975). The latter series included a work entitled *Coming* (1975).

Consisting of a series of nine black-and-white photographic images arranged in a segmented grid, *Coming* included separate images of Gilbert & George with a splash of semen depicted in the center grid. By virtue of the fact that the two men lived and worked exclusively together, homosexuality was always an underlying concern in their work. *Coming*, however, made the unstated

subject visible early in their career, even as their depiction of semen inaugurated a practice of depicting bodily fluids that would continue throughout their career.

The duo also exhibited enormous paintings and charcoal drawings in galleries throughout London at this early stage. Their penchant for huge canvases would also continue throughout their career.

At the end of the 1970s, the artists seemed to be searching for an art form with which they were comfortable and that also allowed them to express messages that were important to them.

One series, entitled *Dirty Word Pictures* (1977–1978), quotes graffiti found in urban spaces throughout the world, but also specifically in their neighborhood. It caused a storm of criticism for the artists' use of expletives.

A work from the series entitled *The Penis* (1978) featured photographs of Gilbert & George awash in the color red. A black-and-white photograph of a graffiti sketch depicting an erect penis ejaculating onto a person's tongue is included, the word "suck" scrawled on a wall next to the drawing.

The series allowed the artists to put graffiti in an exhibition space and forced viewers to acknowledge and think about urban space as a sexual space. The photographic grid form and hand-colored black-and-white photographs used in *Dirty Word Pictures* continue to have meaning for Gilbert & George.

The 1980s

The artists came into their own during the 1980s. At the beginning of the decade they had a traveling midcareer retrospective exhibition at the Stedelijk van Abbemuseum in Eindhoven.

At this time, the artists began to use an increasing number of colors in their photographic works. The presence of color emphasized the slick, stylized, and cartoonlike appearance of their work. The content of these works continued to reflect urban space and morality, as well as the hope and fear associated with modern man and society. Their familiar themes—including religion, sex, and violence—were presented in a more distanced and ironic manner.

Series executed during this period include such titles as *Shit Faith* (1982), in which a Latin cross is formed in the center of the work, which consists of a representation of four brown turds issuing forth from four rosy pink bottoms. The cross functions as an ironic comment on the manner in which the church labels certain things (for example, gay men and excrement) as "dirty."

This work can also be viewed as a denunciation of the Christian faith and its central symbol of hope. Gilbert & George also, however, seem to show faith in a human product that society disposes of immediately and uses as a vulgar profanity.

Also in the 1980s, the artists began to create an increasing number of works with gay themes.

The anatomically explicit work entitled *Hunger* (1982) is illustrative of lust's urgency. This work presents two faces—one red with yellow highlights, the other, yellow with red highlights, painted in the same reversed patterning—engaged in fellatio. The red and yellow colors seem to speak of reciprocal, hot-blooded desire soon to be followed by the electric impulse of sexual climax.

Good (1983) makes a statement about the ambiguity of gay desire. This photographic work is overlaid against a gray-toned brick wall. A Latin cross, the central symbol of the Christian faith, is formed of overlapping red roses, a Catholic symbol for the Virgin Mary. The rose is also a visual representation of the anus, locus of male–male sexual desire. *Rose Hole* (1980) uses the same sexual coding.

A number of the artists' works created during the 1980s center on the penis, male sexuality, and sex between men. *Holy Cock* (1982), for example, depicts a red, erect penis flanked by two testicles superimposed on a white background of flowing semen droplets.

In the mid-1980s, Gilbert & George's works displayed a compositional and chromatic exuberance. This exuberance was obvious in a major exhibition of their work entitled New Moral Works at the Sonnabend Gallery in New York, in 1985.

As the decade ended, however, it was apparent that the tenor of their work had changed in response to the AIDS crisis. An exhibition of works about illness and destruction, Art for AIDS, at the Anthony d'Offay Gallery in London, ran from April 20 through May 20, 1989, and all proceeds were donated to CRUSAIDS, a British AIDS charity organization.

The 1990s

The artists' increasing success and fame were heralded in a major exhibition in Moscow in 1990.

In the final decade of the twentieth century, Gilbert & George continued to create and exhibit gay-themed work. In the triptych entitled *Urinal* (1991), the duo once again combined Christian references with bodily functions and this time took the subject literally into the church by using the form of an altarpiece.

In this work, a photograph of a urinal is superimposed over an image of the interior of a church, placed where an altar would normally be located and positioned in the central panel of the triptych. Representations of the artists are superimposed in two forms: once in yellow-colored full-figures, secondly in white half-portraits shown from the waist down.

The tripartite work, created in one of the traditional forms of an altarpiece, places the locus of gay male public sex in the most important part of any church—its

altar. It both makes the site sacred for gay men and confronts the viewer with gay sex.

The 1990s were also a time in which Gilbert & George focused their work on all forms of bodily excreta, ranging from tears, spit, and blood to urine, semen, and feces. As if that were not enough, the subjects were often photographed under a microscope and then magnified to either life-size or larger than life.

As stated in their manifesto at the beginning of their career, Gilbert & George create deliberately provocative work that is harshly critical of society and its taboos. Seen in this light, the artists' scatological works can be read in three ways: as a "dirty joke," as a source of irreverent humor, or as a means of protest.

Gilbert & George use feces to make the private public, break social taboos, show contempt for established norms, and make a statement about social ills. For them, feces also functions as a metaphor for artistic struggle in general and the dangerous life of gay men in particular.

The artists first used excrement as a theme in their 1983 work entitled *Shitted*, in which they superimposed photographs of themselves facing each other on a wall of vastly magnified, orange-brown turds. Gilbert and George are shown wearing blue and green, with the same brown substance in their mouths. In this work, they seem to refer to themselves as the creators of the "shit" that critics claimed they brought into the art world.

A decade later, in 1993, they exhibited a collection of all of their works on the subject, at the Wolfsburg Kunstmuseum. Two years later, The New Shit Pictures was shown in Cologne and Naked Shit, the complete series, was exhibited at the South London Art Gallery, where the deliberately provocative works were large enough to completely cover the gallery's walls. *In the Shit* (1996) measures 338 x 426 cm (approximately 11 x 14 feet). Hardly a work to be ignored or discreetly removed!

Gilbert & George have also frequently depicted blood, another social taboo. *Bloody Faith* (1996, 1190 x 528 cm), for example, simultaneously reflects something covered with blood, the Eucharist, and the AIDS pandemic. The title also comments on the church's attitude toward gay men and puns on the word *bloody*, a foul epithet used by the British to express anger.

Maintaining a fear of blood, bodily fluids, and nudity is impossible when viewing Gilbert & George's oeuvre. The Fundamental Pictures, created in 1997, was a two-part exhibition shown at both London's Lehmann Maupin Gallery and the Sonnabend Gallery. The gargantuan works depicted macroimages of feces and other bodily secretions labeled with "fundamental" words like *piss*, *shit*, and *spunk*.

One work, entitled *In the Piss* (1997), consists of a larger-than-life frontal nude portrait of the artists, arms over each other's shoulders, against a background of yellow urine crystals. The enormous work is an attempt to confront society's prejudice against male nudity.

Bloody People (1997, 377 x 1143 cm) illustrates the nude pair in "hear, see, and speak no evil" poses.

Gilbert and George are also represented in flesh tone, wearing jockey shorts, in the work entitled *Spit Law* (1997, 254 x 528 cm). The printed passage of Leviticus that condemns men who have sex with each other runs down the center of the work. Images of magnified spit are shown against a red ground. This work makes a clear comment on the biblical text quoted by some Christians to justify homophobia.

During 1997, Gilbert & George also created *Spit Naked* (226 x 317 cm). In this work, they are depicted in the same pose as Michelangelo's *Pietà* (1498–1499), superimposed against a ground of red. The point seems to be that the artists support each other because no one else will, including representatives of the contemporary Christian church. The red background symbolizes the violence shown against gay men and the very real threat of blood infected by the HIV virus.

The New Millennium

The artists continue to create gay-themed works in the new millennium. New Horny Pictures debuted at London's White Cube Gallery in 2001. This series of sixteen works addresses the controversial subject of the gay male escort business. The series consists of sixteen enlarged photographs of individual advertisements of men offering themselves for gay sex. Their gargantuan size not only makes visible the invisible, it forces viewers to recognize the nocturnal, urban environment they normally ignore.

Gilbert & George have often received very negative receptions from critics and the public alike. Nevertheless, they have been included in the most important biennial exhibitions, including Documenta (1972 and 1978), the Venice Biennale (1982), the Sydney Biennial (1984), and the Carnegie International (1985). Moreover, they were awarded London's Turner Prize in 1986 and they continue to exhibit their work around the globe.

Despite its widespread uneasiness about their subject matter, the art establishment has accepted Gilbert & George as artists crucial to contemporary times.

— *Ray Anne Lockard*

BIBLIOGRAPHY

Eccher, Danilo. *Gilbert & George*. Exhibition catalog. Milan: Charta, 1996.

Farson, Daniel. *Gilbert & George: A Portrait*. London: HarperCollins, 1999.

Gilbert & George. *Gilbert et George*. Exhibition catalog. Paris: Paris-Muses; Arles: Diffusion, Actes sud, 1997.

Jahn, Wolf. The Art of Gilbert & George, or, An Aesthetic of Existence. London: Thames and Hudson, 1989.

Ratcliff, Carter. *Gilbert & George: The Complete Pictures, 1971–1985*. Exhibition catalog. London: South Bank Centre, 1986.

Richardson, Brenda. *Gilbert & George*. Exhibition catalog. Baltimore: Baltimore Museum of Art, 1984.

Violette, Robert, ed. *The Words of Gilbert & George; with Portraits of the Artists from 1968–1997*. London: Violette Editions; New York: Distributed Art Publishers, 1997.

SEE ALSO

European Art: Twentieth Century; Contemporary Art; Hockney, David; Michelangelo Buonarroti

Girodet-Trioson, Anne-Louis *(1767–1824)*

A FRENCH NEOCLASSICAL PAINTER OF HISTORICAL AND mythological scenes, Anne-Louis Girodet-Trioson is a transitional figure whose works lie somewhere between the rationalism of Neoclassicism and the flights of fantasy associated with Romanticism.

Born into the bourgeoisie, he became a painter against his parents' objections. As a youth, he studied with the renowned Neoclassical painter Jacques-Louis David (1748–1825). Of all David's students, Girodet was the most gifted and the most erudite. He was also the most rebellious and competitive.

He quickly grasped the intellectual and stylistic tenets of Neoclassicism, but soon set out to violate those very principles in his quest for fame and originality. Instead of taking his subject matter from Roman histories, as Davidian Neoclassicism had required, he turned instead to Greek myths for inspiration. Instead of emphasizing linearity, sculptural form, and masculine virtues, Girodet chose to play with these elements by reversing their expected effects.

In his attempt to forge a new aesthetic sensibility, the homoerotic, the effeminate, and the androgynous played significant roles. These experiments can be seen in his most famous work, *The Sleep of Endymion* (Musée du Louvre, Paris), painted in Italy in 1791 and exhibited in Paris in 1793.

The painting was a critical and public success and earned Girodet a reputation as a poet of paint and brush. The critics loved the painting because of its unconventional treatment of a conventional myth. They admired its mysterious, innovative lighting effects and its dreamy, lyrical, and nocturnal mood. This startlingly original work had a lasting effect on how the male body is represented in art. Even David was not immune to its influence.

The Sleep of Endymion highlights androgyny as a visual theme and provokes an erotic response from the viewer to the nude male body. The image exploits feminine characteristics such as the delicate ringlets of hair that suggestively fall about Endymion's shoulders. These curls are complemented by the overall elongation of form and the waxen quality of the flesh. The taut, rigid angularity of David's male figures is gone, replaced by a passive and indolent reclining figure whose pose is typically associated with the female nude.

The protagonist of the scene is the shepherd boy Endymion, a mortal, asleep in a hidden alcove located atop the mythical Mount Latmos. He was carried here by the moon goddess, Selene, who, appearing in the painting in the guise of moonbeams, shines through the parted foliage held by a smiling, overgrown hybrid figure of Cupid (the boy-god of love) and Zephyr (the personification of the West Wind). She shines upon Endymion, caressing, penetrating, and inhabiting his supple body as he sleeps. The painting is a successful realization of timeless and dreamy erotic desire.

Throughout his long career, Girodet chose to concentrate on subjects that confused and conflated masculine and feminine characteristics. In his turbulent and exotic *Revolt at Cairo* (1810, Versailles), which attests to his interest in Orientalism, a charged homoerotic energy emerges from a physical and emotional contrast between men of different races and psychological dispositions.

After 1810, Girodet's production of large-scale paintings slowed considerably. He became bitter, taciturn, and misanthropic, devoting most of his efforts to translating and illustrating classical literature.

These illustrations, called his "anacreonic" drawings, concentrate on rendering classical stories of heterosexual and homosexual love through a lightness and delicacy of line.

Although the artist's sexual orientation cannot be determined with certainty, he was widely rumored to engage in homosexual affairs. It may well be that his relationship with another painter, Jean-Pierre Péquignot, who died in 1807, was the most meaningful of his life.

— *James Smalls*

BIBLIOGRAPHY

Davis, Whitney. "The Renunciation of Reaction in Girodet's Sleep of Endymion." *Visual Culture: Images and Interpretations*. Norman Bryson, Michael Ann Holly, and Keith Moxey, eds. Hanover, N. H.: Wesleyan University Press, 1994. 168–201.

Levitine, George. *Girodet-Trioson: An Iconographical Study*. New York: Garland, 1978.

Smalls, James. "Making Trouble for Art History: The Queer Case of Girodet." *Art Journal* 55.4 (1996): 20–27.

———. "Homoeroticism and the Quest for Originality in Girodet's *Revolt at Cairo* (1810)." *Nineteenth-Century Contexts: An Interdisciplinary Journal* 20.4 (1999): 455–488.

SEE ALSO

European Art: Neoclassicism; European Art: Nineteenth Century; Subjects of the Visual Arts: Endymion; Subjects of the Visual Arts: Nude Males

Gleeson, James (b. 1915)

ONE OF AUSTRALIA'S MOST ACCLAIMED ARTISTS, JAMES Gleeson embraced Surrealism early in his career and has remained committed to it as a means of exploring and expressing psychological conflicts and conditions.

Gleeson was born in Sydney on November 21, 1915, and grew up in a small town north of the city. His mother raised him after his father died in the great flu epidemic of 1919. An aunt fostered his artistic talent during his formative years, and his career as an artist began in the 1930s.

Gleeson was classically trained as an academic painter at the East Sydney Technical College from 1934 to 1936. He studied at the Sydney Teachers' College from 1937 to 1938. The European Surrealist painters Salvador Dalí and Max Ernst particularly influenced his early work, which was central to the manifestation of the Surrealist movement in Australia during the 1930s.

For Gleeson, however, Surrealism is not simply a movement that flourished during the 1930s; it is a lifelong endeavor that assists his exploration of the forces that drive the subconscious mind and, thereby, create human emotions and behavior.

Gleeson's paintings incorporate imagery that ranges from the recognizable to the indeterminate. Frequently arranged in swirling, brightly colored compositions, their forms, colors, and textures render them visually enticing. Nevertheless, they are as elusive to the mind as they are seductive to the eye; their meanings seem just beyond conscious understanding.

Critics have deemed Gleeson's work macabre, threatening, beautiful, and erotic. Paintings such as *Greek Myth* (1980) reveal homoerotic undertones. In this work, a nude male lies prone in nonrepresentational white, blue, gray, and yellow forms. He appears to float in an indeterminate space that may represent the artist's unconscious mind. Expanding upon this interpretation, one may conclude that the painting illustrates the unconscious as it entices the conscious mind to take pleasure in the male flesh.

Paintings such as *Greek Myth* may represent the universal struggle of the liberation of the individual will from one stronger than its own, such as that of society. Gleeson uses various metaphors to suggest the constraints of convention. Red cloth, frequently shown binding human figures, serves this function prior to 1942. After this date, human figures are often shown entangled in weeds.

Weeds are integral to the composition entitled *Images* (1946). This painting features a central female figure that represents the soul. Around her rotate several male images shown in boxes of varying degrees of transparency, or conscious awareness. A weed ensnares all of the figures in this work.

Through his imagery, Gleeson stresses the difficulty involved in the liberation of the individual will. The artist believes that, as a result of this struggle, the mind seeks to return to the past, to a world of prehuman organisms that pulse with a life force.

Perhaps this belief explains Gleeson's artistic production since 1983. In that year, he began producing abstract compositions that seem to represent a type of pre- or posthuman biomorphic cosmos. Featuring jewel-like tones, these works may illustrate either the beginning or the end of humanity.

Throughout his long artistic career, James Gleeson has explored realms beyond human consciousness in a variety of ways. His paintings reveal his fascination both with the potentials of the subconscious mind and with the idea of extending the boundaries of reality.

— *Joyce M. Youmans*

Bibliography

"Decoding the Secrets of Surrealist James Gleeson." *UTS News* (October 16, 2001): www.uts.edu.au/new/archives/2001/July/04.html

Drury, Nevill, and Anna Voigt. *Fire and Shadow: Spirituality in Contemporary Australian Art*. Roseville East, New South Wales: Craftsman House, 1996.

Free, Renee. *James Gleeson: Images from the Shadows*. Roseville East, New South Wales: Craftsman House, 1993.

Gleeson, James, et al. *James Gleeson: Paintings from the Past Decade*. Victoria, New South Wales: National Gallery of Victoria, 1994.

SEE ALSO

Australian Art; Surrealism; Subjects of the Visual Arts: Nude Males

Gloeden, Baron Wilhelm von (1856–1931)

BARON WILHELM VON GLOEDEN WAS ONE OF THE earliest gay photographers of the male nude. His best-known images—those enormously popular among the Victorians—depict nude boys in garlands or scant robes acting out Homeric themes; but many of his other images, which once totaled over 3,000, are ahistorical, elegant studies of the male body.

Von Gloeden's work is generally remarkable for its technical innovations in shooting outdoors, its kitschy use of "classical" motifs, and its homoerotic content despite the social mores of the nineteenth and early twentieth century. For contemporary gay viewers, the several hundred surviving images evoke a dreamy vision of forbidden desire, idyllic innocence, and a bygone era of agrarian sexual openness.

Like many artists, von Gloeden's current fame is partly owed to highly embellished accounts of the circumstances under which he worked. The standard tale paints von Gloeden as an affluent German—a member of the minor nobility of Mecklenberg in northern Germany—

who, suffering from what was probably tuberculosis, moved to the Sicilian village of Taormina in his twenties.

According to this account, he was instantly enamored of the village boys who eventually became the subjects of his Homeric photographs by day and the objects of his personal pleasure by night. The Baron's family wealth financed a lavish lifestyle; he hosted a slew of guests from throughout Europe, many of whom indulged in the nocturnal orgies he orchestrated at his villa with the local boys.

The bulk of von Gloeden's photographs were made between 1890 and 1914 and belong to a generation of pictures that romanticize pastoral life in the wake of widespread industrialization. Several of his models reportedly remained devoted to him until his death in 1931, shortly after which many of his glass negatives were seized or destroyed by Mussolini's Fascist police under a pornography charge.

Although von Gloeden has been largely mythologized as a charming, generous benefactor and hero of homoerotic photography, it is important also to think of his work in relation to the colonial dynamics of his presence in impoverished Taormina. His subjects' bodies were not classically athletic, but the callused products of hard labor—an effect the aristocratic German attempted to smooth over with a homemade emulsion.

The Baron's economic clout in the small village ensured both a civic stake in his work and tolerance of his open homosexuality. Not only did von Gloeden employ several boys as domestic servants, but he also became a prewar sugar daddy, financing dowries and new businesses for his models. Despite the village's strong Catholic dogmas, von Gloeden was thus able to procure its sons for both his camera's gaze and his guests' (as well as his own) sexual tourism.

Von Gloeden's images epitomize a standard tactic of early homoerotic imagemaking: the "classical" scenes, costumes, and props in his compositions act as alibis for their homoerotic narratives, legitimizing the camera's obsessive gaze upon the boys' bare bodies.

For the mainstream audience that consumed them, the Homeric themes and allusions to antiquity—coupled with the depiction of the pastoral countryside—were crucial for reading von Gloeden's images as nostalgic, asexual visions of a simpler life or as ethnographic portraits.

However, the homoerotic impetus of his work is by no means covert; the lack of moral scrutiny of his work by the Victorians is as surprising as the censorship of his work by the Fascists is predictable. Over and over again, carefully crafted poses, sultry looks, and passionate caresses cement a homoerotic subtext.

Given this, the "classical" themes are also readable as an early example of kitsch: the irreverent recombination of Greek and Roman regalia mixed in with faux leopard-print rugs and potted palms set the boys' eroticism in a melodramatic vision of "old world" sensuality.

Equally important are the ways in which von Gloeden's pictures contribute to a longstanding tradition of the docile, brown-skinned sex object within European art. As his production is contemporaneous with the rise of modern tourism among the wealthy, and as his images were celebrated mainly among affluent socialites, these boys' eroticism is largely informed by racial, cultural, and class difference.

Indeed, many of his photographs were printed in postcard format, as if to capture both the cultural exoticism and sexual availability of the local boys in true souvenir fashion.

— *Jason Goldman*

Bibliography

Berman, Patricia G. "F. Holland Day and His 'Classical' Models: Summer Camp." *History of Photography* 18.4 (Winter 1994): 348–367.

Gloeden, Wilhelm von, Baron. *Taormina.* Altadena, Calif.: Twelve Trees Press, 1990.

Leslie, Charles. *Wilhelm von Gloeden, Photographer.* New York: SoHo Photographic Publishers, 1977.

Pohlman, Ulrich. *Wilhelm von Gloeden: Taormina.* New York: teNeues Publishing, 1998.

Waugh, Thomas. *Hard to Imagine: Gay Male Eroticism in Photography and Film from Their Beginnings to Stonewall.* New York: Columbia University Press, 1996.

Weiermair, Peter. *Wilhelm von Gloeden.* Cologne: Taschen, 1994.

See Also

Photography: Gay Male, Pre-Stonewall; Erotic and Pornographic Art: Gay Male; European Art: Nineteenth Century; Day, F. Holland; Flandrin, Hippolyte; Leslie-Lohman Gay Art Foundation; Subjects of the Visual Arts: Nude Males

Gluck (Hannah Gluckenstein) *(1895–1978)*

BRITISH ARTIST HANNAH GLUCKENSTEIN DEFIED THE conventional roles expected of young women of her class and time. She left her family to become an artist, insisted on being known only as "Gluck," dressed in male attire, and lived openly with women throughout her life. Gluck painted landscapes, floral pieces, and portraits of her friends, family, and lovers.

Hannah Gluckenstein was born to a wealthy Jewish family on August 13, 1895. Her father, Joseph Gluckenstein, owned the J. Lyons & Co. Coffee House and catering empire in London, and her mother, Francesca Hall, was an American opera singer. The parents were not supportive of their daughter's artistic pursuits, but Hannah received her only systematic art training at their

expense, at St. John's Wood School of Art in London from 1913 to 1916.

The dynamic young woman then traveled to Lamorna, Cornwall, where she worked with other artists of the "Newlyn School," a group of landscape painters who formed an artists' colony at Newlyn, Cornwall. On her twenty-first birthday, Gluck's father gave her a trust fund that allowed her to pursue an independent life. By that time, Hannah had cropped her hair, shortened her name to "Gluck," and dressed exclusively in male attire.

Using a portion of her trust funds, Gluck bought a studio in Cornwall. It was there in 1923 that she met the American expatriate artist Romaine Brooks. The two women painted each other's portrait in Gluck's studio.

Brooks's famous portrait of Gluck, *Peter (a Young English Girl),* was executed between 1923 and 1924. During 1925, Gluck painted a daring self-portrait in which she depicted herself wearing a shirt, tie, suspenders, and beret, while smoking a cigarette. The same year, Brooks's portrait of Gluck dressed in male attire was shown in solo exhibitions in Paris, London, and New York.

At the end of the 1920s, Gluck's father increased her capital, allowing her to purchase a larger home, named Bolton House, in Hampstead. Shortly after she was established in Bolton House, she met the decorator and society florist Constance Spry.

Spry's talents as a decorator and florist were in high demand among the aristocracy and the wealthy. She and Gluck were together from 1932 to 1936. During this time, Gluck painted several floral paintings inspired by Spry's arrangements.

Spry decorated the Fine Arts Society galleries for Gluck's third exhibition, in 1932. The walls were paneled in white, modern furniture was added, and each room featured one of Spry's floral arrangements. All of the paintings were hung in the "Gluck frame" that the artist designed and patented. The frame was a triple-tiered design that made her paintings an integral part of the gallery's architecture.

Not only did the relationship between the two women influence the subject of Gluck's work, but the contacts made through Spry's society connections also furthered the artist's career. Many of Spry's clients commissioned and bought Gluck's floral paintings.

Spry also influenced Gluck's attire, turning her androgynous look into haute couture with fashion designs by Victor Stribel and Elsa Schiaparelli. While the two women enjoyed each other's company, many of Spry's clients found Gluck to be fussy and irritating.

In 1936, Spry broke off her relationship with Gluck, but by then the artist had already met and begun to fall in love with Nesta Obermer (Ella Ernestine Sawyer), a socialite who was involved in a marriage of convenience to the American businessman Seymour Obermer. The two women enjoyed concerts, poetry readings, and the theater together.

Although Nesta later systematically destroyed all evidence of her relationship with Gluck, a visual record of Gluck's feelings for Nesta exists in the double portrait she painted entitled *Medallion.*

This work was painted in celebration of what Gluck called her marriage to Nesta on May 25, 1936. The visual statement of two lovers merging into one being expressed an ideal that proved impossible for the women to sustain. The couple were together until 1944, when Nesta decided that she had to break off their relationship because Gluck had become too demanding and possessive.

Soon after England declared war against Germany in 1939, the Auxiliary Fire Service commandeered Bolton House. The War Artists Commission turned down Gluck's application for enlistment. Given the losses she had experienced and the rejection she felt, Gluck understandably began to sink into a deep depression.

Her suffering is already evident in a self-portrait she painted in 1942, two years before she and Nesta parted company. The artist depicted herself with her head tilted back, looking grimly down on the viewer with a defiant and combative expression.

Gluck could not bear to be alone and, after the break-up of her relationship with Nesta Obermer, she immediately pursued Edith Shackleton Heald, the first female reporter in Britain's House of Lords. The women had met at an exhibition of Gluck's work held for Plumpton villagers in February 1944.

The relationship soon developed into one of mutual need, and Edith invited Gluck to live with her and her sister Norma on her family estate, Chantry House, in Steyning, Sussex. When Gluck moved in on October 6, 1944, neither woman realized that it would begin a troubled thirty-year companionship.

The triangular living arrangement caused a permanent rift between Edith and her sister, who moved out two years after Gluck joined the household. The relationship between Gluck and Edith also soon soured. Edith allowed Gluck's economic and emotional needs to dominate her home; and since Edith did not have enough money to purchase a new home, the disharmony led her to travel frequently with friends.

Gluck never recovered from losing Nesta or from the war's devastation. A permanent rift between her and the brother who managed her trust fund also developed after her mother died in 1958. In addition, both Edith and Gluck began to suffer from a variety of illnesses as they aged.

During the years Gluck was with Edith, she allowed her painting to suffer and she faded from the public eye. She did, however, become a life member of the Royal

Society of Arts and was commissioned to paint some portraits of judges between 1955 and 1968, including one of her second cousin, Sir Cyril Salmon (1957–1960).

While Gluck was depressed and relatively inactive during her years at Chantry House, she did indulge her love of quality painting materials. Long frustrated with the quality of paints and canvases, Gluck began a decade-long battle with the British Board of Trade and commercial paint manufacturers. Fortunately, the Arts Council of Great Britain, British Colour Manufacturers Association, and two important museums backed her efforts.

Gluck's tireless work resulted in the formation of the British Standards Institution Technical Committee on Artists' Materials. For the first time, there were published standards regarding the naming and defining of pigments, cold-pressed linseed oil, and canvas.

The artist finally returned to her easel during her old age, and one of her works from this period, a painting of a dead fish head, its flesh mostly eaten away, was a great success. The title, *Rage, Rage against the Dying of the Light* (1970–1973), was taken from the poem Dylan Thomas wrote about his dying father. The artist knew that she was painting death, the loss of love, and the loss of years that had been wasted.

In 1970, Gluck decided to have another exhibition of her work. The three-year process of organizing the exhibition was hard work, and Gluck suffered a heart attack in November 1972. The exhibition at the Fine Arts Society in London opened six months later and was a great success. The fifty-two pieces that Gluck included in the exhibition were highly praised and also sold well. It was, however, to be the last exhibition in Gluck's lifetime.

Gluck and Edith both declined in health during the 1970s. Edith died in a nursing home on November 5, 1976. Gluck had a second heart attack two weeks later. The artist suffered a stroke the following year and died at the age of eighty-two on January 10, 1978.

Gluck was a woman of many contradictions and a person who inspired both great love and profound dislike. She deserves credit for designing the "Gluck frame" and for her efforts to improve the quality of artists' materials. In addition, she served as an early role model for other women-identified women artists.

Most significantly, however, she merits attention as an artist who left her mark on the history of modern art in England. While she exhibited her work in only a few solo exhibitions, all of them were met with critical praise.

A highly successful memorial retrospective exhibition of Gluck's work was held at the Fine Arts Society in London during 1978.

— *Ray Anne Lockard*

BIBLIOGRAPHY

Compton, Susan, ed. *British Art in the Twentieth Century: The Modern Movement*. Munich: Prestel-Verlag, 1987.

Elliott, Bridget. "Performing the Picture or Painting the Other: Romaine Brooks, Gluck and the Question of Decadence in 1923." *Women Artists and Modernism*. Katy Deepwell, ed. Manchester: Manchester University Press; New York: St. Martin's Press, 1998. 70–82.

Fox, Caroline. *Painting in Newlyn, 1800–1930*. Exhibition: July 11–September 1, 1985. London: Barbican Art Gallery, 1985.

Gluck. *The Dilemma of the Painter and Conservator in the Synthetic Age: The Papers and Correspondence of the Artist, Gluck*. Compiled by C. H. Leback-Sitwell. Brighton, England: Grant Thornton, 1980–1989.

————. *The Impermanence of Paintings in Relation to Artists' Materials*. London: Royal Society of Arts, 1964.

Gluck, 1895–1978: Memorial Exhibition. Essay by Tony Carroll. Includes a statement by the artist. Exhibition: December 15, 1980–January 30, 1981. London: Fine Arts Society, 1980.

Souhami, Diana. *Gluck, Her Biography*. London: Weidenfeld & Nicolson, 1988.

SEE ALSO

European Art: Twentieth Century; Brooks, Romaine

González-Torres, Félix *(1957–1996)*

AN AMERICAN ARTIST WHO REACHED PROMINENCE AT the end of the twentieth century, Félix González-Torres is noted for his minimalist and conceptual art, especially his installations oriented to galleries and outdoor spaces. He created art that was at once personal and political and that reflected his activism on behalf of AIDS and gay rights.

González-Torres was born in Guaimaro, Cuba, in 1957, the third of four children. His parents encouraged his interest in art. From 1971 to 1979, he and his sister Gloria lived in Spain, and then Puerto Rico. In 1979, he returned to Cuba to visit his parents; and with them, his sister Mayda, and brother Mario, he escaped Cuba in 1981 during the Mariel boatlift.

He took his B.F.A. at Pratt Institute in Brooklyn in 1983 and his M.F.A. at the International Center for Photography and New York University in 1987. He achieved important recognition in New York and international art circles during the later 1980s and early 1990s. He was invited by the prestigious Whitney Museum of American Art in New York to participate in the 1991 Whitney Biennial.

González-Torres, linked by critics to minimalist and conceptual art, takes his place within a postmodern context by virtue of his commitment to gender and sexual identity. He visualized this commitment in installation art oriented to gallery and outdoor spaces.

Variously utilizing found objects, the written word, and the strategies of commercial media, he shaped an art that was both deeply personal and political. In his art as

well as public life, González-Torres was an AIDS and gay rights activist.

Unlike most activist artists of the period who addressed gay identity and the AIDS crisis, González-Torres was not confrontational or angry in expression. His art, like that of another contemporary gay artist, Ross Bleckner, is elegiac and lyrical. Nonetheless, his art invites viewers to reflect on the universality of the gay experience. Herein lies the political dimension of his art.

"Untitled (Perfect Lovers)," (1987–1990) consists of two round Seth Thomas clocks that hang side by side on the wall. Battery-run, they are synchronized to exactly the same time, including the second hands. Using two identical commercial clocks that touch each other, González-Torres created a haunting metaphor of same-sex love in perfect unison.

The private aspect of this work is the artist's allusion to his personal relationship with a partner who was dying of AIDS. The bracketed dates of the piece mark the period of his lover's disease and death. The resonance of the work expands to include tragic loss, with a sense of "time running out."

This concern for the slow extinguishing of life is also revealed in a series of installation works that González-Torres began in 1992. They consist of strings of low-watt incandescent bulbs hung and festooned in gallery spaces. In concept, the bulbs are allowed to burn out one by one in a poignant ebbing of light and life. As memorials, these radiant garlands eulogize the beloved.

González-Torres's wish to involve viewers actively in his art is manifested in his series of "spills," mounds of objects made up variously of wrapped hard candies, mints, lollipops, cough drops, or candles. Most often stacked in corners of galleries, these sweets were there, at the artist's invitation, for the viewer's taking.

One example is *Untitled (U.S.A. Today), 1992,* a heaped corner of wrapped candies in red, white, and blue foil. The amount of each "spill" was either the ideal weight of the artist's lover or the combined weight of the two. As each "spill" diminished in weight, museum staff replenished it with additional wrapped objects. The visitor was, thus, gifted by a gay man and asked, wittingly or unknowingly, to play a caring role and to empathize with the artist's love and loss.

González-Torres himself died of AIDS-related complications in Miami, Florida, in 1996, at the age of 38, leaving behind a body of work that bridges private experience and public politics and that had gained international acclaim for the artist. — *Richard H. Axsom*

BIBLIOGRAPHY

Bartman, William S., ed. *Félix González-Torres*. With Interview by Tim Rollins, essay by Susan Cahan, and short story by Jan Avgikos. New York: Art Resources Transfer, Inc., 1993.

Deitmar, Elger, ed. *Félix González-Torres*. New York: Distributed Art Publishers, 1997.

Spector, Nancy. *Félix González-Torres*. New York: Harry N. Abrams, 1995.

Weintraub, Linda. *Art on the Edge and Over: Searching for Art's Meaning in Contemporary Society, 1970s–1990s*. Arthur C. Danto, foreword; Thomas McEvilley, afterword. Litchfield, Conn.: Art Insights, Inc., 1996.

SEE ALSO

American Art: Gay Male, Post-Stonewall; Latina/Latino American Art; Contemporary Art; Bleckner, Ross

Goodsir, Agnes Noyes (1864–1939)

AN AUSTRALIAN PORTRAIT PAINTER WHO BECAME PART of the legendary lesbian scene in Paris in the 1920s and 1930s but whose lesbianism always remained closeted, Agnes Goodsir was born in 1864 into a wealthy family in Portland, Victoria. Her father was the commissioner of customs in Melbourne, and he financed her later studies in Europe.

Goodsir's initial art training was in Australia at the Bendigo School of Mines in the 1890s. Since she had begun her formal studies late (in her thirties), she decided that she needed to study overseas. In 1899, there was an "art union," or lottery, of her work in Bendigo to assist her study in Paris.

In Paris, Goodsir studied initially at the Académie Delécluse and later at the Académie Julian and Colarossi's. She lived in Paris until 1912, when she began to alternate living in London and Paris. Her work was well received and shown at the New Salon, the Salon des Indépendants, and the Société Nationale des Beaux-Arts in Paris, and at the Royal Academy and the Royal Institute in London.

Goodsir's work is strongly composed and drawn. Although she produced many watercolors of Paris streetscapes, she was mainly interested in oil paintings. While she also painted still lifes and interiors, her strength lay in portraiture. Among her important sitters were Count Leo Tolstoy, Dame Ellen Terry, and Sir Bertrand Russell.

Goodsir admired the art of many modernists and she was surrounded by the innovations of the avant-garde. But her work, although influenced by contemporary English and French painting, is quite conservative.

Nevertheless, Goodsir's figure studies and portraits of women (particularly her representations of the archetypal independent Parisian woman) have an erotic and radical edge. Her studies of these beautifully dressed and sophisticated women often stress their androgynous qualities, as, for example, in *Type of the Latin Quarter* (ca. 1926). In *Miss G. in Pyjamas* (ca. 1924), Goodsir

uses male clothing to produce an intimate "morning after" portrait of a coquettish woman who is very likely a lesbian.

Goodsir was one of the few Australians elected to the Salon Nationale des Beaux-Arts; and in 1924 she won the silver medal at the Paris Salon for *The Red Cloak*.

At the age of 63 she returned in triumph to Australia to exhibit at Macquarie Galleries, Sydney, and the Fine Arts Gallery, Melbourne. In the nine months she was in Australia she was given several important portrait commissions, including one of the writer Banjo Patterson.

Despite the fact that Australia had many talented and recognized women artists at this time and many of them frequently traveled to Europe, the local reviewers were patronizing in their faint praise of Goodsir's "quality of restraint, for which of course, we should be grateful."

Not surprisingly, the artist never returned to provincial and conservative Australia, which lacked a climate of tolerance for variant sexual preferences.

However, after Goodsir died in 1939, her studio model and "close companion," Mrs. Rachel Dunn, sent several of Goodsir's works back to Australia, where they were placed in State and Regional Galleries.

— *Elizabeth Ashburn*

BIBLIOGRAPHY

Burke, Janine. *Australian Women Artists, 1840–1940.* Collingwood, Victoria: Greenhouse Publications, 1980.

Kerr, Joan, ed. *Heritage: The National Women's Art Book.* Sydney: Craftsman House, 1995.

Quinlan, Karen. *In a Picture Land over the Sea: Agnes Goodsir, 1864–1939.* Catalog from Bendigo Regional Gallery, 1997.

SEE ALSO

Australian Art

Grace, Della
(Del LaGrace Volcano) (b. 1957)

DELLA GRACE, ALSO KNOWN AS DELLA DISGRACE OR Del LaGrace Volcano, is one of the instigators of polymorphous perverse queer culture. Her work questions the performance of gender on several levels, especially the performance of masculinity by lesbians.

She was born Debra Dianne Wood in California in 1957. Born with the external features of a female, she lived the first thirty-seven years of her life as a woman, but since then has been attempting to live as both male and female—as intersexed.

Grace was educated at the San Francisco Art Institute. She obtained a Master's degree from the University of Derby, England. One of the best-known lesbian photographers, she is famous as much for her exhibitionistic shifts in persona as for her sexually explicit work.

The S/M chic of her photographs, combined with her preference for young and attractive models, made her the darling of the heterosexual press and the scapegoat of pro-censorship feminists. However, the theme that dominates her work is not sex but gender.

Her photographs betray an anxiety about the performance of gender—in particular, the performance of masculinity by lesbians. Whether you find her work revolutionary or reactionary depends upon whether you read her use of semiotic codes from gay men's pornography as triumphant appropriation or envious mimicry.

Grace courts notoriety with some skill. Her own identity has metamorphosed from lesbian to hermaphrodyke to transman to intersexed, and her work frequently addresses issues of chrysalization or mutation. Here, "truth" becomes irrelevant. For example, her famous beard is variously claimed to be natural or the result of hormones taken as part of a gender-transitioning process.

Similarly, she has never bothered to engage thoughtfully with criticisms that her work degrades women. Critics, especially feminists or lesbians, are met with insults or posturing. "Some French lesbians seem to be deeply resentful of anything that throws them off their precarious pseudofeminist perch," she remarked, and added: "BOLLOCKS to that, I say! I'm a Gender Terrorist, a walking, talking bomb in The Boys' Club."

Grace's gender politics are deeply felt, but they are highly subjective and do not hold up well against the challenges of her more articulate and politically informed critics.

Grace's photographs, however, are important on several levels. By pillaging gay men's porn and simply not caring whether men get off on her work, she became one of the instigators of polymorphous perverse queer culture. In producing the most unapologetically blatant representations of sex between women, she effectively confronts the desexualization of lesbianism by mainstream lesbian feminists.

Also, by photographing demonstrations, scenes in bars and clubs, drag king contests, and other queer tribal events, she has produced important documentary images of an ever-changing community.

Finally, her portfolio of drag kings ensures that transgender culture is no longer so dominated by the stories of queens, fairies, and male-to-female transitions.

Grace has also experimented with strategies to interfere with the traditional pornographic dynamic between the voyeuristic gaze of the (usually male) audience and the objectified (usually female) body of the model. These experimentations culminate in a series of sexually explicit

images of Grace and a lover fucking with dildos, rimming, and butt-fucking.

By exposing herself as she has exposed her models, Grace asserts community with the women who have posed for her and interrupts the voyeuristic gaze with her own controlling presence. Few women struggling with the male-dominated conventions of erotic art have confronted them with such courage and audacity.

— *Tamsin Wilton*

BIBLIOGRAPHY

Grace, Della. *Love Bites.* London: Gay Men's Press, 1991.

Smyth, Cherry. *Damn Fine Art: by New Lesbian Artists.* London: Cassell, 1996.

Wilton, Tamsin. *Finger-Licking Good: The Ins and Outs of Lesbian Sex.* London: Cassell, 1996.

Volcano, Della Grace, and Judith Halberstam. *The Drag King Book.* London: Serpent's Tail, 1999.

SEE ALSO

Photography: Lesbian, Post-Stonewall; American Art: Lesbian, Post-Stonewall; Erotic and Pornographic Art: Lesbian; Subjects of the Visual Arts: Nude Females

Grant, Duncan (1885–1978)

DUNCAN GRANT WAS ONE OF THE MAJOR BRITISH artists of the twentieth century, as well as the sexual catalyst of that remarkable group of friends, the Bloomsbury circle, which included, among others, writer Lytton Strachey and economist John Maynard Keynes, who were to be among Grant's lovers.

Born Duncan James Corrow Grant in Tothiemurchus, Scotland, on January 21, 1885, into an artistically cultivated Scottish family prominent in governing the British empire, Grant as a child recognized his attraction to other boys and actively sought out sexual encounters with them.

Grant spent his childhood in India but returned to Britain in 1893. He studied art briefly at the Westminster School of Art and at the Slade School, before traveling to Paris in 1906, where he studied with Jacques-Emile Blanche and became acquainted with Picasso and other influential artists of the time. In 1910, he returned to England to exhibit as a Postimpressionist, and then experimented with abstraction.

Acting on his belief in "art on any surface," he painted on walls, tables, tea trays, and other objects, pursuing an ideal of art in everyday life. In 1913, with art critic and fellow Bloomsbury figure Roger Fry, Grant founded the Omega Workshops, which changed the course of applied art and design in Britain.

Famous for his use of color, he was called "the Matisse of Britain." His career flourished and his work was widely commissioned and collected by patrons, including Queen Elizabeth (the late Queen Mother), as well as by museums throughout the world.

The high point of Grant's fame came in 1936, when he was commissioned to decorate the ocean liner *Queen Mary* (though his designs were ultimately rejected as too avant-garde). But, as art historian Kenneth Clark has observed, "no one who loved life and visual experience as much as Duncan could have remained an abstract painter for long, and very soon flowers began to appear on his canvases, and seductive [male] nudes in pastel...."

Just as Grant abandoned abstraction, soon after World War II, the abstract school triumphed. Nevertheless, Grant continued painting in a representational style, where his unabashed depictions of the male figure declared his sexual preference.

Throughout his life, Grant produced homoerotic sketches and paintings. When he was commissioned to decorate the Russell Chantry in Lincoln Cathedral in the late 1950s, he used his lover, the youthful, blond, physically beautiful Paul Roche, as the model for the face and body of Christ.

Simon Watney has speculated that "Perhaps it was this element of frank sensuality that led to the closure of the Chantry in the 1960s, and its conversion to a storeroom, where the murals languished unseen behind heaps of clerical detritus." Fortunately, the chapel has recently been restored.

Despite the oppressiveness of British law and social attitudes condemning homosexuality, Grant lived openly as a gay man. "Never be ashamed," he liked to say. He remarked that his moral sensibility came from the Regency period, the pre-Victorian era noted for its relaxed sexual mores.

The Lemon Gatherers by Duncan Grant.

Although unabashedly homosexual in orientation, Grant was the object of desire of men and women alike. The painter Vanessa Bell, for example, with whom Grant and her husband, art critic Clive Bell, shared a Sussex farmhouse for many years, fell in love with him.

Grant reluctantly yielded when she climbed into bed with him. She became pregnant and, in 1918, gave birth to a daughter she named Angelica. Grant neither acknowledged nor denied his paternity. However, when Angelica was a teenager, Vanessa told her that Grant was her father.

The young woman was traumatized with outrage and bitterness. After her mother's revelation, Angelica initiated an affair with and later married writer David Garnett, whom she knew to have been Grant's lover at the time of her conception.

Grant died peacefully on May 9, 1978, at the age of 92, in the arms of his companion, the poet Paul Roche. Grant's will divided his estate, including the copyrights to his work, between Roche and Angelica Garnett.

Unfortunately, Garnett has used this power to restrict and generally deny permission to reproduce Grant's work. As a result, the artist remains something of a ghostly figure, despite the resurgent interest in representational art and the perennial fascination with Bloomsbury.

— *Douglas Blair Turnbaugh*

BIBLIOGRAPHY

Roche, Paul. *With Duncan Grant in Southern Turkey.* Renfrew, Scotland: Honeyglen, 1982.

Shone, Richard. *Bloomsbury Portraits.* Oxford: Phaidon, 1976.

Turnbaugh, Douglas Blair. *Duncan Grant and the Bloomsbury Group.* Seacaucus, N.J.: Lyle Stuart; London: Bloomsbury, 1987.

———. *Private: The Erotic Art of Duncan Grant.* London: Gay Men's Press, 1989.

Watney, Simon. *The Art of Duncan Grant.* London: John Murray, 1990.

SEE ALSO

European Art: Twentieth Century; Salons; Latin American Art; Pisis, Filippo Tibertelli De

Gray, Eileen (1878–1976)

R ENOWNED DESIGNER OF FURNITURE, RUGS, AND lacquered screens, Eileen Gray also gained fame as an architect who created elegant and spare residences.

Gray was born into a wealthy family in Enniscorthy, Ireland, on August 9, 1878. She grew up in Ireland and London.

Among the first women admitted to the Slade School of Fine Art, Gray studied there from 1898 to 1901 and then in Paris at the Académie Colarossi (1902) and the Académie Julian (1903). After a brief return to England, she moved permanently to France in 1906.

Eileen Gray's early work utilized the art of Oriental lacquer, which involved building a lustrous surface with many layers of resin and fine earth. Using this technique, she embellished screens, lamps, and other forms of furniture.

Around 1909, she began designing natural-toned, abstract, geometrically patterned rugs that Evelyn Wyld (1882–1973), a lesbian and family friend, executed through weaving and knotting. They continued to work together for the next seventeen years.

In 1922, Eileen Gray opened Jean Désert, a showroom/gallery featuring her own lacquered furniture, a decoration service, and rugs manufactured under Evelyn Wyld's supervision. The gallery was run by Gabrielle Bloch (b. ca. 1878)—from a French banking family—whose lover was the U.S.-born dancer Loie Fuller (1862–1928).

Jean Désert remained open until 1930, when Gray became more involved in architecture. During her most active period as a designer of furniture, from 1909 to 1928, she moved from an Art Nouveau–influenced aesthetic to Art Deco, and then to more streamlined, modernist work in leather, wood, glass, and chromed metal.

Around 1922, Gray became lovers with Marisa Damia (1892–1978), a popular singer who encouraged her to bob her hair and wear tailored suits. Why they separated is unknown; however, Damia became Gabrielle Bloch's lover after Loie Fuller's death in 1928.

In 1926, after seeing the first exhibition of photographs by Berenice Abbott (1898–1991), a lesbian who had recently established her own Paris studio, Gray commissioned a portrait of herself. Abbott produced several memorable images, including a crisp, tailored profile.

By 1926, Gray had become involved with Jean Badovici (1893–1956), an architect, editor, and critic fourteen years her junior. He had written about her design work in 1924 and encouraged her interest in architecture. Their romantic involvement ended in 1932.

Gray began designing houses in 1924 and built her first, called E1027, for Badovici between 1926 and 1929. Another important house is Tempa a Pailla at Castellar, on the Riviera, built between 1931 and 1934. Her buildings, mostly elegant and spare residences in France, occupied her until 1958, when she was eighty and losing her eyesight.

Architectural historians admire Gray's buildings for their purity of design and attention to detail. During her later years, she was justifiably distressed when her furniture designs and architecture were credited to others, especially to Badovici.

Although bisexual, Gray was ultimately more interested in work than in passionate attachments. Her most

abiding friendships were with lesbians, especially Kate Weatherby (ca. 1881–1964) and Evelyn Wyld.

Gray was acquainted with expatriate writers Natalie Clifford Barney and Gertrude Stein and the women who frequented their salons, but preferred the company of one of Barney's lovers, painter Romaine Brooks, who bought Gray's rugs and was, perhaps, sympathetic to Gray's reclusive nature.

Eileen Gray died October 31, 1976, and is buried in Père Lachaise Cemetery, Grave # 17606.

— Tee A. Corinne

BIBLIOGRAPHY

Adam, Peter. *Eileen Gray: Architect/Designer.* New York: Harry N. Abrams, 1987; rev. ed., 2000.

Anscombe, Isabelle. *A Woman's Touch: Women in Design from 1860 to the Present Day.* New York: Penguin, 1984.

Burdett, Richard, and Wilfried Wang, eds. *9H On Rigor.* Cambridge, Mass.: MIT Press, 1989.

Constant, Caroline. *Eileen Gray.* London: Phaidon, 2000.

Johnson, J. Stewart. *Eileen Gray, Designer.* New York: Debrett's Peerage for Museum of Modern Art, 1979.

SEE ALSO

Architecture; Abbott, Berenice; Brooks, Romaine; Subjects of the Visual Arts: Nude Females

Hammond, Harmony Lynn (b. 1944)

HARMONY HAMMOND IS A SIGNIFICANT ARTIST WHOSE lesbian feminism is integrated into her painting and sculpture, teaching, writing, and curatorial work.

She arrived in New York in August of 1969, shortly after the Stonewall riots. Born in Chicago in 1944, she had a B.F.A. in painting from the University of Minnesota and a gay artist husband whom she had married at the age of nineteen. She had also spent time in France and Belgium, where she was influenced by collections of African, Oceanic, and Native American art.

In New York Hammond divorced her husband and had a daughter. She came out as a lesbian in 1973.

In 1973, she also helped found the A.I.R. feminist co-op gallery, where she held her first solo show. After this exhibition, she was invited to lecture as a visiting artist in schools and universities. She began publishing essays on art and began to talk with other lesbian artists and to collect slides of their work. Since the 1970s, Hammond has maintained a multidimensional career as artist, teacher, writer, and curator.

Hammond's early political influences included Sagaris, an educational institute for radical feminist thought whose affiliates included such lesbian leaders as Rita Mae Brown, Mary Daly, Dorothy Allison, Charlotte Bunch, Ti-Grace Atkinson, and Marilyn Webb.

She was also influenced by lesbian theorist Monique Wittig and by her experience as a cofounder of *Heresies: A Feminist Publication on Art and Politics* (1976).

Hammond coedited the "Lesbian art and artists" issue of *Heresies* in 1977.

In 1984, Hammond moved to New Mexico. Since 1988, she has taught at the University of Arizona, where she is now a tenured full professor.

Hammond's voice is a powerful and affirming one for lesbians. Since the time she supported herself and her daughter by storytelling in Brooklyn daycare centers, she has written about feminism and the martial arts and about lesbian art and art history.

Her *Lesbian Art in America: A Contemporary History* (2000) is the first history of lesbian art in the United States. Including profiles of eighteen prominent lesbian artists, *Lesbian Art in America* was the recipient of a Lambda Literary Award in the category of Lesbian Studies.

In the early 1990s, she described herself in *New Feminist Criticism* as "an artist, a feminist, a lesbian, middle-class, white. When I'm good, I'm an artist. When I'm bad I'm a feminist. And when I'm horrid, I'm a goddam dyke. I feel like being horrid these days. Given the current political climate around art and the threat of being artistically silenced for being queer and female, I can't afford to be quiet or to let others define who I am and what kind of art I may or may not make."

Throughout her career Hammond has expressed her artistic and political sensibility within the boundaries of modernist and abstract forms. Her works tend to be substantial, intensely colored, and ambiguous.

From *Braided Floorpiece No. 1* (1972), one of her circular, painted, hooked rugs, to her abstract painting *Untitled (Buckets)* (1995), which incorporates found objects that refer to rural women, she has consistently challenged art historical hierarchies that divide art from craft and achievement identified as male from that identified as female.

Hammond has stated that her wrapped rag sculptures of the late 1970s and early 1980s were intended to create a lesbian sensual/sexual presence in the world, where the body part or sexual act is "referenced from a combination of abstract form, and the associations and physical manipulations of the materials themselves."

Kudzu (1981), for example, is 7½ x 7½ feet and looks like a giant, partial, padded rib cage, rife with associations of breathing, breathlessness, and staunch presence. It may also refer to martial arts concepts of *chi* and to oriental script. The materials include cloth, acrylic, gesso, wood, rhoplex, wire, wax, glitter, and charcoal, each with its own visual and tactile associations with the erotic.

Hammond's curatorial work began with an early and significant lesbian exhibition, A Lesbian Show, at New York's Green Street Gallery (1978). Her 1999 exhibit Out West, for Plan B Evolving Arts, Santa Fe, was very well received. — *Marian Evans*

BIBLIOGRAPHY

Brown, Betty Ann. "Hammond, Harmony." *Dictionary of Women Artists.* Delia Gaze, ed. London and Chicago: Fitzroy Dearborn, 1997. 635–637.

Hammond, Harmony. "A Space of Infinite and Pleasurable Possibilities: Lesbian Self-representation in Visual Art." *New Feminist Criticism: Art Identity Action.* Joanna Frueh, Cassandra Langer, and Arlene Raven, eds. New York, Harper Collins, 1994. 97–131.

————. *Lesbian Art in America: A Contemporary History.* New York: Rizzoli International, 2000.

King, Sarah. "Harmony Hammond at Linda Durham." *Art in America* 87.2 (February 1999): 117–118.

Lippard, Lucy. "Binding/Bonding." *Art in America* 70.4 (April 1982): 112–118.

SEE ALSO

Contemporary Art; American Art: Lesbian, Post-Stonewall

Haring, Keith (1958–1990)

DURING THE 1980S, CURIOUS ANTHROPOMORPHIC figures—men, dogs, babies, televisions, hearts, and a wide variety of creatures and objects—characterized by a lack of individual detail, bold outlines drawn in black or primary colors, and halolike rays that emanate from them, became seemingly ubiquitous icons of pop culture.

These simple yet sophisticated designs were the creations of Keith Haring, a young gay artist influenced by the "public art" of New York City graffitists. In his all too brief lifetime, Haring produced these images at a prodigious rate and reached a worldwide audience that transcended differences of race, nationality, gender, age, and sexual orientation.

Keith Allen Haring was born May 4, 1958, in Reading, Pennsylvania, and was raised in Kutztown, a small Pennsylvania Dutch farm community. From early childhood, he drew avidly, beginning with cartoons and gradually progressing to more complex designs.

In his teens, he saw a display of Andy Warhol's work and was impressed by that artist's flat lines, his use of pop icons and mundane objects, and his concept of mass-produced art. Warhol's exaltation of the commonplace would later be a key factor in Haring's art as well.

After graduating from high school, Haring moved to Pittsburgh, where he studied art intermittently at various institutions. His two years in Pittsburgh were crucial in his development, not only as an artist but as a gay man as well; indeed, the realization of both his art and sexuality seem to have been interconnected. Accordingly, he moved to New York City in 1980, in order to be in the center of both the art world and the gay community.

Once in the metropolis, Haring studied at the School of Visual Arts, where he met other young artists such as Kenny Scharf and Jean-Michel Basquiat. From the beginning, his style was unique and "eccentric" in comparison to the work of his peers, but it evolved into its now-famous form as a result of Haring's appreciation of the city's ubiquitous graffiti.

Indeed, he began to create his own "graffiti," drawings of ambiguous-looking animals and a human figure on all fours, in the city's subways.

By 1982, Haring was employed as an assistant to gallery owner Tony Shafrazi, who gave him his first major exhibition. This show enabled Haring to demonstrate his work on a grand scale, and it featured his "dancing men" in various pop cultural attitudes and sexual juxtapositions.

Over the next three years, Haring's work was displayed and reproduced around the world; and, despite its often unmistakably homoerotic content, its humanist elements allowed it to communicate on virtually universal terms. As a result, Haring's designs were used for many public and social awareness campaigns, including AIDS prevention, literacy, UNICEF children's causes, and the fight against South African apartheid.

During the mid-1980s, Haring's work brought him wealth and celebrity. His fans included Yoko Ono, Dennis Hopper, and even Andy Warhol himself. Another devotee, Madonna, explains that his art had such a vast appeal because "there was a lot of innocence and a joy that was coupled with a brutal awareness of the world."

Haring's popularity was such that, in 1986, he opened the Pop Shop in the SoHo district of New York City as a retail outlet for products bearing his iconography. The result, predictably, was the critical accusation that Haring had "sold out" through such a commercial venture.

Haring's response to this accusation was to point out that "high art" itself is an incredibly expensive commodity that is priced beyond the reach of ordinary individuals, and to contend that the Pop Shop enabled such people to obtain art objects at reasonable prices. The Pop Shop has continued to prosper and has since expanded its operations to the Internet.

Haring was among the generation of gay men lost in the first wave of the AIDS epidemic. He was diagnosed with Kaposi's sarcoma in late 1988, but continued his art until, in his last months, he could no longer hold a pencil or brush.

Although his art had always reflected his social consciousness, in Haring's last years many of his works—from the relatively explicit "Safe Sex" poster to the familiar symbolic image of a snake cut in two by a pair of anthropomorphic scissors—was devoted to creating cultural awareness about the disease and other gay rights issues.

He was thirty-one years old when he died, on February 16, 1990, in New York City. — *Patricia Juliana Smith*

BIBLIOGRAPHY

Celant, Germand, ed. *Keith Haring*. Munich: Prestel, 1992.

Gruen, John. *Keith Haring: The Authorized Biography*. New York: Prentice-Hall, 1991.

Haring, Keith. *Keith Haring, 1988: A One-Man Exhibition in Los Angeles of Paintings, Drawings, and Prints*. Los Angeles: M. Kohn Gallery, 1988.

Kurtz, Bruce D., ed. *Keith Haring, Andy Warhol, and Walt Disney*. Munich: Prestel, 1992.

Sussman, Elisabeth. *Keith Haring*. New York: Bulfinch Press, 1997.

SEE ALSO

Contemporary Art; AIDS Activism in the Arts; American Art: Gay Male, Post-Stonewall; Warhol, Andy; Wojnarowicz, David

Hartley, Marsden *(1877–1943)*

A CENTRAL FIGURE IN THE EVOLUTION OF MODERN American art, Marsden Hartley was also among a handful of gay and lesbian artists who came to define the delicate balance between the poetic and the erotic in the early days of the American avant-garde.

He was born Edmund Hartley in Lewiston, Maine, in 1877. His mother died when he was only eight years old, an event that may have haunted him his entire life. Certainly, death was to be the occasion of many of his most memorable paintings.

In 1889, four years after the death of his mother, Hartley's father married Martha Marsden, whose maiden name the painter was to adopt as his first name in 1906. From 1898 to 1904, Hartley studied at the Cleveland School of Art, the New York School of Art, and the National Academy of Design.

In 1909, Hartley landed his first major exhibition at Alfred Stieglitz's highly respected New York gallery, gallery 291, followed by a second exhibition in 1912. In that same year, like many artists of his generation, he made a pilgrimage to Paris, where he met the well-known art collectors Leo and Gertrude Stein.

In 1913, Hartley visited Berlin and Munich, where he met artists Franz Marc and Wassily Kandinsky. While in Germany, he was drawn to the extravagant military parades he saw there and began a series of abstract paintings, the first of which were exhibited in the 1913 Armory show in New York.

Even after the outbreak of World War I in August of 1914, Hartley continued to live in Germany, and only after the death of his close friend, a young German

A portrait of Marsden Hartley by Carl van Vechten.

soldier named Karl von Freyburg, did he return to the United States.

Hartley's famous *Portrait of a German Officer* (1914) includes abstracted versions of von Freyburg's initials and his own. The painting, in which military regalia is arranged to suggest a body, is both a memorial to Hartley's friend and an expression of forbidden desire. Jonathan Weinberg provides a detailed analysis of the painting and what he sees as the overt homosexual content of the entire war motif series.

Not surprisingly, Hartley's paintings of the German military machine were not well received in New York. The artist's fascination with military themes continues to be a topic of debate, as is the nature of his relationship with von Freyburg.

By 1919, Hartley had discontinued not only the war motif series but also his use of abstraction as well. In the years to follow he would do many still lifes, landscapes, and figure studies, but it was not until the late 1930s that

Portrait of a German Officer by Marsden Hartley.

he returned to the masculine subject, though in 1933 he painted another memorial work, *Eight Bells Folly,* dedicated to his friend Hart Crane, the gay poet who committed suicide at sea.

Moving first to Nova Scotia, and then back to Maine in 1935, Hartley renewed his earlier fascination with individual subjectivity, exploring American transcendentalism and Jamesian radical empiricism through the everyday scenes of a fishing village. The works from this period employ a crude realism closer to American Regionalism than to modernist abstraction.

In this style, Hartley created one of his strongest images in *Adelard the Drowned, Master of the "Phantom"* (1938–1939). Based on the death of his close friend Alty Mason, the painting is a touching portrait. Seated with hands crossed, Mason's open shirt and rugged form are softened by a single white flower placed at his temple.

Another portrait in the same series is *Christ Held by Half-Naked Men* (1940–1941), an all-male *pietà* in which Mason is presented both as a Christ-figure and an object of desire.

Harltey's exact relationship to Mason and to other subjects of his paintings is open to speculation, but in her 1997 catalog essay "Changes of Heart: Marsden Hartley's Ideas and Art," Patricia McDonnell writes on the difficulties of being a gay artist in an era when public admission was taboo and costly. — *Ken Gonzales-Day*

BIBLIOGRAPHY

McDonnell, Patricia. "Changes of Heart: Marsden Hartley's Ideas and Art." *Marsden Hartley: American Modern.* Minneapolis: Frederick R. Weisman Museum, University of Minnesota, 1997.

Weinberg, Jonathan. *Speaking for Vice: Homosexuality in the Art of Charles Demuth, Marsden Hartley, and the First American Avant-Garde.* New Haven: Yale University Press, 1993.

SEE ALSO

American Art: Gay Male, 1900–1969; Subjects of the Visual Arts: Sailors and Soldiers; Subjects of the Visual Arts: St. Sebastian

Hepworth, Dorothy and Patricia Preece *(1898–1978)* *(1900–1971)*

BRITISH ARTIST DOROTHY HEPWORTH MAY HAVE produced most of the art sold under the name of her partner and collaborator Patricia Preece, which received major attention between the World Wars.

The two women met while they were students at the Slade School of Art in London, in 1917. They shared a studio in London until 1921, when they moved to Paris to study, Hepworth at Colarossi's studio and Preece at the more experimental André L'hôte.

The two women returned to England in 1925 and became part of the Bloomsbury circle. Hepworth was diffident, retiring, and mannish in her style of dress. In contrast, Preece was fashionable, attractive, and social.

Although they signed all of their paintings with Patricia Preece's name, Hepworth may have produced most of the art. Because of Hepworth's diffidence, Preece dealt with the public and with art galleries and dealers.

The couple had some fear of being known as lesbians and, at times, claimed to be sisters. Preece was known to refer to herself as "née Hepworth."

In 1927, for Hepworth's health, they settled in Cookham-on-Thames, Berkshire, England, a country village where, with Hepworth's father's help, they purchased a house. Hepworth's father sent monthly checks to supplement the women's meager income; however, on his death in November 1930, it was learned that he had lost his fortune in the stock-market crash of 1929. Hepworth's mother struggled to help the couple keep up the mortgage payments on their home.

In 1929, Hepworth and Preece met Stanley Spencer (1891–1959), a painter who had also studied at the Slade and who lived with his wife and two daughters in Cookham. In the early 1930s, Spencer developed an obsessive passion for Preece, who frequently modeled for him in the nude.

Spencer went into debt giving Preece money, clothing, and jewelry. His wife separated from him in 1934 and divorced him in 1937. Spencer then married Preece, but when he attempted to consummate the marriage, Preece immediately fled to Hepworth. Although Spencer and Preece never lived together as man and wife, they never divorced.

Hepworth and Preece's work received major attention between the World Wars. Exhibiting under Preece's name, they showed at Dorothy Warren's gallery, London, in 1928. In 1936, they exhibited at the Lefevre Gallery, London, with a catalog introduced by the gay male painter Duncan Grant, a central figure in the Bloomsbury group. The catalog for their 1938 exhibition at the Leger Galleries, London, was introduced by Clive Bell, Virginia Woolf's brother-in-law.

Two of their major shows took place the year before and the year after Preece married Spencer in 1937. Following this flurry of activity, the women virtually disappeared from the art scene, though Hepworth lived forty more years and Preece thirty-three.

In 1991, a posthumous exhibit of their paintings and drawings was held at the Bloomsbury Workshop, London.

Hepworth and Preece's art is almost unknown today, though a quite beautiful, undated drawing of Preece by Hepworth was published in Emmanuel Cooper's *The Sexual Perspective* (1974). The women have entered history primarily because of Preece's relationship with the much better known Spencer.

Although in this relationship Preece is sometimes portrayed as a con artist taking advantage of a naive and infatuated artist, the truth of the matter is undoubtedly more complicated.

Hepworth and Preece are of great significance to gay and lesbian art history because of their long-lasting relationship and because of the ways they used their personal strengths to create a public life together. Collaborators in life, the women are fittingly buried together. — *Tee A. Corinne*

BIBLIOGRAPHY

Bell, Keith. *Stanley Spencer.* London: Phaidon Press Limited, 1999.

Cooper, Emmanuel. *The Sexual Perspective: Homosexuality and Art in the Last 100 Years in the West.* London and New York: Routledge, 1974. Rev. ed., 1986.

MacCarthy, Fiona. *Stanley Spencer: An English Vision.* New Haven: Yale University Press, 1997.

Spalding, Frances. "Secret Collaborators." *Times Literary Supplement* No. 4623 (November 8, 1991): 10.

Thomas, Alison. *The Art of Hilda Carline, Mrs. Stanley Spencer.* London: Lund Humphries, 1999.

SEE ALSO

European Art: Twentieth Century; Grant, Duncan

Höch, Hannah (1889–1978)

GERMAN BISEXUAL ARTIST HANNAH HÖCH IS BEST known for her photomontages. She assembled images —often taken from popular magazines—into commentaries on gender and politics, frequently critiquing German bourgeois culture. She also made drawings and paintings (oil, watercolor, and gouache), participated in fabric and fashion design, and created dolls.

Hannah Höch was born Anna Therese Johanne Höch into a middle-class family in Gotha, a small town in Thuringia, in 1889. Between 1912 and 1920, she studied art at the Kunstgewerbeschule Charlottenburg (Charlottenburg School of Applied Arts) and the Unterrichtsanstalt des königlichen Kunstgewerbemuseums (School of the Royal Museum of Applied Arts) in Berlin.

The position of women in European society changed rapidly during this period and the "New Woman" was a popular theme to which Höch responded in her art.

Between 1915 and 1922, Höch was involved with Austrian-born artist Raoul Hausmann (1886–1971), a married man. Although Höch wanted Hausmann to leave his wife and daughter and live monogamously with her, he refused to do so.

As members of the Berlin Dada, Höch and Hausmann developed the art of photomontage (photographic images collaged onto paper) as a tool of artistic commentary. Dada—a response to the devastation of World War I—was a tumultuous, anarchistic, nihilistic movement that flourished between 1916 and 1922 in Zurich, New York, Cologne, Hanover, Berlin, and Paris.

Höch's best known work is the 1919–1920 photomontage titled "Cut with the Kitchen Knife Dada through the Last Weimar Beer-Belly Cultural Epoch of Germany," which combines images of men (military, government, Communists, radicals), images of women (dancers, athletes, actresses, artists), pictures of man-made objects (especially gears), and words ("DADA" is repeated three times).

In 1926, almost four years after her 1922 breakup with Hausmann, Höch entered into a lesbian relationship with the Dutch writer and linguist Til Brugman (1888–1958). They remained together for nine years, living in The Hague from 1926 to 1929, then in Berlin.

A collage by Hannah Höch.

The two women collaborated on some projects, including a book, *Scheingehacktes* (1935), for which Höch provided the images and Brugman the text. Later, Höch would remember her time with Brugman as one of the happiest in her life, but also complain of Brugman's possessiveness. During her time with Brugman, she produced a number of photomontages depicting same-sex couples.

During the 1930s, Höch embraced Surrealism, a movement to which her style of juxtaposing disparate human and animal parts was especially well suited.

In 1935, while still involved with Til Brugman, Höch began a romance with businessman and amateur musician Heinz Kurt Matthies, twenty-one years younger than she. They married in 1939, separated in 1942, and divorced in 1944. For the remaining thirty-four years of her life, the artist chose solitude over romance.

Although Höch's art was of a kind particularly denounced by the Nazis as degenerate, the artist managed to survive the Nazi period without suffering persecution.

During the 1940s and 1950s, Höch explored nonobjective abstraction. Not only was this a popular direction in avant-garde art at the time, but it was also safer than the political and social commentaries of her earlier work. Between 1963 and 1973, she returned to images of women as her central theme.

For most of her adult life, Höch maintained close friendships with some of the leading European artists, such as Kurt Schwitters, Theo van Doesburg, and Hans Arp.

Höch died in Berlin in 1978 at the age of eighty-eight.

— *Tee A. Corinne*

BIBLIOGRAPHY

Boswell, Peter, Maria Makela, and Carolyn Lanchner. *The Photomontages of Hannah Höch*. Minneapolis: Walker Art Center, 1996.

Hubert, Renée Riese. "The Revolutionary and the Phoenix: Hannah Höch and Raoul Hausmann." *Magnifying Mirrors: Women, Surrealism, & Partnership*. Lincoln: University of Nebraska Press, 1994. 277–307.

Lavin, Maud. *Cut With the Kitchen Knife: The Weimar Photomontages of Hannah Höch*. New Haven: Yale University Press, 1993.

———. "Hannah Höch's From an Ethnographic Museum." *Women in Dada: Essays on Sex, Gender, and Identity*. Naomi Sawelson-Gorse, ed. Cambridge, Mass.: MIT Press, 1999. 330–359, 641–645.

———. "The Mess of History or the Unclean Hannah Höch." *Inside the Visible: An Elliptical Traverse of Twentieth Century Art in, of, and from the Feminine*. M. Catherine de Zegher, ed. Cambridge, Mass.: MIT Press, 1996. 117–123.

SEE ALSO

European Art: Twentieth Century; Surrealism

Hockney, David (b. 1937)

DAVID HOCKNEY ESTABLISHED HIMSELF AS ONE OF the liveliest and most versatile visual artists of his generation in the 1960s. Through the years since, he has expanded that reputation with prodigious productivity.

His widely seen portraits of friends and lovers have handsomely played their part in breaking down entrenched resistance to the erotic gaze directed at the male body, and his brilliantly colored paintings of sun-drenched swimming pools have captured the essence of Southern California sensuality.

These depictions, along with his portraits of gay male couples in domestic—rather than sensational or sexual—images, may be his greatest contributions to glbtq culture.

Born in Bradford, England, on July 9, 1937, Hockney was the fourth of five children in a family headed by a pair of quiet nonconformists. Employed as an accountant's clerk, his father was a pacifist and an amateur painter; his mother was a vegetarian who neither smoked nor drank alcohol.

Although Hockney became aware of his attraction to other males at age thirteen or fourteen, the repressive climate of the time induced him to remain silent about his preference while he attended the Bradford City Grammar School and began his formal art training at the Bradford School of Art in 1953.

A conscientious objector, Hockney discharged his compulsory military service obligation by working in hospitals for two years. He then began postgraduate work at London's Royal College of Art in September 1959.

There, he made up for years of teenage reticence about his attraction to men by tackling gay issues and subjects with energy and style in paintings such as *Erection* (1959–1960) and *We Two Boys Together Clinging* (1961), the latter inspired by Whitman's poem of the same name.

Doll Boy (1960), a campy yet artful meditation-as-crush on pop singer Cliff Richard, is a perfect early illustration of Hockney's abiding artistic philosophy that "you can't have art without play.... People tend to forget that play is serious, but I know that of course it is."

In 1961, on his first trip to New York, Hockney was fascinated by the contrasts between the American city and hidebound England. He was inspired to dye his hair blond and began to develop the image that would later define him as a part of 1960s "Swinging London": oversized, black-rimmed glasses similar to those worn by the architect Le Corbusier; gold lamé jacket; and mismatched colorful socks.

Hockney threw down the gauntlet to gray, staid England and demanded sartorially that attention be paid to him as a paragon of color and personal, eccentric style. It worked like a press agent's dream and brought him a great deal of attention.

Fresh from a series of triumphs in 1963 that climaxed with his first solo exhibit's selling out in London, Hockney traveled to New York again. In January 1964, he flew on to Los Angeles, unprepared for the visual and emotional impact that city would have on him.

Upon seeing a freeway ramp, he told himself, "My God, this place needs its Piranesi; ...so here I am!" He quickly rented a studio and embarked on a love affair with Southern California that has continued to this day.

When he was an art student at the Royal College, Hockney had objected to the requirement of submitting life drawings of models hired by the school in order to receive a degree. Arguing that Renoir and Michelangelo drew subjects who attracted them and that passionate connection was responsible for the greatness of their work, he had protested that the school's models were unattractive and said he could not draw or paint individuals to whom he did not respond.

He declared that he would be more than happy to draw from life if the school hired models more to his liking. When the school refused to capitulate, Hockney, the "bad boy," still did it his way. To earn his degree, he submitted work based on American physique magazines.

In California, Hockney found many compelling specimens of his ideal model and soon became renowned for his life drawings. Their freshness, intimacy, and visual snap, in fact, for a time made them ultimate representations of late-twentieth-century Los Angeles, defining the city's sensuality in images of sun-drenched swimming pools, palm trees, and languid, muscular, young men. Representative life drawings from this period include *Domestic Scene, Los Angeles* (1963) and *Boy about to Take a Shower* (1964).

In 1966, when he was teaching at UCLA, Hockney was drawn to a nineteen-year-old student by the name of Peter Schlesinger. The relationship with Schlesinger expanded Hockney's emotional horizons and provided him with a new subject: gay men enjoying the sensual delights of Southern California.

Schlesinger figured prominently in Hockney's images of the late 1960s and early 1970s. Jack Hazan's film of 1972, *A Bigger Splash*, focused on the end of the lovers' relationship.

At the same time that he was involved in his first serious relationship, Hockney began to paint a series of double portraits of couples. That series would include paintings of writer Christopher Isherwood and painter Don Bachardy in their Santa Monica home (1968) and of art curator Henry Geldzahler and Christopher Scott in their New York City apartment (1969).

Both of these double portraits assumed iconic status in the 1970s for portraying gay male couples in an everyday

domestic routine, as if reaching such a stage were as simple for homosexuals as for heterosexuals.

In 1967, Hockney illustrated a limited edition of fourteen homoerotic poems by C. P. Cavafy. These etchings beautifully capture the longing and passion of the Greek poet and demonstrate Hockney's accomplishment as a graphic artist.

Hockney's first portraits of archetypally slim, tanned, and sexy California boys may have created openmouthed dismay for their unapologetic homoeroticism when he first exhibited them, but with time such paintings have assumed honored places in late-twentieth-century art history.

The painting of the naked and alluring Peter Schlesinger entitled *The Room, Tarzana* (1967) is a particularly important example. Nude portraits of subsequent partners Gregory Evans (sprawling against pillows and clad only in gym socks, 1976) and Ian Falconer (swimming underwater in a 1982 Polaroid collage) have also been greeted as works of art rather than as scandals.

An important characteristic of Hockney is his susceptibility to stimulus by new media and fresh subjects. The abandon and astonishing invention with which he hurls himself into explorations of all available means to depict the world around him are key features of his continuing growth as an artist.

Over the years he has moved easily from oil paints to acrylics, from pen-and-ink drawing to etching, from the formed dyed paper technique of his 1978 *Paper Pools* series to photographic collages, from Cubist-inspired paintings to designing innovative sets for operas as different as *Tristan und Isolde* and *The Magic Flute*.

He has, however, always remained a storyteller celebrating what brings him pleasure. "My sources are classic, or even epic, themes, landscapes of foreign lands, beautiful people, love, propaganda and major incidents [of my own life]," he says.

In his self-assured quest to grow as an artist in his own way, Hockney has succeeded in convincing large numbers of people to share his view that "Cézanne's apples are lovely and very special, but what finally can compare to the image of another human being?"

— *John McFarland*

BIBLIOGRAPHY

Adam, Peter. *David Hockney and His Friends*. Bath, England: Absolute Press, 1997.

Hockney, David. *David Hockney by David Hockney*. Nikos Stangos, ed. London: Thames and Hudson, 1976.

———. *Paper Pools*. Nikos Stangos, ed. New York: Abrams, 1980.

———. *That's the Way I See It*. Nikos Stangos, ed. San Francisco: Chronicle Books, 1993.

———, and R.B. Kitaj. "R.B. Kitaj and David Hockney Discuss the Case for a Return to the Figurative." *The New Review* 3.34–35 (January–February 1977): 75–77.

———, with text by Lawrence Weschler. *Cameraworks*. New York: Knopf, 1984.

Joyce, Paul. *Hockney on Photography: Conversations with Paul Joyce*. New York: Harmony Books, 1988.

Livingstone, Marco. *David Hockney*. New York: Holt, Rinehart & Winston, 1981; new English edition: London: Thames and Hudson, 1996.

Webb, Peter. *Portrait of David Hockney*. New York: E.P. Dutton, 1988.

SEE ALSO

American Art: Gay Male, 1900–1969; American Art: Gay Male, Post-Stonewall; Photography: Gay Male, Post-Stonewall; Contemporary Art; European Art: Twentieth Century; European Art: Eighteenth Century; Angus, Patrick; Bachardy, Don; Michelangelo Buonarroti; Subjects of the Visual Arts: Bathing Scenes

Hodgkins, Frances *(1869–1947)*

NEW ZEALAND ARTIST FRANCES HODGKINS, AFTER early success as a watercolorist, became one of the leading artists of British modernism. Her development as an artist is especially interesting, for she absorbed a range of artistic influences and moved from one medium to another.

Hodgkins was born in 1869 in Dunedin, then New Zealand's leading center for the arts. She learned to draw and paint at an early age from her father, William Mathew Hodgkins (1833–1898), who was an accomplished amateur watercolorist and a leading figure in Dunedin's small community of artists. Hodgkins developed her predilection for figure painting when she began to take lessons from a visiting Italian painter, Girolam Pieri Nerli, in 1893.

Known in New Zealand for her watercolors of human figures, Francis Hodgkins was a relatively successful provincial artist when she took her first trip to Europe in 1901. In England, Hodgkins met up with New Zealand artist Dorothy Kate Richmond (1861–1935), who may have become her lover, and with whom she toured France and Italy.

During the early 1900s, Impressionism influenced Hodgkins's work in both subject and style. Fluid brushstrokes make her images of female figures at leisure or engrossed in mothering appear to flicker in suggested sunlight. Unlike the great female Impressionist artists Mary Cassatt and Berthe Morisot, who favored oils, watercolor was Hodgkins's medium of choice.

Hodgkins returned to New Zealand in 1903 with Dorothy Kate Richmond and took up residence in Wellington, where the Hodgkins family had settled. The two artists taught art to pupils and exhibited their work.

On the voyage to New Zealand, Hodgkins had met a young English journalist, Thomas Wilby, who left the ship at Cairo. Hodgkins corresponded with Wilby after her return to New Zealand, and in 1904 she agreed to marry him. In 1905, however, the engagement was broken; whether by Hodgkins or Wilby is uncertain.

This was probably the first and only time that Hodgkins considered marriage. Like other talented and ambitious women of the period, she realized the difficulty of combining marriage and motherhood with an artistic career. After the Wilby incident, she was careful to avoid the distractions of close relationships with men. She was also quick to warn her female pupils of the inevitable compromise to their work if they married.

When Hodgkins returned to Europe in 1906, she left Dorothy Richmond behind. Subsequent correspondence indicates that she regretted this decision. From this time on, Hodgkins spent most of her life in Europe, returning to New Zealand for only a few visits.

Hodgkins took her first lessons in oil painting in 1908. During the late teens, she began to experiment fully with this medium and its ability to produce density and texture. She gradually abandoned the Impressionist style and began to integrate Postimpressionist trends, including Cubism and the decorative aspects of Matisse, into her work.

Between 1928 and 1930, Hodgkins added a new painting type to her repertoire that was integral to her future art: the still-life landscape. These works feature abstraction, surrealistic undertones, a color-based and lyrical treatment of form, and an investigation of spatial ambiguity between foreground and background.

Frances Hodgkins began her long artistic career as a minor provincial watercolorist. Various European art movements influenced her work, which was not always original in style and content. By the time she died of a nervous collapse in 1947, however, Hodgkins was regarded as one of the leading artists of the British modern movement.

— *Joyce M. Youmans*

BIBLIOGRAPHY

Buchanan, Iain. *Frances Hodgkins: Paintings and Drawings.* London: Thames and Hudson, 1995.

Eastmond, Elizabeth. "Metaphor and the Self-Portrait: Frances Hodgkins's *Self-Portrait: Still Life* and *Still Life: Self-Portrait.*" *Art History* 22.5 (December 1999): 656–675.

Nunn, Pamela Gerrish. "Frances Hodgkins: A Question of Identity." *Woman's Art Journal* 15 (Fall–Winter 1994–1995): 9–13.

Trevelyan, Jill. *Frances Hodgkins.* Wellington, New Zealand: Museum of New Zealand Te Papa Tongarewa, 1993.

SEE ALSO

New Zealand Art

Homer, Winslow (1836–1910)

ONE OF THE MOST PROLIFIC AND IMPORTANT AMERICAN painters and printmakers of the second half of the nineteenth century, Winslow Homer created a distinctly American, modern classical style.

For this and other reasons, his works have often been compared to the achievements of such prominent nineteenth-century American authors as Henry Thoreau, Herman Melville, and Walt Whitman.

Homer dealt with many of the same themes that these writers did, including the heroism displayed by ordinary individuals when confronted by seemingly insuperable difficulties; the camaraderie and friendships enjoyed by soldiers and working men; and the isolation of the individual in the face of the "Other."

Education and Early Career

Born in Boston on February 24, 1836, Homer was initially trained as an artist by his mother, Henrietta Benson Winslow, who successfully exhibited watercolors of flowers and other still-life subjects throughout her adult life.

Between 1855 and 1857, he was apprenticed to John H. Bufford, a nationally prominent commercial artist, based in Boston; with this training, he began to do freelance work for *Harper's Weekly* and other magazines.

Aspiring to establish himself in the fine-art world, he moved in 1859 to New York, where he took painting lessons and began to exhibit drawings and paintings of urban scenes (for example, *Skating in Central Park*, 1860, shown at the National Academy of Design, April, 1860).

In 1861, Homer was commissioned by *Harper's Weekly* as a special artist/correspondent to record the events of the Civil War. Homer failed to produce the heroic battle scenes that his editors had wanted. Yet his images of the daily lives of ordinary soldiers greatly appealed to the magazine's readers and helped to establish his reputation.

Among other subjects, he represented guard duty (*A Sharp-Shooter on Picket Duty*, wood engraving, 1867); punishments for minor infractions (*A Punishment for Intoxication*, painting, 1863); medical care for the wounded (*The Surgeon at Work at the Rear During an Engagement*, wood engraving, 1862); and recreation (*Soldier Dancing*, drawing, 1862).

As the war ended, Homer revealed the personal "costs" of the conflict in such images as *The Empty Sleeve at Newport* (wood engraving, 1865), which represents a one-armed man, riding in a carriage with a sad, aloof, well-dressed woman.

Simultaneously, he began to develop his mature classicizing style in such idyllic works as *A Game of Croquet* (1866); in this carefully balanced composition, he endowed the two women with the strength and solidity of the figures in ancient Greek reliefs.

On a professional level, Homer's extended stay in Paris, from 1867 to 1869, seems to have been most important in reinforcing his sense of confidence. In contrast to most nineteenth-century American artists who traveled to Europe, he did not substantially alter his style to accord with European conventions.

Although Homer continued to depict the recreation of the prosperous urban middle classes (for example, *Long Beach, New Jersey,* 1869), he increasingly devoted himself to scenes of country life.

He began to create representations of single figures and pairs of hunters, which remained a recurring theme in his work for the rest of his life (for example *The Trapper, Adirondacks,* 1870; and *After the Hunt,* 1892). Although it is often interpreted as a straightforward celebration of rural life, *Snap the Whip* (1872) also suggests the dangers involved in the transition from childhood to adulthood, as the boys tumble into the distance.

Homer's Private Life

Very little is known about Homer's private life. He consistently refused to answer personal questions from critics and potential biographers, and he left no revealing diaries or other personal papers. His reclusiveness is indicated by the fact that he produced no self-portraits; in contrast, most American and European painters of the nineteenth century eagerly exploited the rapidly growing market for images of artists.

Most historians have adamantly maintained that Homer remained a bachelor because he was extraordinarily "shy" around women. However, such deeply moving and psychologically complex pictures as *The Country School* (1871) and *Mending the Nets* (1882), among many others, suggest a respect for and understanding of women that was very unusual for a male artist of the era. Thus, it would seem more plausible to suggest that Homer simply may not have been interested in women sexually.

Constructing Homer as a solitary eccentric, who virtually withdrew from human society, most scholars have overlooked evidence of significant, intimate associations with other men.

One of his closest friends was Albert Kelsey, a fellow artist whom he initially met in 1858 in Massachusetts. In 1867, Kelsey traveled with Homer to Paris, where they lived together for the next two years.

A studio photograph, made while they were in Paris, mimics the conventions of marriage portraits, as do so many photographic portraits of male friends of this period. Kelsey inscribed the back of the photograph with the names "Damon and Pythias," famous ancient Greek heroes and lovers.

In the 1890s, Homer remembered their friendship in the humorous and erotically suggestive drawing *Albert Kelsey riding a giant turtle in the Bahamas.*

A portrait of Winslow Homer by William Howe Downes.

Homer's closest companion in the final years of his life was an African American man, Lewis Wright, who worked as his servant and lived at his Prout's Neck, Maine, estate from 1895 to 1910. There are indications that some of Homer's acquaintances were disconcerted by the apparent closeness of his friendship with Wright. While most "negative" reactions involved race, other "unmentionable" factors may also have been involved.

Images of Male Bonding, Depictions of Women

Throughout his career, Homer created images that celebrated diverse aspects of male friendships. Thus, he depicted soldiers unified in melancholy, longing for peacetime home life (*Home, Sweet Home,* 1863); wilderness guides enjoying the beauties of nature (*Two Guides,* 1871); and fishermen laboring together (*The Herring Net,* 1885) and coping with dangerous storms (*The Signal of Distress,* 1890).

The glorification of male bonding was a prominent theme in nineteenth-century art and literature, but it is hard to find any comparisons in the work of his male contemporaries for Homer's sensitive depictions of the pleasure and strength that women derive from one another.

Thus, he depicted middle-class women relaxing together on pleasant summer days (*The Croquet Match*, 1868; and *Promenade on the Beach*, 1880) and strong women united in their work (*Mussel Gatherers*, 1882). Homer even created a notably romantic image of two women dancing together on a moonlit beach (*Buffalo Girls*, 1890).

By contrast, Homer's depictions of male/female couples often evoke the loneliness and emotional distance of physically close individuals (for example, *All in the Gay and Golden Weather*, wood engraving, 1869). He also expressed the dangers posed to women by men in images such as *To the Rescue* (1907), which shows a man approaching a female couple with a noose.

Throughout the 1870s, Homer created numerous images of a solitary female figure, which surprised and disconcerted critics because of the despair and suppressed tension which they conveyed (such as *Reading*, 1877; and *Blackboard*, 1877). Dark, murky backgrounds (as in *Shall I Tell Your Fortune?*, 1876) intensify the foreboding sense of mystery which these works seem to embody.

It has been demonstrated that the red-haired "woman" depicted in many of these actually was a boy whom Homer hired as a model. The documented identification of the model helps to explain the "masculine" qualities of the figure, which also disturbed contemporary viewers.

Most scholars continue to deny the relevance of the model's gender and insist that the series represents Homer's frustration about a failed romance with a woman. The series does contain various symbolic references to love, but it seems possible that Homer may have been expressing despair about the suppression of same-sex romance in peacetime American society.

Whatever this series may represent, Homer does seem to have undergone some sort of personal crisis in the later 1870s. It may be coincidental, but it is interesting to note that laws against sodomy began to be more rigorously enforced in New York at this time.

Homer's Later Career

Homer precipitously abandoned New York in 1881. He lived for the next two years in Tynemouth, England, a small fishing village on the harsh North Sea coast. There, he created austere and deeply moving images of monumentally scaled figures gazing at the open sea (*Inside the Bar, Tynemouth*, 1883) and struggling to earn a living from it (*Watching the Tempest*, 1881).

When he returned to America, Homer moved permanently to Prout's Neck, Maine, also an isolated coastal town, where he continued to depict individuals heroically working and struggling against storms and other difficulties (for example, *The Fog Warning*, 1885).

Homer shipped his plates back and forth to his printer in New York, as he sought to create large prints that had the same severe, heroic power as his paintings. In some cases, he depicted the same subject in both a painting and a print—as he did, for example, for both *Life Line* (1884), and *Eight Bells* (1887). In contrast to the practice of many nineteenth-century painters, the prints differed in at least some respects from the paintings and attest to Homer's bold exploration of the possibilities of the print medium.

In the 1890s, Homer traveled extensively in the Caribbean and on the American Gulf Coast, where he made countless watercolors, capturing both the beauty of the scenery (*Flower Gardens and Bungalow*, Bermuda, 1899) and the devastation wrought by tropical storms (for example, *After the Hurricane*, 1899).

In his paintings of the Caribbean and of the American South, Homer depicted persons of African descent with a dignity and a lack of stereotype exceptional among white artists of the period. Among the most famous of Homer's Caribbean works is *Gulf Stream* (1899), a heroic and sensually charged representation of the dazed survivor of a tropical storm.

Also during his later years, Homer did a series of paintings of animals and birds that are apparently seeking to escape from hunters (for example, *The Fox Hunt*, 1893; and *Right and Left*, 1909). It is indicative of Homer's continued development as an artist and as an individual that he was able to move from powerful images of hunters to these eloquent expressions of the plight of the hunted.

Homer died on September 29, 1910, in Prout's Neck.

— *Richard G. Mann*

BIBLIOGRAPHY

Adams, Henry. "The Identity of Winslow Homer's Mystery Woman." *The Burlington Magazine* 132 (April 1990): 244–252.

Hendricks, Gordon. *The Life and Work of Winslow Homer*. New York: Harry N. Abrams, 1979.

Reed, Christopher. "The Artist and the Other." *Yale University Art Gallery Bulletin* (Spring 1989): 68–79.

Winslow Homer. Exhibition Catalog. Washington, D. C.: National Gallery of Art, 1995–1996.

SEE ALSO

American Art: Gay Male, Nineteenth Century; Angus, Patrick

Homomonument

UNVEILED IN AMSTERDAM ON SEPTEMBER 5, 1987, THE Homomonument is one of the world's foremost public memorials of the lesbians and gay men who were harassed, imprisoned, or executed during World War II.

While the monument officially remembers the suffering and attempted elimination of homosexual men and women during the Third Reich, it was more widely conceived and executed as a broad acknowledgment of the persecution endured by gay men and lesbians throughout history.

The monument was also intended to function as a political touchstone for the continued fight against hatred and oppression in contemporary times.

Although ideas for a public monument had circulated within lesbian and gay circles soon after the war, and despite complaints about the widespread erasure of homosexual persecution during Hitler's reign, organizing for a public monument was not fully realized until the 1970s, when visibility became an important political objective for many gay and lesbian emancipation groups.

Further political catalysts came in 1970 after gay activists were arrested for attempting to place a lavender wreath on Dam Square in Amsterdam during the annual national memorial service. The wreath, which was intended to draw public attention to the thousands of homosexual women and men who were persecuted during the war, was removed by police and denounced as a disgrace.

Throughout the 1970s, similar wreath-placing demonstrations were executed with varying success, as activists constantly pushed for the inclusion of homosexuals in the public's collective memory of Hitler's "social purification" campaigns.

A coalition of Dutch gay and lesbian organizations finally secured government approval for the memorial in the early 1980s and began the huge task of raising the money necessary to complete it. Through grassroots fundraising, political lobbying, and community organizing, these groups helped forge the infrastructures of action now characteristic of many queer communities in large European and North American cities.

In its reliance on community mobilization and its insistence on public visibility, the struggle for the monument was not simply about the past, but also very much about—and in some senses, crucial to—contemporary strides against homophobia in Europe.

Accordingly, the monument's design simultaneously looks back on gay and lesbian histories as it looks toward the future. Designed by Karin Daan, the monument consists of three large triangles of pinkish granite that together compose one giant triangle.

Each smaller triangle is distinct and serves a different function within the overall space: one extends tranquilly over a nearby canal and is used mainly to leave flowers in memory of the persecuted; another is raised as a sort of podium and is used mainly as a gathering spot; the last triangle is set into the ground, quietly bearing the inscription, "Such an unlimited longing for friendship," a line from the gay poet Jacob Israël De Haan.

Together, the three triangles effectively articulate the Homomonument's mediation between past, present, and future. Its solemn symbolic recognition of war and persecution is balanced by its function as a lively venue for social and political gatherings.

On one level, the design recalls the pink triangles used to designate homosexuals within Nazi concentration camps. But as the pink triangle had by the 1970s been adapted into a political marker of emancipation and pride, its incorporation into the monument's design also signifies the need for continued visibility and resistance to erasure and oppression. —*Jason Goldman*

BIBLIOGRAPHY

Koenders, Pieter. *Het Homomonument/The Homomonument*. Amsterdam: Stitching Homomonument, 1987.

SEE ALSO

Rainbow Flag

Hosmer, Harriet Goodhue *(1830–1908)*

FIGHTING AGAINST SOCIAL BARRIERS THAT KEPT WOMEN in positions of financial dependence, American sculptor Harriet Hosmer was among a small group of successful women artists in the nineteenth century.

Hosmer worked in the Neoclassical style popular in her day, although her works exhibited an approach to content that was markedly unlike that of her contemporaries. She established her reputation as a sculptor despite the commonly held notion that women were not artistically creative or physically capable of enduring the arduous process of carving marble.

Hosmer was raised as a boy by her physician father in Watertown, Massachusetts. Dr. Hosmer had lost his wife and other children to tuberculosis and thought that only the vigorous exercise common to boys could fortify his daughter against disease. He encouraged Hattie's interest in riding and shooting and encouraged her art by allowing her to set up her first studio on the family property.

Hosmer's behavior was considered scandalous. Her mannish dress and outgoing, casual conduct were entirely uncommon among women in her genteel circle and inspired gossip.

With a great sense of adventure, she traveled the Mississippi without a chaperone. She explored mines and won a footrace up a high bluff against several young men. The bluff, near Lansing, Iowa, was christened Mt. Hosmer and still bears that name.

One of Hosmer's early works, *Hesper, the Evening Star* (1852), came to the attention of Boston actress

Charlotte Cushman, a lesbian famous for playing "breeches" or men's parts, who was preparing to move to Rome. Knowing that most American art schools either refused to admit women or charged them more in tuition than men, Cushman convinced Hosmer's father to allow Hattie to move to Rome and live under her care.

Once in Rome, Hosmer was apprenticed to English sculptor John Gibson. This relationship would later be exploited by envious gossips claiming that Gibson actually did Hosmer's work. When Hosmer eventually employed a staff of artisans to carve her conceptions in marble (a practice common at the time), the slander grew until Hosmer filed successful lawsuits requiring several art magazines to retract their accusations of plagiarism.

Cushman's circle of friends consisted mostly of "emancipated" women, and the younger Hosmer quickly became a key figure in this world of creative and intellectual excitement. Fellow expatriate sculptors Anne Whitney and Edmonia Lewis looked to Hosmer as a role model, and she hobnobbed with literary figures such as Robert and Elizabeth Barrett Browning and Nathaniel Hawthorne (who dubbed her "queer").

Hosmer's abrupt personality sparked a great deal of discussion. She had no patience for the strict rules of decorum that regulated behavior among young ladies in polite circles of her day. Instead, she was driven to work long hours in the studio, perfecting her art.

As with other Neoclassical artists, Hosmer often depicted mythological figures and themes. She was drawn to female characters whose stories could be viewed as allegories for her strongly held feminist beliefs.

Zenobia in Chains (1859), for example, depicts a warrior queen captured by enemies and put on display for ridicule in her jewels and finery. This image can easily be read in relation to the condition of nineteenth-century women, who were placed on a pedestal but simultaneously enslaved by harsh financial constraints that bound them to men.

Unlike similar works depicting suffering women (such as Hiram Powers's *The Greek Slave,* 1843), Hosmer shows the queen clothed, proud, and stoic.

Hosmer was an admitted flirt. She shared a close relationship with her boarding-school friend Cornelian Crow, who eventually became her biographer; but her most intense relationship was with Louisa Ashburton, a widowed Scottish noblewoman. The two shared finances and wrote intimate letters in which Hosmer used the term "wedded wife" in reference to herself.

Although intense friendships among women were common, Hosmer dropped her characteristic joking voice in many of the letters to Ashburton while speaking of devotion and also jealousy at the thought of being replaced by another woman. Ironically, Ashburton unsuccessfully

Harriet Hosmer.

proposed to Robert Browning in a peccadillo worthy of any soap opera.

Hosmer eventually returned to America, where she was welcomed as a celebrated artist.

Her portrait of Queen Isabella was shown in the 1893 World's Columbian Exposition and was well received despite the fact that Neoclassicism was then seen as outdated.

Hosmer worked on inventing a perpetual-motion machine before her death in Watertown in 1908.

— *Jeffery Byrd*

Bibliography

Craven, Wayne. *Sculpture in America.* New York: Thomas Y. Crowell, 1968.

Rubenstein, Charlotte Streifer. *American Women Sculptors.* Boston: G.K. Hall, 1990.

Sherwood, Dolly. *Harriet Hosmer, American Sculptor 1830–1908.* Columbia. Mo.: University of Missouri Press, 1991.

See also

American Art: Lesbian, Nineteenth Century; European Art: Neoclassicism; Lewis, Mary Edmonia; Stebbins, Emma; Subjects of the Visual Arts: Nude Females; Whitney, Anne

i

Indian Art

INDIAN ART HAS BEEN QUITE EXPLICIT IN EXPLORING sexuality and the erotic. Most often couples exhibited in the visual media are involved in heterosexual activity, for physical union is regarded as analogous to union with the divine; but some representations depict men and women engaged with one another, with multiple partners, animals, or with inanimate objects, and some images are susceptible to queer readings.

Not only is sexuality celebrated in the arts, but many of India's gods also consider gender to be a fluid affair; some gods either take on attributes of the opposite sex or switch genders completely. Much of the information about the gods is handed down through India's great epics, the *Vedas* (ca. 1500 B.C.E.) and the *Mahabharata* and the *Ramayana* (ca. 500 B.C.E.–500 C.E.).

The Indus Valley Civilization, ca. 2700–1900 B.C.E.

Located in today's Pakistan, and spanning a territory of more than one million square kilometers, the ancient Indus Valley civilization spread from Afghanistan to the mouth of the Indus River. Within this vast terrain several expertly engineered large urban centers have been uncovered, which suggests sophisticated inhabitants, who not only built brick cities with elaborate sewerage systems, but also had a script that has not yet been deciphered.

Among artifacts unearthed from the Indus Valley civilization are artistic prototypes that indicate a uniquely Indian sensibility, including the veneration of both male and female principles. Numerous clay statues of women adorned with flowers and bangles, featuring wide hips and prominent breasts, were found. These depictions point toward a convention carried on in sculpture and observed in both Hindu and Buddhist art.

Hundreds of steatite (a kind of soapstone) seals, ca. 2.3–3.8 cm. (1–1.5 in.), were also discovered. One depicts a male figure seated in a meditation pose, whose head(s) are adorned with a horned headdress and who appears to be in an ithyphallic (or erect) state. Surrounded by animals, he could be a prototype for Shiva in his aspect as "Lord of the Beasts."

Shiva is an important deity to the *hijra* (transvestite) community in India today, for he is often shown not only in aniconic form (that is, represented symbolically), as a *lingam* (erect phallus), but also as an androgynous being. An ancient stone *lingam* found in the Indus Valley indicates the existence of phallic worship.

Lingams today are still revered in numerous places around India as Shiva's emblem and as the generative male energy of the universe. Devotees honor the *lingam* by performing *abhiseka*, the bathing or anointing of the phallus with a substance.

This ritual has been practiced for so long that many *lingams* are smooth and shiny on top from the constant attention. Usually milk is poured over the *lingam,* and when performed by a male devotee, the homoerotic undertone of this devotional rite cannot be denied.

The Vedic Society, ca. 1500–500 B.C.E.

Around the time the Indus Valley civilization mysteriously disappeared (ca. 1500 B.C.E.), Indo-European speaking communities rose to prominence. Literary records reveal the picture of a seminomadic people who, equipped with horses and chariots, were interested in religious ritual, weaponry, and stockbreeding.

These people composed a body of sacred writing, the *Vedas*. Although most of the hymns in the *Rig Veda* (the oldest of the *Vedas*) are dedicated to male deities, Giti Thadani notes that many parts of this text were appropriated from earlier feminine cosmogonies. Her book *Sakhiyani* (1996) speaks of numerous references in this body of sacred writing to the dual and twin feminine and also of a multiplicity of interfeminine relationships.

Both heaven and earth were initially spoken of as two maidens or mothers; and creation was often brought about by the coming together of the dual feminine, the twins, sisters, lovers, or mothers.

The dual goddesses were the first parents who gave birth to sons. The heterosexual relegation of the female goddesses to mere consorts of male deities occurred later than these early feminine cosmogonies. Thadani offers many examples of homoeroticism in these myths, which makes for fascinating reading, but, according to Vanita and Kidwai, some are taken out of context.

However, subsequent stories about same-sex couples having children and the mention of homosexual activity in the epics, as well as in the *Kamasutra*, an ancient sex manual dated to around the second century B.C.E., indicate that homosexual practices were not uncommon in south Asia.

Buddhism, ca. 500 B.C.E.

By the sixth century B.C.E., Vedic society had produced progressively more elaborate sacrificial rites, which resulted in a class/caste system that placed those with the knowledge of how to conduct the rites correctly, the Brahmins, in positions of power. This led to considerable discontent and a number of renunciants emerged.

One of them was the Buddha, Prince Guatama Siddharta. Initially he was depicted aniconically, represented by symbols such as footprints, a tree, or a wheel, rather than anthropomorphically. Gradually, between 100 and 200 C.E., images of the Buddha in human form emerged, portraying him with characteristics that are familiar today. Many early statues of the Buddha, dating from the second-century C.E. Mathura to the fifth-century C.E. Gupta periods, display a slightly androgynous being.

One aspect of the Buddha is Avalokitesvara, the compassionate Buddha. Avalokitesvara is a *boddhisatva* (an emerging Buddha); and Zimmer notes that "in Indian Buddhist tradition, Padmapani or Avalokitesvara is often an ambivalent or polyvalent character."

As Buddhism spread from India to East and Southeast Asia, Avalokiteshvara experienced a gender change. In China he became known as Guanyin, goddess of compassion; and in Japan she is Kwannon, goddess of mercy.

Many early Buddhist structures are adorned with *mithuna* (love couples or amorous pairs) or with abundantly proportioned *yakshis* and *yakshas*, female and male nature spirits. Pillar capitals at the Chaitya cave of Karle (50–75 C.E.) depict *mithuna* couples seated on elephants, but one of the loving couples stands out, for the *mithuna* is of two bare-breasted women embracing.

Often *yakshis* have discolored breasts and genitals from centuries of repeated handling. *Yakshis* not only lent structures auspiciousness, but also functioned as emblems of fertility, and it is interesting to speculate who would have done most of the touching—women or men? A second-century C.E. *yakshi* showing signs of frequent contact is found on a rail pillar from Bhutesar, Mathura, Kushan.

Androgyny

Buddhism faded almost completely from India around the twelfth century, but Hinduism continued to thrive. Around 550 C.E., a rock-cut cave temple was built on the island of Elephanta, outside Bombay, to honor Shiva. Here Shiva can be seen in his aniconic state, as a *lingam*, but also in his androgynous aspect as Ardhanarishvara. Shiva is shown female on the left side of his body and male on the right.

As Ardhanarishvara he is united with his *shakti* (female energy); however, another popular interpretation is that he has merged with his goddess consort Parvati. Ardhanarishvara most often expresses the female aspect of the divine with a breast and the male essence through the *lingam*. The *yoni* (female genitalia) are seldom depicted as a female indicator and androgynes are usually split vertically rather than horizontally.

In Hindu mythology the power of the combined man/woman is a frequent and significant theme. In one instance, when the male gods were incapable of destroying the buffalo demon, Mahisha, they manifested Durga. She is the result of all the male gods combining their energy, so her gender could be interpreted as being rather ambiguous, although today she is worshipped as a female deity.

Durga succeeded in slaying the demon of ignorance, and she can be seen in a dynamically composed stone relief carved ca. 670–700 C.E. in Mamallapuram, south India. The relief depicts the goddess flailing her multiple arms and charging toward the buffalo who stands erect, waiting to meet her challenge.

As Nanda points out, there are numerous examples of "androgynes, impersonators of the opposite sex and individuals...[undergoing] sex changes" among both

deities and humans in Indian art and mythology. Other Hindu gods who sometimes expressed androgyny are Ganesha, Rudra, and Daksa.

The elephant god Ganesha, Shiva and Parvati's child, was created by Parvati alone from water in which she either washed herself or rubbed herself. Other accounts of his birth attribute his origins to the union of Parvati with her maiden, or to Parvati and Ganga, the river goddess. His flaccid trunk and tusk are interpreted as phallic symbols, while his large temples and plump belly are regarded as female indicators.

Rudra is known as the howler and as the god of destruction. He is an aspect of Shiva, who not only castrated himself and set his phallus free, but was, as a primal androgynous being, so frightening to look at even Prajapati/Brahma had to turn away.

The creator god Daksa, a form of Prajapati, was also known as an androgyne who divided his body in half, gave birth to daughters, and finally abandoned the female aspect of himself.

The Third Gender

Hinduism consists of a pantheon of gods. The idea behind the multiple expressions is that *Brahman*, God, is without form, but in order for the mind to meditate upon the divine, it needs a form to which it can attach itself. The infinite can be seen as a diamond, each facet, god or goddess, sparkling distinctly and to be worshipped as one aspect of the whole.

The multiplicity of forms is a manifestation of the universal spirit pervading all things. Not only does Hinduism hold that divine spirit is manifest in all beings, but it also implies that male and female principles are inherent in all people.

As Nanda has pointed out, ancient Hinduism suggested a third gender, which itself was divided into four subcategories, that of the male with desiccated testicles, the castrated male, the hermaphrodite, and the non-menstruating female.

In spite of Indian society's strict adherence to conventional gender roles today, in Hindu belief gender is seen as a relatively fluid affair. The body is regarded as a temporary dwelling for a soul, and androgynous deities reflect this essentially sexless or multisexual aspect of the soul.

The Hijra

In India, the concept of third gender was expressed not only through the language and the androgynous gods, but also through the eunuchs and *hijras*, who are regarded as potent beings, for, in standing between the genders, they are seen as being closer to the divine.

Many of today's *hijras* make a living bestowing blessings on newborn male children, performing at weddings, or working as servants or as prostitutes. In dancing and singing they often outrageously parody women. A wedding, especially among the devout poor, would not be considered complete without the presence and blessings of the potent *hijra*.

Sex Change

Besides manifesting as androgynes, some Hindu gods were also known to switch genders altogether. Usually the sex change occurred so gods could engage in intercourse with a being of their own gender.

In one of his incarnations, Vishnu manifested as Mohini (a beautiful woman) in order to seduce Shiva. Together they produced a dual-gendered god, Ayyappa, who is today honored by the *hijras*, many of whom are Lord Ayyappa's followers.

Krishna, too, transformed into a woman to fight the demon Araka, who, having never set eyes on a woman, was strong only because of his chastity. After being married for three days, the demon was destroyed by his wife.

After the deed, Krishna revealed himself to the other gods in his true form, proclaiming there would be others like him, who, as neither man nor woman, would have the power to utter words, whether a blessing or a curse, that would come true. Today's *hijras* are attributed this power, so hosts take care to reward them generously when they perform at celebratory events.

According to a Tamil version of the *Mahabharata*, Krishna again took on female attributes in order to marry Arjuna's son Aravan. When Aravan offered himself as a sacrifice, he asked for the boon of marriage, but no woman wanted to marry a man about to be killed, so Krishna volunteered. This event is celebrated annually by the *hijras*, who honor and identify with Krishna in his transgendered form.

Shiva also changed sexes, but his reason for doing so was to make love to his wife Parvati as a female. A story in the *Ramayana* describes how, in order to please Parvati, he not only transformed into a woman, but switched the gender of every male who entered the forest where they were making love.

When King Ila stumbled into the grove, he and his stallion were transformed into their female equivalents. But King Ila's brothers pleaded with Shiva, who reversed the spell somewhat by granting Ila the state of being a woman one month and a man the next.

Women also switched genders. The princess Amba, though reborn as Sikhandini, a girl, was brought up by her parents as a boy. When Sikhandini married a princess, her true sex was discovered and she ran to the forest where a *yaksha* exchanged genders with her. From then on she was known as Sikhandin, a great warrior, who helped Arjuna in battle.

Homosexual Relationships

As is apparent from the stories above, sex between people of the same gender was not unheard of in the Hindu epics. A story from the *Ramayana* describes how Hanuman, the monkey god, witnessed women lying in each other's arms as if they were with male lovers; and the *Susruta* (ca. 380–450 C.E.) notes that two women could act like virile men and have intercourse together, but their child would lack bones.

In a text ascribed to a fourteenth-century C.E. poet, King Dilipa's widows who "lived together in extreme love" conceived a child after they made love to one another. Their child was born as a lump of flesh, without bones, but a sage provided him with a sound body. The boy was known as Bhagiratha, the boy born of two vulvas (*bhagas*).

The dual-gendered Ayyappa, born from the union of Shiva and Vishnu (as Mohini), is also known as Skanda or Kartikkeya. Other accounts of his birth attribute his origins to Agni and Shiva. In this version, Ayyappa was born after Agni (the male fire god) swallowed Shiva's semen. Although Shiva reprimanded Agni, saying his action was improper, oral sex between males was not considered "unforgivable or uncreative," as Vanita and Kidwai point out.

Today Skanda, the son of two males, and a god who refused to marry, has a nearly all-male following. Hindu temples dedicated to him, as well as mosques devoted to his Muslim companion Vavar, abound, especially in south India, where yearly up to 50 million devotees make the pilgrimage to the Sabarimale temple in Erumeli, Kerala.

This Hindu temple incorporates a shrine honoring Vavar (in his aniconic form as a sword), for Ayyappa considered Vavar an inseparable part of himself. Ayyappa's devotees also pay homage to the Vavarambalam mosque located outside Erumeli.

Just as Ayyappa felt Vavar to be a vital part of himself, Krishna and Arjuna also expressed similar feelings for each other. Their friendship is described in the *Bhagavad Gita* (part of the *Mahabharata*). As teacher and disciple, they were devoted to one another. Krishna's life meant more to Arjuna than his mother's and Arjuna was more important to Krishna than wives or children.

Although Arjuna was married, on their last day together Krishna spent the night with Arjuna. Parting the next day, they hugged and gazed longingly at each other until they were out of sight.

Cross-Dressing

Cross-dressing is also an activity engaged in by humans and gods alike. The first time the warrior Arjuna took on the appearance of a woman, he worked as a dancer, anticipating the modern-day *hijras*. Years later, when hiding in the forest with his brothers, he again donned female clothing to disguise himself. As a female impersonator,

he found employment at the king's court, where he instructed the princesses in the art of dance.

Today, at festivals and in village theaters in south India, actors playing the part of Arjuna wear saris and paint their faces with one color on the left and another on the right, signifying the dual, or androgynous, aspect of Arjuna and, in O'Flaherty's words, "expressing the sexual ambivalence of the man/woman/eunuch/transvestite."

Evidence of cross-dressing in the visual arts can be seen in a Rajput watercolor painting from 1740, attributed to Nihal Chand, Rajasthan, Kishangarh, which is inscribed on the reverse as "the gathering of the uniformed, wine drinking restless ones." It depicts numerous women surrounding a wealthy but inebriated old man. One of the "women" is a black transvestite, but there is also a couple of ambiguous gender, both dressed as women, who are clearly engaged in sexual activity.

Krishna the cow herder (not to be confused with Krishna from the *Mahabharata*) and his lover the chief *gopi* (cow-girl) Radha, also enjoyed cross-dressing. Kangra paintings of the eighteenth century C.E. often depict a scene of Krishna and Radha exchanging clothes. They not only exchange garments, but also imitate the mannerisms of the opposite sex in divine play called *Lila-hava*.

Another image of Krishna dressed as a woman can be seen in a miniature dated to the eighteenth or nineteenth century C.E. and today displayed in the Kota Palace Museum.

Cross-Dressing Krishna Devotees

Not only Krishna, but also many of his devotees wear female clothing. One of the most famous followers was the teacher and transvestite Caitanya (1500 C.E.). Some regarded Caitanya as the avatar of Krishna, but he felt he was an incarnation of Radha. The myth grew around Caitanya that he was Krishna as Radha incarnate, so his body became the site for Krishna to undergo a sex change and manifest as Radha.

Caitanya dressed as a woman and also observed menstruation rites. S/he met her lifetime companion Jaganath Das (1490–1550) when he was nineteen years old. They saw in one another the incarnation of Radha and Krishna. Das, it is said, was born from Radha's smile and Caitanya from Krishna's laughter.

Caitanya declared Das to be a partial manifestation of Radha and therefore the object of Krishna's supreme devotion. After they met, Das and Caitanya embraced for two and a half days and from then on became constant companions. Caitanya addressed Jaganath as his female friend and s/he in turn saw herself as Caitanya's faithful maidservant.

Some Krishna devotees today continue to cross-dress. Adopting the lives and attitudes of the *gopis*, who enjoyed

numerous love affairs with their lord and lover extraordinaire, they wear female clothing. In performing austerities, male devotees aspire to reincarnate as *gopis* in order to experience divine union with Krishna.

Temple Sculpture, Tenth to Thirteenth Century C.E.

Just as devotees long for sexual union with their lord as a vehicle for union with the divine, many temples in India depict explicit images of sexual practice. The temple itself could be regarded as a metaphor for union between the earthly and the divine, male and female.

An image of a deity is placed in the *garbhagriha*, the dark interior womb chamber, above which rises the *shikara*, the tallest element of the northern-style temple and one that is often covered with sculpture. In cases where the sculpture is erotic, most are depictions of heterosexual *mithuna* couples, but in some instances they are attended by helpers, who not only engage actively with the couple, but also with one another.

An orgiastic group consisting of three women and one man depicted on the southern wall of the Kandariya Mahadeva temple in Khajuraho (1004–1035 C.E.) shows intense interaction between two women as one of them sits on top of the male and the other caresses her and gazes intently into her eyes.

Another sculptural group of a similar configuration from the Kandariya Mahadeva temple's south wall, in Khajuraho, shows a woman facing the viewer, standing on her head, and perhaps engaged in intercourse. She is held by two female attendants on either side and reaches out to touch one of them in her pubic area.

This could also be read as a sculptural group of not just three, but four women enjoying one another, for the figure on top of the woman is seen from behind and is of such ambiguous gender that it could easily be a female, rather than a male, with a narrow waist, wide hips, wearing jewelry and long hair.

Erotic interaction between females can also be observed on the Shiva temple at Ambernath, constructed in 1060 C.E. This relief is badly weathered, but the women's interest in one another is clear.

A sculpture at Khajuraho is less ambiguous, as it shows two women, their lips almost touching, embracing one another. Another sculpture, from the Rhajarani Temple in Bhuveshvar, Orissa, dating from the tenth or eleventh century C.E., depicts two women engaged in oral congress. One stands smiling blissfully, as her lover kneels between her legs.

Two relief sculptures below the *sikhara* of the twelfth-century C.E. temple dedicated to Shiva in Bagali, Chola/Chalukya, depict a man of large proportions casually holding his huge phallus, slung over his shoulder like a feather boa, while another man of much smaller scale kneels on the giant's leg and attempts fellatio. On the same wall a man can be observed in self-fellation, made possible by his enormous penis.

At the Lakshmana temple in Khajuraho (954 C.E.), an orgiastic scene featuring a couple copulating within a group also depicts a man receiving fellatio from a seated male; and at Padhavli near Gwalior, a ruined temple from the Kachchhapaghata period (tenth century C.E.) shows a man within an orgiastic group receiving fellatio from another male.

Paintings

The profusion of lively three-dimensional figures adorning the temples stands in direct contrast to some of the paintings that can be given queer readings. Much of the action in eighteenth-century C.E. paintings occurs within a shallow space; and compared to the dynamism of the sculptures, the paintings also exude an extraordinary sense of serenity. Weighed against the heavy solidity of the temple figures, most of the painted figures could be considered flat and ethereal.

One Rajasthani gouache painting from the eighteenth century C.E. that could be interpreted as homoerotic is called *Anointing and Massage of the Body of a High-caste Woman after Bathing and before Intercourse*. It depicts maids holding up a piece of material to create a private space.

Within the enclosed space, the high-caste woman, seated on a low platform, prominently displays her genitals and awaits the anointing of her privates by one of her female attendants. Apart from their jewelry the women are naked, and as one approaches the high-caste woman's pubic area, another massages her arms, and a third brings oil as the maids look on.

Another painting from the Punjab and dated 1710–1725 is *The Absent Lovers*. Depicted within an extremely shallow space, it shows five ethereal women in a garden. Having just finished bathing, they are nude from the waist up. They are all physically connected, but there appears to be an especially intimate relationship between three of them as they touch one another and gaze soulfully into each other's eyes.

A painting from the Chamba school, at the end of the eighteenth century C.E., creates the illusion of more depth and also portrays women intimately involved with one another. In *Lady Suffering the Sorrows of Love*, the lady lies on her bed, where she is ministered to by female attendants who bring her tea, prepare food for her, massage her feet, fan her, and caress her arms as the lady reaches back to touch one of the women's hands.

Krishna played numerous tricks on the *gopis*. A Kangra miniature from the late eighteenth or early nineteenth century C.E., now in the National Museum, New Delhi, depicts an incident when Krishna hid all of the *gopis'* clothes while they were bathing. Only Krishna's blue feet

are visible, for he is sitting in a tree, under which the women plead for their clothes.

However, a couple of women have remained in the water and seem to have forgotten all about their clothes, for they are engaged in oral congress.

Twentieth-Century C.E. Art

In spite of India's liberal sexual attitudes in the past, the antiquated British law making homosexual liaisons between men illegal is enforced in India today. Considering the recent outcry in India over the screening of the film *Fire* (1997), directed by Indo-Canadian Deepa Mehta, which depicts a scene of lesbian sex, it is no wonder that most homosexuals in India are deeply closeted.

Bhupen Khakhar

However, Bhupen Khakhar (1934–2003) recently emerged as a gay Indian artist. His courage served as a source of inspiration for many others in the Indian gay art scene.

Khakhar joined the faculty of fine arts in Baroda in 1962. His early paintings depict images of men either by themselves or interacting; but whether they are alone or together, they all convey a sense of introspection, stillness, loneliness, and inaccessibility.

Geeta Kapur notes the "uncanny sense of withdrawal in his otherwise social paintings." She describes the sensuousness in his tenderly modeled and brilliantly colored figures as "veiled, tremulous and diffuse," and speaks of the artist as being distanced.

After Khakhar visited Great Britain in the 1980s, he began making more explicit references to male homosexuality in his paintings. For example, *Two Men in Benares* (oil on canvas, 1982) depicts a sexual encounter between two men that takes place in an ambiguous, color-saturated cityscape.

In *Yayati* (1987), Khakhar interprets a scene from the *Mahabharata* wherein an old, impotent king asks a youth for his virility by depicting the moment of transference just as their penises are about to touch.

Green Landscape and *White Angel*, both watercolors from 1995, illustrate men engaged in a variety of homoerotic activities. *An Old Man from Vasad Who Had Five Penises Suffered from Runny Nose* (1995) shows a man swathed in a transparent orange material; his genitalia, with its multiple appendages, resemble a flower found only in dreams.

In 1995, Khakhar also painted *Sakhibav*, an image of a *hijra* draped in transparent saris as s/he drinks tea.

Amrita Sher-Gil

Another artist whose work can be interpreted as queer is Amrita Sher-Gil (1913–1941).

Daughter of a mixed Sikh-Hungarian marriage, she moved to Paris in 1929 to study art. She had affairs with men, but also developed intimate friendships with Marie Louise Chassney, a painter in Paris, and with Edith Lang, a Hungarian pianist.

Amrita's parents destroyed her correspondence with these women after she married her Hungarian cousin Victor. She apparently entered into this marriage of convenience in order to escape dependence on her parents.

In 1934 the artist returned to India, where she evolved a painting technique inspired by the Buddhist cave paintings at Ajanta and by Mughal miniatures. Her paintings depict mostly women in scenes from rural India. Although they appear to be engaged in activity, the figures, reduced in form, emote a tangible stillness— a serenity, a melancholy, a passivity— that contrasts greatly with the ebullience and activity of early Hindu and Buddhist sculptures of females.

The remoteness between the figures is tangible in her painting *Three Girls* (oil on canvas, 1935). Sher-Gil suspends the interactive potential of the group by locking the individuals in silence.

This is also the case with *Hill Women* (1935), which depicts a silent group walking to market, and *The Swing* (1940). Although the women in these works are bathed in luminous tones of red, in spite of their activity and the brilliant color the painting emits a timeless calm.

Solid silence also hangs suspended in the painting *The Bath* (1940), which depicts a solitary female nude wrapped in privacy by a temporary cloth shield, yet exposed to the artist and viewer.

Vivan Sundaram interprets Sher-Gil's painting *Two Girls* (1939) as one in which the physical and emotional longing of two women for one another is tangible.

Although homoeroticism is never explicit in Sher-Gil's paintings, the distance of the figures from one another is remarkably reminiscent of the remoteness expressed in Khakhar's early paintings and may constitute a code for the depiction of homosexuality within an oppressive society. We can only speculate how Sher-Gil would have further developed her art had she lived longer.

Conclusion

Although homosexuality, gender-bending, cross-dressing, and third-gender expression have always had a place in Indian art and culture, today homosexuality in south Asia is deplored by fundamentalists as a Western import. However, it is clear that many of India's favorite gods embraced and celebrated diversity.

Perhaps individuals whose sexual expressions differ from that of the majority can draw strength and inspiration from these roots. There may also be reason to hope for greater tolerance for sexual minorities in India. The recent election of a *hijra* as mayor in Uttar Pradesh may be a harbinger of increased respect for sexual diversity.

— *Eve Millar*

BIBLIOGRAPHY

Bussagli, Mario. *5000 Years of the Art of India.* New York: Harry N. Abrams [ca. 1990].

Craven, Roy. *Indian Art.* Rev. ed. London: Thames and Hudson, 1997.

Dehejia, Vidya. *Indian Art.* London: Phaidon Press, 1997.

Desai, Devangana. *Erotic Sculpture of India.* New Delhi: Tata McGraw-Hill, 1975.

Desai, Vishakha, et al. *Contemporary Art in India. Traditions, Tensions.* New York: Harry N. Abrams, 1996.

Lal, Kanwar. *Erotic Sculpture of Khajuraho.* New Delhi: Asia Press, 1970.

Lerner, Martin. *The Flame and the Lotus.* New York: Harry N. Abrams, 1984.

Nanda, Serena. *Neither Man nor Woman. The Hijras of India.* Belmont, Calif.: Wadsworth, 1990.

O'Flaherty, Wendy Doniger. *Women, Androgynes and Other Mythical Beasts.* Chicago: University of Chicago Press, 1980.

Randhawa, M. S. Kangra. *Paintings on Love.* New Delhi: Patiala House, 1994.

Rawson, Philip. *The Art of Tantra.* London: Thames and Hudson, 1973.

Sundaram, Vivan. *Amrita Sher-Gil.* Bombay: Marg Publications, 1972.

Thadani, Giti. *Sakhiyani.* London: Cassell, 1996.

Vanita, Ruth, and Saleem Kidwai. *Same-Sex Love in India.* New York: St. Martin's Press, 2000.

Watts, Alan. *Erotic Spirituality.* London: Collier-Macmillan, 1971.

Wilhelm Das, Amara. "Tritiya-Prkriti: People of the Third Sex." www.geocities.com/galva108/

Zimmer, Heinrich. *Myths and Symbols in Indian Art and Civilization.* Princeton, N. J.: Princeton University Press, 1946.

members.aol.com/sabrin1315/mohini.htm

www.indiayogi.com/website/phase2/indiangods/ayyapan.asp

www.khushnet.com/ifti/ghalib.htm

hindunet.org/vedas/rigveda/

www.geocities.com/WestHollywood/1769/ganesha.htm

www.geocities.com/WestHollywood/1769/shiva.htm

www.kamat.com/kalranga/letters/heshe.htm

www.ayuherbal.com/susrutasahmita.htm

SEE ALSO

Islamic Art; Khakhar, Bhupen

Islamic Art

THE TERM ISLAMIC ART IS AN ALL-EMBRACING CONCEPT somewhat inadequate to describe the range and diversity of work produced across countries as different as Morocco, Turkey, and India. It includes art produced by Muslim peoples, beginning with, but not limited to, the nomadic Arabs who promulgated the religion of Islam, which in Arabic means "submission" (to the will of God).

With the migration of Mohammed to Medina in 622 C. E., Islam spread across Mesopotamia, Persia, and North Africa, reaching as far as Spain. Embodying primarily a male ethic, Islam reacted strongly against the proliferation of matriarchal cults and traditions and managed to unify a variety of peoples.

Art under Islam

The apparent invisibility of homosexuality in the visual arts of Islam is no indication of its absence in the culture. Indeed, quite the opposite is true. Homosexuality was common in many areas under Islamic domination, more visible in some societies than in others. It is a major theme in early Arabic poetry, which may explain the highly respected position of calligraphy in Arabic art.

Muslims, however, posited the significance of art in ways distinct from that of Europeans. For early Muslims, the difference between public and private space was so sharply delineated that it allowed many works to go unnoticed and unrecorded. Public decorum was paramount, and many images, including homoerotic ones, may have been destroyed.

Another factor that makes accurate assessment of Islamic art difficult is that there was never a serious attempt among Muslim scholars to define or codify a distinct Islamic aesthetic. Even the great historian and sociologist Ibn Khaldoun (1332–1406) makes only cursory reference to art.

Islamic Architecture

In art, Islam emphasizes the primacy of architecture, especially the dome and the freestanding minaret. Key to Islamic architecture is an appreciation of the poised classic lines of repeated arches that come to a halt in the *pishtaq* (Persian for a high arch framed in a rectangular portal), and interiors of stucco or carved wood in intricate geometric patterns. Early Mesopotamian architects achieved the pointed arch at least three centuries before it reached Europe.

Islam's fullest artistic achievement is its mosque architecture, perhaps rivaled only by its miniature painting. Despite the apparent imposed uniformity, mosques vary greatly in style over different eras, from the impressive blue-tiled Shah mosque (1611–1666) of Isfahan with its faience (glazed ceramic) mosaics to the splendor of the mosque of Sultan Suleyman (1550–1557) in Istanbul designed by Sinan, who died a year after it was completed.

Calligraphy and the fine art of the illustrated book are also highly prized, along with textiles and ceramics, which achieved consummate finesse in the Islamic world.

Homosexuality and Islam

At various times in its history, Muslim culture has been known not only for the flourishing of art, but also for tolerance of homosexual relationships. This is true particularly of such reigns as the Abbasids of Baghdad (750–1258), the Umayyads of Cordoba (756–1031), the Seljuks of Persia (1037–1194), the Mamluks of Egypt (1252–1517), and the Ottomans of Turkey (1300–1924).

The tolerance of homosexuality in these epochs is in stark contrast to the more prudish and prohibitive Judeo-Christian ethic that dominated Europe. (The homophobic trend in fundamentalist Islamic regimes is recent and does not recognize homosexuality as an identity, but associates it with prostitution, transvestism, and "subversive" foreign influence.)

Many European visitors to Constantinople and North Africa during the Renaissance, for example, were often outraged by what they perceived as openly condoned sodomitic relationships in the courts of these Islamic societies, and less obvious sapphic ones in the harems. However, the homoerotic feeling that flourished in Islam rarely found expression in nudes or portraits as in Hellenistic or later European art.

Islamic attitudes toward sex are complex. Although homosexuality is prohibited (and sometimes severely punished) by Islamic society in general, it is nevertheless widely practiced. Moreover, same-sex intimacy is encouraged, especially in those societies where the segregation of men and women is most strictly enforced.

Some medieval Arab books of counsel advised young men to take boys as lovers during the summer and women in the winter. Homosexuality is called a "great transgression" in the *Qur'an,* but beautiful youths of both sexes are offered among the rewards of paradise.

The conflicts within Islam regarding homosexuality are highlighted by the fact that Abu Bakr, the first Caliph (successor) after Mohammed's death, advocated that homosexuals should be buried under a wall, while philosopher Ibn Sina (Avicenna, 981–1037), on the other hand, said that kissing boys was permissible, provided it did not lead to immorality.

Ibn Sina even wrote love poems to boys, but he never attempted to explicate homosexuality as a phenomenon in his philosophy, perhaps believing that to attempt to define it would violate Muslim decorum. Very often no distinction was made between the value of love for men and that for women in some Medieval Arab treatises on love.

Love Poetry

Islamic poetry, especially Persian, with its incredible stylization of themes, is frequently homoerotic. Homosexuality found a clear but not unequivocal voice in the "ghazal" or love poem of five to fifteen couplets. These poems, which are remarkable for their emphasis on "the amorous gaze," and on longing and unfulfilled desire, often focus on a beautiful boy.

Some claim that the use of the male pronoun in Islamic love dialogues is largely metaphoric or allegorical. However, the poets Abu Nuwas (ca. 750–ca. 810), al Hallaj (858–922), Ibn Hazm of Cordoba (994–1064), al-Ghazali (1058–1111), Jaladin-al Rumi (1207–1273), among others, all ecstatically praise male adolescent beauty.

Of these, Abu Nuwas, who in the *Tales of One Thousand and One Nights* eulogizes the relative beauty of three boys, is the most famous and most innovative. While editions of the *One Thousand and One Nights,* which were first assembled in late-thirteenth-century Syria and Egypt, were rarely published with illustrations, its homoeroticism is nonetheless apparent.

Wine Poetry

Other instances of the homoerotic turn up in a form called "wine poetry." Intoxication, along with male beauty, was for a number of Sufi mystics and dervishes closely linked to the divine. They saw wine, boys, and dance as emblematic of the relationship to God, and a doorway into paradise from earth.

Another rhetorical form debated the relative merits of the love of girls and the love of boys. Though wit was relished, this conceit, especially in satirical poetry, should not always be taken literally. This genre was extremely popular in Egypt under the Mamluks (the Turkish or Circassian warrior-slave class that came to power in the thirteenth century), who produced the beautiful Ibn Tulun and Mohammed Ali mosques in Cairo.

Illustrated books of aphorisms and anecdotes were a standard and much admired genre, perhaps because poetry was judged more on aesthetic than on theological criteria.

Figure Painting

Another conflicted issue in Islamic Art is *mimesis* or representation. Artwork that depicts human figures or animals is often classed as un-Islamic. Most artists, therefore, remained anonymous and figure painting was identified early on as an idolatrous practice.

While there is in fact no prohibition in the *Qur'an* against representing humans, the *Hadith* (the Islamic traditions) take the stance that representation emulates God, and should therefore be forbidden. Paradoxically, this may be why artists were so greatly honored, perhaps even feared.

Despite the religious stigma against figurative art, it never died out. It even flourished under the Timurids of Northern Iraq and during the Mughal dynasty of Babur (1483–1540) in India. Early Islamic figure painting was greatly influenced by Greek and Hellenistic artists and traditions.

Much of the best figure painting in books dates from twelfth-century Tabriz (Iran) or from sixteenth-century India in the Mughal period, where miniatures flourished, and during the Ottoman period (the sixteenth century through the nineteenth century) in Turkey.

Some artists began to be celebrated for their individual style, or were both calligraphers and painters of illuminated manuscripts. One of the most famous court schools was in Herat (Khorasan, northwest Afghanistan), which was started by Bihzad (ca. 1440–ca. 1514). Along with Shiraz (Iran), the Herat school produced the finest miniatures of the period.

Erotic Miniature Painting

Although there are some frescoes depicting female nudes in private palaces of the Ummayads, there are few surviving works inspired by Eros. Saslow draws attention to "the one significant cluster of homoerotic images" that center on court figures in Persian miniatures of the sixteenth and seventeenth centuries.

These depict overdressed and overrefined cupbearers, usually male, in artificial, lascivious postures. That these lovers locked in ardent embraces are somewhat genderless merely added to the point the artists were making. Some of these miniatures depict lovers sinuously entwined; others portray elegant drinking companions, known as *zarifs*, who were expected to be entertaining conversationalists.

The cult of the dandy reached its zenith in Persia's Safavid dynasty (1502–1736). In *Portrait of Shah Abbas with a Young Page* (1627), Muhammed Qasim presents the handsome Shah and his young lover enfolded in a tender embrace. Other portraits of Shah Abbas, who was a great connoisseur of art as well as head of the Naqsbandiah Sufi order, show the page boy right behind his master, gazing at him lovingly.

The artist Riza-i Abbas, who worked for Shah Abbas, specialized in scenes of young men inhaling the perfume of flowers or being pursued by older men. His scenes varied from the delicate to the crude. One critic goes so far as to say that they "may well have been… 'pin-up' boys for homosexuals." In later life Riza began painting female nudes and was known to consort with wrestlers.

The skill of the painting, combined with the beauty of the calligraphy, would have made these illustrated books treasured items. Topics were often intriguingly titled. In the *Haft Awrang* (Seven Thrones, 1556–1565) commissioned by Sultan Ibrahim Mirza, for example, there are scenes entitled *The Fickle Old Lover is Knocked from the Rooftop*, in which a young man rejects the advances of an older man.

In *The Dervish Picks up His Beloved's Hair from the Hammam Floor*, a Sufi mendicant so adores and abases himself for a beautiful young male that he eventually dies, and the young man who rejected him is moved to become a dervish for his sake. Each highly detailed illustration is seen in full space, a worm's and bird's eye view combined.

A depiction of two female lovers from the *Koka Shastra,* a lesbian allegory from seventeenth-century India with a Hindu influence, shows one figure holding a bow, armed with an arrow, aimed directly into the other's displayed vagina. Attached to the arrow point is a dildo, an image that Pier Paolo Pasolini made startling use of in his film of *The One Thousand and One Nights* (1974).

Patrons may have commissioned artists to make lascivious pictures, often illustrating stories, for their private collections. One illustrated book from nineteenth-century Turkey, the *Khamsa* (Quintet) by Nevi Zade Atai, depicts the routine sodomizing of a boy while other men stand around idly masturbating. But this kind of explicit depiction of male sex is rare in Islam.

Arabesque Motifs

Central to the Islamic sense of design was an intricate, both simple and complex, repeated pattern of woven strand. The basis of this design is the Arabesque, a principle of reciprocal repetition. The Arabesque is usually manifested as undulating stalks, split and curled leaves that fill the surface with ornament.

Its precursors were the Greek and Roman acanthus and cornucopia motifs, but Arabesque became a standard design feature that was also paralleled in music and poetry and influenced European designers from the late eighteenth century onward, including Art Nouveau.

This recurrent motif is perhaps a result of the fact that, until the seventeenth century, Islamic thinkers led the world in astronomy, algebra, trigonometry, and pharmacy. Even in their geometry they were profoundly un-Hellenic.

Whereas Greeks preferred closed circles and polygons, Islamic artists chose open-ended geometric forms such as the ever interlacing polygon. The emphasis was more algebraic than geometric, showing the immateriality of all forms.

Orientalism

Islamic Art is considered to have declined as a result of modern Western influences. A separate, but allied, strand of art produced by Westerners influenced by Muslim culture is termed Orientalism. The value of this work, which was mainly scene painting, but also influenced architecture and music, is debated. However, in recent years there has been some reappraisal of the fixed binary view of East versus West as underscored by critic Edward Said.

While not demeaning the importance of geopolitical bias, the reassessment now focuses on the more protean

transcultural exchange of ideas expressed by Western Orientalist painters, designers, and musicians, many of whom were sincere in their search for new and hybrid forms from Islam that reinvigorated European art.

— *Kieron Devlin*

BIBLIOGRAPHY

Blair, Sheila S., and Jonathan M. Bloom. *The Art and Architecture of Islam, 1200–1800.* New Haven: Yale University Press, 1994.

Blair, Sheila S., and Jonathan M. Bloom. *Islamic Arts.* London: Phaidon, 1997.

Daniel, Marc. "Arab Civilization and Male Love." *Gay Roots: 20 Years of Gay Sunshine: An Anthology of Gay History, Politics, Sex and Culture.* Winston Leyland, ed. San Francisco: Gay Sunshine Press, 1991. 33–75.

El-Said, Issam. *Geometric Concepts in Islamic Art.* London: World of Islam Festival Publication, 1976.

Irwin, Robert. *Islamic Art in Context: Art, Architecture and the Literary World.* New York: Harry N. Abrams, 1997.

MacKenzie, John M. *Orientalism: History, Theory, and the Arts.* Manchester, England: Manchester University Press, 1995.

Murray, Stephen, with Will Roscoe. *Islamic Homosexualities: Culture, History and Literature.* New York: New York University Press, 1997.

Rice, David Talbot. *Islamic Art.* London: Thames and Hudson, 1975.

Saslow, James M. *Pictures and Passions: A History of Homosexuality in the Visual Arts.* New York: Viking, 1999.

Simpson, Marianna Shreve. *Sultan Ibrahim Miraza's Haft Awrang.* New Haven: Yale University Press, 1997.

Savory, Roger. *Iran under the Safavids.* Cambridge: Cambridge University Press, 1980.

Welch, Anthony. *Shah Abbas and the Arts of Isfahan.* New York: The Asia Society, 1973.

SEE ALSO

Indian Art

Israel, Franklin D. (1945–1996)

ONE OF THE MOST EXTRAVAGANTLY GIFTED ARCHITECTS of his generation, Franklin D. Israel imbibed the influence of the great modernists but developed his own distinctive vision that translated the urban experience into physical form.

Israel was born in New York in 1945 and grew up in New Jersey. He studied architecture at the University of Pennsylvania, Yale University, and Columbia University, where he received his Master of Architecture degree in 1971.

After traveling to Italy as winner of the Rome Prize in Architecture and working on the East Coast, Israel moved to Los Angeles in 1979. He taught at the School of Architecture at the University of California at Los Angeles and designed sets for Paramount movies such as *Star Trek: The Motion Picture* (1979) and *Night Games* (1979).

Israel went on to design private houses for a number of prominent gay and straight Hollywood figures and offices for independent film production companies. One of the "Santa Monica" architects, he died on June 10, 1996, aged 50, of AIDS-related complications.

Israel was open to various approaches to design and aware of the urban traditions to be found in Los Angeles, New York, and Rome. Influenced by great modernists such as Rudolf Schindler and Frank Lloyd Wright and inspired by California's free-form, vernacular buildings, he used fragmented forms that echo both the shifting, unstable landscape and the fractured texture of the cityscape.

Israel believed in additive design and he frequently juxtaposed innovative structures with existing buildings. By the time he died, his work commented on and contributed to the creative and heterogeneous culture of Los Angeles.

Israel was responsible for the headquarters of Propaganda Films (1988), Limelight Productions (1991), and Virgin Records (1991), as well as the Art Pavilion in Beverly Hills (1991) and the Fine Arts Facility at the University of California at Riverside (1994). Among the private homes he designed were those of Robert Altman, Joel Grey, and Howard Goldberg and his partner Jim Bean.

The Goldberg-Bean residence (1991) was designed as a series of pavilions linked by a long, blue curvilinear wall. The corridor functions like an urban street, offering unexpected views and experiences. Each of the pavilions faces toward a specific view of downtown Los Angeles, Hollywood, or Santa Monica. Seeking to bridge the gaps in scale between hallway, individual building, and urban context, Israel designed "cities within," interior spaces with variety, color, and surprise.

Inspired by the anxieties and tensions of contemporary life, Israel created work that is bold and edgy, beautiful and challenging, abstract and inventive. He translated the urban experience, including a loss of equilibrium, into physical form.

Israel also used basic materials in imaginative ways. For example, in the Goldberg-Bean residence he placed lead-coated copper panels near mustard-yellow pigmented stucco and juxtaposed fir plywood with redwood battens against concrete-block walls.

Israel's 1996 retrospective exhibit at the Los Angeles Museum of Contemporary Art served as a guide to his body of work. The sculptural environment he designed for the exhibit created ambiguities between wall and ceiling, scale and function, flat and folded, myth and reality. Mirroring both the chaos of the city and its pockets for repose, simple forms collided with each other, opening up new spaces to be explored.

Once diagnosed with HIV, Israel worked hard to be imaginative and distinctive. He took greater risks in the profession and began educating people about living with AIDS. He was survived by his longtime companion, Thomas Haase.

Israel attributed some of his imaginative freedom and openness as a designer to his experience as a gay man. His life and work, the subject of several books and articles, remain provocative and a source of inspiration for other architects.

— *Ira Tattelman*

BIBLIOGRAPHY

Betsky, Aaron. *Drager House.* New York: Phaidon Press, 1996.

Gehry, Frank. *Franklin D. Israel: Buildings + Projects.* New York: Rizzoli, 1992.

Glaser, Garret. "Designs of a Decade." *The Advocate* 711 (July 9, 1996): 51–53.

Koshalek, Richard. "Appreciation." *Los Angeles Times,* June 14, 1996.

Out of Order: Franklin D. Israel. Los Angeles: Museum of Contemporary Art, 1996.

Toy, Maggie. *Frank Israel.* London: Academy Editions, 1994.

SEE ALSO

Architecture

Japanese Art

JAPANESE CULTURE BOTH NOW AND HISTORICALLY HAS been replete with images that, although not obviously homosexual, can be given queer readings, as well as a wide range of representations that contemporary viewers would understand to be homosexual.

Prehistoric and Folk Art

Pottery Haniwa figures from Japan's prehistoric period portray male figures with their erect penises clearly displayed, as well as pottery phalli. Intriguingly, many of these images display wear marks that suggest they were rubbed over a long period of time, probably in the hope that they would confer fertility or increased sexual stamina, but the homoerotic potential of fondling these images, too, cannot be overlooked.

Japanese folk religion has long been concerned with fertility, and even today there are shrines in the countryside that contain ancient stone phalli as well as enormous phalli carved out of single tree trunks. These phalli show great attention to detail and at festival time are paraded around the village by men dressed only in loincloths.

The homoeroticism of these events has not been lost on present-day Japanese gay men, and Japan's main "naked festivals" (*hadaka matsuri*) are advertised and reported upon in Japan's gay press; furthermore, festival scenes and props feature in some contemporary gay video pornography.

Religious Art

Further homoerotic images, this time of beautiful temple acolytes, date from the Heian (794–1185) and Kamakura (1185–1333) periods, when Japan was under pervasive Buddhist influence. At this time, Buddhist monasteries had become renowned as sites for homosexual love in which an older priest (*nenja*) would establish bonds of friendship and love with a child acolyte (*chigo*).

The representation of youthful male figures as repositories of ideal beauty was facilitated by Buddhist and Shinto myths that taught that women, because of their menstrual cycle, were "defiling" and therefore dangerous to male spiritual practitioners.

In religious painting, the beautiful youth became a central figure, and key religious heroes from the Buddhist pantheon were depicted as beautiful boys. These included Kobo Daishi, founder of the Shingon School (in 806), who reputedly introduced boy love from China; and Monjushiri, the *bodhisattva* of wisdom, who later became patron saint of male–male love because of the resemblance of the latter part of his name to the Japanese word for "ass" (*shiri*).

These religious images, in which the youths are depicted with white, powdered moon-like faces, long hair, and dressed in colorful silk, hint at homoeroticism.

It is not until the fourteenth century that we have images depicting unambiguous homosexual interaction. One famous scroll, dated to 1321, is known as the

Chigo no soshi or "*Chigo* notebook" and concerns the relationship between an old abbot and his young acolyte.

Because of his advanced age, the abbot was unable to attain a firm erection and consequently could not penetrate his young lover. Such was the acolyte's devotion, however, that he employed a servant to loosen his anus with unguents and a large dildo in preparation for his nightly visits to the abbot's chambers. The servant's own evident arousal as well as the erection of the youth are clearly portrayed in the scroll.

Unfortunately, we do not possess any pictorial or narrative evidence from Japanese Buddhist nunneries that might suggest the development of a parallel genre of female homoeroticism.

The Tokugawa Period to World War II

If explicitly homosexual themes first entered Japanese art via Buddhist monasteries, it was in the worldly and sophisticated culture of the towns that these images were most fully elaborated. During the Tokugawa period (1603–1867), castle towns were erected throughout Japan and their samurai occupants, many of whom had been educated in Buddhist monasteries during their youth, carried on the transgenerational homosexual practices characteristic of these establishments.

At this time, adult male samurai could establish bonds with young boys of samurai descent who had not yet gone through their coming-of-age ceremony. Known as *wakashudo* or "the way of youths," these transgenerational homosexual relationships were subject to a strict code of etiquette and celebrated in works of art and fiction, the most famous being Ihara Saikaku's *Great Mirror of Male Love* (1687).

The towns also supported large numbers of kabuki actors who, since women were banned from the stage, played both male and female roles. Both male players of female roles (*onnagata*) and the players of youthful male roles (*wakashu*) were available as passive sexual partners for adult men who could afford their services.

Popular at this time were kabuki guidebooks that contained pictures of the actors and praised their beauty, skill, and grace, hinting at the postperformance favors that they also excelled in; some offered not only pictures of the actors' faces but also of their erect penises.

The development of woodblock printing made single-sheet posters of these actors available even to men and women (for they were also available for hire to female patrons) of humble means. Saikaku's *Great Mirror* describes an elderly priest's hermitage in which every inch of the walls has been covered by these early versions of pinup idols.

Most woodblock artists produced erotic prints known as *shunga* ("spring pictures"), and many of them depict homosexual relations between both men and women. Sometimes, an adult male is depicted in a sexual tryst with both a youth and a woman and sometimes with an *onnagata*, or man dressed as a woman, but the adult male is always depicted as the penetrative partner.

Women are sometimes depicted pleasuring themselves with a dildo or pleasuring both themselves and their female partner with a double-headed dildo. But, since the large majority of woodblock artists were male and their anticipated audience was also largely male, it is difficult to read these images as expressions of lesbian desire. There do not seem to be any representations dating from this time that depict women as partners for women outside this economy of male desire.

During the Meiji period (1868–1912) Japan turned toward the West in an effort to modernize. This meant that aspects of Japanese culture deemed "uncivilized" by the censorious Victorian gaze had to be disposed of. Sexually explicit art in general and homosexual representations in particular went underground. Even the phallic stones that had guarded shrine entrances for generations were hidden away or, in many cases, destroyed.

However, this prudish period in Japanese history, which lasted until Japan's defeat in World War II, encouraged a number of artists to address sexual topics in a more self-consciously political manner. These included the artists of the MAVO group, who in the 1920s played with gender identity in both their art and their lives, sometimes appearing cross-dressed.

Cross-dressing as a shock tactic has also been taken up by the contemporary artist Yasumasa Morimura, who often plays with cross-dressed images of himself in his work.

Post–World War II Art

It is not until after World War II that art which might be understood as "gay" in the Western sense developed. At this time, a boom in publishing took place and a number of erotic titles became available. Known as *hentai zasshi* (or "perverse magazines"), they featured lurid tales and illustrations of a wide range of paraphilias including bestiality, pedophilia, bondage, and both male and female homosexuality.

One such magazine, *Fuzoku kitan* ("Strange Stories of the Sex World"), featured the work of Go Mishima (1921–1989), who drew pictures of naked, sexually aroused men in a variety of bondage/discipline sado-masochistic situations and whose work has been exhibited in New York and published in the American S/M magazine *Drummer*.

Mishima (not to be confused with the author Yukio Mishima) went on to have a long career drawing for Japan's gay magazines, the first of which, *Barazoku* ("Rose Clan"), was published in 1971. Mishima drew images of men entirely unlike the feminine beautiful

boys of the earlier tradition, instead focusing upon rough macho types with short hair and tattoos.

This macho style reached its full development in the work of gay artist Gengoroh Tagame (b. 1964), whose sadomasochistic *manga* (or illustrated novels) have been serialized in a number of Japan's gay magazines, most recently *G-Men*. There is now an extensive genre of gay manga art created by self-identified gay men in Japan.

However, the most prolific illustrators of male homosexual love scenes are not men but women, and they appear not in the gay press but in manga aimed at a young female audience. It is women manga illustrators and not gay men who have inherited the tradition of depicting "beautiful boys" in homosexual situations.

Beginning in the early 1970s with artists such as Moto Hagio, the genre known as "boy love" (*shonen'ai*) soon established itself as a favorite with Japanese women and remains popular today.

A much less extensive and far less graphic genre of "girls' love" (*shojo ai*) has also developed, although the creators of these manga, like those of the boy love genre, do not engage in identity politics and would not consider their illustrations to be of "lesbian sex," which in Japan still invokes images of women–women scenes in mainstream male pornography.

The long tradition of depicting homosexual and, from a Western perspective, gender nonnormative acts and figures is still alive and well today in Japanese culture. The less politicized nature of sexuality, particularly homosexuality, in Japan has meant that these representations are less segregated than in the West and are enjoyed by a broader audience.

However, there have been complaints from Japan's growing number of gay rights activists that images of homosexuality in the media serve only to parody and distort real gay life.
— *Mark McLelland*

BIBLIOGRAPHY

Czaja, Michael. *Gods of Myth and Stone: Phallicism in Japanese Folk Religion.* New York and Tokyo: Weatherhill, 1974.

Faure, Bernard. *The Red Thread: Buddhist Approaches to Sexuality.* Princeton, N. J.: Princeton University Press, 1998.

Guth, Christine. "The Divine Boy in Japanese Art." *Monumenta Nipponica* 42.1 (1988): 1–23.

Leupp, Gary. *Male Colors: The Construction of Homosexuality in Tokugawa Japan.* Berkeley: University of California Press, 1995.

McLelland, Mark. *Male Homosexuality in Modern Japan: Cultural Myths and Social Realities.* Richmond, U. K.: Curzon Press, 2000.

Saikaku, Ihara. *The Great Mirror of Male Love.* Paul Gordon Schalow, trans. Stanford, Calif.: Stanford University Press, 1990.

Screech, Timon. *Sex and the Floating World: Erotic Images in Japan 1700–1820.* London: Reaktion Books, 1999.

Watanabe, Tsuneo, and Jun'ichi Iwata. *The Love of the Samurai: A Thousand Years of Japanese Homosexuality.* London: GMP, 1989.

Johns, Jasper (b. 1930)

KNOWN FOR HIS ICONIC YET CRYPTIC PAINTINGS, Jasper Johns is a key figure in the transition from modernism to postmodernism. He has created art with a level of detachment that runs counter to the egocentric position dearly held by the Abstract Expressionist painters one generation his senior, and helped to establish a philosophy in which the viewer rather than the artist is at the center of the creative process.

Johns was born on May 15, 1930, in Augusta, Georgia, and was raised by various relatives after his parents separated. He briefly attended college at the University of South Carolina, then moved to New York.

Johns was drafted into the United States Army in 1950. Following a tour of duty that included a six-month stay in Japan, where he developed an intense interest in Japanese art, he returned to New York and worked in a bookstore, unsure if he wanted to be a painter or a poet. After meeting painter Robert Rauschenberg, he decided to focus on painting.

The two young artists moved into the same building and saw and discussed each other's work on a daily basis. Together they created art based on recognizable images of the outside world rather than the self-expressive abstractions favored by the Abstract Expressionists. Johns created *Painting with Two Balls* (1960) as what seems to be a witty spoof of the overt macho posturing of the New York School.

Johns is best known for his paintings of easily recognizable images, such as the American flag, targets, or maps of the United States. Johns selected these subjects with great detachment, choosing things that he did not have to design himself. He has frequently stated that this mode of selection freed him to think of other aspects of the work, although he does not elaborate on what these other concerns might be.

His interest may be in the intricate surfaces he is able to create through the encaustic process. This ancient method of suspending pigment in wax allows Johns to create rich layered surfaces in which he includes a variety of collaged materials.

Johns also painted a series based on numbers using common, commercially available stencils. Stencil alphabet letters also appear in works such as *Tennyson* (1958), which has little to do with the literary figure except that his name appears stenciled across the bottom of the monochromatic gray canvas.

Although Rauschenberg was somewhat more established when they met, Johns was the partner who received the most attention for his work early on. Indeed, he became famous in the art world almost overnight, following a solo exhibition at the prestigious Leo Castelli Gallery in 1958; all the paintings exhibited in this show

were sold, including four that were purchased by the New York Museum of Modern Art. This disparity in success may have led to the painters' separation in 1961, but none of this is immediately evident in their art.

Through Rauschenberg, Johns met composer John Cage, whose interest in Zen Buddhism also had a great impact on the two. Johns designed sets and costumes and served as an artistic adviser to the dance company helmed by Cage's lover, Merce Cunningham. He collaborated with Cunningham and Cage on the ballet *Un Jour ou Deux* (1973).

The suppression of autobiography that binds the work of Johns, Rauschenberg, and Cage does not lend itself to the expression of explicit gay content. While Rauschenberg seems to have made bows to the initiated (by including images of gay icon Judy Garland, for instance), Johns has made only oblique references to gay poets Hart Crane and Frank O'Hara in his titles. His images have always remained enigmatic and grew increasingly puzzling during the 1970s and 1980s.

Johns's crosshatch paintings, such as *Weeping Women* (1975), are totally nonobjective compositions of repeated lines that seem to have been created though a Cage-inspired system randomly determining the overall design of the work.

The *Tantric Detail Series* (1980–1981) features a pair of testicles. This image does not seem particularly erotic, however, since it is paired with a skull and seems more appropriately grouped in the art historical tradition of the *vanitas,* which emphasizes the vanity and transience of all human endeavors when seen from the light of eternity. Such a reading of the image is consistent with the artist's concern in his later work both to catalog and deconstruct many art historical traditions.

Now in his seventies, Johns enjoys an honored place in the pantheon of American artists. Not only has he received numerous honors and accolades, but his paintings, which regularly sell for astounding sums, are eagerly sought by collectors and museums around the world.
— *Jeffery Byrd*

BIBLIOGRAPHY

Crichton, Michael. *Jasper Johns.* New York: Harry N. Abrams, 1977.

Katz, Jonathan. "The Art of Code: Jasper Johns and Robert Rauschenberg." *Significant Others: Creativity and Intimate Partnership.* Whitney Chadwick and Isabelle de Courtivron, eds. London: Thames and Hudson, 1993. 189–207.

Peterson, Andrea L. T. "Jasper Johns." *Gay & Lesbian Biography.* Michael J. Tyrkus, ed. Detroit: St. James Press, 1997. 252–253.

Rosenthal, Mark. *Jasper Johns: Work Since 1974.* London: Thames and Hudson, 1988.

SEE ALSO

Contemporary Art; American Art: Gay Male, 1900–1969; Pop Art; American Art: Gay Male, Post-Stonewall; Rauschenberg, Robert; Warhol, Andy

Johnson, Philip *(b. 1906)*

CONTROVERSIAL AND PROVOCATIVE, PHILIP JOHNSON has been a towering force in American architecture for many years. Known both for promoting the International Style in the United States and for helping to define postmodern architecture, he has had an uncanny ability to sense new trends and to adapt his style to those trends.

Philip Cortelyou Johnson was born into a wealthy family in Cleveland on July 8, 1906.

After graduating from Harvard with a B.A. in architectural history, he became the founding director of the Department of Architecture at the Museum of Modern Art in New York.

At the age of 26, he cocurated, with Henry Russell Hitchcock, the influential 1932 exhibit entitled International Style: Architecture since 1922. With this exhibit Hitchcock and Johnson effectively brought modern European architecture to America. Johnson also

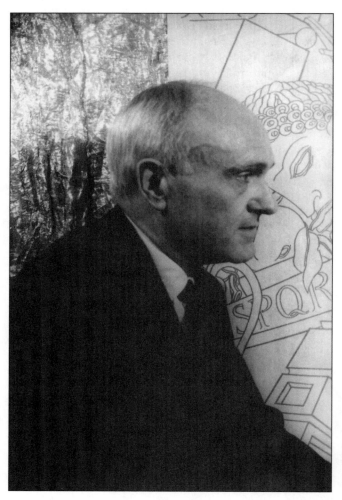

A portrait of Philip Johnson by Carl van Vechten.

used his own personal wealth to introduce Mies van der Rohe and Le Corbusier to the United States.

After a brief period of residence in Europe, during which he spoke admiringly of the Nazi movement (beliefs he later recanted), Johnson returned to the United States to attend Harvard's Graduate School of Design. At the age of 37, after having been an author, historian, museum director, curator, and critic, Johnson became an architect.

In 1949, he designed his own residence in New Canaan, Connecticut. It has since become one of the most famous houses in the world. Made with steel frame and glass, the see-though "Glass House" has an open plan, with a bath and fireplace in a brick cylinder.

In the 1950s, Johnson worked on a number of glass towers, as well as the Crystal Cathedral in Garden Grove, California, (completed in 1980) and, as an associate of van der Rohe, the Seagram Building in New York.

By the 1960s, however, he began to criticize the modernist aesthetic he had championed. With the State Theater at Lincoln Center and the New York State Pavilion at the New York World's Fair, Johnson's style became more eclectic.

When he became partners with John Burgee in 1967, he fully embraced postmodernism. Johnson and Burgee, whose partnership lasted until 1987, designed some of the nation's most visible high-rise projects in Boston,

Dallas, Denver, Houston, Minneapolis, Pittsburgh, and San Francisco. In 1984, his New York City AT&T Building with its Chippendale top became the most talked about building of the year.

Johnson's projects since then have been smaller and more personal. He curated a show on Deconstruction in 1988 and, later, added a visitor's pavilion to his New Canaan estate. This latest addition, built in 1995, is an abstract and disorienting structure painted red and black. Made by spraying concrete onto a metal framework, this new entry hall with gift shop will introduce visitors to Johnson's long and controversial career when the estate (donated to the National Trust for Historic Preservation) opens to the public after his death.

While never completely hiding his long-term relationship with curator David Whitney, which began in 1960, Johnson did not publicly come out as gay until 1994, when his biography by Franz Schulze was released.

Not long afterward, he was asked to design a new sanctuary for the Dallas branch of the Universal Fellowship of Metropolitan Community Churches (MCC), the nation's largest predominantly gay and lesbian religious denomination. Johnson's Cathedral of Hope, still unbuilt because of a lack of funds, is a 2,000-seat sanctuary with an altar under a ceiling that rises more than 100 feet. The design has no parallel lines; the walls twist, tilt, and bend into ceilings and floors.

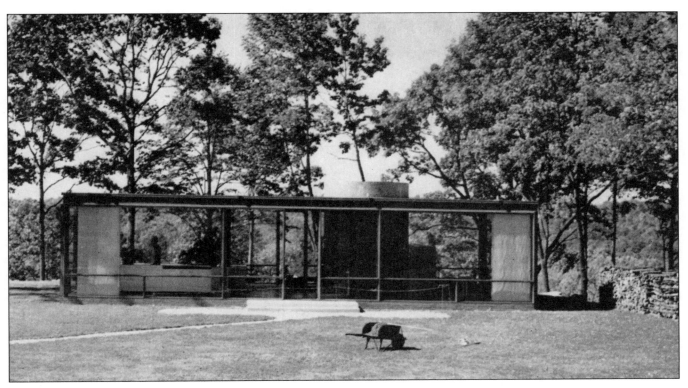

Philip Johnson's "Glass House" in New Canaan, Connecticut.

Monumental, unconventional, and ever changing, the proposed building will be a symbol of strength, hope, and unity. As Herbert Muschamp observed in reaction to the design, "It ministers not only, or even primarily, to the needs of gay people for self-acceptance. It ministers to society's need for self-acceptance; for the wisdom to perceive that gay men and lesbians are integral to society, not alien from it."

Although now in semiretirement, Johnson remains a dominating force in American architecture and a helpful influence and mentor to many younger architects.

Provocative and unpredictable, Johnson has had a chameleon-like career, often reinventing himself, changing architectural allegiances, and not following any particular style. "Whoever commissions buildings buys me. I'm for sale," he once quipped. Although he has been accused of being more interested in style than substance, Johnson has always shown intelligence and enthusiasm.

He received the American Institute of Architects (AIA) 25-Year Award (1975), the AIA Gold Medal (1978), and the first Pritzker Architecture Prize (1979).

— *Ira Tattelman*

BIBLIOGRAPHY

Cook, John W., and Heinrich Klotz. *Conversations with Architects.* New York: Praeger, 1973.

Muschamp, Herbert. "A Building That Echoes A Protean Journey." *The New York Times,* July 7, 1996.

Kipnis, Jeffrey, et al., eds. *Philip Johnson: Recent Work.* London: Academy Editions, 1996.

Knight, Carleton, et al., eds. *Philip Johnson/John Burgee: Architecture 1979–1985.* New York: Rizzoli, 1985.

Schulze, Franz. *Philip Johnson: Life & Work.* New York: Alfred A. Knopf, 1994.

SEE ALSO

Architecture

k

Kahlo, Frida *(1907–1954)*

BISEXUAL MEXICAN ARTIST FRIDA KAHLO HAS BECOME
an international icon for the power and intensity of her
art, and the extraordinary suffering that she experienced
in life.

Born in Mexico on July 6, 1907, to a German photogra-
pher and his Mexican second wife, Kahlo became a central
figure in revolutionary Mexican politics and twentieth-
century art. When childhood polio damaged one leg, the
six year-old's reaction was to become an athlete, an early
indication of her courage and independence.

In 1925, at the age of eighteen, Kahlo suffered appalling
injuries in a streetcar accident, when she was impaled by
an iron handrail smashing through her pelvis. Multiple
fractures to her spine, foot, and pelvic bones meant that
the rest of her life was dominated by a struggle against
severe pain and disability; she underwent thirty-two oper-
ations in thirty years. She died at the age of 47 on July
13, 1954, possibly a suicide.

Following her accident Kahlo started painting,
becoming an important Surrealist. Her paintings, mostly
self-portraits, employ the iconography of ancient
Mesoamerican cultures to depict both her physical suf-
fering and her passion for Mexican politics and for the
love of her life, Diego Rivera, whom she married in 1929.

A famous painter of heroic revolutionary murals,
Rivera was much older than Kahlo and incapable of
sexual fidelity. When he began an affair with her sister,
Kahlo left Mexico. However, she forgave him this and

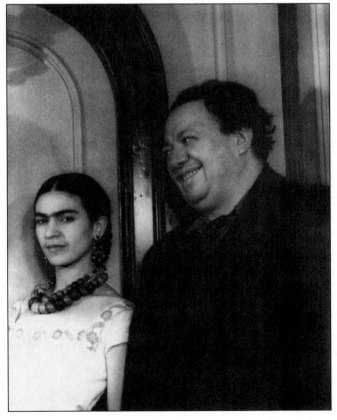

A portrait of Frida Kahlo and Diego Rivera by Carl van Vechten.

other infidelities. She divorced Rivera in 1940, but remarried him later the same year.

Both artists had numerous affairs. Among Kahlo's lovers were Leon Trotsky and other men, but also several women. Available evidence suggests that her male lovers were more important to Kahlo than her lesbian affairs. Her friend Lucienne Bloch recalled Rivera saying, "You know that Frida is a homosexual, don't you?" But the complexity of the artists' marriage warns against taking this statement at face value.

However, Kahlo's queer significance is greater than her few lesbian liaisons suggest, or even her representations of women, some of which are homoerotic. She was a masterly and magical exponent of cross-dressing, deliberately using male "drag" to project power and independence. A family photograph from 1926 shows her in full male attire, confronting the camera with a gaze best described as cocksure. So soon after her accident, this cockiness must have concealed unimaginable pain.

Clothes were extremely important to Kahlo. Although she was much more comfortable in slacks, she adopted ornate Mexican costumes on visits abroad and when at home with Rivera. Her "exotic" beauty was much admired; she was photographed by most of the leading art photographers of the time; and her visit to Paris led to the creation of the "Robe Madame Rivera," an haute couture version of her famous peasant costume.

If Kahlo used dress to make a nationalist political point, she also used it to make a statement about her own independence from feminine norms. Several photographic studies show her in men's clothing, and in one

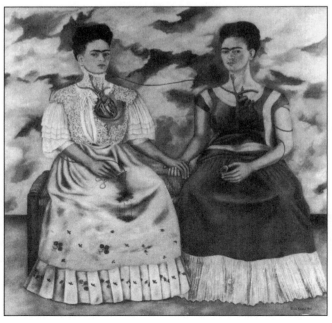

The Two Fridas by Frida Kahlo.

famous self-portrait she sits, shaven-headed, wearing a man's suit, surrounded by discarded tresses.

Heterosexual Freudian Laura Mulvey interprets this as mourning the wounded, castrated female body. A more positive feminist or queer reading recognizes the use of "butch drag" throughout her work to signify strength and independence.

Kahlo was troubling gender long before "lesbian boys" were invented.

Julie Taymor's recent film, *Frida* (2002), starring Salma Hayek as the artist, promises to enshrine Kahlo in the popular imagination as a bisexual icon.

— *Tamsin Wilton*

BIBLIOGRAPHY

Herrera, Hayden. *Frida: A Biography of Frida Kahlo.* New York: Harper & Row, 1983.

Poniatowska, Elena, and Carla Stellweg. *Frida Kahlo: The Camera Seduced.* London: Chatto & Windus, 1992.

Mulvey, Laura. *Visual and Other Pleasures.* London: Macmillan, 1989.

Zamora, Martha. *Frida Kahlo: The Brush of Anguish.* San Francisco: Chronicle Books, 1990.

SEE ALSO

Latin American Art; Surrealism; Subjects of the Visual Arts: Nude Females; Zenil, Nahum B.

Khakhar, Bhupen (1934–2003)

CONTEMPORARY INDIAN ARTIST BHUPEN KHAKHAR earned an international reputation for paintings that are explicitly homosexual in theme, but that also address universal human needs. They are rooted in traditional Indian art, but are startlingly original.

Born in 1934 in Bombay, the self-trained painter lived and worked in Baroda, India. To satisfy the expectations of his family and other members of the middle class, Khakhar initially trained as an accountant. But he had always wanted to become a painter, so he decided to pursue his love for art when he was in his late twenties. As a consequence, he moved to the university town of Baroda in 1962 and completed a degree in art criticism.

Although inspired by traditional Indian painting styles, Khakhar's visual language is completely original. Initially a painter of complex, finely detailed, brightly colored scenes of everyday life, he began painting works with blatant homosexual themes during the 1980s. This type of "coming out" was unprecedented in Indian culture; although many Indians are homosexuals, same-sex themes are exceedingly rare in modern Indian art.

Khakhar frequently painted men nude with erect penises. They touch one another and gaze lovingly into each other's eyes. In the work entitled *Two Men in Benares* (1985), for example, two standing, life-size, nude men hug one another in the left third of the composition. Vignettes of everyday life fill the remaining two-thirds of the canvas.

While a wall separates the upper half of the two men from these scenes, the area that surrounds them from the waist down bleeds into the vignettes. Although partially separated from the scenes, then, the two men are also integrated into them.

Khakhar frequently created secondary spaces in his paintings that are filled with scenes of daily life. This compositional strategy broadens the interpretation of his works. For example, the vignettes in *Two Men in Benares* encourage the viewer to interpret the work as a visual statement about the life experiences of homosexuals in India.

Khakhar used a narrow band of everyday scenes, this time at the top of the canvas, to make the fantastic primary theme of his painting *Yayati* (1987) seem more realistic. According to a myth taken from *The Mahabharata*, the king Yayati, through a curse, began to age prematurely before he had satisfied his sexual appetite. Puru, his youngest son, agreed to exchange his youth for his father's age.

In Khakhar's painted interpretation, this exchange occurs through penis-to-penis contact. Yayati, with white wings, an erect penis, and jewel-toned purple and green skin, hovers prone over Puru, who holds his penis in his right hand. The background, a radiant, seemingly undulating pink, serves to create a plausible alternate reality. The everyday scenes at the top of the canvas heighten this impression as trees grow from, and people walk around in, the pink area.

Although Khakhar experienced prejudice and violence as a result of his sexual preferences, his paintings do not function as protests. Saturated with jewel-toned colors, decorated with gorgeous landscapes, and peopled with a variety of human figures coexisting in harmony, they are celebrations of love and contentment.

Many of the figures in his works gaze into each other's eyes with mutual love, understanding, and desire. Although homosexual in theme, Khakhar's works address universal human needs such as physical closeness, interaction, and pleasure.

Khakhar died on August 8, 2003, in Baroda, India, aged 69.

— *Joyce M. Youmans*

BIBLIOGRAPHY

Hyman, Timothy. *Bhupen Khakhar*. Bombay: Chemould Publications and Arts, 1998.

————. "The Baroda School and Bhupen Khakhar: New Figuration in India." *Art International* 10 (Spring 1990): 60–64.

Sjoman, N. E. "Oriental Pink Lime, the Art of Bhupen Khakar." *Border Crossings* 17 (Winter 1998): 40–43.

SEE ALSO

Indian Art

Klumpke, Anna Elizabeth (1856–1912)

AMERICAN-BORN ARTIST ANNA ELIZABETH KLUMPKE is best known today as the last lover of acclaimed French painter Rosa Bonheur, but she was an accomplished artist in her own right.

Klumpke was born on October 28, 1856, in San Francisco, where she demonstrated a gift for drawing as a young child. Her parents separated and moved their children to Paris when Anna was fifteen.

Her art education began in earnest when she enrolled in the Académie Julian in 1883. She debuted in the Paris Salon a year later. Her continuing acceptance in that important exhibition, numerous prizes, and the high praise her work received on both sides of the Atlantic ensured that influential people learned of her work.

Klumpke first met Rosa Bonheur (1828–1899) on October 15, 1889. This, the thirty-third year of Klumpke's life, was of major importance for her in many other ways. In addition to exhibiting in the Salon, one of her paintings received the bronze medal at the Universal Exposition in Paris, and she painted one of her best-known portraits, that of American suffragist Elizabeth Cady Stanton. She also became the first woman to win the Temple gold medal at the Pennsylvania Academy of Fine Arts.

Klumpke's artistic success led her to Boston in 1891, where she exhibited and developed a successful business as a portraitist and teacher. She secured a solo exhibition in the city during the following year.

In 1897 she wrote to Rosa Bonheur asking permission to paint her portrait. The two women met for the second time on June 16, 1898.

Klumpke was forty-three; her mentor, seventy-seven. While Klumpke worked on her first portrait of Bonheur, the two women became close friends.

One month later, Bonheur asked Klumpke to join her in a personal and professional partnership, for which a formal agreement was signed in August 1898. Bonheur also changed her will and made Klumpke her sole heir. Nine months later, on May 25, 1899, Rosa Bonheur died.

Klumpke painted three important portraits of Bonheur. The first, from 1898, depicted the artist at an easel wearing the men's clothes for which she had secured a license

from the French government. The second portrait, from 1899, depicted Bonheur seated, holding her dog on her lap. Klumpke kept the third portrait of Bonheur, painted posthumously in 1902, for the Musée de l'Atelier de Rosa Bonheur, which she established at By, near Fontainebleau, in 1904.

After Bonheur's death, Klumpke devoted herself to researching the biography Bonheur had asked her to write. It was published in 1908.

Klumpke continued to paint and exhibit her works in both Paris and the United States, but in 1914 she established l'Hôpital de Rosa Bonheur at By, where she nursed wounded soldiers until World War I ended in 1918. Sometime later, she established the Rosa Bonheur Memorial Art School for Women Painters and Sculptors at By and continued to exhibit both her work as well as Bonheur's on both continents.

Klumpke was awarded the Legion of Honor by the French government in 1936. During the 1930s, she returned to San Francisco, where she painted landscapes and portraits. She died in 1942 at the age of 86.

By choosing a career over marriage and opting for a committed relationship with another woman, Klumpke violated every late-Victorian expectation of women. Her artistic work left a visual record of her life and times, including the brief time she loved and lived with Rosa Bonheur, one of the most famous French artists of the nineteenth century.

— *Ray Anne Lockard*

BIBLIOGRAPHY

Dwyer, Britta C. *Anna Klumpke: A Turn of the Century Painter and Her World.* Boston: Northeastern University Press, 1999.

———. "Rosa Bonheur and Her Companion-Artist: What Made Anna Klumpke Special?" *Rosa Bonheur: All Nature's Children.* New York: Dahesh Museum, 1998. 63–78.

Klumpke, Anna Elizabeth. *Memoirs of an Artist.* Lilian Whiting, ed. Boston: Wright & Potter, 1940.

———. *Rosa Bonheur: The Artist's (Auto)biography.* Gretchen Van Slyck, trans. Ann Arbor: University of Michigan Press, 1997. [A translation of Klumpke's *Rosa Bonheur; sa vie, son oeuvre.* Paris: Flammarion, 1908.]

SEE ALSO

American Art: Lesbian, Nineteenth Century; European Art: Nineteenth Century; Bonheur, Rosa

Latin American Art

Many Latin Americans consider homosexual behavior to be deviant and, therefore, harass and attempt to oppress the gay community. Consequently, gay and lesbian Latin American artists frequently use their artworks to portray their desire for sexual and political liberation. Often they combine traditional subject matter with personal insights to stress their desire for acceptance by their communities.

Another crucial context in which homosexual art must be placed is that of Latin American *machismo*. The polarized gender differentiation that prevails in many Latin American societies has contributed to the oppression of homosexuals and limited their expression in the arts.

Given a social climate intolerant of homosexual expression, it is not surprising that interpreting homosexuality in Latin American art is problematic. More often than not, sexuality in Latin American art is presented covertly rather than overtly. As James Saslow has observed, from Mexico to Argentina, "visible expression of homosexuality is handicapped by social attitudes."

Thus, artists wishing to give expression to homosexual themes are obliged to be more constrained than their European and North American counterparts.

Rudi Bleys approaches Latin American art via "homotextuality," which implies the necessity of "reading" artworks according to their sociopolitical contexts. This approach, he says, "allows for cross cultural comparison without falling into the trap of Eurocentric conceptual-ization." It allows consideration of the work of artists who did not identify as homosexuals, but whose work nevertheless somehow conveys homoeroticism.

Mexican Artists

Mexico's rich traditions of folk culture, arts and crafts, and its sometimes tragic history have yielded a fascinating legacy on which modern art has built. Significantly, the attempt to capture a national identity in murals and other art forms, often depicting indigenous peoples, has sometimes resulted in more than a tinge of homoeroticism.

The works of Alberto Fuster (1870–1922), Angel Zárraga (1886–1946), Saturnino Herrán (1887–1918), and José Clemente Orozco (1883–1949), for example, all indicate a subtle appreciation of ambiguous sexuality in their human figures. Orozco's male nudes, never entirely free from erotic overtones, even became the symbols of national identity and of the trend toward *indigenismo*—the use of authentic local culture.

Frida Kahlo

Mexican artist Frida Kahlo (1907–1954) has achieved iconic status for feminists. While the great love of her life was artist Diego Rivera, whom she married in 1929, she also had affairs with other men and women. Her paintings, mostly visually startling, quasi-Surrealist self-portraits, employ the iconography of ancient Mesoamerican cultures.

This she combined with idiosyncratic personal symbols to depict her intense physical suffering and to comment on the representation of women. She often depicts herself in masculine dress, using "butch drag" to suggest her independence and strength. Her hypnotic gaze has come to embody a kind of Mexican female spirit of fortitude.

Kahlo's painting *Duas desnudas en La Selva* (1939) is somewhat atypical of her work in that it suggests a relaxed lesbian eroticism. It depicts two nude women lying in front of a jungle. Embracing each other, they cross ethnic and social barriers to join in intimacy.

Roberto Montenegro

Homosexual artist Roberto Montenegro (1880–1968) felt constrained by his social milieu to refrain from painting overtly homosexual works. He did, however, make sly references to sexuality. The themes closest to his heart had to be coded into his paintings and murals. For example, his *El árbol de la vida* (1922) has a scantily clad figure with a highly androgynous appearance reminiscent of depictions of Saint Sebastian.

Montenegro was highly regarded for his eclectic approach and his ability to work in several media. His drawings of the great dancer Nijinsky (1919) for London publisher Cyril Beaumont exhibit a draftsman's skill equal to that of Aubrey Beardsley, whom he greatly admired.

Nahum B. Zenil

Nahum B. Zenil (b. 1947) is one of a handful of openly gay artists working in Mexico. He received his education at La Esmeralda and La Nacional de Maestros. His original, highly personal style first earned him fame in the 1980s. Today, he is one of Mexico's leading contemporary artists.

Among recurring themes in Zenil's works are his relations with his family (especially his mother), his past as a schoolteacher, his ambivalent feelings about Catholicism, and the realities of being a gay man in a conservative Latin culture. Since the 1970s, Zenil has focused on a single subject: himself. Almost all of the works he has produced in the last twenty years include at least one self-portrait.

Zenil uses himself in his art because, as a gay man in Mexico, he feels marginalized and, therefore, experiences a great sense of solitude. Through self-analysis in his work, he desires to fully accept himself and his lifestyle.

He sees art as a way to purge his mind of some of the pressures he felt growing up gay in a small Mexican town and, later, living in the relatively conservative society of the Mexican capital, where he never feels truly at ease with most of the people around him. He hopes his artwork effects communication between himself and other members of society.

Zenil's works discourage passive viewer interaction. Through painted images of himself, the artist fixes his gaze on those who attempt to penetrate his world; indeed, he seems to challenge and goad the viewer. To underscore the specificity the artist wishes to convey, he often inscribes the scenario represented in his works with his own handwriting. Overall, Zenil uses his art to remind viewers that he—no matter his ethnicity or sexual preference—is human just like them.

The mixed-media work *Esperar la hora que cambiará nuestra costumbre ne es fácil (Waiting for the Time When Our Customs Change Is Not Easy,* 1984) functions as a social commentary on Zenil's status as a gay man living in Mexico. The artist sits nude on a chair in a protective pose: he pulls his knees to his chest and crosses his arms over them.

Although he tries to safeguard himself, he is nevertheless vulnerable; his flaccid penis is visible between his ankles. The artist literally imprisons this picture of himself; knotted twine attached to the surrounding matte crisscrosses the image many times.

Two other mixed-media works from the 1980s directly address the oppression of gay men. *Dos Personajes (Two Persons,* 1984) shows Zenil and his longtime companion, Gerardo Vilchis, from the waist up dressed in suits. Rope tightly binds each of their bodies. Two strips of pink cloth, which match the men's ties, cover Vilchis's eyes and Zenil's mouth. *Suicides* (1987) again represents Zenil and Vilchis wearing suits. This time, a double noose is wrapped around their necks.

Zenil also depicts Vilchis in *Tengo una muñeca (I Have a Doll,* 1979). Vilchis is nude except for the woven *rebozo* (a shawl commonly worn by Latin American women) draped over his shoulders. He sits on a chair cradling a doll in his lap. The work's title refers to the doll, the sitter's penis, and the relationship between artist and sitter. Because in Mexico a "real" man must be dominant and macho, Zenil blatantly flouts national gender norms by eroticizing the penis.

Zenil has long been an ardent supporter of gay rights in Mexico. He plays a prominent role in the Círculo Cultural Gay, an organization active since the early 1980s. Although there are few direct references to the wider issue of lesbian and gay rights in Zenil's art, an exception is *En el Zócalo frente al Palacio Nacional (In the Zócalo in Front of the National Palace,* 1992). In this work, the artist represents himself many times holding various banners with slogans such as "Respect for Human Rights," "Peace," and "Love."

Religious subject matter often appears in Zenil's art. The Virgin of Guadalupe maintains pride of place in the artist's symbolic vocabulary. She often appears above Zenil and Vilchis, blessing their union or casting a protective aura over them. In *Virgen de Guadalupe (Virgin of Guadalupe,* 1984), for example, an apparition of the Virgin appears above the two men, who are in bed.

Julio Galán

Although he emerged from a more privileged background than that of Zenil, Julio Galán (b. 1959) has also made a mark among contemporary Mexican artists. He painted himself seminude, as a young boy, as a witch doctor, or with Aztec headdresses, adding a tone of Baroque kitsch that has become his trademark. This style is melodramatic and might be called high camp.

Galán shares with many Mexican artists an obsession with self-portraits, ambivalence, and doubling. His personal symbolism, which mixes religious elements with cinematic ones, is frequently cryptic, much like that of Kahlo. He is known especially for his critiques of the social construction of gender in such works as *Donde ya no hay sexo* (1985), which depicts the artist as having an ambiguous sexuality, and *Niños con muchos huevos* (1988), which shows two boys kissing.

Roberto Márquez

Roberto Márquez (b. 1958) is noted for his smooth, polished style. He has made a name for himself with dreamlike, revealing self-portraits and contemplative, humanistic nudes of both sexes. His mood-filled paintings are highly accessible and easy to assimilate, but contain disturbing elements that question gender and other boundaries in the manner of Julio Galán. For example, one of Márquez's portraits shows himself as Christ with stigmata, thus appropriating religious iconography and suggesting his own identification with Christ.

Carla Rippey

Although born in Kansas, Carla Rippey (b. 1950) has made Mexico her home. She is one of the few creators of specifically lesbian art in Latin America. Some of her paintings, especially her sensitive female nudes, bravely explore such themes as female narcissism. Bleys describes her painting *Quisiera ser como tú* (1989) as "inscribed with a lesbian *imaginaire*."

Other openly homosexual artists in Mexico include Manuel Rodríguez Lozano (1896–1971), who illustrated Federico García Lorca's poem *Oda a Walt Whitman. El Pensador* (1936), and the brothers Emilio Baz Viaud (1918–1991) and Ben Hur Baz Viaud (b. 1906), who are best known for their portraits. Among lesbian artists must be included Elena Villaseñor (b. 1974), whose work has an erotic flavor; and Patricia Torres (b. 1963), who depicts lesbian sexuality using cartoon imagery and monochromatic surfaces.

Argentina

Although she worked mainly in Paris and was directly connected to the Surrealists, Argentine-born Léonor Fini (1908–1996) resisted labels of all kinds. She set out to be a new type of completely autonomous woman. Although she was largely self-taught, she was brought up in Trieste and thus exposed directly to European influences, and was influenced by artists such as Aubrey Beardsley.

Fini's work is finely crafted and dreamlike, containing recurring imagery such as rotting vegetables, masks, drapery, and provocative nymphets. In this sense her paintings have the flavor of the visionary work of the Symbolists, though she is often categorized as a Surrealist.

According to Emmanuel Cooper, Fini's work has a "cruel kindness." A fine example of this quality is her painting *Le long du chemin* (1966), which depicts two women, one of whom is about to disrobe the other while she is reclining passively in a trance. The atmosphere is charged with sexual tension.

Chile

Chilean Alvaro Guevara (1894–1957) came to England in the 1920s and found himself closely allied with Duncan Grant's Bloomsbury circle and Roger Fry's Omega workshop artists. Guevara's tall, handsome demeanor attracted many people of both sexes. Though he was not open about his male lovers, he often painted male nudes in a style similar to that of Grant and other modernists.

Colombia

Another Latin American artist who was influenced by English and European art was Luis Caballero (1949–1995), who was born in Colombia. Caballero, like many in South America, was an ardent admirer of English neofigurative painter Francis Bacon. His skilled draftsmanship reveals the influence of Spanish painting.

The prime subject of Caballero's work is the nude male body, in various contorted, ecstatic, reclining poses. His declared aim was "to show but not to relate." Some of his larger works have a Romantic excess worthy of Géricault. This excess was subsequently toned down, yet there remained in his figures an unusual force and energy. He once declared that they were painted "with semen, not turpentine."

Brazil

As in Mexico, in Brazil muralism was valued as a public art. Most muralists conveyed a nationalist, socialist, antibourgeois sentiment in their murals.

Such was the case with Candido Portinari (1903–1962), yet he also painted laborers with a decidedly sensual feel. Little is known of the artist's sexual interests, yet his work is decidedly homoerotic. His *O Mestizo* (1934), for example, portrays the rich brown flesh tones and full lips of his local model.

Likewise, nothing can be gathered about the sexual orientation of Hugo Adami (b. 1900), but his painting *O Fugitivo* (1934) dwells lovingly on the perspiring flesh of a reclining black male.

Hélio Oiticic

In Brazil evolved a Neo-Concretism that paralleled the conceptual art movement in Europe and the United States. Hélio Oiticica (1937–1980) was influenced by the abstract work of Russian painter Kasimir Malevich and signed the Neo-Concretists' manifesto in 1959. He traveled to England, but settled in New York.

He became a master of samba and created works that viewers had to experience physically, such as his *penetráveis*, suspended fabrics that revealed spatial relationships and encouraged spectator awareness. He created *bolides* (fireballs/nuclei) composed of rocks, crystals, and soil in glass boxes. His use of inexpensive materials anticipated the "povera" movement in Italy.

He also created *paragoles* (relating to the joy of putting on clothes). These *paragoles,* which looked like body wraps, were designed in order to play with the boundaries of form and content and often provoked new modes of thinking about how clothes signal the gender of the wearer.

Other significant Brazilian artists in whose work there is significant gay content include Darcy Penteado (1926–1987), a book illustrator, fashion designer, and society portraitist, who devoted himself to the gay cause. Glauco Rodriguez (b. 1929), Geraldo Porto (b. 1950), and Edilson Viriato (b. 1966) have also created work with a gay sensibility.

Conclusion

Over the past few decades, interest in Latin American art has increased dramatically. Critics have attempted to assess the artistic impact of multiple social realities, including especially the potent African influence as filtered through Catholic culture.

While Latin American art was formerly alleged to be derivative or stereotyped as full of magic, mystery, and sensuality, it is now clear that Latin American art is in fact refreshingly diverse, highly personal, and very vibrant. The "hybrid" energy of this art is especially evident in the work of the gay, lesbian, and bisexual artists discussed above.

Notwithstanding advances in recent years, however, homosexuality remains almost invisible in many Latin American cultures. Artworks such as those discussed above lend much-needed insight into the social, political, and psychological lives of gay Latin Americans. One of the most powerful messages implicit in their work is the need to counteract the destructive impact of *machismo* and to embrace and celebrate diverse sexualities.

— *Joyce M. Youmans*
Kieron Devlin

BIBLIOGRAPHY

Barnitz, Jacqueline. *Twentieth Century Art of Latin America.* Austin: University of Texas Press, 2001.

Bleys, Rudi C. *Images of Ambiente: Homotextuality and Latin American Art,* 1810 to Today. New York: Continuum, 2000.

Chadwick, Whitney. *Women Artists and the Surrealist Movement.* Boston: Little, Brown, 1985.

Cooper, Emmanuel. *The Sexual Perspective: Homosexuality in Art of the Past 100 Years in the West.* London: Routledge & Kegan Paul, 1986.

Douglas, Eduardo de Jesús. "The Colonial Self: Homosexuality and Mestizaje in the Art of Nahum B. Zenil." *Art Journal* 57.3 (Fall 1998): 14–21.

Herrera, Hayden. *Frida Kahlo.* New York: Harper & Row, 1983.

Saslow, James M. *Pictures and Passions: A History of Homosexuality in the Visual Arts.* New York: Viking, 1999.

Scheldahl, Peter. "Hecho en Mexico." *Village Voice* 41.23 (June 4, 1996): 79.

Sullivan, Edward J. "Witness to the Self/Testigo del Ser." *Nahum B. Zenil: Witness to the Self.* San Francisco: The Mexican Museum, 1996.

SEE ALSO

Latina/Latino American Art; Surrealism; Symbolists; Bacon, Francis; Beardsley, Aubrey; Fini, Léonor; Géricault, Théodore; Grant, Duncan; Kahlo, Frida; Subjects of the Visual Arts: Nude Males; Subjects of the Visual Arts: St. Sebastian; Zenil, Nahum B.

Latina/Latino American Art

Latina and Latino art is an important component of a vital cultural tradition in the United States—the contributions of Americans of Hispanic ancestry, including émigrés, exiles, and those born in the United States. But the very diversity that characterizes the people who helped shape this tradition makes it difficult to generalize about them or the art that they have created. The umbrella terms Latina and Latino comprise a multiplicity of cultures, skin colors, immigration patterns, and even languages.

Not only are Americans of Hispanic descent too diverse to permit easy generalizations, but so is the art that they have produced, utilizing a multiplicity of media and styles. Nevertheless, a number of contexts have been very important to glbtq Latina/Latino American art.

These include urgent social realities such as poverty and discrimination, the power of church and family, and, above all, the legacy of *machismo*, a very polarized gender differentiation found in most Latin American cultures. These influences have helped shape the art created by American gay men and lesbians of Hispanic ancestry.

But perhaps most significant of all is the hybrid nature of Latina/Latino artists, who are heirs to a number of cultural traditions and conflicts. That is, these artists have often grown up in families in which the Latin American cultural traditions are paramount, but they

have also been exposed to European cultural traditions and to the dominant American society and its values, as well as to the inevitable clashes between these traditions. The result is a vital but often conflicted art with a vast range of expression.

For gay and lesbian artists, these clashes may be especially formative, given that Latin American attitudes toward sexuality in general, and homosexuality in particular, tend to be conservative. These attitudes may severely constrain the expression of homoeroticism, though some artists react to this social conservatism with imagery more oblique than explicit, while others more directly challenge negative attitudes toward homosexuality in the Hispanic community, even as they challenge racism and heterosexism in the majority American culture.

The artists discussed below are only a few of the many artists of Hispanic ancestry who have made significant contributions to American art in general and to glbtq art in particular.

Alma López

Contemporary artist Alma López (b. 1964) was born in Mexico and reared in Los Angeles. She grew tired of hearing that, because she is a lesbian, she participates in acts that are perverted and sinful. To the contrary, she believes that love itself is Heaven.

To express this idea, she created a photo-based digital print titled *Heaven* in which a young woman rejects the institutionalized patriarchal system as she gazes at her female lover's image in a golden heart brought to her by an angel.

López created this image in the tradition of the *retablo*, a Mexican painting that functions as a special prayer asking for a miracle or that gives thanks for a miracle that has been received.

López informs her art with personal interpretations of sacred subjects and themes. She focuses on female images in an effort to broaden Latin American visual history and to create a more complex identity for Latinas. She attributes some of her ability to see beauty and strength in women to the fact that she is a lesbian.

Our Lady, a photo collage, challenges the Latin American notion that women are either sexual beings or virgins. The image presents the typically demure Virgin of Guadalupe, a symbol of empowerment for Mexican and Mexican American Catholics, as a strong, contemporary Latina. (The model for the Virgin is performance artist Raquel Salinas.)

She wears a bikini made of roses, since it is this flower that she makes appear as proof of her apparition. *Our Lady*'s head tilts up and back as she gazes defiantly at the viewer. A buxom, bare-breasted angel (modeled by cultural activist Raquel Gutiérrez) holds her aloft.

Ester Medina Hernández

San Francisco artist Ester Medina Hernández (b. 1944) also creates images of strong women. Hernández, one of six children of California migrant farm workers, is a graduate of the University of California, Berkeley. She depicts the dignity, strength, experiences, and dreams of Latina women through printmaking and pastels.

The pastel entitled *La Ofrenda II* (1998) shows the bare back of a Latina woman looking over her right shoulder. With her short punk hairstyle, shaved in stripes and dyed pink over the ear, she does not fit the mold of a demure female. A tattoo of the Virgin of Guadalupe covers her entire back.

Mis Madres (1986) is a tribute to Latina women. The work presents an elderly woman as the center of the universe. She stands in the cosmos, facing the viewer, holding the earth in her left hand.

David Zamora Casas

Mexican American performance and visual artist David Zamora Casas (b. 1960) lives in San Antonio. Casas's work addresses his dual heritage, his gay Latino identity, and his life as an artist. During his stage performances, he uses his dynamic presence and intricately detailed costumes to transform himself from one character into another, for example from a screaming art apostle to a gay activist.

Casas frequently explores androgyny in his painted works, which redefine traditional Mexican art since they combine previously disparate techniques and imagery.

Portrait of a Burnout (1993), for example, is a *retablo* that shows Casas wearing a blue skirt, a vibrantly striped shirt, pink wings, and a huge red Mexican sombrero. His skirt depicts the cosmos, including a shooting star, and he wears a necklace with an ankh, a symbol of eternal life, around his neck. *Portrait of a Burnout* may be interpreted as an icon of a modern-day, androgynous saint.

Love has no Gender (1993) comprises a cross, an androgynous face, and a nude female torso painted on a horizontal strip of tin. Casas incised hearts, gender symbols, and the work's title into the tin surrounding the painted area. Tin cacti decorate each end, along with real, rotting and drying, cacti. The decaying plants may allude to the cycle of renewal and therefore to the transformation innate to androgyny.

Luis Alfaro

Luis Alfaro, a Mexican American performance artist, also uses art to explore androgyny. He sometimes wears outrageous women's outfits, including cheap, short, black lace slips, while shouting hilarious poems that he has written. The street is Alfaro's theater, and he frequently accosts passersby, shouting at them to grab their attention.

Laura Aguilar

California-based lesbian artist Laura Aguilar (b. 1959) has made great visual use of her large body in a series of self-portraits that challenge both norms of physical beauty and concepts of national identity.

As the child of a mother who was part Mexican and part Irish, Aguilar is particularly sensitive to questions of multiple heritages. Some of these questions are apparent in *Three Eagles Flying* (1990), a triptych depicting herself naked bound by ropes, with the Mexican flag covering her face and the U.S. flag covering her lower torso.

Cuban Artists

Many artists, and especially homosexuals, made use of the Mariel boatlift, which shipped Castro's "unwanted" peoples from Havana in the 1980s.

Artist Cabrero Moreno (1923–1981), for example, as an active homosexual, was declared an enemy of Castro's revolution. Art critic Rudi Bleys remarks of Moreno that "his interest in the male body went beyond the reticence of official discourse."

In the past few decades, many Cuban exiles and Cuban Americans have made their mark as artists. Of these, Juan González (1942–1992) was notable for his quest of a spiritualized androgyny, as in *La Cuna* (1976), which depicts a cradle but without a baby. He painted in an elegiac style with a subdued homoeroticism.

Jaime Bellechasse (1956–1993) created idealized drawings of nudes. These figures suggested his belief that the positive side of living in the United States outweighed the negative effects of racism.

Installation artist Félix González-Torres (1957–1995) confronted the tragedy of AIDS in his work and made many sly gay references. He moved to New York in 1979 and developed a unique style, characterized by a provocative conceptual wit. For example, his photograph "Untitled (perfect lovers)" (1991) depicted identical white-faced clocks that represented gay lovers.

Readily accepted by New York's avant-garde artistic community, González-Torres de-emphasized the figurative as he unsentimentally but movingly confronted his own debilitation as a result of AIDS.

Another Cuban installation artist, María Elena González (b. 1957), produced the thought-provoking *Self Service* (1996), in which a phallus called "Gloria" is attached to a wall and becomes normalized as a bathroom appliance. The work invites speculations about gender and sexuality. In her installations, González frequently returns to themes of ecology, cultural identity, and sexual politics.

Raúl Martínez (1927–1995) experimented with Pop Art, and in the process contributed to the development of the poster.

Other Latina/Latino American Artists

Other significant Latina/Latino American artists include Nuyoricans (Puerto Ricans living in New York City) José Luis Cortés (b. 1962), Abnel Rodríguez (b. 1964), Alberto Valderrama (1957–1995), and Reyes Meléndez (b. 1962).

Painters such as Tony de Carlo (b. 1956) and Gil de Montes (b. 1966) also make use of gay imagery, while Miguel Angel Reyes (b. 1964) depicts men with a rough, sexually appealing, macho appearance. Jerome Caja (1958–1995) performed a postapocalyptic drag act, and also exhibited mixed-media works.

Finally, Latino photographers such as Axel Damian Reyes, Gerardo Suter (b. 1957), Franc Franca (b. 1961), and Roberto Rincón have made a name for themselves by utilizing strong imagery celebrating gay male sexuality.

Conclusion

Perhaps the only generalization that can be made about the diverse artists who contribute to the tradition of Latina/Latino glbtq art is that they often confront, with a peculiarly personal urgency, the crucial issues of gender, sexuality, and acceptance that have obsessed American culture generally in the past several decades.

— *Joyce M. Youmans*
Kieron Devlin

BIBLIOGRAPHY

Bleys, Rudi C. *Images of Ambiente: Homotextuality and Latin American Art, 1810 to Today.* New York: Continuum, 2000.

Casas, David Zamora. www.artco.org/sa/casas

Cockcroft, James D., assisted by Jane Canning. *Latino Visions: Contemporary Chicano, Puerto Rican and Cuban-American Artists.* Danbury, Conn.: Franklin Watts, 2000.

Cooper, Emmanuel. *The Sexual Perspective: Homosexuality in Art of the Past 100 Years in the West.* London and New York: Routledge & Keegan Paul, 1986.

López, Alma. "Digital Art by Alma López." *Tongues Magazine: A Queer Latina Webzine.* www.tonguesmagazine.org/artlopez.htm

Mesa-Bains, Amalia. *Ceremony of Spirit: Nature and Memory in Contemporary Latino Art.* San Francisco: The Mexican Museum, 1993.

Saslow, James M. *Pictures and Passions: A History of Homosexuality in the Visual Arts.* New York: Viking, 1999.

SEE ALSO

Latin American Art; American Art: Gay Male, Post-Stonewall; American Art: Lesbian, Post-Stonewall; Contemporary Art; Pop Art; González-Torres, Félix

Laurençin, Marie *(1883–1956)*

FRENCH PAINTER, PORTRAIT ARTIST, AND SET DESIGNER Marie Laurençin had a number of affairs with men,

including fellow Cubist painter Guillaume Apollinaire, but she also had close friendships and affairs with women.

An illegitimate child, Marie Laurençin was born in Paris in 1883 to a Creole mother who worked as a seamstress. She began her art career as a porcelain painter at the Sèvres factory and studied with the flower painter Madeleine Lemaire. She attended the Académie Humbert, where she met Georges Braque. Through Braque, she soon became part of a group that included Picasso.

In 1907, Laurençin exhibited her paintings at the Salon des Indépendants and was introduced to Guillaume Apollinaire. The two artists began a tumultuous affair that lasted until 1913. They strongly influenced each other's vision. Apollinaire referred to Laurençin as a female version of himself. He undoubtedly influenced her dreamy imagery and the symbolism of her work.

Laurençin is the best known of the women associated with the Cubist movement. Certainly, her paintings dating from around 1910 are strongly Cubist. However, as she modestly stated, although the experiments of Cubism fascinated her, she never became a Cubist painter because she was not capable of it.

Her modesty notwithstanding, Laurençin is probably generally omitted from the list of pioneering modernists because of gender prejudice rather than lack of accomplishment.

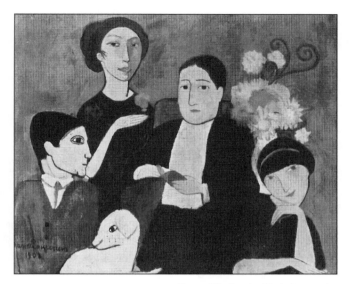

Group D'Artistes by Marie Laurençin.

In 1914, Laurençin married Baron Otto von Wätjen. For the duration of World War I, she and her husband took refuge in Spain. In 1921, she returned to Paris and divorced von Wätjen.

While Laurençin had a succession of male lovers, she also had close female friendships and lesbian relationships. She became part of the female expatriate community in Paris that sought both artistic and sexual liberation. Lesbianism, for many of these women, was a crucial element of their resistance to bourgeois social conventions.

The first American who befriended Laurençin and bought her paintings was Gertrude Stein. Laurençin soon became part of the Stein salon on rue de Fleurus, where artists, writers, and intellectuals met for conversation and inspiration.

Laurençin remained in contact with Gertrude Stein and Alice B. Toklas until Stein's death in 1946 and continued to see Toklas until her own death. She also met Natalie Barney during these early years in Paris and corresponded with her during the period 1940 to 1950. As another expression of her interest in lesbianism, late in her career Laurençin illustrated Sappho's poetry, in a translation by Edith de Beaument that was suppressed by the Nazis.

Laurençin's 1921 exhibition at Rosenberg's Gallery in Paris reestablished her reputation after World War I. She became known particularly as a portraitist, especially of celebrities such as Coco Chanel.

She also established herself as a set and costume designer by collaborating with Francis Poulenc in designing the set and costumes for *Les Biches* (1924) for the Ballets Russes. Her work during this productive period is characterized by the use of strong pastel colors and by the evocation of a fantasy world of quintessential femininity.

A portrait of Marie Laurençin by Carl van Vechten.

Laurençin's work gained important recognition in North America and Europe in the 1920s and 1930s. She was nominated for *Vanity Fair*'s Hall of Fame in 1927 and named chevalier of the Légion d'honneur in 1937.

During World War II, Laurençin remained in Paris even after her apartment was requisitioned by the Germans. After the war she designed the sets and costumes for *Le Déjeuner sur l'herbe* (1945) for Roland Petit's Ballet des Champs-Elysées and *La Belle au bois dormant* (1947) for the Ballets de Monte Carlo.

She died in 1956 and was buried in Père Lachaise Cemetery.

Since her death, the responses to her feminine aesthetic— characterized by a palette of pastel colors and feminine subject matter—have been varied. Some critics make unflattering comparisons of her work with that of her male Cubist contemporaries, while other critics defend her aesthetic choices as prompted by her need to differentiate herself from strong male artists such as Picasso and Braque.

In 1983, the Marie Laurençin Museum in Nagano-Ken, Japan, was inaugurated to celebrate the centenary of her birth.

— Elizabeth Ashburn

Bibliography

Hyland, Douglas K. S., and Heather McPherson. *Marie Laurençin: Artist and Muse.* London: Washington Press for the Birmingham Museum of Art, 1989.

Laurençin, Marie. *Le Carnet des Nuits.* 1942. Geneva: Pierre Cailler, 1956.

Marie Laurençin: Trente Portraits d'Amis. Paris: Libraire Paul Morihien, 1949.

Perry, Gill. *Women Artists and the Parisian Avant-Garde.* Manchester, England: Manchester University Press, 1995.

See also

European Art: Twentieth Century; Abbott, Berenice

Leibovitz, Annie (b. 1949)

ANNIE LEIBOVITZ IS AMONG THE MOST FAMOUS OF contemporary American photographers. Best known for her celebrity portraits and work in advertising, she has in recent years photographed a wider range of subjects. Her work has been shown at major exhibitions in the United States and abroad. She has also published a number of books of her photographs.

Anna-Lou Leibovitz was born October 2, 1949, in Westbury, Connecticut, but moved often during her childhood because her father, Samuel Leibovitz, was a lieutenant colonel in the United States Air Force. Her mother, Marilyn Heit Leibovitz, was a modern-dance teacher who studied with Martha Graham.

In 1967, Leibovitz entered the San Francisco Art Institute, planning to major in painting. During a school vacation, she and her mother traveled to Japan. There Leibovitz bought a camera and began taking pictures. On her return to college, she enrolled in a photography course and "was totally seduced by the wonderment of it all."

In 1970, Leibovitz received her first photographic assignment for the fledgling rock-and-roll magazine *Rolling Stone*, then headquartered in San Francisco. By 1973 she was the chief photographer.

In 1975, she accompanied the Rolling Stones on a long American tour, documenting the band's life on the road and producing a number of photographs that received wide public attention.

Leibovitz's first assignment for *Rolling Stone* was photographing John Lennon, and the former Beatle was also the subject of one of her best-known pictures. In December 1980, she photographed Lennon and his wife, Yoko Ono, for a story on the release of their *Double Fantasy* album. In Leibovitz's portrait, the couple are on their bed, Lennon nude and curled up in a fetal-like position, holding Ono, who is fully clothed.

Only hours after the photo was taken, Lennon was murdered. The editors of *Rolling Stone* wanted to feature Lennon alone on the next cover, but Leibovitz argued successfully for using the picture of the couple.

Leibovitz's early work was in black and white, but in 1974 *Rolling Stone* went to color printing. Not trained in color photography, Leibovitz taught herself the process and evolved a personal style characterized by bright colors and intense lighting.

In 1983, an exhibit of Leibovitz's photographs went on tour through Europe and the United States. A book based on the exhibition, *Annie Leibovitz: Photographs* (1983), became a best-seller.

Shortly thereafter, Leibovitz began working for *Vanity Fair* magazine. The job gave her the opportunity to photograph a wider range of celebrities—artists, writers, and political figures, as well as entertainers.

The poses in which she arranges her subjects are sometimes dramatic, sometimes whimsical, but always striking. One of the most famous and controversial of her photos is a picture of actress Demi Moore, nude and heavily pregnant, which ran on the cover of *Vanity Fair* in the summer of 1991.

The photograph of Moore is stark and direct in its composition, but many of Leibovitz's pictures are elaborately staged. Leibovitz makes a habit of studying her subject thoroughly before a photographic shoot and arranges poses based on her research. "She stages a scene that has many references to the character of the sitter. She packs the picture with visual elements," comments Sylvia Wolf of the Whitney Museum.

Among Leibovitz's best-known works are photographs of Bette Midler in a bed of roses (1979), of Whoopi Goldberg immersed in a bathtub full of milk (1984), and of Arnold Schwarzenegger astride a white horse and clutching a cigar in his mouth (1988).

In 1986, Leibovitz turned her talent for creating memorable images to advertising. Her clients have included major companies such as Honda, Arrow Shirts, and The Gap. In 1987, she won a Clio award for an ad campaign for American Express.

In 1991, the National Portrait Gallery presented an exhibition of Leibovitz's photographs, only its second show of the works of a living photographer. During its five-week run the exhibit attracted more visitors than ordinarily come to the National Portrait Gallery in a year. The featured works were published as a book, *Photographs: Annie Leibovitz 1970–1990* (1991).

Leibovitz is able to get her subjects to use their entire bodies when they pose for her, a talent she exploited as an official photographer for the World Cup Games in Mexico, in 1985. She also photographed American athletes at the 1996 Summer Olympic Games in Atlanta. A book of her photographs, *American Olympians*, appeared the same year.

Leibovitz's awareness of the body in motion is in part a product of her lifelong interest in dance. Her work includes memorable pictures of Mikhail Baryshnikov and his troupe. In 1990, Leibovitz spent three weeks living with and photographing the dancers at White Oak plantation in Florida, creating a photographic record that contains both carefully composed formal portraits and shots of the dancers and choreographer Mark Morris at work.

In recent years, Leibovitz has undertaken several projects of photographing people who are not famous. She has done a series of portraits of people with AIDS, and she went to the Balkans to take pictures of the victims of the war in Bosnia.

In 1992, Leibovitz told an interviewer that "the biological clock is definitely ticking" and that for several years she had been considering having children. However, it was not until 2001, at the age of 52, that she gave birth to a daughter, Sarah Cameron Leibovitz, whom she named after Julia Margaret Cameron, a Victorian Englishwoman who was among the first female professional photographers. Leibovitz has not identified the father of her child, who was conceived through artificial insemination.

For over a decade, Leibovitz has been the close companion of writer Susan Sontag, who was present at the birth of the former's baby, but the two have not publicly discussed the nature of their relationship.

This reticence has brought them criticism from some lesbians and gay men. Outspoken lesbian critic Camille Paglia has remarked that "One of my primary gripes about Sontag from the start was her cowardice about her sex life." When Carl Rollyson and Lisa Paddock's biography *Susan Sontag: The Making of an Icon* suggested that she had lesbian relationships, Sontag's lawyers threatened possible lawsuits; and Norton, the publisher of the book, decided not to issue it in Britain for fear of an action for libel.

Leibovitz is as private as Sontag, noting in a 1999 interview in the *Washington Post* that she and Sontag have separate apartments—although in the same complex—and designating *friend* the appropriate term for their relationship. "You'd be wrong to say anything else," she insisted.

Although Leibovitz and Sontag have been largely silent on the subject of their relationship, they have appeared in public together for years. Leibovitz has been photographed by Sontag's side at the latter's readings and lectures. Sontag accompanied Leibovitz to Mexico and Warsaw for exhibitions of her photographs. The two also traveled to Bosnia together during the war there.

Leibovitz and Sontag collaborated professionally on *Women* (1999), a lavish book of Leibovitz's photographs with an essay by Sontag. The first photograph in the book is of Leibovitz's mother, and the last is of Sontag. Over one hundred women are pictured in the book, and there are thumbnail biographies of all the principal subjects except Sontag and one woman identified only as "Victim of Domestic Violence."

There is some debate as to the value of Leibovitz's photographs as art. Some critics dismiss her work because of its focus on celebrities and its commercialism. Others, however, point to her imagination and creativity in posing her subjects and stress the importance of her photographs as documents of popular culture.

— *Linda Rapp*

Bibliography

Baxter, Sara. "Leibovitz Delays Motherhood until the Last Minute." *The Ottawa Citizen*, November 25, 2001.

Graham, Caroline. "Persuade Me, Baby." *Courier Mail*, December 8, 2001.

Hagen, Charles. "Annie Leibovitz Reveals Herself." *ARTnews* (March 1999): 91–95.

Laing, Allan. "Her eye's on the prize." *The Herald* (Glasgow), May 12, 2001.

Leibovitz, Annie, and Susan Sontag. *Women*. New York: Random House, 1999.

Schorow, Stephanie. "Photo Graphic: Known for Nude Celebrity Photos, Annie Leibovitz Is Proud of Her Intense Focus on 'Women.'" *The Boston Herald*, December 11, 2000.

Span, Paula. "The Restless Eye; At 50 Annie Leibovitz Has Fame, Money, Influence. So Why Is She Still So Driven?" *The Washington Post*, October 24, 1999.

Tait, Robert. "Two Single Women—and a Baby." *The Scotsman*, May 15, 2001.

Van Biema, David. "The (eye) of Annie Leibovitz." *Life* (April 1994): 46.

SEE ALSO

Photography: Lesbian, Post-Stonewall

Lempicka, Tamara de (1898?–1980)

TAMARA DE LEMPICKA ACHIEVED NOTORIETY AND FAME several times during her life and remains popular today for her highly sexualized Art Deco portraits. Her painting *Autoportrait* (1929), an image of herself at the wheel of her automobile, mixes cold, hard textures with luxurious, decadent sensual imagery. It is an excellent example of French Art Deco and high camp.

De Lempicka was born around 1898 in Poland, the child of Boris Gurwik-Gorski, a lawyer, and Malvina Decler, from a wealthy Polish family. She was encouraged by her Decler grandmother to think of herself as exceptional. She became enamored of Italian Renaissance painting in her teens.

Around 1912 she met, and in 1916 married, Tadeusz Lempicka, a lawyer. Soon after their marriage, their daughter Kizette was born. In 1918, the family moved to Paris, where women artists found better opportunities than in any other city. Tamara studied painting with Maurice Denis and André Lhote and attended the Académie de la Grande Chaumière.

De Lempicka was a very physical person. Her first lesbian affair was with a wealthy redhead, probably Ira Perrot, who modeled for her and took her to Italy, paying all expenses.

In Italy, the artist discovered the paintings of Botticelli and Messina and attended lesbian parties. At one such gathering she arranged food tastefully on the body of a nude woman and then slowly ate "her midnight meal." In her trips to Italy, she became part of a circle that included Violette Trefusis—the lover of Vita Sackville-West—and Colette.

These women appreciated bisexual behavior and had numerous affairs with individuals of both sexes. In 1933, de Lempicka began an affair with a singer at the Boîte de Nuit, Suzy Solidar, a friendship that lasted several decades.

Generally, however, the artist pursued older men as social companions but slept with younger and handsome ones. Sophisticated, fashionable, and beautiful, she was often seen caressing a working-class boy one night and a woman the next. Eventually, Tadeusz refused to return to her and in 1928 they were divorced.

By the mid 1930s, de Lempicka's work was extremely well received, though it has never fit neatly within stylistic boundaries. Her stylized and sleekly androgynous Art Deco portraits and compositions softened Cubism into a decadent lushness. She sought the crispness of the old masters and rejected the Impressionists, whom she characterized as "dirty" and "not neat." But she also worked within the modernist tradition of concentrating on the surfaces of paintings.

While her portraits from 1920 to 1940 can be located within the French Art Deco school, her later work touches on other traditions, including Surrealism and still life. Among the unique aspects of her style is the overt lesbianism that informs it, especially in her female nudes.

In 1934, de Lempicka married Baron Raoul Kuffner, who held title to the largest single estate in the Austro-Hungarian Empire. He had asked her in 1928 to paint his mistress, the famous Andalusian dancer Nana de Herrera. The portrait has been seen as something of an assassination, since it makes the graceful dancer appear gauche and awkward. The portraitist soon replaced de Herrera as the baron's mistress.

At the outbreak of war in 1939, de Lempicka and her husband emigrated to America. After a successful one-woman show in Paul Reinhart's Gallery in Los Angeles, de Lempicka and her husband took up residence in director King Vidor's former home in Beverly Hills.

She was soon the "Favorite Artist of the Hollywood Stars." Greta Garbo, Dolores del Rio, and Tyrone Power visited her studio. Even today, de Lempicka's connection with Hollywood continues, as the most avid contemporary collectors of her paintings are Madonna and Jack Nicholson.

De Lempicka died in her sleep in 1980. A play based on her life, *Tamara*, opened in Hollywood in 1985 with Anjelica Huston and had a long run. Although Lempicka's work was out of favor for many years, it has recently enjoyed a new appreciation, ironically for those very qualities of decadence and hedonism that caused critics of the 1960s and 1970s to dismiss her.

— *Elizabeth Ashburn*

BIBLIOGRAPHY

Claridge, Laura. *Tamara de Lempicka: A Life of Deco and Decadence*, New York: Clarkson Potter Publishers, 1999.

de Lempicka, Baroness Kizette. *Passion by Design: The Art and Times of Tamara de Lempicka*. New York: Abbeville Press, 1987.

Neret, Giles. *Tamara de Lempicka*. Cologne: Benedikt Taschen, 1992.

SEE ALSO

European Art: Twentieth Century; Surrealism; Subjects of the Visual Arts: Nude Females

Leonardo da Vinci *(1452–1519)*

A POLYMATH WITH AN EXTRAORDINARY RANGE OF knowledge, Leonardo da Vinci embodies the notion of the aspiring and inquisitive Renaissance Man. One of the greatest painters in the history of art and an outstanding empirical scientist and inventor of machinery, his life was shadowed both by his illegitimacy and rumors of homosexuality.

The child of middle-class notary Ser Piero da Vinci and a local peasant girl, Leonardo was born out of wedlock in Vinci, a town near Florence, on April 15, 1452. He never escaped the stigma of being a bastard.

Denied entrance to university or any of the respected professions because of his birth, he was deprived of the humanist education of his day. For all the limitations his lack of an education imposed on him, however, Leonardo more than compensated for the deprivation by devising his empirical approach to natural phenomena.

In his mid-teens, Leonardo was apprenticed in Florence to Andrea del Verrochio, a sculptor and painter affiliated with the powerful Medici family, under whose guidance the boy's artistic talents quickly flowered.

Leonardo's Sexuality

One of the most traumatizing experiences of Leonardo's life occurred in 1476 while he was still living in Verrochio's house. Sodomy charges were anonymously brought against him and three others for allegedly having sexual relations with a seventeen-year-old male artists' model.

After two hearings the charges were eventually dropped on a technicality. Although he was not convicted, the accusation seems to have haunted Leonardo throughout his life.

Although homosexuality was widespread in Florence, and associated with a number of prominent artists, charges of sodomy could be very serious. In addition, the unfavorable public attention could gravely damage the career of an artist dependent on patronage, including the patronage of the church.

There is no doubt that one effect of the traumatic experience of the trial was that Leonardo doubled his efforts to keep his life private, even going so far as to use mirror writing to keep his thoughts hidden. Hence, little of his emotional life is known directly.

Nevertheless, there is ample evidence for the conclusion of many historians that the artist's primary erotic interests were directed toward men. Throughout his life, Leonardo surrounded himself with beautiful young men, and his drawings and writings evince a deep appreciation for male beauty. In contrast, there is no evidence that Leonardo was ever intimately involved with a woman or even had a close friendship with one.

Indeed, Leonardo's ignorance of women seems obvious in light of his sketches. Whereas he made many studies of the nude male, often featuring detailed attention to the genitalia, he drew few women below the neck. When he did, the genitals are grossly inaccurate and distorted.

Moreover, Leonardo developed close relationships with his (male) students and many references in his notebooks hint at his love for his male companions. Rumors circulated about the nature of his relationship, lasting for almost twenty years, with a "curly-haired youth" named Gian Giacomo de' Caprotti, nicknamed "Salai" (lamb of Satan) for his misbehavior.

In the last ten years of Leonardo's life, Francesco Melzi, a young Lombard aristocrat, became his constant companion and ultimately served as the executor of his estate.

In 1910, Sigmund Freud conducted an extensive psychoanalytic study of Leonardo's sexuality, using the artist's notebooks as his sources. Freud traced Leonardo's homosexuality back to his relationship with his mother and absent father. According to Freud, Leonardo sublimated his sexual urges in his work. The psychoanalyst considered the artist's many unfinished projects as a sign of acute sexual frustration.

Freud's analysis is based upon assumptions that have been challenged and that many consider dubious at best. It is also based on an interpretation of one of Leonardo's dreams that is flawed by translation errors. Thus, Freud's study must be approached with caution; nevertheless, the psychoanalyst deserves credit for confronting directly the question of the artist's sexuality at a time when such questions were the stuff only of scandalous gossip.

Leonardo's Scientific Genius

To escape the scandal of the accusation of sodomy, Leonardo traveled in 1481 or 1482 to Milan, where he designed military equipment for the duke, Ludovico Sforza. The detailed notebooks he carried everywhere are filled with sketches of hand arms, projectiles, flamethrowers, cannons, and crossbows.

Many of Leonardo's inventions are highly impractical, or at least were impractical at the time, but his meticulous drawings reveal a mechanical genius, despite his lack of formal training. Some of his drawings anticipate such later inventions as the bicycle and the helicopter.

By the end of his life, Leonardo had compiled a vast collection of notebooks (over 5,000 manuscript pages), detailing his research on optics, acoustics, mechanics, hydraulics, flight, astronomy, weaponry, and anatomy. During his lifetime, he kept his scientific findings hidden for fear his ideas would be stolen.

After his death, many of Leonardo's papers were lost to the world; some were never recovered. Many believe that had they been shared or published, they might have changed the course of scientific discovery, because his observations prefigured the work of Newton, Galileo, and Kepler.

Leonardo's Paintings

Although Leonardo produced only a small number of paintings, his revolutionary technique and style made him one of the most influential artists of the Renaissance. One measure of the visceral emotion that his works continue to inspire is that they are the most vandalized paintings in the world.

One of Leonardo's first commissions was to paint a mural of *The Last Supper* (1495–1498) in the refectory of Santa Maria delle Grazie, in Milan. Depicting the final meal of Jesus with his disciples, *The Last Supper* is celebrated for its ingenious composition and use of perspective, as well as for its psychological depth. Unlike previous artists, Leonardo skillfully uses shadow to reveal the betrayer Judas' character with subtlety.

Unfortunately, Leonardo executed the image in an experimental fresco technique, and it had deteriorated within fifty years of its completion; yet even in its severely compromised condition it has had a profound influence on the history of art.

Leonardo returned to Florence in 1500, and in 1501 began work on an altarpiece for a community of Servite monks titled *Virgin and Child with Saint Anne*. He left the painting unfinished in 1502 to accept a position as military engineer to the ruthlessly ambitious Cesare Borgia. During this time he became friends with the most celebrated political writer of his day, Niccolò Machiavelli.

Disgusted by Borgia's vicious tactics, Leonardo left Borgia's service after only nine months. However, he did not return to *Virgin and Child with Saint Anne* and the painting remains incomplete.

Leonardo's mature years are filled with some of his most recognizable works. It is impossible to date these with any certainty, but many believe *Mona Lisa* was painted first, followed by *Leda*, and then his final painting, *St. John the Baptist*.

Mona Lisa (or *La Gioconda*, as it is known in Italy), now in the Louvre in Paris, is Leonardo's most famous and most ambiguous painting. Although the painting purports to be a portrait of the wife of a merchant, Francesco del Giocondo, some scholars have speculated that it is an idealized version of the artist's mother or even a self-portrait en travesti.

The identity of the woman remains uncertain, but her enigmatic smile, hinting at a secret joke or private knowledge, has haunted viewers since it was first shown. The painting was never completed or delivered to its owner, and Leonardo carried it with him throughout the last years of his life.

Although only sketches remain of Leonardo's *Leda,* it remains one of the most perplexing works in his oeuvre. His only female nude and his only picture inspired by classical mythology, *Leda* depicts the union of Zeus, disguised as a swan, with Leda, Queen of Lacedaemon.

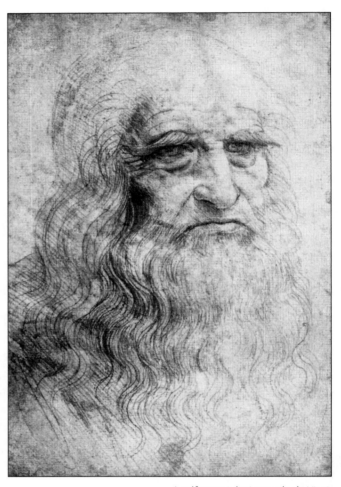

A self portrait by Leonardo da Vinci.

The result of this union was two sets of twins hatched from eggs: the divine Castor and Pollux and the mortals Helen and Cytemnestra. This myth inspired countless artists, but Leonardo's vision is unique in that it highlights the grotesqueness of the rape.

He imbues the image with terror rather than eroticism, yet he also makes the encounter tantalizing and memorable. Fascinated by the natural world and committed to pushing its boundaries, Leonardo was no doubt intrigued by this aberration of the natural order.

In 1507, Leonardo entered the service of King François I of France, first in Milan and later in France itself. Most of his last years were spent in intellectual and scientific pursuits at the court of the king. However, he did complete one major painting during this period, the androgynous *St. John the Baptist*. The model for St. John in this beautiful yet curiously disturbing painting may have been the "lamb of Satan" himself, Gian Giacomo de' Caprotti.

The artist died in Cloux on May 2, 1519.

— Julia Pastore

BIBLIOGRAPHY

Bramley, Serge. *Leonardo: The Artist and the Man.* New York: Penguin 1994.

Dynes, Wayne R. "Leonardo da Vinci." *Gay and Lesbian Biography.* Michael J. Tyrkus, ed. Detroit: St. James Press, 1997. 284–287.

Freud, Sigmund. *Leonardo da Vinci and a Memory of His Childhood.* Alan Tyson, trans. New York: Norton, 1964.

Rocke, Michael. *Forbidden Friendships: Homosexuality and Male Culture in Renaissance Florence.* Oxford: Oxford University Press, 1998.

Saslow, James M. *Ganymede in the Renaissance: Homosexuality in Art and Society.* New Haven: Yale University Press, 1986.

White, Michael. *Leonardo: The First Scientist.* New York: St. Martin's Press, 2000.

SEE ALSO

European Art: Renaissance; Duchamp, Marcel; Michelangelo Buonarroti; Pontormo, Jacopo; Subjects of the Visual Arts: Nude Males

Leslie-Lohman Gay Art Foundation

LIFE PARTNERS CHARLES LESLIE AND FRITZ LOHMAN share an intense interest in homoerotic art and began to build a collection together from the time they met in the early 1960s. At that time, explicit erotica and particularly gay male erotica, no matter how famous the artist who created it, was almost impossible to see. It was hidden from public view, for then it was literally a criminal offense to display it.

In 1969, Leslie and Lohman held a weekend, invitation-only exhibition of their collection of "secret art" in their loft in SoHo. There was great interest and many people attended, so over the next few years further exhibits were held, until in 1975 the two men rented a space and opened an art gallery, perhaps the first in the nation to be exclusively dedicated to promoting explicitly gay art.

In the same spirit of support for gay art, in 1977 Leslie published an illustrated monograph, *Wilhelm von Gloeden, Photographer,* which was influential in the resurrection of von Gloeden's work in the years to come.

Although the Leslie-Lohman gallery did not make money, it was a *succès d'estime* and inspired others. By 1980 there were six gay art galleries in New York City, creating a new and vibrant social and cultural circuit for an avid gay public. Then the AIDS crisis struck, and in the terror many gay businesses that had celebrated gay sex, particularly baths, bars, and movie houses, closed or were shut down. Among these casualties were art galleries.

By the late 1980s, Leslie and Lohman had reconsidered, with a raised consciousness, the issues of gay art and gay liberation. They decided to address these issues by setting up a foundation, in order to have the same tax-exempt status enjoyed by religious, educational, philanthropic, and other not-for-profit organizations.

In 1990, after relentless work by their lawyers—and homophobic responses challenging the organization's goals and purposes—the Leslie-Lohman Gay Art Foundation came into being. Its name marks the first instance of the word *gay* appearing in the federal government's registry of not-for-profit organizations.

The foundation has three primary purposes: (1) to provide free space to exhibit gay and lesbian art; (2) to preserve the estates of gay and lesbian artists, particularly their erotica; and (3) to establish and maintain a collection of work by and an archive of material and information about gay and lesbian artists.

Although work on exhibit may be for sale, the gallery does not sell anything. Rather, it puts artists and collectors in touch with one another to make their own arrangements.

Quentin Crisp called the Leslie-Lohman Gay Art Foundation a truly underground gallery, as it is located in the basement of a building at 131 Prince Street in New York City.

Since its founding, the foundation has shown the work of 550 artists in more than 200 exhibitions; and its permanent collection has grown to approximately 1,000 pieces, including paintings, sculpture, drawings, and photography.

Artists' groups meet at the gallery, films and videos are shown, and a lecture series presents well-known historians, critics, and artists to speak on the subject of gay art, its history, psychology, and aesthetics. The foundation also provides information on the means by which collectors and artists can protect their artwork beyond their lifetimes.

Charles Leslie says, "We regard our work as part of the gay liberation movement."

A goal of the foundation is to have its own building, to house a museum, library, and archive, and adequate space for changing exhibitions. Contributions in aid of the foundation's purposes are tax-deductible. — *Douglas Blair Turnbaugh*

BIBLIOGRAPHY

De Stefano, George. "Artistic Outlaws: Leslie and Lohman Have Fought to Preserve Gay Art for Three Decades." *New York Blade* (March 20, 1998): 21, 23.

Johnson, Douglas. "The Leslie-Lohman Gay Art Foundation: A Community Resource." *Blueboy* (September 1997): 64–67.

Leslie, Charles. *Wilhelm von Gloeden, Photographer. A Brief Introduction to His Life and Work.* New York: Soho Photographic Publishers, 1977.

Sanchez, John. "Leslie-Lohman Gallery: The Ultimate Gay Portfolio." *Genre Magazine* (September 2000): 66–71, 83.

Strong, Lester. "Gay Art Foundation." *Metroline* (April 14, 1994): 38–39, 48.

SEE ALSO

Contemporary Art; American Art: Gay Male, Post-Stonewall; Erotic and Pornographic Art: Gay Male; Gloeden, Baron Wilhelm von; Schwules Museum [Gay Museum]

Lewis, Mary Edmonia (1844–1907)

American sculptor Mary Edmonia Lewis lived most of her life in Rome, where she was a member of a lesbian circle of American expatriates and artists.

Many of the details of her life remain elusive. The only daughter of an Ojibwa (Chippewa) Indian mother and an African American father, Lewis was born in upstate New York, probably on July 4 or July 14, 1844.

Soon orphaned, she was raised by the Mississauga band of her mother's tribe. By her own sometimes exaggerated recollection, she was a spirited, inquisitive child.

Financed by her brother Samuel, a barber turned prospector in California, Lewis became one of the first African American female students in the Young Ladies Preparatory Department at Oberlin College in Ohio. There she studied drawing, demonstrating a clear talent as a teenager. Signing her first drawing simply "Edmonia Lewis," she caused her proper name "Mary" to fall out of use.

Her years at Oberlin were marred by a bizarre incident in which Lewis was accused of poisoning her two white housemates with an aphrodisiac. Although charges against her were eventually dismissed, she was taken by a lynch mob and badly beaten.

Some historians see in this incident the first signs of Lewis's presumed homosexuality; they believe that the women, who were out on dates with male companions when the poison took effect, had been targeted because of romantic jealousy.

Forced to leave Oberlin in 1863, Lewis went to Boston to study with the sculptor Edward A. Brackett, who became her mentor and guided her artistic development. In Boston, she also met and befriended lesbian sculptors Anne Whitney (1821–1915) and Harriet Hosmer (1830–1908).

Aside from the scant tutelage she received from Brackett, Lewis was self-taught as a sculptor. She started as a copyist, but her designs grew more innovative and original with each work. Her earliest works were clay and plaster portraits of well-known abolitionists. Eventually Lewis worked in a Neoclassical style, deriving much of her later subject matter from historical sources.

Lewis decided that she needed to be in a place where she would be nurtured as an artist, so she set sail for Rome in 1865, where she apparently lived for the rest of her life. Lewis's studio near the Spanish Steps was a popular destination for tourists and a gathering place for other expatriate artists and intellectuals, many of them women.

While there has never been any explicit "proof" of Lewis's homosexuality, her inclusion in a lesbian circle in Rome has contributed to the speculation. Henry James famously dubbed this group, which included Emma Stebbins (1815–1882), Whitney, and Hosmer (along with Margaret Foley, 1820–1877), "that strange sisterhood of American 'lady sculptors' who at one time settled upon the seven hills [of Rome] in a white, marmorean flock."

Lewis's decision to enter into a "male" profession also added to the assumptions about her sexual preferences. Moreover, she never married, had no known male companions, and no children. Furthermore, Lewis wore so-called "mannish" attire, somewhat evident in the only known photographic portraits of her, made on a visit to Chicago.

Lewis's monumental masterpiece, *The Death of Cleopatra*, was exhibited at the Centennial Exposition in 1876 in Philadelphia and in Chicago in 1878 and then, unsold, was placed into storage. From there it disappeared: Its remarkable rediscovery paralleled the rediscovery of the artist herself in the late twentieth century.

Not long after Lewis stored the two-ton marble, it turned up on display in a Chicago saloon and eventually ended up at a racetrack as a grave marker for a racehorse named Cleopatra. When the racetrack became a postal service facility in the 1970s, the sculpture was put into a Cicero, Illinois, storage yard, where it languished, exposed to the elements, until a fire inspector enlisted his son's Boy Scout troop to "restore" it with cleaning solutions and paint.

Alerted by a newspaper article, the Historical Society of Forest Park, Illinois, claimed the sculpture and put out inquiries that caught the attention of Lewis biographer Marilyn Richardson. The sculpture was finally turned over to and restored by the Smithsonian Institution. The rediscovery of *The Death of Cleopatra* is all the more important because precious few of Lewis's works survive.

True to character, Lewis's death was as enigmatic as her life—to date no record of it has been found.

— *Carla Williams*

BIBLIOGRAPHY

"Cleopatra: Lost and Found."
 http://nmaa-ryder.si.edu/collections/exhibits/lewis/intro.html

Driskell, David. *Two Centuries of Black American Art*. Los Angeles and New York: Los Angeles County Museum of Art/Alfred A. Knopf, 1976.

Lewis, Samella. *African American Art and Artists*. Berkeley: University of California Press, 1990.

Richardson, Marilyn. "Edmonia Lewis's The Death of Cleopatra." *The International Review of African American Art* 12.2 (1995): 36–52.

Robinson, Jontyle Theresa, et al., eds. *Bearing Witness: Contemporary Works by African American Women Artists*. New York: Spelman College and Rizzoli International Publications, 1996.

San Jose Public Library:
 http://www.sjpl.lib.ca.us/MLK/exhibits/lewis.htm

Wolfe, Rinna Evelyn. *Edmonia Lewis: Wildfire in Marble*. Englewood Cliffs, N. J.: Silver Burdett Press, 1998.

SEE ALSO

African American and African Diaspora Art; American Art: Lesbian, Nineteenth Century; Hosmer, Harriet Goodhue; Stebbins, Emma; Subjects of the Visual Arts: Nude Females; Whitney, Anne

Leyendecker, Joseph C. (1874–1951)

DURING THE DECADES BETWEEN THE TWO WORLD WARS, the "Arrow Man," the advertising figure of the Arrow Collars and Shirts company, became the icon of urbane American masculinity. The unnamed artist-rendered figure, created by J. C. Leyendecker, received more fan mail from adoring women and girls than most leading men of the stage and screen and inspired numerous songs.

Unknown to the public, this epitome of male beauty and heterosexual female admiration was, ironically, the product of a homosexual collaboration that lasted half a century between the artist and his model, Charles Beach. Although Norman Rockwell is today the best-remembered illustrator of early-twentieth-century Americana, Leyendecker's ubiquitous images helped to define mainstream American standards of beauty and sophistication from the 1890s to the 1940s.

Joseph Christian Leyendecker was born in Montabaur, Germany, to a family of Netherlandic extraction, on March 23, 1874. The family immigrated to the United States in 1882, and settled in Chicago. From early childhood, Leyendecker drew images on any available surface, a tendency that his parents encouraged. As they were unable to afford private art lessons for their son, he was apprenticed at fifteen to a Chicago engraver, with whom he began his career by designing advertisements and book illustrations.

During these years, Leyendecker also took night classes at the Art Institute of Chicago. By the time he was nineteen, he showed a mature technical mastery of the illustrator's art and, with his younger brother, Francis X. Leyendecker (1877–1924), traveled to Paris to study at the Académie Julian.

The brothers returned to Chicago in 1898 and established a studio there. Both soon gained numerous commissions for magazine and advertisement illustrations, and in 1899, J. C. Leyendecker produced his first cover for the *Saturday Evening Post*, one of the leading mainstream American publications.

Leyendecker's association with the magazine continued for the next four decades. With his holiday covers for the magazine, he virtually created the popular image of Santa Claus and the New Year's baby that Americans know today.

Suddenly in great demand, the Leyendecker brothers moved to New York in 1900. Their work, characterized by what might best be called a discreet male homoeroticism, typically portrayed handsome young men, particularly athletes, soldiers, sailors, and muscular working men, as heroic figures, recalling the classical ideals of the French Academy and the sinuous lines of Art Nouveau.

By 1914, J. C. Leyendecker had accrued enough wealth to build an estate in New Rochelle, New York, where he lived with his brother, his sister Augusta, and his lover, Charles Beach (1886–1952).

Leyendecker met Beach in 1903, when the young model from Cleveland first posed for him. The artist was impressed not only with Beach's handsome face and physique, but also with his ability to hold poses for extended lengths of time.

Their relationship lasted until Leyendecker's death. Over the next thirty years, Beach's image as the "Arrow Man," as well as Leyendecker's other representations of him, became one of the most widely circulated visual icons in mainstream American culture. In this capacity, Beach became the symbol of American prosperity, sophistication, manliness, and style.

For forty-nine years, Beach functioned as Leyendecker's model, lover, cook, and business manager. The household was extremely careful in maintaining a strict, even secretive, privacy.

Although Beach's features were much in the public's gaze, few actual photographs of him or the Leyendeckers

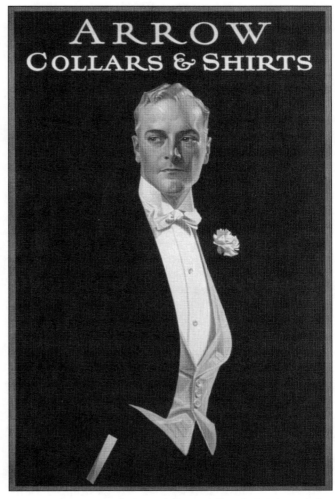

An advertisement for Arrow Collars and Shirts by J. C. Leyendecker.

are to be found. Beach, presumably at Leyendecker's instruction, burned virtually all correspondence and many artworks after the artist's death.

Accordingly, few facts are known about their relationship and the couple's interactions with Leyendecker's siblings.

Frank Leyendecker was, however, also known to be gay, and a rift between the brothers apparently occurred months before the younger man's death, reportedly from a drug overdose, in 1924.

The last years of J. C. Leyendecker's life were overshadowed by financial concerns, as he had spent as lavishly as he earned at the height of his career. By the 1940s, the major magazines increasingly supplanted artist's cover illustrations with photographs. As a result, Beach and Augusta sold many of Leyendecker's art works, which now bring hundreds of thousands of dollars at auction, for a pittance.

Leyendecker died at his home in New Rochelle on July 25, 1951. Beach followed him in death within months.

— *Patricia Juliana Smith*

BIBLIOGRAPHY

Leyendecker, J. C. *The J. C. Leyendecker Poster Book*. Norman Rockwell, intro. New York: Watson-Guptill Publications, 1975.

Schau, Michael. *J. C. Leyendecker*. New York: Watson-Guptill Publications, 1974.

Steine, Kent, and Frederic Taraba. *The J. C. Leyendecker Collection*. Portland, Ore.: Collectors Press, 1995.

SEE ALSO

American Art: Gay Male, 1900–1969

Ligon, Glenn (b. 1960)

ONE OF THE MOST SUCCESSFUL ARTISTS AT WORK today, African American mixed-media artist Glenn Ligon explores important questions of race and gender in his multilayered and deeply resonant work.

Born in 1960 in New York and raised in the Bronx, Glenn Ligon was able to attend a private school in Manhattan thanks to a scholarship. He studied at the Rhode Island School of Design before receiving a B.A. from Wesleyan University in 1982. The recipient of numerous awards and fellowships, he participated in the prestigious Whitney Museum Independent Study Program in 1985.

As much a child of popular culture as of history, Ligon often conflates issues of race and gender and their frequently parallel histories and struggles. He explains: "I am positioning myself against a certain historical experience and trying to find the connection between it and who I am."

Ligon's art is witty, ironic, and compelling in its complex layering of references. In much of his work, he uses carefully selected borrowed texts as a visual as well as a literary and conceptual device.

Everything is fair game: Ligon's work appropriates the iconography of broadsides for escaped slaves (*Runaways*, 1993), African American folklorist Zora Neale Hurston's 1928 essay "How it Feels to be Colored Me" (Untitled [*I Do Not Always Feel Colored*], 1990), James Baldwin's 1953 essay "Stranger in the Village," and Richard Pryor's stand-up jokes (*Mudbone [Liar]*, 1993), which includes allusions to homosexuality in its race-based humor.

Ligon even uses excerpts from Nation of Islam leader Louis Farrakhan's speech given at the Million Man March, which he refines by recasting it through the perspective of a gay black male. The personal is political; Ligon states: "I consider all the work I've done self-portraits filtered through other people's texts."

Ligon's more sexually explicit work includes his reinterpretation of Robert Mapplethorpe's iconic *Black Book*, which featured exploitative, homoerotic photographs of black men. In his installation for the 1993 Whitney Museum Biennial exhibition, Ligon reframes Mapplethorpe's photographs, juxtaposing the explicit photographs with textual criticism written in a detached, academic language (*Notes on the Margin of the "Black Book,"* 1991–1993).

In the series "Albums" (alternately titled "A Feast of Scraps," 1994–1998), Ligon reconfigures the family album to incorporate amateur pornographic snapshots of black men interspersed with his own family photographs. Captioned with such double entendres as "Brother" and "Daddy," as well as vaguely ominous, clipped statements such as "It's not natural" and "Mother knew," the pornographic snapshots claim their rightful, though uneasy, place amid the heterosexual domestic narrative.

Other works that continue the homosexual dialogue and demonstrate Ligon's sharp tongue as well as sharp eye include *Narratives (Plate G)* (1993) and *Snapshots*, which feature cleverly unsettling yet humorous texts, such as "'I'm really into black Americans,' he whispered. 'Especially when they humiliate me.' 'Well,' I replied, 'For starters, I really hate your hair.'"

Ligon has collaborated with Korean American artist Byron Kim on numerous works, including *Rumble, Young Man, Rumble* (1993), a boxing bag stenciled with inflammatory words by Muhammad Ali.

As one of the most successful contemporary artists, Ligon has exhibited internationally, and his work is included in the permanent collections of, among others, the Museum of Modern Art, New York, the San Francisco

Museum of Modern Art, the Hirshhorn Museum in Washington, D.C., the Philadelphia Museum of Art, and the Walker Art Center in Minneapolis.

He lives and works in Brooklyn, New York.

— *Carla Williams*

BIBLIOGRAPHY

Bright, Deborah. "Introduction, Portfolio." *The Passionate Camera: Photography and Bodies of Desire.* Deborah Bright, ed. London and New York: Routledge, 1998. 146, 156–157.

Golden, Thelma. "My Brother." *Black Male: Representations of Masculinity in Contemporary Art.* Thelma Golden, Herman Gray, and John G. Hanhardt, eds. New York: Whitney Museum of American Art, 1994. 19–43.

hooks, bell. "Feminism Inside: Toward a Black Body Politic." *Black Male: Representations of Masculinity in Contemporary Art.* Thelma Golden, Herman Gray, and John G. Hanhardt, eds. New York: Whitney Museum of American Art, 1994. 127–140.

Lord, Catherine. "Queering the Deal." *Pervert.* Catherine Lord, ed. Irvine: The Art Gallery, University of California at Irvine, 1995. 5–20.

Tannenbaum, Judith, et al. *Glenn Ligon: Unbecoming.* Philadelphia: Institute of Contemporary Art, 1997.

SEE ALSO

African American and African Diaspora Art; American Art: Gay Male, Post-Stonewall; Contemporary Art; Photography: Gay Male, Post-Stonewall; Mapplethorpe, Robert

List, Herbert (1903–1975)

GERMAN PHOTOGRAPHER HERBERT LIST CREATED images of young men that are at once homoerotic and avant-garde in technique and sensibility.

Born in Hamburg, Germany, in 1903, List attended the Johanneum Gymnasium. After completing school in 1920, he moved to Heidelberg to learn the family coffee-brokerage business, but he also managed to study art history at Heidelberg University.

List entered the family business in 1924 and traveled on its behalf throughout Brazil, Guatemala, and Costa Rica. In 1929, he returned to Hamburg to run the company's daily affairs. In Hamburg, he befriended the young photographer Andreas Feininger and took his own place among the city's artistic and social avant-garde as a photographer.

List also became an acquaintance of the young Englishman Stephen Spender, who was to draw upon him in creating the character Joachim in his autobiographical novel *The Temple* (written in 1929, but not published until 1988).

In his early photographs, List combines his love of the male figure with an experimental use of double exposure and a quasi-Surrealist fascination with masks and draped fabric.

In 1935, with the rise of the Nazis, List handed the family business over to his brother and relocated to Paris, where he had his first photographic exhibition.

From 1936 to 1940, working for *Harper's Bazaar, Vogue,* and *Life* as a photographer of celebrities, List traveled regularly between Greece, Italy, and Paris until the outbreak of World War II, when he settled in Greece to evade the German occupation of France.

List's photographs from this period are particularly noteworthy. In one of his best-known images, simply entitled "Athens, Greece" (1936), one see a mussy-headed young man, wearing only white briefs, standing in an arched doorway. Before him hangs a transparent curtain. In it, one sees silhouetted leaf forms surrounding an oval image of two swans swimming before a stylized Greek temple, literally veiling List's own desire. Lit from behind, the shadows seem to press up against the figure and give it form.

The image of the adolescent boy remained a recurring subject throughout List's photographic career. In another photograph known as "North Sea, Germany" (ca. 1933), a young boy is set against a clear sky, his crouching form holding a single metal pole. The pole dissects the frame and gives the image a modernist charge.

His body is seen from below, filling the image with all the force of idealized youth. His face is in profile. His blond hair hangs freely in a pose that brilliantly captures the spirit of the *Jugendbewegung,* a popular romantic, nature-oriented, antibourgeois movement that would later be transformed by the Nazis.

After the German army invaded Greece, List was forced to return to Germany. He resettled in Munich, but in 1944, though part-Jewish and known as a homosexual, he was drafted into the military. He served as a map designer in Norway.

After the war, List became an associate member of the photographic agency Magnum, but he rarely accepted assignments. In 1953, his book of photographs taken in Greece, *Licht über Hellas,* begun a decade before, was finally published. In 1958, his second book of photographs, *Caribia,* featuring images taken in the Caribbean, was published.

By 1965, List had given up photography altogether in order to concentrate on his extensive collection of drawings.

Today, List is probably best known for his posthumously published book *Junge Männer,* which contains over seventy images of idyllic young men and boys lying in the sun, swimming, wrestling, or innocently staring into the camera's lens. These images beautifully combine eroticism with an avant-garde sensibility and a curious innocence.

— *Ken Gonzales-Day*

BIBLIOGRAPHY

List, Herbert. *Junge Männer*. Stephen Spender, intro. Max Scheler and Jack Woody, eds. Altadena, Calif.: Twin Palms, 1988.

———. *Herbert List: Photographs 1930–1970*. Text by Günter Metken and Stephen Spender. New York: Rizzoli; London: Thames and Hudson, 1981.

SEE ALSO

Photography: Gay Male, Pre-Stonewall; European Art: Twentieth Century

Lukacs, Attila Richard (b. 1962)

THE WORK OF CANADIAN PAINTER, SCULPTOR, AND installation artist Attila Richard Lukacs is frequently fetishistic and invariably provocative, especially in its depictions of skinheads.

Lukacs was born in 1962 in Edmonton, Alberta. He graduated with honors from the Emily Carr College of Art and Design in Vancouver in 1985.

Lukacs received recognition as a painter while still an art student. In October 1985, he was included in a group show entitled "Young Romantics" at the Vancouver Art Gallery.

Among the works by Lukacs in this exhibit, the painting *Il y a quinze ans que je n'ai fait pas ça* ("I Haven't Done That in Fifteen Years," 1985) unveiled themes, subjects (nude males, monkeys) and painterly styles (figurative representation) that have become principal characteristics of his later works.

With a strategic move to Berlin in 1986, Lukacs positioned himself within the social and cultural environment of the increasingly visible skinhead movement in Germany. A major show at the Künstlerhaus Bethanien in the spring of 1988 not only revealed an increased mastery of his medium, but also featured the direct representation of skinheads with homoerotic subtexts.

Two defining pictures, *Where the Finest Young Men...* (1987) and *Authentic Décor* (1988), bring to the fore the odious subject of neo-Nazi skinheads, but they do so by eroticizing them.

Skinheads are also the topic of *Junge Spartaner fordern Knaben zum Kampf heraus* ("The Young Spartans Challenge the Boys to Fight," 1988), which reveals the appropriation of compositional elements and subject matter from both Edgar Degas's *Young Spartans* (ca. 1860) and Caravaggio's *The Calling of St. Matthew* (ca. 1597–1598).

In 1990, Lukacs turned his attention to promotional material furnished by the United States military academies. He produced a series of paintings featuring youths performing various activities.

The inherent homoeroticism of such male-only training centers is defined in such works as *Gemini* (1990), which depicts two rugged teenagers with shorn heads struggling to climb posts. Of the same year are a series of images depicting skinheads, but whereas in earlier portrayals these hardened youths are represented as intimidating, now there is a perceptible shift in the style—illustrative, decorative, linear—and in the relational attitude: the skinheads begin to touch in overt homosexual activity.

This change in Lukacs's style and attitude culminates in Varieties of Love, a 1992 exhibition held at his longstanding commercial venue, the Diane Farris Gallery in Vancouver. The rough, ruinlike environments of his earlier work give way to Eastern art–influenced decorative backgrounds; and while some figures retain the relics of Lukacs's signature paintings of skinheads, clearly the artist now seems anxious to distance himself from the negative associations with skinheads.

The style and subject matter of these paintings reappear in his work shown at the Phyllis Kind Gallery in New York in early 2000.

Monumental canvases were featured in E-werk, a 1994 exhibition. In *This Town*, Lukacs depicts young workers with trademark shaved heads momentarily pausing from their backbreaking work. Although interpretable as a social commentary on the state of political affairs in postunified Germany, the grimy, fleshy youths are presented in such a way that the gay male viewer may linger with an erotic gaze on their labor-formed pectorals and sweat-covered limbs.

After a ten-year absence from North America, in 1996 Lukacs moved to New York City, where he currently lives. His midcareer work continues to confront viewers with sexual interests and fetishes held by many a gay man (suits, black socks, youths).

In terms of art history, Lukacs appears at the height of a revival of figurative painting in Europe and North America. Critics have praised him and his work, though they generally straddle two positions. On the one hand, they are in awe of his talent and ability as a painter; on the other, they are often at pains to account for the eroticism inherent in the work and for a subject matter they often revile.

In an interview article published in *The Advocate*, Lukacs is quoted as saying, "I'm a homosexual, but I don't consider myself a homosexual artist." Regarding his subject matter, in the same interview, Lukacs states, "For me it's a fetish. Simply, there is a fetishization of the skinhead style. Sex power politics. My work is about the potentiality of the very specialized and stylized culture of skinheads."

— *Eugenio Filice*

BIBLIOGRAPHY

Danker, Jo-Anne Bernie. "Young Romantics: Paintings by Graham Gillmore, Angela Grossmann, Attila Richard Lukacs, Vicky Marshall, Philippe Raphanel, Charles Rea, Derek Root, Mina Totino." *Vanguard* 14.5–6 (Summer 1985): insert.

Dompierre, Louise. *Attila Richard Lukacs: The Power Plant 29 June–10 September 1989.* Toronto: The Power Plant Gallery, 1989.

Kroker, Arthur. *Attila Richard Lukacs.* Vancouver: Diane Ferris Gallery, 1990.

Tazzi, Pier Luigi. *Attila Richard Lukacs: Varieties of Love.* Vancouver: Diane Farris Gallery, 1992.

Whitington, G. Luther. "Skinheads and Jarheads: Artist Attila Richard Lukacs Redefines Macho Men." *The Advocate* (January 15, 1991): 66–67.

SEE ALSO

Canadian Art; Contemporary Art; Caravaggio

Lynes, George Platt (*1907–1955*)

AMERICAN PHOTOGRAPHER GEORGE PLATT LYNES became one of the country's most successful fashion and portrait photographers, but his greatest work may have been his intensely homoerotic dance images and male nudes.

The son of a minister, Lynes was born in Orange, New Jersey, in 1907, and raised near Englewood, New Jersey. He was educated in private schools.

He made his first trip to France in 1925. There he met Gertrude Stein, as well as such luminaries as Jean Cocteau and Pavel Tchelitchew, and two young Americans, Monroe Wheeler and Glenway Westcott. The latter were to become his close friends and lovers.

In 1926, after returning to the United States, he matriculated at Yale but failed to complete his freshman year.

Lynes made a second journey to France in 1928, this time traveling with Westcott and Wheeler, both well known in the literary and avant-garde circles of expatriate France. It was at this time that Lynes began to take portraits of the many celebrities he met.

He eventually photographed Gertrude Stein and Alice B. Toklas, Colette, Dorothy Parker, E. M. Forster, Tennessee Williams, Christopher Isherwood, Aldous Huxley, W. Somerset Maugham, Marsden Hartley, and Henri Cartier-Bresson, among many others.

Upon returning to New York, he began to work as a fashion photographer and lived with Wheeler and Westcott in a *ménage à trois*.

Lynes had the first solo exhibition of his photographs at the Leggett Gallery in 1932, followed by a two-man exhibition at the Julien Levy gallery with the well-known photographer Walker Evans.

By 1933, Lynes was a central figure in the New York photography world. He quickly became known for his highly stylized images characterized by expressionistic lighting, surrealistic props, and suggestive settings.

Throughout the 1930s, he produced portrait and fashion photography for publications such as *Vogue* and *Harper's Bazaar*.

In 1941, Lynes had a solo exhibition at the highly respected Pierre Matisse Gallery in New York, but by 1945 his success, and interest, in portrait and fashion work began to fade—along with his relationship with Westcott and Wheeler.

Early in the 1940s, Lynes fell in love with his studio assistant, George Tichenor. After Tichenor was killed during the war, Lynes had a brief affair with Tichenor's younger brother.

Although Lynes had achieved early fame as a commercial photographer, he also gained a wide reputation for his dance images and a more limited one for his photographs of male nudes.

In 1934, he was invited by Lincoln Kirstein and George Balanchine to photograph the dancers and productions of the American Ballet (later the New York City Ballet). This association, which continued almost to the end of his life, led to some of Lynes's most memorable images.

His photographs of several of the dancers in New York City Ballet's production of Balanchine's *Orpheus* (1950), featuring props designed by the famous sculptor Isamu Noguchi, are especially noteworthy.

In "Nicholas Magallanes and Francisco Moncion in *Orpheus*, New York City Ballet," two nude men clasp hands, the first reclining while the second reaches out to him. Their bodies are perfectly still and yet poised for action. Their taut and defined bodies are set off by the two Noguchi forms, which give the image its Surrealist flair.

In addition to photographing dancers in the 1930s and 1940s, Lynes also photographed several series of male nudes. These photographs frequently depict mythological figures, utilize theatrical lighting, feature symbolic tableaux or props, and are nearly always frankly homoerotic in their appeal.

Given the state of censorship at that time, it is not surprising that Lynes never published these photographs. Instead, he restricted their circulation to friends and admirers. Nevertheless, he considered these private photographs his most significant work, a judgment in which some later critics have concurred.

Lynes moved to Los Angeles in 1946 to head *Vogue*'s Hollywood office, but by 1948 financial pressure forced him to return to New York. Unfortunately, his earlier success was difficult to reclaim, and by late 1951 his failure to pay taxes led the government to close his studio and auction off his cameras.

American Landscape, a photomural by George Platt Lynes.

Lynes's later photographs, particularly his nudes, are marked by a significant change of style. He abandoned the highly staged tableaux of his earlier nudes in favor of a straightforward, even minimalist, aesthetic. Featuring few if any props, these later images are simple and honest portraits of naked men.

In 1949, Lynes began a personal and professional friendship with Dr. Alfred C. Kinsey, who, having published his controversial book *Sexual Behavior in the Human Male* the previous year, was beginning his research on homosexuality and gay male erotica. Although buying and selling nude male photographs was illegal at the time, Kinsey eventually managed to purchase over six hundred of Lynes's prints along with several hundred negatives for his new archive.

Diagnosed with lung cancer in 1954, Lynes spent several months traveling in Europe before his final return to New York, where he was hospitalized and died shortly thereafter.

In his last years, Lynes destroyed many of his negatives and prints, including his fashion photography, as well as his nudes. Although Lynes seemed to fear how his images might be received, surely he would be pleased to know that many of his works have not only survived but continue to find new audiences.

— *Ken Gonzales-Day*

BIBLIOGRAPHY

Crump, James. *George Platt Lynes: Photographs from the Kinsey Institute.* Bruce Weber, intro. Boston: Little, Brown, 1993.

Lynes, George Platt. *The New York City Ballet Photographs Taken by George Platt Lynes: 1935–1955.* New York: City Center of Music and Drama, 1957.

Woody, Jack. *George Platt Lynes: Photographs 1931–1955.* Pasadena, Calif.: Twelve-Trees Press, 1981.

SEE ALSO

Photography: Gay Male, Pre-Stonewall; American Art: Gay Male, 1900–1969; Cadmus, Paul; French, Jared; Hartley, Marsden; Subjects of the Visual Arts: Endymion; Subjects of the Visual Arts: Nude Males; Tchelitchew, Pavel

Mammen, Jeanne (1890–1976)

JEANNE MAMMEN WAS ONE OF THE MOST TALENTED
artists and illustrators to emerge from Germany's
Weimar epoch (1919–1933), the period following World
War I that culminated in the rise to power of the Nazis.

At a time when the predominant style was a frequently
harsh and unflattering realism, Mammen dedicated her
art to the gently satirical, sometimes sympathetic, repre-
sentation of Berlin's diverse constituencies, particularly
the newly visible lesbian.

As a lesbian herself, Mammen produced images of gay
women almost completely lacking in the sensationalism her
artist contemporaries preferred. Whether in dance clubs,
shops, or beds, Mammen's women demonstrate an affec-
tion for each other so palpable that their tenderness, rather
than their sexuality, becomes the subject of representation.

Mammen was born in 1890 in Berlin to a liberal and
prosperous family that encouraged her artistic talents
from an early age. Although German by origin, Mammen
spent most of her youth in Paris, where her family
moved for business reasons in 1900.

At the age of sixteen, she enrolled with her younger
sister in Paris's Académie Julian for a two-year course in
art. Like Käthe Kollwitz and Paula Modersohn-Becker,
who also studied at this academy, Mammen proved an
excellent student. She and her sister extended their stud-
ies a further two years at Brussels's Académie royale des
sciences, des lettres et des beaux-arts de Belgique and
Rome's Villa Medici Accademia di Francia.

Both women returned in 1912 to Paris, where they
rented a studio together and began their careers. At the
age of 22 in 1912, Jeanne began exhibiting in important
Paris and Brussels salons and rapidly won recognition
among critics.

Unfortunately, World War I interrupted the beginning
of a successful career in Paris. As a German family on
the wrong side of the front, the Mammens were forced
to flee France and to abandon their glass-blowing business
and their savings as war compensation. They ultimately
returned to Berlin in near destitution, a situation that
pressured Jeanne to make money from her talents in any
way possible.

These are the conditions that led her to the magazine
and book illustrations for which she is now famous. Her
charge most often consisted in representing the social types
who defined Berlin's growing excitement and notoriety.

Because Mammen effectively arrived in Berlin as a
French woman, she observed her subjects with a critical
distance that was typical of the Weimar era's "New
Objectivity." But unlike her colleagues who often
expressed a troubling ambivalence about their subjects,
Mammen largely signaled a jovial affection for them.

Whether fashionable night revelers, as in *Grosstadt*
(*Metropolis*, 1927), conservative bourgeois men, as in
Derby (ca. 1927), or financially self-sufficient women, as
in *Beim Pferderennen* (*At the Horse Track*, ca. 1929),
her characters are represented with a distinct humanity.

Indeed, her work satirically highlights the traits that make her subjects human.

In the case of her lesbian subjects, however, Mammen often suspended her distance and humor. For example, the series of seven lithographs she originally intended as illustrations for Pierre Louÿs's *Songs of Bilitis* features semiclad women in tender embraces. Their half-closed eyes, pecks on cheeks, and gentle embraces, as in *Freundinnen* (*Girlfriends*) and *Am Morgen* (*In the Morning*), signify the women's deep contentedness with each other.

Other more dramatic works in this series take on subjects such as jealousy, relationships between women of vastly different ages, and the ambience of a lesbian bar. But even in this last image, *Damenbar (Lesbian Bar)*, Mammen softens the distinct male and female look adopted by the central dancing couple, focusing instead on their gentle embrace.

These and the many other lesbian images Mammen created in the Weimar period constitute some of the earliest and most sympathetic representations of lesbians since Sappho.

When the Nazis rose to power, Mammen had to adopt more conservative subject matter, but she survived unnoticed by fascism, making Cubist-inspired painting and sculpture well into the 1970s. Toward the end of her life, Mammen became a near cult figure among members of Berlin's post-1968 feminist movement.

— *Andres Mario Zervigon*

BIBLIOGRAPHY

Kunsthalle in Emden and Stiftung Henri Nannen. *Jeanne Mammen: Köpfe und Szenen, Berlin 1920 bis 1933*. Bonn: VG Bildkunst, 1991.

Michalski, Sérgiusz. *New Objectivity*. Cologne: Taschen, 1994.

Reinhardt, Hildegard. "Jeanne Mammen (1890–1976): Gesellschaftsszenen und Porträtstudien der zwanziger Jahre." *Niederdeutsche Beiträge zur Kunstgeschichte* 21 (1983): 163–188.

Verein der Freunde eines Schwulen Museums in Berlin. *Eldorado: Homosexuelle Frauen und Männer in Berlin 1850–1950, Geschichte, Alltag und Kultur*. Berlin: Edition Hentrich, 1984.

SEE ALSO

European Art: Twentieth Century; Subjects of the Visual Arts: Nude Females; Subjects of the Visual Arts: Prostitution

Mapplethorpe, Robert (1946–1989)

GIFTED AMERICAN PHOTOGRAPHER ROBERT Mapplethorpe brought rigorously formal composition and design, and an objectifying "cool" eye, to extreme subject matter. In so doing, he sparked a firestorm of outrage that led to debate about the public funding of art in the United States.

Born into a Catholic family in Queens, New York, on November 4, 1946, Mapplethorpe grew up in suburban Long Island. He studied painting, sculpture, and drawing at Pratt Institute in Brooklyn from 1963 until 1969, when he moved to the Chelsea Hotel with the singer and poet Patti Smith, who was to become one of his favorite models.

In the early 1970s, Mapplethorpe began making black-and-white photographs. In 1972, he began a long-term intimate relationship with Sam Wagstaff, former curator of the Wadsworth Atheneum in Hartford and the Detroit Institute of Arts, who served as his mentor as well as his lover.

Wagstaff encouraged Mapplethorpe's photography and helped arrange for his first solo show, Polaroids, at the Light Gallery in 1973. Subsequently, Mapplethorpe began exhibiting widely and quickly earned a reputation as an extraordinarily accomplished photographer.

In 1978, Mapplethorpe published the *X Portfolio* and the *Y Portfolio* in limited editions. *X* centers on photographic images of S/M behavior, while *Y* focuses on flowers and still lifes. In 1981, Mapplethorpe published the *Z Portfolio*, which focuses on black men, also in a limited edition.

Together, these three portfolios represent his best-known work and his persistent themes. His photographs typically combine rigorously formal composition and design with extreme—often explicitly sexual—subject matter. Even his still lifes and other nonsexual images convey a strong sexual aura.

Mapplethorpe's gaze is particularly noteworthy for its cool detachment even when recording scenes of intense sexual activity. The artist typically presents masculine bodies as objectified icons of desire.

Mapplethorpe's objectification and fetishization of the black male body has been particularly controversial, especially since the publication of *The Black Book* in 1986. The controversial photograph "Man in a Polyester Suit" (1980), for example, features a black man in a slightly wrinkled three-piece suit. The image is cropped both at the chest and above the knees. Hanging from the suit's fly is a large, semi-erect, uncircumcised penis.

In another image, "Philip Prioleau" (1979), a naked black man is seated on a wooden pedestal, his back facing the viewer, a paper backdrop in the background.

But the accusations of objectification and exploitation have been countered by readings of these images that point out the artist's practice of naming his sitters, and that emphasize the erotic balance between sitter and photographer. As a gay photographer, Mapplethorpe was frequently implicated in his own, sometimes transgressive, sometimes idyllic, desire.

Mapplethorpe imposes a formalist compositional technique on even his most extreme subject matter. Edges

move the eye through the famous images of intense sado-masochistic activity. For example, in "Jim, Sausalito" (1977), one finds a leather-hooded man, his eye and mouth openings unzipped, his body crouching against a metal ladder.

The figure is caught in a square of light in the center of the image and framed by a scratched and peeling concrete wall. The wall suggests an exterior or public area that has been transformed by gay desire into a highly sexualized space. This combination of formal elements and desire is Mapplethorpe's signature contribution as an artist.

In 1986, Mapplethorpe was diagnosed with AIDS. The following year, his companion and mentor Sam Wagstaff died of complications resulting from AIDS.

In 1988, the artist established a charitable foundation to support AIDS research and photography projects.

Also in 1988, Mapplethorpe's first American retrospective was presented at the Whitney Museum of American Art in New York. However, the following year, shortly after the artist's death on March 9, the traveling exhibition Robert Mapplethorpe: The Perfect Moment, begun at the Institute of Contemporary Art in Philadelphia, created a firestorm of controversy.

Senator Jesse Helms actually destroyed an exhibition catalog on the floor of the United States Senate, igniting a debate that ultimately decimated public funding for the arts and challenged First Amendment rights. In a shocking capitulation to political pressure, the Corcoran Gallery in Washington, D. C., cancelled the show just prior to its opening.

In 1990, the exhibition traveled to Cincinnati, where Contemporary Art Center director Dennis Barrie was indicted on charges of obscenity and child pornography. Both Barrie and the museum were subsequently acquitted, but one of the consequences of the charges was to demonstrate how threatening images of gay male sexuality are to many people.

Some of the controversies sparked by Mapplethorpe's photographs have settled, but his work continues to remind us that the perfect moment may be as fleeting as the click of the camera's shutter. — Ken Gonzales-Day

BIBLIOGRAPHY

Bolton, Richard, ed. Culture Wars: Documents from the Recent Controversies in the Arts. New York: New Press, 1992.

Mapplethorpe, Robert. Robert Mapplethorpe, Early Works. John Cheim, ed. New York: Robert Miller Gallery, 1991.

———. Mapplethorpe. Mark Holborn, ed., with an essay by Arthur C. Danto. New York: Estate of Robert Mapplethorpe/Random House, 1992.

Meyer, Richard. "Robert Mapplethorpe and the Discipline of Photography." The Lesbian and Gay Studies Reader. Henry Abelove, Michele Aina Barale, and David Halperin, eds. New York: Routledge, 1993. 360–380.

SEE ALSO

Photography: Gay Male, Post-Stonewall; American Art: Gay Male, Post-Stonewall; Contemporary Art; Erotic and Pornographic Art: Gay Male; Censorship in the Arts; African American and African Diaspora Art; Dureau, George; Flandrin, Hippolyte; Ligon, Glenn; Subjects of the Visual Arts: Nude Females; Subjects of the Visual Arts: Nude Males

Marées, Hans von (1837–1887)

GERMAN-BORN PAINTER HANS VON MARÉES SPENT much of his career in Italy. He is best known for a set of large frescoes painted in the Stazione Zoologica in Naples. In these and other works he depicted male nudes, often in tranquil bucolic settings or in scenes from classical mythology. His work includes homoerotic drawings and paintings, such as Cheiron und Achilles (1883) and Entführung des Ganymed (The Rape of Ganymede, 1887).

Von Marées was born to a prosperous family in Dessau, Germany, on December 24, 1837. As a young man, he went to Berlin to study art at the Akademie and later in the studio of Carl Steffeck, who specialized in equestrian and hunting scenes. Von Marées's early work consisted mainly of equestrian and military subjects. Even after leaving Steffeck's studio and moving to Munich, he continued to choose similar themes for his paintings.

Von Marées also developed an interest in portraiture. His early self-portraits—the first of fifteen that he would eventually paint—show the influence of Rembrandt.

The influence of Venetian painting, with its use of rich colors, can be seen in a number of works that von Marées produced in 1863. He designed decorative panels with mythological themes for the St. Petersburg home of Baron Alexander Lyudwigovich Stieglitz and also painted a woodland scene, Rast der Diana (Diana Resting). Von Marées would return to mythological subjects throughout his career.

In 1864, von Marées left Germany for Italy, where he would remain for most of his life. Commissioned by Adolph Friedrich Graf von Schack to paint copies of works of the old masters, von Marées copied several paintings, but these were, as Christian Lenz states, "not so much painstaking reproductions of the originals as evidence of an independent exploration of the subjects." Not satisfied with the copies, Schack ended von Marées's commission in 1868.

While working in Italy, von Marées met and became enamored of Adolf Hildebrand, a young German sculptor and architect. When Hildebrand went back to Berlin, von Marées followed. He rented a studio and shared it with Hildebrand, who had become his pupil and protégé.

In 1873, both men returned to Italy when von Marées received a commission to paint the decorations

for the Stazione Zoologica in Naples. The two artists collaborated on the project, Hildebrand contributing *trompe l'oeil* architectural elements for the five large frescoes by von Marées.

Two of the frescoes, *Aufbruch der Fisher* (*Fishermen Setting Off*) and *Das Boot* (*The Fishing Boat*), depict Neapolitan boatmen. In the first, six burly men—three of them nude, the others wearing only shorts—are launching a boat. The second shows five men energetically rowing a boat that transports a bored-looking woman who is paying them no attention.

Another pair of frescoes, *Orangenhain; Die Frauen* and *Orangenhain; Die Männer*, depict figures in an orange grove. In the former, two women in contemporary dress are sitting on a bench conversing. The most prominent figure in the second is a nude young man plucking an orange from a tree.

The other figures in the male scene are an elderly man (clothed) digging with a shovel, and two boys, one clothed

and seated, the other nude and lying on the ground. Von Marées would repeat the theme of nude young men in idyllic groves in several subsequent paintings, including *Drei Jünglinge unter Orangenbaümen* (*Three Youths under Orange Trees*, 1875–1880).

The final fresco, *Pergola*, shows friends sitting at an outdoor table and drinking wine. Von Marées placed himself and Hildebrand in the scene. The two sit side by side, their heads close together.

When the fresco project was completed, von Marées and Hildebrand moved to Florence, where they remained for two years. Their romantic relationship ended when Hildebrand fell in love with and married Irene Koppel, a member of the German expatriate community in Rome who had sat for a portrait by von Marées.

Von Marées depicted the end of his romance with Hildebrand in a drawing, *Die Frau zwischen die beiden Männer* (*The Woman between the Two Men*, 1875). In it, von Marées, clad in a loincloth, stands to the left, his gaze direct and his arm extended to the nude Hildebrand. The younger man returns only an oblique regard and makes a tentative gesture toward grasping von Marées's open and outstretched hand. A serene Koppel, dressed in a classical robe, looks fixedly at Hildebrand as she places a laurel wreath on his head.

Hildebrand and Koppel returned to their native Germany, but von Marées remained in Italy and went back to teaching. Beginning in the mid-1870s, he worked with sculptors Artur Volkmann, Peter Bruckmann, and Louis Tuaillon. Von Marées often made sketches for the sculptures that they produced, generally on subjects from classical mythology. Von Marées himself intended to sculpt a marble nude of Nestor and made a series of preparatory sketches, but did not complete the project.

Von Marées died in Rome on July 5, 1887. At the time of his death, his work—apart from the frescoes—was not widely known to the public. Some years later, Hildebrand designed a museum built in Munich in von Marées's memory. Recently, there has been a renewed interest in the artist and his work, as witnessed by exhibitions in Munich and other cities and by an increase in scholarship and criticism.

— *Linda Rapp*

BIBLIOGRAPHY

Aldrich, Robert. "Marées, Hans von." *Who's Who in Gay and Lesbian History from Antiquity to World War II.* Robert Aldrich and Garry Wotherspoon, eds. London and New York: Routledge, 2001. 297.

Lenz, Christian, ed. *Hans von Marées.* Munich: Prestel-Verlag, 1987.

———. "Marées, Hans (Reinhard) von." *The Dictionary of Art.* Jane Turner, ed. New York: Grove's Dictionaries, 1996. 20: 404–406.

SEE ALSO

European Art: Nineteenth Century; Subjects of the Visual Arts: Nude Males

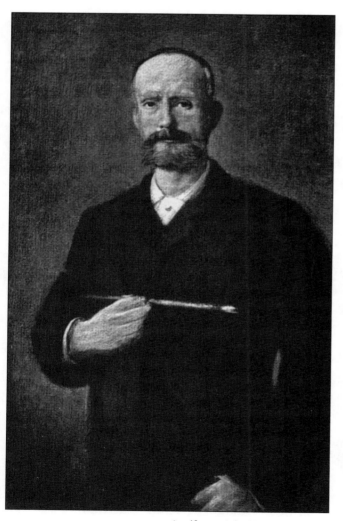

A self portrait by Hans von Marées.

Meurent, Victorine *(1844–1927)*

BEST KNOWN AS THE MODEL FOR A NUMBER OF PAINTings by Édouard Manet, including *Olympia* (1863) and *Déjeuner sur l'herbe* (1863), Victorine Meurent (sometimes spelled Meurend or Meurand) was also an artist in her own right. While none of her work survives and her own identity has been obscured or even replaced by the images she modeled, she has nevertheless emerged as symbolic of the fate of women artists in nineteenth-century France.

Meurent began her modeling career at the age of sixteen, when she posed for Thomas Couture, an artist who also offered drawing classes for women. She first worked for Manet in 1862, posing for a painting entitled *The Street Singer*. He continued to use her as a model at various times until 1874.

Because Manet painted her as a courtesan, viewers and commentators have often assumed that Meurent was a girl of the streets, a wanton and dissolute character. In fact, she came from a family of artisans and aspired to a career in art from an early age.

Manet's biographer Alphonse Tabarant noted Meurent's ambitions—albeit dismissively—saying that she fancied herself an artist at the time she came to work for Manet. In view of her youth, it is hardly surprising that she was not yet an accomplished artist. She was, however, serious about art. In the years to come, she would continue her study of drawing and painting at the Académie Julian and with private instructors.

At some point in the early 1870s, Meurent traveled to America. It is not known how long she spent there or why she made the trip. There is some indication that she hoped to sell paintings, although Tabarant claims that she was motivated by *"une folie sentimentale."*

By 1873, she was back in Paris, dedicating herself to her painting and showing her work for the first time. In 1875, she became the student of Étienne Leroy, a portrait painter whose work had been shown at the prestigious Paris Salon; and, in 1876, one of Meurent's works, a self-portrait, was selected for the Salon's annual show.

Another of her paintings, *Bourgeoise de Nuremberg au XVIe siècle*, appeared in the Salon of 1879. Her work was also included in the exhibitions of 1885 and 1904.

By 1879, when Meurent exhibited at the Salon for the second time, she had become estranged from Manet and his circle. Tabarant states that she was no longer welcome among them due to certain love affairs that had caused her to become the subject of unpleasant gossip, the exact nature of which he does not specify.

Meurent continued to live and work in Paris, but during the 1880s she appears to have fallen on hard times. In 1883, she wrote to Manet's widow, recalling to Madame Manet her late husband's promise to provide her with some money if he succeeded in selling the paintings for which she had posed. She had declined his offer at the time but said that she would remind him of it once her modeling career was over. The appeal to Madame Manet was unavailing.

The next glimpse of Meurent comes in the early 1890s, when her path again crossed that of people from the circle of Manet. They reported that she was frequenting the Montmartre district, drinking heavily, regaling people with her stories, and trying to sell them her drawings. She was said to be *l'amie intime* of Marie Pellegrin, described as a lesbian and a courtesan.

Tabarant calls this period of Meurent's life her *"fin douloureuse"* ("sad end"), but in 1893 she was again exhibiting her artwork, this time at the Palais de l'Industrie.

In 1903, Meurent was admitted to the Société des Artistes Français. Candidates for this organization needed the sponsorship of two members, and one of those who presented Meurent was the society's founder, Tony Robert-Fleury.

For the last two decades of her life, Meurent shared a home in Colombes, a suburb of Paris, with a woman named Marie Dufour. Local census records indicate that Dufour worked at different times as a secretary and a piano teacher. Meurent is listed as an artist.

The two women took turns identifying themselves as *chef*, the head of the household. In the column for the relationship of another resident to the household head, the second woman put *amie* ("female friend").

Sadly, none of Meurent's artwork is known to survive. There is a record of the sale of one of her paintings as late as 1930, but it, along with the rest of her production, has since disappeared.

As Eunice Lipton has argued, Meurent's significance is an emblematic one, revealing how women artists are frequently excluded from art historical discourse and more comfortably assigned the role of the subjects or inspirers rather than the creators of art.

— Linda Rapp

BIBLIOGRAPHY

Hamilton, George Heard. *Manet and his Critics.* New York: Norton, 1969.

Lipton, Eunice. "Representing Sexuality in Women Artists' Biographies: The Cases of Suzanne Valadon and Victorine Meurent." *The Journal of Sex Research* 27 (1990): 81–94.

———. *Alias Olympia: A Woman's Search for Manet's Notorious Model & Her Own Desire.* New York: Meridian, 1992.

Tabarant, Adolphe. *Manet et ses oeuvres.* Paris: Librairie Hachette, 1947.

SEE ALSO

European Art: Nineteenth Century

Michals, Duane (b. 1932)

HOMOEROTIC PHOTOGRAPHY HAS EXISTED ALMOST from the photographic medium's nineteenth-century inception, but more than a century passed before photographer Duane Michals discovered ways in which photography might represent same-sex love and spirituality as compellingly as it did same-sex desire.

Befitting an artist whose works often surrender their meaning gradually, Duane Michals did not become a photographer in the most direct, immediate manner. Born in McKeesport, Pennsylvania, on February 18, 1932, to working-class parents, Michals first took an interest in art as a teenager, enrolling in watercolor classes at the Carnegie Institute in nearby Pittsburgh.

Undergraduate art courses at the University of Denver exposed him to the work of Magritte and other Surrealists, whose oblique, associative methods would eventually inform Michals's self-described quest to "go beyond description" to "reveal the subject not as it looks, but how it feels."

Believing his life's vocation to be graphic design, Michals briefly attended the Parsons School of Design and held various jobs in the publishing industry. During a 1958 trip to the USSR, however, Michals discovered that photography was his métier and passion.

Self-taught, Michals became a successful commercial photographer within a decade's time, a career that continues to this day and has encompassed projects ranging from *Vogue* fashion spreads to *Life* magazine cover shots, from advertising imagery to album cover art.

But it is the noncommercial photography of Duane Michals that represents his primary contribution to queer visual culture. As early as 1970, Michals plotted the psychic terrain of urban gay life with his series "Chance Meeting," in which two men are seen to cruise each other within the sharply receding space of an alley that communicates both the encounter's intensity and also its potential for alienation.

"The Unfortunate Man" (1978) allegorizes the crippling personal effects of gay criminalization, combining photographic image and coarsely handwritten text in what would become Michals's distinctive style. His frequent incorporation of textual elements is not only Michals's accounting for reality beyond the visible world, but also his unassuming participation in the gay literary tradition that occasioned two books of photographic homages: *Homage to Cavafy* (1978) and *Salute, Walt Whitman* (1996). (Among Michals's two dozen books and catalogs, there is also a tribute to René Magritte, with whom Michals shared a fondness for sophisticated visual humor.)

With the publication of his illustrations of ten homoerotic poems by Constantine Cavafy, Michals identified himself publicly as gay, and thereafter one finds in his oeuvre images of tremendous tenderness between men, for example, "Just to Light His Cigarette Was a Pleasure" (1978) and "How Nice to Watch You Take a Bath" (1986).

It should be mentioned that Michals's meditations on human affection were never exclusively gay. Indeed, the impartiality with which the artist's lens has shifted focus among variously gendered pairings is perhaps his most profound commentary on the protean nature of the heart and sexuality.

At the same time, however, the prevalence of male nudes in these works leaves little doubt as to the photographer's orientation, just as Michals makes it clear that he subscribes to classical Western notions of physical beauty.

It is also significant that Michals has often cast himself as a character within his narrative-driven photographic sequences, exposing not only his body but also his personal stake in these open-ended discussions of attraction, aging, desire, love, and mortality.

— *Mark Allen Svede*

BIBLIOGRAPHY

Bailey, Ronald H. *The Photographic Illusion, Duane Michals.* Masters of Contemporary Photography. Dobbs Ferry, N. Y.: Morgan & Morgan, 1975.

Livingstone, Marco. *The Essential Duane Michals.* London: Thames and Hudson; Boston: Bulfinch Press, 1997.

Michals, Duane. *Homage to Cavafy: Ten Poems by Constantine Cavafy, Ten Photographs by Duane Michals.* Edmund Keeley and Philip Sherrard, trans. Duane Michals, preface. Danbury, N. H.: Addison House, 1978.

———. *Salute, Walt Whitman.* Includes selected writings by Whitman. Santa Fe: Twin Palms Publishers, 1996.

www.pdn-pix.com/legends3/michals/

SEE ALSO

Photography: Gay Male, Post-Stonewall; American Art: Gay Male, Post-Stonewall; Surrealism; Subjects of the Visual Arts: Bathing Scenes; Subjects of the Visual Arts: Nude Males; Tress, Arthur

Michelangelo Buonarroti (1475–1564)

MICHELANGELO'S MARBLE STATUE OF DAVID AND HIS frescoes on the vault of the Sistine Chapel are among the most widely recognized examples of Italian Renaissance art, and their maker the most famous artist who ever lived.

By sixteenth-century standards Michelangelo lived to the exceptionally old age of almost eighty-nine, and he continued to work until only a few days before his death. From a working career that spanned more than seventy

years, he left an enormous legacy in sculpture, painting, drawing, and architecture.

Furthermore, apart from occasional visits to north Italian cities such as Bologna and Venice, in all those years Michelangelo never left Florence, where he was born, or Rome, where he died.

Apprenticeship

At the customary age of thirteen, in 1488, Michelangelo became an apprentice of the distinguished painter Domenico Ghirlandaio, who was then at work on the choir frescoes for Santa Maria Novella in Florence, where Michelangelo likely learned to manage the demanding craft of fresco painting.

Before 1490, however, he was in the household of Lorenzo de' Medici, along with some other talented young artists, where he studied among the Greco-Roman sculptures that Lorenzo had collected and placed in a garden on the Piazza San Marco, under the care of Bertoldo di Giovanni, a prominent sculptor and former pupil of Donatello.

Thus, Michelangelo's entire formal education in painting did not exceed two years; and in sculpture we do not know exactly what techniques he and the other boys learned from Bertoldo.

Public Commissions

After Lorenzo's death in 1492, Michelangelo traveled north from Florence, making a brief stop in Venice in 1494 and a longer one in Bologna, where he found work. By 1496, he was in Rome, where, with the help of the banker Jacopo Galli, he obtained commissions for his two earliest large-scale works, the *Bacchus* (Florence, Bargello) and the *Pietà* (Rome, St. Peter's).

By 1500, he was back in Florence, where he achieved immediate fame with the marble *David* (1501–1504, Florence, Accademia). A committee formed for the purpose decided to set up the statue beside the entrance to the Palazzo della Signoria, where it or the present copy has remained ever since 1504 as a symbol of Florentine republican ideals.

To answer a summons to Rome from Pope Julius II della Rovere, in 1505 Michelangelo abandoned a project for a huge fresco, *The Battle of Cascina*, to be painted in open competition with Leonardo da Vinci in the Sala del Maggior Consilio of Florence's Palazzo della Signoria.

Portions of the finished cartoon (or preparatory drawing) survived, and Aristotele da Sangall made a careful copy of the central portion of the composition. These are enough to show that *The Battle of Cascina* was Michelangelo's first large-scale essay in the compositional theme that was to preoccupy him for the rest of his life, namely, muscular male nudes in highly active and complex positions.

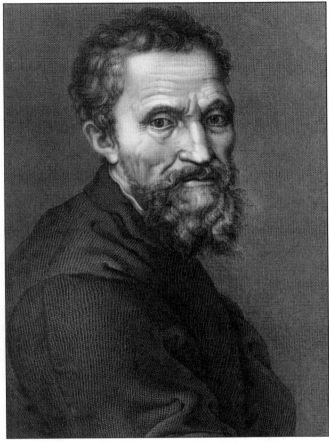

Michelangelo Buonarroti.

Indeed, this theme features prominently in Michelangelo's first project for the pope, which was the design and execution of a colossal tomb, not completed until forty years later, in 1545, in a much-reduced version.

Of the early sculptures intended for the *Julius Tomb*, only the *Moses* (Rome, San Pietro in Vincoli) forms part of the final composition. Other pieces, especially the two so-called *Slaves* (Paris, Louvre) and the group of four *Captives* (Florence, Accademia) remained in the artist's possession until his death.

The most immediate consequence of Julius's 1508 decision to abandon the tomb project was the frescoed vault of the Sistine Chapel, built by Julius's uncle, Pope Sixtus IV, in the late 1470s.

Julius died within a few months of the painting's completion in October 1512, and his successor, Pope Leo X, shifted Michelangelo's energies away from Rome and back to Florence.

Leo X had been born Giovanni de' Medici, son of Lorenzo de' Medici and therefore the artist's childhood friend. With the support of Leo and his first cousin, Cardinal Giulio de' Medici, natural son of Lorenzo's brother Giuliano, Michelangelo undertook extensive work

at San Lorenzo, the Florentine parish church that had been under Medici patronage since the early fifteenth century.

For it, Michelangelo designed a never-built facade, a library, and an independent burial chapel for his patrons' fathers, brothers, and cousins. The work occupied Michelangelo from 1516 until he abandoned the whole project on returning to Rome in 1534.

The reasons for Michelangelo's precipitous departure from Florence have never become entirely clear. We know that he was disappointed with his patrons' support of the Holy Roman Emperor Charles V, who eradicated the ancient Florentine constitution by creating Alessandro de' Medici Duke of Florence and giving his natural daughter, Margaret of Austria, as the new duke's bride.

Once back in Rome, Michelangelo painted the *Last Judgment* on the altar wall of the Sistine Chapel and a pair of enormous frescoes, showing the *Crucifixion of St. Peter* and the *Conversion of St. Paul* for the new pope, Paul III Farnese.

After 1534, in fact, Michelangelo never accepted another commission for sculpture; and once he had completed the second set of frescoes for Paul III in 1545, he never took another commission for a painting. All of that is to say that, after 1534, Michelangelo turned his attention almost exclusively to architecture.

Among the most important projects of his last years are the design for the Campidoglio, the ceremonial civic center of Rome on the Capitoline Hill, and the ongoing work on St. Peter's, begun by Bramante more than forty years before Michelangelo became its architect.

Private and Personal Works

Michelangelo's figural work in sculpture and drawing from the final three decades of his life is almost entirely private and personal in character. In this group one finds the *Pietà* in Florence (before 1555, Museo dell'Opera del Duomo) and the so-called *Rondanini Pietà* (1554–1564, Milan, Castello Sforzesco), both projects for the artist's own tomb.

The enigmatic bust of *Brutus* (Florence, Bargello) may also be dated to this period, along with an important group of highly finished drawings, called "gift" or "presentation" drawings, that Michelangelo made for his most intimate friends. Far more than the works made for public display, these latter give us the insight into the artist's affective and erotic life that otherwise evades any but the most speculative commentary.

Even so, no Renaissance artist is better documented than Michelangelo. In addition to figuring in numerous contemporary records, he was the subject of two biographies published in his lifetime, by Giorgio Vasari (1550) and Ascanio Condivi (1555), as well as the protagonist of a fictional dialogue on the nature of painting by his Portuguese admirer Francisco de Hollanda (1538).

The scores of letters to and from Michelangelo show that he was a prodigious correspondent; and he was also the author of more than 300 surviving poems. All of this has made it possible to draw a portrait of Michelangelo's complex psyche in greater detail than that of any of his contemporaries, with the possible exception of Queen Elizabeth I.

Michelangelo's Sexuality

Speculation about Michelangelo's sexuality first appeared in modern scholarship in the well-documented biography by John Addington Symonds (London, 1893). Despite all subsequent attempts by archival researchers, however, no written evidence has ever come to light that documents Michelangelo's erotic life.

This lacuna in the bounty of evidence cannot have been the result of an oversight, as Renaissance documents of all sorts recount the sexual proclivities of various artists in some detail.

Raphael (1483–1520), for example, seems to have been a great womanizer; and the flamboyant behavior of the Lombard painter Giovanni Antonio Bazzi (1477–1549) earned him the nickname "Il Sodoma" ("Sodom"). Benvenuto Cellini's autobiography records without scruple his sexual escapades with both boys and women; and the second (1568) edition of Vasari's biographies of artists frequently mentions details of their domestic arrangements.

By contrast, contemporary records tell us next to nothing about the sexual behavior of Leonardo da Vinci (1452–1519) or Michelangelo. We do know that neither ever married and that, while still a youth in Florence, Leonardo was once arrested on suspicion of sodomy, the term commonly used to include all homosexual genital behavior.

Of Michelangelo the sources convey only rumors of sodomy. Condivi, whose biography Michelangelo virtually dictated, not only denied the rumors but insisted that the artist observed lifelong chastity. No surviving evidence contradicts that assertion.

However, it is important to remember that Michelangelo was eighty at the time that Condivi wrote, and that the religious climate then dominating Rome and the Papal Curia valorized chastity over marriage itself, even for laymen.

In any case, Renaissance culture did not consider involuntary erotic object-choices to be constituents of personal identity. In this they were no different from the biblical writers who provided the proof-texts for theological condemnations of sodomy.

All alike assumed that sexual behavior was entirely voluntary and that an adult male's object-choice would fall naturally on desirable women, whereas the frequent and commonly acknowledged desire for adolescent boys was held to be the mischievous temptation of pesky demons.

Thus, a Christian was responsible only for his or her behavior, not for the motives that lay behind it. On those grounds moralists insisted that, while homosexual attractions were simple temptations, homosexual acts themselves were, literally, unnatural and therefore deliberate perversions of God's will. In this light it would be anachronistic to claim that Michelangelo or anyone else in the period was "homosexual," "heterosexual," or even "bisexual" in the modern sense of those words.

Whatever descriptive term one chooses as appropriate for the culture in which he lived, three separate bodies of evidence demonstrate that Michelangelo experienced powerful erotic and emotional attachments. With one possible exception, moreover, these psychosexual attachments were limited to other men.

For that reason it seems historically legitimate to discuss Michelangelo's personality as that of a man whose erotic imagination was strongly oriented toward male object-choices. As such, it hardly matters whether Michelangelo ever engaged in a genital relationship with another person.

Letters and Poems

The first two bodies of evidence are Michelangelo's letters and poems. Although he was prickly and argumentative in his professional life, his personal correspondence shows him to have been loving, solicitous, and compassionate toward those with whom he enjoyed close relations. Quite naturally, these qualities feature in his letters to his father and brothers; and on occasion he wrote just as touchingly to his servants.

But, beginning in the 1530s and continuing to the end of his life, one also encounters a higher intensity of the same feelings in his letters to the Roman nobleman Tomaso de' Cavalieri, who outlived him; and, until her death in 1557, to Vittoria Colonna, daughter of a great Roman family and widow of Alfonso d'Avalos, Marchese of Pescara.

As early as the 1520s, Michelangelo wrote some poems indicating that he was enamored of a young Florentine, Gherardo Perini; and the many poems addressed to Tomaso de' Cavalieri, in combination with surviving letters and graphic evidence, leave no doubt that Michelangelo profoundly loved the younger Roman from the time of their introduction in 1533 until the artist's death more than thirty years later.

Typically for the period, Michelangelo cast his poems in highly conventional Petrarchan language and forms. Scholars have argued that the style itself beggars claims that Michelangelo's poetic expressions of love may be read as autobiographical.

Against that assertion, however, it must be noted that Michelangelo's first editor bowdlerized several of the love poems, first published in 1623, by changing masculine pronouns and endings to feminine ones.

Inasmuch as the editor was the artist's own great-nephew, Michelangelo Buonarroti the Younger, one can surmise that the emendations disguised what must have been at the least a family tradition that the poems in question were addressed not to an anonymous woman but to Tomaso de' Cavalieri and, more important, that they were erotic.

It was also in the early 1530s that Michelangelo began his passionate friendship with Vittoria Colonna, an older widow of the highest social rank whom Michelangelo can hardly have courted as a lover.

Their friendship instead grew out of their shared piety, which focused on the image of the suffering Christ as a stimulus to meditation on the expiation of sin through His death and resurrection. In this way Michelangelo and Vittoria Colonna were part of a large group of intellectuals, artists, and aristocrats in the vanguard of sincerely pious laypersons who supported the conciliar movement in the 1530s and 1540s.

They gathered around Ignatius of Loyola and the other early Jesuits; they followed the preaching of the renegade Capuchin friar Bernardino Ochino; and their sense of religion, inspired as it was with fervor but tempered with Humanist skepticism, was simultaneously at one with the spirit of reform then sweeping the Church and an object of suspicious interest on the part of Curial theologians.

Michelangelo's Nudes

To many people, Michelangelo's lifelong allegiance to the heroic male nude as the central and indeed sole integer of his visual imagination has often seemed the surest sign of his homosexual orientation. But this is probably not so.

Written evidence of same-sex attraction in the Renaissance suggests that most adult men were sexually attracted to the soft, curving physiques of adolescent boys rather than to the muscular, physically mature male body. As examples of the former category in works of art, one could cite epicene figures by Benvenuto Cellini, such as the *Apollo and Hyacinth* group, or *Ganymede*, whereas nude statues by Michelangelo, such as the marble *David* or the *Christ* in Rome's Santa Maria sopra Minerva belong to the latter type.

Even so, the flurry of puritanical criticism that broke out on the completion of the *Last Judgment* in 1541 might betray the detection of homoerotic content, but no explicit statement to that effect has come to light. As the objections focused on female as well as male figures, moreover, there can be little doubt that the cries for censorship of the nudes was a generalized matter of decorum.

Presentation Drawings

No inference of erotically charged romantic love is necessary when one turns to a group of drawings that Michelangelo made for Tomaso de' Cavalieri. Usually called "presentation drawings," these and related sheets belong to an entirely new form of graphic art, in which the artist makes a drawing as a finished expression of private thoughts to a specific individual.

Leonardo may have invented the genre, but Michelangelo used it to celebrate his relationships with Vittoria Colonna and Tomaso de' Cavalieri, the only two people for whom he is documented as having created a unique work of art as a token of personal esteem.

The work for Vittoria Colonna is strictly religious in subject matter. For Tomaso de' Cavalieri, however, Michelangelo depicted subjects not from Christian piety, but from pagan myths (*Ganymede*, *Tityus*) and private allegories of a Humanist type (*The Dream of Human Life*).

The homoerotic character of Michelangelo's presentation drawings, confessional letters, and love poetry is unmistakable. It is also resistant of definition in modern terms. At the same time, it would be malicious cant to deny the presence of homoerotic content simply because it does not fit with contemporary, mostly North American, discourses of sexuality.

Michelangelo's Erotic Longings and His Love of God

Above all else, Michelangelo struggled to reconcile his unavoidable erotic longings with his indelible love of God. Nowhere did that struggle leave a deeper trace than in the religious poetry of his late years, where he addresses Jesus with the same passionate affection that he had earlier lavished on Tomaso de' Cavalieri.

In these poems one can detect Michelangelo's painful wrestling with his conclusion that the means of earthly love open to him could not provide the immanent metaphor of heavenly love that the comforts of marriage bring to most men and women.

Far more than his works in painting and sculpture, Michelangelo's poems show him to have been among the very first Europeans to problematize homosexual experience as an intractable constituent of the self.

Influence

While it is true that the scholarly literature is silent on the matter of Michelangelo's affections until Symonds's biography of the 1890s, there is plenty of reason to believe that artists in immediately succeeding generations who are known to have entertained same-sex attractions mined the treasure of Michelangelo's male nudes for uses that cannot be interpreted as other than homoerotic.

Of these, Michelangelo Merisi da Caravaggio is most obvious; and others, such as Michelangelo's contemporary Cellini, make it clear that there has always been a

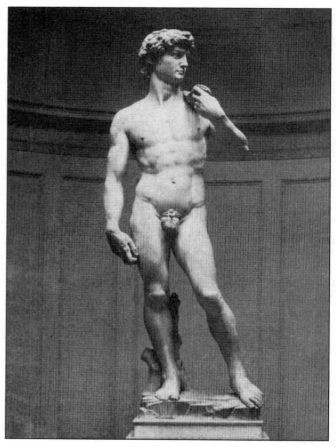

Michelangelo's *David.*

current of opinion that Michelangelo's sexual nature was oriented toward other men. However, it is only in very recent times, since the 1970s, that famous works by Michelangelo have become icons of contemporary gay culture.

Especially in the United States, the critical fortunes both of the *David* and the male nudes (*ignudi*) on the Sistine Ceiling have risen with the emergence of a thoroughly masculine, indeed *hyper*masculine, popular image for gay men.

However unlikely it may seem in this connection, the only historical evidence for the possible perception of the *David*'s erotic attraction for Florentines of Michelangelo's generation is the fact that, soon after the statue came to rest at the Palazzo della Signoria, a gilded circlet of bronze leaves was made to cover his nudity both front and rear.

While it is of course true that the statue may have elicited highly sexual responses from both male and female viewers ever since 1504, no recorded evidence of any kind would support a historical interpretation based on the *David*'s supposed homoerotic content.

— *William Hood*

BIBLIOGRAPHY

Ackerman, James S. *The Architecture of Michelangelo*. 2nd ed. Chicago: University of Chicago Press, 1986.

Condivi, Ascanio. *A Life of Michael-Angelo*. Alice Sedgwick Wohl, trans. Helmut Wohl, ed. University Park: Pennsylvania State University Press, 1999.

Hibbard, Howard. *Michelangelo*. 2nd ed. Cambridge, Mass.: Harper & Row, 1985.

Hirst, Michael. *Michelangelo and His Drawings*. New Haven: Yale University Press, 1988.

Michelangelo. *Michelangelo. The Complete Poems*. James Saslow, trans. New Haven: Yale University Press, 1991.

———. *Selected Readings*. William E. Wallace, ed. New York: Garland Publishing, 1999.

Rocke, Michael. *Forbidden Friendships: Homosexuality and Male Culture in Renaissance Florence*. New York: Oxford University Press, 1996.

Saslow, James. *Ganymede in the Renaissance: Homosexuality in Art and Society*. New Haven: Yale University Press, 1986.

Vasari, Giorgio. *The Lives of the Artists: A Selection*. George Bull, trans. London: Penguin Books, 1987.

SEE ALSO

European Art: Renaissance; European Art: Baroque; Erotic and Pornographic Art: Gay Male; Caravaggio; Cellini, Benvenuto; Leonardo da Vinci; Pontormo, Jacopo; Sodoma, Il (Giovanni Antonio Bazzi); Subjects of the Visual Arts: David and Jonathan; Subjects of the Visual Arts: Dionysus; Subjects of the Visual Arts: Ganymede; Subjects of the Visual Arts: Hercules; Subjects of the Visual Arts: Nude Females; Subjects of the Visual Arts: Nude Males

Minton, John *(1917–1957)*

JOHN MINTON WAS A PAINTER OF LANDSCAPES, TOWN scenes, and figure subjects in oil and watercolor, as well as an acclaimed illustrator. Minton's homosexuality was an important influence on his work. One of his main themes was the young male figure in emotionally charged settings.

Like many middle-class gay men of his generation, Minton was drawn to men who fulfilled a manly ideal, and this attraction manifested itself in much of his work, where he portrayed his handsome working-class lovers and other ideals of masculinity such as Guardsmen and matadors.

A key figure of the 1940s neo-Romantic movement and a celebrity of London's bohemia, Minton lived and worked with most of the younger generation of neo-Romantic artists, including Michael Ayrton, Robert Colquhoun, Robert MacBryde, and Keith Vaughan.

Born on December 25, 1917, Minton studied at St John's Wood School of Art from 1935 to 1938 and later went on to teach at Camberwell School of Art (1943–1946), Central School of Art and Crafts

(1946–1948), and the Royal College of Art (1948 until his death in 1957).

Minton's early work focused on the urban landscape he discovered during nocturnal jaunts around London, where he also discovered an active sexual underground. Visits to Spain in 1949 and Jamaica in 1950 offered Minton a fresh repertoire of subjects and enriched his palette of colors.

Although Minton was dedicated to painting, his reputation developed as a result of his skill as an illustrator. He produced a large number of illustrations for a wide range of books, such as *Time Was Away* by Alan Ross (1948) and *French Country Cooking* by Elizabeth David (1951), as well as for magazines such as *The Listener* and *The Radio Times*.

Minton's illustrative style became the fashionable norm of the 1940s, but after 1950, with the arrival and increasing popularity of abstraction, his figurative style went out of fashion.

Between 1950 and 1952, Minton lived openly with his lover, Ricky Stride, a bodybuilding ex-sailor. Theirs was a volatile relationship that ended as a result of almost constant fighting, which often resulted in violence on Stride's part.

On January 12, 1950, *The Listener* published a letter Minton wrote in response to a review of a new biography of Oscar Wilde by Herbert Read in which Dr. Marie Stopes discussed Wilde's sexuality and relationship with Lord Alfred Douglas in a denigrating fashion. Outraged, Minton pointed out the enormous contribution made to society by homosexuals, highlighted the fact that "the same vicious law which imprisoned Wilde still operates," and pleaded for a "saner and more comprehensive attitude toward the homosexual in society."

Minton's character revealed some great contradictions—his wild gaiety and love of wit and banter disguised and competed with an inner melancholy that verged on depression. Toward the end of his life, Minton began to express an obsession with death, and he was particularly moved by the death of film star and symbol of disaffected youth James Dean, in September 1955.

Minton's last painting, which remained unfinished, was initially based upon a car crash that he had witnessed in Spain; but it also, he told his friend Ruskin Spear, represented "James Dean and all that." As a result, the painting was posthumously titled *Composition: The Death of James Dean*.

On January 20, 1957, John Minton committed suicide by taking an overdose of Tuinal.

— *Shaun Cole*

BIBLIOGRAPHY

Graham, Rigby. *John Minton: A Commemorative Exhibition*. Aylestone, Leicester, U. K.: Cog Press, 1967.

John Minton, 1917–1957. An Exhibition of Paintings, Drawings and Illustrations. London: Arts Council of Great Britain, 1958.

John Minton, 1917–1957: Paintings, Drawings, Illustrations and Stage Designs. J. Rothenstein, intro. Reading, U. K.: Reading Museum and Art Gallery, 1974.

John Minton, 1917–1957: A Selective Retrospective. Newtown, Wales: Oriel 31, 1994.

Spalding, Frances. *Dance Till the Stars Come Down: A Biography of John Minton.* London: Hodder & Stoughton, 1991.

SEE ALSO

European Art: Twentieth Century; Vaughan, Keith

Morgan, Julia *(1872–1957)*

PIONEERING CALIFORNIA ARCHITECT JULIA MORGAN designed more than 700 buildings, including many commissioned by women's groups, but she is most remembered as the architect of San Simeon, the Hearst Castle, north of Los Angeles.

Morgan was born in San Francisco to an upper-middle-class family on January 20, 1872. She was reared in Oakland, California.

She earned an undergraduate degree in civil engineering from the University of California, Berkeley, in 1894 and was the first woman accepted into the architecture program at L'Ecole des Beaux-Arts in Paris. (Although Morgan arrived in Paris in 1896, it took her two years to convince L'Ecole that women should be allowed to study architecture.)

After serving stints in the offices of Paris and San Francisco architects, Morgan opened her own architectural firm in San Francisco in 1904. By then, she was living in a remodeled Victorian home.

The first woman architect to be registered in California, Morgan designed many residences in Berkeley, Claremont, and Piedmont and such institutional buildings in Berkeley as the Baptist Divinity School, Phoebe Apperson Hearst Memorial Gymnasium, St. John's Presbyterian Church, and Women's City Club.

She also designed a large number of buildings commissioned by women's groups in California, Hawaii, and Utah, including social clubs, sorority houses, and YWCAs. Commissions from women's organizations provided financial and professional support for Morgan while she designed the spaces that helped promote the women's movement.

As Sara Holmes Boutelle writes, "Morgan understood women's organizations, their goals, and limitations, not just because of her gender, but also because she shared their determination to improve the lives of individuals and groups who could not take social action on their own."

An expert in such construction methods as reinforced concrete, Morgan gained a reputation for excellence in both engineering and aesthetics.

Her style, which developed from the Arts and Crafts movement and a local Northern California tradition in the use of wood, is characterized by red and brown tones, horizontal lines that lead the eye into the landscape, exposed support beams, and plenty of shingles. The Asilomar Conference Center in Pacific Grove, founded in 1913 as the Western conference center of the YWCA, is typical of her work in that it grows comfortably out of its site.

Morgan's sense of proportion and harmony distinguished her from other designers in the Bay Area. She was also sensitive to the needs of her clients and the purposes of the buildings she designed.

In 1919, newspaperman William Randolph Hearst hired Morgan to build San Simeon, the elaborate Hearst Castle, north of Los Angeles. La Cuesta Encantada (The Enchanted Hill), as it is called, consists of over 150 rooms in the main building and guest houses, 127 acres of gardens, terraces, indoor and outdoor pools, and a private zoo.

The extraordinary scale of the project entailed an eclectic array of architectural details and decoration that necessitated the collaboration of hundreds of workers. Artisans carved, cast, wove, plastered, and painted the surfaces of the buildings that make up the complex.

For twenty-five years, Morgan collaborated with Hearst on the design of buildings, the purchase of art, and the placement of antiques for San Simeon.

She designed not only San Simeon, but also Wyntoon, Hearst's northern estate, built on 50,000 acres of forested land near Mount Shasta, along the McCloud River in California. "The effect of the 'village' is Bavarian," Boutelle writes, "but the symmetry of each building and the careful siting around the central green are more Beaux-Arts.... Morgan's use of the local stone and wood is characteristically sensitive."

When Morgan retired, in 1951, she had designed more than 700 buildings. Her popularity as an architect can be attributed to her attention to detail and craftsmanship, and her ability to design projects that met the needs of her clients.

At a time of emerging feminism, she could hardly avoid becoming a role model for younger women. Known for her compassion and pragmatism, she treated her employees as an extended family, sharing profits and helping with education loans.

Morgan led a private and quiet life. Little is known for certain about her emotional and affectional attachments, but she is believed to have been a lesbian. She was part of a network of accomplished professional women, many of whom were her clients.

Morgan was devoted to her profession and insisted that her projects speak for her. Perhaps as a self-protective gesture and a means of preserving her privacy, she main-

tained that architecture should be part of the visual, rather than verbal, world.

Morgan died on February 2, 1957.

— *Ira Tattelman*

BIBLIOGRAPHY

Aidala, Thomas R. *Hearst Castle San Simeon*. New York: Hudson Hill Press, 1981.

Boutelle, Sara Holmes. *Julia Morgan, Architect*. New York: Abbeville Press, 1988.

Julia Morgan Collection. Robert E. Kennedy Library, California Polytechnic State University, San Luis Obispo.

Paine, Judith. "Pioneer Women Architects." *Women in American Architecture: A Historic and Contemporary Perspective*. Susan Torre, ed. New York: Whitney Library of Design, 1977. 54–69.

Wadsworth, Ginger. *Julia Morgan, Architect of Dreams*. Minneapolis: Lerner, 1990.

SEE ALSO

Architecture; Arts and Crafts Movement

Native American Art

BEFORE THE EUROPEAN CONQUEST, MANY NORTH American Indian tribes recognized more than two genders. In fact, mixed genders were among the most widespread and distinctive features of Native American societies. Those individuals who combined the behavior, dress, and social roles of males and females were considered distinct from either sex.

Mixed-gender individuals who were biologically male have been documented in over 155 of the estimated 400 tribes in North America at the time of European contact. In approximately fifty of these groups, a formal status also existed for females who undertook a male lifestyle.

Since Native American worldviews emphasize and appreciate transformation and change, gender alteration was considered natural. Individuals were encouraged to live their lives in the gender role(s) that best suited them.

Sometimes, particularly among the American Indians of the Great Plains, visions or dreams were considered powerful and life defining and were responsible for gender change. Some individuals altered their genders several times during the course of their lives.

Cross-Dressing

The most visible marker of mixed-gender status among North American Indians was some form of cross-dressing. In some tribes, biological males of mixed gender dressed distinctly from both men and women. In other cases, they only partially cross-dressed, or not at all.

Cross-dressing varied even more for biological females. They often only wore men's clothing when hunting or in battle. (Warrior women were not necessarily mixed-gender individuals. Most Plains tribes had women warriors who accompanied war parties on certain occasions—for example, if they were avenging the death of a family member.)

It should be noted that the term *cross-dressing* does not adequately describe the pre-contact Native American practice whereby men and women donned the clothing of the opposite sex. Since it was possible for men and women in many of these societies to become social females and males, respectively, those who dressed in the clothing of the opposite sex were not actually cross-dressing.

Sexual and Emotional Relations

Mixed-gender Native Americans typically formed sexual and emotional relations with members of their own biological sex. Since it was possible for them to change their gender, their relationships were not homosexual as defined in contemporary Western terms.

In addition, Native Americans typically believed that individuals possessed a gender identity, but not a corresponding sexual identity.

Some mixed-gender individuals who were biological males had relationships with women, though in most cases these were men who were already warriors and husbands and who altered their gender because of a vision or

dream. Interestingly, mixed-gender individuals never had relationships with one another.

The mixed-gender role in certain Native American tribes provided an opportunity for women to assume the male role permanently and to marry women. Among the Mohave of Colorado, a girl who exhibited interest in male activities could choose at puberty to dress her hair in the male style and have her nose pierced like the men, instead of receiving a chin tattoo like other women.

In turn, the Mohave publicly acknowledged the status of the mixed-gender girl. They performed an initiation ceremony that recognized her identity as a social male, after which she assumed a male name and was granted the marriage rites of a male. These public rites validated her mixed-gender identity and signified to the community that she was to be treated as a man.

Artistic Depictions of Mixed-Gender Individuals

Mixed-gender individuals were depicted in a variety of North American Indian art forms. Artists of the Great Plains documented them on clothing and ledger drawings. In one drawing from 1889, a Cheyenne artist presents a female in battle wearing a man's breechcloth and holding a gun in her hand.

In a tempera-on-bristol work titled *Berdache* (1987), Cherokee artist Joe Lawrence Lembo depicts an individual who simultaneously possesses male and female traits. Lembo divides the figure in half; male garments (a loincloth) clothe the proper left side while female attire (a dress) covers the proper right side. Similarly, the hairstyle is divided by gender, and the figure wears an earring only in the proper right ear.

Berdache reveals the social and economic impact that mixed-gender individuals had on the community. Since women tended the crops, the figure's proper right hand holds ears of corn. The proper left hand grasps a bow and arrow because men killed game for food.

Mixed-gender individuals either fulfilled the duties of the opposite sex or blended the responsibilities of both sexes. He or she, then, embodied the interdependent nature of male and female roles and, by extension, the positive, cohesive aspects of the entire community.

The Status of Mixed-Gender Individuals

Since mixed-gender individuals frequently undertook the work duties of both sexes, they had a greater opportunity for personal and material gain than individuals who lived their lives in the role of a single gender. Some tribes, including the Navajo of the Southwest, granted mixed-gender individuals an elevated political and social status.

Many North American Indians believed that mixed-gender individuals contained both a male and a female inner spirit. The Sioux of the Great Plains, for example, thought that sometimes, when a woman was going to have twins, the two babies formed into one, into a half man–half woman being who was not a hermaphrodite.

Transformation and Special Powers

Mixed-gender men and women also embodied transformation, an important component of most Native American belief systems. Lembo's painting *Berdache* draws a parallel between the cycles of night and day (and, by extension, the seasons) and gender fluctuation. In his work, the moon is above the female side of the figure, and the sun is over the male side.

Mixed-gender individuals were often thought to have special powers. They sometimes held sacred positions, including shaman, healer, seer, and prophet. In addition, Native Americans often assigned the origins of gender diversity to the spirit world, which overruled biological sex.

As only one example, the Bella Coola, who reside in western Canada, have a god named Skheents who is biologically male and possesses an alternate gender. In pre-conquest times, individuals who exhibited a proclivity for shifting their gender were said to have been influenced by Skheents.

In mythology, Skheents is the first berry-picker, an honorable position since berries are an important seasonal food for the Bella Coola. Skheents guards a bevy of heavenly young maidens and is one of the village ancestors.

The Bella Coola make masks that represent Skheents and portray him in dances celebrating the berry harvest. During these performances, Skheents's face and voice are those of a woman, but he also possesses masculine characteristics.

Man-woman Kachinas

Among the people who resided in the pueblos of New Mexico and Arizona, man-woman kachinas, or gods, were portrayed in masked dances and ceremonies. Among the Hopi, one such kachina, called Hé-é-é, is known as the Warrior Maiden Kachina. Hé-é-é represents a warrior spirit and is described as either a man dressed in women's clothes or a woman using men's equipment, depending on the mesa where one hears the story.

At Second Mesa, the Hopi say that Hé-é-é represents a young man who was changing clothes with his bride in a cornfield. He was only half-dressed with his pants on under the dress, and with only one side of his hair in the style of a maiden (a whorl on each side of the head), when he saw enemies approaching. Grabbing his weapons, he fought them off until assistance arrived.

At Third Mesa, the Hopi describe Hé-é-é as a young maiden who had fixed only one side of her hair when enemies drew near. She grabbed her father's weapons and fought until help came.

Despite the variation of stories, Hé-é-é is consistently known as a powerful warrior. During one ceremony, the masked dancer who represents Hé-é-é leads a band of fearsome warrior kachinas that protect the ritual procession.

Mixed-Gender Artists

American Indians with mixed genders were not only depicted in art; they themselves produced artwork. Biological males often specialized in crafts, such as pottery, beadwork, and textile-making, which typically were the pursuits of women. In many tribes, mixed-gender individuals were among the most productive and accomplished artists of their communities.

Some of them were so talented that their names were recorded and their works cataloged. The Navajo Hastíín Klah, for example, is well known for his tapestries. As only one other example of many, the Laguna Arroh-ah-och produced beautiful pottery in the late nineteenth century.

The European Impact

Europeans had an impact on the lives of mixed-gender individuals when they arrived in North America. European attempts to suppress alternate-gender traditions ranged from the regulation of mixed-gender individuals in missions and boarding schools to their actual murder.

By the turn of the twentieth century, Native American attitudes toward sex and gender had been influenced by European values. No longer accepted and embraced, mixed-gender individuals frequently were disparaged.

Although alternate-gender traditions disappeared among some tribes, the institution went underground among others. In a few tribes it has continued to the present, and in others the tradition is being revived.

— *Joyce M. Youmans*

BIBLIOGRAPHY

Blackwood, Evelyn. "Sexuality and Gender in Certain Native American Tribes: The Case of Cross-Gender Females." *Ethnographic Studies of Homosexuality*. Wayne R. Dynes, ed. New York and London: Garland, 1992. 23–38.

Kenny, Maurice. "Tinseled Bucks: A Historical Study in Indian Homosexuality." *Living the Spirit: A Gay American Indian Anthology*. Will Roscoe, ed. New York: St. Martin's Press, 1988. 15–31.

Lang, Sabine. *Men as Women, Women as Men: Changing Gender in Native American Cultures*. Austin: University of Texas Press, 1998.

———. "Lesbians, Men-Women and Two-Spirits: Homosexuality and Gender in Native American Cultures." *Female Desires: Same-Sex Relations and Transgender Practices Across Cultures*. Evelyn Blackwood and Saskia E. Wieringa, eds. New York: Columbia University Press, 1999. 91–116.

McIlwraith, T. F. *The Bella Coola Indians*. 2 vols. Toronto: University of Toronto Press, 1948.

Roscoe, Will. *Changing Ones: Third and Fourth Genders in Native North America*. New York: St. Martin's Press, 1998.

Schaafsma, Polly. *Kachinas in the Pueblo World*. Albuquerque: University of New Mexico Press, 1994.

Sun, Midnight. "Sex/Gender Systems in Native North America." *Living the Spirit: A Gay American Indian Anthology*. Will Roscoe, ed. New York: St. Martin's Press, 1998. 32–47.

Williams, Walter L. *The Spirit and the Flesh: Sexual Diversity in American Indian Culture*. Boston: Beacon Press, 1986.

Wright, Barton. *Kachinas: A Hopi Artist's Documentary*. Flagstaff, Ariz.: Northland Press, 1973.

SEE ALSO

Pacific Art

New Zealand Art

NEW ZEALAND IS WIDELY KNOWN FOR ITS DIVERSE artistic production, which includes work by painters, filmmakers, dancers, and singers. For at least the past two centuries, many gay and lesbian artists have hailed from this small group of islands that lies just off the southeastern coast of Australia.

Frances Hodgkins

Perhaps the most famous bisexual New Zealand artist is the painter Frances Hodgkins (1869–1947), who trained as a watercolorist on the islands in the late nineteenth century. She spent most of her adult life in England and, by the end of her career, was regarded as one of the leading artists of the British modern movement.

Hodgkins lived for some time with a woman, never married, and warned her female students about the difficulty of combining marriage and motherhood with an artistic career.

Two self-portraits created during the 1930s illustrate her rejection of the conventional female role. Both self-portraits conflate the genre of self-representation with that of still life, wittily challenging the parameters of both. The still-life objects function as metaphors for Hodgkins's person and character.

The oil-on-cardboard painting entitled *Self-Portrait: Still Life* (ca. 1935) deconstructs, and therefore questions, traditional femininity. A centrally placed bowl, a pink rose, and a pink high-heeled shoe signify the self, the ideally feminine (according to society). Disembodied from any logical context, these objects seem strange and even, in the case of the shoe, ludicrous.

They encourage the viewer to ask: Why are these particular objects considered feminine? What qualities make an object, and by extension a person, feminine?

And why are these particular qualities considered feminine at all?

Compositionally, *Self-Portrait: Still Life* functions as an abstract, decorative painting. By combining traditionally feminine objects to create an ornamental pattern, Hodgkins suggests that femininity is something that is both relative and constructed: it is like an ornament that can be added to, but is not inherent in, humans.

In a painting closely related to *Self-Portrait: Still Life* and entitled *Still Life: Self-Portrait* (ca. 1933), Hodgkins depicts similar motifs on a canvas. This time, however, she sets a mirror—for obvious reasons a device typically found in self-portraiture—in the center of the composition. The mirror symbolizes Hodgkins's refusal to reflect conventional appearance.

Fiona Clark

In stark contrast to Hodgkins's symbolic and metaphoric paintings are the documentary-style photographs of contemporary artist Fiona Clark (b. 1954). Although Clark works in the mainstream documentary tradition, she is an innovator in terms of her subject matter and approach.

Clark has a twenty-year record of photographing groups in society that were, and sometimes still are, socially marginalized. She has worked almost exclusively in color since her days in art school in Auckland in the early 1970s.

While still in school, she photographed a series of transvestites that is uncompromising in its depiction of reality. The works focus on both single and multiple subjects who are portrayed with a sensitivity that conveys transvestism as a matter of fact, not as something that is sensational, strange, or shameful.

After leaving art school, Clark continued to produce images that documented the gay, lesbian, and transgender communities of New Zealand. Amy Bock, a lesbian who lived in New Zealand as a man during the early twentieth century, provided the inspiration for one series of images. Club 47, a lesbian nightclub located in New Plymouth, became the focus of another.

Clark's documentary style, combined with the empathy she feels toward her subjects, results in powerful photographs. The artist's works have helped ameliorate prejudice and social disdain toward those groups that are portrayed.

Mika

Like Clark's photographs, the performances of the cabaret star Mika have encouraged widespread acceptance and understanding of homosexuality. In the 1990s, Mika became New Zealand's best-loved drag queen. He is a Maori (the people who are indigenous to New Zealand), and he was born in Te Wai Pounamu, which is located on the southern island of Aotearoa.

Mika began singing as a small child, and at age fourteen began to perform publicly. After a period of acting, singing, and dancing in the *Maori Theatre in Education Company*, he embarked on a solo career. Today he tours internationally.

Mika's choreography fuses Maori, Polynesian, and European dance traditions into what he calls an "urban Maori dance style." He is passionate about the need for fresh, diverse Maori art forms. While he acknowledges the importance of his pre–European contact, or traditional, Maori heritage and pays homage to it during his performances, he also stresses that Maori culture is not dead: it is vital, complex, and ever changing.

Mika's performances often stir controversy since attempts to portray contemporary Maori life often create great debate. Thus, even Mika's most lighthearted shows overflow with content. The artist combines cabaret shows and Maori culture since both reflect an aspect of himself, and also because he despises the notion that indigenous work must be serious and mystical and bereft of joy and fun.

The artistic productions of Frances Hodgkins, Fiona Clark, and Mika are diverse, but they share a similar goal: to break stereotypes and encourage the acceptance of lifestyles that are not considered mainstream. While Hodgkins left her mark in the middle of the twentieth century, Clark and Mika continue to create new and exciting works.

— *Joyce M. Youmans*

BIBLIOGRAPHY

Buchanan, Iain. *Frances Hodgkins: Paintings and Drawings*. London: Thames and Hudson, 1995.

Eastmond, Elizabeth. "Metaphor and the Self-Portrait: Frances Hodgkins's Self-Portrait: Still Life and Still Life: Self-Portrait." *Art History* 22.5 (December 1999): 656–675.

Ireland, Peter. "Fiona Clark Biographical Details." www.virtual.tart.co.nz/Fiona/fiona.htm

Mika. www.mika.co.nz/

Nunn, Pamela Gerrish. "Frances Hodgkins: A Question of Identity." *Woman's Art Journal* 15 (Fall–Winter 1994–1995): 9–13.

Shepheard, Nicola. "Kiwi Cabaret Icon Mika on Drag, Dance and Urban Maori Culture." *Nzine*, October 27, 2001. www.nzine.co.nz/features/mika.html

Trevelyan, Jill. *Frances Hodgkins*. Wellington, New Zealand: Museum of New Zealand Te Papa Tongarewa, 1993.

SEE ALSO

Photography: Lesbian, Post-Stonewall; Hodgkins, Frances

Ocaña, José Pérez *(1947–1983)*

SPANISH DRAG ARTIST AND PAINTER JOSÉ ANGEL PÉREZ Ocaña was a fixture of the countercultural scene in Barcelona in the 1970s. He was the subject of a milestone film in Spanish cinema, *Ocaña, retrat intermitent,* by gay director Ventura Pons.

Although Ocaña is strongly associated with Barcelona, where he spent most of his adult life and where he came to public attention, he was a native of Andalusia, born on March 24, 1947, in Cantillana, near Seville. He loved the region, which he described as being "like a Surrealist painting," and absorbed its culture and customs—even if he sometimes stood them on their heads.

Ocaña developed a sense of individuality early on. As a boy he failed to conform to masculine stereotypes. He was a gentle child who was attracted to art and enjoyed dressing up, which sometimes made him the object of abuse.

In adulthood, Ocaña would stubbornly reject marginalizing labels; he did not wish to be known as a transvestite, insisting that he should merely be considered a person who enjoyed cross-dressing.

In 1971, Ocaña moved from Andalusia to Barcelona in Catalonia—a more cosmopolitan milieu yet also marginalized. Among the targets of the repressive policies of the Franco regime were cultural and linguistic minorities such as the Catalans.

In the 1970s, Barcelona became a center of counterculture, and Ocaña established himself as a player on the scene. He gained a following in the gay community, and gay cartoonist Nazario featured him as a character in his comic books. Especially during the "transition" period following Franco's death in 1975, he was a highly visible figure in the city, strolling along Las Ramblas, the main street, in extravagant costumes and staging "happenings" or *procesiones*.

The *procesiones* combined camp with the traditions of his native Andalusia, in particular the parades of Holy Week, for which the region is famous. In these, *cofradías* ("brotherhoods") of Catholic men carry huge, elaborately decorated floats containing large statues of saints, often the Virgin Mary. Groups of penitents march behind them.

Ocaña created his own version. Using papier-mâché figures of virgins and little angels that he had exhibited in a leading underground art gallery, he led a procession throughout the city, causing a sensation.

Although Franco was gone, many of the repressive laws against minorities remained in place. Nevertheless, the political climate allowed somewhat freer expression than before.

Particularly vigorous demonstrations occurred in the summer of 1978, when, in defiance of the law, gay men, lesbians, transvestites, and transsexuals demonstrated in protest in Barcelona, supported by Socialists, Communists, feminists, Catalan nationalists, and members of other marginalized groups.

On one occasion, at a rock festival at nearby Canet de Mar, Ocaña and several friends took to the stage dressed as female flamenco dancers (another nod by Ocaña to the culture of his native region). At the end of the performance, Ocaña stripped off his costume and tossed it into the audience. Nude except for a carnation in his hair and a pair of high heels, he finished with a flourish of foot-tapping dancing, described as "intense" and "orgasmic," as the crowd cheered wildly.

Gay Catalan director Ventura Pons used this performance as the final scene in his first film, the documentary *Ocaña, retrat intermitent* (*Ocaña: Intermittent Portrait*, 1978). The greater part of the film, however, simply has Ocaña sitting on his bed in a Barcelona apartment and speaking (in Spanish despite the Catalan title) about his life, his friends and lovers, his sexuality, his painting, and his sense of identity.

The film, which quickly became a cult favorite, was shown at the 1978 Cannes Film Festival, where it was well received. It has been hailed as a groundbreaking work of Spanish cinema that helped open discussion of sexuality and sexual politics.

Ocaña's paintings are modern in style and show the influence of Chagall, Modigliani, and Matisse. In his earlier work he favored themes that reflected the Andalusian culture in which he grew up. Among these are paintings with religious content, such as angels and images of the Virgin.

Although Ocaña was aware of the complicity of the church in the oppression of homosexuals, he was intrigued by the color, pageantry, and emotion of religious rites, as well as by the sensuality often found in religious art.

His later work included paintings of urban subjects.

Shortly before his death, Ocaña painted *Premonición* (*Premonition*, 1978), which shows him lying on his bed in Barcelona while friends hold a wake.

Ocaña died in Cantillana on September 18, 1983, of an AIDS-related disease. After his death, his family established a small private museum of his paintings.

— *Linda Rapp*

BIBLIOGRAPHY

Mira, Alberto. "Ocaña, José Pérez." *Who's Who in Contemporary Gay and Lesbian Culture from World War II to the Present Day.* Robert Aldrich and Garry Wotherspoon, eds. London and New York: Routledge, 2001. 308–309.

"Ocaña." www.galeria-cavecanem.com/expo/ocaña/expo_ocaña.html.

Trueba, Fernando. "La alegre marginación." *El País* (Madrid), June 14, 1978: www.venturapons.com/filmografía/retratp.html.

Vilarós, Teresa M. *El mono del desencanto: Una crítica cultural de la transición española.* Mexico City and Madrid: Siglo Veintiuno Editores, S.A., 1998.

SEE ALSO

European Art: Twentieth Century

Pacific Art

UNTIL THE MID-TWENTIETH CENTURY, APPROXIMATELY 10 to 20 percent of those cultures living on islands in the Pacific Ocean practiced male homosexuality in a ritual context. In Papua New Guinea, Irian Jaya, New Caledonia, New Britain, and Vanuatu, homosexuality was considered a necessary activity that "grew" boys into mature adult men.

In Pacific cultures, male homosexuality was transitory and age graded. Older partners were thought to pass their knowledge and power to younger boys via semen.

Sambian Initiation

Among the Sambia, who inhabit the Southeastern Highlands of Papua New Guinea, every male had to go through a series of six stages of initiation that lasted approximately ten years.

Teenagers who were between puberty and the age of marriage "implanted" their semen daily in boys between age nine and puberty, so that it would spread its perceived male virtue through their growing bodies. At marriage, youths became bisexuals for a time. After fatherhood, homosexuality ceased as men became exclusively heterosexual. This process was typical of other Pacific cultures.

Pacific Island men were absolutely convinced of their innate lack of semen and of the necessity of the homosexual rituals, and they transmitted their convictions to boys through ritual teaching. Their beliefs were sub-

stantiated when, after years of ritualized homosexuality, the signs of strength and masculinity took physical form in the initiates.

Ritual Flutes

Older initiates and adult men typically taught young Pacific Island initiates the mechanics of homosexual fellatio through the use of ritual flutes. During the flute ceremony, men passed a flute from initiate to initiate, encouraging each boy to insert it into his mouth. Initiated men then equated the flute with the penis and told the boys that they must ingest semen to grow into mature men. The boys were also sworn to secrecy.

Throughout the Pacific Islands, flutes took a variety of shapes and forms and were made from a range of materials. Among the Sambia, they were made from freshly cut bamboo left open at one end. In Vanuatu, flutes took on a variety of forms, from short and undecorated to long and beautifully incised with patterns including plants, marine animals, spirit faces, and erotic designs.

Bullroarers

Bullroarers also symbolized masculinity in Pacific cultures. Shaped like flat, pointed ovals, these wooden objects often are covered with geometric and organic forms pigmented red, white, and black. One end is pierced to accommodate a cord. Men use this cord to

swing the bullroarer through the air so that it spins on its own axis. The resulting noise sounds like the howls and roars of animals. Pacific Islanders say that bullroarers emit the voices of the spirits.

The Sosum Ritual

A central rite of the first stage of male initiation for the Marind-anim of southeast Irian Jaya is called the sosum ritual. Sosum, which is also the Marind-anim word for bullroarer, is an ancestor whose penis was cut off by his female partner's mother while he was entrapped in copulation.

During the sosum ritual, men danced around a giant red effigy of Sosum's penis to the sound of bullroarers and flutes. Afterward, they enticed the initiates into homosexual intercourse.

The sosum ritual may symbolize the belief of Marind-anim men that vaginal intercourse can result in physical pollution and death. Some scholars have hypothesized that homosexual activities resulted from this particular belief. Indeed, Marind-anim myths are replete with tales of dema—ancestors such as Sosum who were trapped in intercourse—and of dema who were castrated by mothers of girls with whom they had sex.

Vanuatu

On Vanuatu, homosexual behavior is believed to generate a power that can both physically and spiritually transform the participants and, by extension, others. The roots of this generalized belief are found in male initiation rituals.

As with other Pacific Island cultures, the penis is a recurrent theme during initiation in Vanuatu. To underscore the importance of the penis, each initiate receives a wrapper of the type that will be worn around his penis for the rest of his life. These woven textiles are sometimes created with dyed fiber and decorated with geometric designs.

Shark symbolism was a recurrent theme during male initiation in Vanuatu. Various masks danced in during initiations represent sharks, and the ends of some flutes are reminiscent of open fish mouths.

The shark was valued for its ferocity, a vital masculine trait. Additionally, it held a powerful position in Vanuatu mythology. As the messenger of the ancestral underworld, the shark functioned as a bridge between the world of the living and that of the dead.

Conclusion

Some Pacific Island cultures continue to practice ritualized male homosexuality today. Others abandoned these activities under the instruction of missionaries and the influence of Western culture.

— *Joyce M. Youmans*

BIBLIOGRAPHY

Allen, Michael R. "Ritualized Homosexuality, Male Power, and Political Organization in North Vanuatu: A Comparative Analysis." *Ritualized Homosexuality in Melanesia*. Gilbert H. Herdt, ed. Berkeley: University of California Press, 1984. 83–126.

Bonnemaison, Joël, et al., eds. *Arts of Vanuatu*. Honolulu: University of Hawaii Press, 1996.

Herdt, Gilbert H. *Guardians of the Flutes: Idioms of Masculinity*. New York: McGraw-Hill, 1981.

———. *The Sambia: Ritual and Gender in New Guinea*. New York: Holt, Rinehart and Winston, 1987.

———. "Semen Depletion and the Sense of Maleness." *Oceanic Homosexualities*. Stephen O. Murray, ed. New York: Garland, 1992. 33–65.

Lidz, Theodore, and Ruth Wilmanns Lidz. *Oedipus in the Stone Age: A Psychoanalytic Study of Masculinization in Papua New Guinea*. Madison, Conn.: International Universities Press, 1989.

Van Baal, J. "The Dialectics of Sex in Marind-anim Culture." *Ritualized Homosexuality in Melanesia*. Gilbert H. Herdt, ed. Berkeley: University of California Press, 1984. 128–166.

SEE ALSO

Native American Art

Parmigianino
(Francesco Mazzola) (1503–1540)

PARMIGIANINO (LITERALLY, "THE LITTLE GUY FROM Parma") is the name given to the sixteenth-century Italian Renaissance painter Francesco Mazzola. Hailing from the Emilian town of Parma in north-central Italy, where he was born in 1503, Parmigianino is almost universally recognized as one of the most important practitioners of the cultural style that dominated Italy and much of Europe in the mid-to-late sixteenth century: Mannerism.

Little is reliably known about the personal life of this rather eccentric painter, a lifelong bachelor, though much has been speculated. However, his superbly refined and tortuously complex style has often appealed to a gay male audience sensitive to the extremes of taste embodied by Mannerism.

Parmigianino also often imbued his subjects with an overt or subtle eroticism, some of which may be interpreted homoerotically.

Reared by two painter uncles in Parma, Francesco was something of a prodigy, commissioned to paint important frescoes in the Cathedral of Parma at the age of nineteen, in 1522. Two years later, he was in Rome, presenting one of his most famous works to Pope Clement VII: *Self-Portrait in a Convex Mirror*.

This work, a virtuoso bust-length depiction of the young artist as though reflected in a curving, convex

mirror, already showed many of the characteristics of Parmigianino's later work: facility, grace, and, especially, *invenzione* (inventiveness or imagination). The power of the work is such that it inspired poet John Ashbery to write his poem of the same name almost four centuries later.

Leaving Rome after the Sack in 1527, Parmigianino wandered through Italy, eventually returning to Parma after a successful stay in Bologna.

Around this time, he painted the famous *Cupid Carving His Bow*, which depicts a highly androgynous Cupid carving a deadly-looking bow for his arrows of love, as two putti struggle at his feet.

This painting refers to Renaissance ideas about love as a painful experience, but the ambivalent gender of the main figure marks an interest in androgyny that, while it toys with expressions of sexual identity, relates to the artist's documented interests in the arcane science of alchemy.

Toward the end of his life, Parmigianino was reportedly obsessed with alchemical experimentation, to the detriment of his artistic career.

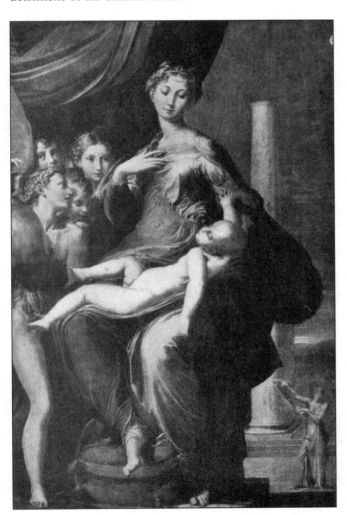

Madonna of the Long Neck by Parmigianino.

Parmigianino's most famous work, *Madonna of the Long Neck*, from around 1535, was never finished. The artist's interest in gender ambiguity is clearly evident here in the androgynous attendants who swarm at the Virgin's right side. An oversized, almost alien-looking Christ child sprawls languidly across her lap while a mysterious, tiny figure of a prophet unrolls a scroll in the background. The Virgin herself, with her greatly elongated proportions and contrived pose, epitomizes the hyperbolic grace and artifice that were hallmarks of Mannerism.

While Parmigianino's drawings do include overtly homoerotic images and male nudes (such as the *Figure Study* of 1526–1527), his own sexual orientation is as ambiguous as the androgynes he painted. Cecil Gould sums it up coyly: "Judging from the totality of his art, I suspect that his instincts were bisexual."

The appeal of the artist to a gay audience is his exploration of an extreme aestheticism that can be appreciated for its artistic imagination as well as for its camp excessiveness.

— *Joe A. Thomas*

BIBLIOGRAPHY

Fagiolo dell'Arco, Maurizio. *Il Parmigianino: Un saggio sul'ermetismo nel Cinquecento*. Rome: Mario Bulzone Editore, 1970.

Freedberg, Sydney. *Parmigianino: His Works in Painting*. Cambridge, Mass.: Harvard University Press, 1950.

Gould, Cecil. *Parmigianino*. New York: Abbeville Press, 1994.

Popham, A. E. *Catalog of the Drawings of Parmigianino*. 3 vols. New Haven: Yale University Press, 1971.

SEE ALSO

European Art: Mannerism; European Art: Renaissance; Fuseli, Henry; Subjects of the Visual Arts: Ganymede

Parsons, Betty *(1900–1982)*

AMERICAN ARTIST AND GALLERY OWNER BETTY PARSONS retreated into the closet during the McCarthy years, but she supported gay, lesbian, and bisexual artists during a period of repression.

Betty Bierne Pierson was born into a wealthy New York City family in 1900. Influenced by the innovative art she saw in the famous Armory show of 1913, she sought out what she thought of as "new" in art for the rest of her life.

In 1920, she married Schuyler Livingston Parsons (1892–1967), a rich, homosexual alcoholic, eight years her senior. The marriage lasted three years.

Betty Parsons, as she would be known for the rest of her life, divorced in Paris in 1923 and remained there for the next decade, supported by alimony. She sought out

older members of the expatriate lesbian community such as Natalie Clifford Barney, Romaine Brooks, Sylvia Beach, Gertrude Stein, and Alice B. Toklas.

She had her portrait made by photographer Berenice Abbott, two years her senior, and was taken under the wing of Janet Flanner, who wrote for *The New Yorker* under the pen name "Genet."

For eight of the ten years Parsons lived in Paris, she conducted a love affair with a woman, the English painter Adge Baker, with whom she maintained a friendship for the rest of her life.

The Great Depression ended Parsons's financial support. She returned to the United States in 1933. She spent two years in Southern California, where she had male lovers, crushes on a few women, and a serious flirtation—if not actual sex—with Greta Garbo.

After serving an apprenticeship in the New York art world, Parsons opened the Betty Parsons Gallery in New York City in 1946. Through exhibiting select abstract art and giving the Abstract Expressionists their first public exposure, the gallery became one of the most prestigious of the mid-twentieth century. It closed in 1981, a year before Parsons's death.

From the mid-1940s until the mid-1950s, Parsons was involved in a passionate—though not exclusive—relationship with actress and painter Strelsa van Scriver (ca. 1915–1963). While quite open about her lesbianism when she lived in Paris in the 1920s and 1930s, Parsons became closeted in the more repressive atmosphere of the United States following World War II.

Nevertheless, Parsons exhibited the work of a number of lesbian and gay male artists, including Sonia Sekula (1918–1963), a Swiss-born openly lesbian painter, and the much more private Agnes Martin (b. 1912). Among the gay male or bisexual artists whose work she sponsored are Forrest Bess (1911–1977), Theodoros Stamos (1922–1997), Ellsworth Kelly (b. 1923), Robert Rauschenberg (b. 1925), and Alfonso Ossorio (1916–1990).

Parsons was also herself an artist. Each summer she closed the gallery and concentrated on her own painting and sculpture, ultimately showing in high-profile galleries.

Conscious of the homophobia in the art world and fearful of being ostracized, Parsons maintained an air of privacy about her personal life. Yet she agreed to biographer Lee Hall's request for full disclosure about her life. Parsons's forthrightness allowed Hall to write about Parsons's life with an unusual openness, which was not how she lived.

Parsons's support of gay, lesbian, and bisexual artists at a time of social oppression and her willingness to have the fullness of her life shared in her biography mark important contributions to lesbian and gay history and culture.

— *Tee A. Corinne*

BIBLIOGRAPHY

Gibson, Ann. *Abstract Expressionism: Other Politics.* New Haven: Yale University Press, 1999.

———. "Lesbian Identity and the Politics of Representation in Betty Parsons' Gallery." *Gay and Lesbian Studies in Art History.* Whitney Davis, ed. New York: Harrington Park Press, 1994. 245–270.

Hall, Lee. *Betty Parsons: Artist, Dealer, Collector.* New York: Harry N. Abrams, 1991.

SEE ALSO

American Art: Lesbian, 1900–1969; American Art: Gay Male, 1900–1969; Abbott, Berenice; Brooks, Romaine; Rauschenberg, Robert

Percier, Charles and Pierre Fontaine
(1764–1838)
(1762–1853)

FRENCH ARCHITECTS AND DESIGNERS CHARLES PERCIER-Bassant and Pierre-François-Léonard Fontaine were among the founders and principal exponents of the neoclassic Empire style. They incorporated elements of the art of antiquity into designs for their own time, always striving for harmony between a building and its setting, a room and its decorative features. They are known for the grace and elegance of their work and for their devotion to each other.

Both Fontaine and Percier were made officers of the French Légion d'honneur for their contributions to art.

Fontaine came from a line of architects and builders. He had his first experience of the profession when, at the age of sixteen, he went to Isle-Adam, north of Paris, with his father, who was working on fountains and hydraulic systems at the castle of the Prince de Conti.

The architect in charge of the project, André, recognized the young Fontaine's interest and aptitude for architecture and allowed him to copy designs and also to work on the construction site to gain practical knowledge. A young draftsman on the project, Jean-Thomas Thibault, also worked with Fontaine, teaching him the basics of the profession.

Realizing that Fontaine had the talent and dedication to be a successful architect, his father sent him to study with Antoine-François Peyre in Paris. Fontaine spent six years in Peyre's studio, and while there he met Charles Percier.

Percier was the son of a bridge-keeper at the Tuileries and a seamstress in the service of the queen. As a boy he attracted attention for his meticulous drawings of the uniforms of the officers that he saw at the palace, and he received lessons from a drawing master who taught art to the ladies of the court.

Fontaine and Percier went on to study at the Académie des Beaux-Arts, where both excelled. In 1785,

Fontaine took second place in the prestigious Prix de Rome competition for architecture students. Although he did not receive the scholarship that went with the first prize, he went to study in Rome, where Percier joined him the following year after himself winning the competition.

In Italy the two young men devoted themselves to the study of classical architecture. They shared a studio and often traveled to the countryside together. Their obsession with the arts of antiquity earned them the nickname "the two Etruscans" from their classmates.

While in Rome, Percier and Fontaine made "a pact of friendship founded on respect and confidence." Both pledged never to marry.

The outbreak of the French Revolution in 1789 brought financial ruin to Fontaine's father, who called his son home to help support the family. Finding no opportunity in his native Pontoise, Fontaine moved to Paris.

Percier initially stayed in Rome, but, encountering public hostility toward the French, soon decided to give up the remainder of his scholarship. He made his way north to Paris and moved in with Fontaine.

In 1792, Percier was offered a post as the director of set design at the Paris Opera. He insisted that Fontaine be employed as well. The pair spent four years at the job, painting backdrops of classical scenes for the popular plays of the day.

The two also designed furniture and restored private houses. Their decorating work at the residence of a Monsieur Chauvelin caught the eye of his neighbor Joséphine Bonaparte, who engaged the pair to refurbish her house, Malmaison.

On the occasion of their interview for the job at Malmaison, Fontaine and Percier met Napoleon. As a result they were hired to decorate the Hôtel des Invalides, the first of their many public projects.

In 1801, Napoleon named Fontaine architect to the government, an appointment that Fontaine insisted on sharing with Percier.

Percier and Fontaine were responsible for refurbishing the palaces at Fontainebleau, Strasbourg, and Versailles. The Empire style that they created drew on the classical art and architecture that they so loved. Their aim was not to replicate the buildings of antiquity, but to translate classic designs into a modern idiom. They insisted that plans should suit the nature of the project and that architectural and decorative elements should complement each other harmoniously.

Among their projects in the capital was the design of the newly laid-out rue de Rivoli with its symmetrical buildings and arcades. They also contributed to the planning of new bridges across the Seine.

Another task was the completion and renovation of the Louvre Palace and the design for the space linking it with the Tuileries Palace. For this project Fontaine

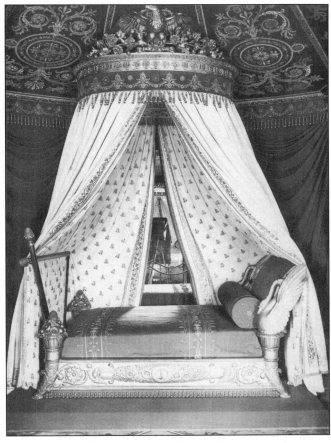

The empress' bedchamber at Malmaison by Percier and Fontaine.

and Percier designed the Arc de Triomphe du Carrousel (1806–1807), which stands in the courtyard of the Louvre. The elegant monument, inspired by the Arch of Septimus Severus in Rome, is considered one of their masterpieces.

Toward the end of 1804, Napoleon dismissed Percier from his service. The reserved Percier tended to work behind the scene and left dealing with the public to his more outgoing companion. Fontaine argued for the retention of Percier, stressing the importance of his contributions, but the emperor was not swayed. An incensed Fontaine recorded in his diary "It would appear that I am alone, but we will continue to work together and share the benefits, as in the past."

The two did continue to collaborate on various projects, including a vexed plan to build a palace for Napoleon's son. Fontaine and Percier submitted numerous designs over a four-year period, but abandoned the project in 1814 because Napoleon's military campaigns left him without sufficient funds for the construction.

Once Percier no longer had official state duties, he was able to devote time to teaching and to work in the decorative arts. His design work included furniture, clocks, and Sèvres vases.

Fontaine undertook many construction and restoration projects, including the completion of the Palais Royal (1814–1831), the restoration of the Théâtre-Français after a fire (1822), and restorations of the Élysée Palace (1816), the Château de Neuilly (1819–1831), and the Château d'Eu (1824–1833).

After Percier died, on September 5, 1838, Fontaine wrote to a friend, "I have lost half of myself; how many months or days can be left to me?"

In fact Fontaine continued to work well into his old age, finally resigning his post as architect of the Louvre and Tuileries Palaces in 1848, at the age of eighty-six. He died on October 10, 1853. — *Linda Rapp*

BIBLIOGRAPHY

Culot, Maurice. "Fontaine, Pierre-François-Léonard." *The Dictionary of Art.* Jane Turner, ed. New York: Grove's Dictionaries, 1996. 11:256–259.

———. "Percier(-Bassant), Charles." *The Dictionary of Art.* Jane Turner, ed. New York: Grove's Dictionaries, 1996. 24:387–389.

Fouche, Maurice. *Percier et Fontaine.* Paris: Librairie Renouard, 1904.

SEE ALSO

Architecture

Photography: Gay Male, Post-Stonewall

THE STONEWALL RIOTS SHOULD NOT BE SEEN AS THE only shaping force in the development of contemporary gay male photography, but it makes a convenient dividing line. Put simply, Stonewall contributed to the sexual revolution and the sexual revolution contributed to the development and visibility of a gay male subculture that in turn contributed to gay male photography.

Although erotica may be the first genre that comes to mind when gay male photography is mentioned, the category comprises more than erotic photography. As a meaningful element of the fine arts and contemporary culture, gay male photography must also be recognized for its particular contributions to fine art, photojournalism, and advertising, as well as erotica.

Contributing Factors in the Development of Gay Male Photography

Since Stonewall, gay male photography has become decidedly more political. In the 1970s, in the heady atmosphere of gay liberation and community building, gay male photographers were particularly concerned with documentary and photojournalism. Sexual liberation, self-representation, and community documentation became popular photographic themes.

In the 1980s and 1990s, acceptance and commodification of the male body emerged as a staple of gay male photography, as epitomized by the famous Calvin Klein underwear ads in New York's Times Square.

Although the male body has always been a crucially important image for gay male photographers and for advertising to the gay male community, the Calvin Klein ads were a marketing breakthrough that continues to influence advertising and representation.

But perhaps the greatest single influence on contemporary gay male photography was AIDS, whose impact began to be felt most strongly in the mid-to-late 1980s. If Stonewall solidified the celebration of the male body found in earlier periods, then AIDS forced photographers to see the gay male body very differently.

Moreover, the health crisis redefined notions of community, which no longer coalesced solely around the eroticism of the male body, but now also around questions of frailty, mortality, illness, loss, and transformation.

The Stigmatized Status of Gay Male Photography

Gay male photography was already a thriving creative and economic force for many photographers and consumers before 1969. But the commercialization of gay male photography became infinitely easier in the post-Stonewall world. However, this ease should not be confused with acceptance. Today, in fine art galleries and museums, gay male photography continues to be stigmatized as a marginal or subcultural art form.

The stigmatization of gay male photography, of course, parallels the state of gays within society as a whole. However, with gay mayors in Berlin and Paris, along with gay and lesbian elected officials across the United States, the gay and lesbian community is finding increasing acceptance, which translates into increasing acceptance for gay and lesbian art.

Ambiguity in Gay Male Photography

Not all images that fall under the rubric of gay male photography are fine art, just as not all erotic images of the male body are pornographic. This ambiguity may in fact be the clearest expression of what has been gained since Stonewall.

Strict boundaries continue to fall away, and distinctions, both subtle and extreme, can be found between fine art, pornography, and a wide range of politically charged visual strategies. Gay male photography can sell clothes and cologne, embrace S/M subcultural practices, celebrate gender bending, and increasingly encompass just about any subject.

Representative Gay Male Photographers

The following is an alphabetically arranged summary listing—representative rather than comprehensive—of

some gay male photographers who have contributed to glbtq culture since Stonewall.

Al Baltrop

Born in the Bronx, New York, in 1948, Al Baltrop currently lives and works in New York City. A Vietnam War veteran, he worked as a mover and a lithographer and spent much of the 1970s in and around the West Side piers. Pre-AIDS New York was the age of discos, bathhouses, and gay bars; and Baltrop, working from a Dodge van, began to photograph the ebullient gay life he saw in the city.

Taking pictures since his teens, Baltrop briefly studied at the School for Visual Arts. His photographs are at once remarkable documents and aesthetically striking art. They depict beautiful young men, homeless youth, voyeurs, sunbathers, homeless queens, all clinging to the edge of Manhattan amid deteriorating buildings, meatpacking plants, and abandoned piers. Baltrop's photographs remind us of loss and change.

Mark I. Chester

Born in Milwaukee in 1950, Mark I. Chester lives and works in San Francisco. Self-described as a gay radical sex photographer, Chester has photographed a wide variety of hooded and bound men, often in rather simple, even elegantly composed images that document and celebrate the gay male S/M community.

Chester works as a commercial photographer, and his flyers and posters are ubiquitous in the San Francisco gay and lesbian community.

George Daniell

George Daniell (b. 1911) worked as a freelance commercial photographer from the 1930s to the 1960s and became well known for striking black-and-white photographs of celebrities such as Sophia Loren, Audrey Hepburn, Tennessee Williams, W. H. Auden, and Georgia O'Keeffe.

However, his most important work, in addition to his paintings, are his photographs of dockworkers, fishermen, swimmers, and ballet dancers, which celebrate the male figure. His sensual photographs are only now being recognized as important contributions to gay male photography.

George Dureau

New Orleans artist George Dureau (b. 1930) may be best known for his paintings and drawings, but his black-and-white photographs, often of black youths, street trade, dwarfs, and amputees, are not only striking in their own right but also have had an immense influence on the work of Robert Mapplethorpe, among others.

Although Mapplethorpe adopted many of the same compositions and poses utilized by Dureau, the effects of the two men's work are quite different. Whereas Mapplethorpe's photography aspires to a kind of classical objectivity, Dureau's is warmer and more involved, evincing compassion as well as desire.

Robert Flynt

Robert Flynt (b. 1956) lives and works in New York City. He creates surreal and sensual photomontages of the male nude. At times, using an underwater camera, Flynt captures the weightless and ethereal movements of his models. He frequently collaborates with performance artists and dancers. His work is in the collection of the Museum of Modern Art, the Metropolitan Museum of Art, and the Los Angeles County Museum of Art.

Flynt frequently utilizes secondary images drawn from a variety of sources, including anatomy charts, first aid textbooks, X rays, astronomical maps, nineteenth-century etchings, menswear catalogs, and even classic Roman sculptures. Such overlapping of images allows Flynt to create collagelike effects that begin with the male form but ultimately transcend it.

His work is complex, reminiscent of nineteenth-century photography and alternative process–based photography from the 1970s, but employing contemporary innovations that replace darkroom manipulations with digital ones. He has published several books, including *Compound Fracture* (1996).

Robert Giard

In 1985, photographer Robert Giard (b. 1939) set out to create an archive of portraits of gay and lesbian writers from across the United States. His intention was to present visible evidence of their presence in our culture and to document their particular voices. His book, *Particular Voices: Portraits of Gay and Lesbian Writers* (1998) contains 182 of the more than 500 portraits Giard has made.

Gilbert & George

British artists Gilbert Proesch (b. 1943) and George Passmore (b. 1942) began collaborating in the late 1960s, when they adopted the name Gilbert & George. They met and studied at St. Martins School of Art in London, in 1967.

Pushing the boundaries of artmaking, they were first known for their performance piece *The Singing Sculpture*, in which, with hands and face covered in metallic paint, they became literally a singing sculpture. In foregrounding action, time, and space, Gilbert & George challenged the material privileging of the object over the artistic intention.

The duo is perhaps best known for their large-scale photographic collages in which they often represent themselves. Created from individual squares, the larger

images are several meters tall. Homoerotic in content, many of their photographic works have a gay subtext and often confront political and social issues.

David Hockney

Born in Bradford, England, in 1937, Hockney now lives in England and Los Angeles. He began his career as a painter working in a highly figurative manner. He quickly earned an unusual degree of success, becoming one of the best-known artists of his time, and soon branched out into stage design.

Hockney employs the solid color fields usually associated with modernist abstraction but does so in the service of his compositions. He thus creates images that are striking in their palette and distinguished by the juxtaposition of solidly rendered figures and objects against flat, abstracted fields of color. His paintings and etchings are often strongly homoerotic, especially those now known as the "Love Paintings."

Hockney began using photography to assist his painting and to photograph his young male friends and models. As he continued to experiment with Polaroid cameras, he began to combine individual Polaroid images to create larger composite images. These popular Polaroid and snapshot assemblage pieces suggest the same playfulness found in his other artistic works.

Although not strictly a photographer, Hockney has made an important contribution to gay male photography. His photographic works now have as many fans as his paintings, drawings, and set designs.

Peter Hujar

Peter Hujar (1934–1987) lived and worked in New York City. He photographed a wide array of subject matter: nudes, animals, fashion, still lifes, Italian landscapes, erotica, street people, and transvestites, always finding beauty in unexpected places.

Hujar's best-known photograph, "Candy Darling on her Deathbed" (1973), is both gentle and heroic. His ability to show compassion is a constant in his work, from his early portraits of handicapped children to his late self-portraits.

In 1994, the Stedelijk Museum in Amsterdam joined the Fotomuseum in Zurich to assemble the first major exhibition of Hujar's work. The retrospective included some 183 images and an accompanying catalog entitled *Peter Hujar: A Retrospective*. Hujar died of an AIDS-related illness in 1987.

Robert Mapplethorpe

Robert Mapplethorpe (1946–1989) became one of the most famous gay male artists of his time as a result of the controversy surrounding his 1989 exhibit The Perfect Moment. Perhaps best known for his X *and* Y *portfolios*,

composed of S/M and flower images, respectively, Mapplethorpe combines cool elegance of composition, stylized forms, and shocking subject matter.

Mapplethorpe's work actually spans a range of media and subject matter, but it was his documentation of S/M practices that thrust his work into the center of the controversy over censorship in the arts. He died of an AIDS-related illness.

Duane Michals

Born in Pennsylvania in 1932, Duane Michals settled in New York in the late 1950s and became known as a commercial and fashion photographer. He first exhibited in 1963, and by 1970 his work had been shown at the Museum of Modern Art. He has published over twenty books of his work, including *The Portraits of Duane Michals 1958–1988* (1989).

His early work became well known for its insistent, and often humorous, use of the narrative series. Many such works actually incorporated handwritten text onto the images. Thematically, Michals has a recurrent fascination with making tangible the intangible realm of love, death, dreams, and wishes. His works deal with human sexuality, both straight and gay, but always in a charmingly moving and innocent manner.

Pierre Molinier

Born in Agen, France, Molinier (1900–1976) had some formal training and lived in Paris for a brief period. But most of his life was spent in Bordeaux, where he remained until his death. Molinier began his career as a painter, but by 1950 he had begun to produce the self-portraiture for which he is best known. He had a solo exhibition in André Breton's Paris gallery in 1955.

The bulk of Molinier's photographs were incorporated into photomontage, or photographic collage, which allowed him to alter and repeat any given element. As a result, he created fantastic works, in which, for example, an army of figures could be seen cavorting behind fetishized masks, stiletto heels, and corsets.

Using himself and other models, he then positioned these fantastically gendered figures into erotic compositions that ranged from autoeroticism to tangled bodies. His work explores transvestism and autoerotic fetishism.

Molinier's elaborate suicide in 1976—he shot himself while lying on his bed before a mirror—initially baffled police and secured his legacy. The police at first assumed that he was the victim of foul play, but his suicide was simply another extension of his enigmatic art practice.

Mark Morrisroe

Born in Massachusetts, Mark Morrisroe (1959–1989) created photographs that have been included in numerous museum and gallery exhibitions nationwide, including

the 1997 exhibit My Life. Mark Morrisroe: Polaroids 1977–1989 at the Museum of Contemporary Art (MOCA) in Los Angeles.

The exhibition included 188 portraits, the majority of which were self-portraits. The most striking element in these technically informal works is the voyeuristic appeal of the Polaroids themselves. Morrisroe used a 195 Polaroid Land camera and a nearly unlimited supply of film donated by the director of marketing and communications at the Polaroid Corporation.

Captured over a twelve-year period, Morrisroe's naked body in these photographs deteriorates from youthful beauty to near-skeletal wasting as a result of his illness. The self-conscious innocence of Morrisroe's early work is unforgettable.

Pierre et Gilles

Working collaboratively since the mid-1970s, when they first met, fell in love, and began making art together, Pierre Commoy and Gilles Blanchard have managed to create images that speak to a generation of gay men.

Using traditional photo-retouching techniques, painted backdrops, and display items such as fake flowers and fake snow, all combined with their predilection for buff-bodied pretty boys, they create camp-infused confections from classic themes, transforming religious saints and sailors into sexy celebrities.

Because of its unashamed sentimentality and unapologetic gay overtones, their work exists somewhere between high art and low culture. It has been seen more often in reproduction and advertisements than in originals.

However, recently Pierre et Gilles were the subject of a traveling retrospective exhibition, organized by New York's New Museum for Contemporary Art, which also showed at the Yerba Buena Center for the Arts in San Francisco. The exhibition included fifty-six of their ornately framed portraits and launched their new Swatch watch complete with a photo of a mermaid and a sailor.

Jack Pierson

Born in Plymouth, Massachusetts, in 1960, Jack Pierson now lives and works in both Provincetown and New York City. Working with found objects, photography, and installation, Pierson creates work that has less to do with traditional fine art photography than it does with photography as an extension of his own conceptual art practice.

Indebted to the snapshot tradition, Pierson's images present a fragmented world infused with haunting solitude. Quickly taken and often blurry, the photographs juxtapose sexy young men in disheveled bedrooms with grainy images of flowers, found signs, and even American flags, cumulatively suggesting a groggy-eyed look at a media-saturated culture in which everything is already reminiscent of something else.

Pierson's work has been shown in galleries and museums. His books All of a Sudden (1995) and The Lonely Life (1997) display Pierson's signature style: soft focus, grainy, saturated colors, flowers, fragmented bodies all printed to the end of the page, texture against texture.

In one spread, a distant village is set against a blurry flower in the foreground; in another, palm trees sway in a pink sky. These books, like his exhibitions, suggest a kind of post-Disco melancholia that superbly melds emotional longing with hangovers and ennui.

Walter Pfeiffer

Born in 1946, Walter Pfeiffer lives and works in Zurich. His work has been exhibited at Frankfurt's Kunstverein (1981), Basel's Kunsthalle (1987), Bern's Kunstmuseum (1989), Stockholm's Maritmen Museum (1999), and Zurich's Kunsthaus (1999–2000).

His recent book Welcome Aboard, Photography 1980–2000 contains a vast array of homoerotic images, many with a documentary feel.

Ken Probst

An American born in Switzerland, Probst is best known for his book (por ne-graf'ik), which takes a behind-the-scenes look at California's porn industry. Adopting a semidocumentary style, it offers a surprising look at the difficult and often mundane work of creating erotic videos.

Probst captures on film those in-between and often awkward moments that describe the real space of the set, as opposed to the highly constructed fantasy of erotic desire.

Compositionally, the images are charged by a modernist desire for line, texture, and form, at times nearly abstracting the events portrayed. A single sock is both a humorous detail and a compositional device to move the eye. A difficult camera angle becomes a humorous mise en scène. A bottle of lubricant is little more than a mundane fact. Even the pictures of actors resting between shoots tell us that creating desire can be a lot of work.

John Rand

Born in Oakland, California, in 1956, Rand currently lives in Los Angeles. His photographs have been included in a variety of publications including Artweek, Bear, American Bear, and International Drummer.

Working in black-and-white photography, Rand reflects a curious blend of documentary and erotic photography traditions. He is engaged in documenting "bear" culture, one of the most prominent subcultures within the gay community.

His work is driven by a personal engagement in this community, and as such his project stands as a reevaluation of the idealized male form. In eroticizing hairy, heavyset bodies, Rand hopes to challenge the dominance of the gym body as the apex of gay male culture.

Herb Ritts

Born in Los Angeles, Herb Ritts (1952–2002) studied economics at Bard College. His first success as a photographer came in 1978, when Ritts shot actors Jon Voigt and Ricky Schroeder. Throughout the late 1970s and early 1980s, he continued working in the entertainment industry in Los Angeles as a celebrity portraitist.

His photographs have appeared in *Interview, Harper's Bazaar, Vogue,* and *Elle.* In 1985, Ritts exhibited his photographs in a gallery setting for the first time.

Remarkably, in a six-year period, Ritts published four books. The first, *Men/Women* (1989), used the human figure in a sensuous and graphically charged manner, taking the best of both fine art and commercial photography traditions.

The second, *Duo* (1991), presented a series of gay couples in the nude. Sexualized by their nudity, and normalized by their humanity, the project drew from both studio and ethnographic portrait styles.

The third, *Notorious* (1992), showcased Ritts's success as a celebrity portraitist. His first major museum exhibition was held at the Museum of Fine Arts in Boston, in 1986.

Wolfgang Tilmans

Born in 1968 in Germany, where he was raised, Wolfgang Tilmans currently lives and works in London. He has been featured in numerous solo and group exhibitions worldwide, including at the Museum of Modern Art in New York, the 1998 Berlin Biennale, the Institute of Contemporary Art in Boston, and the Stedelijk Museum in Amsterdam, to name just a few.

In 2000, Tilmans was awarded the highly prestigious Turner Prize in Photography. His photographs have appeared in *i-D, Interview, Vogue,* and *Raygun.* His latest book, *Burg,* a retrospective of his photography over the last five years, was published in 1998.

One of the youngest photographers to receive international recognition, Tilmans not surprisingly focuses on youth culture in his photography. His work may be described as stylistically a cross between snapshot and documentary.

Tilmans shows us the interiors of bedrooms, empty Chinese food containers, and random events that are less concerned with photo history than with photography's evocative power. In one photo, a young man with a Mohawk haircut urinates on a chair. The image's transgressive ambiguity is at once both mundane and erotic.

Arthur Tress

Born in Brooklyn, New York, in 1940, Tress currently lives and works in Cambria, California. From 1962 to 1968, he created documentary photographs throughout Europe. His work is in major museum collections such as the Museum of Modern Art in New York and the Centre Georges Pompidou in Paris.

His recent retrospective at the Corcoran Gallery of Art in Washington, D. C., entitled Fantastic Voyage: Photographs 1956–2000, surveyed the vast terrain of his photographic career. The exhibition included his little-seen early documentary work; the surreal dream imagery found in three of his best-known photographic series, "Dream Collector," "Shadow," and "Theater of the Mind"; and his exploration of sexuality and eroticism. As a photographer, Tress has touched on nearly all the major themes of his time.

Bruce Weber

Born in Greensburg, Pennsylvania, in 1946, Weber is well known as a commercial photographer. He has also produced commercials, videos, and a number of films, including *Broken Noses* (1987). In recent years, his photographic work has been increasingly shown in museums and galleries.

Weber's projects usually construct a world filled with celebrities or exquisitely defined, freckle-faced youths, usually caught boxing, rowing, swimming, or sleeping, all in a self-conscious naturalism that presumes to be as innocent as it is erotic.

David Wojnarowicz

Born in New Jersey, David Wojnarowicz (1954–1992) suffered abuse as a child and grew up largely on the streets, managing somewhat amazingly to acquire a good education despite his troubled youth.

In 1979, living in New York's East Village, he began both his photographic series "Arthur Rimbaud in New York" and his street paintings. As Rimbaud, an alienated Wojnarowicz can be seen riding the New York City subway, eating in a café, and even masturbating.

Wojnarowicz worked in a wide range of media throughout his career but is best known for the series of photo-based works that were at the center of a National Endowment for the Arts (NEA) funding controversy in the late 1980s, "Tongues of Flame."

Controversial because of their explicit gay content, they juxtaposed images culled from gay pornography with images from popular culture. In 1990, Wojnarowicz and the Center for Constitutional Rights sued Donald Wildmon and the American Family Association for illegally reproducing artwork from the "Tongues of Flames" catalog.

His works, which resonate with the anger and frustration felt by gay men in the face of AIDS and homophobia, have been included in a traveling retrospective.

— *Ken Gonzales-Day*

BIBLIOGRAPHY

Cameron, Dan, and Lisa Phillips. *Pierre et Gilles*. London: Merrell Publishers, 2000.

Deitcher, David, and Wolfgang Tilmans. *Burg*. Cologne: Taschen, 1998.

Farson, Daniel. *Around the World with Gilbert & George: A Portrait*. London: Trafalgar Square, 1999.

Flynt, Robert. *Compound Fracture*. Santa Fe: Twin Palms, 1996.

Giard, Robert. *Particular Voices: Portraits of Gay And Lesbian Writers*. Cambridge, Mass.: MIT Press, 1998.

Gorsen, Peter. "The Artist's Desiring Gaze on Objects of Fetishism." *Pierre Molinier: Plug In Editions*. Winnipeg, Canada: Art Press, 1997.

Hujar, Peter. *Peter Hujar: A Retrospective*. New York: Scalo, 1994.

Livingston, Marco, and Duane Michals. *The Essential Duane Michals*. Boston: Bulfinch Press, 1997.

Lorenz, Richard. *Arthur Tress: Fantastic Voyage: Photographs 1956–2000*. Boston: Bulfinch Press, 2001.

Morrisroe, Mark. *Mark Morrisroe*. Santa Fe: Twin Palms, 1999.

Pierson, Jack. *The Lonely Life*. Gerard A. Goodrow and Peter Weiermair, eds. Zurich: Edition Stemmle, 1997.

Pfeiffer, Walter. *Welcome Aboard, Photography 1980–2000*. New York: Scalo, 2000.

Probst, Ken. *(por ne-graf'ik)*. Santa Fe: Twin Palms, 1999.

Ritts, Herb. *Work*. Boston: Bulfinch Press, 1996.

Wojnarowicz, David. *David Wojnarowicz: Tongues of Flame*. Barry Blinderman, ed. Normal, Ill.: University Galleries, Illinois State University, 1990.

SEE ALSO

Photography: Gay Male, Pre-Stonewall; Photography: Lesbian, Post-Stonewall; Erotic and Pornographic Art: Gay Male; Censorship in the Arts; Dureau, George; Gilbert & George; Hockney, David; Mapplethorpe, Robert; Michals, Duane; Pierre et Gilles; Ritts, Herb; Subjects of the Visual Arts: Nude Males; Tress, Arthur; Weber, Bruce; Wojnarowicz, David

Photography: Gay Male, Pre-Stonewall

THOMAS WAUGH PROVIDES AN EXTENSIVE HISTORY OF early erotic photography in *Hard to Imagine: Gay Male Eroticism inPhotography and Film from Their Beginnings to Stonewall*. He identifies four central categories of photographic imagery: fine art (avant-garde, fashion, or Art Academy); physical culture (mail-order or athletic alibi); illicit (legally or culturally pornographic), and instrumental (scholarly or social agendas produced under legal, sexological, or political auspices).

The Blurring of Categories

While such categories are useful, it should be remembered that any given photograph may fall within several categories simultaneously.

For example, the photographs of George Platt Lynes that Alfred Kinsey collected for the Kinsey Institute are at once illicit, instrumental, and fine art. That is, they were originally produced at least in part with pornographic intent and were therefore illegal; but they served the instrumental purpose of illustrating homosexual desire for Dr. Kinsey, while also achieving the luminosity of fine art.

Pre-Stonewall gay male photography comprises a surprisingly large and varied body of work, ranging from simple documentation of gay male lives and social circles to artistic studies of the eroticized male form, images whose homoeroticism is conveyed subtly and indirectly, and works whose intent is primarily pornographic.

Early Photography

The first examples of photographs that may be labeled as gay male photography are to be found in scrapbooks, archives, and exhibitions. Several of these are discussed in David Deitcher's *Dear Friends: American Photographs of Men Together, 1840–1918*, a recent publication and exhibition at the International Center of Photography in New York.

Deitcher's book presents an extensive collection of photographs depicting male couples and small groups. The sexuality of these couples and groups is clearly open to speculation, but even if one cannot be absolutely certain that the images are of men self-consciously attracted to other men, they nevertheless tell a marvelous story of intimate friendships between men.

These photographs indicate that the medium from the very beginning was used to document homosocial relations and possibly homosexuality.

A genre of early European photographs, the Academic Nude, provides the first examples of clearly homoerotic photography. Ostensibly intended to assist artists in their studios, these studies of nude men and boys were also used to illustrate human anatomy and movement; but the images of hard-bodied men undoubtedly spawned other forms of creativity.

The most celebrated photographer of the academic nude was Guglielmo Marconi, who was active in France in the 1860s and 1870s.

Early Fine Art Photography

The first major gay fine art photographer was F. Holland Day (1864–1933). He began his career as a publisher in New England, but his photographs brought him into contact with Oscar Wilde's homophile circle.

Day mastered pictorialist techniques, creating dreamlike soft-focus images that blended homoerotic images of young men with Christian themes of martyrdom and suffering. His self-portrait as the crucified Christ shocked Victorian audiences as much as his practice of selecting young male models from the streets of London.

Baron Wilhelm von Gloeden

Also known to Wilde was the work of Wilhelm von Gloeden (1856–1931). A German nobleman, von Gloeden worked primarily in Italy and made his living by producing a wide range of tourist cards spanning everything from the conventional to the pornographic.

Employing classical themes, von Gloeden favored the dark-skinned Sicilian, who sparked for him not only exoticism but also a renewed interest in the Classical age, where love between a man and a boy was often more than platonic.

Thematically similar to von Gloeden's photography is the work of Vincenzo Galdi (1856–1931) and Wilhelm von Plüschow (1852–1930), both of whom also worked in Italy.

Two minor photographers also working in Taormina at the turn of the twentieth century were Arthur Schulz, a German sculptor by training who published a book of nudes in Leipzig around the turn of the century, and Gaetano d'Agata, a follower of von Gloeden.

European Innovators

In 1930s Germany, Herbert List (1903–1975) helped bring a new sophistication to homoerotic photography. Best known in his lifetime as a fashion and celebrity photographer for *Harper's Bazaar* and *Vogue*, today List is most acclaimed for his idyllic images of young men and boys lying in the sun, swimming, wrestling, or innocently staring into the camera.

Evocative of the popular nature-oriented, antibourgeois German youth movement that would later be tragically transformed by the Nazis, List's images convey both innocence and an avant-garde sensibility.

Avant-Garde Photographers

List was part of a new breed of photographers in both Europe and America who depicted the male nude with an avant-garde sense of composition. Many of these artists were fashion photographers associated with such magazines as *Vogue* and *Harper's Bazaar*. They attempted to make a clear break with the pictorialist aspirations to painterly imagery of photographers such as Day and von Gloeden.

Of these new photographers, George Hoyningen-Hene (1900–1968) may have been the most influential. A Baltic baron whose family had fled the Russian Revolution, Hoyningen-Hene brought a sense of modernity to his photographic work, skillfully fusing bold compositions to his fashion work. He was the presiding fashion photographer at *Vogue* from 1926 to 1935. His colleague and lover, the German photographer Horst P. Horst (1906–1999), also found a place in the annals of *Vogue*.

Another young *Vogue* photographer who achieved commercial success and name recognition was Cecil

Beaton (1904–1980). A theatrical designer as well as a photographer, he is best known for his celebrity portraits, often of gay friends. Beaton also worked for *Vanity Fair*. He covered World War II as a photojournalist, later became the official photographer for the British Royal Family, and was eventually knighted.

Referred to as the "Dandy Photographer," he rarely addressed gay themes overtly, but several historians and scholars have noted subtle homoerotic elements in his work.

American Fine Art Photography

In 1937, three artist friends—Paul Cadmus (1904–1999), Jared French (1905–1988), and Margaret French (d. 1998)—began to experiment with photography during their trips to Fire Island and Provincetown. Known as the PAJAMA Group (for Paul-Jared-Margaret), they photographed their intimate, largely gay and bisexual, circle over two decades, but especially from 1937 to 1945.

Their images document a substratum of gay life during a crucial decade, while also providing insight into a period of great creativity and freedom for the artists. Cadmus and Jared French, who were probably lovers before French's 1937 marriage to Margaret Hoening, are best known for their paintings, and their photographs probably influenced their paintings in various ways.

George Platt Lynes

In an era when erotic photography of the male nude was not only taboo but also illegal, George Platt Lynes (1907–1955) was a true pioneer, creating well-crafted images whose originality reached beyond their sexually charged themes.

Today, Lynes's photographs for George Balanchine's ballet *Orpheus* are his most widely recognized works. They anticipate the later erotic male nudes, which are startlingly beautiful in their honesty and simplicity. Dr. Alfred C. Kinsey, the pioneering sexologist who published *Sexual Behavior in the Human Male* in 1948, began collecting Lynes's homoerotic work in the 1950s, and today the Kinsey Institute has the largest collection of his work.

Minor White

More cerebral than the work of Lynes are the images of Minor White (1908–1976). Attempting to use the camera to explore spiritual depths, or to transform the carnal into the spiritual, White avoids overt eroticism, even in his highly suggestive images of male nudes. Still, his photographs achieve a subtle homoeroticism that is often more powerful because of the artist's oblique approach.

Physical Culture

As early as 1930, Henry Annas Studio in Texas was producing beefcake images of musclebound men in desert

settings. By the 1940s, a wide variety of homoerotic imagery began to be available to a wide public through male fitness or physique magazines such as *Strength and Health, Muscle Power, Pictorial, Fizeek Art Quarterly,* and *Tomorrow's Man.* Produced for a growing but largely underground gay subculture, these magazines used fitness as a pretext for depicting buffed-out and oiled-up athletes.

As the gay subculture grew, so did the variety of magazines available. In the 1950s, a Chicago photographer working under the name "Kris" began creating images of midwestern men in seedy rooms sporting G-strings. The connection between these photographs and physical fitness was remote indeed.

Similarly, on the West Coast the photographic image was already moving from strict representations of weight lifters and barbells to pictures of naked young men in campy interior shots or wrestling in the great outdoors. Not surprisingly, given the legal and moral climate of the times, many of the photographers of these pictures published their work anonymously or under pseudonyms.

At the end of the 1950s, photo studios such as Bob Mizer's Athletic Model Guild (AMG), the Western Photography Guild, and Spartan of Hollywood began to emerge. These enterprises marketed their photographs somewhat more openly to gay consumers than had the earlier magazines. Although they gradually dropped the pretense to physical culture or bodybuilding interest, they generally communicated with their audience in coded terms rather than directly.

Bruce of Los Angeles

By the end of the 1950s, Bruce Harry Bellas (1909–1974), better known as Bruce of Los Angeles, had emerged as one of the leading photographers of the eroticized male body.

Born in Alliance, Nebraska, Bellas began careers in chemistry and teaching before moving in the early 1940s to California, where he first worked as a freelance photographer, documenting bodybuilding competitions.

By the late 1940s, Bellas had become a staff photographer for Joe Weider's bodybuilding publications and spent much of his time traveling to bodybuilding contests in several states. His photographs appeared in such magazines as *Strength and Health, Muscle Power,* and *Tomorrow's Man.*

By the 1960s, Bellas was able to publish his own magazine, *The Male Figure.* Postal regulations forbade the posting of frontal male nudity until 1968, and as a result many of his nudes were sold out of the hotel rooms he occupied on his travels across the country.

Bruce utilized a wide range of motifs and props, so it was not unusual to see a model dressed as a cowboy, a construction worker, a buccaneer, a Spartan wrestler, or simply relaxing *al fresco*.

Conclusion

Pre-Stonewall gay male photography is sparse in images documenting gay community, but rich in images of same-sex desire. The contemporary interest in queer cultural imagery raises questions about the interrelationship of high and low cultural forms. Perhaps that complex relationship is most clearly illustrated by reference to pre-Stonewall gay male photography, which ranges from the high-art aspirations of F. Holland Day and Minor White to the soft porn of Bruce of Los Angeles.

While some scholars have dismissed the artistic importance of subcultural work, others argue that distinctions between high and low art simply mask class privilege and academic elitism. No matter the verdict, pre-Stonewall gay male photography offers an abundance of images that blur the boundaries between art, erotica, and social history.

— *Ken Gonzales-Day*

Bibliography

Cadmus, Paul, Margaret French, and Jared French. *Collaboration: The Photographs of Paul Cadmus, Margaret French and Jared French.* Santa Fe: Twelve Trees Press, 1992.

Crump, James. *George Platt Lynes: Photographs from the Kinsey Institute.* Bruce Weber, intro. Bulfinch Press Book; New York: Little, Brown and Company, 1993.

Deitcher, David. *Dear Friends: American Photographs of Men Together, 1840–1919.* New York: Harry N. Abrams, 2001.

Dolinsky, Jim, ed. *Bruce of Los Angeles.* Berlin: Bruno Gmünder, 1990.

Gonzales-Day, Ken. "Visual Arts." *St. James Press Gay and Lesbian Almanac.* Neil Schlager, ed. Detroit: St. James Press, 1998. 489–504.

Waugh, Thomas. *Hard to Imagine: Gay Male Eroticism in Photography and Film from Their Beginnings to Stonewall.* New York: Columbia University Press, 1996.

Woody, Jack. *George Platt Lynes: Photographs 1931–55.* Pasadena: Twelve Trees Press, 1981.

See Also

Photography: Gay Male, Post-Stonewall; Erotic and Pornographic Art: Gay Male; Beaton, Cecil; Cadmus, Paul; Day, F. Holland; French, Jared; Gloeden, Baron Wilhelm von; List, Herbert; Lynes, George Platt; White, Minor

Photography: Lesbian, Post-Stonewall

SINCE STONEWALL, THE PHOTOGRAPHIC REPRESENTATION of lesbians has been increasingly recognized as an important subject. The strong emphasis on photographic practice in the last twenty years and the growing access of lesbians to photographic and digital technologies have made possible the development of a significant body of lesbian photography.

While much of this work has been consciously political, Harmony Hammond points out that any lesbian imagery inevitably has a gendered and sexual particularity that questions and disrupts modernist ideas of universality.

The Categories of Post-Stonewall Lesbian Photography

Although the period of lesbian chic in the early 1990s briefly created a palatable and depoliticized lesbianism for the mainstream, it also drew attention to previously ignored lesbian artists. Their work appeared in specifically lesbian exhibitions and in publications such as *Stolen Glances: Lesbians Take Photographs* by Tessa Boffin (1960–1993) and Jean Fraser (b. 1955).

In this 1991 book, Boffin and Fraser usefully divide post-Stonewall lesbian photographs into four categories: documentation of individuals and activities within the various lesbian communities, images of lesbians in the mainstream heterosexual press, photographs that explore a lesbian sensibility, and photographs that deal overtly with lesbian issues.

These categories are useful, but they are not exhaustive. Nor are they mutually exclusive; that is, any particular photograph might fall into more than a single category. Particularly interesting are those images that counteract the traditional invisibility of lesbians and lesbian communities; those that attempt to capture a particular lesbian sensibility; and those that confront specific problems and issues within lesbian communities.

Documentation of Lesbians and Lesbian Communities

Boffin and Fraser point out that, in response to the historical invisibility of lesbians, there has been a concerted effort by lesbian photographers to document all aspects of lesbian existence. Many lesbian photographs fill family albums and have been influential in extending the meaning and definition of family. Through photographing their social lives, significant events, and political actions, lesbian photographers have used the gay press and other publications to create an enduring lesbian archive.

In North America during the 1970s, lesbian photographers such as Cathy Cade (b. 1942) and JEB (Joan E. Biren, b. 1944) documented lesbians of various ages, races, and classes in order to deconstruct the stereotypical images of lesbians that prevailed at that time.

Cathy Cade originally began taking photographs to document her concern for social justice. The Women's Liberation Movement gave her both an ideology and a subject—political demonstrations against the oppression of women. Similarly, Bettye Lane traveled around the world photographing women's demonstrations, meetings, and events.

At the same time, JEB toured America with slide shows that illustrated the history of lesbian photography. For over twenty-five years, she has been photographing lesbian mothers, a preoccupation she shares with British photographer Brenda Prince (b. 1950).

Other post-Stonewall photographers who document individuals and activities within the various lesbian communities include Judy Francesconi (b. 1959), Chloe Atkins (b. 1954), and Linda Kliewer (b. 1953).

In her series "Women with Women," Francesoni captures loving and positive images of lesbians. Atkins documents nightclub events in San Francisco and has developed series of photographs of drag kings and lesbian athletes. Kliewer has photographed middle-American lesbians and served as the cinematographer for *Ballot Measure 9* (1993), an award-winning film about the fight against antigay politics in Oregon.

Theresa Thadani (b. 1960) also contributes to the photojournalistic documentation of lesbians. Trista Sordillo's (b. 1970) photographs in her "Lesbian Invisibility Series," including "Butch/Femme" (1995), is a continuing project, documenting and honoring friends from her lesbian community. In Sydney, Mazz and C. Moore Hardy (b. 1955) have also extensively documented lesbians, transsexuals, and bisexuals and their community events.

In the 1970s, Nan Goldin (b. 1953) began taking photographs of the gritty reality of those who live outside the spaces of conventional sexual identity. Her slide show of 700 images, "The Ballad of Sexual Dependency" (1982), later excerpted in her book of the same name (1986), told the story of her life as a bisexual, intertwined with the stories of her friends. She portrays a morally ambiguous world inhabited largely by drag queens and transsexuals.

Universal versus Specifically Lesbian Images

Images of lesbians have also appeared in heterosexual and mainstream galleries and magazines. These photographs were particularly visible during the brief period of lesbian chic. They were often produced by lesbian photographers who felt that their images were aesthetic and universal and transcended issues of sexuality and politics.

In contrast to the universalizing photographers are those who seek to produce photographs with a lesbian "aura" or sensibility. Mainly active in the 1970s, but by no means extinct today, these photographers search for a female aesthetic. Their work often grows out of consciousness-raising efforts and is based on the shared experiences of lesbians and their biological community.

These artists frequently use nature-based imagery and often equate lesbian sex with spirituality. Tee Corinne (b. 1943), for example, in her search for ways to represent a lesbian sensibility, produced mandalas through multiple photographic prints of women having

oral sex or through double-exposed photographs of close-ups of women's genitals superimposed over landscape backgrounds.

She chose to publish her photographs rather than exhibit them in order to reach a wider cross section of the public and to provide a publicly accessible lesbian history.

Overtly Political Images

In their final category, Boffin and Fraser place photographs that clearly deal with lesbian issues in an overtly political way. Among these issues are the form and control of depictions of lesbian sexuality, the struggles against homophobic attacks, the depoliticizing and co-opting of lesbians through lesbian chic, and the conservative tendencies in postmodern theory.

The photographers who confront these issues often embrace strategies of representation informed by aspects of postmodernist practice, such as appropriation, pastiche, charade, irony, and parody. They retain a belief in a progressive and transgressive photographic practice despite their understanding that a politics of resistance can no longer be based on the unity and coherence of a lesbian aesthetic or experience.

Consequently, lesbians subvert and appropriate popular forms such as cartoons, Westerns, soap operas, and Hollywood films to question representations of marginality and difference.

Deborah Bright (b. 1950), for instance, inserts images of herself as "butch-girl" into the conventional narrative stills of earlier Hollywood films. She exploits the gaps, elisions, and contradictions of the genre to assert a previously banished lesbian presence.

Similarly, Australian photographer Fiona Arnold (b. 1958) uses found objects and photographs of herself to produce quirky and amusing pastiched images such as "The Dirty Dozen" (1995).

Another Australian photographer, Tina Fiveash (b. 1970), appropriates images from magazines and advertisements of the 1950s to create a missing lesbian history. She constructs environments for her photographs in order to re-present a contemporary dream of the past through her sexualized historical gaze.

Using a photographic booth manufactured in Japan that morphs digital images of offspring for couples, Michelle Barker (b. 1969) and Anna Munster developed the installation piece *The Love Machine* (1995), where they are presented as a couple, together with their "instant" morphed family, an Asian boy, a Caucasian girl, and an African American girl.

Since 1991, Jill Casid (b. 1966) and Maria DeGuzman (b. 1964), as the queer feminist partnership SPIR—Conceptual Photography, have been working in collaboration with each other and with friends and colleagues to produce narrative photo-text sequences and single images that attempt to transform myths, stereotypes, and icons and visualize ideas in a seductive form.

This work is an extension of many of the issues they have been exploring in their scholarship, including the negotiations of identity construction; the performance and performativity of ethnicity, gender, and "orientation" (sexual and otherwise); and the connection of the "image" to the "cliché."

Depictions of Lesbian Sexuality

The depiction of lesbian sexuality by lesbians had one of its earliest manifestations in JEB's photograph of herself and her girlfriend kissing in the early 1970s. By the 1990s, the development of a queer S/M culture and the increased numbers of female-to-male transsexuals had greatly broadened the range of experience available to photographers.

Masculine iconography, such as gay male pornography, has been exploited by photographers such as Della Grace (b. 1957) in order to challenge the normative image of lesbian sex and to comment on the economic power and privilege of the gay male.

Grace insists that she is not mapping gay male sexuality onto the lesbian body, but is using a "butch" or fetish iconography for the purposes of self-conscious parody. Now the "hermaphrodyke" Del LaGrace Volcano, he has recently focused on images of drag kings and female-to-male transgendered persons.

In New Zealand, Rebecca Swan (b. 1968) has also extensively documented the experiences and identities of transsexuals.

In her photographic series "Dirty Girls in London" (1988), Jill Posener (b. 1953) stages passionate and blatant images of lesbians making out in familiar public locations. She claims that these images are political acts analogous to lesbian graffiti in making lesbian sexuality publicly visible.

Catherine Opie (b. 1961) combines her documentation of the queer leather community with a larger interest in community and identity. She sees lesbian identity as fluid and expanding, offering opportunities for playing with gender-bending through performance and cross-dressing.

In her "Portrait" series, Cheryl Smith explores the tension between absence and presence, between gaining and losing a sense of community.

Opie, Chloe Atkins (b. 1954), and many other lesbian photographers have produced lesbian pornographic shots for magazines such as *On Our Backs*. These images, and the sexual activities they depict, are often the subject of bitter controversy among lesbians.

In 1990, Kiss & Tell—Susan Stewart (b. 1952), Persimmon Blackbridge (b. 1951), and Lizard Jones

(b. 1961)—an art collective in Vancouver, used the intense debates around sexual practice to create the photographic exhibition Drawing the Line. Their photographs depicted a continuum of lesbian sexual practice ranging from kissing to whipping, bondage, and voyeurism.

This project encouraged viewers to comment by writing directly on plastic over the prints. The collective hoped to encourage a wide and diverse range of views to be expressed.

Advertising Images

Since 1990, the increasingly conservative climate in many parts of the world, censorship in the United States, and political action around AIDS have generated a refocusing on the body and a new style of visual activism.

Through the lesbian arm of Queer Nation, the Dyke Action Machine (DAM) team of Carrie Moyer (b. 1960) and Sue Schaffner (b. 1964) used slick photographic designs on bus and telephone kiosks to critique the marketing of family and the construction of difference through advertising.

In Australia, the Word of Mouth collective used the "Lovely Mothers Project" (1993–1994) to oppose lesbians losing custody of their children. To change public perceptions of lesbians as mothers and daughters, they used street posters and billboards.

Similarly, Chloe Atkins won an award in California for a billboard showing a lesbian couple, one of whom was very pregnant, with the caption "Another Traditional Family." Lesbians also challenge ideas of "individual genius" when they use various modes of collective photographic practice.

Lesbian photographers have also transformed advertising to make a lesbian presence visible. In Australia, for example, Kay Schumack (b. 1953) has utilized the format of advertisements to examine lesbian poolroom culture and street presence, while Marion Moore (b. 1958) used her series "Centrefold" (1996) to subvert the stereotyped perception of lesbian body image.

Jill Posener, formerly of London and now in San Francisco, was photo editor of *On Our Backs* for two years and in 1996 coedited *Nothing but the Girl* with Susie Bright. She has produced two books of political graffiti photos (*Louder than Words*, 1986, and *Spray It Loud*, 1982) that include lesbian graffiti attacking mainstream advertising.

Tessa Boffin's series of photographs called "Angel Rebels: Lesbians and Safer Sex" (1989) considers the influence of AIDS on lesbians and how they can maintain their sexual expression despite the vilification of homosexuals by the mainstream press. As her lifestyle became her art practice, Boffin frequently performed in the London nightclub scene as a "queer pervert faggot boy-girl drag queen."

Non-Anglo Lesbian Photographers

Non-Anglo lesbians are increasingly active in exploring the multiple problems of cultural displacement.

In 1986, Laura Aguilar (b. 1959) began her "Latina Lesbians" series, intended to document positive images of Latinas to counteract negative stereotypes and increase racial understanding. She recently exhibited thirty-three black-and-white prints of her own corpulent body posed against a landscape of other women of various body types. Her images are at once defiant and subversive.

Photographers such as Gaye Chan (b. 1957), Hanh Thi Pham (b. 1954), Jean Weisinger (b. 1954), Zone Paraiso Montoya (b. 1966), and Hulleah Tsinhnanjinni (b. 1954) in the United States and Mumtaz Karimjee (b. 1950) and Ingrid Pollard (b. 1953) in the United Kingdom produce images that establish non-Anglo lesbian identities.

The aboriginal artist Rea (b. 1962) uses her digital photography to address the racist treatment of Koori people in Australia. She likens the black woman's body to that of the lesbian as equally invisible.

Sometimes at odds with their ethnic communities' beliefs and values, these artists work across a range of oppressions, including especially homophobia and racism, to assert their racial, political, and sexual identities.

Conclusion

The rapidly expanding range of lesbian photography is beginning to redress the paucity of images available to lesbians and other members of subcultures that remain largely invisible or misrepresented in mainstream culture.

—*Elizabeth Ashburn*

BIBLIOGRAPHY

Ashburn, Elizabeth. *Lesbian Art: An Encounter with Power.* Sydney: Craftsman House, 1996.

Atkins, Chloe. *Girls' Night Out.* New York: St. Martin's Press, 1998.

Biren, Joan E. *Eye to Eye: Portraits of Lesbians.* Weatherby Lake, Mo.: Glad Hag Books, 1979.

Blake, Nayland, et al., eds. *A Different Light: Visual Culture, Sexual Identity, Queer Practice.* San Francisco: City Light Books, 1995.

Blank, Joani, ed. *Femalia.* San Francisco: Down There Press, 1993.

Boffin, Tessa, and Jean Fraser, eds. *Stolen Glances: Lesbians Take Photographs.* London: Pandora Press, 1991.

Bright, Deborah, ed. *The Passionate Camera: Photography and Bodies of Desire.* London: Routledge, 1998.

Bright, Susie, and Jill Posener, eds. *Nothing but the Girl.* New York: Cassell, 1996.

Goldin, Nan. *The Battle of Sexual Dependency.* New York: Aperture, 1986.

Grover, Jan Zita. "Dykes in Context: Some Problems in Minority Representation." *The Contest of Meaning: Critical Histories of Photography.* Richard Bolton, ed. Cambridge, Mass.: MIT Press, 1989. 163–203.

Hammond, Harmony. *Lesbian Art in America: A Contemporary History.* New York: Rizzoli International Publications, 2000.

Kelley, Caffyn, ed. *Forbidden Subjects: Self-Portraits by Lesbian Artists.* North Vancouver, B.C.: Gallerie, 1992.

Kiss & Tell (Susan Stewart, Persimmon Blackbridge, and Lizard Jones). *Drawing the Line: Lesbian Sexual Politics on the Wall.* Vancouver, B.C.: Press Gang Publications, 1991.

Neumaier, Diane, ed. *Reframings: New American Feminist Photographers.* Philadelphia: Temple University Press, 1995.

Smyth, Cheryl. *Damn Fine Art.* London: Cassell, 1996.

See also

Photography: Lesbian, Pre-Stonewall; African American and African Diaspora Art; Canadian Art; American Art: Lesbian, Post-Stonewall; Erotic and Pornographic Art: Lesbian; Biren, Joan Elizabeth (JEB); Corinne, Tee; Grace, Della (Del LaGrace Volcano); Hammond, Harmony Lynn; Leibovitz, Annie

Photography: Lesbian, Pre-Stonewall

IT IS LIKELY THAT LESBIANS BEGAN MAKING PHOTOGRAPHS almost as soon as the medium was invented, in 1839, but the record of those images has been obscured by time, disinterest, and overt hostility. However, the past thirty years of scholarship—primarily by lesbian and feminist researchers—has produced enough material to permit a dialogue about photographs made by lesbian-identified or lesbian-identifiable women.

For some, the term *lesbian photography* presents a complicated reality. As used here, it means photographs made by women who participated in loving—often physical—relationships with other women. Within a lesbian context, the most significant of these early images are those that reflect lesbian iconography, convey relationships, or show the photographer looking at and recording her beloved.

How openly pre-Stonewall lesbian women might behave in public depended on a combination of factors, including economics, geographic location, race, ethnicity, and position in time. Paris, with its lack of inhibiting laws and long history of independent women, was a haven for lesbians decades before it became the expatriate destination of choice in the 1920s. Greenwich Village in the 1910s and Berlin in the 1920s and early 1930s also particularly drew women who loved women.

The Loving Eye

The vast majority of photographic images made by lesbians remain hidden in private photo albums and never reach public display. Representative of this group are pictures by Norma Jean Coleman (1924–1998) and Phyllis Ann Farley (1932–1984), whose scrapbooks are in the Lesbian Herstory Archives, in Brooklyn, New York. Made between 1941 and 1984, they visually affirm friendship groups and domestic relationships.

As is often true in pictures such as these, one member of a couple will take a photograph of the other, then switch places, producing images obviously made at the same time and against the same background.

The earliest lesbian-produced work currently known is by Emma Jane Gay (1830–1919). For many years, Gay maintained an unrequited love for anthropologist Alice Fletcher, with whom she lived in Washington, D.C. Gay photographed Fletcher at work in the West with the controversial U.S. land allocation program. She documented camp life, the landscape, Native American tribal women and children, as well as men. Later, Gay moved to England, where she found her love returned by a woman doctor.

Edith Watson (1861–1943), thirty years younger than Emma Jane Gay, was a U.S.-born photojournalist who spent much of her adult life photographing in Canada, where she produced images for magazines, newspapers, and tourist brochures. Her intimate companion for thirty years was writer Victoria Hayward.

In loving portraits of Hayward—such as one taken in 1916 beside the Atlantic Ocean, in which Hayward stands at the water's edge with her skirt bunched around her thighs—the lesbianism of the imagemaker is most apparent.

Southwestern U.S. photographer Laura Gilpin (1891–1979) studied in New York City before returning to Colorado to work. She is best known for her photographs of the Navajo, but she also frequently photographed Elizabeth W. Forster, her dearest love for more than fifty years. Like Emma Jane Gay, Gilpin sometimes photographed Forster in a group setting, as if she were just anyone, the anonymous "visiting nurse" in a scene with a sick Native elder or holding a lamb and a Navajo child.

Iconic Imagery

Iconic photographs have a symbolic or signaling effect, an import greater than their surface information. They make announcements or answer questions—for example, about the look of women as couples or as rebels. Such photographs have a quality of being "set apart" from the world and are often used as points of departure for study, communication, or worship.

U.S.-born Alice Austen (1866–1952), though she traveled to Europe and New England, lived almost her entire life on Staten Island, where she photographed her family, friends, and neighbors, often in iconic poses. There were other lesbians in her friendship group and hints of intimacy are frequent in her work: women embracing, touching another's leg possessively, smoking, hanging out in bed.

In a frequently reproduced image by Austen, three women wearing men's clothes and mustaches pose. An

umbrella handle rises irreverently between the legs of one. Another lesbian iconic image shows two pairs of women embracing.

Frances Benjamin Johnston (1864–1952), an early photographer and photojournalist, appears to have had no male lovers and at least one long-term relationship with a woman, photographer Mattie Edwards Hewitt (d. 1956). The two women shared a studio and home in New York City from 1909 to 1917.

Queer-related photographs produced by Johnston include images of homosexual-appearing men, male sailors dancing together, and a portrait of Natalie Clifford Barney (1876–1972) as a young woman.

However, the image that most clearly reflects Johnston's life is not one of relationship but of independence. Taken in 1896, the self-portrait shows the photographer seated in profile, the ankle of one leg resting on the knee of the other in a position of masculine power. She holds a beer stein in one hand and a cigarette in the other.

Margarethe Mather (ca. 1885–1952) was an art photographer who had a studio with Edward Weston in Southern California in 1914. She was part of an extended lesbian friendship network and left photographs of dykey-looking women and of her young, androgynous-appearing gay male roommate.

Images by French Jewish photographer Claude Cahun (Lucy Schwob) (1894–1954) are at home in a postmodernist discourse of fluid gender roles and constructed identities. She was active in the theater, and some of her self-presentations—male, Buddha, femme-doll—may have been produced in conjunction with plays in which she was acting.

Lesbian Erotics

Unless sexual desire is encoded into images of them, lesbians are frequently interpreted as spinsters, old maids, or merely women friends who live together without any special category of relationship. Historically, the physical manifestations of love have been visually portrayed in nude images of the beloved. Lesbians, no less than gay males and heterosexuals of both sexes, have participated in and contributed to this genre of imagemaking.

In 1900, in an early exploration of lesbian eros, Natalie Clifford Barney collaborated with her former lover Evaline Palmer (born about 1876) and her then current lover poet Renée Vivien (Pauline Mary Tarn) (1877–1909) in making nude studies of each other in Bar Harbor, Maine. Barney took the negatives to Paris to be developed and printed.

One of Natalie Barney's later loves was painter Romaine Brooks (1874–1970). A U.S. citizen, Brooks was born in Rome and spent most of her adult life in France. Outrageously wealthy, she created photographic self-portraits, nude images of Ida Rubinstein (a relationship that predated Brooks's with Barney), and images of herself and Barney paired as if documenting their relationship for posterity.

Canadian Clara Sipprell (1885–1975) did not have the luxury of wealth. She supported herself through soft-focus images of people, still lifes, and landscapes. She produced a few lovely female nude studies in 1915 and 1925. Sipprell lived with three women sequentially, although the relationships may have been chaste. The names of two are recorded along with hers on the small bronze memorial tablet affixed to an outcropping of granite, her choice in lieu of a gravestone.

A bisexual, Ruth Bernhard (b. 1905) is one of the primary definers of the nude female in twentieth-century photography. She created luminous, sometimes surreal images of bodies and of shells, among other subjects. One of her images—of an interracial pair of women lovers—has a memorable quality of distilled passion.

Definitive Portraits

Portraits are the staple of lesbian-themed imagery. They answer questions about lesbian self-presentation and lesbians as spectators. Lesbians and bisexuals are likely to appear frequently as subjects in the work of lesbian photographers, in part because they share intimate friendship circles.

In addition, however, lesbian and bisexual subjects may be more likely to commission images from photographers whom they suspect or know to be lesbian because they may assume that they and their relationships will be portrayed sympathetically.

American midwesterner Berenice Abbott (1898–1991) moved to Paris in 1921, where she became the favorite portrait photographer of the younger generation of expatriate lesbian writers and artists including Janet Flanner, Solita Solano, Sylvia Beach, Djuna Barnes, Jane Heap, and Margaret Anderson.

Abbott returned to New York City in 1929 and photographed the city at a time of rapid change. She also made photographic images illustrating principles of science for educational texts, but continued photographing lesbians. She moved to Maine in 1966 and remained there for the rest of her life.

Best known for her portraits, the German Jewish photographer Gisèle Freund (1912–2000) arrived in Paris almost a decade after Berenice Abbott. She became friends with Sylvia Beach and Adrienne Monnier, who introduced her to the major English and French literary figures. Freund photographed Virginia Woolf, Vita Sackville-West, James Joyce, and Marguerite Yourcenar, as well as Beach and, especially, Monnier, who became her lover.

Freund fled the Nazis to South America, then lived in the U.S., and later returned to France. A lesbian sensibility is most visible in her portrait of Sackville-West at

her writing table with a photograph of Virginia Woolf visible behind her.

Times Change

Perhaps because of advances made by the gay and lesbian liberation movements, Rollie McKenna (b. 1918)—best known for her photographic studies of Dylan Thomas—could write in 1991 of involvements with both men and women.

Likewise, at the end of the twentieth century, Ruth Bernhard (b. 1905) felt free to write of her relationships with women and with an African American man; and the biographer of Germaine Krull (1897–1985) could write in an unapologetic way of Krull's one affair with a married woman (amid many with male lovers).

The transition to the increased openness of the late twentieth century is most apparent in the images of Kay Tobin Lahusen (b. 1930), which were published in the lesbian publication *The Ladder* between 1964 and 1966. Tobin Lahusen's lover, Barbara Gittings, was the magazine's editor and often appeared in her photographs.

Tobin Lahusen's work was the first by an openly lesbian photographer to be published in the United States. At first, lesbians would only pose back-to-camera, in silhouette, or with sunglasses.

Although much has changed in the availability of images of openly lesbian women, in the early twenty-first century most lesbian photographers who have gained mainstream success remain closeted.

— *Tee A. Corinne*

BIBLIOGRAPHY

Berch, Bettina. *The Woman behind the Lens: The Life and Work of Frances Benjamin Johnston, 1864–1952.* Charlottesville: University Press of Virginia, 2000.

Boffin, Tessa, and Jean Fraser, eds. *Stolen Glances: Lesbians Take Photographs.* London and San Francisco: Pandora/HarperSanFrancisco, 1991.

Chadwick, Whitney. *Amazons in the Drawing Room: The Art of Romaine Brooks.* Berkeley: University of California Press, 2000.

Corinne, Tee A. "Photography." *Lesbian Histories and Cultures.* Bonnie Zimmerman, ed. New York: Garland, 2000. 588–592.

———. "Who's Looking, What Are They Seeing?" *n.paradoxa* 6 (2000): 33–39.

Freund, Gisèle. *Gisèle Freund: Photographer.* New York: Harry N. Abrams, 1985.

———. *The World In My Camera.* June Guicharnaud, trans. New York: Dial Press, 1974.

Gay, E. Jane. *With the Nez Perces.* Lincoln: University of Nebraska Press, 1987.

Goujon, Jean-Paul. *Album Secret: Renée Vivien, Natalie Barney, Eva Palmer.* Paris: Éditions à l'Écart, 1984.

Justema, William, and Lawrence Jasud. *Margrethe Mather.* Tucson: Center for Creative Photography, University of Arizona, 1979.

Kling, Jean L. *Alice Pike Barney: Her Life and Art.* Washington, D. C.: Smithsonian Institution, 1994.

Leperlier, François. *Claude Cahun, L'Écart et la métamorphose.* Paris: Jean-Michel Place, 1992.

Mark, Joan. *A Stranger in Her Native Land, Alice Fletcher and the American Indians.* Lincoln: University of Nebraska Press, 1988.

McCabe, Mary Kennedy. *Clara Sipprell: Pictorial Photographer.* Fort Worth: Amon Carter Museum, 1990.

McKenna, Rollie. *A Life in Photography.* New York: Knopf, 1991.

Mitchell, Margaretta K. *Ruth Bernhard: Between Art and Life.* San Francisco: Chronicle Books, 2000.

Novotny, Ann. *Alice's World: The Life and Photography of an American Original: Alice Austen, 1866–1952.* Old Greenwich, Conn.: Chatham Press, 1976.

Rooney, Frances. *Working Light: The Wandering Life of Photographer Edith S. Watson.* Ottawa: Carleton University Press, 1996.

Sandweiss, Martha A. *Laura Gilpin: An Enduring Grace.* Fort Worth: Amon Carter Museum, 1986.

Weiss, Andrea. *Paris Was a Woman.* San Francisco: HarperSanFrancisco, 1995.

SEE ALSO

Photography: Lesbian, Post-Stonewall; Photography: Gay Male, Pre-Stonewall; Abbott, Berenice; Austen, Alice; Bernhard, Ruth; Brooks, Romaine; Cahun, Claude; Sipprell, Clara Estelle; Subjects of the Visual Arts: Nude Females

Pierre et Gilles *(founded 1976)*

THE FRENCH DUO PIERRE ET GILLES POSE AN INTEResting paradox: their painted photographs are stylistically unique, bearing a highly specialized aesthetic that is uniquely their own, yet their work is patently derivative, made from the overt mixing of preexisting imagery, styles, genres, and pictorial traditions.

While all artists work under the influences of the visual world around them, Pierre et Gilles have taken the next step; their pictures are the result of a grab bag of aesthetic interests and speak to a love affair with visual culture, taking equal pleasure in divinity and banality, beauty and smut.

The duo's work is remarkable not only for the seeming ease with which so many disparate influences—such as Renaissance and Baroque paintings, pornographic images, commercial photographs, and gaudy Catholic prayer cards—come together, but also for the visual effect achieved by the application of paint onto photographic surfaces.

Everything in their work is seen through a hazy, unreal veneer that commands the unsettling perfection of a print ad, the warm, still light of a Vermeer, the emotive detail of a church fresco, and the buffed, supple promise of a dirty magazine.

The story of Pierre et Gilles—Pierre Commoy and Gilles Blanchard—bears the same fairy-tale characteristics as much of their work: the young men, both born in the early 1950s in western France, fell madly in love in the mid-1970s after meeting at a party and going home together.

They soon began collaborating artistically, Pierre bringing the fruits of his formal training as a photographer, Gilles bringing his talents as a painter. Together, they have created a prolific body of work that now numbers in the several hundreds, including several flamboyant self-portraits.

In today's world, where unearthly visual effects are increasingly achieved with a computer, it may seem as though Pierre et Gilles's images are further results of digital dream-weaving. But make no mistake about it: their works are one-of-a-kind, handmade objects, a fact that belies their frequent reproduction for use as magazine covers, advertisements, CD covers, and the like.

Artifice is central in Pierre et Gilles's work: Their human subjects are set in frontal, didactic poses against alluring but deliberately fake-looking backdrops. Drawing equally from portraiture, tableaux, fashion photography, and the celluloid media, their pictures serve as fanciful documentation for an array of subjects, each with its own discrete story.

This is especially true of Pierre et Gilles's series of saints, wherein allegories of miracles are rendered in the same unreal patina as the hustlers, porn actors, and movie stars who populate other works.

The artists also routinely depict scenes from mythology, historical figures, current events, nudes, children, and what can only be described as celebrities playing dress-up. The common thread: an insistence on the (artificial) beauty of their subjects and a disregard for the limitations of their real-world referents.

That does not mean, however, that their pictures forsake complexity or criticism for beauty. While Pierre et Gilles's choice of subjects, as well as their stylistic milieu, might suggest a sort of universal humanism of shiny, happy people, the artists are equally interested in imposing on their pictures an explicitly gay (often critical) perspective.

Like many other gay artists, Pierre et Gilles focus heavily on the male body (within and outside the context of same-sex lust), while casting women as nostalgic, glamorous camp icons.

But beyond that, Pierre et Gilles capture the nuances of modern gay life by casting male subjects who are beautiful but melancholy, in the throes of both pleasure and pain, hunting for illicit encounters, torn by political strife, or haunted by the potential for disease, death, and hatred. Heavy face makeup, scant costumes, drag, and uniforms play with notions of masculinity and the indelible male body.

Moreover, the artists' emphasis on artifice and their signature dreamlike surfaces constitute a double-edged response to the prominence of the body beautiful in mainstream gay culture by both reveling in and mocking notions of perfection, superficiality, aestheticism, and a proverbial place over the rainbow.

Thus, perhaps what makes Pierre et Gilles's work so compelling is that it achieves considerable complexity with remarkable unpretentiousness and accessibility. While their pictures certainly engage the postmodern tactic of remaking preexisting subjects, narratives, and pictorial conventions into new, highly self-conscious images, the artists hardly seem to champion postmodern critiques as the means through which to consider them.

Rather, they insist foremost on the allure of their impossible images, while also bringing new critical possibilities to the pleasures of eye candy.

— *Jason Goldman*

BIBLIOGRAPHY

Cameron, Dan. *Pierre et Gilles.* New York: Merrell and New Museum of Contemporary Art, 2000.

Marcadé, Bernard, and Dan Cameron. *Pierre et Gilles: The Complete Works, 1976–1996.* New York: Taschen, 1997.

SEE ALSO

Photography: Gay Male, Post-Stonewall; Contemporary Art; European Art: Twentieth Century; Pop Art

Pisis, Filippo Tibertelli De *(1896–1956)*

WITH A STYLE THAT COMBINED ELEMENTS OF META-physical and Impressionist painting, avant-garde Italian artist Filippo De Pisis did not belong to any one particular artistic movement. His individualism may have contributed to a certain marginalization of his art, yet he gained acclaim for his cityscapes, still lifes, and voluptuous male nudes. His work is distinguished by a palpable sensuality.

As a young man De Pisis earned a university degree in literature, with an eye to a possible career as a writer. Although painting became his principal means of artistic expression, he continued to write poetry and other works throughout his life.

De Pisis came from the Tibertelli family, established in Ferrara since the fourteenth century. The founder of the family, Filippo Tibertelli da Pisa, was a condottiere, or commander of a troop of mercenaries, from Pisa whose reputation rose to near-mythic proportions over the years. De Pisis changed his name from Luigi Filippo Tibertelli in recognition of his ancestor's place of origin.

Ferrara was dominated by Socialists and anticlericals at the time of De Pisis's birth on May 11, 1896, and so the staunchly Catholic Tibertelli family found itself somewhat isolated from the social life of the city. De Pisis's parents chose to have their seven children educated at home by priests and later at a private high school.

De Pisis began to study drawing at the age of six, but it was not his sole interest. He was also fascinated by antique objects and developed a love of nature, especially butterflies, of which he had a large collection.

At eighteen, De Pisis entered the University of Bologna, where he studied literature and philosophy. He also continued to paint. During his college years he met the brothers Giorgio De Chirico and Albert Savinio. Through them and their circle, he became exposed to the French avant-garde in literature and art, and he entered into correspondence with poets Guillaume Apollinaire and Tristan Tzara.

After graduating from the university, De Pisis went to Rome, where he worked for four years as a high school teacher. He began dedicating himself seriously to painting, producing still lifes that featured unexpected juxtapositions of objects and also some landscapes. An exhibition of his works was presented at Rome's Galleria Bragaglia in 1920.

In artwork not intended for public display De Pisis sought to create an ideal androgynous human figure. He wrote "L'elemento maschile e femminile è fuso strettamente in ogni individuo" ("The masculine and feminine element is tightly fused in every person.") In his celebration of androgyny De Pisis rejected traditional heterosexual sex roles.

In the early 1920s, De Pisis also became aware of his homosexuality. He wrote of sexual fantasies in his diary, and he eventually fell in love with a young man named Berto. De Pisis wrote of enjoying his lover's body, which he said caused him "delirium and pangs of the soul."

De Pisis moved to Paris in 1925 to study the work of French artists, especially Eugène Delacroix and Édouard Manet, whom he particularly admired. The political situation in Italy may have contributed to his decision to leave Italy since the country was then in Fascist control.

Although De Pisis described himself as neutral—neither for nor against the Fascists—he was attacked in Italian newspapers as disloyal for abandoning his country and might have been declared a traitor had not Fascist minister Italo Balbo, an old schoolmate, intervened on his behalf.

In Paris De Pisis moved in circles of artists and writers, meeting Henri Matisse, Jean Cocteau, Pablo Picasso, and James Joyce, among others. Giorgio De Chirico was also among his associates there.

De Pisis continued painting still lifes and also produced city scenes of Paris, including a series of watercolors for a book, *Questo è Parigi* (*This Is Paris*, 1931), written by his friend Giovanni Comisso.

In addition, he created paintings of the male figure, such as *Nudino sulla pelle di tigre* (*Nude man on a tiger skin*, 1931). He generally recruited his models from young working-class men whom he encountered on the street. In his diaries he recorded appreciative comments about the bodies of his subjects.

In the late 1930s, De Pisis made several trips to England, where he worked with artists Vanessa Bell and Duncan Grant of the Bloomsbury group. He subsequently held successful exhibitions of his paintings of London.

When World War II broke out, De Pisis moved back to Italy, settling first in Milan. The Fascists were still suspicious of him, and once threatened to arrest him as a "perturber of morals."

After the overthrow of the Fascist government in 1943, De Pisis moved to Venice, where he soon established a reputation as an eccentric character. He dressed as a dandy and appeared in public with his pet parrot on his shoulder. He maintained a large house and his own gondola. He continued recruiting young men to be his nude models, and made notes about them in his diaries— "*delizioso*" being a frequent description.

De Pisis chose one of these models, Bruno Scarpa, to be his gondolier. The handsome Scarpa, decked out in the splendid livery that De Pisis had designed for him, also served at De Pisis's afternoon teas, which attracted a diverse group of guests.

De Pisis was known for his evening entertaining as well. To celebrate the end of the war, he threw a party at which twenty boys—"*uno più bello dell'altro*" ("each one more beautiful than the other"), he noted in his diary— danced wearing only strings of shells around their loins. Local police raided the event, described in the *Giornale di Venezia* as an "*assemblea orgiastica*," and arrested nineteen people including De Pisis, who spent a night in jail.

Despite his growing notoriety, De Pisis enjoyed professional success and critical acclaim. At the 1948 Venice Biennale a room was devoted to some thirty of his works. He was not, however, awarded the grand prize, apparently because of objections on the ground of his sexuality.

At about this time, De Pisis's health began to decline due to a nervous disorder, and he found it necessary to enter a neurological clinic near Milan. Despite his medical problems, he continued to paint nearly until his death on April 2, 1956.

De Pisis's art is at once individual and synthetic. Because his work is not within a particular movement, it has to some extent been marginalized. Barry Schwabsky states that "de Pisis was…uncannily able to pay rich and explicit pictorial homage to other artists without violating the canons of his own style."

Matthew Gale and Valerio Rivosecchi describe his "distinct style" as "fresh and sensual" and contend that it "is shared by his male nudes, cityscapes and extraordinary still lifes, in their liberal juxtaposition of disparate objects and free ordering of space, the whole suspended in delicate patterns of light and patches of colour."

Loredana Parmesani also alludes to the sensuality of De Pisis's painting, saying that in it "[e]veryday simplicity oozes with lust, eroticism [and] voluptuousness."

The Museo d'Arte Moderna e Contemporanea Filippo de Pisis in his native Ferrara has a collection of some 200 works—oil paintings, watercolors, and drawings. Subjects include still lifes, cityscapes, and paintings of young men, described as *voluttosi nudi maschili* ("voluptuous male nudes").

— *Linda Rapp*

BIBLIOGRAPHY

Gale, Matthew, and Valerio Rivosecchi. "De Pisis, (Luigi) Filippo (Tibertelli)." *The Dictionary of Art.* Jane Turner, ed. New York: Grove's Dictionaries, 1996. 8:772.

Parmesani, Loredana. "Filippo De Pisis." *Flash Art* 110 (January 1983): 32–35.

Schwabsky, Barry. "The Paintings of Filippo De Pisis." *Arts Magazine* 62 (January 1988): 56–57.

Seymour, Mark. "De Pisis, Filippo." *Who's Who in Gay & Lesbian History From Antiquity to World War II.* Robert Aldrich and Garry Wotherspoon, eds. London and New York: Routledge, 2001. 123–125.

Zanotto, Sandro. *Filippo De Pisis ogni giorno.* Vicenza, Italy: Neri Pozza Editore, 1996.

SEE ALSO

European Art: Twentieth Century; Grant, Duncan; Subjects of the Visual Arts: Nude Males

Pontormo, Jacopo *(1494–1557)*

JACOPO CARRUCCI DA PONTORMO (USUALLY CALLED simply Pontormo) was one of the most original and fascinating artists of the Italian Renaissance.

Born in Empoli, Italy, on May 24, 1494, he was to play a decisive role in defining Mannerism, the late-Renaissance style (prevailing from approximately 1520 to 1600) that featured stylized (often elongated) human figures, sudden shifts in spatial perspective, displays of artistic virtuosity for its own sake, and complex, ambiguous narratives.

Pontormo is especially known for his innovative handling of formal elements and his complex and ambiguous treatment of subject matter.

Pontormo's dairies suggest that his life was as "strained" as his artworks often seem to be. Statements in his private papers and comments by acquaintances support the theory that Pontormo's relationships defied the gender and sexual norms being enforced with increased rigor in sixteenth-century Italy. However, his "difference" seems to have provoked deep feelings of guilt and despair.

The account of Pontormo by his contemporary Giorgio Vasari (often considered the first modern art historian) reveals many of the categorizations that recur throughout the early modern era in biographies of "bachelors" who may have been emotionally and sexually involved with others of the same sex.

Thus, Vasari repeatedly describes him as strange and bizarre, and he further insists that Pontormo was a solitary man, who virtually fled from the company of others. Yet Vasari acknowledges that Pontormo deeply loved his students, especially Battista Naldini and Agnolo Bronzino (who emerged as the leading artist in Florence during the mid-sixteenth century).

Vasari's claim that Pontormo always was concerned to have Naldini and Bronzino nearby is supported by the artist's diary, which is filled with many expressions of intense longing for them. Pontormo never referred to his pupils in explicitly sexual terms, and, for that reason, most scholars have insisted that Pontormo cannot be regarded as a "gay" artist.

Obviously, no sixteenth-century artist can be reconstructed purely in terms of modern identity categories. However, no special pleading is involved in suggesting that the intensity of Pontormo's desire for Bronzino (known to have been beautiful and elegant) and Naldini may have had a sensual component, whether or not it was acted upon.

Pontormo's awareness of the nature of his feelings may have inspired in him the sense of guilt and self-damnation that pervades his diaries.

To solidify his relationship with Naldini, Pontormo adopted him, and he unsuccessfully sought to do the same for Bronzino. Upon Pontormo's death, on January 1, 1557, Bronzino wrote a series of sonnets that proclaim the intensity of his love for his master. Citing the closeness of their relationship, Bronzino also filed a claim for the estate of Pontormo, who had not made a will.

Pontormo's restlessness and his unwillingness to conform to the prevailing artistic norms made it impossible for him to remain long as an apprentice with any single painter. Thus, between 1508 and 1512, he studied briefly with a series of major artists, including Leonardo da Vinci, Piero di Cosimo, and Andrea del Sarto.

One of his first major commissions, *The Visitation* (1515), already contained premonitions of his highly original mature approach to the creation of religious scenes. In this asymmetrical composition, the elongated figures are twisted in complex serpentine poses, and the

expressions and gestures of many of them seem to have little immediate relevance to the primary visitation scene. In the foreground, a beautiful nude boy languidly scratches his outstretched leg.

Pontormo's artistic "eccentricity" is fully displayed in *Joseph in Egypt* (1518), one of his most famous paintings, now in the National Gallery, London.

In this panel, the artist managed to combine several different parts of the biblical narrative by placing them within separate spatial compartments; this narrative complexity appealed to very sophisticated, highly educated viewers, who were able to "decipher" the artist's clues.

Pontormo defied virtually all conventions of earlier Renaissance art in endowing his figures with surprising hardness and angularity, while making statues seem soft and pliable. The bright colors deliberately clash in a way that must have seemed shocking to viewers, accustomed to the soft tones of Pontormo's teachers.

The boy seated on a step in the center foreground (again, scratching an outstretched leg in a pose that seems to have appealed to Pontormo) has long been considered to be a portrait of the young Bronzino.

Impressed by this scene of Joseph's life, the powerful Medici family commissioned Pontormo to decorate the walls of a summer villa outside Florence, at Poggio a Caiano (1520–1521). His depictions of mythological scenes there, such as *Vertumnus and Pomona*, feature beautiful, languid adolescent boys, some with erect penises.

Between 1523 and 1525, Pontormo and Bronzino sought refuge from an outbreak of the plague in the monastery of the Certosa di Val d'Ema, near Florence. Pontormo's diary notations from this period reveal that he felt that his life was in danger because his sinfulness might have provoked the spread of the illness.

In the cloister of the Certosa, Pontormo executed a series of scenes of the Passion with a searing emotional intensity. In defiance of Renaissance conventions of perspective, the space is flattened and literally tilted up. Thus, the figures—even more angular and elongated than in his earlier works—are pushed out, as if to confront the viewer. The intense but ambiguous facial expressions seem to challenge the role of the spectator in the events being unfolded.

Returning to Florence, Pontormo continued to create powerful religious works, such as the *Deposition of Christ* (1526–1528). In this painting, he retained the compressed space, elongated figural proportions, and anguished expressions of the Certosa series.

But, continuing to vary his style, he now made the figures seem fully three-dimensional and highly muscled in deliberate imitation of Michelangelo, whose figure of Christ from the *Pietà* of 1495 is quoted.

Pontormo was also active as a portraitist, creating such works as *Portrait of a Halberdier* (1529–1530, now

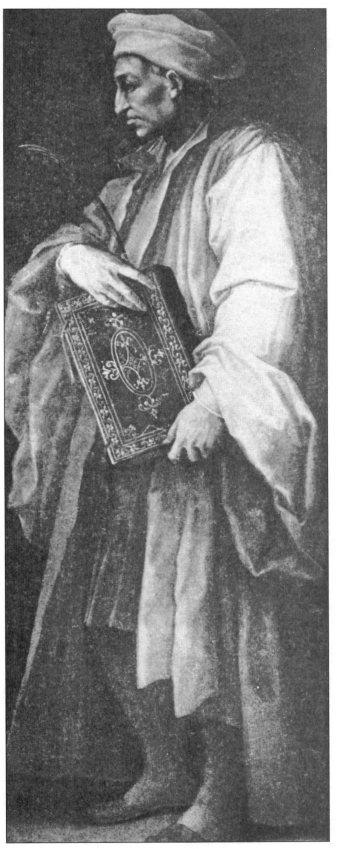

A portrait of Cosimo de Medici by Jacopo Pontormo.

in the J. Paul Getty Museum). This elongated figure turns in a graceful, serpentine pose; the facial expression and hand gestures convey intense but ambiguous feelings, the specific nature of which has long been debated by scholars.

Unfortunately, the frescoes for San Lorenzo in Florence (1546–1556), the primary focus of his creative energies in his later years, have all been destroyed. However, the drawings for these reveal continuing creative explorations of the infinite possibilities of figural poses.

Pontormo most fully revealed his love of the male body in several panoramic scenes of martyrdom, such as the *Martyrdom of Ten Thousand* (date uncertain). Here, seemingly countless nude men, shown with relatively classicizing proportions (unusual in Pontormo's work), turn and twist in graceful poses.

Executions are depicted in the distance, but the primary goal of this painting seems to be the display of the beauties of the male body—of which the commander in charge seems fully aware, to judge by the bulging cloth around his crotch.

Despite the guilt evident in his writings, Pontormo here seems to be celebrating the splendor of the flesh, rather than consigning it to the destruction required by the subject.

In its boldness, Pontormo's art may be an expression of the desire for freedom from constraints which he was not able to realize fully in his life. — *Richard G. Mann*

BIBLIOGRAPHY

Clapp, F. M. *Jacop Carucci da Pontormo: His Life and Work.* New Haven: Yale University Press, 1916.

Cooper, Emmanuel. *The Sexual Perspective.* London and New York: Routledge, 1994.

Cox-Rearick, J. *The Drawings of Pontormo.* 2nd ed. New York: Hacker Art Books, 1981.

Vasari, Giorgio. *Lives of the Painters, Sculptors, and Architects (1568).* Gaston C. du Vere, trans. David Ekserdijan, ed. 2 vols. New York: Knopf, 1996.

See also

European Art: Mannerism; Bronzino, Agnolo; Leonardo da Vinci; Michelangelo Buonarroti

Pop Art

POP ART IS THE SCHOOL OF PAINTING AND SCULPTURE of the early 1960s that utilized the subjects, techniques, or stylistic conventions of the mass media and popular culture, either separately or in tandem with each other.

First appearing in England in the 1950s, it flourished in the United States during the early 1960s, the moment of Pop's greatest popularity. Although it was an international style—with practitioners in Asia and Latin America, as well as in the Soviet Union and western Europe—its most famous manifestations were seen in the work of American artists such as Roy Lichtenstein, Claes Oldenburg, Mel Ramos, James Rosenquist, Andy Warhol, and Tom Wesselmann.

These artists worked in a variety of styles. Lichtenstein enlarged and altered panels from romance and war comics, even copying the small dots that were a result of commercial color separation processes. Rosenquist, a former professional billboard painter, painted enormous canvases with a jarring array of images suggestively juxtaposed from various media sources, primarily advertising.

The most famous of the Pop artists proved to be Warhol. He successfully integrated commercial printing processes into his work, distancing himself from the tortured paint surfaces of the Abstract Expressionists who preceded him. His focus on celebrities and fame in his work proved prophetic, as he himself soon became a media celebrity and Pop Art became co-opted by the very mass media that it plundered for subjects.

The Turn to Popular Culture

Pop Art is among the most important visual arts movements of the twentieth century. The Pop artists turned to popular culture and advertising for sources to create representational works that defied the modernist hierarchy of avant-garde and kitsch, established decades earlier by the influential modernist critic Clement Greenberg.

Breaking with the modernist tradition of abstraction (which by the early 1960s had become institutionalized in the form of Abstract Expressionism), Pop Art seemed to some observers to be frivolous and reactionary. However, it actually represents a turning point in the history of twentieth-century art.

Modernism had long insisted upon a strict hierarchy of taste. Contemporary society's blurring of "high" and "low" culture began simultaneously with Pop's parallel blurring of artistic hierarchies. As one of the hallmarks of postmodernity, this erasure of qualitative distinctions suggests that Pop is among the earliest manifestations of the postmodern.

The Return to Representation

Pop Art's return to representation was made possible by the work of Jasper Johns and Robert Rauschenberg in the 1950s. In paintings such as *Flag*, from 1955, Johns explored the narrow ground between the real and the depicted. In so doing he reintroduced a conceptual component into art that had initially been explored by French artist Marcel Duchamp earlier in the century.

Rauschenberg's complex multimedia works, such as *Bed*, from 1955, combined Abstract Expressionist brushwork with both real and depicted objects, pointing

out the constructed nature of both. Significantly, Johns and Rauschenberg were partners both artistically and romantically in the late 1950s during this groundbreaking period.

Pop Art's similar but more radical use of images and techniques from mass media created great consternation in the art world.

Pop Art and Camp

Although only one of the most famous group of Pop artists was gay (Warhol), the new art's connection with the work of earlier gay artists such as Rauschenberg and Johns is clear.

Furthermore, during the early 1960s the straight world was beginning to discover the camp sensibility (exemplified by the 1964 publication of Susan Sontag's "Notes on Camp"). Because camp was seen as the triumph of style over substance, when the Pop artists elevated their reviled media images to the arena of "high art," they paralleled the camp celebration of and commitment to the marginal.

Pop's self-consciousness about style in both "low" and "high" art inextricably linked it to camp, and resulted in numerous homophobic attacks on Pop and its practitioners.

Pop's Success and Its Influence

This resistance by the art world establishment did not prevent the public from enjoying and collecting Pop Art. The Pop artists achieved quick financial success (much to the dismay of the staunchly heterosexual Abstract Expressionists) and soon assumed canonical status in art history.

Its affinities with the camp sensibility have always provided Pop with a substantial gay audience. Pop has subsequently had a significant influence on later art and artists, opening the doors for everything from Photorealism in the 1970s to the ironic examination of the mundane that has dominated much contemporary art.

— *Joe A. Thomas*

BIBLIOGRAPHY

Ferguson, Russell, ed. *Hand-Painted Pop: American Art in Transition.* New York: Rizzoli International Publications, 1992.

Livingstone, Marco. *Pop Art: A Continuing History.* New York: Harry N. Abrams, 1990.

Stich, Sidra. *Made in USA: An Americanization in Modern Art, The '50s and '60s.* Berkeley: University of California Press, 1987.

Thomas, Joe A. "Pop Art and the Forgotten Codes of Camp." *Memory and Oblivion: Proceedings of the XXIXth International Congress of the History of Art.* Russell Weinink and Jeroen Stumpel, eds. Dordrecht: Kluwer Academic Publishers, 1999. 989–995.

SEE ALSO

American Art: Gay Male, 1900–1969; Duchamp, Marcel; Johns, Jasper; Rauschenberg, Robert; Warhol, Andy

Pulp Paperbacks and Their Covers

As MUCH AN ARTIFACT OF LESBIAN POPULAR CULTURE as a source of amusing kitsch in today's more tolerant political climate, pulp fiction paperbacks (named for the inexpensive paper on which they were printed) remain a fascinating slice of life from the 1950s and 1960s.

It was hard to miss those cheap books with their lurid covers and "shocking" tag lines, such as "She Hated Men and Turned to a Lesbian for Comfort!" Strangely enough, unlike today, lesbian-themed novels were easily available in almost any drugstore—and their publishers unknowingly provided a kind of lifeline for gay women living in a terrifically oppressive time.

While some of these books were penned by men using female pseudonyms, the majority were written by lesbians for lesbians.

Despite the buxom cover models featured to help sell the books to a male audience, there was some fairly serious literature among the pulp ranks. Indeed, author Ann Bannon, whose first pulpy book, *Odd Girl Out*, was published by Gold Medal in 1957, refers to the 1950s and 1960s as the "Golden Age of lesbian writing and publication."

Mixed in with the ultrasleazy "adult" titles such as *Satan Was a Lesbian* (1966) and *Killer Dyke* (1964), which were clearly intended to function as soft-core pornography, were some profound examinations of lesbian life, such as Claire Morgan's—that is, Patricia Highsmith's—*The Price of Salt* (1952), Ann Bannon's *Beebo Brinker* series (1957–1962), Valerie Taylor's *A World Without Men* (1963), and even reprints of Gale Wilhelm's *Torchlight to Valhalla* (1938) and Radclyffe Hall's classic, *The Well of Loneliness* (1928).

Primarily because of publishers' concerns about obscenity charges, the genre was characterized by unhappy endings, in which lesbian relationships were brought to a screeching halt one way or another. Often one woman "turned" straight and was married off, while the other—who might remain a confirmed gay bachelorette—drifted away, was committed to an insane asylum, or killed herself.

Books written by men or determined to expose the "perversity" of homosexuality usually described lesbians as nymphomaniacs and sexual predators corrupting innocent young girls in a shadowy underworld.

Even when written by a lesbian author, the censorship enforced upon the books often resulted in a misogynistic or homophobic tinge unintended by the writer. Indeed, one of the most interesting aspects of the pulps is the tension that often resulted from the authors' attempts to present lesbian love sympathetically while also adhering to the publishers' demands that the novels serve a cautionary purpose and end unhappily.

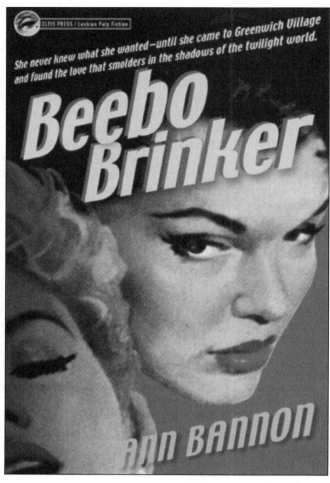

The cover of Ann Bannon's *Beebo Brinker.*

Many lesbian authors implied that the pathology of lesbianism depicted in the stories—madness, suicide, adultery, etc.—was the result not of homosexuality per se, but of the social intolerance that homosexuals face.

If the books' protagonists were to achieve a happy homosexual life by story's end, they could be considered obscene—and that was bad news for the publisher. Tereska Torres's book *Women's Barracks* (1950), for example, was made an exhibit by the U.S. House of Representatives' Select Committee on Current Pornographic Materials in 1952.

And Vin Packer's best-selling book *Spring Fire*, a lesbian classic published in 1952, might have featured a rosier conclusion were it not for the editor's one stipulation: the book could not end happily. A publisher's defense to charges of obscenity could be that the books were intended to warn readers of the dangers of homosexuality.

Authors also did not have any say over book covers, which featured artwork and photographs that often had nothing whatsoever to do with the plot lines. Infamously sensationalistic, the covers usually portrayed lesbians as incredibly glamorous, ultrafemme vixens, often displaying deep cleavage and clad only in skimpy lingerie.

As Bannon explains, many of the female subjects looked like they "could have easily walked off those pulp covers and onto the pages of *Harper's Bazaar*"—no "real girl" in the 1950s lounged about in peach silk slips or half-buttoned blouses.

Or the cover might illustrate a hyperbolically butch–femme duo—the butch a short-haired brunette or redhead wearing pants, the femme a blonde cheerleader type—with a man sulking or looking worried in the background.

For all the stereotyping of the cover art and the pathologizing of lesbianism that mark the pulp novels, they had an immense impact on lesbian culture of the 1950s and 1960s. In crucial ways, they subverted the social and political prohibitions against homosexual expression during the McCarthy era. They also served a valuable purpose in reassuring isolated women that they were not alone.

Clearly, we have come a long way since those days of "twilight girls" and "forbidden love," as lesbian literature no longer requires misleading cover art to appeal to straight male readers, or extensive editing to evade obscenity charges. But women like Bannon and Taylor provided some much needed representation and authenticity to lesbians who could not form a community at the time, while other, usually pseudonymous, writers provided sheer amusement.

A guilty pleasure to many women at the time of their publication, pulps still intrigue and entertain contemporary lesbians.

— *Teresa Theophano*

BIBLIOGRAPHY

Smith, Terri L. "As the Twilight World Turns." *Out in All Directions: A Treasury of Gay and Lesbian America.* Lynn Witt, Sherry Thomas, and Eric Marcus, eds. New York: Warner Books, 1995.

Zimet, Jaye. *Strange Sisters: The Art of Lesbian Pulp Fiction 1949–1969.* New York: Viking, 1999.

SEE ALSO

American Art: Lesbian, 1900–1969

Raffalovich, Marc André *(1864–1934)*

RUSSIAN-BORN ENGLISH POET AND WRITER ON SEXUALITY Marc André Raffalovich is best known today for his patronage of the arts and for his long friendship with John Gray, who may have been the model for Oscar Wilde's Dorian Gray and who became a Roman Catholic priest in Edinburgh.

In 1863, Marie and Hermann Raffalovich moved from Odessa to Paris. There, Marie began to contribute articles on art exhibitions to the *Journal de Saint-Pétersbourg*. She also kept a popular salon, the guests of which included Henri Bergson, Sarah Bernhardt, Colette, Joris-Karl Huysmans, and Gustave Moreau.

Their younger son, Marc André, was raised in this cultured environment. Moving to England in 1882, he settled in London and, like his mother, nurtured friendships with artists and writers, including Aubrey Beardsley, Lily Langtry, Ouida, Walter Pater, Charles Shannon, Charles Ricketts, and James McNeill Whistler.

Oscar Wilde critiqued André's salon as nothing more than a saloon (which he nevertheless frequented), while Raffalovich himself voiced discomfort with what he saw as Wilde's sexual immorality.

Raffalovich's views on sexuality appear in the five books of poetry and two novels that he published between 1884 and 1896. As Robert Browning observed, Raffalovich's poems often erase the sex of the object of desire, thereby encouraging same-sex readings. The works also reflect the influence of Uranian poetry and its view of same-sex desire as innocent and pure.

Among his nonfiction works, the most famous is *Uranisme et Unisexualité* (1896), which established his reputation as an expert on homosexuality. According to Raffalovich, "unisexuality" is a mode of sexual expression as valid as heterosexuality. It is noble and pure, however, only when practiced by a "sublime invert," who fulfills his desires not through intercourse but through celibate friendship, spirituality, and art.

In 1895, Raffalovich became a patron of Aubrey Beardsley, who—because of his ties to Wilde—had been dismissed from his job as art editor of *The Yellow Book* upon Wilde's conviction for gross indecency. Raffalovich and Beardsley became close, Beardsley reading drafts of the writer's work and Raffalovich commissioning a likeness of himself by the artist.

Unfortunately, the portrait was never done, but Beardsley did draw a frontispiece for Raffalovich's poetry collection *The Thread and the Path*. The publisher, however, refused to include it because the figure was hermaphroditic.

A few years later, when Beardsley was on his deathbed, Raffalovich sent a monthly check so that his mother could stay at home to look after him.

In 1892, critic Arthur Symons introduced Raffalovich to the love of his life, John Gray, a poet influenced by the

French Symbolists and a member of Wilde's inner circle. Remarkably beautiful, Gray was widely rumored to be the inspiration for the protagonist of Wilde's notorious novel *The Picture of Dorian Gray* (1891). Until his break with Wilde in 1893, Gray encouraged the rumors, sometimes signing his name as "Dorian."

Raffalovich gave Gray extensive financial support, even paying his expenses when the young man went to Rome to study for the priesthood in 1898. "Sebastian" was the baptismal name Raffalovich chose for himself when, under Gray's influence, he converted to Catholicism in 1896. In 1902, he moved to Edinburgh, where Gray had taken a position as a curate.

Settling in Scotland to be near Gray, Raffalovich contributed generously to the construction of St. Peter's Church, in Morningside, a middle-class suburb of Edinburgh, where Gray became rector and where Raffalovich attended Mass daily.

Raffalovich continued to attract and support artists such as Eric Gill, Dorothy Johnston, Eric Robertson, and Cecile Walton. Guests to his home included Max Beerbohm, the art scholar Herbert Read, Hubert Wellington (the Principal of the Edinburgh College of Art), and the sculptor Aelred Whitacre.

Raffalovich was finally hosting the salon that he had envisioned. His support of artists continued throughout the remainder of his life. —*Dennis Denisoff*

BIBLIOGRAPHY

Benkovitz, Miriam J. *Aubrey Beardsley: An Account of His Life.* New York: G. P. Putnam's Sons, 1981.

McCormak, Jerusha Hull. *The Man Who Was Dorian Gray.* New York: St. Martin's Press, 2000.

Sewell, B. *Footnote to the Nineties: A Memoir of John Gray and André Raffalovich.* London: Cecil and Emilia Woolf, 1968.

———, ed. *Two Friends: John Gray and André Raffalovich: Essays Biographical and Critical.* Aylesford, Kent: Saint Albert's Press, 1963.

SEE ALSO

European Art: Nineteenth Century; Beardsley, Aubrey; Ricketts, Charles, and Charles Shannon

Rainbow Flag

THE RAINBOW FLAG, A POPULAR AND INTERNATIONALLY recognized symbol of gay and lesbian pride, was designed by Gilbert Baker in 1978.

In response to the request of the committee organizing the San Francisco Gay and Lesbian Freedom Day Parade for a symbol that could be used year after year, Baker created a flag with eight horizontal stripes of different colors. After two huge rainbow flags were flown at the parade that year, the symbol gained immediate popularity in the San Francisco gay community.

The Original and the Revised Designs

In Gilbert's original design, each of the eight colors represented a concept. Hot pink stood for sexuality, red for life, orange for healing, yellow for the sun, green for nature, turquoise for art, indigo for harmony, and violet for spirit. Baker, together with some two dozen volunteers at the San Francisco Gay Center, dyed fabric and sewed the first flags.

Demand for rainbow flags made it necessary to find a source of mass production. The Paramount Flag Company of San Francisco undertook the job in 1979. Before commercial production began, lack of availability of materials and cost considerations caused a change in the design of the flag.

The hot pink and turquoise stripes were eliminated, and the indigo was replaced with blue, yielding the form that is used today. In 1986, the rainbow flag was recognized as an official flag by the International Flag Association.

Some versions of the rainbow flag add a white lambda or a pink triangle to the design. AIDS activist Leonard Matlovich proposed adding a black stripe to the bottom of the flag to symbolize the AIDS crisis. He intended that the black stripes should be removed from the flags and burned when a cure for AIDS is found. His suggestion, however, has not been widely adopted.

A Symbol of Pride, a Source of Controversy

The rainbow flag is frequently a feature of gay and lesbian pride parades. A particularly spectacular example— one mile in length—was seen in the 1994 New York parade commemorating the twenty-fifth anniversary of Stonewall. Flag-bearers, who had donated money for the provision of services to people with AIDS, were given pieces of the flag as a memento of the event.

The rainbow flag has sometimes been flown at government buildings. In June, 1999, for example, it was raised at city halls in San Francisco and Worcester, Massachusetts.

The display in Worcester drew a citizen complaint at a city council meeting. Mayor Raymond V. Mariano called the complainant's remarks "the most obvious example of hate and bigotry" that he had heard in almost two decades on the council, and a unanimous decision by the council kept the flag aloft.

In the same month, a rainbow flag was displayed on the grounds of the statehouse in Columbus, Ohio, in conjunction with a Gay Pride march. Charles Spingola, a street preacher, and Toni Peters, the daughter of a Baptist minister, tore down and burned the flag, for which both were convicted of criminal damaging.

Businesses sometimes fly the rainbow flag to indicate that they are gay friendly or as an expression of pride by the owners. Such displays occasionally lead to controversy.

In 1998, for example, Selectman John Miller of Ogunquit, Maine, demanded that innkeepers David Mills and Garry John remove a rainbow flag from their building. In the ensuing weeks, five rainbow flags were stolen from the inn, openly gay Selectman Robert G. Brown resigned in protest, and citizens collected more than four times the number of signatures needed to recall Miller.

In 2000, pumpkin farmers Eric Cox and Gina Richard of Centreville, Virginia, became targets of a boycott by the Vienna, Virginia, chapter of Tradition of Roman Catholic Homes (TORCH) because of two rainbow flags that had flown at their farm for over ten years.

The flags, which Cox and Richard had first put up as "a cheery addition" to their décor, took on added meaning for them when their daughter came out as a lesbian. The boycott was largely unsuccessful. Despite pressure from Vienna TORCH, the Springfield TORCH chapter supported the farm, as did various local gay, lesbian, transgender, and bisexual groups.

Also in 2000, San Diego apartment-building owners Peter Janpaul and Anthony Block were criticized on a talk radio show for flying the rainbow flag, but their tenants had no objection. When President Clinton attended a fund-raiser at the building, one of his Secret Service agents told Janpaul, "I appreciate what you're doing for us."

The practice of flying the rainbow flag to indicate the pride of a gay household enjoyed a particular vogue in the late 1980s, especially in the San Francisco area. In 1988, John Stout of West Hollywood, California, successfully sued his landlords for the right to display a rainbow flag on the balcony of his apartment.

A similar dispute arose in 2000 in Gwinnett, Georgia, when developers of a subdivision told a gay couple, Stace Duvall and Ed Graham, to remove their rainbow flag because it was not "in good taste." According to the Architectural Control Committee, the only flags in good taste were the American flag and the flag of the state of Georgia, formerly the symbol of the Confederacy.

When Duvall and Graham replaced their rainbow flag with the state flag as a protest, neighbors complained, leading the developers to ban all flags pending completion of the subdivision and formation of a homeowners' association.

The rainbow motif, whether in the form of a flag or not, has come to symbolize Gay Pride. In Traverse City, Michigan, in 2000, in the wake of a series of hate crimes including an attack on a worker at a gay bar, the city commission approved a bumper sticker with a rainbow pattern and stylized human figures resembling jigsaw-puzzle pieces and the motto "We are Traverse City."

The intention of the commissioners was to put some of the stickers on city vehicles and distribute the rest to citizens in order to promote unity. Instead, they found themselves in the middle of a heated debate. Gay-rights groups praised the choice of the rainbow design, while opponents condemned it.

The commission eventually stopped distributing the stickers, removed those on official vehicles, and sold the remainder to a local civil rights advocacy group, Hate-Free TC, which made them available to the public.

The Rainbow Sash Movement

The rainbow has also been adopted by the Rainbow Sash Movement (RSM), a group of gay Catholics and their supporters. Founded in Australia in 1998, RSM, which now also has branches in England and the United States, is seeking a dialogue with Catholic leaders about the church's teachings regarding homosexuality. Members wear their rainbow sashes when seeking to receive communion during Mass.

In Melbourne, Australia, Westminster, England, New York City, Washington, D.C., and Chicago, sash-wearers have been refused the Eucharist, but the dioceses of Rochester, New York, and St. Paul–Minneapolis, Minnesota, have welcomed RSM members.

The rainbow flag continues to be a powerful and popular symbol. It is used as part of the design of many products, including apparel, jewelry, decorative objects, and items for pets.

— *Linda Rapp*

BIBLIOGRAPHY

Baker, Gilbert, and John O'Brien. "The Prideful Story of Our Rainbow Flag." *IGLA (International Gay & Lesbian Archives) Bulletin* no. 10 (Spring–Summer 1994).

Butterbaugh, Laura, April Jackson, and Amy Branner. "Commemorating Stonewall: International March on the United Nations." *off our backs* 24.8 (September 30, 1994): 17.

DeGenaro, William. "Rainbow Flag." *Gay Histories and Cultures: An Encyclopedia.* George E. Haggerty, ed. New York: Garland, 2000. 733–734.

Flesher, John. "Traverse City Votes to Sell Controversial Stickers." *South Bend (Ind.) Tribune*, February 23, 2001.

"Flown with Pride." *Washington Times*, June 22, 1999.

Freiberg, Peter. "Rainbow Sash Group Works to Gain Acceptance." *Washington (D.C.) Blade*, September 7, 2001.

Hartstein, Larry. "U.S. Flag Tests Subdivision; Flap in Gwinnett over Gay Banner." *Atlanta Constitution*, September 15, 2000.

Hogan, Steve, and Lee Hudson, eds. "Rainbow Flag." *Completely Queer: The Gay and Lesbian Encyclopedia.* New York: Henry Holt, 1998. 470–471.

Kotsopoulos, Nick. "Gay Pride Display Scorned." *Worcester (Mass.) Telegram & Gazette*, June 3, 1999.

Jones, Welton. "Raising a Rainbow up the Flagpole." *San Diego Union-Tribune*, November 27, 2000.

Malnic, Eric. "Out-of-Court Settlement Reached in Battle over Gay Pride Flag." *Los Angeles Times*, December 21, 1988.

Mayhood, Kevin. "Man Guilty of Tearing Down Flag." *Columbus Dispatch*, February 17, 2000.

———. "Woman Fined, Given Probation for Burning Gay-Pride Flag." *Columbus Dispatch*, March 15, 2000.

"Rainbow Flag Fiasco Could Send Maine Official Flying." *The Advocate* 771 (October 27, 1998): 18.

Russell, Ron. "Removal of 'Gay Pride' Flag Ordered: Tenant Suit Accuses Apartment Owner of Bias." *Los Angeles Times*, December 8, 1988.

Smith, Leef. "Politics of Pumpkin Picking." *Washington Post*, October 12, 2000).

SEE ALSO

Homomonument; Segal, George

Rauschenberg, Robert *(b. 1925)*

ROBERT RAUSCHENBERG IS ONE OF THE MOST PROLIFIC and innovative artists of the late twentieth and early twenty-first centuries. He was at the core of a group of interdisciplinary artists including Jasper Johns, John Cage, and Merce Cunningham, whose influence on the face of American art has been nothing short of revolutionary.

Dubbed both Neo-Dada for their use of found objects and Proto-Pop for their inclusion of media imagery, Rauschenberg and Johns led painting away from the introspection of the dominant Abstract Expressionist movement to the everyday world of common objects and recognizable imagery, thus paving the way for such Pop painters as Andy Warhol.

Rauschenberg was born to a blue-collar family in Port Arthur, Texas, on October 22, 1925. After a tour in the navy, he attended the Kansas City Art Institute and the Académie Julian in Paris. He also spent several summers in the late 1940s and early 1950s at Black Mountain College in North Carolina.

The experimental atmosphere at Black Mountain encouraged artists of all disciplines to share ideas and to collaborate. Rauschenberg participated in an early multimedia performance there with composer John Cage and choreographer Merce Cunningham. Cage's interest in Zen Buddhism and his philosophy of favoring outside inspiration rather than personal expression had a great impact on Rauschenberg.

Rauschenberg began including common objects in his art through collage and assemblage. He often employed the bravura brushwork of the Abstract Expressionists, but he also incorporated objects from real life such as pillows, brooms, tires, and all manner of salvaged detritus. *Monogram* (1955–1959), for example, includes a stuffed goat. He liked to say that he operated in the gap between art and life. He christened these works "combines."

Rauschenberg moved to New York City in 1949 and was briefly married to painter Susan Weil. In 1953, he met Jasper Johns, and they formed an intense personal and creative relationship that lasted until 1961. The painters critiqued one another's work, exchanged ideas, and together established a mode of making art that challenged Abstract Expressionism's emphasis on self-revelation.

Rauschenberg questioned the connection between feelings and paint both verbally and visually. For example, in *Factum I* (1957) he apes the spontaneously "unique" drips and splatters of Action Painting and then cleverly reproduces them in *Factum II* (1957).

Rauschenberg's de-emphasis of the self in his work is particularly meaningful when analyzed in the context of McCarthy-era homophobia. How can a gay man explore his inner feelings if revealing his true self means having to face ostracism and even persecution?

In response, Rauschenberg's strategies ranged from campy coding—including such telling tidbits as photos of Judy Garland in *Bantam* (1954)—to witty all-out assault—undrawing the work of an older artist in *Erased de Kooning* (1953).

After the rupture of his relationship with Johns, Rauschenberg explored the potential of silkscreen printing in a series of paintings featuring appropriated images. These pictorially complex works feature photographic images lifted from the news of the day, and they can almost be read as history paintings. With their inclusion in the 1964 Venice Biennale, the artist gained international prominence.

Rauschenberg continued working in a variety of media throughout the 1970s, and in 1985 he launched the ambitious Rauschenberg Overseas Cultural Interchange (ROCI). This global enterprise of traveling, exhibiting, and collaborating provided a perfect conduit for Rauschenberg's continued work in the gap between art and life. The ROCI project posits art as a conduit for social interaction and intercultural diplomacy.

In the 1990s, Rauschenberg revived the ancient fresco process, though typically he used photographically based images embedded in the plaster surfaces. For Rauschenberg, this interplay of material and image is reflective of his larger philosophy regarding the connections between art and life.

— *Jeffery Byrd*

BIBLIOGRAPHY

Hunter, Sam. *Robert Rauschenberg*. New York: Rizzoli, 1999.

Katz, Jonathan. "The Art of Code: Jasper Johns and Robert Rauschenberg." *Significant Others, Creativity and Intimate Partnership*. Whitney Chadwick and Isabelle de Courtivron, eds. London: Thames and Hudson, 1993. 189–207.

SEE ALSO

American Art: Gay Male, 1900–1969; Contemporary Art; Pop Art; Johns, Jasper; Parsons, Betty; Warhol, Andy

Ricketts, Charles (1866–1931)
and Charles Shannon (1863–1937)

VERSATILE BRITISH ARTISTS RICKETTS AND SHANNON were longtime partners in life and in art. They both became members of the Royal Academy and, in addition to pursuing independent careers as artists, often collaborated on creative projects.

Shannon is best known for his painting and lithography, Ricketts for his contributions as a book designer and illustrator and for designing costumes and sets for the theater. Together they accumulated an impressive and eclectic collection of art.

Charles Hazelwood (or Haslewood) Shannon was born on April 26, 1863, in Quarrington, Lincolnshire. He was the son of the Reverend Frederick William Shannon and his first wife, Catherine Emma Manthorpe. As a boy, Shannon showed a talent for art and an interest in pursuing it as a career, and so when he was eighteen his father sent him to study wood-engraving at the City and Guilds Technical Art School in London, where he met Ricketts.

Charles de Sousy Ricketts was born on October 2, 1866, in Geneva, where his father, Charles Robert Ricketts, was studying painting after having been invalided out of the Royal Marine Light Infantry. Ricketts's mother, Hélène Jouhan (née de Sousy), was a Frenchwoman who was, according to Ricketts, "bred Italian." She may have been the illegitimate daughter of a French count.

Ricketts's parents soon settled near London, but because doctors advised that the English climate was too hard on Mrs. Ricketts, she and her son moved back to the Continent. Ricketts spent much of his youth in France and Italy. Too sickly to attend school regularly, he was educated mostly by governesses or left to his own devices. He became an avid reader and museum-goer.

Upon the death of his mother, Ricketts, aged thirteen, returned to England to live with his father, who died two years later. His paternal grandfather provided for him to enroll in the City and Guilds Technical Art School in 1882.

Ricketts and Shannon met shortly thereafter and soon took lodgings together. After completing their courses, they considered continuing their studies in France and went to Paris to seek the advice of Pierre Puvis de Chavanne, a painter whom Ricketts in particular admired. He recommended that they instead return to England and begin working as artists.

The two arrived at a compromise solution: Ricketts would find work as an illustrator to support them while Shannon devoted himself to developing his talents as a painter.

Ricketts and Shannon moved to The Vale, Chelsea, and Ricketts began drawing for magazines. He regarded these drawings as mere hackwork and later tried to buy back and destroy as many as possible.

Lord Frederic Leighton, the President of the Royal Academy, was, however, sufficiently impressed to commission a drawing to encourage the young artist. Ricketts produced *Oedipus and the Sphinx* (1891), which Leighton described as having a "weird charm" and being "full of imagination."

Shannon, meanwhile, had taught himself lithography. Like Whistler, he realized that lithography could be used for original artistic expression, not merely as a means of reproducing images.

Shannon's skill was such that he was described as "one of the most gracefully accomplished and scholarly lithographers of the day." He is regarded in particular as the master of lithographic portraiture.

In 1889, Ricketts and Shannon produced the first issue of their "occasional" magazine, *The Dial*. Four more issues would appear, the last in 1897. The illustrations in the magazine are notable for being some of the first Symbolist art in Britain.

Ricketts and Shannon sent a complimentary copy of the first issue of *The Dial* to Oscar Wilde, who came to their house in The Vale to praise their work. The young men soon became friends with Wilde and proved steadfast ones. They were supportive of him during his trial and imprisonment. Ricketts visited Wilde in jail and after his release helped him financially.

Wilde provided the pair with an important professional opportunity, illustrating his books. Ricketts, sometimes in collaboration with Shannon, did drawings for all of Wilde's books except *Salomé* (which was illustrated by Aubrey Beardsley).

When Ricketts's design for the cover of *A House of Pomegranates* (1891) was panned, Wilde defended it, saying, "There are only two people in the world whom it is absolutely necessary that the cover should please. One is Mr. Ricketts, who designed it, the other is myself, whose book it binds. We both admire it immensely."

Wilde delighted in the company of the young artists, calling The Vale "the one house in London where you will never be bored." Ricketts and Shannon's circle also included writers Edith Cooper and Katherine Bradley (who wrote together as Michael Field), W. B. Yeats, John Gray, George Bernard Shaw, Thomas Sturge Moore, and Cecil Lewis.

In 1896, Ricketts and Shannon founded the Vale Press. Their aim to was to have complete control over the production of all aspects of the book—including typeface, illustration, and even binding.

In addition to their illustrations of Wilde's works, they had also illustrated and decorated two other books, *Daphnis and Chloe*, by Longus (1893), and *Hero and Leander*, by Christopher Marlowe and George Chapman

(1894), published by the firm of Mathews and Lane. The first Vale Press book, *The Early Poems of John Milton*, was published in 1896.

Ricketts created three type fonts—the Vale, the Avon, and the King's—for the Vale Press books and also designed elaborate initial letters and intricate decorative borders in an Art Nouveau style.

In 1899, a fire at the Ballantyne Press, where the books were made, resulted in the loss of many of the woodcuts for the decorations. Ricketts and Shannon persevered, completing a thirty-seven-volume edition of Shakespeare then in progress, but closed the Vale Press in 1904.

At this point Ricketts began to work at oil painting, a medium in which Shannon already excelled, specializing in formal portraits, and biblical and classical scenes. Ricketts did not enjoy equal success and, although he continued to do some painting, turned his attention to other artistic pursuits—sculpture, lithography, jewelry design, and stage design.

He became especially well known for his stage work. Between 1906 and 1931, he was involved in over fifty productions, designing costumes and sets, and sometimes even making properties and lighting the stage.

In addition to their own creative pursuits, Ricketts and Shannon were avid collectors of art. Although their income was always modest, they were able to acquire a diverse collection that included Japanese prints, Greek and Egyptian antiquities, and drawings by such masters as Rembrandt and Rubens. Ricketts was especially canny at recognizing undervalued works. He used this ability to advantage as an advisor to the National Gallery of Canada.

Although they spent their entire adult lives together, Ricketts and Shannon never publicly identified themselves as a homosexual couple. Commentators believe that Ricketts was certainly a homosexual, but Shannon seems at least occasionally to have been attracted to women. His relationship with Kathleen Bruce, of whom he painted several portraits, caused considerable anxiety to Ricketts, who recorded in his diary his fear that Shannon might marry.

In January 1929, Shannon fell while hanging a picture. He never completely recovered his health or senses and remained an invalid until his death in 1937. Ricketts died of heart failure in 1931.

Although some of their remarkable collection of art was sold to provide for Shannon in his final years, many of the Asian pieces now belong to the British Museum, and most of the others are in the Fitzwilliam Museum, Cambridge.

— *Linda Rapp*

Bibliography

Binnie, Eric. *The Theatrical Designs of Charles Ricketts*. Ann Arbor, Mich.: UMI Research Press, 1979.

Calloway, Stephen. *Charles Ricketts: Subtle and Fantastic Designer*. London: Thames and Hudson, 1979.

Cooper, Emmanuel. "Ricketts, Charles (de Sousy)." *The Dictionary of Art*. Jane Turner, ed. New York: Grove's Dictionaries, 1996. 26:360.

———. "Shannon, Charles (Hazelwood)." *The Dictionary of Art*. Jane Turner, ed. New York: Grove's Dictionaries, 1996. 28:555.

Corbett, David Peters. "Collaborative Resistance: Charles Ricketts as Illustrator of Oscar Wilde." *Word & Image* 10.1 (January–March 1994): 22–37.

Darracott, Joseph. *The World of Charles Ricketts*. London: Eyre Methuen, 1980.

Delaney, J. G. P. *Charles Ricketts: A Biography*. Oxford: Clarendon Press, 1990.

Delaney, Paul. "Charles Shannon: Master of Lithography." *Connoisseur* 200 (March 1979): 200–205.

Denney, Colleen. "English Book Designers and the Role of the Modern Book at L'Art Nouveau; Part Two: Relations between England and the Continent." *Arts Magazine* 6.10 (June 1987): 49–57.

Fitzwilliam Museum. *All for Art: The Ricketts and Shannon Collection*. Cambridge: Cambridge University Press, 1979.

Johnson, Diana L. *Fantastic Illustration and Design in Britain, 1850–1930*. Providence: Museum of Art, Rhode Island School of Design, 1979.

Ricketts, Charles. *Oscar Wilde: Recollections*. Bloomsbury: Nonesuch Press, 1932.

———. *Self-Portrait: Taken from the Letters & Journals of Charles Ricketts, R.A.* Cecil Lewis, ed. London: Peter Davies, 1939.

Taylor, John Russell. *The Art Nouveau Book in Britain*. London: Methuen, 1966.

See Also

European Art: Nineteenth Century; Symbolists; Beardsley, Aubrey; Raffalovich, Marc André

Ritts, Herb (1952–2002)

AWARD-WINNING AMERICAN PHOTOGRAPHER HERB Ritts was acclaimed for his artistic and insightful pictures, many of them in black and white. Best known for his magazine covers, photos of celebrities, and extremely successful ad campaigns for such top fashion designers as Giorgio Armani, Gianni Versace, and Ralph Lauren, and for companies including Revlon and Tag Heuer, he is of special interest to the glbtq community because of the homoerotic qualities and the "homosexual iconography" in many of his photographs.

Ritts's work was the subject of two important exhibitions, one in Boston in 1996 and the other in Paris in 2000.

While Ritts favored a "classical sensuality" in the tradition of George Platt Lynes, his versatility and accessibility led to a high demand for his commercial work.

Herbert Ritts Jr. enjoyed a comfortable childhood. Born on August 13, 1952, to parents who owned a profitable furniture business in California, young Ritts grew up in glamorous surroundings, with movie stars for neighbors. His family lived in a mansion in Beverly Hills and also had a summer home on fashionable Santa Catalina Island.

After high school, Ritts enrolled at Bard College in Annandale-on-Hudson, New York, where he majored in economics and also studied art history. Following his graduation in 1975, he returned to his native California and worked as a sales representative for the family business.

At that point Ritts had not decided what profession to pursue, but he certainly was not considering a career in photography, which he had only recently taken up as a hobby. It happened, however, that in 1978 he had his camera with him when he and a friend—the then little-known actor Richard Gere—had to stop at a gas station to repair a flat tire. Among the pictures that Ritts snapped was one of a sweaty Gere clad in jeans and a tank top, his arms languidly stretched over his head, and a cigarette dangling from his mouth.

Soon thereafter, when Gere received widespread attention for his role in Paul Schrader's *American Gigolo* (1980), Ritts sent his photos to Gere's publicist. "A few months later she sent me *Vogue, Esquire,* and *Elle.* They all used my pictures. I got checks too," Ritts recalled. *Newsweek* also ran a photo of Jon Voight that Ritts had managed to take when he made his way onto the set of Franco Zeffirelli's *The Champ* (1979).

Ritts had found his calling as a photographer, and his pictures were in demand. Within a few years his photos were gracing the covers of *Vanity Fair, Vogue, GQ, Harper's Bazaar,* and *Interview.* He also did fashion spreads for important designers such as Gianni Versace and Ralph Lauren.

Ritts's photographs were the basis of a number of provocative and extremely successful advertising campaigns, including ones for Revlon, Donna Karan, The Gap, and Calvin Klein. Hank Stuever of the *Washington Post* commented that "most of his homoerotic 'nudes' actually wore Calvin Klein briefs."

Ritts delighted in the portrayal of an idealized—even exaggerated—human form. One of his best-known works, "Fred with Tires" (1984), shows an almost impossibly muscular young man clad only in jeans that sag slightly below his waist.

Ritts became well known for dramatic black-and-white photographs that focused on a single part of the subject's body. His portrait of Olympic heptathlon champion Jackie Joyner-Kersee captures her lower torso and powerful thighs in midleap; her head appears only in shadow on the ground.

Many of Ritts's photographs celebrate the well-developed body. Some of his images have been compared to classical statuary because of the exquisiteness of the subjects' form. Other photos, however, show human vulnerability: Christopher Reeve posing in his wheelchair, Elizabeth Taylor revealing her scar after brain surgery, the brilliant physicist Stephen Hawking struggling against his frailty.

Ritts published a number of books of photographs, including *Pictures* (1988), *Men-Women* (1989), *Duo* (1991), *Notorious* (1992), *Africa* (1994), *Modern Souls* (1995), and *Work* (1996).

The publication of *Work* coincided with an exhibition of Ritts's photographs at the Boston Museum of Fine Arts. Museum director Malcolm Rogers described Ritts as having "an ability to create unforgettable images of great force and beauty" and also "a sense of the bizarre, of style and drama, [and] of erotic energy." He added that Ritts's images show "a world without barriers of race or barriers of sexuality."

Two of Ritts's books, however, speak to issues of race and sexuality. The photos in *Africa* depict the daily lives of indigenous peoples of eastern Africa. Ritts was pleased when Nelson Mandela praised the book, commenting that "it reminded him of his childhood."

Duo celebrated the relationship of 1983 Mr. Universe Bob Paris and his then-partner Rob Jackson.

Ritts's male nudes have been described as having "a profoundly intimate feeling." The photographer himself felt that his pictures reflected a "classic sensuality" rather than a "gay sensibility." Nevertheless, although his images are widely admired by mainstream audiences, they have a particular appeal to gay viewers.

Ritts was always candid about his own sexuality. He realized that he was gay while he was in college. He soon came out to his parents, who were accepting and supportive.

In 1993, Ritts appeared in "The Gay '90s," an NBC news special about the life of gays in the last decade of the twentieth century. After the program aired, he received many letters, some from gay teens who had contemplated suicide. Ritts stated that he had not considered himself a role model, but "you suddenly get one of these letters, [and] you realize how important it is that there be encouragement for gay people."

Although he is best known for his still photographs, Ritts also directed music videos, including two MTV Award winners, Janet Jackson's "Love Will Never Do (Without You)" (Best Female Video, 1991) and Chris Isaak's "Wicked Game" (Best Male Video, 1991). In addition, he directed Madonna's "Cherish" (1989), in which the singer cavorted on a beach with "hunky mermen," as well as videos for Shakira, 'N SYNC, Jennifer Lopez, and Britney Spears.

Ritts will also be remembered for his vigorous fund-raising efforts in the quest for a cure for AIDS, in particular for his efforts on behalf of amfAR, the American Foundation for AIDS Research.

Ritts kept working until just a few days before his death. Among his last projects were the cover shot for the March 2003 issue of *Vanity Fair* and a photo session with United Nations Secretary General Kofi Annan.

Ritts died in Los Angeles on December 26, 2002, of complications from pneumonia. He had been diagnosed as HIV-positive years before, and although his death was not specifically HIV related, the virus had compromised his immune system.

He is survived by his partner, Erik Hyman, an entertainment attorney.

— *Linda Rapp*

BIBLIOGRAPHY

Downey, Ryan J. "Photographer/Video Director Herb Ritts Dies at Age 50." mtv.com. www.mtv.com/news/articles/1459303/12262002/shakira.jhtml.

"Herb Ritts: Photographer Who Created a New Style for Pictures of Celebrities and Was Lauded by Hollywood Stars and Fashion Designers." *The Daily Telegraph* (London), December 28, 2002.

"Herb Ritts: Photographer Who Turned the Glamorous Celebrity Lifestyle into Art." *The Guardian* (London), December 28, 2002.

Isherwood, Charles. "Work in Progress." *The Advocate* 720 (November 12, 1996): 50.

"Photographer Herb Ritts's Death Came After Years of Battling HIV." *The Advocate*. www.advocate.com/new_news.asp?id=7319&sd=12/28/02-12/30/02;.

Rogers, Malcolm. "The Director's Perspective on Herb Ritts: Work." Boston Museum of Fine Arts. www.boston.com/mfa/ritts/pressroom/director.htm.

Stuever, Hank. "The Flash of Fame; Photographer Herb Ritts Blurred the Line Between Art and Commerce." *The Washington Post*, December 28, 2002.

SEE ALSO

Photography: Gay Male, Post-Stonewall; Lynes, George Platt

Rudolph, Paul (1918–1997)

MODERNIST ARCHITECT PAUL RUDOLPH WAS ONE OF THE most esteemed American architects of the 1960s, when he was the influential chair of the School of Architecture at Yale University.

Rudolph was born on October 23, 1918, in Elkton, Kentucky. He graduated from the Alabama Polytechnic Institute in 1940. After serving in the U.S. Navy from 1943 to 1946, he entered Harvard's Graduate School of Design, where he graduated in 1947 with a Master's degree in architecture.

Although he studied with Walter Gropius, Rudolph moved away from the clean lines of modernist glass and steel to the more monolithic forms of Brutalism.

He practiced architecture and graphic design in Florida, Boston, and New York, and lived in New Haven while serving as Chair of the Architecture Department at Yale University from the late 1950s to the mid-1960s.

During his lifetime, he designed private homes, multiple-family housing, and public buildings in North America, Europe, Africa, the Middle East, and Asia.

Rudolph's most famous work is the Art and Architecture Building at Yale, completed in 1963. This concrete building just outside Yale's urban campus is bold and complex. Hollow vertical towers contain stairs, elevators, or mechanical systems.

The changing character of natural light through large skylights illuminates the dramatic main interior space, overlooked by mezzanines and bridges. There are over thirty changes of level to accommodate offices, studios, and meeting spaces, rooms defined more by the planes of floors and ceilings than by walls.

Often under attack by both students and administrators for being inhospitable and confusing, and suffering from the wear and tear of daily use, the building has seen better days. In 2000, Sid R. Bass donated $20 million to Yale for the restoration of the "heroically flawed masterpiece."

Additional highlights from Rudolph's career include expressive buildings at colleges and universities including Colgate, Dartmouth, Emory, Southeastern Massachusetts, and Wellesley.

The Walker Guest House in Sanibel Island, Florida, is a modern, light, wood building that includes pivoting panels that enclose, ventilate, and shade the inhabitants.

The unfinished State Service Center in Boston includes long, circuitous walkways that penetrate deep into the mass of the building.

For his own residence on Beekman Place in Manhattan, Rudolph created a mirror-covered, steel-framed mix of balconies and stairs that has the look of a labyrinth and an intimate discotheque, an ideal setting for voyeurism and exhibitionism.

Rudolph's work is designed to excite and challenge its occupants. Lively and rugged, the buildings are often made from exposed concrete surfaces. The strong vertical striations are obtained with either ribbed-block or ribbed-wood forms. The rough texture is achieved by hammering away at the poured concrete to expose the inner aggregate.

The interiors are dynamic, playing with light and shadow, drama and abstraction. Beams slide past vertical supports; walls are de-emphasized. Built-in furnishings enhance and divide the spaces.

Like many architects of the period, Rudolph believed that urban design could contribute to social reform. Many

of his unbuilt urban projects were based on the "plug-in city," an idea that included mobile residential or work units that plugged into a larger framework for mechanical, electrical, and plumbing services.

His Oriental Gardens Housing Project, built in New Haven in 1970, used mobile home units. Ill-conceived and eventually uninhabitable, the project was demolished in 1981.

Rudolph was uncompromising and egocentric. He was also versatile and imaginative. "Architecture is a personal effort, and the fewer people coming between you and your work the better. This keeps some people from practicing architecture," he remarked, and added: "If an architect cares enough, and practices architecture as an art, then he must initiate design; he must create rather than make judgments."

Controversial and influential through the 1960s, Rudolph was fairly open about his sexuality. Yet the extent to which his homosexuality contributed to his exaggeratedly masculine aesthetic can only be speculative.

Rudolph died in Manhattan on August 8, 1997.

Rudolph's reputation, in decline for some time, is beginning to rise again. — *Ira Tattelman*

BIBLIOGRAPHY

Cook, John W., and Heinrich Klotz. *Conversations with Architects.* New York: Praeger Publishers, 1973.

Heyer, Paul. *Architects on Architecture: New Directions in America.* New York: Walker and Company, 1966.

Moholy-Nagy, Sibyl. *The Architecture of Paul Rudolph.* New York: Praeger Publishers, 1970.

Monk, Anthony. *The Art and Architecture of Paul Rudolph.* New York: John Wiley & Sons, 1999.

Spade, Rupert, ed. *Paul Rudolph.* London: Thames and Hudson, 1971.

SEE ALSO

Architecture

S

Salons

NO ONE HAS DISPUTED THE SIGNIFICANT CONTRIBUTION of women in the cultural history of salons, but what is often overlooked in mainstream publications on the topic is that many of these salon hostesses and attendees were lesbian, bisexual, or gay.

Eighteenth- and Nineteenth-Century Parisian Salons

The tradition of literary gatherings began in Renaissance France and Italy, but it was in eighteenth-century Paris that the salon gained prominence for lively intellectual conversation in the fields of arts and letters.

The hostesses of these events were typically women of some distinction, whether by title or personal wealth. The meetings were often referred to by the day of the week on which they were held. Topics of conversation ranged from (but were not limited to) matters of literary and social taste and, increasingly, political issues.

Salon conversation was characterized by a blend of wit and oral brilliance. A notable salon hostess of eighteenth-century Paris was Madeleine de Scudéry. Famous for her "Saturdays of Sappho," she recreated salon society in her novels. What is striking about these assemblies is that they were presided over by women, a rare example of female control in a literary realm.

During the nineteenth century, Paris salons became showcases for musicians such as Chopin and Liszt. Because salons encouraged exchanges of ideas and more often than not tolerated alternative lifestyles, they were a safe gathering place for individuals of varying sexual orientations.

Marcel Proust depicted his personal experience with salon life in *À la recherche du temps perdu* with the rival salons of the Duchesse de Guermantes and Madame Verdurin.

Americans in Paris: Natalie Barney, Gertrude Stein, and Sylvia Beach

Of the many American women who came to Paris in the early part of the twentieth century, three in particular made a tremendous impact in the world of arts and letters.

Natalie Barney, a lively, wealthy, unapologetic lesbian from Ohio, settled in Paris to escape the demands of her social class and to live in an atmosphere that was more tolerant of homosexuality. Her contribution to salon cultural history cannot be overstated. Her weekly gatherings were legendary and hosted such figures as Colette, André Gide, Marcel Proust, Djuna Barnes, and, later, Truman Capote and Greta Garbo.

Barney's "Fridays"—held at her home at 20, rue Jacob, on the Left Bank—continued for sixty years. As Solita Solano observed, "Natalie did not collect modern art, she collected people." Behind the house was a Greek temple dedicated to friendship. Here was the backdrop for the many *tableaux vivants* featuring Colette during her dance-hall days and the infamous Mata Hari.

Barney considered herself a disciple of Sappho, not just for her sexual preferences, but also for her genuine desire to promote the creative talents of women. Before establishing her salon, Barney and one of her early lovers, the poet Renée Vivien, expressed a desire to establish a women-only colony on the island of Lesbos, the birthplace of Sappho.

Barney's Académie des Femmes (a counterpart to the then all-male Académie-Française) fulfilled this dream of continuing a tradition to provide a venue where women could perform, create, engage in meaningful conversation, and safely express their desire for one another.

Not far from Barney's house, Gertrude Stein held Saturday evening gatherings at 27, rue du Fleurus, the home she shared with Alice B. Toklas. Her guest list was a who's who of artists and writers living in Paris during the early part of the twentieth century: Picasso, Matisse, Apollinaire, Hemingway, and Sherwood Anderson are only a few of the notables who came by to look at her famous art collection and to talk about the direction of modernism.

In contrast to Barney's women-centered salons, Stein's visitors were predominantly male. If there were any wives in tow, they were entertained by Toklas in a separate room. Toklas also provided the all-important refreshments and food that were a part of salon gatherings.

In spite of Stein's adoption of such patriarchal attitudes, she and Toklas did circulate among and correspond with other members of the lesbian literati in Paris at the time, among whom were Natalie Barney and Sylvia Beach.

Although not a salon in the traditional sense, Sylvia Beach's Shakespeare & Company at 12, rue de l'Odéon fulfilled a similar purpose. It was more than just a bookstore and lending library. It was also a meeting place for American writers living in Paris between the wars.

Beach's support for writers extended to publishing James Joyce's *Ulysses* when no other publisher would touch it, this in spite of the fact that its publication nearly bankrupted her.

Beach and her lover Adrienne Monnier, owner of her own bookstore, *La Maison des Amis de Livres*, gave continued financial as well as moral support to the writers who frequented their bookstores.

As a testimony to the gratitude that her clientele felt for Beach's endeavors on their behalf, they rallied to offer their assistance when Beach herself fell upon hard financial times. Their aid allowed Shakespeare & Company to stay in operation until Nazi occupation forced the shop to close down for good in 1941.

"Movers and Shakers": Mabel Dodge Luhan's American Salon

Mabel Dodge Luhan, a wealthy arts patron who knew Natalie Barney from boarding school in Paris, returned to America and later established a salon in her apartment at 23 Fifth Avenue, just on the edge of Greenwich Village in New York City. This salon attracted many avant-garde artists and other members of New York's radical bohemian subculture.

Although only in existence from 1912 to 1914, Luhan's salon became one of the most famous in the United States. Present at her events were birth-control advocate Margaret Sanger, critic and novelist Carl Van Vechten, and journalist John Reed, among many others. Although not a gifted conversationalist or artist herself, Luhan seemed to have a gift for accumulating the best and the brightest around her.

As one might expect, the evenings at Luhan's salon attracted a colorful crowd where, as Van Vechten described, "ladies with bobbed hair and mannish cut garments" sat alongside men in evening dress and workmen's clothes.

Although primarily heterosexual, Luhan frankly details her passionate physical encounters with young women during her youth in her autobiography *Intimate Memories* (1933). It was in these memoirs that she dubbed her salon attendees "the movers and shakers" of history.

The Bloomsbury Group

After the death of their father in 1904 and before their marriages, sisters Virginia and Vanessa Stephen (later Virginia Woolf and Vanessa Bell) opened their home to a select circle of friends known as the Bloomsbury group, named for the London district where they lived.

Because of its predominance of gay and bisexual members, the group was disparagingly referred to as "Bloomsbuggers." The Bloomsbury salon expanded after the marriages of the sisters and came to exert an important influence on British art and literature in the twentieth century.

Among the collection of friends who gathered at various times in Bloomsbury could be counted novelist E. M. Forster, biographer Lytton Strachey, economist John Maynard Keynes, and artists Duncan Grant and Dora Carrington.

Based on a mutual interest in the arts and a growing disdain for the social and sexual restrictions of the Victorian era, these meetings significantly affected the development of modernist literature and art in early twentieth-century England.

— *Robin Imhof*

BIBLIOGRAPHY

Benstock, Shari. *Women of the Left Bank: Paris, 1900–1940.* Austin: University of Texas Press, 1986.

Crunden, Robert M. *American Salons: Encounters with European Modernism, 1885–1917.* New York: Oxford University Press, 1993

Fitch, Noel Riley. *Sylvia Beach and the Lost Generation: A History of Literary Paris in the Twenties and Thirties.* New York: Norton, 1983.

Gadd, David. *The Loving Friends: A Portrait of Bloomsbury.* New York: Harcourt Brace Jovanovich, 1975.

Lougee, Carolyn C. *Le Paradis des Femmes: Women, Salons, and Social Stratification in Seventeenth-Century France.* Princeton, N. J.: Princeton University Press, 1976.

Quennell, Peter, ed. *Genius in the Drawing-Room: The Literary Salon in the Nineteenth and Twentieth Centuries.* London: Weidenfeld & Nicolson, 1980.

Rodriguez, Suzanne. *Wild Heart. A Life: Natalie Clifford Barney's Journey from Victorian America to the Literary Salons of Paris.* New York: Ecco/HarperCollins, 2002.

SEE ALSO

Carrington, Dora; Grant, Duncan

Sargent, John Singer (1856–1925)

Everyone who was anyone around the turn of the twentieth century had a portrait painted by John Singer Sargent. The wealthy, famous, and noble on both sides of the Atlantic flocked to the London studio of this expatriate American, sealing his reputation as one of the most famous and recognizable of American artists.

Born January 12, 1856, in Florence, Italy, to American parents, Sargent lived a vagabond childhood, traveling throughout Europe with his parents. In 1874, he went to Paris to study painting.

A trip to Madrid in 1879 inspired the masterpiece of his youth, *El Jaleo* (1882). In somber colors reminiscent of Velázquez and Goya, *El Jaleo* depicts the passion and sensuality of flamenco dance and music.

Earthy and exotic, it created a scandal when it was exhibited, establishing a pattern whereby Sargent earned fame (and occasionally infamy) by shocking the artistic establishment and the social arbiters of his day.

Controversy followed other early portraits, such as that of gynecologist *Dr. Samuel Jean Pozzi at Home* (1881).

The famous full-length portrait of New Orleans beauty Virginie Gautreau (1884) brought Sargent notoriety. Considered ostentatious and brazen, the portrait of Madame Gautreau in a strapless black gown with a plunging neckline was eviscerated by the critics as scandalous.

From a contemporary perspective, it is particularly noteworthy as a depiction of a sexually aware and desiring woman and as a comment on Parisian social pretensions. Sargent eventually changed the title to *Portrait of Madame X* to protect the sitter.

To escape the scandal created by the *Portrait of Madame X,* in 1886 Sargent moved to London, where paintings such as *Carnation, Lily, Lilly, Rose* (1885–1886) and *Lady Agnew of Lochnaw* (1892–1893) triumphed at the Royal Academy and where he established a brilliant career as a society and celebrity portraitist.

Because of his ability to capture the essence of male power and female beauty without superficiality, Sargent is considered by some to be "vanity's butler" for making everyone appear dashing and beautiful.

However, Sargent's work is often unsparingly candid, depicting his sitters' insecurity and awkwardness as well as their beauty and power. The delicate brushwork, nuanced color, and ingenious use of setting make his portraits uniquely vibrant and alive.

Although Sargent's portraits sold for high prices and made his career, the assembly-line nature of the work increasingly dissatisfied him. From 1900 to 1907, he painted fifteen to twenty-five portraits per year.

After painting over 700 portraits, he dedicated his last years to producing large murals for the Boston Public Library, the Museum of Fine Art in Boston, and Harvard University, as well as numerous watercolors. These works remain largely unrecognized.

Critics frequently comment on the tension between respectability and sensuality in Sargent's work, especially

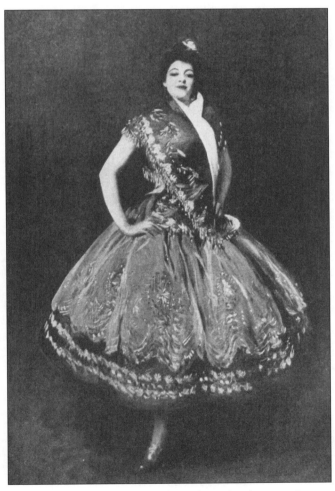

La Carmencita by John Singer Sargent.

his ability to suggest the transgressive without actually violating social proprieties. Many find the same tension in Sargent's personal life.

Although he had many friends, including Henry James and Robert Louis Stevenson, and associated with aesthetes and dandies such as Oscar Wilde and Robert de Montesquiou, Sargent was known as distant and reserved. He had no great romantic attachments, only flirtations with women and deep friendships with men.

Rumors circulated about his relationship with his longtime model and assistant Nicola d'Inverno, but no physical liaison of any kind has been documented. At Sargent's death, his family destroyed his personal papers, so the evidence for Sargent's homosexuality resides largely in his work, especially his genre paintings and male nudes.

American art historian Trevor J. Fairbrother believes that Sargent's drawings of the male nude show that Sargent had homosexual leanings. Gently erotic, with an unabashed attention to genitalia, these were never exhibited.

Also of note is an early portrait that evokes a homosexual sensibility, W. Graham Robertson (1894), in which a slender twenty-eight-year-old dandy, dressed in a smoking jacket, stands in a provocative pose, while an elderly poodle rests on the floor.

One of his most beautiful works is Nude Study of Thomas E. McKeller (1917–1920). Found in his studio at his death, this oil painting of one of Sargent's favorite models, legs sprawled and eyes raised, challenges interpretation.

Also surprisingly erotic is the unfinished Boston Public Library mural Triumph of Religion (1890–1919), which features numerous images of young male bodies.

After a life filled with honors and prizes, Sargent died on April 15, 1925, in London. His gravestone inscription reads "To work is to pray." — Julia Pastore

BIBLIOGRAPHY

Fairbrother, Trevor. John Singer Sargent. New York: Henry N. Abrams, 1994.

————. John Singer Sargent: The Sensualist. New Haven: Yale University Press, 2000.

Kilmurray, Elaine, and Richard Ormond, eds. John Singer Sargent. Princeton, N. J.: Princeton University Press, 1998.

Murphy, Michael J. "Sargent, John Singer." Who's Who in Gay and Lesbian History from Antiquity to World War II. Robert Aldrich and Garry Wotherspoon, eds. London: Routledge, 2001. 393–394.

Olson, Stanley. John Singer Sargent: His Portrait. New York: St. Martin's Press, 2001.

SEE ALSO

European Art: Nineteenth Century; American Art: Gay Male, Nineteenth Century; Subjects of the Visual Arts: Nude Females; Subjects of the Visual Arts: Nude Males; Tuke, Henry Scott

Schwules Museum (Gay Museum)

BERLIN'S SCHWULES MUSEUM, ESTABLISHED IN THE late 1980s, is a private institution dedicated to preserving, exhibiting, and discovering homosexual history, art, and culture. Located in the Kreuzberg district of former West Berlin, long the center of gay life in the city, the museum is composed of three main divisions: archives, library, and exhibitions.

The Mission

The Schwules Museum was founded as a "living collection" for presenting to the public exhibitions, catalogs, essays, lectures, and film screenings. Its targeted audience includes everyone—gay men, lesbians, bisexuals, transsexuals, and heterosexuals—who would like to inform and be informed, in a professional and scientific manner, on all topics relating to homosexuality, both historically and contemporarily.

The museum is a repository for diverse collections—including records of self-help groups, public institutions, and churches, as well as memoirs, oral histories, and literary and artistic works. It is the mission of the museum to build from such diverse sources a continually expanding chronicle of gay social history and to document the history and development of gay liberation movements.

Although the museum is interested in all aspects of homosexual history and culture, it has a particular concern with the persecution of gay men and lesbians under fascism. The treatment of gay men and lesbians by the Third Reich is a topic of specialization and continuing research.

This topic is dealt with extensively in museum publications and exhibitions, including the famous 1997 exhibit entitled Goodbye To Berlin? 100 Jahre Schwulenbewegung (Goodbye to Berlin? 100 Years of the Gay Movement).

Goodbye To Berlin? 100 Jahre Schwulenbewegung

The beginning of the early European gay rights movement is generally dated to May 15, 1897, when four courageous individuals met for the first time in Berlin to initiate resistance to Paragraph 175 of the German Penal Code, which imposed severe penalties on individuals convicted of homosexual acts.

The exhibit Goodbye to Berlin opened at the Academy of Art in Berlin, under the cosponsorship of the Schwules Museum, on the 100th anniversary of this signal event.

The exhibit documented every significant milestone in gay and lesbian history of the 100 years between 1897 and 1997. Although the scope of the exhibit was global, the focus was on German culture and history. The title of the exhibit, alluding to Christopher Isherwood's Berlin Stories, suggests the pivotal role of Berlin to glbtq history in the years between the world wars.

On view were artworks, photographs, letters, and other documents that illustrated the lives of glbtq people at various epochs from the era of Bismark and the Kaisers to the Golden Age of the Weimar Republic (when German culture itself reached its artistic zenith), and from the bleak period of suppression and persecution in the Third Reich to the time of recovery and organizing in the post–World War II years, culminating finally in the gay liberation movement sparked by the Stonewall riots of 1969.

The exhibit was a great success. Fortunately, the beautifully produced, richly illustrated, and deeply informative catalog provides a permanent record of the exhibit and itself constitutes a valuable history of the gay rights movement.

Recent Exhibitions

The museum currently has two exhibition rooms in which it presents exhibitions on topics ranging from art and history to the everyday lives of gay men and women. Unfortunately, a lack of exhibition space prevents the museum from installing a permanent exhibit on the history of gay persecution and gay liberation.

Recent exhibitions have paid homage to the anniversaries of two international German celebrities: Marlene und das Dritte Geschlecht: Hommage zu Marlene Dietrichs 100. Geburtstag (December 5, 2001–April 15, 2002), a retrospective in commemoration of Marlene Dietrich's 100th birthday; and Fabrik der Gefühle: Hommage an Rainer Werner Fassbinder (May 29–October 28, 2002), a retrospective in commemoration of the twentieth anniversary of the death of filmmaker Rainer Werner Fassbinder.

The Dietrich exhibit shed light on the actress's relationships in several spheres, especially her role as gay and lesbian icon. Among many other documents, the exhibit featured photographs by Cecil Beaton, letters, costumes, props, and numerous objects from the Dietrich estate, many of which were exhibited for the first time in this homage to Germany's unique contribution to film and glbtq culture.

The Fassbinder exhibit brought together photographs, film clips, and posters to document the director's life and work, and the centrality of his homosexuality to both. Drawing from private collections as well as from material loaned by the Fassbinder Foundation and other museums, the exhibit centered on the role of women in Fassbinder's films, illustrating how the director's own life experiences influenced these parts.

Another recent exhibition at the Schwules Museum was entitled C'est mon homme ("It's My Man"). The exhibit consisted of a collection of male nude photographs from the French artist association Passage à l'acte.

Research

Besides collecting and exhibiting documents of gay culture, a major interest of the Schwules Museum is research. Assembling, writing, and documenting a living gay history is a formidable task and an area in which much work needs to be done.

The museum is interested in becoming a repository for university research, such as doctoral theses, and also in assisting scholars in using its archives for research purposes. Memoirs and records from the 1920s, the Nazi era, and the 1950s and 1960s constitute a large portion of the Schwules Museum library and may be used for research.

Volunteers and Support

As a private institution, the Schwules Museum is largely dependent upon donations and endowments, since it receives a subsidy of less than 5,000 euros annually from the Berlin Senate and has monthly expenses in excess of 3,000 euros.

Not surprisingly, the Schwules Museum is dependent on a cadre of dedicated volunteers with diverse interests and talents. It also welcomes the donation of books, magazines, objects, documents, and art, to increase its holdings.

With volunteer help and a dedicated staff, the museum hopes to educate the public, foster understanding, dismantle prejudice, and open new dialogues with members of the majority culture.

Located at Mehringdamm 61, in a courtyard adjacent to the gay restaurant-bar Café Melitta Sundstrom, the Schwules Musuem is open every day except Tuesdays. Generally, two exhibitions run concurrently and are open to the public. Access to the library and archives is by appointment only.

— *Andrew Leblanc*

BIBLIOGRAPHY

Bollé, Michael, and Rolf Bothe. *Eldorado: Homosexeulle Frauen und Männer in Berlin 1850–1950; Geschichte, Alltag, und Kultur.* 2nd ed. Berlin: Edition Hentrich and Verlag Rosa Winkel, 1992.

Goodbye To Berlin? 100 Jahre Schwulenbewegung. Eine Ausstellung des Schwules Museums und der Akademie der Künste. Monika Hingst et al., eds. Berlin: Verlag Rosa Winkel, 1997.

Gordon, Mel. *Voluptuous Panic: The Erotic World of Weimar Berlin.* Los Angeles: Feral House, 2000.

www.geocities.com/schwulesmuseum/wir.htm

SEE ALSO

Leslie-Lohman Gay Art Foundation; Homomonument; Beaton, Cecil; Segal, George

Segal, George

IN 1979, POP SCULPTOR GEORGE SEGAL WAS COMMISsioned by the Mildred Andrews Fund, a private Cleveland-based foundation that supports public art, to create a work that would commemorate New York City's Stonewall Rebellion, the 1969 riot that conveniently (if somewhat simplistically) marks the beginning of the modern gay liberation movement.

The result was the first piece of public art commemorating the struggle of glbtq people for equality, predating Amsterdam's "Homomonument" by some seven years.

Tellingly, Segal's sculpture has, from the very beginning, been at the center of controversy and suffered the kinds of assaults and bashings that glbtq people themselves have all too often experienced.

The Sculpture

The sculpture, entitled *Gay Liberation*, is a lifelike, life-size bronze group, painted white, depicting four figures: a standing male couple and a seated female couple. One of the men holds the shoulder of his partner; one of the seated women gently touches her friend's thigh. The poses are nondramatic, but quietly powerful, suggesting depths of love and companionship.

Segal's aim in his depiction of the couples was to normalize and domesticize homosexual relationships, rescuing them from the sensationalized, oversexualized images so common in the popular media. At the same time, however, Segal emphasizes the physical element of relationships. The partners' soulful gazing into each other's eyes symbolizes commitment and communion, but their touching represents physical intimacy.

As David Lindsey has observed, "*Gay Liberation* is all about touch and tender, affirmative embrace."

The artist himself remarked, "The sculpture concentrates on tenderness, gentleness, and sensitivity as expressed in gesture. It makes the delicate point that gay people are as feeling as anyone else."

The political significance of the mundane reality of loving couples is suggested by the title, *Gay Liberation*. Segal's choice to define gay liberation in terms of ordinary, committed relationships is itself profoundly political. It quietly but unmistakably affirms the unexceptionable observation that the aspirations of gay men and lesbians are no different from those of heterosexual couples. The personal is made political in this case not by the artist or by the couples, but by the social and legal prohibitions against the most basic of human needs, the need to love and be loved.

Some critics complained that the figures appear too sad, but the complex interior life the figures display expresses, at least in part, the ambiguous place gay men and lesbians occupy in the American public consciousness, surely cause enough for sadness.

The subsequent history of the sculpture illustrates the difficulties some people have in accepting even so elemental a premise as the humanity of glbtq people, as well as the impossibility of satisfying completely the needs of a diverse and sometimes divided community.

The Controversy

The idea for a sculpture to honor the gay and lesbian rights movement on the tenth anniversary of Stonewall originated with Bruce Voeller (1944–1994), cofounder and first executive director of the National Gay Rights Task Force and the founder of the Mariposa Foundation.

Voeller approached Peter Putnam (1925–1987), an eccentric philanthropist who had established the Mildred Andrews Fund in honor of his mother, to finance the project. The terms for the commission specified only that the work "had to be loving and caring, and show the affection that is the hallmark of gay people.... And it had to have equal representation of men and women."

In addition, Putnam insisted that the memorial be installed on public land or nowhere at all.

Segal was, at first, uncertain about accepting the project. His initial reaction was that the sculpture should be done by a gay artist. But he finally concluded, "I'm extremely sympathetic to the problems that gay people have. They're human beings first. I couldn't refuse to do it."

The plan was to create two castings of *Gay Liberation* and to install them in two locations, in New York City's Sheridan Park, near the site of the Stonewall Inn in Greenwich Village, where the events of the summer of 1969 launched the gay liberation movement, and in Los Angeles.

However, even the famously liberal Village was not ready for gay liberation, at least in 1980. Although the sculpture was intended as a gift to the city, it had to be approved by a host of city organizations and community groups. Most of the Greenwich Village political leaders, including Representatives Theodore Weiss and Bella Abzug, endorsed the project, as did the *Village Voice* and the city's Director of Historic Parks.

However, many local residents opposed the plans for the installation. Some, mostly Italian Catholics, frankly objected to the subject matter, as they also objected to the gay men and lesbians who were moving into their neighborhood and changing its character. Others objected ostensibly on the grounds that the sculpture was too large for the park, that it was inappropriate to the neighborhood's architecture, and that it would attract undesirable elements and "ghettoize" the area.

Some gay men and lesbians opposed the installation as well. Some protested that the monument to Stonewall

should be designed by a homosexual chosen by the community. Others complained that the figures were "cruising clones" and not sufficiently representative of the community.

Anonymous notes and telephone calls to city hall threatened to blow up the statue.

Although *Gay Liberation* had been approved by the city's Fine Arts Commission, Community Board Two, and the Landmarks Commission, the city failed to allocate the funding to install the work and to provide landscape architecture for the park.

The casting that had been made for installation in Los Angeles met a similar fate. The local government refused to accept the work.

Move to Stanford

Given the reaction against the statue by the residents and governments of New York City and Los Angeles, the decision was made to seek an alternate site for the sculp-

ture. It was decided to offer *Gay Liberation* for installation on the Stanford University campus in Palo Alto, California, a campus famous for its public sculptures. After much wrangling, and the approval of two faculty committees and the president of the university, the Stanford Board of Regents finally voted to accept the sculpture as a long-term loan.

Less than a month after the sculpture was installed in February 1984, the work was attacked with a ball-peen hammer. The vandal(s) struck the figures about forty times, gouging the faces and torsos, and inflicting an estimated $50,000 worth of damage. The statue was removed from display and placed in storage.

The assault sent a chill through the glbtq community at Stanford and across the nation. That such a violent attack, so reminiscent of hate crimes almost routinely visited upon glbtq people, could take place on the campus of a major university, in the shadow of San Francisco, with its large and active gay and lesbian community,

George Segal's *Gay Liberation* in New York City's Sheridan Park.

underscored the vulnerability of the lesbian and gay movement.

The day after *Gay Liberation* was attacked in 1984, members of the Stanford community began placing flowers at the site. A week later, 200 people gathered in White Plaza to denounce the crime. Segal issued a statement, remarking that his point in *Gay Liberation* was "a human one regarding our common humanity with homosexuals. I'm distressed that disagreement with the statement took this violent, brutal form."

After being repaired, the sculpture remained in storage for over a year, then was quietly reinstalled. Less than a year later, however, it was attacked again. Someone spray-painted the word "AIDS" on the male couple.

In 1994, the sculpture was again vandalized, this time by several drunken members of Stanford's football team, who splattered the white statue with black paint and wedged a bench between two of the four figures, resulting in approximately $8,000 worth of damage.

The local district attorney's office charged two of the students with felony vandalism and four with misdemeanor vandalism. At an on-campus forum, lesbian and gay students expressed their anger that hate-crime charges could not be brought because the California hate-crime statute is triggered only by the violation of an individual's—rather than an institution's—civil rights.

The glbtq community's anger was heightened into rage when a wrestling coach minimized the incident and attributed the uproar to "students [who] are almost force-fed political correctness" and to police who made sure that "everyone knew" about the incident.

The culprits were eventually sentenced to probation and community service. The judge suggested that they take a class in gay studies.

Installation in New York

The other casting of the sculpture had been briefly and temporarily installed in a public park in Madison, Wisconsin, and occasionally exhibited in galleries. In 1992, however, New York City finally agreed to place it in Sheridan Park, just across the street from the site of Stonewall Inn.

At the dedication ceremony, on June 23, 1992, Segal expressed surprise that there were no religious protesters. One local resident explained that most of the neighbors who had objected to the original plans for the installation on religious grounds had either died or moved away.

Still, the installation in New York again ignited controversy. Some gay and lesbian groups continued to object that a straight man was chosen to memorialize Stonewall; others complained variously that gay and lesbian groups were not consulted about the design and that the depiction was too explicit, not sufficiently explicit, featured only middle-class white couples, privileged committed

relationships, and omitted other elements of the glbtq community.

Eventually the controversy faded, and *Gay Liberation* is now a fully accepted and respected sight in the neighborhood for which it was originally intended.

The Artist

Segal took the criticisms from the radical groups in stride. Jokingly acknowledging himself as "an unregenerate heterosexual," he continued to insist that such a condition did not "prevent him from having an insight into the natures of my gay friends."

Segal, who was born on November 26, 1924, in New York City, was actually an obvious choice to design a monument to gay liberation. By the time of the commission, he had become America's leading sculptor of public monuments and memorials. Besides, as Voeller remarked at one meeting, all the gay and lesbian artists of comparable stature, most of them deeply closeted, had turned down the commission.

Moreover, Segal had already demonstrated an unusual sensitivity in the depiction of lesbian couples in works such as *Lovers on a Bed I* (1976) and *The Girl Friends* (1969).

Segal was educated at Cooper Union, Pratt Institute, New York University, and Rutgers University. He earned an early reputation as a painter, but in the 1960s he turned to sculpture, using plaster casts of individuals—often friends and neighbors—to create lifelike mannequins.

Associated with the Pop artists of the 1960s, he created sculptures of ordinary people placed in everyday environments. His works are familiar in their subject matter and form, yet haunting in their ghostly stillness. In installations such as *The Subway* (1968) or *The Diner* (1964–1968) or *Walk, Don't Walk* (1976), he manages to convey interior feelings of loneliness and isolation, while also discovering the miracles of daily life.

Early in his career, Segal avoided bronze, believing that it was too inert to achieve the expressive quality he sought. However, in 1971, with *The Dancers*, he developed a technique known as double-casting that used both plaster and bronze. In this technique, molten metal is poured into the interior of a plaster cast, reproducing in great detail the texture of skin and clothing. Using double-casting, he was able to create realistic, lifelike figures that were also durable enough to function as permanent, outdoor, public art.

As a result of this process, *Gay Liberation* is at once literally "monumental" and intimate. It captures the ordinariness of the human interaction between the lovers, yet it also freezes the interaction in time and space and art. Hence, the sculpture underlines its important point about the humanity of the lovers, yet it does so simply and naturally by means of the intimacy it both captures and replicates.

Among Segal's other monuments are *In Memory of May 4, 1970: Abraham and Isaac* (1978), a memorial of the Kent State University slayings; the San Francisco Holocaust Memorial (1983); and sculptures for the Franklin Delano Roosevelt Memorial in Washington, D. C. (1997).

Segal died of complications from cancer on June 9, 2000.

— *Claude J. Summers*

BIBLIOGRAPHY

Breshears, Gene. "Art Imitates...." *Sans Fig Leaf: Occasional Thoughts on Life, the Universe, and Everything.* www.sansfigleaf.com/2000/f000615.htm

"George Segal: American Still Life." www.pbs.org/georgesegal/index/index.html

Hunter, Sam, and Don Hawthorne. *George Segal.* New York: Rizzoli, 1984.

Hunter, Sam. *George Segal.* New York: Rizzoli, 1989.

Lindsey, Daryl. "George Segal." *Salon.com* (June 12, 2000): dir.salon.com/people/log/2000/06/12/gsegal/index.html

Saslow, James. *Pictures and Passions: A History of Homosexuality in the Visual Arts.* New York: Penguin Putnam, 1999.

SEE ALSO

Pop Art; Homomonument

Sipprell, Clara Estelle *(1885–1975)*

A LEADING PHOTOGRAPHER OF HER DAY, CLARA Sipprell was a short, stout woman who thought of herself as tall and thin. She smoked cigarettes, cigars, and pipes; liked bourbon and driving fast convertibles; and never cut her hair but often tucked it under a fedora, safari helmet, or cloche hat. She preferred capes because of their drama and freedom of movement, jewelry with large stones in heavy settings, and embroidered Slavic clothing.

Sipprell's father died before her birth on Halloween, 1885, in Tillsonburg, Ontario, Canada. In 1895, she and her mother moved from Canada to Buffalo, New York, where several of her five older brothers had established themselves. She was introduced to photography in the portrait studio of her brother Francis James Sipprell, where she later worked as an assistant and ultimately became a partner in the business (1905–1915).

In the early 1900s, Buffalo was a center of the aesthetic movement called pictorialism, which sought to create photographs that were as artful as paintings; often their images were characterized by a dreamy quality and soft focus.

Sipprell became one of the foremost practitioners of pictorial photography in the United States. She produced autochromes (color) and platinum, bromoil, gum, and carbon prints; won awards in exhibitions; and had her work published in magazines in the United States and Europe.

As a portrait photographer, Sipprell sought to convey a sense of the whole person and what made each unique. She also photographed landscapes, still lifes, female nudes, major individuals in the arts and government, and people in countries in which she traveled, including Yugoslavia, Italy, Russia, Mexico, and Sweden.

In 1915, Sipprell, then thirty, moved to New York City with Jessica E. Beers, with whom she lived until 1923. She opened a photographic studio in Greenwich Village and eventually became a contract photographer for the Ethical Culture School, where Beers was a principal.

A Russian immigrant, Irina Khrabroff, was first her student and later her traveling companion, close friend, and business manager. As a student, Khrabroff spent her winters living with Sipprell and Beers in New York City. In 1923, when Khrabroff married, Beers moved out of the apartment, but Sipprell continued living there with Khrabroff and her husband until 1933.

Around 1937, Phyllis Fenner (1899–1982)—a writer, librarian, and anthologist of children's books—became Sipprell's housemate and traveling companion. This relationship continued through the final thirty-eight years of Sipprell's life. In the mid-1960s, they had Harold Olmstead build them a house in Manchester, Vermont.

Clara Sipprell died in April 1975, at the age of eighty-nine. Her ashes are buried in a plot near an outcropping of rock in Manchester. Attached to the rock is a small bronze tablet on which, in accordance with her wishes, are engraved her own name along with the names of Jessica Beers and Phyllis Fenner.

It is not clear whether or not Sipprell's relationships were sexual or even romantic, yet their length and stability, and the evidence of the memorial marker, indicate an extraordinary level of commitment.

— *Tee A. Corinne*

BIBLIOGRAPHY

McCabe, Mary Kennedy. *Clara Sipprell: Pictorial Photographer.* Fort Worth: Amon Carter Museum, 1990.

Sipprell, Clara. *Moment of Light: Photographs by Clara Sipprell.* New York: John Day, 1966.

SEE ALSO

Photography: Lesbian, Pre-Stonewall; American Art: Lesbian, 1900–1969; Subjects of the Visual Arts: Nude Females

Sodoma, Il
(Giovanni Antonio Bazzi) *(1477–1549)*

A PROLIFIC PAINTER WHO DOMINATED THE ART SCENE of early-sixteenth-century Siena, Giovanni Antonio Bazzi (better known as Il Sodoma) produced images with sentimental appeal. Born in 1477, the son of a shoemaker, Bazzi was apprenticed to a local painter in the north Italian town of Vercelli for much of the 1490s but had moved to Siena by 1502.

A husband and father of two children, he is nevertheless regarded anachronistically by some as a proud, "outspoken" homosexual who was surrounded by, in James Saslow's words, "an entourage of foppish boys." This picture derives from one source, the biography published by Giorgio Vasari in 1568. Bazzi is presented there as an eccentric, self-indulgent, overdressed, and amusing collector of animals.

For Vasari, and all subsequent commentators, the chief evidence about Bazzi's sexuality hinges on the nickname "Il Sodoma."

"Since he always had about him boys and beardless youths, whom he loved beyond the usual (*fuor di modo*), he acquired the byname of Sodoma; and in this name, far from taking umbrage or offence, he used to glory, writing songs and verses about it." According to Vasari, after one of Sodoma's horses won a Florentine race, chanting of the nickname offended local citizens.

Madonna and Child by Il Sodoma.

Actually, the name "Il Sodoma" was voluntarily adopted by March 1513, when it appeared in Siena's racing records. The word is Italian for the biblical city Sodom, from whence comes the noun *sodomia*. The variety of spellings (for examples, Sogdoma, Sodone) may suggest his name was not always associated with sexuality or sin.

What perhaps began as a racing-stable name was then used throughout Sodoma's life. It occurs, for example, in communal records and the patronage documents of a religious confraternity, his own letters to princes, his mother-in-law's will, and the inventory of goods drawn up when he died.

Only one document from the artist's lifetime indicates that anyone thought the name could refer to sexual practice. Nine Latin couplets, published in 1517 in Siena, celebrated Sodoma's picture of Lucrezia, probably the painting that earned him a knighthood from Pope Leo X. The last four lines satirically play with the nickname and say outright that "Sodoma is a bugger (*Sodoma pedico est*)."

Humor and sexual double entendre is more evident in a mock tax return Sodoma may have penned in 1531, though this document could be a seventeenth-century forgery. Nothing definite about his sex life can be deduced from the burlesque lines.

What is clear is that Sodoma was not a modern, "out" gay man; he was a showman (who named his son Apelles), and may have been erotically interested in both sexes. His widespread acceptance in Italian culture of his day is indicated by honors and frequent employment from civic and religious patrons alike.

Another nickname, used by monastic patrons in 1505, was "Joker." If anything, flaunting of such a self-promoting sobriquet as "Sodom" attracted admiration and renown.

Sodoma's art is often charged with sentimental affects of same-sex intimacy. He painted androgynous, youthful beauties, such as *St. Sebastian* (1525). Franciscan monks in their Sienese cloister enjoyed the sight of a muscular, curvaceous *Christ at the Column* (ca. 1514).

Decorating the Roman bedroom of the Sienese banker Agostino Chigi around 1516–1518, Sodoma's fresco of the *Marriage of Alexander and Roxane* highlighted the emperor's beautiful male lover Hephaestion.

Sodoma also depicted fondness and physical tenderness between women. Groups of lightly clad women hold hands, gaze at, or touch each other in such scenes as *Prostitutes Invited to the Monastery* at the Abbey of Monte Oliveto (1505–1508) or the *Tent of Darius* in Chigi's bedroom. Frescoes for St. Catherine of Siena's hometown chapel (1526) included the saint swooning in ecstasy, delicately supported by two loving female attendants.

— *Patricia Simons*

BIBLIOGRAPHY

Cust, Robert H. Hobart. *Giovanni Antonio Bazzi hitherto usually styled "Sodoma." The Man and the Painter 1477–1549.* New York: E. P. Dutton, 1906.

Saslow, James M. *Pictures and Passions: A History of Homosexuality in the Visual Arts.* New York: Viking, 1999.

Vasari, Giorgio. *Lives of the Most Eminent Painters, Sculptors and Architects.* Trans. Gaston Du C. de Vere. New York: Harry N. Abrams, 1979. 3:1593–1605.

SEE ALSO

European Art: Renaissance; Michelangelo Buonarroti; Subjects of the Visual Arts: Nude Males; Subjects of the Visual Arts: St. Sebastian

Solomon, Simeon (1840–1905)

KNOWN FOR HIS ASSOCIATION WITH THE PRE-RAPHAELITES and the Aesthetic Movement, Simeon Solomon lived a life marked by both stunning success and wasteful tragedy.

He is significant for glbtq culture, for he chose to live openly as a homosexual at a time when it was not socially acceptable to do so; he wrote an important prose poem that may be read as a defense of male–male desire; and he created works depicting androgynous male figures who are representative of homoerotic love.

In addition, Solomon may be seen as a victim of late-nineteenth-century English homophobia.

Although he had earned recognition as an artist, Solomon's life and career deteriorated after his arrest for "buggery" in 1873. He lived most of the remaining thirty-two years of his life as a social outcast and his work faded into oblivion after his death in 1905. It has only recently been reexamined.

Simeon, the youngest of eight children born to Meyer Solomon and Kathe Levey, was born on October 9, 1840. The Solomon family was the first Orthodox Jewish family permitted to conduct business in London during the nineteenth century.

Solomon's father became a prominent merchant in the city. Kathe Levey was an artist, as were two of Simeon's siblings—his brother Abraham (1823–1862) and his sister Rebecca (1832–1886).

At age ten, Simeon began to take art lessons from Abraham, who had attended the Royal Academy of Art School. Two years later, Simeon attended Carey's Art Academy in the city and his sister, Rebecca, exhibited at the Royal Academy of Art for the first time.

Four years later, Simeon also premiered at the Royal Academy Summer Art Exhibition. His work continued to be shown in the same exhibition through 1872.

Reflective of his Jewish background, Solomon's early works, such as *Isaac Offered* (1858), *Saul* (1859), *Moses in His Mother's Arms* (1860), *Shadrach, Meschach and Abednego* (1863), and *Habet!* (1865), were based on Hebrew themes. Some of these Hebraic paintings, such as *David Playing the Harp before Saul* (1859), portray sexually ambiguous situations.

During 1857, Solomon met Pre-Raphaelite artists in the home of the group's leader, Dante Gabriel Rossetti. Among the artists and authors he met were Edward Burne-Jones, Frederic Leighton, William Morris, and Algernon Charles Swinburne.

Solomon learned the group's manner of draftsmanship and designed some stained glass pieces for William Morris's firm, Morris, Marshall, and Faulkner and Co. The contact with the Pre-Raphaelites, especially Burne-Jones, probably influenced Solomon's adoption of a more androgynous figure style.

By 1863, Solomon had also designed stained glass with Edward Burne-Jones for All Saints Church in Middleton and modeled for Rossetti's stained glass *Sermon on the Mount* at Christ Church in London.

The opening of the Dudley Gallery in London in 1865 allowed Solomon and other artists to exhibit works with more daring subjects than those accepted at the Royal Academy.

During these years Solomon created such works of homoerotic content as *Sappho and Erinna in a Garden at Mytelene* (1864), *Love among the School Boys* (1866), *The Bride and Bridegroom* (1866), *Sad Love* (1866), *Love in Autumn* (1866), and two versions of *Bacchus* (1866 and 1867).

These works envision an alternative to straitened Victorian ideals of heterosexual love and matrimony. Solomon exhibited frequently at the Dudley Gallery through 1872.

In 1864, Solomon began a close friendship with Swinburne, whose own fascination with flagellation rites, lesbianism, and decadence provided a wealth of subject matter for Solomon. His illustrations for Swinburne's novel *Lesbia Brandon* (1865) and poem "The Flogging Block" (1865), for example, allowed Solomon to explore deeply transgressive subjects.

In the late 1860s, Solomon began to travel to Italy in order to study the old masters. These trips stimulated his imagination and resulted in works on classical themes.

During this period, Solomon moved away from his family's Judaism toward an interest in the Anglo-Catholic Church. The church's use of colorful vestments and altar linens, as well as stained glass and grand architecture, liturgy, and music, appealed to Solomon's aesthetic sense.

During 1867, Solomon traveled to Italy as the lover of Oscar Browning, who was later to become headmaster of Eton and a don at Cambridge. The couple journeyed to Rome and Genoa again in 1870. While in

the Mediterranean, Simeon began to write his prose poem entitled "A Vision of Love Revealed in Sleep."

The 1870 trip, however, ended on a regrettable note. According to written accounts of some friends, the couple left the country earlier than planned. The trip's abrupt end may have been caused by legal reasons related to their same-sex relationship. If that is true, it is no coincidence that Simeon's troubles with alcohol began around this time.

The artist completed his prose poem when he returned to England, and it was privately published in 1871. The poem is a spiritual allegory that illuminates the iconography of Solomon's paintings and that may be read as a defense of homosexual relations. While the work won critical acclaim from John Addington Symonds, it was condemned by others and was never republished in England.

Solomon, however, continued to create art. He exhibited three works at the Dudley Gallery and drew a portrait of critic Walter Pater in 1872.

Then tragedy struck.

The artist was arrested on February 11, 1873, for having sex in a public lavatory with a sixty-year-old stableman, George Roberts. Both men were charged with indecent exposure and the attempt to commit "buggery." They went to court thirteen days later, were judged guilty, fined £100, and later sentenced to eighteen months in prison at hard labor.

At the intervention of a wealthy cousin, Meyer Solomon, the artist's sentence was reduced to police supervision. (Roberts was not so fortunate.)

Eager to escape the shame he felt, Solomon traveled to France for a time. However, he was arrested there on March 4, 1874, for the same reasons. The French court fined him 16 francs and sentenced him to three months in prison. The nineteen-year-old man he was with received a lesser sentence.

After these legal experiences, the artist was never the same. Most London galleries, previous patrons, and former friends, including Swinburne, shunned him.

He did receive some support: some gallery owners gave him monetary advances, one former patron remained loyal, some friends assisted him, and his cousin Meyer Solomon commissioned several paintings from him.

Still, the artist remained depressed and became increasingly reliant on alcohol in an attempt to numb his shame and the pain of society's rejection.

Solomon's depression was exacerbated by the loss of his livelihood and the deaths of immediate family members. His older brother and first art teacher, Abraham, had already died at the age of thirty-nine in 1862, on the same day that he was elected an Associate of the Royal Academy. His older sister, Rebecca, a fellow artist, was in a fatal accident with a cab and died at the age of

fifty-six on November 20, 1888. The following month, his mother, also an artist, died of natural causes.

Solomon continued to paint well into the mid-1890s. The works of the later period of his life are expressive of his feelings of hopelessness, alienation, fear of rejection, and thoughts of death. These themes are signaled by the titles of the works: *Love at the Waters of Oblivion* (1891), *Tormented Soul* (1894), *Death Awaiting Sleep* (1896), and *Twilight and Sleep* (1897).

Simeon spent his final years living alternately in the St. Giles Workhouse and on the street. He often was reduced to begging.

He suffered a heart attack on May 25, 1905, and had a second one within three months. He died of heart failure aggravated by bronchitis and alcoholism on August 14, 1905.

Even though he had forsaken his Jewish faith, he was buried in Willesden Jewish Cemetery.

The London *Times* did not publish an obituary, but the artist was not entirely forgotten. He was honored with an exhibition of 122 works at the Baillie Gallery from December 9, 1905, until January 13, 1906. Also in 1906, Burlington House in London held a retrospective exhibition of Simeon's work, and sixteen of his pieces were included in the 37th Winter Exhibition of Works of the Old Masters and Deceased Masters of the British School, held at the Royal Academy.

In addition, sixteen of his works were included in a 1906 exhibition of works by Jewish artists at the Whitechapel Art Gallery. *Simeon Solomon, an Appreciation*, by Julia Ellsworth, was published in New York in 1908.

However, Simeon soon fell into neglect. His contribution to British art in general, and to the Pre-Raphaelite movement in particular, was lost to scholars for nearly a century.

Solomon and his work have been reexamined through the lens of gender studies only during the 1990s. A Web site devoted to him has recently been mounted on the Internet by art historian Roberto Ferrari. It includes digital images of some works, full text files of some writings about the artist, and a comprehensive bibliography. The site should facilitate scholarly study of this important Victorian artist.

— *Ray Anne Lockard*

BIBLIOGRAPHY

Burman, Rickie, ed. *From Prodigy to Outcast, Simeon Solomon: Pre-Raphaelite Artist*. London: Jewish Museum, 2001.

Collins, Jeffrey Laird. "Prototype, Posing and Preference in the Illustrations of Frederick Sandys and Simeon Solomon." *Pocket Cathedrals: Pre-Raphaelite Book Illustration*. Susan Casteras, ed. New Haven: Yale Center for British Art, 1991. 79–91, 110.

Cruise, Colin. "'Lovely Devils': Simeon Solomon and Pre-Raphaelite Masculinity." *Re-Framing the Pre-Raphaelites: Historical and Theoretical Essays*. Ellen Harding, ed. Aldershot, England: Scolar Press, 1996. 195–210.

———. "Simeon Solomon: A Drama of Desire." *The Jewish Quarterly* 45 (Fall 1998): 62–67.

Ferrari, Roberto. Simeon Solomon Research Archives. www.fau.edu/solomon/

Morgan, Thais E. "Perverse Male Bodies: Simeon Solomon and Algernon Charles Swinburne." *Outlooks: Lesbian and Gay Sexualities and Visual Cultures.* Peter Horne and Reine Lewis, eds. New York: Routledge, 1996. 61–85.

———. "Victorian Effeminacies." *Victorian Sexual Dissidence.* Richard Dellamora, ed. Chicago: University of Chicago Press, 1999. 109–125.

Seymour, Gayle M. "Simeon Solomon and the Biblical Construction of Marginal Identity in Victorian England." *Reclaiming the Sacred: The Bible in Gay and Lesbian Culture.* Raymond-Jean Frontain, ed. New York: Haworth, 1997. 97–119.

Solomon: A Family of Painters: Abraham Solomon (1823–1862), Rebecca Solomon (1832–1866), Simeon Solomon (1840–1905). Exhibition: November 8–December 31, 1985, Geffrye Museum; January 18–March 9, 1986, Birmingham Museum of Art. London: Inner London Education Authority, 1985.

Solomon, Simeon. *A Vision of Love Revealed in Sleep.* London: F. S. Ellis, 1871. Reprint. *Nineteenth-Century Writings on Homosexuality: A Sourcebook.* Chris White, ed. London: Routledge, 1999. 289–309.

SEE ALSO

European Art: Nineteenth Century; Beardsley, Aubrey; Subjects of the Visual Arts: David and Jonathan; Subjects of the Visual Arts: Dionysus; Subjects of the Visual Arts: Nude Males; Subjects of the Visual Arts: Sappho

Stebbins, Emma *(1815–1882)*

EMMA STEBBINS WAS PART OF WHAT HENRY JAMES called "a white Marmorean flock" of women sculptors who went to Rome in the mid-1800s to learn to work in marble. She is remembered for sculpture produced in a ten-year period between 1859 and 1869, when she was in her forties and early fifties.

Her career in art was supported by her own commissions, her wealthy New York family, and her lover, who was the most famous English-language actress of the mid-nineteenth century.

Stebbins was born on September 1, 1815, and raised in New York City, the third daughter and sixth of nine children of a bank president and a Nova Scotia–born mother. Her family encouraged her talents in art and writing. She studied at various American studios and was elected to the National Academy of Design in 1843. She exhibited in National Academy and other shows.

In 1857, at the age of forty-one, Stebbins went to Rome for further study. In that city—home to a sizable Anglo-American colony—she found a large infrastructure supporting art: teachers, technicians, artists, students, and a flow of international collectors. Stebbins remained in Rome for the next decade, during which the United States Civil War (1861–1865) took place.

Shortly after arriving in Rome, Stebbins met Charlotte Saunders Cushman (1816–1876). Handsome, charismatic, and an exceptionally successful actress, Cushman was recovering from the breakup of a ten-year relationship with actress and writer Matilda Hays. After an Easter trip to Naples in 1857, Stebbins and Cushman decided to spend their lives together.

Stebbins and Cushman's friendship circle included lesbian sculptor Harriet Hosmer (1830–1908) and African American/Native American sculptor (Mary) Edmonia Lewis (1843–ca. 1911), who may also have been a lesbian. They were also acquainted with French lesbian painter Rosa Bonheur.

Emma Stebbins.

In Rome, Stebbins—who had originally trained as a painter—shifted her interest to an idealized form of figure sculpture. After a period of study, she supported herself through sculpture commissions, many from Americans. Cushman promoted her work and, at least once, raised funds for casting a major piece.

An early commission was a portrait bust of Cushman made in 1859–1860. Cushman had a prominent jaw of the type often referred to as "lantern," which Stebbins handled with grace and dignity. Her bronze statue of educator Horace Mann was installed outside the State House in Boston in 1865.

Stebbins's best-known work rises above the Bethesda Fountain in New York City's Central Park. Unveiled in May 1873, *Angel of the Waters* is a draped, winged, bronze figure with arms spread downward, blessing the water below. Her pedestal is supported by four cherubs representing Health, Temperance, Purity, and Peace.

When, in 1869, Cushman was operated on for breast cancer, Stebbins devoted herself to nursing her lover. The following year, the couple returned to the United States.

Cushman died of pneumonia in Boston in 1876, at the age of fifty-nine. She is buried in Mount Auburn Cemetery in Cambridge. Following Cushman's death, Stebbins wrote the actress's biography and compiled her correspondence: *Charlotte Cushman: Her Letters and Memories of Her Life* (1878).

After the death of Cushman, Emma Stebbins produced no more sculpture. She died in New York in 1882, at age sixty-seven, of "phthisis," a progressive wasting disease, and is buried in Greenwood Cemetery, Brooklyn, New York.

— *Tee A. Corinne*

BIBLIOGRAPHY

Gerdts, William H. "Stebbins, Emma." *Notable American Women, 1607–1950: A Biographical Dictionary.* Edward T. James et al., eds. Cambridge, Mass.: Harvard University Press, 1975. 3:354–355.

Leach, Joseph. *Bright Particular Star: The Life and Times of Charlotte Cushman.* New Haven: Yale University Press, 1970.

Rubinstein, Charlotte Streifer. "Emma Stebbins." *American Women Artists: From Early Indian Times to the Present.* New York: Avon, 1982. 85–86.

———. "Emma Stebbins." *American Women Sculptors: A History of Women Working in Three Dimensions.* Boston: G.K. Hall, 1990. 63–66.

SEE ALSO

American Art: Lesbian, Nineteenth Century; Bonheur, Rosa; Hosmer, Harriet Goodhue; Lewis, Mary Edmonia; Subjects of the Visual Arts: Nude Females; Whitney, Anne

Subjects of the Visual Arts: Androgyny

ANDROGYNY, AS OPPOSED TO HERMAPHRODITISM, IS based on gender ambiguity rather than the display of dual sexual characteristics. An androgyne is a figure of uncertain gender in whom identifying sexual characteristics are stylized or combined.

In practice, however, artists have had little reason to observe such fine distinctions, and as a subject in art, androgyny and hermaphroditism have often been confused. Thus, the history of androgyny in visual culture is somewhat tortuous and vaguely defined; however, it nevertheless constitutes a significant and recurrent subject in art, and one that has often held special significance for glbtq people.

As a subject, androgyny has occurred in diverse geographical contexts throughout the history of art. Androgynous figures crop up in ancient Egyptian representations of gods and goddesses; likewise, Hindu deities, with their vast multitude of avatars, or personae, may simultaneously exist as both sexes, and artistic representations frequently express this fact. The Shiva Ardhanisvara, for instance—seen in numerous examples in both painting and sculpture—is male on one side and female on the other.

In times and places in which the representation of humans is forbidden or under suspicion (as occurs at various moments in both Christian and Islamic art), figures were stylized to avoid excessive naturalism, and in the process distinguishing sexual characteristics were sometimes blurred or eliminated.

In fact, probably the most famous androgynes in Western art are angels, who have no sex, consistent with the belief that the angel of the Annunciation played no role in the conception of Christ. A good example of this kind of representation is Fra Angelico's famous *Annunciation* (ca. 1437) in the monastery of San Marco in Florence.

The contemporary image of the androgyne as a beautiful youth of indeterminate sex is at least partly a legacy of Johann Joachim Winckelmann, the "father" of modern art history. The homosexual Winckelmann's adoration of Greek art (and European interest in Greek culture in general) included in many cases an undercurrent of fascination with the ancient Greek idolization of the beautiful boy, whose beauty was frequently compared to that of a woman.

Conceptions of the androgyne from the Renaissance onward in the West largely relied on such classical ideas, including the notion that the original state of humankind was androgynous (a theory attributed to Herodotus). The continuing popularity of the beautiful, androgynous inhabitants of Edward Burne-Jones's *Song of Love* (1868–1877) demonstrates the androgyne's ongoing appeal.

The notion of the homosexual as a sort of feminine man or masculine woman (an "invert") has contributed greatly to the popular connection of androgyny with homosexuality. Oppressed and secretive gays of earlier generations could use such images as coded references for mutual identification; and they frequently identified with androgynes as a symbol of their difference. Thus, androgynous figures in visual culture have continued to resonate with a gay and lesbian audience.

— *Joe A. Thomas*

BIBLIOGRAPHY

Feuerstein, Günther. *Androgynos: Das Mann-Weibliche in Kunst und Architektur.* Stuttgart: Edition Axel Menges, 1997.

MacLeod, Catriona. *Embodying Ambiguity: Androgyny and Aesthetics from Winckelmann to Keller.* Detroit: Wayne State University Press, 1998.

O'Flaherty, Wendy Doniger. *Women, Androgynes, and Other Mythical Beasts.* Chicago: University of Chicago Press, 1980.

Zolla, Elémire. *The Androgyne: Reconciliation of Male and Female.* New York: Crossroads, 1981.

SEE ALSO

Classical Art; Indian Art; Subjects of the Visual Arts: Hermaphrodites

The Apollo Belvedere.

Subjects of the Visual Arts: Bathing Scenes

SCENES OF PEOPLE BATHING, WHETHER IN GYMNASIUMS, hammams, pools, or private bathtubs, have attracted artists and patrons of all sexual persuasions for centuries. A common theme in painting since the Renaissance, bathing scenes were adopted by photographers in the nineteenth and twentieth centuries, giving us some of our most enduring images of the seminaked or completely nude human form. Bathing scenes are often suffused with a distinctly homoerotic atmosphere.

Coded Sexuality

The naked body interacting with water is the focus of most bathing scenes, but they often artfully reveal or code hidden erotic longings. The viewer is thus cast in the role of privileged voyeur, as we are drawn closely into the depicted scene.

Artists living in times when sexual openness was impossible sometimes used sly codes in their bath scenes to reveal their interests. Depicting Bathsheba with her close female attendant, for example, often signaled female same-sex intimacy.

This coded element is evident in Albrecht Dürer's *The Bathhouse* (1497), a wood engraving in which, according to Emmanuel Cooper, "homoerotic allusions abound."

Hans Block's *The Bath at Leuk* (1597) may similarly allude to homosexuality. It portrays perhaps a heretical cult that condoned mixed-group bathing, yet some of the men seem more interested in each other.

Heterosexual artists often used codes to hint voyeuristically at female homoeroticism, as in *Bain Turc* (1862) by Jean-August-Dominique Ingres. Though not known for his sense of humor, Ingres painted twenty-five

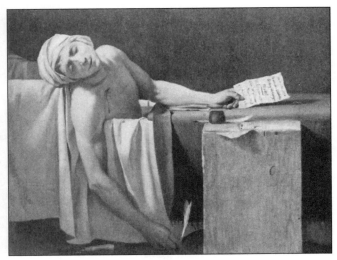

The Death of Marat by Jacques Louis David.

naked ladies in a Turkish bath, some cavorting in a manner that suggests sexual intimacy.

In the nineteenth century, the fact that this painting was geared to an exclusively male heterosexual gaze was not subject to question. However, in the twentieth century, questioning the gaze became a significant gesture. Hence, Sylvia Sleigh showed in her *Turkish Bath* (1973) how the situation in Ingres's painting could be reversed by altering the gaze. She assumes a female voyeur who watches males who are depicted as naked, passive, almost emasculated, lounging creatures.

Thomas Eakins

One of the most important homoerotic bathing scenes is Thomas Eakins's *The Swimming Hole* (1883). Evoking a tradition of idyllic pastoral settings, the painting nevertheless strongly conveys homoeroticism.

Eakins, a disciple of poet Walt Whitman, regarded himself as a "scientific realist." He made photographic studies of his naked students at the Philadelphia Academy. Seemingly to concentrate on the anatomical, he used the freer photo studies as models for the more static painting, but his works suggest that a sexual interest may also have been an incentive.

The Eakins painting typifies the documentary strand of the bathing-scene genre. This approach allowed for ambivalent suggestions of the erotic under the guise of idyllic Neoclassicism, which could be regarded as instructive and therefore respectable.

Other painters and photographers who employed his approach include Peter Henry Emerson, Edward Weston, and Frank Meadow Sutcliffe. The latter's photograph "Water Rats" (1886), which depicts naked young boys who were paid a penny each to pose, caused a minor scandal with local clergy, who objected and threatened to excommunicate the artist.

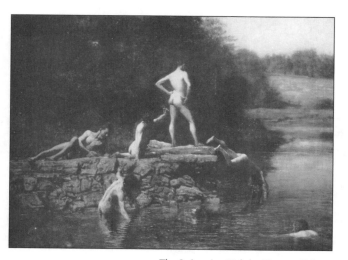

The Swimming Hole by Thomas Eakins.

Distinct Themes

Bathing scenes can show the vulnerability of a human body. Pierre Bonnard (1867–1947), for example, returned again and again to scenes of his wife Marthe floating loosely in the bathtub. Marthe suffered a malady that required long spells in the bath, reminding us that one of the most impressive bathtub scenes is *The Death of Marat* (1793) by Jacques-Louis David (1748–1825).

Marat too was obliged to spend time in the bath, providing the artist with a key moment, a time at which people are most vulnerable, thus adding a dramatic, nonerotic dimension to bathing scenes.

The Twentieth Century

In the twentieth century, bathing scenes painted by two members of the Bloomsbury group show two distinctly idiosyncratic approaches. Vanessa Bell's *Woman and a Tub* (1917) depicts a single introspective, self-absorbed female nude standing beside the bathtub and is not overtly erotic.

Duncan Grant's *Bathing* (1911), on the other hand, offers a lyrical, stylized view of the sequential motion of a male body in the act of swimming. Both artists in their way demonstrate a fresh approach to the subject.

Paul Cadmus's *The Bath* (1951), painted in egg tempera on wood panel, illustrates an approach both modern and retro. One figure on the left is looking in the mirror and the other one is seen bathing in the tub. Cadmus used Jack Fontan and Jensen Yow from among his circle of friends as models. It is a very formal, technically accomplished composition, yet it nevertheless conveys a slyly modern—and perhaps postcoital—feel to the homoerotic domesticity of its two male figures.

David Hockney

David Hockney has created some of the best-known homoerotic bathing scenes, especially in his depictions of Los Angeles swimming pools. *Two Boys in a Pool* (1965), for example, shows a stylized world of unabashed *plein air* nudity in bright Californian light. Although Hockney's style in these early works may seem flattened and impersonal, its static quality gives it a peculiar resonance.

Hockney's early work was heavily influenced by photography, especially images from Bob Mizer's *Physique Pictorial*. These photos particularly influenced Hockney's series of shower paintings and domestic scenes, which often highlighted the male backside as an area of particular interest.

Hockney also painted his lover Peter Schlesinger in the bathtub, continuing what is unquestionably a kind of portraiture with absolute intimacy and an enduring tradition in art.

— *Kieron Devlin*

BIBLIOGRAPHY

Cooper, Emmanuel. *The Sexual Perspective in Art: Homosexuality and Art in the Last 100 Years in the West.* London: Routledge Kegan Paul, 1986.

Ellenzweig, Allen. *The Homoerotic Photograph: Male Images from Durieu/Delacroix to Mapplethorpe.* New York: Columbia University Press, 1992.

Livingstone, Marco. *David Hockney.* London: Thames and Hudson, 1996.

Melville, Robert. *Erotic Art of the West.* New York: Putnam's, 1973.

Weiemair, Peter. *The Hidden Image: Photographs of the Male Nude in the Nineteenth and Twentieth Centuries.* Cambridge, Mass.: MIT Press, 1988.

SEE ALSO

Photography: Gay Male, Pre-Stonewall; Cadmus, Paul; Dürer, Albrecht; Eakins, Thomas; Grant, Duncan; Hockney, David; Subjects of the Visual Arts: Nude Females; Subjects of the Visual Arts: Nude Males

Subjects of the Visual Arts: Bicycles

BICYCLES, INTRODUCED IN EUROPE AROUND 1863, were the first democratic means of transportation. In practical terms, bicycles eliminated the reliance on the horse and buggy.

The golden age of bicycles came in the 1890s, and they were particularly fashionable in cosmopolitan cities such as New York, London, and Paris. Men smoked fewer cigars, wore cheaper suits, and forwent hats and shaves, while men and women read less and stopped regularly observing the Sabbath—all as a result of the bicycle craze.

During this golden age, campaigns were waged to encourage women to ride and, as a result, the bicycle became both a symbol and a means of women's liberation.

With the new transportation came a "rational dress" movement for women, who could not reasonably be expected to ride in full skirts, wearing the average of thirty-seven pounds of clothing that was common before the advent of the cycle. As a result of the cycling craze, bloomers in the 1880s at last became a viable fashion option for women, though feminists had pushed for years for their acceptance.

Another direct result of cycling's popularity was a rise in female athletes—cycle riding had proved that exercise was not detrimental to women as was commonly believed. However, women cyclists were criticized for abandoning their femininity and becoming "mannish" or "manly women."

In the United States, an image of singer Katie Lawrence appeared in men's clothing on the sheet music for the

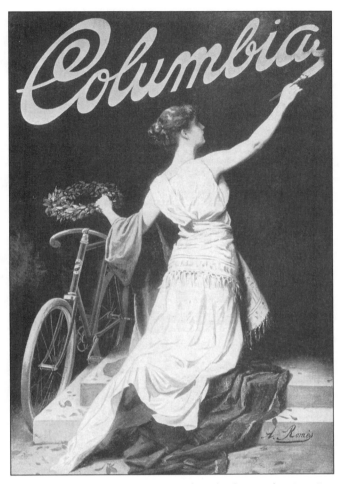

An advertisement for Columbia Bicycles circa 1893.

1892 popular song "Daisy Bell," a love song to a cycling woman about a bicycle built for two.

Bicycling was also associated with men's sexuality. In the late nineteenth century, popular-press cartoons often depicted weakened men having to assume women's household chores because women were busy being athletic, while men who lived in cities or led inactive lives were considered "effeminate." Cycling was advocated as a means through which they would recover their manhood.

In France, Art Nouveau advertisements for bicycles often included nude or otherwise liberated women; one ad from around 1899 for Liberator Cycles depicted a bare-breasted helmeted Amazonian warrior alongside her wheels, while another from around 1895 for Cottereau Cycles showed a woman astride her cycle while breast-feeding.

In Staten Island, New York, lesbian photographer Alice Austen often pictured her bloomer-wearing women friends astride their bikes. In what would be some of her only commercial work, Austen made the illustrations for Violet Ward's book *Bicycling for Ladies* (1896).

Many artists, including Czech Art Nouveau master Alphonse Mucha, created advertising posters for bicycles. Perhaps the most famous uses of bicycles in art are French artist Marcel Duchamp's 1913 "ready-made" sculpture *Bicycle Wheel*, made of a bicycle wheel and fork, and Pablo Picasso's 1943 assemblage *Bull's Head*, constructed with a handlebar and a bicycle seat.

— *Carla Williams*

BIBLIOGRAPHY

"Amazing Bikes: Two Centuries on Two Wheels": http://www.museumca.org/exhibit/exhib_amazing_bikes.html

Dodge, Pryor. *The Bicycle*. Paris and New York: Flammarion, 1996.

Marks, Patricia. *Bicycles, Bangs, and Bloomers: The New Woman in the Popular Press*. Lexington: University Press of Kentucky, 1990.

SEE ALSO

Austen, Alice; Duchamp, Marcel

Subjects of the Visual Arts: David and Jonathan

THE BIBLICAL NARRATIVE OF KING DAVID, CONTAINED in the First and Second Books of Samuel and the opening chapter of the First Book of Kings, invites the reader to visualize homoerotically the shepherd boy turned warrior and king.

The narrator volunteers that David is "ruddy, and withal of a beautiful countenance, and goodly to look to" (1 Sam. 16:12), a remarkable statement in that, apart from Absalom and the Bridegroom of The Song of Solomon, the Bible shows no interest in any other male character's physical beauty.

Emphasis is laid not on David's size or strength, but on his complexion and coloring, and on the fact that he has beautiful eyes; his power clearly lies in his youth and attractiveness.

What is more, in the only instance in the Bible that records the effect of a man's beauty on its beholders, David is repeatedly the object of other characters' visual scrutiny, the prophet Samuel satisfied that David's comeliness is proof that he is the chosen of Yahweh, while David's adversary on the battlefield, the Philistine giant Goliath, foolishly dismisses David as a pretty boy (1 Sam. 17:42).

It is not surprising, when the biblical narrative insists that David be looked at and admired, that he should emerge in Western art as the incarnation of male physical attractiveness, and that visual representations of his relationships with other men be regularly invested with homoerotic significance.

Michelangelo's David

The premier representation of David is Michelangelo's fourteen-foot-tall statue, completed in 1504. Sculpted from a piece of perfectly white marble, a physically mature David holds a slingshot in one hand and focuses his thoughts as he prepares to enter the fight against Goliath.

While David was presumably intended as a symbol of Florentine republican spirit (allegorically, the giant represents Tyranny), its colossal, uncompromising nudity and its perfection of physical form have made it an icon of male sexual attractiveness.

Michelangelo shrewdly uses biblical tradition to sanction the glorification of the naked male body, justifying a reassertion of Greco-Roman aesthetics under the guise of Christian homiletics.

Complaining that handsome men like himself are expected to do all the work in sex, television's Al Bundy offers as his most telling case in point, "You don't ask the statue of David to move a little." Bundy's comment indicates the extent to which Michelangelo's David has been absorbed by popular culture as the icon of male physical perfection, the statue itself capable of supplying erotic satisfaction to the viewer.

In *Fully Exposed*, Emmanuel Cooper prints John S. Barrington's "Jack Cooper Posing as 'David'" (ca. 1950), which presents the photographer's physical ideal in the pose of Michelangelo's statue, and Lea Andrews's eight-foot-tall photographic self-portrait as Michelangelo's David (1987), in which the statue's groin is superimposed over the model's in a challenge to culture's idealization of erotic reality. Both use Michelangelo's sculpture to comment upon contemporary social fashioning of masculinity.

Whether transformed into a set of refrigerator magnets that allow the statue's naked figure to be variously dressed as a surfer boy, football player, or leather punk, or appropriated to advertise everything from health insurance to amyl nitrate, Michelangelo's David has become one of Western culture's most visible sexual fetishes.

When film and opera director Franco Zeffirelli commissioned from Tom of Finland a contemporary recension of Michelangelo's David, the artist produced a figure with broader chest, more prominent nipples, and a genital endowment "at least quadruple the size of the one Michelangelo gave him. And…instead of wearing a frown of determination, Tom's David slyly peeks at the viewer as if to say, 'I know what you're looking at!'"

Even in the process of parodying Michelangelo's David, Tom of Finland reaffirms the Renaissance statue as an erotic, particularly homoerotic, ideal.

David and Saul

David's name in Hebrew means "beloved," and the ambivalent nature of his relations with Saul, Goliath, and Jonathan in the biblical narrative has invited repre-

sentation as well of his ability to arouse love or sexual desire in others.

By depicting Saul and David as two men in close contact wearing only jockstraps, for example, Robert Medley (b. 1905) not only comments upon the repressed homoerotic desire that possibly drove the older man alternately to persecute and then call to his side his attractive young rival, but also, by transferring their rivalry to the tennis or handball court, suggests the underlying homoeroticism of many contemporary competitive sports.

David and Goliath

Not surprisingly, David's defeat of Goliath has witnessed an iconographic transformation nearly as complex as that associated with Michelangelo's David. Because the Bible calls attention to Goliath's awareness of David's beauty, some readers speculate that Goliath was defeated by the sight of David's beauty rather than by the stone that the boy fired from his slingshot.

Donatello's famous bronze (ca. 1430–1440) presents David as a nude ephebe whose left foot stands triumphantly upon the severed head of his enemy. The ambisexual grace of the boy—coupled with the triumph of Cupid depicted on the defeated Philistine's helmet, and the curve of the helmet's plume along the inside of the naked boy's thigh, sinuously inching toward his buttocks—suggests a celebration of pederastic love.

Donatello's supposed representation of himself as Goliath initiated a tradition in which a homosexual artist depicts himself as the defeated giant, and his male beloved as the beautiful, victorious boy.

Caravaggio, for example, painted three versions of David with the head of Goliath, suggesting an obsession with the motif. In *David II* (ca. 1606, Galleria Borghese), Caravaggio's lover Cecco Boneri posed as David, whose loosely fastened trousers call attention to his crotch, and whose sharply angled sword suggests sexual violence; the head of Goliath that the boy holds at arm length is clearly the artist's self-portrait.

Paul Cadmus's *Study for a David and Goliath* (1971) offers a playful variation upon this iconographic tradition, presenting a domestic scene in which Cadmus sits on the floor drawing, his back supported by the bed on which his lover, Jon Andersson, partly reclines.

The T square that the naked Andersson holds to help the artist in his work becomes a sword, while the red scarf around Cadmus's neck suggests the bloody severing of the artist's/Goliath's head from his body.

Andersson, a dancer by profession, whose perfectly muscled body Cadmus repeatedly drew in the course of their long partnership, grins malevolently at the viewer, possibly suggesting—in biographer David Leddick's words—"how beauty can undo the importance of art in an artist's life."

The Representation of David and the Artist's Sexual Orientation

Like the story of martyred St. Sebastian, the narrative of David's victory over Goliath provided biblical justification for the representation of naked male beauty of which numerous Renaissance artists, both gay and straight, availed themselves.

Too sensuous a representation of naked David, however, has proved enough to raise questions regarding an artist's sexual orientation, as in the cases of Aubin Vouet's depiction of an androgynous boy in *David Holding the Head of Goliath* (ca. 1622–1626, Bordeaux) and Guido Reni's *David Contemplating the Head of Goliath* (ca. 1605, Louvre).

In the latter, the teenaged boy's sensuality is emphasized by the rich fur draped across his torso, and by the unnecessarily jaunty plume in his fashionable cap. The head of Reni's Goliath is apparently a portrait of the artist's professional rival, Caravaggio, suggesting that the painting may be a comment upon what contemporaries perceived to be the sexual irregularities of Caravaggio's life.

Indeed, throughout the history of the motif, the severed head of the boy's adult male admirer suggests the danger of the gaze, whether biblically authorized or not, that David's naked beauty invites, making the motif one of the most psychologically complex in the history of the representation of desire.

David and Jonathan

Finally, the biblical narrative's emphasis upon David's relationship with Jonathan, the son of David's predecessor, Saul, adds another homoerotic dimension to his representation. "The soul of Jonathan was knit with the soul of David," the narrator records, "and Jonathan loved him as his own soul" (1 Sam. 18:1).

Later, when Saul's murderous jealousy causes his young rival to flee the court, the two friends suffer a poignant parting at which "they kissed one another, and wept one with another, until David exceeded" (1 Sam. 20:41).

Jonathan's death alongside his father in battle with the Philistines occasions from David this powerful lament: "The beauty of Israel is slain upon the high places; how are the mighty fallen!... I am very distressed for thee, my brother Jonathan; very pleasant hast thou been unto me: thy love was wonderful, passing the love of women" (2 Sam. 1:19–26).

In the Middle Ages, David and Jonathan's embrace became the Christian icon of male friendship, figuratively related to Jesus' sitting with the head of John, his beloved, laid against his chest. Numerous medieval manuscript illuminations depict them embracing or exchanging what was typologically considered to be the Christian kiss of peace, as for example in the early-fourteenth-century French *Somme le roi* (reproduced in Saslow).

But in the light of the biblical narrative's repeated emphasis upon David and Jonathan's emotionally expansive and physically intimate relationship, the homoerotic possibility of such an embrace is impossible to discount, the viewer of such illustrations not always certain what he or she sees.

In 1983, the San Francisco chapter of Dignity celebrated its tenth anniversary by printing a poster-sized imitation of what appears to be a seventeenth-century Russian icon of David and Jonathan embracing, the organization's name providing an interpretive context that medieval manuscripts otherwise lack.

An even more telling example of such interpretive ambiguity is Sir Frederic Leighton's *Jonathan's Token to David*, exhibited at the Royal Academy in 1868, which depicts the incident narrated in 1 Samuel 20 wherein, by the ruse of practicing archery with a servant boy, Jonathan alerts the outlaw David of the need to flee the murderous wrath of King Saul.

In *The Sexual Perspective*, Emmanuel Cooper analyzes the homoerotic appeal of Leighton's Jonathan (who, significantly, repeats the pose of Michelangelo's David) and his servant boy, but fails to note that Jonathan's wistful gaze is directed off the canvas, presumably toward the retreating David, whom Jonathan understands he will never see again.

The biblical narrative notes that "the lad" who waited on Jonathan and was essential to the lovers' stratagem "knew not anything: only Jonathan and David knew the matter" (1 Sam. 20:39), making him an excellent stand-in for the naive viewer: a witness to—yet oblivious of—the homoerotic drama of Leighton's painting and of so many other homoerotically suggestive representations of David in art.

Gay Composers

David's story, especially his lament for Jonathan following the latter's death in battle, has proved an inspiration to gay composers as well. In his autobiography, *Knowing When to Stop* (1994), composer Ned Rorem reports that in 1947, when he dared to set the lament to music, a classmate at New York's prestigious Juilliard School warned him that "the 'gay' text (young David bewailing to Jonathan: 'Thy love to me was wonderful, passing the love of women') would outrage the faculty."

And, after failing to engage first Igor Stravinsky and later Erik Satie as his collaborator on a ballet titled *David*, Jean Cocteau printed a David and Goliath drawing on the cover of the inaugural issue of *Le Mot* (1914).

Shortly before his death in 1990, Leonard Bernstein began what he described in his working papers as an opera on the "Saul, David, Jonathan Triangle" that would hinge "upon suggestions, lightly done," of both the father's and the son's sexual attraction to David.

According to biographer Humphrey Burton, Bernstein "even drafted the dialogue for a full-blown love scene between David and Jonathan." Like so many of Bernstein's other projects in his last years, however, the opera was not completed.

It would be more than ten years before gay audiences could hear a biblically inspired oratorio on the subject of homosexual love: On May 30, 2001, the Gay Gotham Chorus, in conjunction with the Cosmopolitan Symphony Orchestra, premiered a choral version of Stefan Weisman's 1996 epic poem, *David and Jonathan*, which applies to his lover, Jonathan, David's line in the Psalter: "Of all men you are the most handsome, your lips are moist with grace."

— *Raymond-Jean Frontain*

BIBLIOGRAPHY

Burton, Humphrey. *Leonard Bernstein*. New York: Doubleday, 1994.

Cooper, Emmanuel. *Fully Exposed: The Male Nude in Photography*. 2nd ed. London: Routledge, 1995.

———.*The Sexual Perspective: Homosexuality and Art in the Last 100 Years in the West*. 2nd ed. London: Routledge, 1994.

Hooven, F. Valentine, III. *Tom of Finland: His Life and Times*. New York: St. Martin's Press, 1993.

Leddick, David. *Intimate Companions: A Triography of George Platt Lynes, Paul Cadmus, Lincoln Kirstein, and Their Circle*. New York: St. Martin's Press, 2000.

Saslow, James M. *Pictures and Passions: A History of Homosexuality in the Visual Arts*. New York: Viking, 1999.

Schneider, Laurie. "Donatello's Bronze David." *Art Bulletin* 55 (June 1973): 213–216.

Seymour, Gayle M. "Simeon Solomon and the Biblical Construction of Marginal Identity in Victorian England." *Reclaiming the Sacred: The Bible in Gay and Lesbian Culture*. Raymond-Jean Frontain, ed. New York: Harrington Park Press, 1997. 97–119.

SEE ALSO

European Art: Renaissance; Cadmus, Paul; Caravaggio; Donatello; Michelangelo Buonarroti; Subjects of the Visual Arts: Nude Males; Tom of Finland

Subjects of the Visual Arts: Diana

THE GREEK ARTEMIS, OR ROMAN DIANA, IS THE GODDESS of chastity. She exemplifies and protects virginity, and for married women she models strict avoidance of adultery.

Protectress of the hunt, Diana is pictured amid her attendant nymphs in a landscape, or resting at a secluded pool. In the latter case, her nymphs lovingly care for her body, removing clothing, drying her after the bath, and generally enacting a considerable degree of physical intimacy. Sometimes, voyeuristic Actaeon disrupts them, in

which case concerted attempts to hide their nakedness can result in them touching each other in erotic ways.

Diana, guardian of purity, is also pictured fighting Venus, goddess of sex and desire, or with her followers resisting lascivious satyrs. Diana is a militant enforcer of same-sex seclusion among women.

One of the most popular tales concerns the nymph Callisto. Jupiter lusted after this devoted member of Diana's band, and he managed to seduce her by taking on the disguise of Diana herself. Callisto thus experienced what she thought was her mistress kissing her "not modestly, nor as a maiden kisses" (Ovid, *Metamorphoses* 2:401–507; *Fasti* 2:153–192).

She resisted only after Jupiter went further and embraced her so that she realized the body was masculine. Subsequently raped and pregnant, the ashamed maiden tried to hide her state but was eventually discovered when she disrobed at the pool. The pregnancy was taken as a betrayal of the vows of chastity, and Diana angrily expelled Callisto.

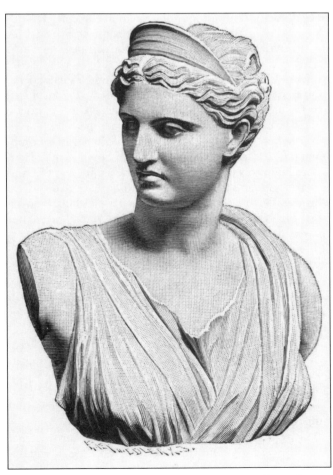

An engraving of a classical bust of Diana.

Images of the seduction, in prints or as paintings, often depicted two female figures in close contact. For example, the episode decorated a lunette when the cycle of Callisto's myth was chosen in the 1540s for the bathing suite of the French king Francis I. Primaticcio's now-lost wall painting of Callisto being kissed and fondled by "Diana" is recorded in Pierre Milan's contemporary engraving.

Domestic objects and paintings in women's chambers upheld Diana and her all-female associations as exemplary models. Women like queen Christina of Sweden or the seventeenth-century writer Mlle de Scudéry represented themselves as Diana, surrounded by women, loving Callisto. Lower-class women branded as "witches" sometimes gathered in Diana's name.

— *Patricia Simons*

BIBLIOGRAPHY

Reid, Jane Davidson. *The Oxford Guide to Classical Mythology in the Arts, 1300–1990s.* 2 vols. New York: Oxford University Press, 1993.

Simons, Patricia. "Lesbian (In)Visibility in Italian Renaissance Culture: Diana and Other Cases of donna con donna." *Journal of Homosexuality* 27 (1994): 81–122. Reprinted in *Gay and Lesbian Studies in Art History.* Whitney Davis, ed. New York: Haworth Press, 1994. 81–122.

Traub, Valerie. "The Perversion of 'Lesbian' Desire.'" *History Workshop Journal* 41 (Spring 1996): 23–49.

SEE ALSO

Classical Art; European Art: Renaissance

Subjects of the Visual Arts: Dildos

WOMEN WITH DILDOS ARE REPRESENTED IN MANY cultures (for example, Japan and Mughal India), but to date we know most about their representation in Europe.

The ancient Greeks displayed a *phallos* during certain religious rituals. Women could be in charge of this cult object, and the legend of Isis credited that goddess with inventing it. The Greeks also had specific words for a dildo (*olisbos* or *baubon*). Sappho may refer to "receivers of the *olisbos*" (Fragment 99.5); Aristophanes' comedy *Lysistrata* speaks of women satisfied by the leather devices.

Vase paintings depict women, primarily alone, putting dildos to sexual use. One instance may show a woman with a strapped-on dildo about to enter a woman from the rear. Another strap-on is probably present in a damaged painting from a Pompeian bathhouse.

A few medieval manuscripts show women plucking "fruits" from a phallus tree. For centuries, Catholic penitentials condemned women who possessed "instruments."

By the fourteenth century, secular writers such as Boccaccio and Sercambi envisaged women wielding them either alone or with each other, and in 1534 Aretino's orgy set in a nunnery had novices using glass dildos (*Ragionamento* I). A decade or so earlier, an engraving by Marcantonio Raimondi pictured a standing nymph calmly penetrating herself with one.

During the sixteenth and seventeenth centuries, court gossip in France and England mentioned women owning what was frequently represented as a salacious import. The English word "dildo" is first recorded around 1592, in a poem by John Nashe. John Donne in his licentious elegies also refers to dildos. In the eighteenth century, Fuseli drew a woman wearing one, while pornographic hacks pictured ladies openly shopping for dildos.

Whether in Renaissance carnival songs or modern pornographic photographs, the dildo is most frequently represented by way of humorous "phallic symbols" such as vegetables or bottles.

So-called phallic substitutes might be regarded as threatening in misogynist polemic, but comments in other genres such as comedy and fields such as medicine indicate more complex attitudes. Notably, Greek satyrs or male youths are occasionally shown with dildos, and men brandish them in some pornography.

Today, sex toys are parodied (for example, by the lesbian cartoonist Alison Bechdel)—and sold to people with a wide variety of sexual interests. Lesbian theorists discuss appropriation of an object that does not have to be seen as inherently masculine. — *Patricia Simons*

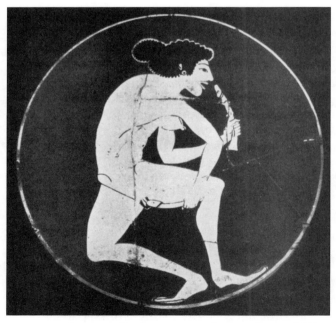

An ancient Greek vase painting depicting the use of dildos.

BIBLIOGRAPHY

Butler, Judith. "The Lesbian Phallus and the Morphological Imaginary." *differences* 4 (Spring 1992): 133–171.

Clarke, John R. *Looking at Lovemaking. Constructions of Sexuality in Roman Art 100 B.C.–A.D. 250.* Berkeley: University of California Press, 1998.

Findlay, Heather. "Freud's 'Fetishism' and the Lesbian Dildo Debates." *Feminist Studies* 18 (Fall 1992): 563–579.

Kilmer, Martin F. *Greek Erotica on Attic Red-Figure Vases.* London: Duckworth, 1993.

SEE ALSO

Classical Art; European Art: Medieval; European Art: Renaissance; Fuseli, Henry

Subjects of the Visual Arts: Dionysus

ONE OF THE TWELVE GREAT OLYMPIAN GODS, DIONYSUS is the Greek god of wine, revelry, and orgiastic delights. His Roman counterpart is Bacchus. His name appears as early as the second millennium B.C.E. as a fertility deity, but his popularity and association with wine and the harvest date from about the eighth century B.C.E., when the first theatrical productions were held each year in his honor.

Dionysus was the son of the chief god Zeus and the mortal Semele. In a jealous rage, Zeus's wife, Hera, tricked Semele into asking Zeus to reveal himself in his divine state. The epiphany was so overpowering that it killed her.

Zeus rescued Semele's unborn child from her womb, however, and implanted him into his own thigh, from where Dionysus was born. He was raised by nymphs and disguised in women's clothing to hide him from Hera. This dual birth of both man and woman and his wearing of women's clothes made him a patron god of hermaphrodites and transvestites.

Three Homeric hymns are dedicated to Dionysus, one of them telling how he was kidnapped by pirates who mistook him for a prince. When they refused to let him go, Dionysus transformed the ship into a vineyard, turned himself into a lion, ate the captain, and changed all of the sailors into dolphins.

Dionysus spared only one sailor, because he had recognized Dionysus as a god and pleaded with his mates to release him. Later myths name this sailor Acoetes and claim he was Dionysus's lover and his first high priest.

Nonnus's *Dionysiaca* names the Phyrigian boy Ampelos as Dionysus's first lover. When the boy was killed by a bull, the god transformed him into a vine.

Followers of Dionysus often took part in the Bacchanalia, a frenzied festival that incorporated wine with dancing and sexual activity. The animalistic instinct

associated with the Bacchanalia empowered his women followers, known as Maenads, who in their release from sanity and inhibitions allegedly would tear apart animals or children and devour the raw flesh.

Such is the case in the fifth-century B.C.E. play *The Bacchae*, by Euripides. Pentheus has the stranger Dionysus arrested for impropriety, but when the god manages to tempt the king to don women's clothes and spy on the Maenads, they attack him and tear his body apart.

This complete release of all sense of morality and social mores in favor of animalistic instincts eventually gave rise to the characterological concept "Dionysian," in contrast to "Apollonian," or rational and logical. The Dionysian individual values feeling more than intellect and emotion more than rationality.

Early Greek pottery depicts Dionysus as a bearded man, but by the fifth century B.C.E., he appears as a beautiful youth. He is usually seen holding a thyrsus, a spear with a large pinecone at the tip, and wearing a grapevine on his head and leopard skin around his body. His followers include sexually charged creatures such as the god Pan, satyrs, nymphs, and fauns.

Dionysus has been extremely popular as a subject in Western art. *The Oxford Guide to Classical Mythology in the Arts, 1300–1990s* cites about 600 visual works of art depicting Dionysus or a Bacchanalia festival.

Around 1496, the young Michelangelo carved in marble a homoerotic Dionysus as a nude drunken youth. Titian continued the Renaissance image of the youth in his painting *Bacchus and Ariadne* (ca. 1523), where the god is caught midrapture by the beautiful Ariadne.

About 1595, Caravaggio painted Bacchus in one of the first Baroque paintings, using the god of wine to tempt the viewer, drawing him into the painting by offering him a glass of wine. This Bacchus is a seductive youth whose robe slides off his shoulder, revealing his bare chest.

Interestingly, however, Caravaggio later painted another version of Bacchus that depicts the god as a shriveled, sickly figure victimized by alcohol. This portrayal of the god as an ugly creature continued during the Baroque period, with artists seemingly merging him with another Dionysian figure, Silenus, a fat drunken man who rides a donkey.

In the nineteenth century, the English artist Simeon Solomon painted at least three versions of Dionysus, the first of which is now lost. An exquisite 1867 oil portrait of Bacchus's face reveals Titian's influence on the artist, but his 1866 watercolor of the same subject is homoerotic in its depiction of a partially nude Bacchus holding the phallic thyrsus in his hand.

— *Roberto C. Ferrari*

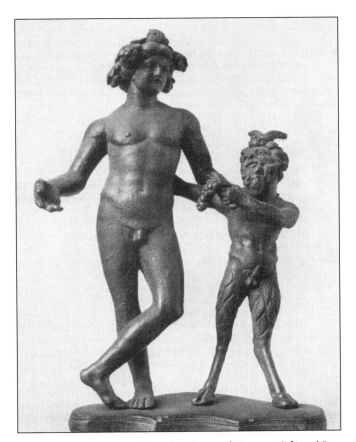

A classical sculpture of Dionysus (left) and Pan.

BIBLIOGRAPHY

Bremmer, Jan N. "Transvestite Dionysos." *Rites of Passage in Ancient Greece: Literature, Religion, Society.* Mark W. Padilla, ed. Lewisburg, Penn.: Bucknell University Press, 1999. 183–200.

Csapo, Eric. "Riding the Phallus for Dionysus: Iconology, Ritual, and Gender-role De/Construction." *Phoenix* 51.3–4 (1997): 253–295 + 8 pages of plates.

Evans, Arthur. *The God of Ecstasy: Sex-Roles and the Madness of Dionysos.* New York: St. Martin's Press, 1988.

Reid, Jane Davidson. "Dionysus." *The Oxford Guide to Classical Mythology in the Arts, 1300–1990s.* New York: Oxford University Press, 1993. 2:258–271, 348–369.

SEE ALSO

Classical Art; European Art: Renaissance; European Art: Baroque; European Art: Nineteenth Century; Caravaggio; Michelangelo Buonarroti; Solomon, Simeon

Subjects of the Visual Arts: Endymion

IN CLASSICAL MYTHOLOGY, ENDYMION WAS A HANDSOME young shepherd (sometimes a king) from Elis or Caria. Selene (Phoebe, Artemis, Diana), the moon goddess, fell in love with him and consequently neglected her lunar responsibilities.

As a result, Zeus offered Endymion a choice: death in whatever way he preferred, or eternal sleep with perpetual youth. Endymion chose the latter. He slept in a cave on Mount Latmus, where Selene continued to visit him.

The Greek poet Licymnius of Chios, however, suggests that it was the god Hypnos (Sleep) who loved Endymion and lulled him to sleep with his eyes open so that the god might forever gaze into them.

Endymion was represented in ancient art as recumbent, usually nude or seminude, asleep, with one arm crooked behind his head. This motif appears commonly on sarcophagi of the Roman Empire. In the funerary context, the presence of Endymion suggests the possibility of a dreamlike existence beyond death.

In domestic paintings and mosaics, the figure of Endymion is primarily erotic and represents not only male physical beauty, but also youthful innocence and sexual accessibility.

Numerous post-Classical artists painted the story of Endymion—for example, Titian (ca. 1508), Tintoretto (ca. 1575–1580), Poussin (ca. 1630), Rubens (ca. 1636), van Loo (1731), and Fragonard (ca. 1753–1755).

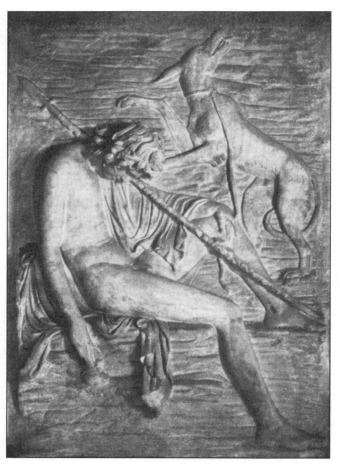

An ancient marble frieze depicting Endymion.

Most notable is *Endymion Asleep* (1793), by Anne-Louis Girodet, who captured not only the subtle effect of moonlight, but also the utter passivity of the supine Endymion.

In Jungian psychology, Endymion exemplifies the *puer aeternus* (eternal youth), ageless, timeless, and fragilely connected to the invisible world, yet—at the same time—narcissistic, phallic, effeminate, and pensive.

Homoerotic photographers have evoked these "Endymion" qualities in numerous untitled compositions—luminous dreamboys, forever young and eternally available. A titled example is George Platt Lynes's "Endymion and Selene" (ca. 1939).

— *Martin D. Snyder*

BIBLIOGRAPHY

Crow, Thomas, *Emulation: Making Artists for Revolutionary France.* New Haven and London: Yale University Press, 1995.

Hillman, James, ed. *Puer Papers.* Dallas: Spring Publications, 1980.

Koortbojian, Michael. *Myth, Meaning and Memory on Roman Sarcophagi.* Berkeley: University of California Press, 1995.

Leddick, David. *George Platt Lynes.* Cologne: Taschen, 2000.

Mayerson, Philip. *Classical Mythology in Literature, Art, and Music.* Glenview, Ill.: Scott, Foresman and Company, 1971.

SEE ALSO

Classical Art; European Art: Renaissance; European Art: Neoclassicism; European Art: Nineteenth Century; Photography: Gay Male, Pre-Stonewall; Girodet-Trioson, Anne-Louis; Lynes, George Platt

Subjects of the Visual Arts: Ganymede

GANYMEDE, A PHRYGIAN SHEPHERD OR HUNTER, WAS the son of Tros, the legendary king of Troy. Taken with his remarkable beauty, Jupiter abducted the youth to serve as cupbearer to the Olympian gods.

In some literary versions of the story, such as Ovid's *Metamorphoses* (10:152–161), Jupiter transforms himself into an eagle to snatch the youth from earth; while in others, such as Virgil's *Aeneid* (5:252–257), Jupiter sends an eagle to fetch the boy.

In art, Ganymede is most often depicted with the eagle and is sometimes accompanied by a dog.

Since antiquity, Ganymede has served as an artistic expression for homosexuality. The ancient popularity of the homoerotic myth is apparent from the frequent vase depictions of Jupiter giving Ganymede a cockerel, a common gift to youths from older male admirers. The theme also appears in ancient statuary, where Jupiter lovingly embraces the Phrygian youth.

The myth becomes less common in the Middle Ages, but still occurs in literature, manuscript illumination, and sculptural decoration as a subject of censure, warning viewers not to follow the sinful ways of the pagan immortals.

In the Renaissance, the figure recovers its earlier popularity through the Italian humanists. While they sometimes turn the myth into an allegory of the soul's ascent toward Heaven, as in Alciati's *Emblemata*, it most often serves as a symbol of male homosexuality, particularly of pederasty, the love of an older man for a youth.

Ganymede's homoerotic tradition flourishes at this time in the art of Michelangelo, Correggio, Parmigianino, and Giulio Romano.

However, by the mid-sixteenth century, reformers in the Catholic Church begin to frown upon mythology and nudity in art. As a consequence, Ganymede's popularity begins to wane. There are depictions of the youth in seventeenth-century Italian art, such as Annibale Carracci's *Rape of Ganymede* (1596–1600) and Pietro da Cortona's *Planetary Rooms* (1641), but they appear with less frequency and most lack any homoerotic charge.

While Ganymede also appears in Dutch and English art of the time, in such works as Rembrandt's *The Rape of Ganymede* (1635), Rubens's *Rape of Ganymede* (1635), and Inigo Jones's *Coelum Brittanicum* (1634), and continues to be depicted in French art into the early nineteenth century, the allegory never again attains the notoriety it enjoyed in sixteenth-century Italy. — *Peter R. Griffith*

BIBLIOGRAPHY

Barkan, Leonard. *Transforming Passion: Ganymede and the Erotics of Humanism.* Stanford, Calif.: Stanford University Press, 1991.

Forsyth, Ilene H. "The Ganymede Capital at Vézelay." *Gesta* 15 (1976): 241–246.

Kempter, Gerda. *Ganymed: Studien zur Typologie, Ikonographie und Ikonologie.* Cologne: Böhlau Verlag, 1980.

Panofsky, Erwin. *Studies in Iconology.* New York: Harper & Row, 1972.

Russell, Margarita. "The Iconography of Rembrandt's Rape of Ganymede." *Simiolus* 9 (1977): 5–18.

Saslow, James. *Ganymede in the Renaissance.* New Haven: Yale University Press, 1986.

Worley, Michael Preston. "The Image of Ganymede in France, 1730–1820: The Survival of a Homoerotic Myth." *Art Bulletin* 76 (1994): 630–643.

SEE ALSO

Classical Art; European Art: Renaissance; Michelangelo Buonarroti; Parmigianino (Francesco Mazzola)

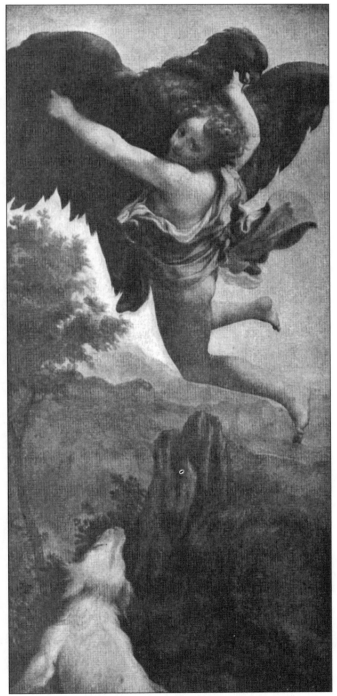

The Abduction of Ganymede by Correggio.

Subjects of the Visual Arts: Harmodius and Aristogeiton *(Sixth Century–514 B.C.E.)*

ATHENIAN LOVERS HARMODIUS (ALTERNATIVELY TRANS-literated as Harmodios) and Aristogeiton (Aristogiton) were remembered in ancient Greece as the great tyrannicides.

Aristogeiton resented the advances made by Hipparchus, the brother of the reigning tyrant, Hippias, toward his friend Harmodius. Rebuffed, Hipparchus insulted Aristogeiton's sister and forbade her to take part

in the Panathenaic Procession, thus disparaging her virginity and questioning her marriageability.

Provoked by this personal quarrel, the two friends planned to assassinate the two brothers. At the Greater Panathenaea festival in 514 B.C.E., Hipparchus was stabbed, but Hippias was not hurt. Harmodius was killed on the spot, and Aristogeiton was executed under torture.

After Hippias's expulsion in 510 B.C.E., Harmodius and Aristogeiton were made heroes of Athens, celebrated as patriots, democrats, lovers, and martyrs. Two public statues (the first pillars to commemorate mortal benefactors), created by Antenor, were erected in the agora; *skolia* (drinking songs) celebrated their courage; coins were struck with their image; a law forbade speaking ill of the couple; their descendants were given hereditary privileges, such as *sitesis* (the right to take meals at public expense in the town hall), *ateleia* (exemption from liturgies), and *proedria* (front-row seats in the theater); and their names were prohibited for slaves.

One *skolion* proclaims: "I will carry my sword in a myrtle bough / Just like Harmodios and Aristogeiton / When they killed the tyrant / And made Athens a place of equality under the law." The two lovers are thus presented as a model of *isonomia*, of political equality and responsible rulership.

Thucydides (who, together with Herodotus and Aristotle, is our main source for details about the lives of the couple, who nevertheless remain rather shadowy) stresses the lovers' *eros* time and again, thus linking erotics and politics.

It may also be significant that Harmodius and Aristogeiton, one aristocratic and the other lower in rank, bridged class barriers, representing a particularly democratic mode of sexuality, which was later to be celebrated by such English gay writers as Edward Carpenter and E. M. Forster.

Pausanias, in Plato's *Symposium*, celebrates Harmodius and Aristogeiton as an example of how *eros* can foster idealism. For them, the pursuit of freedom (at least in terms of Athenian ideology) was more important than their life. And in the *Republic*, Plato, again alluding to the famous couple, proposes that the ideal philosopher subdues tyrants, liberates the city, and founds a just regime for all citizens—all because of his erotic attachment to truth.

After Xerxes stole Antenor's statues during the Persian Wars, in 480 B.C.E. (returned about 150 years later, probably by Alexander the Great), a second statue group in bronze was erected by Kritios and Nesiotes. In this group, Aristogeiton, the *erastes* or lover, appears mature, steady, and older, while Harmodius, the *eromenos* or beloved, is young, bold, and eager. As customary, both stand in the nude.

As Sara Monoson notes, "their postures are similar, and the composition employs a large number of parallel axes, giving the impression that their movements are choreographed: they are depicted acting in concert, as a unity." The two lovers thus invite comparison to, identification with, and emulation of the Greek pederastic ideal, a homoerotic bond to savor for Greek boys and men alike.

In addition to depiction in art, the couple has also been celebrated in Western literature. For example, Montaigne, in his *Essays*, expresses his love for Etienne de la Boétie by evoking the famous pair (1580–1595); Lord Byron pays tribute to the heroes in *Childe Harold's Pilgrimage* (1812–1818); A. C. Swinburne in "Athens: An Ode" (1882); Edgar Allan Poe in "Hymn to Aristogeiton and Harmodius" (1827); H. D. (Hilda Doolittle) in "Myrtle Bough" (1927); and Mary Renault in *The Praise Singer* (1978). Less flatteringly, even Hitler and Stalin appropriated the two for Nazi and Communist propaganda.

Harmodius and Aristogeiton stand in a long line of homoerotic couples celebrated in the ancient world: Zeus and Ganymede, Apollo and Hyacinthus, Hercules and Hylas, Achilles and Patroclus, Orestes and Pylades, David and Jonathan, Gilgamesh and Enkidu, Nisus and Euryalus, Hadrian and Antinous, and Castor and Pollux. On them is based a founding myth that homoerotic love conquers all.

— *Nikolai Endres*

BIBLIOGRAPHY

Dover, Kenneth J. *Greek Homosexuality*. Updated and with a new postscript. Cambridge, Mass.: Harvard University Press, 1989.

Hubbard, Thomas K., ed. *Homosexuality in Greece and Rome: A Sourcebook of Basic Documents*. Berkeley: University of California Press, 2003.

Ludwig, Paul W. *Eros and Polis: Desire and Community in Greek Political Theory*. Cambridge: Cambridge University Press, 2002.

Monoson, S. Sara. *Plato's Democratic Entanglements: Athenian Politics and the Practice of Philosophy*. Princeton, N. J.: Princeton University Press, 2000.

Percy, William Armstrong III. *Pederasty and Pedagogy in Archaic Greece*. Urbana and Chicago: University of Illinois Press, 1996.

Stewart, Andrew. *Art, Desire, and the Body in Ancient Greece*. New York: Cambridge University Press, 1997.

Taylor, Michael W. *The Tyrant Slayers: The Heroic Image in Fifth Century B. C. Athenian Art and Politics*. 2nd ed. Salem, N. H.: Ayer, 1991.

Wohl, Victoria. "The Eros of Alcibiades." *Classical Antiquity* 18 (Oct. 1999): 349–85.

SEE ALSO

Classical Art; Subjects of the Visual Arts: Nude Males

Subjects of the Visual Arts: Hercules

HERCULES IS AN EXEMPLARY HERO, PERSONIFYING bravery, fortitude, and strength. His myths are a reminder that such a supreme manifestation of virility and physicality can also encompass sexual deeds outside the heteronormative.

Hercules is complex and multivalent. He was dual by birth, fathered by Jupiter with the mortal Alcmene. His feats thus had a godlike quality, and apotheosis after death ensured his place on Olympus.

But his path was far from smooth, and he especially suffered bouts of madness. After murdering his children, Hercules undertook Twelve Labors as penance. These and other feats came to stand for moral triumph as well as physical victory.

In the Greek tradition, according to Nicole Loraux, his insanity and painful death "constitutes a means of experiencing femininity in his body."

One of his exploits particularly enabled depiction of close physical contact with another male body. The giant Antaeus drew his strength from Mother Earth and thus was defeated when Hercules wrestled him off the ground.

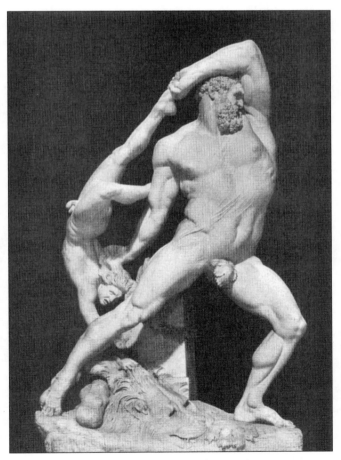

Hercules and Antaeus by Antonio Canova.

Many artists—such as Mantegna and Michelangelo—enjoyed the challenge of representing two naked, muscular, male bodies grappling at close quarters.

Usually, Hercules lifted Antaeus up so that the giant's buttocks were near or touching the hero's genitals. Sometimes, Hercules stood directly behind the elevated giant.

Intimations of sodomy are especially clear in a Florentine "Picture Chronicle" attributed to Maso Finiguerra or the workshop of his pupil Baccio Baldini, and dated to the 1460s or early 1470s (British Museum). The entwined couple of a beardless youth and a mature adult seem to share the same torso. Conquered Antaeus is in the throes of orgasmic "death."

Alongside his heroic exploits, Hercules was a man given to pleasures. He had several affairs with women, but was most often pictured with a Lydian queen, Omphale. As her slave and lover, Hercules cross-dressed and took up spinning. Images of this effeminized Hercules illustrated the adage Love conquers all.

But Greek legend also claimed that Hercules loved the golden-haired youth Hylas. Poliziano's *Orpheus*, first staged in 1480, has its chief protagonist repudiate women and praise male-only love since it is practiced by the gods: "To this holy love did Hercules concede."

— *Patricia Simons*

BIBLIOGRAPHY

Loraux, Nicole. "Herakles: The Super-male and the Feminine." *Before Sexuality: The Construction of Erotic Experience in the Ancient Greek World.* David M. Halperin, John J. Winkler, and Froma Zeitlin, eds. Princeton, N. J.: Princeton University Press, 1990. 21–52.

Reid, Jane Davidson. *The Oxford Guide to Classical Mythology in the Arts, 1300–1990s.* 2 vols. New York: Oxford University Press, 1993.

SEE ALSO

Classical Art; European Art: Renaissance; Michelangelo Buonarroti

Subjects of the Visual Arts: Hermaphrodites

IN CLASSICAL MYTHOLOGY, THE NYMPH SALMACIS LOVED the handsome but unresponsive Hermaphroditus, son of Hermes and Aphrodite. When he bathed in her spring, she forcibly embraced him. As Hermaphroditus struggled to free himself, Salmacis prayed that they never part. The gods granted her wish, and the two became a single being with both male and female sexual characteristics. (Ovid, *Metamorphoses*, 4.285.)

In ancient art, Hermaphroditus, either specifically or as a generalized type, is a common subject. He is either nude or lifts his garment to expose his genitals; alternatively, a satyr, who mistakes him for a woman, assaults him.

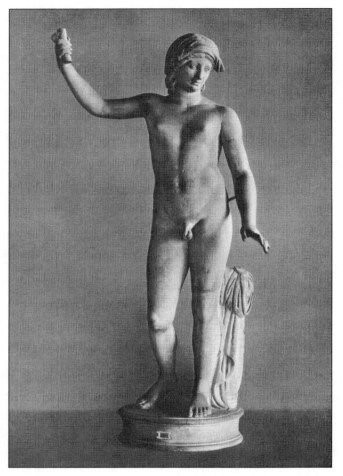

A classical sculpture of a hermaphrodite.

Since the Renaissance, hermaphrodites have most commonly been depicted as medical anomalies or sideshow freaks. However, contemporary scholars, such as Anne Fausto-Sterling, have demonstrated that hermaphrodites represent a naturally occurring alternative to the rigid designation of sex as exclusively male or female.

This new appreciation of hermaphrodites has affected the visual arts. See, for example, the notion of hermaphroditic architecture in Günther Feuerstein's *Androgynos* and the treatment of transsexuality in Charles Moffat's paintings *Archive XIV: The Hermaphroditus/Salmacis Series.* — *Martin D. Snyder*

BIBLIOGRAPHY

Ajootian, Aileen. "The Only Happy Couple: Hermaphrodites and Gender." *Naked Truths: Women, Sexuality, and Gender in Classical Art and Archaeology.* Ann Olga Koloski-Ostrow and Claire L. Lyons, eds. London: Routledge, 1997. 220–242.

Clarke, John R. *Looking at Lovemaking: Constructions of Sexuality in Roman Art 100 B.C.–A.D. 250.* Berkeley: University of California Press, 1998.

Fausto-Sterling, Anne. *Sexing the Body: Gender Politics and the Construction of Sexuality.* New York: Basic Books, 2000.

Gilbert, Ruth. *Early Modern Hermaphrodites: Sex and Other Stories.* New York: Palgrave, 2002.

Raehs, Andrea. *Zur Ikonographie des Hermaphroditen: Begriff und Problem von Hermaphrodismus und Androgynie in der Kunst.* Frankfurt: P. Lang, 1990.

SEE ALSO

Classical Art; European Art: Renaissance; European Art: Neoclassicism; Subjects of the Visual Arts: Androgyny

The most famous portrayal represents Hermaphroditus asleep, lying on his stomach, head turned to the side, and torso twisted just enough to reveal his breast and genitals. (National Museum of the Terme, Rome, and the Louvre, Paris.)

Hermaphrodites disappear from post-Classical art history until the Renaissance, when writers of alchemical treatises rediscovered them as noneorotic symbols for the union of opposites (a potent image for later Jungian psychology) and emblem books portrayed them as symbols of marriage. (For a modern interpretation, see Marc Chagall's *Homage to Appollinaire*, 1911.)

The tale of Hermaphroditus and Salmacis was portrayed occasionally in Renaissance and Neoclassical art. Among the depictions are the following: Jan Gossaert (Jan de Mabuse), *The Metamorphosis of Hermaphroditus and the Nymph Salmacis* (1505); Bartholomaeus Spranger, *Salmacis and Hermaphroditus* (1581); Francesco Albani, *Salmacis Falling in Love with Hermaphroditus* (ca. 1660) and *Salmacis Kissing Hermaphroditus in the Water* (1660); and François-Joseph Navez, *The Nymph Salmacis and Hermaphroditus* (1829).

Subjects of the Visual Arts: Narcissus

THE MYTH OF NARCISSUS AS TOLD IN OVID'S *Metamorphoses* was probably intended as a moral fable against excessive pride. The son of a river god and a nymph, Narcissus was a beautiful youth loved by both men and women. Because of his good looks, however, he was very proud, and he spurned the advances of everyone who approached him.

The nymph Echo (who had been punished by Juno to repeat the words of all who spoke to her) saw him wandering in the woods one day and fell in love with him. When Narcissus realized he was lost and cried out for help, Echo responded. Eventually she revealed herself, and he spurned her as he had all who loved him.

To punish him for his pride, the gods cursed him: he would feel the unrequited love he instilled in others. When he bent to drink from a lake, he saw his own reflection and fell in love with it. His efforts to reach out and kiss

himself proved fruitless, but because he was so in love with his reflection, he could not leave. He eventually died and was transformed into a flower.

Narcissus, like Ganymede, has functioned frequently in the arts as a symbol of same-sex passion. This meaning has been ascribed to the figure probably because of the affection of men for him and because he finally fell in love with a man (himself). Narcissus has also been seen as masturbatory because of his self-love and effeminate because of his focus on his own beauty.

The term *narcissism* was first used by the sexologist Havelock Ellis to define "self-love." Sigmund Freud later expanded the notion of narcissism. He viewed the Narcissus myth as symbolically homosexual in its context, the love of one for another of the same gender who shares identical interests and appearances with the narcissist.

The Oxford Guide to Classical Mythology in the Arts, 1300–1990s cites about 100 visual works of art featuring Narcissus. Among the more famous artists who depicted him are Raphael, Domenichino, Cellini, Caravaggio, Poussin, and Lorrain.

Early representations of Narcissus usually show him as a teenaged, sometimes cherubic, youth staring longingly into water. He is often seen in these works at the moment when he has discovered his reflection.

Late Baroque and Rococo depictions often place Narcissus in Arcadia and tend to emphasize the idealism of classical culture rather than the myth itself.

More modern representations are narrative and illustrate the temptation of youthful beauty. Solomon J. Solomon's *Echo and Narcissus* (1895) shows Echo swooning over Narcissus while the handsome youth ignores her and stares at his reflection. Gustave Moreau's *Narcissus* (ca. 1890) depicts the youth nude as an odalisque surrounded by lush foliage, his eyes staring at the viewer rather than at himself.

— *Roberto C. Ferrari*

BIBLIOGRAPHY

Reid, Jane Davidson. "Narcissus." *The Oxford Guide to Classical Mythology in the Arts, 1300–1990s*. New York: Oxford University Press, 1993. 2:692–702.

SEE ALSO

European Art: Renaissance; European Art: Neoclassicism; European Art: Nineteenth Century; Caravaggio; Cellini, Benvenuto; Solomon, Simeon

Subjects of the Visual Arts: Nude Females

A S GODDESSES, SEDUCTRESSES, SAINTS, SINNERS, AND muses, the female has been a recurring subject in art for millennia. Nude depictions of women appear in most cultures, on both sides of the equator, and in rich variety.

The early Woman (Venus) of Willendorf is rendered replete with voluptuous curves, while ancient Cycladic goddesses are depicted as skinny figured, with arms crossed at their waists. African female nude figures often grace utilitarian objects, while Indian nudes dance alone ecstatically and sometimes embrace in same-sex groups. Central American art includes fierce nude Aztec goddesses, and Peruvian ceramic pots show women giving birth or making love. Medieval Irish "Sheela na gig" nude sculptures spread their legs and hold their vulvas open.

An artist's passion usually influences the way he or she portrays a nude figure of whatever gender. Michelangelo (1475–1564), for instance, whose passion was for men, masculinized his female nudes, as did gay photographer Robert Mapplethorpe (1946–1989) in his studies of bodybuilder Lisa Lyon. In contrast, bisexual architect-designer Eileen Gray (1878–1976) created the reverse effect by portraying feminized male nudes on a 1913 lacquered screen.

John Singer Sargent (1856–1925), whose studies of nude men are sensual and sensitive, produced only one female nude, a rigidly stiff image. Dancer-choreographer Arnie Zane (1948–1988) produced desexualized— but often tender—nude photographs of women dancers.

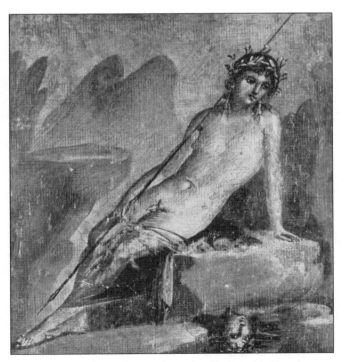

Narcissus as depicted in a wall painting discovered in Herculaneum.

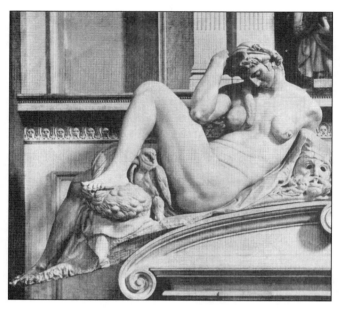

Night, a detail from a tomb designed by Michelangelo.

Women Artists

Prior to the late nineteenth century in Europe and the United States, it was considered improper for women to use nudes as the subject of their art. They were excluded from studying the nude with their male counterparts in art schools. Some, such as Gwen John (1868–1939), made nude self-portraits in order to bypass social restrictions.

It has been difficult for researchers to locate complete studies of women artists' work, especially nudes, both because their work was not valued as highly as men's when it was made and because less has been researched and published about it. Some work has been lost, such as the nude photographs of a female friend made by lesbian Frances Benjamin Johnston (1864–1952) early in her career and circulated within her circle of women friends.

Unlike many gay male artists, most lesbian and many bisexual women artists working before the 1970s— sculptor Louise Nevelson (1900–1988), painter Nell Blaine (1922–1996), and photographer Berenice Abbott (1898–1991), for example—avoided the nude. Yet, for a few, the unclothed female was a rich vehicle with which to communicate their ideas.

Nineteenth-Century Lesbian Sculptors

In the second half of the nineteenth century, numerous American and British women artists traveled to Rome to study marble sculpture. These included lesbians Emma Stebbins (1815–1882), Anne Whitney (1821–1915), and Harriet Hosmer (1830–1908). Stebbins's friendship circle included African American/Native American sculptor Mary Edmonia Lewis (1843–1909), who may have been lesbian.

These women chiseled nude and seminude (primarily female) figures and also produced figures draped as if with wet cloth that clung revealingly to the body underneath. At least once, Hosmer occasioned scandal by depicting a (respectable) woman friend instead of a professional model.

American sculptors Florence Wyle (1881?–1968) and Frances Loring (ca. 1887–1968) met in art school in Chicago and lived briefly in New York City before moving permanently to Toronto. They crafted nude and draped female figures in marble, a practice they continued long after the public's taste had moved on.

Early-Twentieth-Century Lesbian and Bisexual Artists

Women artists of the early twentieth century took diverse approaches to nude imagery. In the 1910s and 1920s, American lesbian photographers Laura Gilpin (1891–1979) and Clara Sipprell (1885–1975) created dreamy, soft-focus, desexualized images of nude females.

Working in Germany in the 1920s and 1930s, Jeanne Mammen (1890–1976) produced graphics, including nude and seminude female figures, for gay and lesbian periodicals. With the coming to power of the anti-gay Nazis, the queer side of Mammen's illustrating career ended. Her contemporary, bisexual collage artist Hannah Höch (1889–1978), pasted disparate body parts together, creating images that comment on gender and politics.

Bisexual Polish-born artist Tamara de Lempicka (1898–1980), working in Paris, painted full-bodied and sensuously languid Art Deco nudes.

Bisexual Mexican Jewish painter Frida Kahlo (1910–1954), on the other hand, imbued her nudes with autobiographical content, often referencing her numerous bodily injuries (including polio, a broken backbone, an injured pelvis, and numerous surgeries) and physical and psychological pain. She also portrayed sensual female nudes together and nudes as nurturers.

Working in France, Buenos Aires–born bisexual painter Léonor Fini (1908–1996) created surrealistic dreamworlds peopled by ethereal women and androgynous men who seem to drift in and out of their clothing.

Muse

It can be argued that there is an intimate link between the gender of one's muse and that of one's sexual partners. In the 1910s, American artist Romaine Brooks (1874–1970) became obsessed with the body of one of her lovers, Ida Rubinstein (1894–1996). She produced paintings of Rubinstein nude and a series of nude photographs that may have been used as studies for paintings.

She also painted a seminude portrait of bisexual American artist-designer Eyre de Lanux (1894–1996). Lanux, in turn, made a drawing of the lover she shared

with Brooks, Natalie Clifford Barney (1876–1972). In Lanux's drawing, Barney reclines, her eyes half-closed, her breasts bared. A recent erotic encounter between artist and subject is clearly implied.

For some, such as photographer Ruth Bernhard (b. 1905), who had relationships with both men and women, inspiration seems to have been particularly linked to her female nudes. Bernhard, in fact, would appear to have had a lesbian muse from the large number of images of nude females she made between 1935 and 1970. In her single nude male image, the figure appears crucified.

Neon artist Lili Lakich (b. 1944), whose career began in the decade prior to the Stonewall riots of 1969, memorialized one of her lovers, nude, in *Donna Impaled as a Constellation*, a 1983 construction of aluminum and argon, helium, and neon lights.

The Influence of Feminism

Beginning in the 1960s, Swedish-born bisexual painter Monica Sjoo (b. 1938) utilized goddess imagery in her paintings. Her large nude *God Giving Birth* created controversy in the 1970s.

In the early 1970s, lesbian feminist activity surfaced in many countries around the world, bringing with it the opportunity for lesbian and bisexual artists to raise openly issues of the body and the muse that had previously been silenced.

Since that time, books and magazines have been the primary way that lesbian-produced, lesbian-themed art has circulated. Throughout the 1970s, American-born documentary photographer JEB (Joan E. Biren, b. 1944) established a feminist approach to nude imagery by showing ordinary-looking women in desexualized contexts, often in open-air settings.

In the 1980s, drawings by American lesbian artist Sudie Rakusin (b. 1948) of nude and seminude women as warriors and priestesses dominated women's counterculture periodicals in the United States.

Whereas Rakusin's nudes are curvaceous and spiritually inclined, those of painter-printmaker Max White (b. 1954) are sharp-edged and spiky. Like Rakusin's, White's early work circulated in lesbian and feminist publications.

In the late 1980s and 1990s, lesbian photographer Roberta Almerez (b. 1953)—whose parents were Puerto Rican and Filipino—was one of the few American lesbians of color to publish nudes both in more general lesbian-produced sex magazines and in lesbians-of-color magazines such as *Esto No Tiene Nombre*.

Picturing disability has been a recurring theme in lesbian feminist art. Dutch photographer Gon Buurman (b. 1939) has published nude images of differently abled women embracing. American sculptor Nancy Fried (b. 1945), American photographer Deborah Bright (b. 1950), and New Zealand photographer Rebecca Swan (b. 1968)

have used as subject their experiences with breast cancer and its effect on their bodies.

Fried and Bright have each produced self-portraits after mastectomies. U.S. photographer Cathy Cade (b. 1942) integrated a nude disabled woman, with cane, into her sociologically inflected *Lesbian Photo Album* (1987).

Women of Size

Late-twentieth-century feminism also included a reaction against the "beauty" industry and the oppressiveness of compulsory thinness.

Since the late 1970s, American photographer Katie Niles (b. 1951) has explored her own sturdy body, both nude and clothed. In each self-portrait she is smoking a pipe. In 1996, her color photograph of nude and seminude, fat, pierced, and tattooed lesbians participating in a safer-sex orgy gained international attention when it was published in the anthology edited by Susie Bright and Jill Posener, *Nothing But the Girl: The Blatant Lesbian Image* (1996).

Cookie (Annjohnna) Andrews-Hunt (1952–1995)— active with The Fat Avengers, a lesbian fat activist group based in Seattle—photographed and participated in the Northwest U.S. feminist, fat, and leather communities and helped produce *Images of Our Flesh*, a 1983 calendar of photographs of fat women.

Bisexual photographer Laurie Toby Edison (b. 1942), skinny herself, visually defined the fat nude female in the book and traveling show *Women En Large: Images of Fat Nudes* (1994). California-based photographer Laura Aguilar (b. 1959) uses her own ample body in a myriad of large self-portraits. She has also created a series of paired portraits in which the same individual or couple appears clothed and unclothed.

Lovemaking Imagery

By the end of the nineteenth century, sapphic love was being written about by women. As the twentieth century began, Natalie Clifford Barney, working with her lovers Eva Palmer (b. ca. 1876) and poet Renée Vivien (born Pauline Mary Tarn, 1877–1909), produced bucolic and Amazonian nude photographs and at least one overtly erotic image. Two decades later, bisexual Germaine Krull (1897–1985) photographed sensual and sexual encounters between women.

Publishing in Paris during the first half of the twentieth century, women illustrators such as Gerda Wegener (1885–1940), Clara Tice (1888–1973), Mariette Lydis (1887–1970), Margit Gaal (active in the 1920s), and Suzanne Ballivet (active 1930s–1955) produced sexual graphics of women making love. In the 1970s, bisexual Betty Dodson (b. 1929) drew lovemaking images of same- and mixed-gender couples, details of female genitalia, and an all-woman group sex party.

In the late 1970s and early 1980s, Uruguayan-born Diana Blok (b. 1952) and Dutch-born Marlo Broekmans (b. 1953)—photographers and lovers—created romantic, erotically inflected double self-portraits.

Late in the twentieth century, lesbian painters Lorraine Inzalaco (b.1946) and Patricia Cronin (b. 1963) made lyrical visual explorations of nudes and lovemaking. In the 1990s, Nicole Eisenman (b. 1963) painted confrontational, rowdy, and irreverent images of multifigured sexual activity.

Photography, however, has been the favorite medium for lesbians to depict sex. Photographers who have utilized the female nude in sexual situations include Jill Posener (b. 1953) from England; Cyndra MacDowall (b. 1953) from Canada; Laurence Jangey-Paget (b. 1965) from France; Parminder Sekhon (b. 1968) from England; C. Moore Hardy (b. 1955) from Australia; and Marcelina Martin (b. 1950), Judy Francesconi (b. 1959), Honey Lee Cottrell (b. 1945), Phyllis Christopher (b. 1963), and Tee A. Corinne (b. 1943) from the United States.

Transsexual and Intersexual Imagery

Imaging hermaphroditism has been a part of art since ancient times. In the early twentieth century, sexologist Magnus Hirschfeld (1868–1935) gathered photographs of hermaphrodites and images that seemed to support the concept of a "third sex."

Two photographers who started their lives with female bodies, Del LaGrace Volcano (formerly known as Della Grace, b. 1957) and female-to-male transsexual Loren Cameron (b. 1959), have used their own and others' nude bodies-in-transition as the subject of photographic inquiry.

The Vulnerable Body

Each generation tends to think that it has invented sex, or at least its edgier practices. Sometime before the end of World War II, the French Jewish lesbian photographer Claude Cahun (born Lucy Schwob, 1894–1954) made self-portraits showing herself involved in sadomasochistic lovemaking with her life companion. These images were confiscated and destroyed by the Nazis. Only a brief written trace of them remains.

The last two decades of the twentieth century saw a different reaction from the earlier revolt against the body beautiful. This reaction took the form of images of bodies pierced and incised and images that appear to indicate violent sexual activity.

Examples include the work of Catherine Opie (b. 1961) and of Claire Garrotte (b. 1962). Opie's large, half-nude color self-portrait photographs feature designs or words scratched into her skin (and, in one, forty-six hypodermic needles inserted through her skin). Garrotte's multiyear photographic study of a lesbian threesome includes images of sadomasochistic activity.

Other artists, such as Vietnamese-born lesbian photographer and installation artist Hanh Thi Pham (b. 1954), have used images of their unclothed and semiclothed bodies to effect political or social commentaries.

Exhibiting the Lesbian Body

Issues surrounding control of "the gaze" surfaced frequently in the 1970s. As a consequence, many lesbian artists chose "women only" exhibition spaces, such as women's bars and women's centers, as a way to limit the viewing audience. Images of nudes and vulvas were especially protected.

By 1980, however, bisexual writer and artist Kate Millett (b. 1934) was exhibiting photographs of women's genitals in an office building corridor in New York City.

In 1992, Zoe Leonard (b. 1961)—as part of Documenta IX in Kassel, Germany—replaced each portrait painting of a man in one eighteenth-century gallery in the Kunsthalle Museum with a photographic close-up of female genitalia; paintings of women were left hanging. Millett's and Leonard's public displays of taboo imagery expanded the psychological space for the female nude.

Lola Flash (b. 1969), an African American photographer who lives in London, uses color reversals in order to complicate issues of race. A number of her sensuous compositions have been published on covers of books.

During the early 1990s, working counter to the dominant lesbian feminist emphasis on honesty, three Canadian lesbians photographed staged sexual tableaux and then asked viewers to draw literal lines on the walls of the show to indicate where censorship should take place. The artists, calling themselves Kiss & Tell, were designer-writer Lizard Jones (b. 1961), photographer Susan Stewart (b. 1952), and sculptor Persimmon Blackbridge (b. 1951).

Beginning in 1998, Lesbian ConneXion/s—a photo exhibit by lesbian and bisexual women, most of whom live in northern Europe—was exhibited in the Netherlands, Belgium, Slovenia, Croatia, Russia, and the United States.

The show, which is still touring, includes female nudes by Sandra Vitaljic (b. 1972) of Zagreb, Olga Stefaniuk (b. 1954) of Warsaw, Kirsten Plathof (b. 1960) and Gundula Krause (b. 1967) of Berlin, Yvonne Anne Driehuis (b. 1957) of Utrecht, Marian Bakker (b. 1944) and Lorena Bernardi (b. 1960) of Amsterdam, Sophie Anquez (b. 1962) of Paris, and Tanya Sazansky (b. 1971) of Moscow, among others.

Lesbian ConneXion/s is noteworthy for the variety of its nudes. The images range from Bernardi's classic profiles in which one woman arches her back against another's pregnant belly to Anquez's crop-haired, skinny young women squeezing their breasts to create cleavage, and from Stefaniuk's nude-in-landscape to Vitaljic's hairless figure biting her own shoulder.

These images at once reference the past and reflect some of the multifaceted ways that contemporary artists explore and update female nude imagery. — *Tee A. Corinne*

BIBLIOGRAPHY

Bright, Susie, and Jill Posener, eds. *Nothing But the Girl: The Blatant Lesbian Image.* London and New York: Freedom Editions/Cassell, 1996.

Cade, Cathy. *A Lesbian Photo Album: The Lives of Seven Lesbian Feminists.* Oakland: Waterwomen Books, 1987.

Cameron, Loren. *Body Alchemy: Transsexual Portraits.* San Francisco: Cleis Press, 1996.

Francesconi, Judy. *Visual Sonnets.* West Hollywood: Shake-It-Up Productions, 2000.

Goujon, Jean-Paul. *Album Secret: Renee Vivien, Natalie Barney, Eva Palmer.* Paris: Éditions À l'Écart, 1984.

Hardy, C. Moore. "Lesbian Erotica and Impossible Images." *Sex In Public: Australian Sexual Cultures.* Jill Julius Matthews, ed. St. Leonards, Australia: Allen & Unwin, 1997.

Kelley, Caffyn, ed. *Forbidden Subjects: Self-Portraits by Lesbian Artists.* North Vancouver, B.C.: Gallerie Publications, 1992.

Kiss & Tell (Susan Stewart, Persimmon Blackbridge, and Lizard Jones). *Drawing the Line: Lesbian Sexual Politics on the Wall.* Vancouver, B.C.: Press Gang Publishers, 1991.

Lakich, Lili. *Neon Lovers Glow in the Dark.* Los Angeles: Museum of Neon Art, 1986.

Leong, Russell, ed. *Asian American Sexualities: Dimensions of the Gay & Lesbian Experience.* New York: Routledge, 1996.

Mariechild, Diane, and Marcelina Martin. *Lesbian Sacred Sexuality.* Oakland: Wingbow Press, 1995.

Nössler, Regina. *Nice Girls Don't: Erotische Fotografien by Laurence Jaugey-Paget.* Tübingen, Germany: Konkursbuch Verlag Claudia Gehrke, 1999.

Snellings, Lieve. *Lesbian ConneXion/s Vlaanderen—Some Day They Will Remember Us.* Middelkerke-Leffinge, Belgium: Lover, 1999.

SEE ALSO

American Art: Lesbian, Nineteenth Century; American Art: Lesbian, 1900–1969; American Art: Lesbian, Post-Stonewall; Photography: Lesbian, Pre-Stonewall; Photography: Lesbian, Post-Stonewall; Abbott, Berenice; Bernhard, Ruth; Biren, Joan Elizabeth (JEB); Brooks, Romaine; Cahun, Claude; Edison, Laurie Toby; Fini, Léonor; Grace, Della (Del LaGrace Volcano); Gray, Eileen; Höch, Hannah; Hosmer, Harriet Goodhue; Kahlo, Frida; Lempicka, Tamara de; Lewis, Mary Edmonia; Mammen, Jeanne; Mapplethorpe, Robert; Michelangelo Buonarroti; Sargent, John Singer; Sipprell, Clara Estelle; Stebbins, Emma; Whitney, Anne

Subjects of the Visual Arts: Nude Males

THROUGHOUT MUCH OF HISTORY, THE NUDE MALE figure was virtually the only subject that could be used to articulate homoerotic desire in publicly displayed works of art. In most cases, representations of nude males were intended to embody the spiritual and political ideals of the societies in which they were produced. Only rarely were erotic qualities overtly emphasized in public works. Nevertheless, artists, patrons, and viewers who recognized the sensual appeal of these figures almost certainly exploited them to nourish their romantic lives.

In many cultures, sexually explicit depictions of male nudes were confined to works of art intended for discreet, private "consumption." Unfortunately, the study of these images has been inhibited by the efforts of successive waves of conservative political and religious groups, who have sought to find and destroy "offensive" erotic works.

For a variety of reasons, most modern scholars have been reluctant to study and publish extant images. The recovery and systematic analysis of visual expressions of homoerotic desire in earlier cultures remain urgent tasks for scholars.

In the post-Stonewall era, many artists have publicly exhibited images of nude men infused with erotic desire. Moreover, contemporary artists have utilized nude figures to explain complex political, social, and spiritual issues from distinctly queer perspectives.

Because the nude male has been a major theme in the visual arts, this article can mention only representative examples from various periods; important artists and works are necessarily omitted. For the purposes of this essay, the terms *gay* and *queer* are used to refer to any images relevant to the study of same-sex love. However, these modern categories do not adequately express the open-ended understanding of sexuality characteristic of many earlier cultures.

Ancient Art

A fluid conception of sexuality characterized the ancient civilizations of India. Among the major living religions, Hinduism was unique in celebrating all manifestations of sexuality as means to transcend the limits of temporal, earthly existence and to attain unity with the divine principle.

In accord with these beliefs, the exteriors of many temple complexes in India originally were covered by sculptural figures of men and women enthusiastically engaged in all kinds of sexual play. These images simultaneously represented both deities and ordinary mortals.

Although mixed-gender configurations predominated, same-sex couples and groups also were shown. Successive waves of Islamic and British invaders succeeded in destroying most of the sexual scenes on Hindu temples, but some examples have remained intact, as at the Vishvanatha Temple at Khajuraho (950–1050).

In contrast to later Western practice, ancient Greek culture esteemed erotic bonds among men, believing that they could, among other positive contributions, encourage heroism in war.

Thus, for example, it was generally recognized that Harmodius and Aristogeiton, who established democracy in Athens through their courageous attack on dictatorship in 514 B.C.E., were devoted lovers. The Tyrannicide Monument *(*477 B.C.E., based upon the original of 510 B.C.E.) was erected in Athens to commemorate their patriotic achievement.

This monument has great importance in art history as one of the earliest and most impressive manifestations of the characteristic Classical Greek expression of social values through the use of idealized, but anatomically correct, nude male figures.

The emotional rapport of the men is suggested by the way that Aristogeiton extends his arm, as if to shield his partner from attack. However, their relationship is not otherwise indicated; the public context of the sculptural monument restrained the explicit expression of their love, which was, however, readily acknowledged in written sources.

Although they did not depict sexually explicit themes in large-scale sculpture, ancient Greeks frequently represented erotic interactions among nude male figures in the painted decoration of vases and pots.

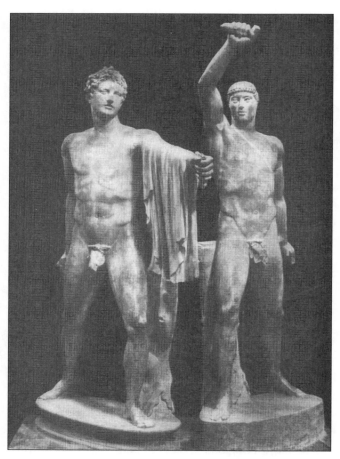

An ancient sculpture of Harmodius and Aristogiton.

The scenes ranged from casual flirtations between bearded older and smooth-faced younger men (for example, *Men and Youths Courting*, painted in approximately 540 B.C.E. by the Berlin Painter on a black-figure amphora) to wild "orgies" (for example, *Dionysian Revelry,* on a black-figure vase of the 6th century B.C.E., and *"Boisterous" Satyrs,* on a cup by the Nikosthenes Painter, 6th century B.C.E.).

Despite their exuberance, these images rigorously adhere to conventions which (at least in theory) regulated same-sex relations among men in ancient Greece. Men were encouraged to nurture the physical and intellectual skills of "worthy" youths. Sex was an accepted part of these relationships, provided that the (older) men consistently assumed the "active" roles. Once a youth had passed through puberty, men were expected to "break off" any intimate associations with their protégés.

Nude male figures reveal that conceptions of gender and sexuality had broadened considerably during the Hellenistic era (approximately 330–150 B.C.E.). The Apollo Belvedere (a marble copy of the bronze original of 300 B.C.E.), one of the most influential ancient statues, exemplifies the androgynous treatment of the male nude which became increasingly frequent in the Hellenistic period. Elongated proportions, smooth flesh, and graceful pose distinguish this statue from such earlier classical works as the Tyrannicide Monument.

At the opposite extreme of the Apollo Belvedere is the Farnese Hercules (a Roman copy of a Hellenistic original of approximately 330 B.C.E.), notable for its exaggerated muscularity and bulky proportions. The legends of both Apollo and Hercules included numerous same-sex encounters; thus, as in modern "gay" culture, "feminized" and "ultramasculine" figures equally could be associated with homoerotic desire.

The charismatic and powerful leader Alexander the Great (d. 323 B.C.E.) is known to have been deeply devoted to his soldier-companions. His love for his advisor and companion Hephaestion is celebrated in a Hellenistic relief (preserved in a Roman Syrian marble copy, approximately 200 B.C.E.) which shows the nude Alexander standing next to the clothed figure of his lover.

Ancient Roman artists produced numerous copies of Greek nude figures for wealthy patrons, but the Romans were less likely than the Greeks to employ full nudity in public images of national leaders and heroes. Although not illegal, same-sex love was no longer commonly associated with patriotic virtue or with the education of young men.

Nevertheless, the Emperor Hadrian (reigned 117–138 C.E.) sought to promote devotion to his lover, Antinous; after his accidental death (d. 130 C.E.), the Emperor commissioned numerous (partially clothed) statues of the beautiful young man for display throughout the empire.

Same-sex love also was celebrated in the famous sculptural group variously identified as the Ildefonso Group and as *Castor and Pollux* (Madrid: Prado, date uncertain), which depicts two nude, athletic figures casually embracing. However, outside the imperial court, men who favored the passive role in same-sex intercourse were generally regarded as an inferior class, and a variety of derogatory terms were devised to refer to them.

Despite (or perhaps because of) the decline in the valuation of same-sex relations, a vibrant homosexual subculture emerged in the physical and social "fringes" of Roman cities. Quickly and cheaply painted scenes of lively nude male figures engaged in a wide variety of sexual activities covered the walls of bathhouses (such as the House of Jupiter and Ganymede, Ostia, Italy, 184–192 C.E.), which served as gathering places for men who were attracted to other men.

The Warren Cup (first century C.E.), an exquisitely executed silver vessel, deserves special mention, as it depicts beautiful and dignified figures breaking the taboos that normally limited same-sex experiences in Rome. In violation of the principle that citizens should assume only "active" sexual roles, one side of the Warren Cup shows a citizen lowering himself onto the penis of a "foreign" worker; the evident eagerness with which he seats himself on the penis also challenges limited notions of "top" and "bottom."

Early Modern Art

As part of wide-ranging efforts to impose uniform "moral" standards, homosexual acts were made illegal throughout Europe during the medieval period. Regarded as an incitement to lust, nudity of any kind was discouraged in the visual arts.

Not surprisingly, men who were attracted to other men played a major role in reviving the classical theme of the nude male figure during the Renaissance; only a few of these major figures can be noted here.

For example, Donatello, whose attraction to young men is well documented, created the first life-size nude male statue since the ancient Roman period: the bronze *David* (1430s). In an elegant contrapposto pose, directly based on ancient Greek works, David stands with one foot on the head of the slain Goliath.

Emphasizing the erotic implications of this statue are the feathers of Goliath's helmet, which extend all the way up David's legs to his crotch. The educated Renaissance viewer certainly would have understood the implications of the triumph of Eros depicted on the helmet. Although stripped of his garments, David is shown wearing a hat, popular among young working-class youths in Florence. The intense naturalism with which the adolescent body is depicted suggests the artist's careful (and admiring) study of his apprentices.

Although prohibitions against homosexual acts were still rigorously enforced, Giovanni Antonio Bazzi (1477–1549) boldly chose to be called by the nickname "Il Sodoma" (Sodom). His numerous paintings of nude martyred saints (such as *Saint Sebastian*, 1542) evoke both the sensual beauties of the male body and the physical and verbal abuse that his public stance "provoked."

Renaissance artists generally depended upon the requirements of mythological and religious subjects to justify the inclusion of nude figures. However, the prominent German artist Albrecht Dürer portrayed naked men provocatively gazing at one another in the contemporary setting of *The Bathhouse* (woodcut, 1496); he emphasized the sexual implications of the scene by placing a cock (rooster) on top of the large faucet that projected in front of one of the figures.

The most famous of all Renaissance artists, Michelangelo's utilized the nude male figure to represent the highest ideals of his culture: whether political, as in the case of *David* (1504), a symbol of the Republic of Florence, or spiritual, as in the case of the *Risen Christ* (1516). Their sensual beauty so disconcerted many contemporary viewers that their genitals were concealed (in opposition to the will of the artist) a few years after their completion.

In contrast to Il Sodoma, Michelangelo fully absorbed Catholic proscriptions against same-sex intimacy, and his diaries and letters reveal that he suffered from profound guilt because of his love for other men. He revealed his conflicting feelings about his sexual desires in a pair of drawings made in 1533 for his beloved Tomasso Cavalieri: *Ganymede,* which depicts the beautiful, nude adolescent being carried up to heaven by an embracing eagle, and *Tityos,* which shows an eagle eating the intestines of a very similar figure.

At the beginning of the seventeenth century, Caravaggio, who boldly flaunted his attraction to other men, created numerous homoerotic works, including provocative variations upon famous representations of nude figures by Michelangelo. For instance, his *Love Triumphant* (1602), based upon an allegorical statue of *Victory* by Michelangelo (1530s), shows a naturalistically depicted street youth trampling on symbols of human achievement.

Caravaggio's overt challenge to constrictive moral standards was not continued by later artists during the Baroque era, when both artists and their works increasingly were expected to conform to heterosexual "norms." However, Guido Reni's *Saint Sebastian* (1615) eloquently reveals that nude figures, required by certain devotional and mythological subjects, could be infused with a languid and subtly subversive sexuality.

At the same time that Catholic and Protestant reform movements were seeking to restrict both nudity and

homoeroticism in European art, Japan witnessed a remarkable flourishing of sexually explicit art, which was avidly collected by the prosperous middle classes. Many famous and popular artists depicted scenes of lovemaking in the male and female brothels legalized throughout the reign of the Tokugawa dynasty (1603–1868).

Only a relatively small percentage of the many hundreds of scenes of male prostitutes and their clients depict full nudity; Yoshida Hanbei's *A Sexually Excited Male Prostitute with a Client* (woodblock print, 1705) and the anonymous *Sexually Aroused Men Kissing* (woodblock print, mid-eighteenth century) are among those that do.

More typically, as in Nishikawa Sukenobu's *Customer with Boy Prostitute* (scroll painting, early eighteenth century), the figures were shown with some items of clothing to indicate social class and sexual roles. However, genitals and anus consistently were not only exposed but emphasized through enlargement, strong outlining, and other devices.

Nineteenth-Century Art

At the height of the French Revolution, in 1791, sodomy among consenting adults was decriminalized, and the Napoleonic Code of 1804 reaffirmed the legalization of same-sex relations. Thus, it is not surprising that numerous prominent artists exhibited paintings of overtly homoerotic nudes at the Paris Salons in the early nineteenth century.

For example, the sinuously posed nude figures of Achilles and Patroclus establish a sensual mood in Ingres's *Achilles Receiving the Ambassadors of Agamemnon* (1801).

Hippolyte Flandrin's *Figure d'Etude* (1835), which depicts a youthful model with his head bent down onto his raised knees, freed the homoerotic subject from the requirements of a mythological or historical theme.

Because the pose conceals the genitals, rules of "propriety" were respected, and a reproduction of this painting (purchased for the Louvre by Napoleon III) could be displayed openly in one's home without fear of reprisal; the mountain setting also dignified Flandrin's work by infusing it with the mood of the "sublime," so esteemed by the Romantic movement.

This painting quickly became a widely recognized and enduring symbol of same-sex desire; it continues to be referenced in innumerable ads directed to the gay community (for causes ranging from AIDS prevention to ocean cruises). The many later variations of Flandrin's famous composition include Robert Mapplethorpe's *Ajitto* (1981), which depicts an African American model with an erect penis.

Despite Flandrin's example, most nineteenth-century artists depended on classical themes to "justify" sensual

depictions of nude male figures. Thus, for example, Jean Delville's *School of Plato* (1898) depicts the ancient philosopher surrounded by languidly posed, nude youths; Delville's androgynous conception of the nude was characteristic of many of the artists associated with the Aesthetic Movement of the late nineteenth century.

Among adherents of this style, Simeon Solomon is particularly noteworthy because he raised complex personal and social issues through his treatments of such subjects as *Bridegroom and Sad Love* (1865); this painting represents a nude youth dispassionately kissing the forehead of his bride while he fondles the genitals of the sorrowful adult Cupid standing alongside him.

Such powerful treatments of the problems affecting same-sex love in modern Britain caused Solomon to be ostracized by many other artists, even before his career was cut short by the scandal surrounding his arrest in 1873 for soliciting sex in a London public toilet.

The new medium of photography was exploited by artists seeking to record the beauties of the male figure. Settling in Taormina, Sicily, in the 1880s, the German baron Wihelm von Gloeden devoted himself to photographing local youths, posed nude with garlands and other classical attributes. Justifying his project by the goal of recreating the splendors of the ancient world, he established a successful mail-order business, selling his works to wealthy men throughout Europe and the Americas.

The American painter Thomas Eakins also recorded the appearance of nude youths in numerous photographs, which he intended as preparatory studies for such paintings as *The Swimming Hole* (1885). Inspired by Walt Whitman's glorification of the common man, Eakins sought to create naturalistic, distinctly American images of heroic, nude male figures.

Twentieth-Century Art

In the first decades of the twentieth century, well-known artists began to create more sexually explicit and accurate images of the lifestyles of men in the nascent "gay" subculture. For instance, in the late 1910s, the American painter Charles Demuth created several watercolors of men engaged in sexual play in New York bathhouses; he restricted the circulation of these works, giving them as gifts to close friends.

Later in the century, George Platt Lynes, a prominent fashion photographer, created elegantly posed, intensely erotic photographs of men (such as *Nude Man*, 1932) for a carefully screened and discreet wealthy clientele. A friend of his, painter Paul Cadmus, boldly created for public display monumental paintings depicting the lives of urban gay men; these included numerous paintings of nudes, such as *Horseplay* (1935) and *The Bath* (1951).

Deliberately positioning himself outside the mainstream art world, the prolific Tom of Finland (Touko

Laaksonen) created countless drawings of nude working-class men, joyfully engaging in S/M sexual play. In the late 1940s and early 1950s, he informally circulated his images through "underground" networks, based in European gay bars.

The subsequent publication of his images in magazines catering to the emerging gay "market" helped to make them widely available. His portrayals of self-confident, athletic, and highly sexed men served as prototypes for gay "clones" in the 1970s and later decades.

Among the many later gay artists influenced by Tom of Finland's work is the prominent Japanese painter Sadao Hasegawa. In such works as *Lion Dance* (1982) and *Secret Ritual* (1987), Hasegawa successfully sought to incorporate Tom's hypermasculinity and exuberant sexuality into innovative depictions of themes ultimately inspired by the spiritual traditions of Buddhism and Hinduism.

In the 1980s, Robert Mapplethorpe defied taboos that still restricted exposure of explicit depictions of (homo)sexuality. In prominent fine arts galleries and museums in the United States and Europe, he exhibited carefully and elegantly composed close-up photographs that captured nude men in the midst of fisting and other S/M activities.

The Perfect Moment, a nationally touring exhibition of his work (1988–1990), provoked unprecedented furor, culminating in the arrest and trial of a museum curator on charges of disseminating pornography. Even many gay community leaders criticized the intense sexuality of Mapplethorpe's work as inappropriate in the era of AIDS.

In addition, his "Black Male" series (including such images as "Thomas on a Pedestal," 1986) was attacked for its objectification of the black body. However, Mapplethorpe eloquently defended his goal of portraying the beauties of individuals who were overlooked in the mainstream art world.

Breaking with conventions that effectively restricted nude male images to depictions of athletic, young, white men, many recent artists have sought to produce works of art that reflect the actual diversity and complexity of queer communities.

Such photographers as Australian Jamie Dunbar (for example, "Posithiv Sex Happens," 1993) and Americans Mark I. Chester (for example, "Robert Chesley—ks portrait," 1991), George Dureau ("Wilbert Hines," 1983), Lyle Ashton Harris ("Constructs," 1989), and Peter Hujar ("Manny," undated) have devoted themselves to creating powerful nude images of men who would normally be excluded from representation because of their age, social class, HIV status, physical condition, or race.

Numerous contemporary queer artists have exploited the nude figure to create provocative narratives, with great psychological and political resonance. For instance,

Nigerian-born photographer Rotimi Fani-Kayode conceived several transcultural series ("Metaphysick: Every Moment Counts," 1991, among others) that synthesized Western conceptions of erotic art with Yoruba spiritual traditions.

The prominent Mexican artist Nahum Zenil has made his own nude body the primary subject of his work. In *Dart Game* (1994), Zenil depicts himself (in the pose of Leonardo da Vinci's Vitruvian Man, a symbol of Renaissance ideals) against a target with the colors of the Mexican flag; he thus reveals the dangers to which he willingly has subjected himself as a very outspoken proponent of gay rights.

Sunil Gupta (a Canadian citizen and United Kingdom resident, born in India) is among the many contemporary queer artists who have found inspiration in historical art. For example, in the photographic series "No Solutions" (1990), Gupta depicted himself and his British partner (in various stages of undress) in positions that are deliberately evocative of ancient Hindu erotic sculpture.

To reinforce the references to earlier Hindu work, Gupta paired each of his photographs with a popular Indian religious print. Displayed with captions taken from an Indian government proposal to ban sex between Indian citizens and foreigners, "No Solutions" raised a variety of urgent political, spiritual, and personal questions. This piece eloquently reveals the links between historical and contemporary queer culture, and it well exemplifies the vitality and complexity of recent images of the male nude.

— *Richard G. Mann*

BIBLIOGRAPHY

Cooper, Emmanuel. *Fully Exposed. The Male Nude in Photography*. London and New York: Routledge, 1990.

———. *The Sexual Perspective: Homosexuality and Art in the Last 100 Years in the West*. 2nd ed. London and New York: Routledge, 1990.

Davis, Whitney, ed. *Gay and Lesbian Studies in Art History*. New York: Harrington Park Press, 1994.

Saslow, James M. *Pictures and Passions: A History of Homosexuality in the Visual Arts*. New York: Penguin Putnam, 1999.

SEE ALSO

Indian Art; Classical Art; European Art: Medieval; European Art: Renaissance; European Art: Baroque; European Art: Nineteenth Century; Japanese Art; Photography: Gay Male, Pre-Stonewall; Photography: Gay Male, Post-Stonewall; American Art: Gay Male, Nineteenth Century; American Art: Gay Male, 1900–1969; American Art: Gay Male, Post-Stonewall; African American and African Diaspora Art; Erotic and Pornographic Art: Gay Male; Cadmus, Paul; Caravaggio; Demuth, Charles; Donatello; Dureau, George; Dürer, Albrecht; Eakins, Thomas; Fani-Kayode, Rotimi; Flandrin, Hippolyte; Gloeden, Baron Wilhelm von; Lynes, George Platt; Mapplethorpe, Robert; Michelangelo Buonarroti; Sodoma, Il (Giovanni Antonio Bazzi); Solomon, Simeon; Subjects of the Visual Arts: Ganymede; Subjects of the Visual Arts: Harmodius and Aristogeiton; Subjects of the Visual Arts: Hercules; Subjects of the Visual Arts: St. Sebastian; Tom of Finland; Zenil, Nahum B.

Subjects of the Visual Arts: Orpheus

ORPHEUS, A LEGENDARY POET OF GREEK MYTHOLOGY, was renowned for his skill with the lyre. It was said that he could soothe both the human soul and wild beasts with his song. In addition to his music, Orpheus passionately loved his wife, Eurydice, whose death, for which he blamed himself, broke his heart.

According to the myth, after her loss Orpheus despised women and turned his romantic attention to boys. He was then killed by the Thracian women for bringing homosexuality to Thrace.

The earliest references to Orpheus's homosexuality come from Phanocles' *Loves* (225 B.C.E.), a catalog of poems about the loves of the gods and heroes for beautiful boys, and Ovid's *Metamorphoses* (10:78–85), whose popularity is most likely responsible for keeping the entire Orpheus myth alive.

Most writers and artists since Hellenistic times have ignored the homosexual aspect of Orpheus, concentrat-

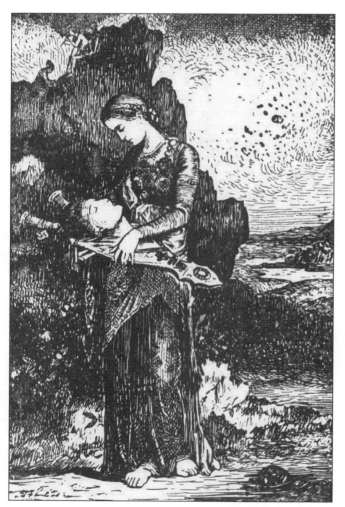

An engraving of Orpheus' beheading based on a painting by Gustav Moreau.

ing on him as the classical pattern of the poet-musician. Even medieval moralists in their reworking of the *Metamorphoses* into the *Ovide Moralisé* did not always focus disparaging commentary on the poet's sexuality.

Colard Mansion provides one of the few early modern illustrations of Orpheus's homosexuality, in a continuous narrative showing a sexual encounter between Orpheus and a young man, and the poet's resulting death (*Ovide Moralisé*, 1484). The artist used the storybook-like construction to make clear to his viewer that sinful passion for young lads results in an untimely demise.

Ten years later, the German artist Albrecht Dürer rendered Orpheus's death at the hands of the Thracian women in his *Death of Orpheus*. Dürer inserts a plaque just above the dying poet's head, reading "Orpheus, The First Pederast," to make clear the reason for the attack. What Dürer intended with the image remains unclear, but he may have been influenced by popular discussion of homosexuality in Italy.

In Italy the death of Orpheus appears in two major Renaissance works of art: Giulio Romano's *Sala di Ovidio*, in the Palazzo del Te (1527–1534) and Andrea Mantegna's *Camera degli Sposi*, in the Castello San Giorgio (1465–1474). A contemporary viewer of these rooms would have been familiar with the Ovidian tale, but Orpheus's role in the decoration of these rooms is minor. It is doubtful whether either of these artists was commenting on contemporary homosexuality as much as simply drawing on the popular classical tradition of the Renaissance.

— *Peter R. Griffith*

BIBLIOGRAPHY

Bate, Jonathan. *Shakespeare and Ovid*. Oxford: Clarendon Press, 1993.

Friedman, John Block. *Orpheus in the Middle Ages*. Cambridge, Mass.: Harvard University Press, 1970.

Kosinski, Dorothy. "The Image of Orpheus in Symbolist Art and Literature." Ph.D. diss., New York University, 1985.

Semmelrath, Hannelore. "Der Orpheus Mythos in der Kunst der italienischen Renaissance." Ph.D. diss., Cologne, 1994.

Segal, Charles. *Orpheus: The Myth of the Poet*. Baltimore: Johns Hopkins University Press, 1989.

SEE ALSO

European Art: Renaissance; Dürer, Albrecht

Subjects of the Visual Arts: Priapus

PRIAPUS WAS A PHRYGIAN FERTILITY GOD WHOSE CULT spread throughout the Hellenistic world. Depicted with enormous genitals, he ensured fertility and good fortune. Priapus was the protector of gardens, vineyards,

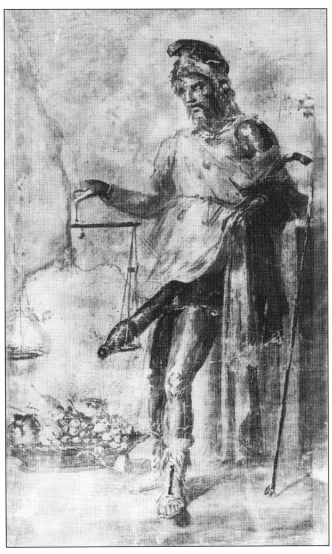

A Pompeiian painting of Priapus weighing his penis.

against a sack of coins. The same house contains a fountain statue of Priapus that spurted water from his organ. Such images navigate the humorous interspace between the sacred and the grotesque.

The mythology of Priapus has two notable tales. In one, Priapus argues with an ass about relative penis size. Priapus wins the contest and beats the ass to death (Hyginus, *Astronomica* 2:23). In the other, Priapus lusts after the nymph Lotis. He tries to rape her as she sleeps, but just as he is about to ravage her, an ass alerts her with his braying (Ovid, *Fasti* 1:391).

This latter tale is the subject of one of the few post-Classical representations of Priapus, Giovanni Bellini's *Feast of the Gods* (1514), in which Priapus is depicted lifting the skirt of the sleeping Lotis. There is also a drawing of the birth of Priapus by Poussin (1620–1623) and a bronze sculpture of the god by Picasso (1952).

— *Martin D. Snyder*

BIBLIOGRAPHY

Aghion, Irene, Claire Barbillon, and François Lissarrague. *Gods and Heroes of Classical Antiquity*. Leonard M. Amico, trans. Paris: Flammarion, 1994.

Carabelli, Giancarlo. *In the Image of Priapus*. London: Duckworth, 1996.

Clarke, John R. *Looking at Lovemaking: Constructions of Sexuality in Roman Art 100 B.C.–A.D. 250*. Berkeley: University of California Press, 1998.

Megow, Wolf-Rudiger. "Priapos." *Lexicon Iconographicum Mythologiae Classicae*. Zurich: Artemis Verlag, ca. 1981–1997. 8.1:1028–1044.

Richlin, Amy. *The Garden of Priapus: Sexuality and Aggression in Roman Humor*. Rev. ed. New York: Oxford University Press, 1992.

SEE ALSO

Classical Art

and orchards; his statue served as both scarecrow and guardian divinity.

He was, moreover, the patron of all in need of luck, especially men and women in search of sexual satisfaction. Although he is generally depicted as heterosexual in his tastes, Priapus numbered among his devotees men who were attracted to other men.

Equally important was Priapus's ability to ward off the evil eye. He threatened potential evildoers with forcible penetration, a painful experience considering the huge size of his phallus. People commonly wore the phallic amulet of Priapus and decorated their dwellings with images of his erect penis.

Priapus is commonly represented nude or holding garden produce in his mantle, which he raises to reveal his tumid penis. A large painting from the House of the Vettii (Pompeii) portrays Priapus weighing his phallus

Subjects of the Visual Arts: Prostitution

MODERN ART HISTORIANS HAVE GIVEN VERY LITTLE attention to visual representations of prostitution, especially those involving sexualities and gender constructions that challenge heterosexist norms. To a large extent, the neglect of this important theme is due to the same moralizing attitudes that long limited studies of queer issues of any sort.

Investigation of queer prostitution in art has been hindered by several factors, including the systematic destruction of relevant images. Moreover, very few of the extant representations from earlier periods have been published.

Further complicating the study of the images of queer prostitution is the circumstance that many of them can

be securely distinguished from representations of other types of sexual encounters only by reference to contextual information, which is seldom readily accessible.

Ancient Art

Images of same-sex prostitution extend far back into history. Among the oldest preserved scenes of homoerotic encounters are Greek vase paintings (sixth–fourth centuries B.C.E.), which depict various stages of the courtship of boys (ranging in age from the time of puberty to seventeen years old) by men.

Although male prostitution was illegal, a few of these scenes show a man offering a bag of money to a boy. The economic exchanges routinely involved in these complex relationships were more usually signified by the inclusion of a cock, hare, or stag, which were obligatory courting gifts.

While many of the vase paintings feature explicit scenes of intercourse and foreplay, others depict the instruction in intellectual, moral, and athletic values and skills that constituted an important component of the relationship between Greek men and the boys under their care.

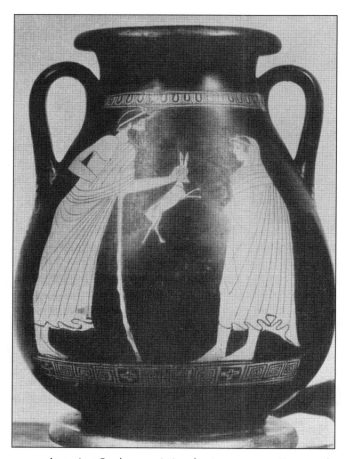

An ancient Greek vase painting showing a man courting a youth.

The vase paintings eloquently reveal that while prostitution inherently involves the sale of sexual activities for some type of economic benefit, it also often involves many other types of exchanges as well, including various psychological and spiritual factors.

The joyfully cavorting pairs and groups of figures that originally covered the exteriors of many Hindu temples probably were intended to allude, at least in part, to the sacred prostitution practiced at them. Hinduism embraced sexuality as a means through which one could transcend earthly limitations and surrender in ecstasy to the godhead.

The temple complex at Khajuraho (950–1050) features one of the largest displays of sculpture to survive British efforts to eradicate this aspect of Indian culture; varied same-sex couplings are depicted with the same zeal and objectivity as those involving both sexes.

The blunt commodification of sexuality can be exemplified by the quickly painted frescoes on the walls of many ancient Roman bathhouses and brothels. In most instances, same-sex encounters are presented alongside scenes of heterosexual intercourse.

However, the so-called House of Jupiter and Ganymede (184–192 C.E.), an apartment building that undoubtedly served as a brothel at the Roman port of Ostia, is decorated exclusively with frescoes and graffiti describing many types of sexual encounters between pairs and groups of men.

The Art of Tokugawa Japan

Colored woodcuts produced in Tokugawa Japan (1603–1868) provide the most extensive visual documentation ever produced of same-sex prostitution. For perhaps the only time in recorded history, brothel scenes were avidly collected by large numbers of ordinary middle-class collectors.

Moronobu, Shunsho, and Utamaro were among the leading artists who recorded life in the "floating world" pleasure quarters of cities, where working and middle-class Japanese citizens could procure entertainment at the legalized brothels, as well as at kabuki theaters and restaurants.

Approximately half of the many hundreds of Tokugawa-era prints of brothels involve same-sex male prostitution. Some scenes wittily reveal the monetary basis of the transactions in brothels; for instance, the anonymous *An interrupted tryst with a male prostitute* (ca. 1700) shows a madam stopping a man who has exceeded his allotted time as he is about to penetrate the youth lying beneath him.

However, numerous other images poetically evoke a mood of tender romance between the prostitute and client (for example, Nishikawa Sukenobu's *Customer with boy prostitute*, ca. 1740).

Same-sex prostitution enabled clients to bypass otherwise rigorously enforced gender and sexual norms. Thus, many of the images show the erect penises of male prostitutes protruding through the women's attire that they habitually wore.

Although women could (and did) freely utilize the services of both male and female prostitutes, only about 10 percent of brothel scenes represent women as clients. It has been suggested that most of the relatively rare lesbian brothel scenes (such as Katsushika Hokusai's *Lesbian sex with double-headed dildo*, early 1800s) may have been intended primarily to titillate male viewers, but they certainly could have been purchased and enjoyed by women as well.

The Art of Early Modern Europe

In contrast to the situation in Tokugawa Japan, scenes of same-sex prostitution were relatively rare in early modern Europe, no doubt because of the rigorous suppression of any type of "deviant" behavior. However, it seems likely that many of Caravaggio's early scenes of youths (such as *The Musicians*, 1596) represent the street hustlers with whom he is known to have associated.

A pair of eighteenth-century Venetian prints evokes the allure of transgender prostitution. One of these images depicts a full-bosomed woman in male attire; the other shows a lavishly dressed man, whose (apparently) very large penis has caused his skirts to bulge out.

Most preserved early modern European images depict same-sex prostitution from a very negative point of view. For instance, a sixteenth-century Italian majolica plate depicts a monk with a large money bag lustily pointing at the buttocks of a naked boy beneath an inscription that can be translated, "I am a monk, I act like a hare."

Toward the end of the nineteenth century, several Symbolist artists catered to the fascination of avant-garde circles with "decadence." Thus, the Belgian artist Félicien Rops produced numerous engravings of lesbian brothel scenes, with notably morbid overtones.

Pre-Stonewall Twentieth-Century Art

In the context of the emerging gay and lesbian communities in major American and European cities in the pre-Stonewall era of the twentieth century, several artists provided more objective images of same-sex prostitution.

For example, in a remarkable series of watercolors which he allowed only his most intimate gay friends to see, Charles Demuth depicted the solicitation of street hustlers and other types of anonymous sexual encounters. In many of his exhibited paintings, Paul Cadmus also included coded references to same-sex prostitution.

In the free environment of 1920s Berlin, Jeanne Mammen created numerous illustrations of lesbian prostitution and other aspects of the women's club "scene" for lesbian periodicals and other publications.

Physique Pictorial (published by Bob Mizer from 1952 to 1992) and other "underground" erotic publications of the post–World War II era included many scenes of same-sex prostitution and other activities that flagrantly challenged the legal restrictions of mainstream society.

Similarly, lurid covers (and texts) of women's pulp novels of the 1940s and 1950s often presented provocative images of lesbian prostitution.

Andy Warhol made male prostitution the central theme of many of his early, kitschy films, most notably *Blow Job* (1963). Later in his career, Warhol incorporated prostitution into the making of his art by hiring street hustlers to urinate on his *Oxidation Paintings* (1978).

Post-Stonewall Art

In the post-Stonewall era, several queer artists have made prostitution a primary theme of their work. Prominent among them is David Wojnarowicz, who depicted his experiences as a street hustler in fiercely angry, yet intensely erotic, paintings and prints, as well as in powerful prose works.

Wojnarowicz's close friend, photographer Peter Hujar, created dignified portraits of queer and transgender prostitutes. Hujar often suggested the inner strength that enabled his subjects to cope with poverty and other difficulties.

The world of hustlers and their clients is also depicted in several works by Patrick Angus.

Queer and transgender sex workers also are featured prominently in "The Ballad of Sexual Dependency" and other ongoing photographic projects by Nan Goldin. Her loving and inclusive representation of prostitutes as an essential part of the panorama of her extended family signifies an important transformation in the treatment of this important subject.

— *Richard G. Mann*

BIBLIOGRAPHY

Cooper, Emmanuel. *The Sexual Perspective: Homosexuality and Art in the Last 100 Years in the West.* 2nd ed. London and New York: Routledge, 1994.

Davis, Whitney, ed. *Gay and Lesbian Studies in Art History.* New York: Harrington Park Press, 1994.

Leupp, Gary P. *Male Colors.* Berkeley: University of California Press, 1995.

Saslow, James M. *Pictures and Passions: A History of Homosexuality in the Visual Arts.* New York: Penguin Putnam, 1999.

SEE ALSO

American Art: Gay Male, 1900–1969; American Art: Gay Male, Post-Stonewall; American Art: Lesbian, Post-Stonewall; European Art: Twentieth Century; Classical Art; Indian Art; Japanese Art; Symbolists; Pulp Paperbacks and Their Covers; Angus, Patrick; Cadmus, Paul; Caravaggio; Demuth, Charles; Mammen, Jeanne; Warhol, Andy; Wojnarowicz, David

Subjects of the Visual Arts: Psyche

PSYCHE, A LATE ADDITION TO OLYMPIAN DIVINITIES, was a beautiful young girl whose name in Greek means "soul." One source claims that she was the daughter of the Sun (divine light) and Endelechia (the ripeness of Time).

The story of her relationship to Cupid (Amor) is frequently read as an allegory of the human confrontation with desire and the divine. Although universal, the story has a particular resonance for gay people, whose identity is tied closely to desire. Moreover, while Psyche is female, she may be read as a symbol of the male soul; hence, images of Psyche often blur gender boundaries.

The various versions of the story of Psyche most frequently emphasize the tribulations caused by jealousy and desire. As a young girl, she gained a reputation for great beauty. When Venus (Aphrodite) learned of her beauty, she was unnerved by the competition and instructed her son Cupid (Amor) to make Psyche fall in love with an ugly monster. Cupid, however, on seeing Psyche, immediately fell in love with her himself.

Cupid could not reveal his divine nature, so he visited Psyche in darkness. The girl's jealous sisters claimed that Cupid was really a terrible creature who would devour her. When Psyche managed to uncover him while he was sleeping, she was transfixed by his beauty. However, she accidentally dropped hot oil on his naked shoulder—one of the incidents in her life most popular with artists.

Angered, Cupid abandoned her to her fate. Psyche was condemned to wander the earth performing onerous tasks assigned by Venus. She attempted suicide and ended up in the underworld. Cupid eventually relented and appealed to Zeus to allow him to marry her and thus make her divine. They had a child called Voluptas.

The primary source for the romance of Cupid and Psyche is Lucius Apuleius's riotous novel, *Metamorphoses*, or *The Golden Ass* (second century C.E.). Apuleius's Psyche is a searching, inquisitive girl who is basically good but credulous.

She shines a light into the mystery of love too impulsively, only to watch it vanish. The drudgery of her punishment is also her education and eventual liberation into her divine aspect. The allegory fuses Greek myth with the initiation rites of Eleusis and Platonic idealism.

Psyche has inspired operas by Pier Francesco Cavalli and Jean-Baptiste Lully, ballets by Mikhail Fokine and Frederick Ashton, and appears as often in painting and sculpture as in literature. Frequently depicted naked and with wings, Psyche is often linked to Cupid but is also seen solo in a number of artists' works.

The best-known depictions of Psyche from the Renaissance are those by Giorgione and Raphael. In the seventeenth century, Caravaggio, Titian, Velázquez, and Poussin all turned to the subject of Psyche.

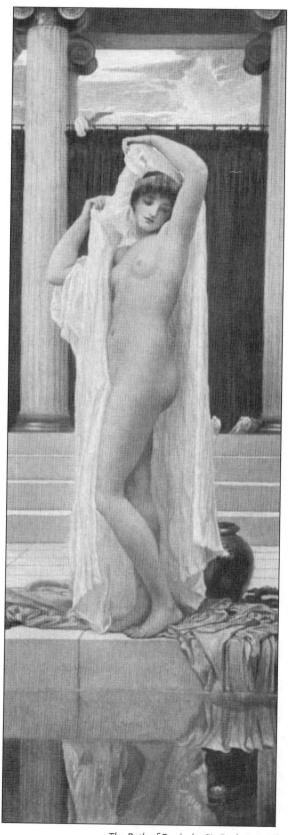

The Bath of Psyche by Sir Frederic Leighton.

In the late eighteenth century, Romantics Henry Fuseli and William Blake both did a series of visionary engravings inspired by her.

The painting *Cupid and Psyche* (1817) by Jacques-Louis David is especially noteworthy, as it has a cheeky eroticism, and lacks the innocence of other treatments.

Some artists returned to Psyche numerous times, among them Peter Paul Rubens, François Boucher, Auguste Rodin, and Edward Burne-Jones. Burne-Jones's painting *Cupid and Psyche* (1865–1887) and Rodin's marble sculpture *Cupid Embracing Psyche* (1908) are two outstanding examples. Burne-Jones makes Cupid and Psyche practically twins, as does the Rodin statue, where they are almost fused together, thus collapsing the male/female divide.

Literary inspirations also testify to the abiding allure of Psyche's story. Walter Pater made it the centerpiece of his novel *Marius the Epicurean* (1885), feeling that it expressed the ideal of a perfect imaginative love. Eudora Welty, in *The Robber Bridegroom* (1942), and Thomas Mann, in *Doktor Faustus* (1947), used it thematically. Joyce Carol Oates and James Merrill, among many others, refer to Psyche in their poetry.

The term *psyche* now more commonly refers to the mind in its subconscious aspect rather than to the soul. In psychology, some experts regard her story as indicative of female psychic development, whereas others interpret Psyche as representing the *anima* (Latin for soul), a female image of the male soul.

— *Kieron Devlin*

Bibliography

Apuleius, Lucius. *The Golden Ass.* William Adlington, trans. Wordsworth Classics of World Literature. Ware, Hertfordshire, England: Wordsworth Editions, 1996.

Gollnick, James Timothy. *Love and the Soul: Psychological Interpretations of the Eros and Psyche Myth.* Waterloo, Ont.: Wilfrid Laurier University Press, 1992.

Kenney, E. J., ed. *Psyche et Cupido.* Cambridge: Cambridge University Press, 1990.

Pater, Walter. *Marius the Epicurean.* London: Macmillan, 1885.

Reid, Jane Davidson, ed. *The Oxford Guide to Classical Mythology in the Arts, 1300–1990s.* New York: Oxford University Press, 1993.

Vertova, Luisa. "Cupid and Psyche in Renaissance Painting before Raphael." *Journal of the Warburg and Courtauld Institute* 42 (1979): 104–121.

See Also

Caravaggio; Fuseli, Henry

Subjects of the Visual Arts: Sailors and Soldiers

SOLDIERS AND SAILORS CONSTITUTE A LONG-STANDING presence in gay male visual culture.

Across and beyond the heavily coded abstractions of Marsden Hartley, who painted about his love for a German soldier; the exaggerated fetishism of Tom of Finland, who established an entire erotic aesthetic based on the uniform; the inclusion of a seaman/GI among The Village People, a discotheque cross section of butch fantasy roles; and on to the seemingly endless "hard service" plots of contemporary gay male porn, which set army barracks, close quarters, and shore leaves as the backdrops of same-sex lust, soldiers and sailors are an easily recognizable mainstay of the gay visual vernacular in the West.

As is often the case in queer strategies of representation, the erotic appeal behind these archetypes is ironic and multilayered, at once idolizing, undermining, and reinterpreting the rugged masculinity, virile physicality, and forthright patriotism that sailors and soldiers purportedly symbolize.

While the meanings that soldiers and sailors signify have certainly changed over the years, one aspect of their eroticism seems fairly consistent: a play on their ambiguous identity as "straight."

The image of the sexually available, morally capricious, ever horny serviceman emerged in the early 1900s during a time when the identity "homosexual" was determined greatly by a man's role in sexual encounters with other men, not necessarily his attraction to them in the first place; only the "feminine" or receptive partner qualified socially as gay.

This ruling social code, known commonly as "trade," allowed soldiers and sailors to occupy a complex place in the gay worlds of World War I–era America; they were at once common players in gay urban culture—enjoying countless romps with civilian men during shore leaves and weekend passes—and patently detached from that culture and the social ramifications membership within it otherwise held.

Thus began what would become a long romance between gay culture and not only the servicemen themselves, but also the allure of their uncompromising hetero-masculinity.

While configurations of sexual identity have changed over the years, the precocious in-betweenness of the swarthy serviceman is central even in contemporary representations.

The World War I–era works of gay painter Charles Demuth (1883–1935) and the slightly later paintings of Paul Cadmus (1904–1999) readily depict the concept of trade, as sailors lounge in ambiguous fraternal groupings or are juxtaposed against queeny civilians—the "real" gay men—who lure them.

These paintings attest to the possibilities for sexual encounters between men in urban culture during the first half of the last century and posit the sailor's heteromasculinity as a key component of his homoeroticism.

As the photochemical media became the privileged form of gay imagery starting in the 1950s, soldiers and sailors became part of a vast vocabulary of the beefcake pinup and bodybuilding photography.

The supposed heterosexuality of these erotic archetypes took on a new twist in the pages of physique magazines, which maintained an asexual veneer of wholesome (heterosexual) athleticism even though they were meant (in their production, marketing, and distribution) to tantalize the sexual tastes of gay men.

To be sure, these physique photographs became the erotic fodder for Tom of Finland, who later produced less ambiguous (although no more dreamy) images: Strapping marines in tight uniforms eye each other while grabbing their bulging crotches or, in other drawings, explore the pleasures of corporal discipline.

As Tom of Finland's works were made expressly for gay audiences and as they cast soldiers and sailors in hard-core man-to-man encounters, they seem to share a certain narrative perspective with contemporary gay male pornography. In both cases, as "barracks buddies" submit to each other's advances, there seems to be less evidence that these men are "really straight."

However, it says a great deal that the action in current military-genre gay male video porn is often framed as circumstantial. The premise of sex-starved men, iso-lated in a strictly homosocial environment, who are wanton enough to do anything (or anyone) to get off, permits the idea to persist that lust among soldiers and sailors might not be "truly gay."

While contemporary viewers may tend to read the visual centrality of sailors and soldiers as commensurate with the "we are everywhere" slogans of current gay politics, their popularity is more likely an indicator of the psychic power that heteromasculinity wields in the formation of gay desire and, in true postmodern fashion, our collective impulse to rewrite it.

Nonetheless, awareness of the circumstances that resulted in the infamous "Don't Ask, Don't Tell" policy of the U.S. armed forces and the harassment facing gay servicemen makes it nearly impossible to read homoerotic images of soldiers and sailors in an apolitical light.

— *Jason Goldman*

BIBLIOGRAPHY

Chauncey, George. *Gay New York: Gender, Urban Culture, and the Making of the Gay Male World, 1890–1940.* New York: Basic Books, 1994.

Cooper, Emmanuel. *The Sexual Perspective: Homosexuality and Art in the Last 100 Years in the West.* New York: Routledge, 1994.

Waugh, Thomas. *Hard to Imagine: Gay Male Eroticism in Photography and Film from Their Beginnings to Stonewall.* New York: Columbia University Press, 1996.

SEE ALSO

American Art: Gay Male, 1900–1969; American Art: Gay Male, Post-Stonewall; Erotic and Pornographic Art: Gay Male; Cadmus, Paul; Demuth, Charles; Hartley, Marsden; Tom of Finland

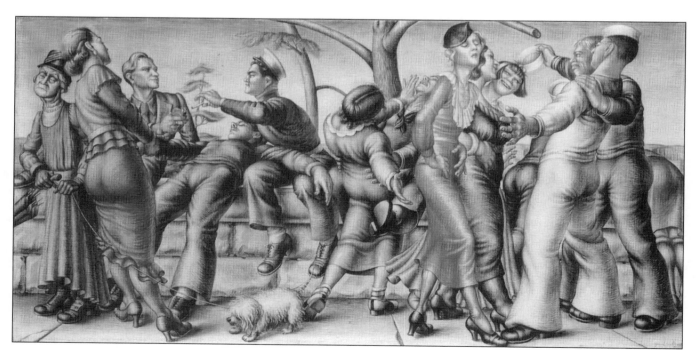

The Fleet's In by Paul Cadmus.

Subjects of the Visual Arts: Sappho

DESPITE SAPPHO'S STATUS AS MOST ANCIENT LESBIAN foremother, her image is almost entirely absent from modern and contemporary lesbian art. The great esteem in which she was held in the Classical era was certainly reflected in visual art of the period; statues of her were erected in public places and coins were struck bearing her portrait. Some of these were later collected by Renée Vivien during a "pilgrimage" to Lesbos.

Sappho was an occasional subject for the "historical" painters of Victorian England, particularly Sir Lawrence Alma Tadema. Sappho was probably chosen as the subject of these paintings because, in painting the historical figure, "accuracy" could justify otherwise scandalous images of scantily clad young women.

Alma Tadema depicted Sappho for the same reason that he painted the frenzy of the Maenads or girlish frolics in Roman bathhouses: These subjects provided maximum opportunity for titillation. Alma Tadema's Sappho is, moreover, pointedly heterosexual.

Another Victorian, Simeon Solomon, also painted Sappho in the "classical" style. But Solomon's own homosexuality lends this work a darker eroticism. In his famous painting *Sappho and Erinna in a Garden at Mytilene* (1864, displayed in the Tate Gallery, London), Erinna swoons with desire in Sappho's embrace.

Feminist artists, of whatever sexuality, have largely ignored her. The "women of the Left Bank," expatriate lesbians from England and the United States who gathered in Paris between the world wars, certainly took inspiration from Sappho, but they did not paint or draw her.

Later in the twentieth century, heterosexual artist Judy Chicago included Sappho in her *Dinner Party* project (1974–1979), in which famous women from history are each represented by an embroidered place setting and a sculpted ceramic plate, but this is one of only a handful of images.

Given that feminist and lesbian artists commonly make use of other female figures from classical times, the paucity of representations of Sappho is puzzling. — *Tamsin Wilton*

BIBLIOGRAPHY

Chicago, Judy. *Embroidering Our Heritage: The Dinner Party Needlework.* New York: Doubleday, 1980.

Morgan, Thaïs. "Perverse Male Bodies: Simeon Solomon and Algernon Charles Swinburne." *Outlooks: Lesbian and Gay Sexualities and Visual Cultures.* Peter Horne and Reina Lewis, eds. London: Routledge, 1996. 61–85.

Weiss, Andrea. *Paris Was a Woman: Portraits from the Left Bank.* London: Pandora, 1995.

Wilton, Tamsin. *Lesbian Studies: Setting an Agenda.* London: Routledge, 1995.

SEE ALSO

Classical Art; Chicago, Judy; Solomon, Simeon

Sappho.

Subjects of the Visual Arts: St. Sebastian

THERE IS HARDLY ANYTHING UNUSUAL OR PARTICULARLY compelling about a gay icon who is young, beautiful, white, shirtless, and baby-faced. But what if this same boyish icon had emerged from a key historical antagonist of same-sex desire: the teachings of Christianity?

The case of Saint Sebastian, who was martyred in 287, animates several complex questions about the evolution of a gay idol, not the least of which is his so-called appropriation from the hallowed pages of church history and martyrology to the visual, literary, and filmic works of numerous gay artists.

For example, Sebastian appears in the work of Marsden Hartley, F. Holland Day, Frank O'Hara, Marcel Proust, Derek Jarman, and Pierre et Gilles, to name but a prominent few; and he was a featured subject of a host of Renaissance and Baroque artists (including Tintoretto, Mantegna, Titian, Guido Reni, Giorgione, Botticelli, and "Il Sodoma") whose works inspired an explicitly homosexual cult of Saint Sebastian in the nineteenth century.

Sebastian's broad and long-standing presence in queer artistic production suggests that there is more to his appeal than the good looks with which he is most often rendered. Rather, several coexisting elements of his narrative make him an enduring trope of modern gay fascination.

Renaissance representations of Saint Sebastian—mostly paintings of a tender, loinclothed youth writhing in the ecstasy of the arrows that pierce him—are perhaps ground zero for his appointment as the patron saint of gay sensuality.

And for seemingly obvious reasons. Sebastian's supple, near-naked body; the "wink-wink" symbolism of the penetrating arrows; his thrown-back head expressing a mixture of pleasure and pain; and his inviting gaze all readily contribute to his homoerotic appeal. But Sebastian's entry into gay cultures in the first place most certainly involves his origins as an emblem of Christian godliness and martyrdom.

Same-sex desire is often, on many levels, about the crossing of lines, the overturning of sacred norms, the pleasure of the forbidden. Both the story of Sebastian and his subsequent role in modern gay cultures epitomize this subversive impulse: Sebastian revels in the pleasure of his own martyrdom as gay men revel in gazing upon an off-limits emblem of Christian holiness. By all accounts, Sebastian is a very good "bad object-choice."

The question of whether Sebastian himself was gay is largely moot. While some historical records suggest a notable affection between the saint and his male superiors,

after almost two thousand years Sebastian's sexuality is not only greatly speculative, but also rather inconsequential.

However, while it is doubtful that a buried homosexual existence could justify his current camp popularity, it seems equally doubtful that his homoerotic associations can be explained away as the superficial afterthoughts, revisions, or cross-readings of a willful contemporary gay purview.

Like many personages who are continually reiterated, Sebastian has essentially grown up alongside modern notions of sexuality and the formation of gay consciousness, becoming an accessible touchstone of both gay desire and gay experience in the process.

As Richard A. Kaye aptly notes, "contemporary gay men have seen in Sebastian at once a stunning advertisement for homosexual desire (indeed, a homoerotic ideal), and a prototypical portrait of tortured closet case."

The melancholy tone of Sebastian imagery—to say nothing of Sebastian's accompanying torment—is a ready parallel to the feelings of shame, rejection, inverted desire, and loneliness endured by queer people in a homophobic society.

The coding of these maladies is perhaps all the more effective because it is not easily separable from—indeed, it is rendered by the same means as—Sebastian's come-hither beauty and sexual availability.

In all, Sebastian's narrative complexity, vernacular resonance, and theological origins speak volumes of the queer representational strategies through which he is deployed.

— *Jason Goldman*

BIBLIOGRAPHY

Kaye, Richard A. "Losing His Religion: Saint Sebastian as Contemporary Gay Martyr." *Outlooks: Lesbian and Gay Sexualities and Visual Cultures.* Peter Horne and Reina Lewis, eds. New York: Routledge, 1996. 86–105.

SEE ALSO

European Art: Renaissance; European Art: Nineteenth Century; Day, F. Holland; Hartley, Marsden; Pierre et Gilles; Il Sodoma (Giovanni Antonio Bazzi)

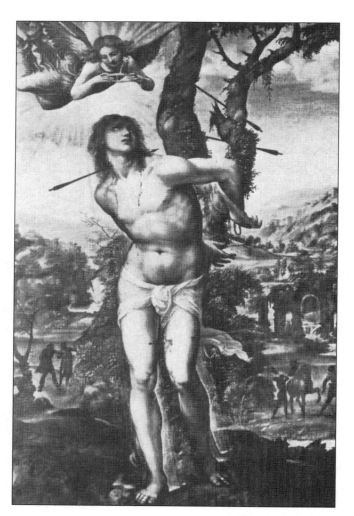

St. Sebastian by Sodoma.

Subjects of the Visual Arts: Vampires

AN INVENTION OF THE NINETEENTH CENTURY, THE artistic vampire, as opposed to the vampire of folklore, is connected not with disease but with sexuality. For authors, artists, and filmmakers, artistic vampires represent a common sexualized metaphor—the release of insurgent passion and emotion—that includes such details as the erotic foreplay of vampires' attacks and the creatures' dependency on the bodily fluid of their victims.

From its inception, as an outsider within polite society, the artistic vampire has been consistently linked with homosexuality. Samuel Taylor Coleridge's "Christabel" (1797) portended a lesbian vampire, while John Polidori's "The Vampyre" (1819) depicted a young man's homosocial desire for the dominant male vampire.

While this association pervaded much of the Victorian era, by the beginning of the twentieth century, the sexual vampire gave way to a more horrific image, and the first vampire films, F. W. Murnau's *Nosferatu* (1919) and Tod Browning's *London After Midnight* (1925), reflect this trend. Early vampire cinema is remarkably heterosexist, belying the literary tradition that spawned it.

The sexual revolution of the 1960s, coupled with the Stonewall riots of 1969 and a new public awareness of homosexuality, soon altered things, and gay and lesbian themes became commonplace in vampire cinema.

The first important homosexual vampire film was Roy Ward Baker's *The Vampire Lovers* (1970), an adaptation of J. Sheridan Le Fanu's *Carmilla*. Other gay vampires appeared simultaneously in Roman Polanski's *The Fearless Vampire Killers* (1967), Lancer Brooks's *Sons of Satan* (1973), Ulli Lommel's *Tenderness of Wolves* (1973), Jimmy Sangster's *Lust for a Vampire* (1973), and even in a gay pornographic film, Patrick Dromgoole's *Does Dracula Really Suck?* (1969?).

This marriage of metaphor—vampire to homosexual—remained a constant throughout the 1970s, culminating in Tony Scott's *The Hunger* (1983).

Now permanently linked with sexuality in such films as Neil Jordan's *Interview with the Vampire* (1994), Abel Ferrara's *The Addiction* (1995), Michael Almereyda's *Nadja* (1995), and David DeCocteau's *The Brotherhood* (2000), homosexuality remains a common if not constant theme, a sexual metaphor that continues to bind representations of vampires with homosexuals in the arts.

— *Michael G. Cornelius*

BIBLIOGRAPHY

Auerbach, Nina. *Our Vampires, Ourselves.* Chicago: University of Chicago Press, 1995.

Beebe, John. "He Must Have Wept When He Made You: The Homoerotic Pathos in the Movie Version of Interview with the Vampire." *The Anne Rice Reader.* Katherine Ramsland, ed. New York: Ballantine Books, 1997.

Benshoff, Harry M. *Monsters in the Closet: Homosexuality and the Horror Film.* Manchester, England: Manchester University Press, 1997.

Melton, J. Gordon. *The Vampire Book.* Detroit: Visible Ink Press, 1994.

"Queer Horror." www.queerhorror.com

Weiss, Andrea. *Vampires and Violets: Lesbians in Film.* Kitchener, Ontario: Pandora Press, 2001.

Surrealism

SURREALISM IS AN ARTISTIC MOVEMENT THAT GREW OUT of Dadaism and flourished in Europe shortly after the end of World War I. Influenced by the psychological writings of Sigmund Freud (1856–1939) and Carl Jung (1875–1961), and their belief that the workings of the mind can be discerned through the interpretation of dreams, Surrealists believed in freeing themselves of any conscious control that might impede their artistic expression. For them, art was an expression of the subconscious.

Surrealism quickly attained an avant-garde status. Although enormously popular in Europe, Surrealism, in an attempt to distance itself from normative expression, nonetheless allied itself with outsiders. As a result, homosexual communities and artists quickly accepted the new form of expression.

The period after World War I in Europe was marked by great disruption and upheaval. The old political order had been shattered, and a tinge of hopefulness pervaded the Continental artistic community. Dadaism, the forerunner to Surrealism in which artistic works deliberately defied convention or comprehension, was heavily influenced by the ongoing war and was, consequently, a dark and negative type of expression. Surrealism grew out of Dadaism but also essentially grew away from it.

Far from being negative, Surrealism focused on positive expression. This combination of the realities of the aftermath of World War I and the dreamy hopefulness of the Continent between the world wars helps account for the seemingly contradictory elements of Surrealism as it attempted to reconnect seemingly disjointed ideals: light and dark, the conscious and the unconscious, hope and despair, rationalism and irrationalism, dream and fantasy.

Surrealism began as a literary movement in France, but quickly became most popularly connected with the art world. Led by André Breton (1896–1966), a poet and critic who in 1924 published "The Surrealist Manifesto," Surrealism soon became the "new" and "exciting" form of artistic expression worldwide, a popular alternative to the highly formalized Cubist movement that had recently dominated the art world.

At its essence, Surrealism celebrates primitive art, the work of children or madmen. Ordinary forms and objects are used in often strange and stunning ways to create art. Surrealism often depicts what should not, or could not, actually exist; for example, the famous painting *Portrait of Edward James* (1937) by René Magritte (1898–1967) depicts the back of a man's head as he looks into a mirror, only to see the identical back of the head reflected in the mirror.

Over time, two distinct groups of Surrealist painters emerged: the automatists, who favored the domination

of the conscious over the subconscious, and the veristic Surrealists, who favored the subconscious over the conscious. Pablo Picasso (1881–1974), though not considered a true Surrealist, was the foremost of the automatists, while Salvador Dalí (1904–1989) emerged as the most famous of the veristic Surrealists.

The major Surrealistic painters of the time now read like a who's who of twentieth-century art masters: Dalí, Magritte, Jean Arp (1887–1966), Max Ernst (1891–1976), André Masson (1896–1987), Yves Tanguy (1900–1955), Pierre Roy (1880–1950), Paul Delvaux (1897–1994), and Joan Miró (1893–1983).

With the popularity of cinema growing in Europe throughout this time, it is no surprise that Surrealism also became a cinematic expression, especially in France. The most prominent Surrealist filmmakers are Jean Cocteau (1889–1963) and Luis Buñuel (1900–1983), who collaborated with Dalí on one of his films, *L'Age d'Or* (1930).

While Surrealism is still considered a popular artistic movement among homosexual artists, the initial and most influential members of the Surrealist movement were noisily antihomosexual. Breton, perhaps as a means of asserting his masculinity, was a loud and frequent critic of gay artists and authors, often complaining that he was the sole heterosexual in the field of Surrealism.

Dalí, too, was uncomfortably antihomosexual. Speculation abounds as to his true sexuality, especially in light of his rumored affairs with poet Federico García Lorca (1898–1936) and others, but nonetheless, he was known for his antihomosexual views.

Breton and Dalí considered homosexuals to have too much influence in the artistic community in general, as critics, artists, and gallery owners, and often railed against this allegedly baneful influence.

The Surrealist writers had their homosexual members, such as Rene Crevel (1900–1935), but the Surrealist painters seem reticent about sexuality, their own and others. Surrealists were said to worship women, but they rarely included female painters in their artistic circles.

Given the fluidity of their paintings and the aggressive nature of their subject choices, it is difficult to discern interpretations of homosexuality, homoeroticism, or even homosociality in their works.

In Dalí, for example, sexuality is often brutal, carnal, or grotesque, but in most instances it is almost always overtly masculine, feminine, or masculine/feminine; gender rarely seems confused or ambiguous.

Dalí's painting *Crucifixion* (1954) presents a typical example. Dalí's interpretation of Christ on the cross, often an eroticized form in art, is extreme and austere; the draped woman gazing at the hovering form of Christ on the enormous geodesic cross suggests heterosexual longing, though there is nothing in the features of Christ himself that suggests homoerotic desire on the part of the artist. Through both topic and depiction, typical sexuality is subverted, but not in any way that suggests homosexual desire.

Surrealistic filmmakers, like Surrealist writers, had more freedom in their celluloid creations, and one can find splashes of homoeroticism in the works of Cocteau and Buñuel.

Buñuel's film *Los Olvidaros* (1950), for example, features a minor homosexual character (who, alas, is portrayed in a typically predatory manner) and also presents a male-dominant homosocial portrait of street life in poverty-stricken, urban Mexico.

Cocteau, who was himself homosexual, offers similar glimpses of homosexuality in his works.

Surrealism failed to achieve significant popularity in 1930s America, and as World War II loomed, the movement began to wane in Europe as well. Its influences, however, are widespread; and Surrealism and the Surrealists, despite the antihomosexual stance of their leaders, have been embraced by homosexual communities and artists worldwide.

Thus, while Surrealism as a visual art did not initially embrace its homosexual members, it is now often the homosexual painters, critics, and writers who have worked to keep the movement alive as an artistic expression.

— *Michael G. Cornelius*

BIBLIOGRAPHY

Bataille, Georges. *The Absence of Myth: Writings on Surrealism.* Michael Richardson, ed. and trans. London: Verso, 1994.

Breton, André. *Surrealism and Painting.* Simon Watson Taylor, trans. New York: Harper and Row, 1972.

Caws, Mary Ann. *The Surrealist Look: An Erotics of Encounter.* Cambridge, Mass.: MIT Press, 1999.

Jean, Marcel, ed. *The Autobiography of Surrealism.* New York: Viking Press, 1980.

Lomas, David. *The Haunted Self: Surrealism, Psychoanalysis, Subjectivity.* New Haven: Yale University Press, 2001.

Matthews, J. H. *Imagery of Surrealism.* Syracuse, N. Y.: Syracuse University Press, 1977.

———. *Languages of Surrealism.* Columbia: University of Missouri Press, 1986.

Nadeau, Maurice. *The History of Surrealism.* Richard Howard, trans. New York: Macmillan, 1965.

Walz, Robin. *Pulp Surrealism: Insolent Popular Culture in Early Twentieth-Century Paris.* Los Angeles: University of California Press, 2000.

SEE ALSO

European Art: Twentieth Century

Symbolists

THE SYMBOLIST MOVEMENT IN PAINTING AND LITERA-ture flourished from 1886 to 1905. It was the first self-consciously queer movement in Western art history. Characterized by strange mythological or mystical themes, it evinced a preoccupation with (and sometimes even celebration of) death, dreams, evil, decadence, femmes fatales, androgyny, perversity, and the occult.

The roots of the Symbolist movement were in Romanticism and it shared some features of Mannerism, while anticipating such later movements as Art Nouveau, Expressionism, and Surrealism.

The Cult of the Diva, however, with its attendant homoerotic impulse, was central to the ethos of the Symbolists, who were also called Decadents—a term more or less interchangeable with homosexuality in the public mind at the end of the nineteenth century.

Symbolism is hard to define since it embraced different media and its practitioners were highly idiosyncratic. Strictly speaking, unlike the Impressionists, Symbolists leaned more to darkness than light, judging by the recurrence of perverse, morbid, or supernatural themes.

The movement was a reaction against an increasingly industrial society and against the perceived limits of Impressionism. Symbolists differed from Academic painters in their more experimental use of paint, tone, and color and their lack of regard for socially acceptable themes.

In their work, animals were often fantasy hybrids: unicorns, chimeras, griffins, and sphinxes, with the occasional peacock or swan; and figures tended to be androgynous, cruel, or erotic.

Gustave Moreau

Symbolism's finest exemplar is French painter Gustave Moreau. His work attempted to reach beyond the real, to depict emotionally charged states that he thematically elaborated with leitmotifs as in Wagnerian operas. He continually retouched his paintings, never regarding them as finished. For example, he worked on *The Suitors* intermittently from 1852 to 1872.

Moreau's paintings are suffused with eroticism. They feature languid, jeweled, or epicene figures in ceremonial poses. His male figures are usually passive, frail, and seminaked. He wanted these figures to be emblematic of what he termed "ideal somnambulism," neither active nor inactive. He believed only in what he did not see, and drew on a system of almost Cabbalistic correspondences and personal allusions to make vivid his feverish inner world.

The use of symbols did not originate with the Symbolist movement. Indeed, symbols are prevalent in the work of old masters, yet Moreau pioneered by fusing symbol with technique. He experimented with watercolor and with thickly applied paint in the manner of Delacroix, and thereby foreshadowed Abstract Expressionism.

Moreau lived with his mother for most of his adult life. He was an intensely private person, and from this distance his sexual orientation is impossible to determine with certainty. His work, however, profoundly influenced other painters and writers who were homosexual or bisexual.

Pierre Puvis de Chavannes

In addition to Moreau, Pierre Puvis de Chavannes was also a prominent member of the French Symbolist movement. Chavanne's work echoes the frescoes of Piero Della Francesca and Odilon Redon. He was a fine illustrator of macabre subjects, some inspired by Edgar Allen Poe.

Chavannes liked to think of himself as more traditional than Moreau and the other Symbolists, yet the influence of his restrained, disconcertingly static compositions on painters matched that of Moreau's.

J.-K. Huysmans

Symbolist artists were particularly enamored of the *poètes maudits* (accursed poets), especially as exemplified by Baudelaire, Mallarmé, Verlaine, and Rimbaud. But novelist J.-K. Huysmans wrote the bible of the Decadents in *À Rebours* (*Against Nature*, 1884), a work much admired by Oscar Wilde.

The protagonist of *Against Nature* is Des Esseintes, a man so disillusioned with the normal that he retreats into a hermetic world and becomes an obsessive collector—of all sorts of objects, including clothes, rare works in Latin, décor, spangled jewels, paintings, liturgical music, and sins. Eventually Des Esseintes has a homosexual encounter. Interestingly, the novel includes a gushing, ecstatic description of a painting of *Salome* by Moreau.

Cult of the Diva

Salome was vital to Moreau and all Symbolists because she represented to them the ultimate castrating female. Moreover, her story has clear hints of male Oedipal anxieties, and even sadomasochism. Salome became a metaphor for the new man troubled by his gender role.

Symbolist artists tended to be fastidious aesthetes, dandies, reclusive hermits, or mystics, and they were frequently attracted to the priesthood. Most were what we would now classify as homosexual or bisexual; they were certainly not traditionally heterosexual.

They were, however, obsessed with the female muse in her various guises. Figures such as Eve, Lilith, Judith, Medusa, Pandora, and Jezebel recur in their works, usually as wicked divas. Whereas in Baroque art female figures tend to be the victims of male cruelty and sexual assault, in Symbolist art men are more often sexual victims.

The Pont-Aven School

Although Paul Gauguin defined himself as an Ideist or Synthetist artist rather than a Symbolist, he was adored by many Symbolist artists, some of whom influenced his own work. His followers formed the school of Pont-Aven in Brittany.

Among them was Charles Filiger, whose primitive, naive style in the depiction of farm boys in Brittany and of Christ-figures attests to his struggle with homosexuality and religion. His work also provides an example of Symbolist sacred or mystical art.

Influence of Symbolism

Gauguin himself became Symbolism's chief disseminator and frequently evinced the influence of Symbolism in his own work. He achieved an astonishing subtlety and unity of feeling in *The Vision after the Sermon* (1884) and *Where Do We Come From? What Are We? Where Are We Going?* (1897), which is at once exotic, symbolic, and philosophic.

After Gauguin left for Tahiti, a small group of artists gathered around Paul Sérusier and called themselves the Nabis (*prophet* in Hebrew). This group included Maurice Denis, Pierre Bonnard, and Edward Vuillard.

Even Picasso flirted with Symbolism before moving on to Cubism. In this sense Symbolism is best seen as not so much a style as a thematic approach, a cult of self that led artists to produce their weirdest, most visionary paintings.

The English Aesthetic Movement

The Aesthetic Movement in England paralleled many of the doctrines of French Symbolism. It too was a revolt against vulgarity and increasing industrialization. It also manifested the same longing for deeper meaning and the same idealistic temperament and drew heavily on Medieval and early Renaissance art.

Edward Burne-Jones

Edward Burne-Jones, whose outstanding body of work is radiant and harmoniously composed and reminiscent of Mantegna or Botticelli, did not subscribe to a Decadent aesthetic and was happily married.

He did, however, produce many resonant images of anatomically indeterminate or androgynous figures. For example, his multiple female figures in *The Golden Stairs* (1880) have the musculature of beautiful adolescent boy clones. This androgynous image was considered a utopian ideal, a presexual state or a union of the sexes into a kind of third sex. It was the idealized transgender of its time.

Aubrey Beardsley

The supreme English Decadent artist was Aubrey Beardsley, whose career was as brief as it was brilliant.

His work is strikingly original: Once seen, it is never forgotten. His illustrations of Aristophanes' *Lysistrata* (1896), featuring ill-concealed phalli and stylized pubic hair, and of Wilde's *Salome* (1894), in which he caricatured Wilde's plump face in the moon, are benchmarks of witty provocation.

Beardsley's freeing of the Arabesque line almost certainly triggered the decorative excesses in Art Nouveau. His expert draftsman's skills perfectly suited the expanding medium of print.

Beardsley's personal motifs included erections and sexual fetishes for such objects as shoes, feathers, scissors, powder puffs, and curling locks of hair. He drew these objects with a frankness that seems the antithesis of realism and bourgeois Victorian values.

His nearest equivalent on the Continent was Belgian artist Félicien Rops, whom many regarded as the lowest, most vulgar of Symbolists for his frank depiction of Satanic cults and demonic erections.

The Salon de la Rose+Croix and the Salon des XX

Among the most eccentric of French Symbolists was the self-styled Sâr (*magus* in ancient Persian) Joséphin Péladan, a man who believed hermaphroditism would save Europe from decline. He wore a dress, but kept his beard. Péladan is crucial more for the force of his public persona than for his writings or art. He was a kind of proto-hippie spin master.

In 1892, Péladan formed the Salon de la Rose+Croix, a quasi-Occult order whose mission in art was "to ruin realism." These salons provided a public space for Symbolists, the Pont-Aven group, and the Nabis to exhibit. Péladan entrusted much of the running of the salons to Jean Delville, a Neoplatonist, whose *Satan's Treasures* (1895) is a typical expression of the Symbolist aesthetic: It depicts a swarm of violently enflamed naked bodies going to hell.

In Belgium, Symbolism found unique expression in the work of Fernand Khnopff, one of Péladan's favorite artists. Khnopff along with Carlos Schwabe formed a faction among Rose+Croix painters. They belonged to the Salons des XX (The Twenty).

The titles of Khnopff's works are intriguing: *I Lock the Door Upon Myself* (1891), *The Caresses of the Sphinx* (1896), and *Silence* (1896), for example. His paintings are asymmetrical, meticulously and purposefully composed, like the work of Burne-Jones. They are moody and enigmatic, reflecting the artist's taciturn, introspective temperament.

A celibate, reputedly in love with his sister, Khnopff depicted female figures who either are her, or, perversely, look like her. Among his trademark motifs is the winged head, representing Hypnos, the god of sleep. He is doubtless the model for the artist in Allan Hollinghurst's

novel *The Folding Star* (1994), set in Khnopff's famously melancholy home city of Bruges, which Baudelaire once called "Venice in black."

Conclusion

By 1898, the Symbolist aesthetic was all but sidelined by other movements. Critic Octave Mirbeau, in the aftermath of the Wilde scandal of 1895, castigated the Symbolist movement as being only for "snobs, Jews and pederasts." During the late twentieth century, however, Symbolists enjoyed a new popularity. To Phillipe Jullian, they were "the dandies of the soul."

Symbolists shrank from bright lights in order to make the ineffable manifest. In the process, they revealed their homosexual orientation or other minority erotic interest. They tried to make a kind of subtle, ambiguous music for the eye. Although their work varies enormously in quality, it still manages to fascinate and enthrall.

— Kieron Devlin

BIBLIOGRAPHY

Dorra, Henri, ed. *Symbolist Art Theories: A Critical Anthology.* Berkeley: University of California Press, 1994.

Gibson, Michael. *Symbolistes.* Michael Gibson, trans. New York: Abrams, 1988.

Jullian, Phillipe. *The Symbolists.* Mary Anne Stevens, trans. New York: Phaidon, 1973.

Lucie-Smith, Edward. *Symbolist Art.* London: Thames and Hudson, 1972.

Théberge, Pierre, ed. *Lost Paradise: Symbolist Europe.* Montreal: Museum of Fine Arts, 1995.

SEE ALSO

European Art: Nineteenth Century; European Art: Baroque; European Art: Mannerism; European Art: Medieval; European Art: Renaissance; Surrealism; Beardsley, Aubrey

Tchelitchew, Pavel *(1898–1957)*

RUSSIAN-BORN PAINTER, SCULPTOR, AND SET DESIGNER Pavel Tchelitchew (pronounced CHEL lee chef; also chel LEE chef) created a number of works that illustrate homoerotic desire.

Tchelitchew was born September 21, 1898, in the Kaluga district near Moscow, on the estate of his aristocratic family. He was educated by a series of French, German, and English governesses, who encouraged his interest in the arts.

His father, a follower of Tolstoyian principles, supported his desire to become a painter. In spite of his father's liberal views, however, the family was expelled from its property in 1918 following the revolution of 1917.

Tchelitchew joined the White army, and the family fled to Kiev, which was not yet under Communist control. While in Kiev, he studied with Alexandra Exter and produced his first theater designs.

By 1920, he was in Odessa, escaping the advancing Red armies. He went on to Berlin via Istanbul. In Berlin he met Allen Tanner, an American pianist, and became his lover. In 1923, they moved to Paris and Tchelitchew began painting portraits of the avant-garde and homosexual elite.

Tchelitchew developed a predilection for outrageous blues and pinks, calling himself the "Prince of Bad Taste."

Gertrude Stein noticed his entry in the 1925 Salon D'Automne, *Basket of Strawberries* (1925), and bought the entire contents of his studio.

In addition to becoming an accomplished painter, he also became one of the most innovative stage designers of the period and designed ballets for Diaghilev and the Ballets Russes in Paris.

Tchelitchew's American debut was in a group show of drawings at New York's Museum of Modern Art, in 1930.

In 1934, he moved to New York with his new lover, writer and critic Charles Henri Ford, and exhibited in the Julien Levy Gallery. He and Ford were at the center of a social world of wealthy homosexuals, such as Lincoln Kirstein, for whom he also designed ballets.

He continued his work in design for Balanchine's fledgling American Ballet and for A. Everett "Chick" Austin, a friend and director of the pioneering Wadsworth Atheneum in Hartford, Connecticut.

In 1952, Tchelitchew became a U.S. citizen, but shortly afterward moved to Frascati, Italy. He suffered a heart attack in 1956 and died on July 31, 1957, in Rome, with Ford by his bedside.

While Tchelitchew was trained in traditional classical drawing, his earliest influences were Cubism and Constructivism. He soon reacted against their emphasis on the geometric shapes of cones and cubes and began working in curves, a decision that led to his representational style, which used every traditional device of anatomy and perspective.

In 1926, he was included by the Galerie Druet, Paris, in a group show the title of which gave rise to the

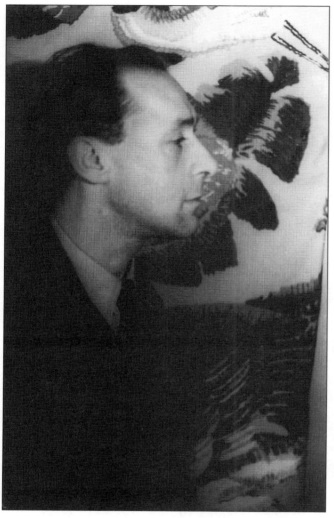

A portrait of Pavel Tchelitchew by Carl van Vechten.

Tchelitchew's later style developed as a result of his search for "interior landscapes" inspired by metamorphoses of the human body.

His works include, in addition to well-known nudes such as *Tattooed Man* (1934), a number of pen-and-ink sketches that illustrate homoerotic desire, some of which are housed in the Kinsey Collection of erotic art.

The artist also executed watercolor illustrations of the gay novel *The Young and Evil* (1933), by Ford and Parker Tyler. These illustrations were not published with the text until 1988.

Tchelitchew's critical reputation declined in the 1950s and 1960s along with the decline of interest in figurative art. The retrospective that was the opening exhibition of Huntington Hartford's conservative Gallery of Modern Art in New York, in 1964, was the last museum survey of his career until the 1998 exhibition at the Katonah Museum of Art in Katonah, New York.

— *Daniel Starr*

BIBLIOGRAPHY

Duncan, Michael. *Pavel Tchelitchew: The Landscape of the Body.* Katonah, N.Y.: Katonah Museum of Art, 1998.

Kirstein, Lincoln. *Tchelitchev.* Santa Fe, N. M.: Twelve Trees Press, 1994.

Leddick, David. *The Homoerotic Art of Pavel Tchelitchev, 1929–1939.* North Pomfret, Vt.: Elysium Press, 1999.

Soby, James Thrall. *Tchelitchew: Paintings, Drawings.* New York: Museum of Modern Art, 1942.

Tyler, Parker. *The Divine Comedy of Pavel Tchelitchew: A Biography.* New York: Fleet, 1967.

SEE ALSO

American Art: Gay Male, 1900–1969; Symbolists

appellation "neo-Romantic," a designation applied to an amorphous combination of figurative painters of various temperaments and attitudes. The artist always disapproved of the term; and in spite of similarities of his work with such artists as Salvador Dalí, he also always denied any association with Surrealism.

Phenomena (1936–1938), the first painting of a projected series of three major works, aroused violent reactions because of its lurid color and characterization of persons then still alive (including a self-portrait and images of Gertrude Stein and Alice B. Toklas). The most prominent of the nude male figures in this painting is Nicholas Magallanes, a favorite model, who later became a famous dancer.

The second work, *Hide and Seek* (1940–1942), a strikingly red painting of an enormous tree composed of human body parts, remains one of the most popular paintings in the Museum of Modern Art. The final work in the series was never finished.

Tom of Finland
(Touko Laaksonen) (1920–1991)

BORN TOUKO LAAKSONEN IN THE VILLAGE OF KAARINA, Finland, on May 8, 1920, to schoolteacher parents, the man who was to become Tom of Finland evinced an interest in art as a child. He moved to Helsinki in 1939, where he attended art school and began to create the erotic drawings that would later bring him fame.

In April 1940, after Finland had capitulated to the Soviet Union, Laaksonen was drafted into the army and, in late 1944, saw military action resisting the German invasion of Russia.

After World War II, he worked in advertising, while continuing to draw. He became a member of the Helsinki bohemian set, but avoided the small gay subculture because it was dominated by flamboyantly effeminate

homosexuals. In 1953, he met Veli, the man who would become his life partner.

In 1956, Laaksonen submitted his drawings to the American bodybuilding magazine *Physique Pictorial*. The editor was delighted with the work and featured Laaksonen's drawing of a lumberjack on the cover of the magazine's Spring 1957 issue.

Like many of the illustrators and photographers whose work appeared in such implicitly gay publications, Laaksonen chose to be published under a pseudonym. Hence was born "Tom of Finland."

At a time when pornography was strictly regulated and individuals could face prison sentences for erotic drawings, Tom's work was particularly daring. Rejecting the use of slender or boyish men to signal a queer subtext, Tom chose to construct the gay male body as a square-jawed, scruffy and stubbled, hypermasculine knot of bulging muscles with narrow waist and broad shoulders.

In a series entitled "Men of the Forests of Finland," Tom contributed numerous images to *Physique Pictorial* in 1957. His lumberjacks are predatory aggressors who cut down trees and play on logs.

In time, Tom expanded his pantheon of rugged physical types to include the sailor, biker, policeman, and prison guard, providing a little something for everyone. It has been argued that such images may have provided a fantasy space, a mental training ground, for those young men in America's heartland who, in the 1960s and 1970s, would shape the gay rights movement.

Tom's protagonists deserve as much recognition for being well drawn as for their devilish grins, tight jeans, and worked-out bodies, but these attributes are themselves significant, for they suggested a gay subculture that was defiantly rejecting the invisibility, homophobia, and indignities of pre-Stonewall life.

At a time when an action as simple as going to a gay bar could mean a night in jail for homosexuals, the openness and visibility of Tom's depictions were especially shocking.

Placed in parks, forests, locker rooms, bars, and prison cells, Tom's men seem to wander an array of secluded public spaces but usually not far from small groups of interested onlookers. Their denim-bound erections, bursting buttons, and turned-up short-sleeves can barely conceal the irrepressible optimism of a gay liberation that was yet to come.

Although innocently posed in the early years, Tom's drawings became more explicit later and they came to take on a more aggressive edge. His work parallels the gay liberation movement (and the relaxation of censorship in the face of the sexual revolution of the 1960s and 1970s) in that it progresses to depict nudity, the fully erect penis, leather accoutrements, and eventually S/M scenes.

At times in his drawings, Tom allows the engorged member a scale and prominence not found in nature but perfectly at home in the highly charged world of gay male desire.

Part of the significance of Tom's work is that it so openly depicts sexual desire between conventionally masculine men. Indeed, Tom's drawings present a hyper-masculine, working-class version of homosexual manhood that anticipated the emergence of the "clone" look in the 1970s.

But despite the exaggerated masculinity of his subjects, and even the brutality of some of their actions, Tom also injects both tenderness and amusement into his depictions.

Laaksonen worked in advertising until 1973, when he was finally able to support himself through his art. After 1973, his work began to be exhibited in museums and galleries worldwide. For many, it continues to be the quintessence of gay male erotic art.

In 1979, with his friend and business manager Durk Dehner, Laaksonen founded the Tom of Finland Company, which led in 1986 to the creation of the Tom of Finland Foundation, which is the official archive of Tom's work and a collection of gay male erotic art.

Laaksonen's longtime companion, Veli, died in 1981, and the artist in 1991. — *Ken Gonzales-Day*

BIBLIOGRAPHY

Hooven, F. Valentine. *Tom of Finland: His Life and Times*. London: St. Martin's Press, 1994.

Ramakers, Michael. *Dirty Pictures: Tom of Finland, Masculinity, and Homosexuality*. London: St. Martin's Press, 2000.

———. *Tom of Finland: The Art of Pleasure*. Cologne: Taschen, 1998.

SEE ALSO

European Art: Twentieth Century; Erotic and Pornographic Art: Gay Male; American Art: Gay Male, 1900–1969; Contemporary Art; Subjects of the Visual Arts: David and Jonathan; Subjects of the Visual Arts: Nude Males; Subjects of the Visual Arts: Sailors and Soldiers

Tress, Arthur (b. 1940)

THE UNCOMPROMISING, POETIC IMAGERY OF AMERICAN photographer Arthur Tress is the stuff of dreams, called forth from the artist's reckoning with the world and his place in it.

A New Yorker, Tress was born on November 24, 1940. He began his photographic career at age twelve, making snapshots of dilapidated mansions and Coney Island decay. An introverted child of divorce, Tress moved between two worlds—his lower-class mother's neighborhoods and his nouveau riche, remarried father's more prosperous one, observing and eventually photographing both milieus.

As he recalls, from a very young age he was already aware that his sexuality was different from most of his classmates and he was drawn to subject matter that was similarly marginalized and different.

During his studies at Bard College, Tress explored painting and filmmaking but was ultimately committed to still photography. Although he worked in a documentary style, from the beginning his imagery was characterized by a Surrealist sensibility.

After graduation Tress traveled the world, in part financed by his father and also supporting himself by making ethnographic and documentary images. During his travels he became increasingly influenced by his experience of other cultures, particularly in matters of spirituality and consciousness.

Tress's first book, *The Dream Collector* (1972), was an attempt to visualize children's dreams, often featuring children whom Tress had interviewed as models. His second book, *Shadow: A Novel in Photographs* (1975), showed "portraits" of the photographer's shadow and explored the idea that the shadow literally and metaphorically represented one's dark side.

Theater of the Mind (1976), which included an essay by his friend and mentor, gay photographer Duane Michals, explored adult fantasies and marked the introduction in Tress's work of overtly erotic imagery. As Tress explained, he sought to make "photographs [that] attempt to make explicit...sexual passions and ironies," albeit with spiritual dimensions.

Early on, Tress began to incorporate fabricated and staged imagery. His deliberate combination of document with fabrication supports a desire to bear witness to his life—so crucial to many gays and lesbians—but not to be beholden to a particular kind of representation or aesthetic.

Tress's most famous image, "Stephan Brecht, Bride and Groom" (1970), of the actor in character for his role in *The Grand Tarot*, is an eloquent, enigmatic exploration of gender and identity that neither denies nor embraces either.

Around 1972, Tress consciously began to include what he called "the more intimate spheres of a gay sexuality and homoerotic fantasy life." *Facing Up* (1977–1980), alternately titled *Phallic Phantasy*, was Tress's first explicitly conscious exploration of his sexuality in which he exclusively photographed male nudes.

Many of these images were included in Tress's homoerotic homage, *Male of the Species: Four Decades of Photography of Arthur Tress* (1999), which culls imagery from Tress's forty-year career of exploring the male body and sexuality. The sensual photographs, sequenced in a loose narrative of experience from youth to death, matter-of-factly infuse male sexuality with humor and irony.

In contrast, Tress's obsessive constructions made and photographed for the "Hospital" series (1984–1987) are a garish, nightmarish reckoning with health-related issues and death in the era of AIDS.

In 2001, the Corcoran Gallery of Art in Washington, D.C., (the same museum that achieved notoriety for canceling a controversial Robert Mapplethorpe retrospective in 1989) mounted a retrospective exhibition of Tress's photographs with an accompanying catalog.

— *Carla Williams*

BIBLIOGRAPHY

Tress, Arthur, with essay by Yves Navarre. *Arthur Tress: Facing Up*. New York: St. Martin's Press, 1980.

———. *Arthur Tress: Fantastic Voyage: Photographs 1956–2000*. Richard Lorenz and John Wood, eds. New York: Bulfinch Press, 2001.

———, with text by John Minahan. *The Dream Collector*. Richmond, Va.: Westover Publishing Company, 1972.

———. *Fish Tank Sonata*. Boston: Bulfinch Press, 2000.

———. *Male of the Species: Four Decades of Photography of Arthur Tress*. David Sprigle, ed. Santa Monica: FotoFactory Press, 1999.

———. *Shadow*. New York: Avon Books, 1975.

———. *The Teapot Opera: In Three Acts*. New York: Abbeville Press, 1988.

———, with text by Duane Michals et al. *Theater of the Mind*. Dobbs Ferry, N. Y.: Morgan and Morgan, 1976.

Weiermair, Peter, ed. *Arthur Tress*. Zurich: Edition Stemmle, 1995.

www.arthurtress.com

SEE ALSO

Photography: Gay Male, Post-Stonewall; Michals, Duane; Mapplethorpe, Robert

Tsarouchis, Yannis *(1910–1989)*

ONE OF THE MOST IMPORTANT TWENTIETH-CENTURY Greek painters, Yannis Tsarouchis (sometimes spelled Yiannis or Giannis) is one of a group of Greek artists who helped both portray and define modern Greek identity. A deeply sensual painter, much influenced by the French Impressionists, Tsarouchis is also a significant gay artist who filled his canvases with homoerotic images of vulnerable men and (to a much lesser extent) strong women.

Born in the port city of Piraeus, near Athens, on January 13, 1910, Tsarouchis began his art studies in 1928 at the Higher School of Fine Arts in Athens. While still in school, he began to train in the studio of another influential Greek modernist, the Byzantine artist Fotis Kontoglou.

However, it was a trip to Paris in the mid-1930s that influenced Tsarouchis's art most deeply. Immersed in the bohemian lifestyle of the times, the young Greek drank in the art of such contemporaries as Renoir, Manet, Picasso, and Matisse.

Once back in a Greece torn by war, Tsarouchis began to paint the young men in uniform who were preparing to defend their homeland. During the 1940s, Greece was a nation both ancient and new, having won independence from the Ottoman Turks only in 1830. Tsarouchis was filled with a desire to express the complex ingredients that composed "Greekness."

In this effort, his art became a similar synthesis of complex ingredients. He combined the technique and vision he had learned from the Impressionists with the elements of classical Hellenistic sculpture and vase painting he had loved from his youth and of the Byzantine art that represents the oriental side of the Greek aesthetic. Even the folk arts of weaving, shadow theater, and icon painting influenced his work as he began to paint the soldiers and sailors he admired.

These paintings, such as *Young Man Posing as an Olympic Statue* (1939), *Sailor with Coffee Cup* (1954), and *Sailor Dreaming of Love* (1955), capture not only a Greek identity but also a gay sensibility, with young men gazing out of the canvas with haunted eyes while their large hands rest gently in their laps.

In *The Thinker* (1936), Tsarouchis takes an Impressionist classic and transforms it into an icon for his own culture. Unlike Rodin's imposing sculpture, the Tsarouchis painting depicts a modern young Greek sitting on a café stool, a faraway look in his eye and a cigarette in one dangling hand.

Tsarouchis had a lifelong love of theater and frequently worked as a set and costume designer. In exile in Europe in 1967, waiting out the years of military dictatorship in Greece, he designed sets for productions at Milan's La Scala and London's Covent Garden, as well as the Avignon Festival in France. After his return to his homeland in the mid-1970s, he designed an acclaimed operatic set for Franco Zeffirelli's production of Cherubini's *Médée* at the ancient amphitheater at Epidauros.

Tsarouchis was beloved in Greece for his contribution to and respect for Greek culture. In 1982, the Yannis Tsarouchis Foundation was established. When the artist died on July 20, 1989, in Athens, he left money in his will to support the foundation named in his honor.

The Foundation runs the Yannis Tsarouchis Museum in the artist's home in the Athenian suburb of Maroussi.

— *Tina Gianoulis*

BIBLIOGRAPHY

Kafetsi, Anna. "Yannis Tsarouchis: Between East and West." www.culture.gr/6/69/698/e69805.html

Schina, Athena. "The Immortal Images of Yannis Tsarouchis." *Athena Magazine* No. 33 (July–August, 1983): 122–125.

SEE ALSO

Art: Twentieth Century

Tuke, Henry Scott (1858–1929)

IN THE LATE 1880s, BRITISH ARTIST HENRY SCOTT TUKE became part of a circle of poets and writers who wrote about and discussed the beauty of male youth. Tuke's paintings typically celebrate male beauty, as well as the artist's lifelong love of the sea, swimming, and sailing.

Tuke was born in York in 1858 to Quaker parents and moved with them to London in 1874. He was educated at the Slade School of Art, traveled to Italy in 1880, and lived in Paris from 1881 until 1883.

In Paris, he studied with the French history painter Paul Laurens and met the American painter John Singer Sargent.

Tuke also met Oscar Wilde in the 1880s and developed connections with the Uranian poets and writers, who celebrated the adolescent male. He wrote a sonnet to youth that was published anonymously in the journal *The Artist* and also contributed an essay to *The Studio*, another journal that published Uranian verse and essays.

Tuke settled in a Cornish town near Falmouth Bay in 1885. He converted his boat into a floating studio and living quarters where he could pose his models and entertain his friends. Although he was also an accomplished portraitist, most of his works depict young men who swim, dive, and lounge on a boat or on the beach.

Early in his career, Tuke's major compositions were narrative or anecdotal. In the oil painting *All Hands to the Pumps!* (1888–1889), for example, seven figures aboard a sailboat on a violent, stormy sea exercise their strength and endurance to fight the elements. Overall, however, the painting possesses a contrived quality that does not successfully convey the drama of the moment.

In several other canvases from this period, Tuke attempts to situate his studies of male nudes within mythological contexts. The resultant works, among them *Cupid and Sea Nymphs* (1898–1899), have a stiff, lifeless quality.

While attempting to discover in which settings to position his nudes, Tuke realized that he desired to examine the human form separate from any meaning-laden context. During the 1890s, he began to render nude figures without reference to mythological or narrative themes. This method particularly suited Tuke: His handling of paint became freer, and he began using bold, fresh color.

August Blue (1893–1894), one of the most famous paintings from this period, is a study of four nude youths bathing from a boat in crystal-clear water under bright blue skies. The work conveys a sense of enjoyment, of the simple innocence of sunlight on flesh, sea, and sky. With *August Blue*, Tuke established a genre that celebrates male beauty and the seeming timelessness of youth.

Tuke's paintings of nude youths illustrate sensual, rather than sexual, feelings. They are not explicit either in the relationships they describe or in the details of the body.

The oil painting *Noonday Heat* (1903), for example, presents two youths who, relaxing on the beach, are completely engrossed in their own private world. They look at one another, perhaps engaged in conversation. Since neither of them addresses the viewer, their relationship seems intimate, exclusive, and ambiguous.

Similarly, the watercolor *Two Boys on a Beach* (1909) captures a close, intense relationship. In this work, the absence of a horizon heightens the feeling of intimacy.

Tuke only rarely painted the genitals of his models, thereby de-emphasizing a sexual reading of his works. The artist generally arranged his models so that anatomical details are concealed. In frontal views, shadows or draped pieces of clothing obscure the genitals.

Tuke's de-emphasis of the sexual may explain why his work, and his close friendships with many of his models, created no scandals.

Henry Scott Tuke worked outside the mainstream of his contemporaries. During a time when smooth, concealed brushstrokes were in vogue, Tuke favored rough, visible brushstrokes. He excelled at combining this type of brushstroke with color to produce unusual lighting effects that stall the viewer's eye on the nude male body.

Tuke also moved away from the popular historical and mythological scenes, indeed from any type of narration, and studied everyday life as a worthy subject matter.

Although Tuke is best known today for his gently homoerotic paintings, in his own time he was also well known as a portraitist and maintained a London studio to work on his commissions. Among his best-known portraits is that of soldier and writer T. E. Lawrence.

After a long illness, Tuke died at Falmouth in 1929.

— *Joyce M. Youmans*

Bibliography

Cooper, Emmanuel. *The Life and Work of Henry Scott Tuke, 1858–1929.* London: GMP Publishers Ltd., 1987.

Phillips, David L. "Tuke, Henry Scott." *Who's Who in Gay and Lesbian History from Antiquity to World War II.* Robert Aldrich and Garry Wotherspoon, eds. London: Routledge, 2001. 448–449.

Saville, Julia. "The Romance of Boys Bathing: Poetic Precedents and Respondents to the Paintings of Henry Scott Tuke." *Victorian Sexual Dissidence.* Richard Dellamora, ed. Chicago: University of Chicago Press, 1999. 253–277.

Talley, M. Kirby, Jr. "Henry Scott Tuke: August Blue." *Art News* 93.10 (December 1994): 103–104.

SEE ALSO

European Art: Nineteenth Century; European Art: Twentieth Century; Sargent, John Singer

Vaughan, Keith (1912–1977)

A PAINTER OF FIGURES AND LANDSCAPES IN OILS AND gouache, British artist Keith Vaughan specialized in the depiction of male nudes in landscape.

Vaughan was born on August 23, 1912, at Selsey Bill in Sussex, England, but moved to London with his family soon after his birth. He received no formal art training and worked in advertising until 1939, when he became a full-time painter.

During World War II, he served with the Pioneer Corps. He used his travel opportunities to study landscape throughout Britain and was able to make drawings and gouache paintings.

Twelve of the sketches and paintings Vaughan made during this period were purchased by the War Artists' Advisory Committee and displayed at the National Gallery in London, alongside works by artists such as Graham Sutherland, Henry Moore, and John Piper, whom Vaughan greatly admired.

In 1946 Vaughan shared a house with fellow artist John Minton, who introduced him to Duncan Macdonald at the Lefevre Gallery, where he held his first exhibition of oil paintings and continued to exhibit until 1952.

Vaughan was above all else enthralled by the male human body, which, as Bernard Denvir observed in the catalog of an exhibition held at Birmingham City Museum and Art Gallery in 1981, "assumed in his work an importance it had never known before in the history of British painting."

Vaughan's paintings depicted "Man," often naked and usually too indistinct to identify as individual portraits, in relation to his landscape, his environment, his space. Implicit in much of his work is man as a homosexual in opposition to his fellow man and a hostile world. The work is that of someone who felt himself to be an outsider, looking at situations and relationships in which he cannot participate.

Vaughan's paintings are true to his experience: Each figure and element of his landscapes was drawn from a place he had visited, a landscape he had walked through, or a person he had known.

Throughout his career, Vaughan maintained a difference between the works he intended for exhibition and those that were purely private. This second group—created throughout his career—consists of several hundred pencil and pen-and-ink drawings all depicting young men.

Although the tone of the drawings altered during his career, and range from the tender to the erotic, they are free of the inhibitions that sometimes appear in his paintings intended for exhibition. They reveal more fully his love for and obsession with the young male body.

Vaughan also designed book jackets and textiles and in 1958 received the Designer of the Year award for his work with the progressive textile firm Edinburgh Weavers.

Vaughan was also commissioned to make a number of public works of art. The Arts Council invited him to create a mural, entitled *At the Beginning of Time*, for the

Dome of Discovery at the Festival of Britain in 1951. In 1954, he designed an abstract ceramic mural for Corby New Town, Northamptonshire. In 1963, London County Council commissioned him to paint a mural for the Aboyne Estate Clubroom in Wandsworth, London.

Vaughan taught at Camberwell School of Art, London (1946–1948), the Central School, London (1948–1957), and the Slade School (1959–1977). He became an Honorary Fellow of the Royal College of Art in 1964, and in 1965 he was awarded a CBE (Citizen of the British Empire).

Like many gay men of his generation and class, Vaughan was troubled by insecurities about his sexuality. Much of what is known about his sexuality comes from his journals, which he began writing in August 1939 and continued until the morning of his death thirty-eight years later.

On the ground that "the truth is not necessarily beautiful but is of value and helpful to others," he decided to be truthful about his homosexuality. Following this line, he wrote explicitly about his sexual practices with other men, masturbation, and experiments with sadomasochism.

Vaughan's journals give insight into the relationships he had with other men, particularly with his working-class lovers, John McGuiness and Johnny Walsh, and his long-term companion and lover, Ramsey Dyke McClure. Like many middle-class gay men of his generation, he was attracted to an ideal of working-class masculinity. This inclination proved frustrating for him, as he longed to find a partner who could be his intellectual equal as well as attracting him physically.

Although Vaughan wrote freely about his sexuality in his journals (and in the erotic short stories he wrote for his own pleasure), he was a product of his age. He had grown up at a time when gay men were driven underground into their own subculture and made to feel guilty about their sexual preferences.

Even though the artist lived to see the advent of the gay liberation movement, he failed to embrace it or to understand its significance. "Gay Lib just seems to want homosexuals to come out and flaunt themselves, declare their tastes—but why?" he asked in his journal.

After being diagnosed with bowel cancer in 1975, and also suffering from severe kidney disease and depression, Keith Vaughan committed suicide on November 4, 1977, by taking an overdose of drugs. — Shaun Cole

BIBLIOGRAPHY

Ball, John Nicholas. *Keith Vaughan: Images of Man: Figurative Paintings, 1946–1960.* Exhibition catalog, Birmingham City Museum and Art Gallery. Essays by Bernard Denvir, Hetty Einzig, and Bryan Robertson. London: Inner London Education Authority, 1981.

Graham, Philip, and Stephen Boyd, eds. *Keith Vaughan, 1912–1977: Drawings of the Young Male.* Edward Lucie-Smith, intro. London: Éditions A. Walter, 1991.

Keith Vaughan 1912–1977. William Joll, intro. London: Agnew, 1990.

Lax, Julian. *Keith Vaughan: A Collection of Paintings, Gouaches, Drawings and Lithographs.* London: Julian Lax, 2000.

Vaughan, Keith. *Journal & Drawings, 1939–1965.* London: A. Ross, 1966.

———. *Journals 1939–1977.* Alan Ross, ed. London: Murray, 1989.

Yorke, Malcolm. *Keith Vaughan: His Life and Work.* London: Constable, 1990.

SEE ALSO

European Art: Twentieth Century; Minton, John; Subjects of the Visual Arts: Nude Males

Video Art

VIDEO ART IS CREATED BY CAPTURING IMAGES AND sounds for playback on a video monitor or for video projection. Korean-born artist Nam June Paik pioneered the medium in the late 1960s, making it only slightly older than the gay rights movement. Although facilitated by Japanese technology, video art was initially developed primarily by American artists within the era's politically volatile social context.

The commercial availability and portability of the early video camera facilitated the medium's use by visual artists, including painters, sculptors, and performance artists. During the late 1960s and 1970s, video art was monitor based and often politically charged to the point that artists formed collectives such as TVTV (Top Value Television), which infiltrated the 1972 Republican convention.

Video Art's Popularity with Queer Artists

Early video art's "outsider" status enhanced its popularity among queer artists. Since 1980, advanced technology and the growing legitimacy of the form have allowed video artists to explore other forms of video presentation, including projection and installation, and to move from videotape to digital video.

In video, the prevalence of human performance or spontaneously recorded action centralizes and often politicizes the human form, an aspect of the medium that makes it particularly expressive for queer artists. Additionally, video art's opportunities for activism, personal revelation, and documentary have been seized by queer artists.

Glbtq video art falls into four major categories: AIDS activism (whose major practitioners include Gregg Bordowitz, Tom Kalin, and Alisa Lebow), confrontation (Sadie Benning, Cecilia Dougherty, Thomas Harris, Kathy High, Kalin, Lebow, and David Wojnarowicz), coming out (Benning, Bordowitz, Sandi DuBowski, and Richard Fung), and traditional documentary (Maria Beatty and Ellen Spiro).

AIDS Activism

Video artists have engaged in AIDS activism in a number of ways, including through major projects such as Video Against AIDS (1989), The Estate Project's AIDS Activist Video Preservation Program (1989), and The Ashes Action (1996).

The focus of many AIDS activist video pieces is coping with HIV/AIDS, which often documents the artist's personal experience. Artists such as Gregg Bordowitz and Alisa Lebow explore how they personally contracted the virus.

Often an artist, Bordowitz for example, will video rallies and support groups in order to document movements such as ACT UP; Bordowitz also uses satire to indict mainstream attitudes toward HIV/AIDS. Lebow rejects the mainstream political approach and portrays an angrier, more confrontational, and unapologetic reaction to the virus.

Tom Kalin, like Lebow, is highly confrontational; however, Kalin rejects a personal method and frames his treatment of the crisis in an artful documentary of mainstream society's reaction to AIDS, *They Are Lost to Vision Altogether* (1989).

His voice-over dialogue is recorded directly from prime-time news coverage of the crisis, which describes AIDS as a disease affecting "gay men, intravenous drug users, and Haitians." The voice-over accompanies news footage of the early years of the crisis interspersed with vintage, early-twentieth-century clips of accidents and disasters.

Confrontation

Tom Kalin's art focuses not only on AIDS activism, but also on confrontational, taboo issues such as extreme sexual acts. Other confrontational artists include Kathy High, whose *Icky and Kathy Trilogy* (1999) explores incest and other forbidden forms of sexual desire.

David Wojnarowicz's most important video installation is *American Heads of Family, Heads of State* (1989–1990). It is a mixed-media installation, containing macabre images (both from the media and created by Wojnarowicz), which incorporates his writings, sculpture, found art, and monitor-based videos. The piece is a personal and politicized reaction to his dying from AIDS.

Wojnarowicz's confrontational manner and personal concerns are mirrored thematically, if not stylistically, by Sadie Benning. Throughout the 1990s, Benning has been among the most acclaimed lesbian video artists; her work has been exhibited at the Museum of Modern Art and the Whitney Biennial (1997).

Her *Flat is Beautiful* (1998) is a lyrical black-and-white piece concerning the rapid maturation and sexualization of a fifth-grade girl. Benning's work is stylistically diverse; she often works with puppetry, masks, and music video.

Coming Out

Benning locked herself in her room for three weeks at the age of fifteen to create personal, revelatory video pieces. These pieces, from her career's infancy, document her early understandings of lesbianism. They constitute a personal coming-out discourse, a concern of many queer video artists, particularly since 1980, as video art has moved into museum and gallery spaces and even private collections.

Richard Fung's *Sea in the Blood* (2000) documents the artist's relationship with his dying sister, the only family member to whom he came out. Fung relates his sister's leukemia to his partner's battle with AIDS. Often, glbtq artists, such as Bordowitz and Sandi DuBowski, focus on the decision whether or not to come out to family members.

Documentary Video

A subcategory of both glbtq video art and mainstream video art is documentary. Some queer video artists go beyond the satirically artful work of artists such as Bordowitz to document important glbtq issues, such as AIDS awareness, or cultural expressions, such as performance art, in more straightforward documentaries.

Notable among these artists are Maria Beatty and Ellen Spiro. In *Party Safe with DiAna and Bambi* (1992), Spiro concentrates on safe-sex practices for males and females, gay and straight. Specifically, she documents a national safe-sex party tour by two women from Columbia, South Carolina.

Conclusion

Queer video artists are not easily categorized because they explore diverse issues, often in diverse styles. However, because video art can be such a personally expressive medium, queer video artists frequently focus on subject matter directly concerned with the queer experience.

— *Brandon Hayes*
Staci Nicholson

BIBLIOGRAPHY

Hill, Chris, ed. *Rewind: Video Art and Alternative Media in the United States 1968–1980.* Chicago: Video Data Bank, 1996.

Holden, Stephen. "When and How AIDS Activism Finally Found Its Voice and Power." *New York Times,* December 1, 2000.

Spaulding, Karen Lee, ed. *Being & Time: The Emergence of Video Projection.* Buffalo: The Buffalo Fine Arts Academy, 1996.

Rush, Michael. *New Media in 20th Century Art.* New York: Thames and Hudson, 1999.

SEE ALSO

Contemporary Art; American Art: Gay Male, Post-Stonewall; American Art: Lesbian, Post-Stonewall; Wojnarowicz, David

Walker, Dame Ethel *(1861–1951)*

DAME ETHEL WALKER PRODUCED HER MOST SIGNIFI-cant paintings late in life, from the time she was in her fifties until her death at the age of ninety.

Well-known during her lifetime and named a Dame of the British Empire in 1943, Walker is no longer considered a major artist. Although many of her paintings belong to the collections of British galleries, today they are rarely exhibited and scholars seldom mention them.

Walker's works may have fallen out of favor because of her identification with the Impressionist movement, in which she never achieved eminence.

Walker was born in Edinburgh on June 9, 1861. Her Yorkshire father, Arthur Walker, was from a family of iron-founders, and her mother, Isabella Robertson, was Scottish. Walker received her secondary school education in Brondesbury, London, where her drawing master, Hector Caffieri, encouraged her to develop her artistic talent.

After secondary school, Walker attended the Ridley School of Art. Nevertheless, she did not exhibit any special interest in art until she formed a close friendship with Clara Christian in the 1880s. The two women attended the Putney School of Art and then lived, studied, and worked together as fellow artists.

Walker also attended the Westminster School of Art, where Frederick Brown was a teacher. Around 1893, she followed him to the Slade School of Art for further study.

Walker produced a large body of work in different genres; she painted portraits, flowers, seascapes, land-scapes, and mythical subjects. Walker's influences include Impressionism and Greek and Renaissance art. To these, the artist added her lifelong pleasure in color, light, paint, and the female form.

Walker is perhaps best known for her portraits of women in which she captures her sitters' individual temperaments and expressions. Indeed, she was less concerned with reproducing the sitters' exact likenesses than in catching their strong personalities and psychological states. Her obvious, tactile brushstrokes obscure unnecessary detail, thereby allowing Walker to emphasize the compositional aspects that seize the mood of the moment.

In *The Mauve Dress* (ca. 1930), for example, the sitter's long, full dress seems to weigh her down with its heavy brushstrokes. The woman rests her right elbow on a piece of furniture while leaning her head on her right hand. Her left arm rests heavy and lifeless across her lap. The dress seems to sap the life out of the sitter, who has a dreamy, pensive expression on her face.

Perhaps the sitter's—and by extension, Walker's—disdain for heavy, cumbersome female clothing in this painting can be traced to the artist's vocal hatred of cosmetics. She often rebuked women, even strangers, in public for using makeup. Her models removed their lipstick and nail polish before entering her studio, for fear of inciting her temper.

Walker painted a series of works that seem to be based on generic mythological themes. These paintings,

pigmented with radiant color, depict groups of unclad females who appear to be performing nature-based rituals. Walker loosely bases her female figures on archetypal classical and Renaissance human forms.

Over twenty-five female figures fill the relatively small 16 x 25 ¹/₂-inch canvas titled *Invocation* (date unknown). A group of scantily clad and nude women stand and kneel around three dancers who are draped with sheer cloth. A quadruped, probably a goat, stands in the center of the canvas, partially concealed by one of the dancers. Birds flutter overhead.

The painting's elegant, sinuous line gives the viewer the impression that the scene is filled with harmony and grace. The activity depicted in *Invocation* is joyful in a quiet, restrained way.

All of Dame Ethel Walker's paintings share one characteristic: they vibrate with the rhythm of the human spirit that, according to the artist, animates visible reality. Walker makes this belief palpable to the viewer through her use of animated brushstrokes, strong compositions, and bright colors.

— *Joyce M. Youmans*

BIBLIOGRAPHY

Earp, T. W., et al. *Ethel Walker, Frances Hodgkins, and Gwen John: A Memorial Exhibition.* London: Arts Council of Great Britain, 1952.

Pearce, Brian Louis. *Dame Ethel Walker: An Essay in Reassessment.* Exeter, England: Stride Publications, 1997.

See also

European Art: Twentieth Century; Subjects of the Visual Arts: Nude Females

Warhol, Andy *(1928–1987)*

ANDY WARHOL IS BEST REMEMBERED AS THE AVATAR of Pop Art. A child of the advertising age, he began his career as a commercial illustrator in the late 1950s. Even his first major appearance as an artist in 1961 was commercial: five paintings as backdrop in a display window at New York's Bonwit Teller department store.

Born Andrew Warhola Jr. on August 6, 1928, into a working-class family in Forest City, Pennsylvania, Warhol attended art school at the Carnegie Institute of Technology in Pittsburgh. He moved to New York in 1949, where he changed his named to Andy Warhol and made friendships with Jasper Johns and Robert Rauschenberg.

Warhol's work needs to be seen as part of the contentious pluralism in the arts that characterized the early 1960s, as artists joined the assault on conventional pieties and prejudices.

In 1966, *Time* magazine warned the public that Pop Art threatened "normal" masculinity because it insisted on reducing art to the "trivial," by which *Time* meant camp. As Susan Sontag had reported in her seminal 1964 essay "Notes on 'Camp,'" camp embraced extravagance, effeminacy, and an obsession with surface appearances.

Indeed, the gayness that Warhol projected in both his art and his public persona contrasted sharply with the macho posturing that had dominated the art world in the 1950s. But such openness carried a price.

When Warhol asked why his idols, Jasper Johns and Robert Rauschenberg, avoided him, a mutual friend, filmmaker Emil de Antonio, answered, "Okay, Andy, if you really want to hear it straight, I'll lay it out for you. You're too swish, and that upsets them." In defiance, Warhol emphasized his effeminacy even more.

Like Johns and Rauschenberg, Warhol was influenced by the ideas of Marcel Duchamp, manifested particularly in the recycling of imagery that both celebrates and subverts modern mass culture.

Warhol's silkscreened repetitions of such mundane objects as soup cans and Brillo boxes, and similarly mass-produced icons such as film stars, made them chic. His appropriations comment, coolly and ironically, on the collapse of the distinction between high and popular art, and on modern obsessions with consumer goods and media-manipulated celebrity.

From childhood Warhol embraced the myth of stardom. His attraction to the young and famous motivated some of his first silkscreen paintings, which were based on images of Troy Donahue and Elvis Presley and date from 1962. Warhol's identification with these celebrities is twofold, both as objects of desire and as role models.

But he also screened images of death and disasters taken from the tabloids. When the theme of tragedy coincided with his fascination with stardom, Warhol found the subjects of his best-known groups of celebrity portraits: Marilyn Monroe, Elizabeth Taylor, and Jacqueline Kennedy.

In his "Gold Marilyn" series, initiated shortly after her suicide in August 1962, Warhol contrived the effect of a gilded Byzantine icon, but substituted for the Virgin Mary an image whose face is suffused with eroticism. It stunningly evokes the need to love and to be loved.

With his increasing success, Warhol became a celebrity himself. Hailed as "court painter to the '70s," he amassed a fortune. Critics debate whether his later silkscreen portraits celebrate or satirize the worlds of money, glamour, and style that he himself increasingly inhabited. Warhol's characteristic attitude remained deadpan; he insisted that his work had no meaning.

Despite his persona of decadent artist, Warhol clung to what might seem, in the context of the jet-set glamour

of his public image, an archaic piety. He maintained a quiet, surreptitious devotion to the Catholic Church.

He was never political, and more a voyeuristic dandy than an engaged homosexual. Nevertheless, he supported the careers of gay artists such as Keith Haring and Jean-Michel Basquiat.

He died on February 22, 1987, soon after gall bladder surgery. His will established a foundation to help young artists.

Today, Warhol has entered the canon of significant American artists, his importance signaled by the fact that Pittsburgh has named a museum in his honor and retrospectives of his career attract large crowds. As Robert Summers points out, however, even supposedly comprehensive exhibits distort his achievement by whitewashing him as "asexual" and divesting his work of its queer content and connections.

— *Peter J. Holliday*

BIBLIOGRAPHY

Bockris, Victor. *The Life and Death of Andy Warhol.* New York: Bantam, 1989.

Crone, Rainer. *Andy Warhol.* New York: Praeger, 1970.

McShine, Kynaston, ed. *Andy Warhol: A Retrospective.* New York: Museum of Modern Art, 1989.

Rosenblum, Robert. "Andy Warhol: Court Painter to the 70s." *Andy Warhol: Portraits of the 70s.* David Whitney, ed. New York: Random House, 1979. 8–21.

Silver, Kenneth. "Modes of Disclosure: The Construction of Gay Identity and the Rise of Pop." *Hand-Painted Pop: American Art in Transition, 1955–62.* Russell Ferguson, ed. Los Angeles: Museum of Contemporary Art; New York: Rizzoli International, 1992. 179–203.

Sontag, Susan. "Notes on 'Camp.'" *Against Interpretation and Other Essays.* New York: Farrar Straus & Giroux, 1964. 275–92.

Summers, Robert. "Taking the Swish out of Warhol." www.advocate.com (June 24, 2002): www.advocate.com/html/stories/867/867_warhol.asp

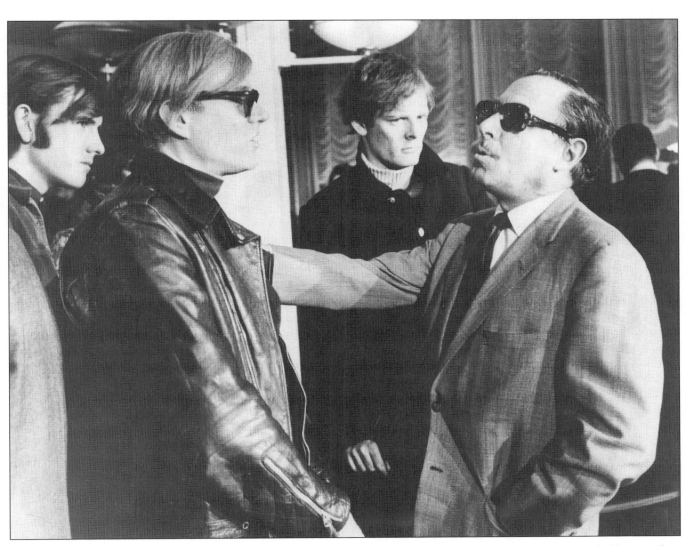

Andy Warhol (left) with Tennessee Williams photographed by J. Cavalline.

Warhol, Andy, and Pat Hackett. *POPism. The Warhol '60s.* New York: Harcourt, Brace, Jovanovich, 1980.

SEE ALSO

American Art: Gay Male, Post-Stonewall; Pop Art; American Art: Gay Male, 1900–1969; Contemporary Art; Censorship in the Arts; Duchamp, Marcel; Johns, Jasper; Haring, Keith; Rauschenberg, Robert

Weber, Bruce (b. 1946)

A NYONE WHO HAS EVER GAZED UPON THE CHISELED models in an ad for Calvin Klein underwear has probably been experiencing a photograph made by Bruce Weber. Working for Klein, Ralph Lauren, and a slew of other designers, Weber became one of the preeminent photographers of the fashion industry in the 1980s and continues to be one of the world's most popular commercial photographers.

In addition to his advertisements, however, Weber has published several books of his photographs, made several films, and had his work widely exhibited in museums and galleries.

Weber's success is owed to his bold, sexy portrayal of the male body and an erotic, yet nostalgic take on American adolescence. The widespread resurgence of the male nude in photography and the pictorial ubiquity of the muscle hunk during the 1980s are due largely to Weber's influence.

Yet, ironically, the breadth of his contributions is perhaps best measured in its seeming invisibility: Weber has worked so widely within commercial photography and his signature style is so emulated that the reenvisioned male beauty for which he is credited may now seem commonplace.

Simply put, Weber's photographs are populated by beautiful people. Many of his subjects are celebrities and lend his images a glamorous, Hollywood appeal. But the vast majority of Weber's works feature amateur young men, a choice that reveals a key element of his visual world: a whole-milk, boy-next-door sensuality based on the idyllic, all-American white youth.

That is, Weber's images enlist those wholesome aspects of American culture that most resist—and therefore most compel—homoeroticism.

In 1987, for example, Weber produced *The Andy Book*, an entire volume of steamy photographs that worship the rough physicality of small-town high school boxer Andy Minsker.

Similarly, his 1991 book *Bear Pond,* which features young lads skinny-dipping and cavorting with the photographer's dogs, centers on a sort of erotic nostalgia: the comely wholesomeness of young bodies in old-fashioned

summertime recreation, replete with Go Fetch and the backdrop of our beloved National Parks.

Weber typically works in black and white, which also contributes to the wistful, memoir-quality of his pictures.

But for all the calculated, layered homoeroticism in Weber's work, the homosexual act itself is keenly kept out of the picture: Weber is vigilant, even in his most explicitly homoerotic works, about leaving narrative room for platonic brotherhood, no matter how incredulous we may be.

This feature is especially evident in Weber's recent commercial work for Abercrombie & Fitch, a trendy American clothier. The pictures for the company's print ads and lavish catalogs (which, after some controversy, one must now be eighteen to purchase) idolize a sort of collegiate sexual culture in which young men are everywhere on display: the indomitable prowess of the captain of the football team; the anything-goes debauchery of Spring Break; the sweaty camaraderie of team sports; or the sadomasochistic hazing of fraternity pledges.

Despite the mainstream pretenses of the Abercrombie campaign (and its mainstream target demographic), Weber's tantalizing, over-the-top depictions of homoerotic possibility have lent these ads widespread gay currency and, not incidentally, have gained the company entrée into a lucrative gay consumer base.

Much as Weber's pictures for Calvin Klein underwear made that designer's white briefs the signifier par excellence of ideal gay male physicality in the early 1990s, Weber's work for Abercrombie has launched their merchandise into gay consciousness; A&F regalia surfaces in gay street culture, gay pornography, and many places in between.

It is difficult to say for certain whether Weber's pictures, by introducing the potential for man-to-man lust, further advance or subtly undermine the idol status of the muscle-bound white men he so loves to photograph. However, the fact that the A&F campaign's homoerotic texts go largely unnoticed by straight consumers—and must for the campaign to be effective—speaks to the subversive limitations of Weber's art.

Born on March 29, 1946, in rural Greensburg, Pennsylvania, Weber has attributed his interest in photography to his father's tradition of taking family pictures every Sunday and his photographic style to the all-American aesthetics of his pastoral childhood home.

Weber first studied theater in Ohio, then went on to pursue filmmaking at New York University in the 1960s. While in New York, he studied photography under Lisette Model and was also influenced by his friend, photographer Diane Arbus.

Although Weber is best known for his advertising photography, he has also earned acclaim for his filmmaking. His documentary focusing on the life of jazz trumpeter

Chet Baker, *Let's Get Lost* (1989), was nominated for an Academy Award.

His most recent feature, *Chop Suey* (2001), highlights one of Weber's "discoveries," a gorgeous hunk named Peter Johnson who became a highly paid photographic model; but it is also an autobiographical work in which Weber examines his own career and interests, including his passion for legendary lesbian cabaret performer Frances Faye.

Weber has also directed music videos for Chris Isaak and the Pet Shop Boys.

Although Weber is widely credited with elevating advertising photography to an art form, a more compelling effect of his practice may be the way in which it collapses, rather than elevates, the ad with the artful photograph.

The erotic traits so celebrated in Weber's images are themselves readable as market commodities. His privileged, youth-only world of smooth white skin on seething, untouchable bodies partakes of the formal language of advertising; Weber's men are redolent, seductive, and too perfect, partly accessible through the act of consuming, but ultimately unattainable.

Like any good advertisement, his pictures incite, but never fully quench, the viewer's desire.

— *Jason Goldman*

BIBLIOGRAPHY

Hainley, Bruce, and David Rimanelli. "Shock of the Newfoundland: Bruce Weber's Canine Camera." *Artforum International* 33 (April 1995): 78–81.

Leddick, David. *The Male Nude.* New York: Taschen, 1998.

Weber, Bruce. *Bruce Weber.* New York: Knopf: 1988.

——. *Hotel Room with a View.* Washington, D. C.: Smithsonian Institution Press, 1992.

SEE ALSO

Photography: Gay Male, Post-Stonewall; Subjects of the Visual Arts: Nude Males

White, Minor *(1908–1976)*

ONE OF THE MOST INFLUENTIAL PHOTOGRAPHERS OF the second half of the twentieth century, Minor White was also a renowned teacher, critic, editor, and curator. A homosexual at a time when homosexuality was strictly forbidden in this country, White's sexuality was troubling to him. Nevertheless, he expressed it in his work.

Given the homophobic times in which he lived, however, it is not surprising that he suppressed the photographs of male nudes that he created early in his career.

Early Life

Minor Martin White was born on July 9, 1908, in Minneapolis, to Charles Henry White, a bookkeeper, and Florence Martin White, a dressmaker. He became interested in photography at the age of ten when his grandfather, an amateur photographer, gave him a box Brownie camera. Two years later, when his grandfather died, White inherited the older man's photographic equipment.

White graduated from high school in 1927 and entered the University of Minnesota, where he became aware of his sexual orientation. His homosexuality was a source of torment for him, and it also disturbed his parents when he told them of his feelings.

At the university, White also learned the rudiments of photography, wrote poetry, and, after a hiatus in his education, obtained a B.S. degree in botany, with a minor in English, in 1934.

Becoming a Photographer

Shortly after graduating from college, White purchased a 35 mm Argus camera and traveled to the West Coast. He worked at the Beverly Hotel in Portland, Oregon, as a night clerk from 1937 to 1938 and began his career in photography.

While in Portland, White lived at the YMCA. He was active in the Oregon Camera Club and spent his time photographing, exhibiting, and teaching photography to eager students.

In 1938, White was chosen as a creative photographer for the Works Progress Administration. His assignment was to photograph the Portland waterfront and the city's nineteenth-century iron-facade buildings, which were beginning to be demolished.

White also arranged two exhibitions for the WPA during that time. One was on early Portland architecture; the other, on the Portland waterfront.

In 1940, the WPA sent White to teach photography in its Art Center located in La Grande, Oregon, near the Idaho border. He later directed the Center and wrote art criticism for local exhibitions while he was there.

White returned to Portland in 1941 with the intention of establishing a photography business. In the same year, he participated in the Image of Freedom exhibition at the Museum of Modern Art in New York. Recognizing the high quality of White's work, the museum acquired some of his images for its permanent collection.

White's first one-man exhibition, of photographs taken in eastern Oregon, was held at the Portland Art Museum in 1942. His photographs were also published in *Fair Is Our Land,* edited by Samuel Chamberlain during that year. In addition, the Portland Art Museum commissioned White to photograph the Dolph and Lindley houses, two historical residences in the city.

The Army Years

White served in the U. S. Army Intelligence Corps from 1942 to 1945. He participated in the Battle of the Philippines and was awarded a bronze star. He took some portraits of soldiers in his unit stationed in Hawaii. He also completed a book-length manuscript entitled "Eight Lessons in Photography," an exercise that anticipated his later career as teacher.

Prior to joining the army, White had seriously discussed the Catholic faith with a good friend in La Grande. In the army, in 1943, he was baptized by a chaplain. This was an important step on a wide-ranging spiritual search that lasted throughout White's lifetime, one that would lead him to Buddhism and mysticism. During these years, he continued to wrestle with his homosexual feelings.

The New York Years

After being discharged from the army, White moved to New York City, where he studied aesthetics and art history with Meyer Shapiro at Columbia University from 1945 to 1946.

In New York, he met Beaumont Newhall, curator of photography at the Museum of Modern Art, and his wife, Nancy. The Newhalls introduced White to photographers such as Alfred Stieglitz, Berenice Abbott, Henry Callahan, Edward Steichen, Paul Strand, and Brett and Edward Weston, among others.

A meeting with Alfred Stieglitz in which the two artists discussed the older photographer's theory of Equivalents was a seminal event in White's life, especially as this meeting was coupled with viewing a retrospective exhibition of Edward Weston's work.

The California Years

In 1946, White accepted an invitation by Ansel Adams to become his assistant on the faculty of the California School of Fine Arts in San Francisco. He remained on the faculty until 1953. During his six-year career there, White discovered that he and Adams shared the same approach to aesthetics and photographic technique. They became close friends and also shared a friendship and many discussions about photography with Edward Weston.

A small group of photographers, including the Newhalls, Dorothea Lange, and Barbara Morgan, met at Adams's house, where they decided to found a photography magazine that would publish and discuss serious photography. White became the editor of the newly founded *Aperture* quarterly in 1952. Modeled after Stieglitz's publication *Camerawork*, *Aperture* continues today. It did more than any other publication to improve the quality of photographic publishing in the last half of the twentieth century.

Photographic Sequences

Meanwhile, in the immediate post–World War II years, White struggled with one of his photographic sequences. Entitled "Second Sequence / Amputations," the series was completed in 1946 and was scheduled for exhibition at San Francisco's Palace of the Legion of Honor. The exhibition was, however, canceled because White refused to exhibit the pictures without the accompanying poetry that he had written, which the museum decreed was too personal and insufficiently patriotic.

White's first encounter with censorship did not prevent him from continuing to create work out of step with his times. However, it may have made him increasingly self-conscious about the homoerotic content of many of his images and it may have led him to think of a divide between work that was for public exhibition and work that was for his personal enjoyment and fulfillment.

White's 1946 groupings of photographs in a nonnarrative form attempted to depict the private emotions of the individual soldier and the ambiguity of postwar patriotism. Despite the cancellation of the Palace of the Legion of Honor show, within a short time White exhibited a sequence entitled "Song without Words." It was circulated around the country by the American Federation of Arts. It and related sequences were White's attempts to suggest obliquely the emotional turmoil he felt over his love and desire for men.

White's Style

White had been interested in the theater throughout his life, beginning in high school, and it was natural that he sometimes worked as a photographer for theater groups. The influence of theatrical work can be seen in much of his photography in his dramatic compositions, expressionistic lighting, and the manner in which he revealed the character of his models.

More than any other photographer of his time, White attempted to explore the depths he perceived beneath the surfaces of things and within his models. He avoided the pictorialism of photographers such as F. Holland Day or the surrealism of artists such as George Platt Lynes, but he attempted to infuse into his photographs a spirituality that might transform the worldly and the carnal.

White's Nudes

An early sequence that White entitled "The Temptation of Saint Anthony Is Mirrors" serves as an example. Consisting of nudes and portraits of a model named Tom Murphy, the sequence is one of White's most evocative. It was also the first time he allowed himself to portray the nude male body.

A famous image from the sequence simply entitled "Tom Murphy" (1947) illustrates White's theatrical lighting, as well as his need to closet his homosexuality

and to transform the carnal into the spiritual. The model is depicted seated on the beach, feet and hands pushed flat on a piece of textured wood. A beautifully formed piece of driftwood is artistically placed to rise up through the bend in the model's left leg and rest on his right shoulder. The wood covers the model's genitals, but it also makes a telling statement about what is unrevealed and forbidden.

The object of the photographer's gaze is concealed but the subject of the photograph is definitely declared. Murphy's head is buried in such deep shadow as to appear decapitated. He was the "hidden" subject of four other male nudes in a group that White created during 1948.

By 1950, the photographer was working with another young man. In the "Fifth Sequence / Portrait of a Young Man As Actor," White worked in collaboration with the sitter, Mark Adams, who was also an artist and amateur actor.

Although White's male nudes are an important achievement, they were not shown in public until the important 1989 exhibition entitled Minor White: The Eye That Shapes.

Postwar Success

The first postwar exhibition of White's photography occurred at the San Francisco Museum of Art in 1948. A variety of exhibition venues began to open to White during the 1950s. He directed How to Read a Photograph at the San Francisco Museum of Art in 1953, and became Assistant Curator at the George Eastman House, a photography museum in Rochester, New York, during the same year. White served as curator of exhibitions there for four years and also edited Image magazine.

Among the shows he directed during these years were Camera Consciousness (1954), The Pictorial Image (1955), and Lyrical and Accurate (1956). A large exhibition of his own work, Sequence 13: Return to the Bud, was also presented at Eastman House in 1959.

Distinguished Teacher

White taught photography part time at Rochester Institute of Technology in 1955. In 1956, he resigned his position at George Eastman House to become a full-time lecturer in photography at Rochester, a position he held from 1956 to 1964.

During this time, White also began to conduct workshops throughout the country, a practice he would continue for the rest of his life. As a teacher, White influenced several fine contemporary photographers, including Paul Caponigro, Walter Chappell, Nathan Lyons, and Jerry Uelsmann, among others.

In Rochester, White further developed his interests in mysticism and Eastern philosophy and the teachings of Gurdieff. He would later take these ideas into the class-

room and use them to teach his students how to clear the mind and become fully present to a photographic subject.

In 1962, White was a founding member of the Society for Photographic Education, and three years later he was made visiting professor in the Department of Architecture at MIT. White was promoted to a tenured professorship in 1969 and continued to teach and organize exhibitions there until 1974.

The year he received tenure, White also saw the publication of the first monograph of his photographs, Mirrors, Messages, and Manifestations: Photographs and Writings 1938–1968. The volume accompanied a major traveling exhibition of White's work that originated at the Philadelphia Museum of Art in 1970, a year in which he was also awarded a Guggenheim Fellowship and began the Hotchkiss Workshop in Creative Photography in Connecticut.

White's Last Years

Although he was diagnosed with angina as early as 1966, White lived an extremely active life. While he curated exhibitions and taught at MIT, he also created his own work, conducted workshops, and gave seminars across the country. The pace was grueling and it began to affect his health.

White retired from the faculty of MIT during 1974 in an effort to reduce stress, but was also appointed Senior Lecturer and became a Fellow of the MIT Council of the Arts in 1975. He resigned as editor of Aperture the same year but also saw the first substantial exhibition of his photographs tour Europe.

White loved his work and accepted offers to lecture at the Victoria and Albert Museum, teach some classes in England, and participate in a symposium at the University of Arizona in Tucson. Finally, however, he suffered a heart attack that hospitalized him for several weeks.

But even the heart attack failed to stop his work. When he recovered, he became consulting editor of Parabola magazine and received an honorary doctorate of fine arts from the San Francisco Art Institute.

He continued to work selectively until he died of a second heart attack, in Boston, on June 24, 1976.

A Closeted Life

Throughout his life White maintained a careful silence about his homosexuality. Painfully conscious of the need to maintain his career, especially his teaching career, which could have been destroyed by a whiff of scandal, he refused to exhibit photographs that were sexually explicit. Even the male nudes that he created but failed to exhibit were portrayed in a way that kept the model's identity in the shadows.

In spite of the psychological and emotional toll such closeting exacted of him, White was able to create art of

a very high order. A deeply religious man who made a spiritual journey of his whole life, White made his art an integral part of that journey. One of the greatest photographers of the twentieth century, he was also one of the century's greatest teachers of photography.

— *Ray Anne Lockard*

BIBLIOGRAPHY

Buerger, Janet E. "Minor White (1908–1976): The Significance of Formal Quality in His Photographs." *Image* 19.3 (September 1976): 20–32.

Bunnell, Peter, ed. *Minor White: The Eye that Shapes.* Princeton, N.J.: Princeton University Art Museum, 1989.

Ellenzweig, Allen. *The Homoerotic Photograph: Male Images from Durieu/Delacroix to Mapplethorpe.* New York: Columbia University Press, 1992.

Harms, Valerie. "The Teaching Legacy of Minor White." *Camera* 35 21. 5 (June 1977): 52–53, 64, 66.

Holborn, Mark. *Minor White, A Living Remembrance.* New York: Aperture, 1984.

Hooven, F. Valentine, III. "White, Minor." *Gay Histories and Cultures: An Encyclopedia.* George E. Haggerty, ed. New York: Garland, 2000. 947–948.

Pultz, John. "Equivalence, Symbolism, and Minor White's Way into the Language of Photography." *Record of the Art Museum, Princeton University* 39.1–2 (1980): 28–39.

Sekula, Alan. "On the Invention of Photographic Meaning." *Artforum* 13 (January 1975): 36–45.

White, Minor. *Minor White: Rites and Passages.* New York: Aperture, 1978.

SEE ALSO

Photography: Gay Male, Pre-Stonewall; Censorship in the Arts; Abbott, Berenice; Day, F. Holland; Lynes, George Platt; Subjects of the Visual Arts: Nude Males

Whitney, Anne *(1821–1915)*

HAILING FROM A WEALTHY, LIBERAL, UNITARIAN Boston family, sculptor Anne Whitney was politically active in support of abolition and women's equality. Her choice of subjects—abolitionists, feminists, and blacks—reflected her political and social beliefs.

As a woman artist in a male-dominated field, Whitney experienced her own struggles for equality: In 1875, having been a sculptor for nearly twenty years, she entered a national competition for a sculpture of the abolitionist Clark Sumner. Whitney won the commission, only to be denied the job when it was realized that she was a woman.

It was "publicly decreed that a woman could not accurately sculpt a man's legs." Outraged all the more because the abolitionist subject was dear to her heart, and determined that such discrimination would not happen to her again, she never entered another competition.

Prior to becoming a sculptor, Whitney, who was born on September 2, 1821, ran a small school in Salem, Massachusetts, from 1846 to 1848. During that time she began to write verse and became a published author, with work in *Harper's* and *Atlantic Monthly* magazines. She became well known as a poet, and her collected poems were published in 1859.

By that time, however, she had begun to model sculptures. Her earliest known work is a portrait bust of a young girl, *Laura Brown* (1859; National Museum of American Art, Smithsonian Institution). She also sculpted members of her family and the painter Abby Adeline Manning, with whom Whitney is said to have had a "Boston marriage."

Manning's work has since fallen into obscurity, and she is remembered now primarily as Whitney's longtime companion.

Having been previously educated at home and at a girls' school in Maine, but eager to learn her craft, in 1862 Whitney took a studio next door to and began studying with Boston sculptor William Rimmer.

During this time she modeled what is believed to be the first male nude by an American woman artist. She later reworked the plaster piece into her sculpture *The Lotus Eater* (Newark Museum). Her first life-sized work was *Lady Godiva* (private collection), whom she depicted disrobing in an act of protest against taxation of the poor.

During this time in Boston, Whitney befriended women sculptors Harrier Hosmer (1820–1908), her neighbor, and Mary Edmonia Lewis (1844–1909), who had recently relocated to Boston from Ohio and whom Whitney briefly instructed.

Like Hosmer and Lewis before her, Whitney went to Rome in 1866, seeking to broaden her skills. Years later, Henry James dubbed lesbians Hosmer, Whitney, Lewis, and Emma Stebbins (along with nonlesbians Louisa Lander, Margaret Foley, Florence Freeman, and Vinnie Ream Hoxie) "that strange sisterhood of American 'lady sculptors' who at one time settled upon the seven hills [of Rome] in a white, marmorean flock," referring to their preference for the fine white marble quarried near Rome.

All of these artists worked primarily in the Neoclassical style, producing monumental sculptures of historical and allegorical female subjects. During her time in Rome, Whitney created *Roma* (1869), an unidealized image of an old peasant woman, her dress hemmed with small medallions of famous Italian artworks as a symbol of the poverty and decay of the ancient city. Due to its critical content, however, Roman authorities banned it and Whitney had to sneak it out of the country.

Anne Whitney.

Upon her return to the United States, in 1871, Whitney received a commission for the Capitol Building in Washington, D.C., to create a sculpture of Revolutionary War hero Samuel Adams. Before it was sent to Washington, it was displayed at the Boston Athenaeum; Bostonians liked it so much they commissioned a bronze copy, which stands in Adams Square in front of Faneuil Hall.

In 1876, Whitney established her four-story studio at 92 Mount Vernon Street on Beacon Hill in Boston, where she worked for eighteen years.

In 1893, she executed a portrait bust of her friend, feminist Lucy Stone, which was commissioned for the Woman's Building at the World's Columbian Exposition in Chicago, and is now in the Boston Public Library.

Although Whitney protested the segregation of women's art, she was eager to memorialize Stone, whom Whitney met while raising money with feminist Elizabeth Blackwell to establish a women's hospital. Stone was the first Massachusetts woman to earn a college degree; and she kept her name when she married, inspiring later feminists to dub themselves "Lucy Stoners."

An early conservationist, Whitney purchased a 225-acre farm in Shelburne, Vermont, where she and Manning spent their summers. Whitney later taught at Wellesley College, and in 1902, righting a twenty-five-year injustice,

a bronze she cast from a reworked model of the abolitionist Sumner was erected near Harvard Square in Cambridge. Her Mount Vernon Street studio is now a featured stop on a walking tour of Beacon Hill.

— *Carla Williams*

BIBLIOGRAPHY

Gerdts, William H., Jr., et al. *The White Marmorean Flock: Nineteenth Century American Women Neoclassical Sculptors.* Exhibition catalog. Poughkeepsie, New York: Vassar College Art Gallery, 1972.

Hirshler, Erica. *A Studio of Her Own: Boston Women Artists, 1870–1940.* Exhibition catalog. Boston: Museum of Fine Arts, 2001.

Rubenstein, Charlotte Streifer. *American Women Sculptors: A History of Women Working in Three Dimensions.* Boston: G. K. Hall & Co., 1990.

Tufts, Eleanor. "Anne Whitney." *North American Women Artists of the Twentieth Century: A Biographical Dictionary.* Jules Heller and Nancy G. Heller, eds. New York: Garland, 1995.

SEE ALSO

American Art: Lesbian, Nineteenth Century; Hosmer, Harriet Goodhue; Lewis, Mary Edmonia; Stebbins, Emma

Wojnarowicz, David (1954–1992)

AMERICAN ARTIST AND WRITER DAVID WOJNAROWICZ is critical to the history of late-twentieth-century contemporary art. The first American gay artist to respond to the AIDS crisis with anger and moral outrage, he used his art as a polemical tool with which to indict those he held responsible for the AIDS epidemic and to document his own suffering.

Surprisingly, Wojnarowicz had no extensive formal training. Born in Red Bank, New Jersey, into a severely dysfunctional family in 1954, he dropped out of high school soon after acknowledging his homosexuality as an adolescent. He was a street kid in New York City at the age of sixteen, turning tricks in Times Square and keeping company with hustlers and other outsiders.

Wojnarowicz found salvation in making art and writing. Yet the rawness of his life experiences would always be the stuff of a highly personal and confrontational art.

As a young man, Wojnarowicz hitchhiked across the United States and lived in San Francisco and Paris for several months. In 1978, he settled in New York.

By the early 1980s, he had become, like graffiti artists Jean-Michel Basquiat and Keith Haring, a vital fixture in the East Village art scene in lower Manhattan.

Wojnarowicz had his first solo exhibitions in New York in the early 1980s. In 1985, he had a major exhibition at the Institute of Contemporary Art at the University of Pennsylvania in Philadelphia. His growing

prominence as a nationally recognized artist is witnessed by invitations to participate in the 1987 and 1991 Whitney Biennials at the Whitney Museum of American Art in New York.

Wojnarowicz came to maturity as a contemporary artist and writer during a decade when the arts sought increasingly to address issues of gender, race, and ethnicity. A younger postmodern generation of artists gave expression to these concerns in nontraditional media and often worked in multimedia.

For example, Wojnarowicz expressed himself in film, installation art, sculpture, photography, performance art, painting, collage, drawing, and writing. Indeed, he became as fine a writer as he was a visual artist.

Before being diagnosed HIV-positive in 1987, Wojnarowicz tracked in his confessional art a life that vacillated between sensual abandon and despair, bringing into focus a dark vision of existence that drew upon the examples of Arthur Rimbaud and Jean Genet.

Also influenced by Pop Art and the example of the writers of the Beat movement of the 1950s, Wojnarowicz drew upon images of popular culture and uniquely American idioms, though often rendering them ironically or satirically.

Frequently unabashedly homoerotic, Wojnarowicz's pre-AIDS art also often commented trenchantly on a failure of love in contemporary society. In *Fuck You Faggot Fucker,* a 1984 photographic collage, he juxtaposes the vivid dream of love with its often bleak reality.

Another early work, *Peter Hujar Dreaming/Yukio Mishima: St. Sebastian* (1982), in acrylic and spray paint on Masonite, is particularly interesting for its self-conscious use of gay iconography.

With the onset of his disease, Wojnarowicz turned fiercely political. The tragedy and injustices of the AIDS epidemic within the gay community became the central subject in his art and writings.

He took to task the medical community and the federal government for their indifference to the pressing health issues of gay men. He passionately protested the fact that, as he put it, so many people were dying "slow and vicious and unnecessary deaths because fags and dykes and junkies are expendable in this country."

Wojnarowicz took a public stand against homophobia in published interviews and essays that earned him the vitriolic ire of the conservative religious right, specifically Reverend Donald Wildmon of the American Family Association, Senator Jesse Helms, and John Cardinal O'Connor.

Wojnarowicz was the first American gay artist to step forward in anger and give expression to his moral outrage. His "post-diagnostic art," as he called it, indicted all those he held responsible for the social and private horrors of those dying from AIDS, including himself.

Toward the end of his life, his defiant art was a polemical and poignant record of his cruel demise.

Of all the media and formats for which Wojnarowicz is known, the works that combine image and text are the most complex and moving, offering the best summary of his art.

An untitled work from 1992, the year he died, presents a gelatin silver print (a black-and-white photograph) with a text in blood-red ink screen-printed on it. Both the photograph and the text are Wojnarowicz's own.

The photograph is of the artist's joined and bandaged hands, his palms opened in a pathetic and imploring gesture. Registering the ravages of disease, the torn and dirty bandages suggest the hands of a leper. Wojnarowicz presents himself as the reviled social outcast.

The text is from the chapter "Spiral" in Wojnarowicz's book *Memories That Smell Like Gasoline* (1992). The last portion of the quoted passage reads: "I am shouting my invisible words. I am getting so weary. I am growing tired. I am waving at you from here. I am crawling and looking for the aperture of complete and final emptiness. I am vibrating in isolation among you. I am screaming but it comes out like pieces of clear ice. I am signaling that the volume of all this is too high. I am waving. I am waving my hands. I am disappearing. I am disappearing but not fast enough."

In another gelatin silver print made by Wojnarowicz in the year of his death, he rephrased these sentiments in an extreme close-up of his head as it is half-buried in dirt that barely leaves mouth, nose, and closed eyes visible. The artist offers himself as a living death mask.

Wojnarowicz's grim imagery of rage and despair has its source in the specifics of a dying gay man, yet it also stands, more generally, as a memorial to injustice and human suffering.

He died on July 22, 1992.

— *Richard H. Axsom*

BIBLIOGRAPHY

Wojnarowicz, David. *David Wojnarowicz: Brush Fires in a Social Landscape.* New York: Aperture, 1995.

———. *Fever: Art of David Wojnarowicz.* Dan Cameron, Mysoon Rizk, and Cynthia Carr, eds. New Museum Books 2. New York: Rizzoli International Publications, 1999.

SEE ALSO

Contemporary Art; American Art: Gay Male, Post-Stonewall; Photography: Gay Male, Post-Stonewall; Pop Art; Video Art; AIDS Activism in the Arts; Haring, Keith; Subjects of the Visual Arts: Prostitution; Subjects of the Visual Arts: St. Sebastian

Wolfe, Elsie de (1865–1950)

ALTHOUGH INTERIOR DECORATING IS NOW WIDELY considered—indeed, stereotyped as—a career for gay men, an American lesbian was, in fact, to a great extent responsible for the creation of this profession. Not only did Elsie de Wolfe spearhead a cultural movement of home aesthetics, she was also one of the central figures of an elite New York "Amazon enclave" that included some of the most glamorous figures of the Broadway stage during the early years of the twentieth century.

Nor were these her only accomplishments: She also has the distinction of being the inventor of both the Pink Lady cocktail (which she made with Cointreau liqueur, grapefruit juice, and gin) and the infamous blue hair rinse favored by many graying ladies.

She was born Ella Anderson de Wolfe on December 20, 1865, the daughter of a wealthy New York family. Her parents sent her to a finishing school in Edinburgh, and after her education she "came out" (in the older meaning of the term) as a debutante at the court of Queen Victoria. Until the age of twenty-five, she led the life of indolence usual for young, unmarried women of her background and occasionally participated in amateur dramatics.

In 1890, de Wolfe's father, a prominent physician, died and left the family with considerable debts from his compulsive gambling. Rather than marry for money, she chose to be independent and self-supporting, and thus she began her career as a stage actress, although at the time it was at best a dubious profession for a woman of genteel upbringing. In the theatrical world, de Wolfe was known for her striking mode of dressing, and she drew audiences for her clothes as much as for her acting.

During this period, de Wolfe became the lover and partner of Elisabeth ("Bessie") Marbury, a prominent Broadway agent and producer. Theirs was an almost prototypical "butch–femme" relationship, and they became the objects of constant gossip in high society, as they were alleged to have hosted "sapphic orgies" at the Sutton Place home of their friend Anne Morgan, the daughter of financier J. P. Morgan. Beyond any doubt, they mentored many young lesbians in the New York theatrical world, including Katherine Cornell, Eva Le Gallienne, and Mercedes de Acosta.

At the age of forty, de Wolfe had passed her prime as an actress. She had already achieved some acclaim as a set designer and for decorating the house in which she lived with Marbury. Thus, at her partner's urging, she retired from acting to devote herself to creating a new career, that of decorating interiors for wealthy clients whom she knew through her social circle.

De Wolfe's first major commission was the decoration of the Colony Club, an exclusive New York social club

Elsie de Wolfe.

for women, and her services were soon very much in demand. She created a vogue for light and airy open space, as opposed to Victorian styles then predominant, which favored overstuffed furniture and an abundance of *objets d'art*. To achieve this airy effect, she utilized mirrors and light colors, particularly beige. (Indeed, she was said to have exclaimed upon first seeing the Parthenon in Greece, "Beige! It's my color!")

Although de Wolfe's influence was initially felt in the homes of the New York elite who formed her first clientele, her dictates on home aesthetics soon reached mainstream middle-class Americans by means of her newspaper and magazine columns. These writings were collected and published as *The House in Good Taste* (1913).

De Wolfe had a lifelong love of France and, with Marbury and Morgan, bought and restored the Villa Trianon at Versailles, where they entertained lavishly. She volunteered as a nurse during World War I and was awarded the Croix de Guerre and the Legion of Honor by the French government for her services to the wounded.

At the age of sixty, to the astonishment of all who knew her, de Wolfe married British diplomat Sir Charles Mendl. The marriage was platonic—de Wolfe was said to have married Mendl for his title—and while Marbury at first felt betrayed, the relationship between the two women continued until Marbury's death, in 1933.

De Wolfe published her autobiography, *After All*, in 1935. She came back to the United States at the beginning of World War II, but later returned to France, where she died at the Villa Trianon on July 12, 1950.

— *Patricia Juliana Smith*

BIBLIOGRAPHY

Bemelmans, Ludwig. *To the One I Love Best*. New York: Viking, 1955.

Campbell, Nina. *Elsie de Wolfe: A Decorative Life*. New York: Clarkson Potter, 1992.

De Wolfe, Elsie. *After All*. [1935]. New York: Arno Press, 1974.

Lewis, Alfred Allan. *Ladies and Not-So-Gentle Women*. New York: Viking, 2000.

Smith, Jane S. *Elsie de Wolfe: A Life in the High Style*. New York: Atheneum, 1982.

SEE ALSO

Architecture; Beaton, Cecil

Wood, Thelma Ellen *(1901–1970)*

THELMA WOOD MIGHT HAVE REMAINED AN OBSCURE artist practicing the obscure craft of silverpoint drawing if Djuna Barnes had not fictionalized their intense, eight-year affair in the classic lesbian novel *Nightwood*.

The second of four children, Thelma Wood was born in Kansas on July 3, 1901, and grew up in St. Louis. Wood loved animals, was a good cook, and drank rum and cola. She was almost six feet tall, boyish looking, and sexually magnetic.

Around 1921, she moved from St. Louis to Paris in order to study sculpture. She had a brief affair with the bisexual poet Edna St. Vincent Millay (1892–1950) and visited Berlin, a party city for those with foreign money.

In the fall of 1921, Berenice Abbott (1898–1991) became her lover for a brief time. Abbott—who later gained fame as a photographer—remained a friend for life. She introduced Wood to Djuna Barnes and later photographed them.

Barnes and Wood began a passionate relationship that lasted from 1921 to 1929. Fueled by sex, alcohol, and sometimes marijuana—and marred at times by infidelities, jealousy, and violence—the relationship was the "great love" of each of their lives. Although Barnes wanted their relationship to be monogamous (and for

many years thought it was), Wood sought out casual sexual partners of both genders.

Barnes encouraged Wood to take up silverpoint, in which fine-line images are created on paper from the residue of silver from a stylus. Wood crafted erotically charged drawings of animals, exotic plants, and fetishistic objects such as shoes.

Although very little of her work survives, Wood's drawings were exhibited at least once, at Milch Galleries in New York City in 1931, where they were favorably reviewed.

Wood's sketchbook from a trip to Berlin is in the Barnes papers at the University of Maryland–College Park.

In 1928—before the end of her relationship with Barnes—Wood began an affair with Henriette McCrea Metcalf (1888–1981). A small, loquacious bisexual who loved to rescue people and animals, Metcalf was born into a wealthy Chicago family, but spent much of her childhood in Paris.

When Wood moved to Greenwich Village in New York City in 1928, Metcalf followed. Wood continued to write and visit Barnes, to whom she still professed her love.

In 1932, Metcalf supported Wood's art studies in Florence. In 1934, they moved to Sandy Hook, Connecticut. In Westport, Connecticut, Wood tried (with Metcalf's financial assistance) to run a gourmet catering business, which failed. Complicating their relationship, Wood continued to seek out drinking and sexual companions.

When *Nightwood*, Barnes's brilliant, vindictive novel, was published in 1936, Wood—called "Robin Vote" in the book—was outraged and stopped speaking to the novelist. Wood felt misrepresented and claimed that the publication of the book ruined her life.

Around 1942 or 1943, Metcalf offered Wood money to move out of their shared house and end their sixteen-year relationship. Once the separation was complete, Metcalf never spoke to Wood again, even when Wood, dying, requested to see her.

Around 1943, perhaps precipitating the break with Metcalf, Wood became involved with Margaret Behrens (1908–1986)—a realtor and antique dealer—and moved into Behrens's home in Monroe, Connecticut. She did odd jobs for Behrens in a relationship that lasted until Wood's death twenty-seven years later.

In the late 1960s, Wood developed breast cancer, which spread to her spine and lungs. She died on December 10, 1970, in Danbury Hospital. Her ashes were interred in the Behrens's plot in Bridgeport, Connecticut.

— *Tee A. Corinne*

BIBLIOGRAPHY

Broe, Mary Lynn, ed. *Silence and Power: A Reevaluation of Djuna Barnes*. Carbondale and Edwardsville: Southern Illinois University Press, 1991.

Cooper, Emmanuel. *The Sexual Perspective: Homosexuality and Art in the Last 100 Years in the West.* London and New York: Routledge & Kegan Paul, 1974.

Field, Andrew. *Djuna: The Life and Times of Djuna Barnes.* New York: G. P. Putnam's Sons, 1983.

Herring, Phillip. *Djuna: The Life and Work of Djuna Barnes.* New York: Viking, 1995.

———. "Djuna Barnes and Thelma Wood: The Vengeance of Nightwood." *Journal of Modern Literature* 18.1 (1992): 5–18.

SEE ALSO

American Art: Lesbian, 1900–1969; Abbott, Berenice

Z

Zenil, Nahum B. *(b. 1947)*

NAHUM B. ZENIL EMERGED ON THE INTERNATIONAL art scene in the 1980s as part of a generation of Mexican artists who were reexamining the artistic traditions of their country as well as their personal positions within Mexican contemporary culture. Zenil's art, mostly autobiographical, has consistently acknowledged and utilized his identity as a gay man to define his artistic personality.

In a number of ways, Zenil has looked to the art of Frida Kahlo, with its strong dose of self-examination and criticism, as a beacon of inspiration. The portrait of Kahlo is sometimes incorporated into Zenil's works and he creates a lively dialogue between his own portrait and that of Kahlo, whose art has often been seen as representing the triumph of will over adversity.

Employing an often small, intimate format, he reworks a number of traditional Mexican forms of artistic expression, such as the *retablo* or ex-voto form of art. This genre is comprised of images that give thanks to God, the Virgin Mary, or a saint for a favor received. Zenil appropriates this picture type and utilizes it to express a unique blending of religious and secular concepts, most of them related to his status as a gay man in the "macho" society of Mexico.

Zenil was born on a ranch in Chicontepec (Veracruz) in 1947. He studied to be a primary school teacher and received a degree in 1959 from the Escuela Nacional de Maestros in Mexico City. He soon discovered his interest in art and enrolled in the Escuela Nacional de Pintura y Escultura (called "La Esmeralda"), taking classes there from 1968 until 1972.

His first one-artist exhibition, at which he showed purely abstract work, took place in Mexico City in 1974. He continued to work as a schoolteacher in the Mexican capital until 1982, at which time he decided to devote himself full time to painting and drawing.

Virtually all of the work that Zenil has exhibited since the early 1980s has incorporated images of himself, his longtime partner Gerardo Vilchis, his mother, and, at times, his students.

Zenil's preferred medium is mixed media (drawing, watercolor, and applied found objects) on paper. In the first half of the 1990s, he executed a significant body of paintings on canvas, but the toxicity of the materials he used severely compromised his health and he was obliged to return to the paper format.

The use of paper with collage and drawing lends an intimate feel to his art, and he consciously strives to draw the viewer into the realm of the innermost details of his private life, offering a glimpse into the ways in which he utilizes his sexual openness to combat stereotypes and prejudice.

In a number of his paintings and drawings text and image often play symbiotic roles. The texts often describe Zenil's frustration with sexual clichés and his hope that one day gay men and lesbians will receive equal treatment in Mexican society.

In many of his images Zenil also engages with traditional religious iconography. The Virgin of Guadalupe, the most revered religious symbol in Mexican society, is central to much of his work. At times the Virgin is given the face of Zenil's mother. At other times, the Virgin of Guadalupe watches over and protects the union of the artist and Gerardo Vilchis.

Irony, acute social commentary, and humor also play key roles in the work of Zenil. His satires of certain Mexican art critics who have condemned his lifestyle are poignant and sharp critiques of the individuals concerned, as well as of the Mexican art world at large.

Zenil has also served as a strong supporter of gay and lesbian social and artistic causes in Mexico. He was one of the founders of the Semana Cultural Gay (Gay Cultural Week), held every year at the Museo Universitario del Chopo, an important museum in the Mexican capital; and he continues to provide encouragement to many artists whose work deals openly with their sexuality or with issues of sexual identity.

Zenil's work has been seen in numerous group exhibitions throughout Latin America, North America, Asia, and Australia. He has had significant one-artist shows throughout Mexico, most recently at the Museo de Arte Moderno, Mexico City, in 1999.

A major traveling exhibition of his work was seen in San Francisco, Cambridge, Massachusetts, and New York City in 1996–1997. Zenil's art is part of the permanent collections of such institutions as Mexico City's Museo de Arte Moderno and New York's Metropolitan Museum of Art.

— *Edward J. Sullivan*

BIBLIOGRAPHY

Douglas, Eduardo De Jesús. "The Colonial Self: Homosexuality and Mestizaje in the Art of Nahum B. Zenil." *Art Journal* 57.3 (1998): 14–21.

Nahum B. Zenil: El gran circo del mundo. Exhibition catalog. Mexico City: Museo de Arte Moderno, 1999.

Nahum B. Zenil: Presente. Exhibition catalog. Monterrey, Mexico: Museo de Arte Contemporáneo de Monterrey, 1991.

Sullivan, Edward J., and Clayton C. Kirking. *Nahum B. Zenil: Witness to the Self. Testigo del Ser.* Exhibition catalog. San Francisco: The Mexican Museum, 1996.

———. "Nahum Zenil and the Politics of the Soul." *Arte en Colombia* (December 1989): 76–79.

SEE ALSO

Latin American Art; Kahlo, Frida; Subjects of the Visual Arts: Nude Males

notes on contributors

MICHELLE ANTOINETTE, a Ph.D. candidate at Monash University, Australia, studies contemporary Southeast Asian art and identity. A scholar of Australian and Asian visual arts, her recent publications in Australian art journals review the work of contemporary Australian and Asian artists. Entries: Dobell, Sir William; Friend, Donald

ELIZABETH ASHBURN, Professor and Head of the School of Art in the College of Fine Arts at the University of New South Wales, Australia, is author of *Lesbian Art: An Encounter with Power* and numerous articles. She is copresident of the Australian Center for Gay and Lesbian Research. Entries: Fini, Léonor; Goodsir, Agnes Noyes; Laurençin, Marie; Lempicka, Tamara de; Photography: Lesbian, Post-Stonewall

RICHARD H. AXSOM is Senior Curator of Prints and Photographs at the Grand Rapids Art Museum. He is Professor Emeritus of Art History at the University of Michigan–Dearborn, where he taught courses on the history of modern and contemporary art. His extensive publications on contemporary prints include *catalogues raisonnés* for Ellsworth Kelly, Claes Oldenburg, Frank Stella, and Tony Winters. Entries: Bleckner, Ross; Contemporary Art; González-Torres, Félix; Wojnarowicz, David

JEFFERY BYRD, Professor of Art at the University of Northern Iowa, is a performance artist and photographer whose work has been featured in numerous solo exhibitions and journals. He has performed at New York City's Lincoln Center and Alternative Museum, Boston's Institute of Contemporary Art, Chicago's N.A.M.E. Gallery, and Cleveland's Performance Festival. Entries: Hosmer, Harriet Goodhue; Johns, Jasper; Rauschenberg, Robert

SHAUN COLE is Curator of Designs at the Victoria and Albert Museum. He is author of *"Don We Now Our Gay Apparel": Gay Men's Dress in the Twentieth Century* and has curated numerous exhibitions, including Graphic Responses to AIDS (1996), Fashion on Paper (1997), and Dressing the Male (1999), as well as two innovative "Days of Record" to document Tattooing (2000) and Black British Hairstyles and Nail Art (2001). Entries: Minton, John; Vaughan, Keith

TEE A. CORINNE is a photographer and writer. Her articles about lesbian art and artists have appeared in numerous journals and encyclopedias. Her books include *The Cunt Coloring Book, Yantras of Womanlove, Dreams of the Woman Who Loved Sex, Courting Pleasure*, and *Intimacies*. She is the editor of *FABB: The Feminist Art Books Bulletin*, coeditor of the *Queer Caucus for Art Newsletter*, and member of the editorial advisory board of www.glbtq.com. Entries: Abbott, Berenice; Bernhard, Ruth; Biren, Joan Elizabeth (JEB); Cahun, Claude; Edison, Laurie Toby; Gray, Eileen; Hepworth, Dorothy, and Patricia Preece; Höch, Hannah; Parsons, Betty; Photography: Lesbian, Pre-Stonewall; Sipprell, Clara Estelle; Stebbins, Emma; Subjects of the Visual Arts: Nude Females; Wood, Thelma Ellen

MICHAEL G. CORNELIUS is a doctoral student in early British literatures at the University of Rhode Island. He is the author of a novel, *Creating Man*. Entries: Bronzino, Agnolo; Duquesnoy, Jérôme; Subjects of the Visual Arts: Vampires; Surrealism

DENNIS DENISOFF teaches gender and sexuality studies and popular literature and culture at Ryerson University. A novelist and poet, he is also author of *Aestheticism and Sexual Parody*, editor of *Queeries: An Anthology of Gay Male Prose*, and coeditor of *Perennial Decay: On the Aesthetics and Politics of Decadence*. Entry: Raffalovich, Marc André

KIERON DEVLIN studied Art & Design at Manchester Art School, England. He holds a Master's degree from Leicester University and an M.F.A. in Creative Writing from New York City's New School. He is working on a novel and a collection of short stories. Entries: European Art: Eighteenth Century; Islamic Art; Latin American Art; Latina/Latino American Art; Subjects of the Visual Arts: Bathing Scenes; Subjects of the Visual Arts: Psyche; Symbolists

NIKOLAI ENDRES received his Ph.D. in Comparative Literature from the University of North Carolina–Chapel Hill in 2000. As an assistant professor at Western Kentucky University, he teaches Great Books, British literature, classics, mythology, and gay and lesbian studies. He has published on Plato, André Gide, Oscar Wilde, Mary Renault, Gore Vidal, and Petronius. He is working on a book-length study of Platonic love in Plato's *Symposium* and *Phaedrus*, Petronius' *Satyricon*, Wilde's *The Picture of Dorian Gray*, Forster's *Maurice*, Mann's *Death in Venice*, Gide's *Corydon*, Vidal's *The City and the Pillar*, Renault's *The Charioteer*, and Yourcenar's *Memoirs of Hadrian*; as well as a study of Petronius' *Nachleben* in modern literature. Entry: Subjects of the Visual Arts: Harmodius and Aristogeiton

MARIAN EVANS, artist, lawyer, academic, and activist, curated I Am: KO AHAU, the only lesbian and gay exhibition ever hosted by a New Zealand municipal gallery. She is currently making documentaries and a website about lesbian-made landscapes. Entry: Hammond, Harmony Lynn

ROBERTO C. FERRARI is the Arts & Humanities Librarian at Florida Atlantic University. His research interests include the late Victorian period and the Pre-Raphaelite and Aesthetic art movements. He created the Simeon Solomon Research Archive. (http://www.fau.edu.solomon).

Entries: Arts and Crafts Movement; European Art: Nineteenth Century; Subjects of the Visual Arts: Dionysus; Subjects of the Visual Arts: Narcissus

EUGENIO FILICE is a doctoral student in art history at McGill University. He is currently preparing a dissertation on representation of gay men in contemporary Canadian art, and on the revival of figurative painting that occurred during the late 1970s and 1980s. Entries: Canadian Art; Lukacs, Attila Richard

RAYMOND-JEAN FRONTAIN is Professor of English at the University of Central Arkansas. He has published widely on seventeenth-century English literature and on English adaptations of biblical literature. He is editor of *Reclaiming the Sacred: The Bible in Gay and Lesbian Culture*. He is engaged in a study of the David figure in homoerotic art and literature. Entries: Caravaggio; Subjects of the Visual Arts: David and Jonathan

TINA GIANOULIS is an essayist and freelance writer who has contributed to a number of encyclopedias and anthologies, as well as to journals such as *Sinister Wisdom*. Entry: Tsarouchis, Yannis

JASON GOLDMAN is currently pursuing a Ph.D. in Art History at the University of Southern California. His academic interests include the history of photography, twentieth-century art, pornography, contemporary art, and contemporary visual culture. Entries: Breker, Arno; Day, F. Holland; Erotic and Pornographic Art: Gay Male; Gloeden, Baron Wilhelm von; Homomonument; Pierre et Gilles; Subjects of the Visual Arts: Sailors and Soldiers; Subjects of the Visual Arts: St. Sebastian; Weber, Bruce

KEN GONZALES-DAY is a Professor of Art at Scripps College in Claremont, California. His art has been included in solo and group shows in Los Angeles, Guadalajara, Mexico City, and New York. He has published in *Art Journal, Art & Text, Artissues, Artpapers*, and *Poliester*. Entries: Cadmus, Paul; Hartley, Marsden; List, Herbert; Lynes, George Platt; Mapplethorpe, Robert; Photography: Gay Male, Post-Stonewall; Photography: Gay Male, Pre-Stonewall; Tom of Finland

PETER R. GRIFFITH is an independent art historian and freelance translator. Formerly from New England, he now makes his home in the Netherlands. Entries: Dürer, Albrecht; Subjects of the Visual Arts: Ganymede; Subjects of the Visual Arts: Orpheus

BRANDON HAYES is a recent graduate of the Honors Program at the University of Michigan–Dearborn. Founder of a theater group, he has produced and directed Tony Kushner's *Angels in America,* among other plays. Entry: Video Art

PETER J. HOLLIDAY, Professor of the History of Art and Classical Archaeology at California State University, Long Beach, has written extensively on Greek and Roman art and their legacies and on issues in contemporary art criticism. Entry: Warhol, Andy

WILLIAM HOOD is Mildred C. Jay Professor of Art at Oberlin College, where he has taught since 1974. He has published on a variety of subjects in Renaissance and Baroque art. His book *Fra Angelico at San Marco* won the George Wittenborn Prize and was a finalist in the Premio Salimbeni Competition in Italy. His book-in-progress is entitled *Made Men: Essays on the Heroic Male Nude from Michelangelo to Mapplethorpe.* Entry: Michelangelo Buonarroti

ROBIN IMHOF is a Reference Librarian at San Francisco State University. She specializes in nineteenth-century Symbolist and Decadent literature. Entry: Salons

CRAIG KACZOROWSKI writes extensively on media, culture, and the arts. He holds an M.A. in English Language and Literature, with a focus on contemporary critical theory, from the University of Chicago. He comments on national media trends for two newspaper-industry magazines. Entries: AIDS Activism in the Arts; Censorship in the Arts

NATALIE BOYMEL KAMPEN is Ann Whitney Olin Professor of Women's Studies and Art History at Barnard College, Columbia University. She has written books and articles on Roman art and culture and on problems of gender and visual representation. She is currently at work on a book about Roman family imagery. Entry: Classical Art

FREDERICK LAMP is Curator of African Art at the Yale University Art Gallery. He is the author of *Art of the Baga: A Drama of Cultural Reinvention* and *La Guinée et ses Héritages Culturels,* as well as numerous articles. Entry: African Art: Traditional

ANDREW LEBLANC earned his M.A. in German at Schiller International University, Heidelberg. His post-graduate studies and degree in education were completed at Tulane and Loyola Universities in New Orleans. He teaches German and French for New Orleans Public Schools and heads a German school-exchange program with the German-American-Partnership Program. Entry: Schwules Museum (Gay Museum)

RAY ANNE LOCKARD is Head of the Frick Fine Arts Library at the University of Pittsburgh. Active in the Art Libraries Society of North America (ARLIS/NA), she was a founding member and the first chairperson of the Gay and Lesbian Interests Round Table of ARLIS/NA. She has also served as cochair of the Gay and Lesbian Caucus of the College Art Association. Entries: Austen, Alice; Bonheur, Rosa; Brooks, Romaine; Carrington, Dora; Gilbert & George; Gluck (Hannah Gluckenstein); Klumpke, Anna Elizabeth; Solomon, Simeon; White, Minor

RICHARD G. MANN is Professor of Art at San Francisco State University, where he regularly offers a two-semester multicultural course in Queer Art History. His publications include *El Greco and His Patrons* and *Spanish Paintings of the Fifteenth through Nineteenth Centuries.* Entries: American Art: Gay Male, 1900–1969; American Art: Gay Male, Nineteenth Century; American Art: Gay Male, Post-Stonewall; El Greco; Homer, Winslow; Pontormo, Jacopo; Subjects of the Visual Arts: Nude Males; Subjects of the Visual Arts: Prostitution

JOHN MCFARLAND is a Seattle-based critic, essayist, and short story writer. He is author of the award-winning picture book *The Exploding Frog and Other Fables from Aesop.* He has contributed to such anthologies as *Letters to Our Children: Lesbian and Gay Adults Speak to the New Generation, The Book Club Book, The Isherwood Century,* and *Letters to J. D. Salinger.* Entry: Hockney, David

MARK MCLELLAND is a postdoctoral research fellow at the Centre for Critical and Cultural Studies at the University of Queensland, where he researches and writes about sexuality and the media in Japan. He is author of *Male Homosexuality in Modern Japan: Cultural Myths and Social Realities* and editor of *Japanese Cybercultures.* He serves on the editorial advisory board of www.glbtq.com. Entry: Japanese Art

EVE MILLAR, of mixed cultural heritage, has lived in a number of countries and continents. She is currently a student in the history of art department at the University of Victoria, specializing in South Asian Art. Entry: Indian Art

STACI NICHOLSON is a recent graduate of the University of Michigan–Dearborn. She plans to focus on modern and contemporary art in graduate school. Entry: Video Art

JULIA PASTORE is a New York–based freelance writer who works in book publishing. Entries: Duchamp, Marcel; Leonardo da Vinci; Sargent, John Singer

LINDA RAPP teaches French and Spanish at the University of Michigan–Dearborn. She freelances as a writer, tutor, and translator. She is Assistant to the General Editor of www.glbtq.com. Entries: Bazille, Jean-Frédéric; Fuseli, Henry; Leibovitz, Annie; Marées, Hans von; Meurent, Victorine; Ocaña, José Pérez; Percier, Charles, and Pierre Fontaine; Pisis, Filippo Tibertelli De; Rainbow Flag; Ricketts, Charles, and Charles Shannon; Ritts, Herb

SUSAN RICHARDS is founder and Coordinator of the Queer Artist Project of the Lesbian and Gay Historical Society of San Diego. As an artist, she works in mixed media, assemblage, printmaking, digital imaging, and video. She is also a psychotherapist in private practice with specialties in creativity and the unconscious, dream work, and the resolution of creative blocks. Entry: Cooling, Janet

PATRICIA SIMONS, Associate Professor of the History of Art and Women's Studies at the University of Michigan, serves on the editorial advisory board of www.glbtq.com. Her scholarly interests include the art of Renaissance Italy, with a special focus on the representation of gender and sexuality, and interdisciplinary research on the construction of authority and identity. Entries: Donatello; European Art: Renaissance; Sodoma, Il; Subjects of the Visual Arts: Diana; Subjects of the Visual Arts: Dildos; Subjects of the Visual Arts: Hercules

JAMES SMALLS is Associate Professor of Art History and Theory at the University of Maryland, Baltimore County. He teaches and publishes on the interrelatedness of race, gender, and queer sexualities in nineteenth-century and modern art and in twentieth-century black visual culture. Entries: Barthé, James Richmond; European Art: Neoclassicism; Flandrin, Hippolyte; Géricault, Théodore; Girodet-Trioson, Anne-Louis

PATRICIA JULIANA SMITH is Assistant Professor of English at Hofstra University. With Corinne Blackmer, she has edited a collection of essays, *En Travesti: Women, Gender Subversion, Opera*. She is also author of *Lesbian Panic: Homoeroticism in Modern British Women's Fiction* and editor of *The Queer Sixties* and *The Gay and Lesbian Book of Quotations*. She serves on the editorial advisory board of www.glbtq.com. Entries: Beaton, Cecil; Blunt, Anthony; Haring, Keith; Leyendecker, Joseph C.; Wolfe, Elsie de

MARTIN SNYDER is Associate Secretary of the American Association of University Professors and Director of Planning and Development. His academic interests focus on the continuity of the classical tradition, particularly in American literature and art. Entries: Subjects of the Visual Arts: Endymion; Subjects of the Visual Arts: Hermaphrodites; Subjects of the Visual Arts: Priapus

DANIEL A. STARR is Chief Librarian, Technical Services and Planning, at The Museum of Modern Art Library, New York. Entry: Tchelitchew, Pavel

EDWARD J. SULLIVAN is Professor of Art History and Chair of the Department of Fine Arts at New York University. He is the author of over twenty-five books and exhibition catalogs on the subject of modern and contemporary Latin American art. Entry: Zenil, Nahum B.

CLAUDE J. SUMMERS is William E. Stirton Professor Emeritus in the Humanities and Professor Emeritus of English at the University of Michigan–Dearborn. He has published widely on seventeenth- and twentieth-century English literature, including book-length studies of E. M. Forster and Christopher Isherwood, as well as *Gay Fictions: Wilde to Stonewall* and *Homosexuality in Renaissance and Enlightenment England: Literary representations in Historical Context*. He is General Editor of www.glbtq.com. Entries: Beardsley, Aubrey; Dureau, George; Segal, George

MARK ALLEN SVEDE is a historian and curator whose work often addresses marginalized artists and communities. He publishes extensively about Latvian visual culture, ranging from nonconformist art and underground film to hippie fashion and dissident architecture. He also works as a residential architect. Entries: Demuth, Charles; Michals, Duane

IRA TATTELMAN is an architect, artist, and independent scholar living in Washington, D.C. He has published in such books and journals as *Queer Frontiers: Millennial Geographies; Genders and Generations; Public Sex, Gay Space; Queers in Space: Communities, Public Places, Sites of Resistance; The Best of The Harvard Gay & Lesbian Review;, Lambda Book Report;* and *Journal of Homosexuality*. Entries: Architecture; Israel, Franklin D.; Johnson, Philip; Morgan, Julia; Rudolph, Paul

TERESA THEOPHANO, a freelance writer and editor, is an MSW student at the Hunter School of Social Work, specializing in community organizing with GLBTQ populations. Entries: Bachardy, Don; Elbe, Lili; Pulp Paperbacks and Their Covers

JOE A. THOMAS is Associate Professor and Chair of the Art Department at Clarion University of Pennsylvania. His research focuses primarily on issues of sexuality and representation, but also digresses into American Pop Art and Italian Mannerism. Entries: European Art: Mannerism; Parmigianino (Francesco Mazzola); Pop Art; Subjects of the Visual Arts: Androgyny

WILLIAM J. TRAVIS, formerly Associate Professor of Art History at the University of Michigan–Dearborn, received his Ph.D. from the Institute of Fine Arts at New York University. He has published numerous articles on medieval art and iconography and is currently studying the sculptural decoration of the Ducal Palace in Venice. Entry: European Art: Medieval

DOUGLAS BLAIR TURNBAUGH is Representative to the U.S.A. and Membre Conseiller of the Conseil International de la Danse/UNESCO. A contributor to *New York Magazine, The Atlantic, Playbill, The Advocate, RFD, James White Review, New York Native, Performing Arts Journal, Ecrits sur Nijinsky,* among others, he is author of *Duncan Grant and the Bloomsbury Group; Private: The Erotic Art of Duncan Grant; Strip Show: Paintings by Patrick Angus;* and *Beat It: 28 Drawings.* He has been awarded the Nijinsky medal (Poland) and the Diaghilev medal (Russia). His *Serge Diaghilev* is forthcoming. Entries: Angus, Patrick; Cellini, Benvenuto; Grant, Duncan; Leslie-Lohman Gay Art Foundation

KELLY A. WACKER is Assistant Professor of Art History at the University of Montevallo in Alabama. She earned her Ph.D. at the University of Louisville, where she wrote her dissertation on Land Art and the work of Alice Aycock, Nancy Holt, and Mary Miss. She served as Editor in Chief of *Parnassus: The Allen R. Hite Art Institute Graduate Journal.* Entry: Chicago, Judy

CARLA WILLIAMS is a writer and photographer from Los Angeles, who lives and works in Santa Fe. Her writings and images can be found on her website at www.carlagirl.net. Entries: Abbéma, Louise; African American and African Diaspora Art; American Art: Lesbian, 1900–1969; American Art: Lesbian, Nineteenth Century; American Art: Lesbian, Post-Stonewall; Eakins, Thomas; Fani-Kayode, Rotimi; Lewis, Mary Edmonia; Ligon, Glenn; Subjects of the Visual Arts: Bicycles; Tress, Arthur; Whitney, Anne

TAMSIN WILTON is Reader in Sociology at the University of the West of England, Bristol. She has published widely on lesbian and gay issues since 1988, and has visited many countries to lecture on lesbian studies and on the sociology of HIV/AIDS. Her books include *Lesbian Studies: Setting an Agenda; Immortal, Invisible: Lesbians and the Moving Image;* and *Sexualities in Health and Social Care.* Entries: Corinne, Tee; Erotic and Pornographic Art: Lesbian; Grace, Della (Del LaGrace Volcano); Kahlo, Frida; Subjects of the Visual Arts: Sappho

JOYCE M. YOUMANS is Curatorial Assistant in the Department of African Art at the Nelson-Atkins Museum of Art in Kansas City. She curated the exhibition Another Africa. Her article "African Art at the Nelson-Atkins Museum of Art" appears in *African Arts.* Her research interests include contemporary Western and African art, the abject in visual art, and pragmatist aesthetics. Entries: African Art: Contemporary; Australian Art; European Art: Twentieth Century; French, Jared; Gleeson, James; Hodgkins, Frances; Khakhar, Bhupen; Latin American Art; Latina/Latino American Art; Native American Art; New Zealand Art; Pacific Art; Tuke, Henry Scott; Walker, Dame Ethel

ANDRES MARIO ZERVIGON earned his Ph.D. from Harvard University and is now Associate Professor of Art History at California's University of La Verne. He specializes in the art and design of Germany's Weimar period and in the painting of Britain's post–World War II era. Entries: Bacon, Francis; Mammen, Jeanne

index of names

A

Abbas, Riza-i 187
Abbas, Shah 187
Abbéma, Louise 1–2
Abbott, Berenice 2–3, 25, 52, 162, 244, 258, 306, 344, 350
Abercrombie, Stanley 36
Abu Bakr 186
Abu Nuwas 186
Abzug, Bella 282
Acosta, Mercedes de 349
ACT UP 14, 23, 85
Adam, Margie 53
Adam, Robert 120, 121
Adami, Hugo 203
Adams, Ansel 52, 344
Adams, Mark 345
Adams, Samuel 28, 347
Adelman, Shonagh 70
Aguilar, Laura 32, 206, 256, 307
Ajamu 11
Albani, Francesco 304
Alciati, Andrea 301
Alexander, David 22
Alexander the Great 286, 302, 310
Alfaro, Luis 205
Ali, Muhammad 216
Allison, Dorothy 165
Allston, Washington 18–19

Alma Tadema, Sir Lawrence 321
Almereyda, Michael 323
Almerez, Roberta 307
Altman, Robert 188
Anderson, Margaret 2, 258
Anderson, Sherwood 278
Andersson, Jon 67, 295
Andrews, Lea 294
Andrews, Mildred 282
Andrews, Stephan 69
Andrews-Hunt, Cookie 307
Angelico, Fra (Guido di Pietro) 290
Angus, Patrick 33–34, 78, 317
Annan, Kofi 274
Annas, Henry 252–53
Anquez, Sophie 308
Antenor 302
Antinous 82, 122, 135, 302, 310
Antonio, Emil de 340
Apollinaire, Guillaume 206, 207, 261, 278
Apuleius, Lucius 318
Arbus, Diane 342
Aretino, Pietro 136, 298
Aristogeiton 301–302, 310
Aristophanes 49, 133, 326
Aristotle 302
Armani, Giorgio 272

Armey, Dick 78
Arnold, Fiona 255
Arp, Hans 170
Arp, Jean 324
Asch, Barbara 31
Ashbee, C. R. 37, 38
Ashbery, John 243
Ashburton, Louisa 177
Ashton, Frederick 318
Atai, Nevi Zade 187
Atget, Eugène 25
Atkins, Chloe 254, 255, 256
Atkinson, Ti-Grace 165
Attoe, Wayne 36
Auden, W. H. 44, 122, 247
Augustine, Karen 13
Austen, Alice 25, 26, 38–40, 257–58, 294
Austen, Alice Cornell 38
Ayrton, Michael 231

B

Babur 186
Baca, Judith F. 32
Bachardy, Don 18, 43–44, 171
Bacon, Francis ix, 44–45, 139, 203
Badovici, Jean 162
Baker, Adge 244
Baker, Chet 343

Baker, Gilbert 268
Baker, Roy Ward 323
Bakker, B. de 118
Bakker, Marian 308
Balanchine, George 219, 252
Balbo, Italo 261
Baldini, Baccio 303
Baldwin, James 216
Ballivet, Suzanne 307
Baltrop, Al 247
Bamber, Judith 33
Bamgboyé, Oladélé 11
Bannon, Ann 265, 266
Baptiste, Otis 101
Barker, Michelle 255
Barnes, Djuna 2, 24–25, 114, 258, 277, 351
Barney, Alice Pike 62
Barney, Natalie Clifford 24, 25, 26, 62, 63, 163, 207, 244, 258, 277–78, 307
Barrie, Dennis 22, 223
Barrington, John S. 294
Barthé, James Richmond 10, 11, 45–47
Barthes, Roland 85
Bartlett, Jennifer 88
Bartolommeo, Fra 123
Baryshnikov, Mikhail 209
Basquiat, Jean-Michel 166, 341, 347
Bass, Sid R. 274
Battista, Giovanni 117
Baudelaire, Charles 47, 325
Baz Viaud, Ben Hur 203
Baz Viaud, Emilio 203
Bazille, Gaston 47
Bazille, Jean-Frédéric 47–48, 131
Bazzi, Giovanni Antonio (Il Sodoma) 134, 228, 286–87, 311, 321
Beach, Charles 16, 215–16
Beach, Sylvia 2, 67, 244, 258, 277–78
Bean, Jim 188
Beardsley, Aubrey 48–50, 68, 93, 95, 114, 133, 202, 203, 267, 271, 326
Beaton, Cecil 50–52, 108, 252, 281
Beatty, Maria 336, 337
Beaument, Edith de 207
Beaumont, Cyril 202
Bechdel, Alison 298
Beckford, William 35, 120, 122–23

Beckman, Laurel 32
Beerbohm, Max 268
Beers, Jessica E. 285
Beham, Barthel 135
Beham, Hans Sebald 135
Beham, Lorenz 102–103
Behrens, Margaret 350
Bell, Clive 162, 169
Bell, Vanessa 162, 261, 278, 292
Bellas, Bruce Harry (Bruce of Los Angeles) 253
Bellechasse, Jaime 206
Bellini, Giovanni 134, 315
Bellmer, Hans 142
Bennett, Alan 55
Benning, Sadie 33, 336, 337
Bentham, Jeremy x
Bergson, Henri 267
Bernardi, Lorena 308
Bernhard, Ruth 52–53, 258, 259, 307
Bernhardt, Sarah 1–2, 267
Bernstein, Leonard 296
Berry, Mary 122
Bess, Forrest 17, 244
Betsky, Aaron 36
Bevier, Suzanne 31
Bingham, Henrietta 73
Biren, Joan E. (JEB) 30, 53–54, 84, 254, 255, 307
Blackbridge, Persimmon 69, 115, 255–56, 308
Blackwell, Elizabeth 347
Blade (Neil Blate) 17
Blaine, Nell 306
Blake, Nayland 32, 88
Blake, William 123, 148, 319
Blanchard, Gil 249, 259–60, 321
Blanche, Jacques-Emil 161
Blate, Neil 17
Bleckner, Ross 54, 85, 86, 88, 89, 159
Bleys, Rudi 201, 203, 206
Bloch, Gabrielle 162
Bloch, Lucienne 198
Block, Anthony 269
Block, Gay 32
Block, Hans 291
Blockton, Lula Mae 31
Blok, Diana 308
Blunt, Anthony 55–56
Boccaccio, Giovanni 298
Bock, Amy 238
Boétie, Etienne de la 302

Boffin, Tessa 115, 254, 255, 256
Bologna, Giovanni 124
Boneri, Francesco "Cecco" 72, 295
Bonheur, Juliette 56
Bonheur, Raymond 56, 58, 131
Bonheur, Rosa 1, 28, 29, 56–58, 130, 131–32, 133, 199–200, 289
Bonheur, Sophie 56
Bonnard, Marthe 292
Bonnard, Pierre 292, 326
Boone, Daniel 145
Boorstein, Jonathan 36
Bordowitz, Gregg 336, 337
Borgatti, Renata 62
Borgia, Cesare 212
Boswell, John 125
Botticelli, Sandro 132, 134, 321, 326
Boucher, François 121, 130, 319
Boudin, Eugène 47
Boullée, Étienne-Louis 129
Boutelle, Sara 35, 232
Bowery, Leigh 40
Boyle, Andrew 55
Brackett, Edward A. 28, 214
Bradley, Katherine 271
Bramante, Donato 228
Brancusi, Constantin 96
Brandt, Pam 33
Brantôme, Seigneur de 136
Braque, Georges 207, 208
Brecht, Stephan 332
Breker, Arno 59–60
Brenan, Gerald 73
Breton, André 142, 323, 324
Brettel, Richard 130
Bright, Deborah 32, 255, 307
Bright, Susie 256, 307
Brinkley, Christie 36
Broekmans, Marlo 308
Bronson, A. A. 69
Bronzino, Agnolo 60–61, 123, 124, 134, 135, 262, 263
Brooke, Kaucyila 25, 32
Brooks, John Ellingham 25, 61
Brooks, Lancer 323
Brooks, Romaine 25, 32, 61–63, 114, 157, 163, 244, 258, 306–307
Brown, Colin 146
Brown, Fred 73
Brown, Frederick 339
Brown, Jerry 44
Brown, Lancelot "Capability" 121

Brown, Rita Mae 53, 165
Brown, Robert G. 269
Brown, Tony 101
Browning, Elizabeth Barrett 177
Browning, Oscar 287–88
Browning, Robert 177, 267
Browning, Tod 323
Bruce, Kathleen 272
Bruce of Los Angeles (Bruce Harry Bellas) 253
Bruckmann, Peter 224
Brugman, Til 170
Brundage, James 125
Brundage, Miss 27, 29
Bryden, Charles 44
Bryher (Winifred Ellerman) 2, 46
Buchanan, Patrick 78
Buchsbaum, Alan 35, 36
Buemi, Vanessa 41
Bufford, John H. 173
Bunch, Charlotte 53, 165
Buñuel, Luis 324
Burgee, John 195
Burgess, Guy 55
Burlington, Richard Boyle, Lord 120
Burne-Jones, Sir Edward 48, 132, 287, 290, 319, 326
Burton, Humphrey 296
Butchies, The 33
Buurman, Gon 307
Bynum, Caroline Walker 126
Byron, George Gordon, Lord 122, 302

C
Caballero, Luis 87, 203
Cade, Kathy 30, 254, 307
Cadmus, Paul 34, 46, 65–67, 77, 87, 112, 144–45, 252, 292, 295, 312, 317, 319–20
Caffieri, Hector 339
Cage, John 194, 270
Cahun, Claude ix, 67–68, 137, 138, 258, 308
Caitanya 182
Caja, Jerome 206
Califia, Pat 90
Callahan, Henry 344
Cameron, Daniel J. 31–32, 85
Cameron, Julia Margaret 209
Cameron, Loren 308
Camille, Michael 126
Campbell, Colin 69

Canaletto, Giovanni Antonio 121
Canova, Antonio 128
Caponigro, Paul 345
Capote, Truman 277
Caprotti, Gian Giacomo de' 211, 212
Caravaggio, Michelangelo Merisi da ix, xiii, 70–73, 116, 117, 218, 230, 295, 299, 305, 311, 317, 318
Carland, Tammy Rae 33
Carlo, Tony de 206
Carlyle, Florence 69
Carolus-Duran (Charles-Auguste-Emile Durand) 1–2
Carpenter, Edward x, 37, 38, 132, 302
Carricci, Annibale 119, 301
Carracci, Lodovico 119
Carrington, Dora 73–74, 278
Carrington, Leonora 142
Carrington, Noel 74
Cartier-Bresson, Henri 219
Casas, David Zamora 205
Casid, Jill 255
Cass, Deborah 33
Cassatt, Mary 172
Cavafy, C. P. 172, 226
Cavalieri, Tomaso de' 229, 230, 311
Cavalli, Pier Francesco 318
Cellini, Benvenuto 74–75, 132, 134–35, 228, 229, 230, 305
Cesari, Giuseppe (Cavaliere d'Arpino) 119
Cézanne, Paul 96, 172
Chadwick, Whitney 142
Chagall, Marc 240, 304
Chamberlain, Samuel 343
Champa, Kermit S. 47
Chan, Gaye 32, 256
Chand, Nihal 182
Chanel, Coco 2, 207
Chang, Shu Lea 33
Chaplin, Charles 1
Chapman, George 271
Chappell, Walter 345
Charles V, Holy Roman Emperor 228
Chassney, Louise 184
Chavanne, Pierre Puvis de 271, 325
Chester, Mark I. 22, 247, 313
Chesterfield, Philip Dormer Stanhope, Earl of 120

Chicago, Judy 31, 79–80, 84, 89, 321
Chigi, Agostino 286
Chippendale, Thomas 120
Chirico, Giorgio De 261
Chopin, Frédéric 277
Christian, Clara 137, 339
Christian, Meg 53
Christina, Queen of Sweden 119, 297
Christopher, Phyllis 308
Cione, Nardo di 127
Clark, Fiona 238
Clark, Kenneth 161
Clement VII, Pope 75, 242
Cleveland, Grover 26
Clinton, Bill 86, 269
Cocteau, Jean 2, 59, 62, 108, 219, 261, 296, 324
Cody, William F. 57
Cogniet, Léon 56
Coleman, Norma Jean 257
Coleridge, Samuel Taylor 323
Colette 210, 219, 267, 277
Collins, Jess 17
Colonna, Vittoria 229, 230
Colquhoun, Robert 231
Comisso, Giovanni 261
Commoy, Pierre 249, 259–60, 321
Condivi, Ascanio 228
Condor, Charles 68
Constable, John 131
Cooling, Janet ix, 31, 32, 89–90
Cooper, Edith 271
Cooper, Emmanuel 130, 169, 203, 291, 294, 296
Coplans, John 88
Corinne, Tee A. ix, 30–31, 78, 84, 90–91, 115, 254–55, 308
Corlin, Jackie 90
Cornell, Katherine 349
Correggio, Antonio da 119, 135, 301
Cortés, José Luis 206
Cortona, Pietro da 301
Cosimo, Piero di 262
Cottrell, Honey Lee 308
Coull, Karen 41
Courbet, Gustave 47, 48, 131, 132
Courtenay, William 120, 122
Courtois, Gustave 61
Couture, Thomas 225
Cox, Eric 269
Cram, Ralph Adams 35

Crane, Hart 194
Crevel, Rene 324
Crisp, Quentin 34, 213
Cronin, Patricia 308
Crow, Cornelian 177
Cullen, Charles 46
Cullen, Countee 46
Culver, Casse 53
Cunningham, Imogen 52
Cunningham, Merce 194, 270
Cushman, Charlotte 29, 177, 289–90
Cuvillies, François 120

D

Daan, Karin 176
Dalí, Salvador 142, 155, 324, 330
Daly, Mary 165
D'Amato, Alfonse 78
Damer, Anne 122
Damia, Marisa 162
Damon, Betsy 31
Daniell, George 247
Daniels, Jimmie 46
D'Annunzio, Gabriele 62
Dante Alighieri 127
Das, Jaganath 182
Davenport, Guy 67
David, Elizabeth 231
David, Jacques-Louis 123, 128, 130, 154, 292
Davis, Bette 44
Day, F. Holland 16, 93–95, 251, 252, 253, 321, 344
Dean, James 231
De Busscher, Edmond 100
DeCocteau, David 323
Degas, Edgar 144, 218
DeGuzman, Maria 255
De Haan, Jacob Israël 176
Deharme, Lise 68
Dehner, Durk 331
Deitcher, David 251
Delacroix, Eugène 47, 48, 131, 261, 325
Del Monte, Cardinal Francesco 71, 117
del Rio, Dolores 210
Delvaux, Paul 324
Delville, Jean 133, 312, 326
De Maistre, Roy 45
Dement, Linda 41
Demuth, Charles 76–77, 95–96, 112, 312, 317, 319–20
Denis, Maurice 210, 326

Dent, J. M. 49
Denvir, Bernard 335
Derrida, Jacques 85
Diaghilev, Serge 329
Diashi, Kobo 191
Dickinson, Emily 34
Diderot, Denis 121
Dietrich, Marlene 139, 281
Dobell, Sir William 40, 96–97
Dodson, Betty 307
Doesburg, Theo van 170
Dolce, Lodovico 136
Domenichino (Domenico Zampieri) 305
Donahue, Troy 340
Donatello 97–99, 134, 135, 227, 295, 311
Donne, John 70, 298
Doolittle, Hilda (H. D.) 302
Dorion, Pierre 69
Dougherty, Cecilia 336
Douglas, Lord Alfred 231
Draper, Muriel 63
Dreamer, Etana 31
Drexler, Arthur 36
Driehuis, Yvonne Anne 308
Dromgoole, Patrick 323
Drysdale, Russell 146
DuBowski, Sandi 336, 337
Dubsky, Mario 22
Duchamp, Marcel 2, 95, 99, 137–38, 264, 294, 340
Duckworth, Jacqui 11, 116
Dufour, Marie 225
Dunbar, Jamie 313
Duncan, Robert 17
Dunn, Rachel 160
Dunye, Cheryl 13
Duquesnoy, François 100, 118
Duquesnoy, Jérôme 100, 117, 118
Duquesnoy, Jérôme the Elder 100
Dureau, George ix, 22, 100–102, 247, 313
Dürer, Albrecht 102–103, 135, 291, 311, 314
Duvall, Stace 269
Dyer, George 45
Dyke Action Machine 33, 256

E

Eakins, Thomas 18, 20, 34, 47, 95, 105–106, 111, 292, 312
Eastlake, Charles 56
Eastman, George 26

Ebershoff, David 109
Eccleston, Gertrude 39
Edison, Laurie Toby 106–107, 307
Eisenman, Nicole 33, 308
El Greco (Domenikos Theotokopoulos) ix, 107–109
Elbe, Lili (Einar Wegener) 109
Elizabeth, the Queen Mother 50, 161
Ellerman, Winifred (Bryher) 2, 46
Elliott, Daisy 39
Ellis, Darrel 12
Ellis, Havelock 67, 305
Ellis, Thomas 12
Ellsworth, Julia 288
Emerson, Peter Henry 292
Enwezor, Okwui 11
Episalla, Joy 33
Ernst, Max 2, 155, 324
Estermann, Carlos 7
Eugénie, Empress of France 57
Euripides 299
Evans, Gregory 172
Evans, Walker 219
Evans-Prichard, Edward E. 7
Evergon 69, 70
Exter, Alexandra 229

F

Fabo, Andy 69
Fairbrother, Trevor J. 280
Falconer, Ian 172
Falstein, Jessie 31
Fani-Kayode, Rotimi 4–5, 11, 139–40, 141–42, 313
Farley, Phyllis Ann 257
Farrakhan, Louis 216
Fassbinder, Rainer Werner 281
Fateman, Johanna 33
Fausto-Sterling, Anne 304
Faye, Frances 343
Feininger, Andreas 217
Feldman, Maxine 53
Fenner, Phyllis 285
Ferrara, Abel 323
Ferrari, Roberto 288
Ferri, Roger 35
Ferrill, Valeria "Mikki" 13
Fetting, Renier 85
Feuerstein, Günther 304
Ficino, Marsalio 135
fierce pussy 33
Filiger, Charles 133, 326
Fine, Maxine 31

Fini, Léonor 114, 137, 142–43, 203, 306
Finiguerra, Maso 303
Finley, Karen 32, 78
Fiorentino, Rosso 123, 147
Fischer, Konrad 151
Fishman, Louise 30, 31, 84
Fiveash, Tina 40, 255
Flandrin, Hippolyte 110, 130, 131, 143–44, 312
Flanner, Janet 2, 25, 244, 258
Flash, Lola 308
Flaxman, John 123, 129
Fleck, John 32, 78, 86
Fleming, Martha 70
Fletcher, Alice 257
Floris, Frans 124
Flynt, Robert 247
Fokine, Mikhail 318
Foley, Margaret 28, 214, 346
Fonda, Jane 44
Fontaine, Pierre 244–46
Fontan, Jack 292
Ford, Charles Henri 329, 330
Forster, E. M. 66, 219, 278, 302
Forster, Elizabeth 257
Foster, James 44
Foucault, Michel xii, 85, 125
Foujita, Leonard Tsuguharu 2
Foy, Raymond 18
Fragonard, Jean-Honoré 300
Franca, Franc 206
Francesca, Piero della 325
Francesconi, Judy 254, 308
François I, King of France 75, 124, 212, 297
Fraser, Jean 254, 255
Frederick the Great, King of Prussia 122
Freedberg, Sydney 123
Freeman, Florence 28, 346
French, Jared 46, 65, 144–45, 252
Freud, Lucien 88
Freud, Sigmund 211, 305, 323
Freund, Gisèle 258–59
Frey, Agnes 102
Freyburg, Karl von 16, 168
Fried, Nancy 31, 307
Friedländer, Walter 125
Friend, Donald 40, 145–47
Froling, Alison 33
Fry, Roger 68, 73, 161, 203
Fuller, Loie 162
Fung, Richard 23, 69, 336, 337

Fuseli, Henry 123, 147–48, 298, 318
Fuseli, Sophia Rawlins 148
Füssli, Johann Caspar 147
Fuster, Alberto 201

G
Gaal, Margit 307
Galán, Julio 203
Galdi, Vincenzo 252
Gale, Matthew 262
Galli, Jacopo 227
Gambart, Ernest 56
Garbo, Greta 51, 210, 244, 277
García Lorca, Federico 203, 324
Garland, Judy 194, 270
Garnett, Angelica 162
Garnett, David 162
Garnier, Charles 2
Garrotte, Claire 308
Gauguin, Paul 326
Gautier, Théophile 49, 143
Gautreau, Virginie 279
Gay, Emma Jane 25, 257
Geldzahler, Henry 18, 171
General Idea 69
Genet, Jean 108, 348
Gerald of Wales 127
Gere, Richard 36, 273
Géricault, Théodore 131, 149–50, 203
Gertler, Mark 73, 146
Ghazali, Abu Hamid al 186
Ghirlandaio, Domenico 227
Giard, Robert 247
Gibson, John 29, 177
Gide, André 2, 277
Gilbert, Creighton 72
Gilbert & George 84, 151–54, 247–48
Gill, Eric 268
Gilpin, Laura 257, 306
Ginsberg, Allen 76
Giocondo, Francesco del 212
Giorgione (Giorgio Barbarelli) 318, 321
Giovanni, Bertoldo di 227
Girodet-Trioson, Anne-Louis 154, 300
Gittings, Barbara 44, 259
Giustiniani, Vincenzo 117
Gleeson, James 41, 155
Gleyre, Charles 47
Gloeden, Wilhelm von, Baron 94, 111, 133, 144, 155–56, 213, 252, 312

Gluck (Hannah Gluckenstein) 25, 32, 62, 156–58
Gluckenstein, Joseph 156, 157
Gober, Robert 86, 88, 89
Goddard, Ella 61
Goddard, St. Mar 61
Goethe, Wolfgang von 121
Goff, Bruce Alonzo 35
Goldberg, Howard 188
Goldberg, Whoopi 209
Goldin, Nan 254, 317
Goldsby, Jackie 12
Gomez, Jewelle 12
González, Juan 206
González, María Elena 206
González-Torres, Félix ix, 24, 54, 88, 89, 158–59, 206
Goodsir, Agnes Noyes 40, 159–60
Goodstein, David B. 44
Gossaert, Jan 304
Gould, Cecil 243
Goya, Francisco de 121
Grace, Della (Del LaGrace Volcano) 32, 115, 160–61, 255, 308
Graham, Ed 269
Gran Fury 14, 23, 85–86
Grant, Duncan 161–62, 169, 203, 261, 278, 292
Gray, Eileen 2, 162–63, 305
Gray, John 267–68, 271
Gray, Thomas 122
Greenberg, Clement 264
Gregg, Pam 32
Grenier, Richard 78
Grey, Joel 188
Greyson, John 69
Griffin, Richard 146
Gropius, Walter 274
Group Material 85, 88
Guardi, Francesco 121
Guarracino, Attilio 146
Guevara, Alvaro 203
Gunn, Thom 72
Gupta, Sunil 11, 313
Gutiérrez, Raquel 205
Gwenwald, Morgan 115

H
Haberlandt, Michael 8
Hadrian, Emperor of Rome 82, 122, 135, 302, 310
Hagio, Moto 193
Hall, Francesca 156, 157

Hall, Lee 244
Hall, Radclyffe 25, 62, 76, 265
Hallaj, Al 186
Hals, Frans 20
Hambley, Wilfred 8
Hamilton, Mel 35
Hammer, Barbara 26, 40
Hammond, Harmony 31, 83, 84, 87, 165–66, 254
Hanbei, Yoshida 312
Hanna, Kathleen 33
Hardy, C. Moore 254, 308
Hari, Mata 277
Haring, Keith ix, 22, 85, 87, 89, 166–67, 341, 347
Harmodius 301–302, 310
Harris, Lyle Ashton 11, 12, 23, 313
Harris, Thomas 336
Harris, Thomas Allen 12, 23
Harrison, Benjamin 26
Harrison, Peter 21
Hartford, Huntington 330
Hartley, Marsden 16, 95, 96, 167–68, 219, 319, 321
Hasegawa, Sadao 313
Hassan, Salah M. 11
Hastings, Judith 69
Hausmann, Raoul 169–70
Hawking, Stephen 273
Hawthorne, Nathaniel 28, 177
Hayek, Salma 198
Hays, Matilda 289
Hayward, Victoria 257
Hazan, Jack 171
Hazm, Ibn 186
Heald, Edith Shackleton 157–58
Heap, Jane 2, 3, 258
Hearst, William Randolph 232
Hegel, Georg Wilhelm Friedrich 121
Heimbach, Wolfgang 119
Helms, Jesse 15, 78, 86, 88, 223, 348
Hemingway, Ernest 108, 278
Henner, Jean-Jacques 1
Hepburn, Audrey 247
Hepburn, Katharine 44
Hephaestion 286, 310
Hepworth, Dorothy 168–69
Hergemöller, Bernd-Ulrich 125
Hernández, Ester Medina 205
Herodotus 290, 302
Herrán, Saturnino 201
Herrera, Nana de 210
Hewitt, Mattie Edwards 26, 258

Higgs, David 36–37
High, Kathy 336, 337
Highsmith, Patricia 265
Hildebrand, Adolf 223–24
Hipparchus 301–302
Hippias 301, 302
Hirschfeld, Magnus 308
Hirst, Alex 141–42
Hitchcock, Henry Russell 194
Hitler, Adolph 59, 176, 302
Höch, Hannah 138–39, 169–70, 306
Hockney, David ix, 18, 34, 44, 84, 122, 139, 151, 171–72, 248, 292–93
Hodgkins, Frances 172–73, 237–38
Hodgkins, William Mathew 172
Hoening, Margaret 144–45, 252
Hofmannsthal, Hugo von 122
Hogarth, William 122
Hokusai, Katsushika 317
Holditch, Kenneth 100
Hollanda, Francisco de 228
Hollinghurst, Allan 326–27
Homer 143, 298
Homer, Winslow ix, 18, 19–20, 34, 173–75
Hoolboom, Mike 69
Hopper, Dennis 166
Hopper, Edward 34
Horn, Timothy 40–41
Horst, Horst P. 252
Hosmer, Harriet Goodhue 27, 28, 29, 176–77, 214, 289, 306, 346
Howe, Delmas 24
Hoyningen-Hene, George 252
Hoxie, Vinnie Ream 28, 346
Hoyer, Niels (Ernst Ludwig Hathorn Jacobson) 109
Hughes, Holly 32, 78, 86
Hughes, Langston 46
Hujar, Peter 22, 248, 313, 317, 348
Hurston, Zora Neale 46, 216
Huysmans, Joris-Karl 267, 325
Huxley, Aldous 44, 219
Hyginus 315
Hyman, Erik 274

I

Ignatius of Loyola, St. 229
Indiana, Robert 84, 85
Ingres, J. A. D. 128, 130, 131, 143, 292, 312
Inverno, Nicola d' 280

Inzalaco, Lorraine 308
Isaak, Chris 273, 343
Isherwood, Christopher 18, 43, 44, 66, 171, 219, 280
Israel, Franklin D. 35, 36, 188–89

J

Jackman, Harold 46
Jackson, Janet 273
Jackson, Michael 12
Jackson, Rob 273
Jacob, François Honoré-Georges 129
Jacobson, Ernst Ludwig Hathorn (Niels Hoyer) 109
Jagger, Mick 36
James, Henry 28, 214, 280, 289, 346
Jangey-Paget, Laurence 116, 308
Janpaul, Peter 269
Janson, H. W. 97, 130
Jarman, Derek 72, 321
JEB (Joan E. Biren) 30, 53–54, 84, 254, 255, 307
Jelenski, Constanine 137
Jess (Jess Collins) 17
John, Gwen 306
Johns, Jasper 17, 84, 87, 193–94, 264–65, 270, 340
Johnson, Jed 36
Johnson, Peter 343
Johnson, Philip ix, 35, 36, 194–96
Johnston, Dorothy 268
Johnston, Frances Benjamin 25–26, 258, 306
Jones, Cleve 15
Jones, G. B. 33
Jones, Inigo 301
Jones, Lizard 69, 115, 255–56, 308
Jones, William 120
Jongkind, Johan Barthold 47
Jonson, Ben 49
Jordan, Neil 323
Joséphine, Empress of France 245
Joyce, James 2, 25, 258, 261, 278
Joyner-Kersee, Jackie 273
Julien, Isaac 11
Julius II, Pope 227
Jullian, Phillipe 327
Jung, Carl 145, 323

K

Kahlo, Frida ix, 142, 197–98, 201–202, 203, 306, 353

Kalin, Tom 336, 337
Kallman, Chester 122
Kameny, Frank 44
Kaminski, Mark 35
Kandinsky, Wassily 167
Kanievska, Marek 55
Kapur, Geeta 184
Karimjee, Mumtaz 116, 256
Kauffmann, Angelica 121
Kaufmann, Edgar, Jr. 46
Kaye, Richard A. 322
Keaton, Diane 36
Keats, John 93, 120
Keller, H. Lynn 13
Kelly, Deborah 40
Kelly, Ellsworth 26, 44, 244
Kelsey, Albert 19, 174
Kennedy, Jacqueline 340
Kent, William 121
Keynes, John Maynard 161, 278
Khakhar, Bhupen ix, 184, 198–99
Khaldoun, Ibn 185
Khnopff, Fernand 133, 326–27
Khrabroff, Irina 285
Kidwai, Saleen 180, 182
Kight, Morris 44
Kim, Byron 216
King, Mary Ann 31
Kinsey, Alfred C. xi, 220, 251,
 252, 330
Kinsman, Gary 69
Kirstein, Lincoln 17, 46, 65, 67,
 144, 219, 329
Kiss & Tell 69, 115, 255–56, 308
Klah, Hastíín 237
Klein, Calvin 246, 273, 342
Klein, Gloria 31
Kliewer, Linda 254
Klumpke, Anna Elizabeth 29,
 57–58, 132, 199–200
Kollwitz, Käthe 221
Kontuglou, Fotis 332
Koppel, Irene 224
Krause, Gundula 308
Kreighoff, Cornelius 68
Kris 253
Krull, Germaine 259, 307
Kuffner, Raoul, Baron 210

L

Laaksonen, Touko ix, 17, 87,
 112–13, 294, 312–13, 319,
 320, 330–31
LaBruce, Bruce 69

Lakich, Lili 31, 307
Lander, Louisa 28, 346
Landolt, Anna 147
Landseer, Edwin 56
Lane, Bettye 254
Lane, John 49
Lang, Edith 184
Langdon, Helen 72
Lange, Dorothea 344
Langer, Eli 70
Langtry, Lily 267
Lanux, Eyre de 306–307
Lapido 146
Lapointe, Lyne 70
Lauren, Ralph 342
Laurençin, Marie 2, 206–208
Laurens, Paul 333
Lavater, Johann 147
Lawrence, D. H. 76
Lawrence, Katie 293
Lawrence, T. E. 334
Laycock, Ross 24
Lebow, Alisa 336, 337
Le Corbusier (Charles Édouard
 Jeanneret) 175, 195
Leddick, David 295
Ledoux, Claude-Nicolas 129
Le Fanu, J. Sheridan 323
Le Gallienne, Eva 3, 349
Le Gallienne, Gwen 2, 3
Leibovitz, Annie 208–210
Leibovitz, Marilyn Heit 208, 209
Leighton, Frederic xiii, 132, 271,
 287, 296
Lemaire, Madeleine 207
Lembo, Joe Lawrence 236
Lempicka, Tadeusz de 210
Lempicka, Tamara de ix, 210, 306
Lennon, John 208
Lenz, Christian 223
Leo X, Pope 227, 286
Leonard, Michael 87
Leonard, Zoe 32, 33, 308
Leonardo da Vinci 99, 134,
 211–13, 227, 228, 230, 262, 313
Lepri, Stanislao 137
Leroy, Étienne 225
Lesbian Avengers 33
Leslie, Charles 213
Lesseps, Ferdinand de 2
Le Tigre 33
Levey, Michael 120
Levitt, Nina 69
Lewis, Cecil 271

Lewis, Mary Edmonia 10, 11,
 28–29, 177, 214, 289, 306, 346
Lewis, Samuel 214
Lexier, Micah 69
Leyendecker, Augusta 215, 216
Leyendecker, Francis X. 215–16
Leyendecker, Joseph Christian 16,
 215–16
Lhote, André 210
Lichtenstein, Roy 264
Licymnius of Chios 300
Ligon, Glenn 12, 23, 87, 89, 216–17
Lindsay, Yvonne 31
Lindsey, David 282
Lipton, Eunice 225
List, Herbert 217–18, 252
Liszt, Franz 277
Locher, Robert 95, 96
Lochrie, Karma 126
Locke, Alain 46, 47
Lohman, Fritz 213
Lommel, Ulli 323
Long, Sydney 146
Longus 271
Longval, Gloria 31
Loo, Louis Michel van 300
López, Alma 205
Lopez, Jennifer 273
Lopez, Yolanda 32
Loraux, Nicole 303
Lord, Catherine 87
Loren, Sophia 247
Loring, Frances 69, 306
Louÿs, Pierre 222
Loy, Myrna 44
Lucian (pseudo) 80–81
Ludwig II, King of Bavaria 35
Luhan, Mabel Dodge 278
Lukacs, Attila Richard 69, 87,
 218–19
Lully, Jean-Baptiste 318
Lydes, Mariette 307
Lynes, George Platt 17, 65, 144,
 219–20, 251, 252, 272, 300,
 312, 344
Lyon, Lisa 305
Lyon, Phyllis 44, 53
Lyons, Nathan 345
Lypsinka 15

M

MacAdams, Cynthia 114
MacBryde, Robert 231
Macdonald, Duncan 335

MacDowall, Cyndra 69, 308
Macdowell, Susan 20, 105
Machado, Rodolfo 36
Mackintoch, Charles Rennie 37
Maclean, Donald 55
MacMahon, E. G. 97
Madekurozwa, Bulelwa 4, 5
Madonna 166, 273
Magallanes, Nicholas 219, 330
Magritte, Rene 226, 323, 324
Maidment, Ian 147
Maître, Edmond 47
Majoli, Monica 32
Malevich, Kasimir 204
Malherbe, Suzanne 67–68, 138
Mallarmé, Stéphane 325
Malory, Sir Thomas 49
Mammen, Jeanne 221–22, 306,
 317
Mandela, Nelson 273
Manet, Édouard 4–5, 139–40,
 225, 261, 332
Mann, Thomas 319
Manning, Abby Adeline 28, 346,
 347
Mansion, Colard 314
Mantegna, Andrea 303, 314, 321,
 326
Mapplethorpe, Robert ix, 11, 12,
 17, 21, 22, 23, 44, 77–78, 86,
 87, 101, 113, 144, 216, 222–23,
 247, 248, 305, 312, 313, 332
Marais, Jean 59
Marbury, Elisabeth "Bessie" 349,
 350
Marc, Franz 167
Marconi, Guglielmo 251
Marées, Hans von 223–24
Mariano, Raymond V. 268
Marin, John 95
Marlowe, Christopher 271
Márquez, Roberto 203
Marsh, Julia 39
Marsh, Reginald 34
Marshall, Frances 74
Martin, Agnes 244
Martin, Del 44, 53
Martin, Marcelina 308
Martin, Rosy 13
Martinac, Paula 36–37
Martínez, Raúl 206
Masaccio 132
Mason, Alti 168
Masson, André 142, 324

Mather, Margarethe 258
Mathews, Thomas 126
Matisse, Henri 161, 173, 240,
 261, 278, 332
Matlovich, Leonard 268
Matthies, Heinz Kurt 170
Maugham, W. Somerset 219
Mayberry, John 45
Mazz 254
Mazzola, Francesco (Parmigianino)
 123, 135, 136, 147, 242–43
McAlmon, Robert 2, 96
McCausland, Elizabeth 3, 52
McDermott, David 86, 87
McDonnell, Patricia 168
McGough, Peter 86, 87
McGuinnes, John 336
McKay, Claude 46
McKeller, Thomas E. 280
McKenna, Rollie 259
McKenzie, Robert Tait 68
McKinley, William 26
McClure, Ramsey 336
McQueen, Steve 11
Medici, Alessandro de' 228
Medici, Cosimo I de', Duke 60,
 75, 97, 124, 135
Medici, Giuliano de' 227
Medici, Giulio de', Cardinal 227
Medici, Lorenzo de', Duke 227
Medley, Robert 295
Mehta, Deepa 184
Meléndez, Reyes 206
Melville, Herman 173
Melzi, Francesco 211
Mendl, Sir Charles 350
Mengs, Anton Raphael 147
Meninsky, Bernard 146
Mercer, Kobena 11, 23
Merrill, James 44, 319
Metcalf, Henriette McCrea 350
Meurent, Victorine 225
Micas, Nathalie 56, 57, 58, 131
Michals, Duane 24, 226, 248, 332
Michelangelo Buonarroti ix, xiii,
 46, 75, 110, 117, 132, 134,
 135, 136, 147, 149, 153, 171,
 226–31, 263, 294, 295, 296,
 299, 301, 303, 305, 311
Michelangelo Buonarroti the
 Younger 229
Midler, Bette 36, 209
Mika 238
Milan, Pierre 297

Millay, Edna St. Vincent 3, 350
Miller, Isabel 29
Miller, John 269
Miller, Tim 15, 32, 78
Millett, Kate 31, 84, 308
Mills, David 269
Milton, John 147, 148, 272
Minsker, Andy 342
Minton, John 231–32, 335
Mirabeau, Octave 327
Miró, Joan 324
Mirza, Sultan Ibrahim 187
Mishima, Go 192–93
Mishima, Yukio 119, 192, 348
Mitchell, Margaretta K. 52
Mizer, Bob 17, 253, 292, 317
Model, Lisette 342
Modersohn-Becker, Paula 221
Modigliani, Amedeo 240
Moffat, Charles 304
Moffett, Donald 23
Molinier, Pierre 248
Moncion, Francisco 219
Monet, Claude 47, 48
Monnier, Adrienne 2, 258, 278
Monoson, Sara 302
Monroe, Marilyn 340
Montaigne, Michel de 302
Montenegro, Roberto 202
Montes, Gil de 206
Montesquiou, Robert de 61–62,
 280
Montherlant, Henri de 59
Montoya, Zone Paraiso 256
Moore, Charles 35, 36
Moore, Demi 208
Moore, Henry 335
Moore, Iris 23
Moore, Marion 256
Moore, Thomas Sturge 271
Moreau, Gustave xiii, 133, 267,
 305, 325
Moreno, Cabrero 206
Morgan, Anne 349
Morgan, Barbara 344
Morgan, Claire 265
Morgan, J. P. 349
Morgan, Julia ix, 35, 232–33
Morimura, Yasumasa 192
Morisot, Berthe 172
Moronobu, Hishikawa 316
Morrice, James Wilson 68–69
Morris, Mark 209
Morris, William 38, 287

Morrisroe, Mark 248–49
Mostovoy, Tracy 32
Motherwell, Robert 101
Moyer, Carrie 33, 256
Mozart, Wolfgang 120
Mucha, Alphonse 294
Mueller, Oswald 38
Mulvey, Laura 198
Munn, Edward Stopford 38
Munster, Anna 255
Murat, Violette 2
Murch, Walter 17
Murnau, F. W. 323
Murphy, Tom 344–45
Murray, Samuel 20
Muschamp, Herbert 36, 196
Muybridge, Eadweard 45, 106

N
Naldini, Battista 262
Nanda, Serena 180, 181
Napoleon I, Emperor of France 245
Napoleon III, Emperor of France 312
Nashe, John 298
Navez, François-Joseph 304
Nazario 239
Nelson, Dona 31
Nevelson, Louise 306
Newhall, Beaumont 344
Newhall, Nancy 344
Newman, Barnett 26
Nijinsky, Vaslav 202
Niles, Katie 115, 307
Nin, Anaïs 44
Noble, Elaine 44
Noguchi, Isamu 219
Nonnus 298
'N SYNC 273
Nugent, Richard Bruce 11, 16, 47

O
Oates, Joyce Carol 319
Obermer, Nesta 157
Ocaña, José Pérez 239–40
Ochino, Bernardino 229
O'Connor, John, Cardinal 88, 348
Ofili, Chris 11
O'Flaherty, Wendy Doniger 182
Oguibe, Olu 11
O'Hara, Frank 194, 321
Oiticica, Hélio 204
O'Keeffe, Georgia 96, 247

O'Leary, Jean 44
Oldenburg, Claes 264
Olley, Margaret 97
Olmstead, Harold 285
Omu 146
Ono, Yoko 166, 208
Opie, Catherine 32, 255, 308
Orozco, José Clemente 201
Ossorio, Alphonso 17, 244
Ouida 267
Ovid 297, 300, 314, 315

P
Packer, Vin 266
Paddock, Lisa 209
Paglia, Camille 209
Palmer, Evaline 258, 307
Paradis, Marc 70
Paris, Bob 273
Parker, Dorothy 219
Parmesani, Loredana 262
Parmigianino (Francesco Mazzola) 123, 135, 136, 147, 242–43, 301
Parsons, Betty 2, 17, 26, 243–44
Parsons, Schuyler Livingston 243
Partridge, Ralph 73, 74
Partz, Felix 69
Pasolini, Pier Paolo 72, 187
Passage à l'acte 281
Passmore, George 84, 151–54, 247–48
Pater, Walter 120, 132, 267, 288, 319
Patrick, Robert 34
Patten, Mary 33
Patterson, Banjo 160
Paul III, Pope 75, 228
Paul VI, Pope 75
Pears, Peter 44
Péladan, Joséphin 326
Pellegrin, Marie 225
Penelope, Julia 90
Pennell, Joseph 49
Penrose, Bernard 74
Penteado, Darcy 204
Péquignot, Jean-Pierre 154
Percier, Charles 244–46
Pérez, Antonio 135
Perini, Gherardo 229
Perlin, Bernard 65
Perlmutter, Tylia 2
Perrot, Ira 210
Perry, Troy 44

Pet Shop Boys 343
Peterzano, Simone 71
Peyre, Antoine-François 244
Pfeiffer, Walter 249
Pham, Hanh Thi 256, 308
Phanocles 314
Philby, Harold "Kim" 55
Phimister, Eveline 52
Phranc 33
Paik, Nam June 336
Picasso, Pablo 34, 45, 88, 161, 207, 208, 261, 278, 294, 315, 324, 332
Pierre et Gilles 249, 259–60, 321
Pierson, Jack 249
Pinero, Miguel 23
Pinto, Jody 31
Piper, John 335
Piranesi, Giovanni Battista 121, 171
Pirckheimer, Willibald 102–103, 135
Pisa, Guido da 126
Pisis, Filippo Tibertilli De 260–62
Plathof, Kirsten 308
Plato 302, 312
Plüschow, Wilhelm von 252
Plutarch 143
Pocahontas 77
Poe, Edgar Allan 302, 325
Polanski, Roman 323
Polidori, John 323
Poliziano, Angelo 97, 303
Pollard, Ingrid 11, 256
Pollock, Jackson 17, 26
Pomo Afro Homo 15
Pons, Ventura 239, 240
Pontormo, Jacopo 60, 123, 262–64
Pope, Alexander 49
Pope-Hennessy, John 98
Porterfield, Todd 47, 48
Portinari, Candido 203
Porto, Geraldo 204
Posener, Jill 32, 115, 255, 256, 307, 308
Poulenc, Francis 207
Poussin, Nicolas 300, 305, 315, 318
Power, Hiram 177
Power, Tyrone 210
Preboste, Francesco 108
Preece, Patricia 168–69
Prendergast, Maurice Brazil 68
Presley, Elvis 340

Primaticcio, Francesco 124, 136, 297

Prince, Brenda 254

Probst, Ken 249

Proesch, Gilbert 84, 151–54, 247–48

Proust, Marcel 61–62, 277, 321

Pryor, Richard 216

Pugin, A. W. N. 37

Putnam, Peter 282

Q

Qasim, Muhammed 187

Quaintance, George 17

R

Radin, Mary 46

Raffalovich, Marc André 49, 267–68

Raffalovich, Marie 267

Raimondi, Marcantonio 135, 298

Rakusin, Sudie 114, 307

Ramos, Mel 264

Rand, John 249

Randall, Lillian 126

Rando, Flavia 31

Raphael 123, 132, 305, 318

Rauschenberg, Robert 17, 84, 87, 193–94, 244, 264–65, 270, 340

Raven, Arlene 31

Ray, Man 2, 25, 99, 138

Raymond, Eleanor 35

Rea 256

Read, Herbert 231, 268

Reagan, Ronald 85, 86

Redon, Odilon 325

Reed, John 278

Reeve, Christopher 273

Rembrandt Harmenszoon van Rijn 118–19, 223, 272, 301

Renault, Mary 302

Reni, Guido 119, 295, 311, 321

Renoir, August 47, 48, 131, 171, 332

Reyes, Axel Damian 206

Reyes, Miguel Angel 206

Reynolds, Sir Joshua 147

Rhoads, Beverly 32

Rice, Price 52

Richard, Cliff 171

Richard, Gina 269

Richardson, Marilyn 214

Richmond, Dorothy Kate 172, 173

Ricketts, Charles 267, 271–72

Riggs, Marlon 12, 23

Rimbaud, Arthur 47, 133, 250, 325, 348

Rimmer, William 346

Rincón, Roberto 206

Ripley, Sue 39

Rippey, Carla 203

Ritts, Herb 250, 272–74

Rivera, Diego 197–98, 201

Rivosecchi, Valerio 262

Robbins, Mark 36

Robert-Fleury, Tony 225

Roberts, George 288

Robertson, Eric 268

Robertson, W. Graham 21, 280

Roche, Paul 161, 162

Rocke, Michael 134

Rockefeller, Nelson A. 77

Rockwell, Norman 215

Rodin, Auguste 95, 319, 333

Rodríguez, Abnel 206

Rodriguez, Eugene 23

Rodriguez, Glauco 204

Rodríguez Lozano, Manuel 203

Rogers, Ginger 44

Rogers, Malcolm 273

Rollyson, Carl 209

Romano, Giulio 123–24, 301, 314

Roosevelt, Henry Latrobe 66

Roosevelt, Theodore 26

Rops, Félicien 317, 326

Rorem, Ned 296

Rosenblum, Nancy 32

Rosenblum, Robert 130

Rosenquist, James 264

Ross, Alan 231

Ross, Robert 133

Rossetti, Dante Gabriel 132, 287

Rothko, Mark 26

Roy, Pierre 324

Rubbo, Datillo 146

Rubens, Peter Paul 88, 100, 119, 272, 300, 319

Rubenstein, Ida 62, 258, 306

Rudolph, Paul 35–36, 274–75

Rumi, Jaladin-Al 186

Rus, Meyer 36

Ruskin, John 37, 38, 56

Russell, Bertrand 159

Russell, Jim 36

S

Saalfield, Catherine 32

Sackville-West, Vita 210, 258–59

Sade, Marquis de 119

Said, Edward 187

Saikaku, Ihara 192

Saitowitz, Stanley 36

Salinas, Raquel 205

Salmon, Sir Cyril 158

Samson, JD 33

Sand, George 131

Sanders, Joel 36

Sando, Sandra de 31

Sangall, Aristotele da 227

Sanger, Margaret 278

Sangster, Jimmy 323

Sappho 62, 81, 132, 207, 222, 277, 278, 321

Sargent, John Singer 18, 20–21, 279–80, 305, 333

Sargent, Margaret 2

Sarto, Andrea del 262

Saslow, James 98, 126, 127, 130, 187, 201, 286, 296

Satie, Erik 296

Sattler, Alexina 99

Savinio, Albert 261

Saxon, Lyle 46

Sazansky, Tanya 308

Scarola, Amy 31

Scarpa, Bruno 261

Schack, Adolph von 223

Schaffner, Sue 33, 256

Schapiro, Miriam 31, 79

Scharf, Kenny 166

Schindler, Rudolf 188

Schlesinger, Peter 171, 172, 293

Schmidt, Thomas Lanigan 87

Schorr, Collier 32

Schrader, Paul 273

Schroeder, Ricky 250

Schulze, Franz 195

Schumack, Kay 256

Schwabe, Carlos 326

Schwabsky, Barry 261

Schwarz, David 36

Schwarzenegger, Arnold 209

Schwitters, Kurt 170

Scott, Christopher 171

Scott, Tony 323

Scriver, Strelsa van 244

Scudéry, Madeleine de 277, 297

Sebastian, St. x, 108, 119, 133, 135, 202, 286, 295, 311, 321–22, 348

Segal, George 282–85

Sekhon, Parminder 308

Sekula, Sonja 26, 244
Sercambi, Giovanni di 298
Serrano, Andres 78, 86, 88
Sérusier, Paul 326
Sforza, Ludovico, Duke 211
Shafrazi, Tony 166
Shakespeare, William 147, 148
Shakira 273
Shand-Tucci, Douglass 35
Shannon, Charles 267, 271–72
Shapiro, Meyer 344
Shaw, George Bernard 271
Shearman, John 123, 125
Sher-Gil, Amrita 184
Shonibare, Yinka 11
Shunsho, Katsugawa 316
Sigler, Hollis 84
Sillman, Amy 31
Silvetti, Jorge 36
Sina, Ibn 186
Sinan 185
Sipprell, Clara Estelle 258, 285,
 306
Sipprell, Francis James 285
Sisley, Alfred 47
Sitwell, Edith 50
Sitwell, Osbert 50
Sitwell, Sacheverell 50
Sixtus IV, Pope 227
Sjoo, Monica 114, 307
Sleigh, Sylvia 292
Smith, Cheryl 255
Smith, John 66, 77
Smith, Joshua 97
Smith, Kiki 88
Smith, Patti 222
Smithers, Leonard 49
Smollett, Tobias 147
Snyder, Joan 30, 84, 89
Sodoma, Il (Giovanni Antonio
 Bazzi) 134, 228, 286–87, 311,
 321
Solanas, Valerie 30
Solano, Solita 2, 258, 277
Solidar, Suzy 210
Solomon, Abraham 287, 288
Solomon, Kathe Levey 287, 288
Solomon, Meyer 287, 288
Solomon, Rebecca 287, 288
Solomon, Simeon 130, 132, 133,
 287–89, 299, 312, 321
Solomon, Solomon J. 305
Somé, Malidoma Patrice 7
Somere, Constant de 118

Sontag, Susan 209, 265, 340
Sordillo, Trista 254
Spears, Britney 273
Spence, Jo 13
Spencer, Stanley 169
Spender, Stephen 217
Spiro, Ellen 336, 337
Spranger, Bartholomaeus 304
Spry, Constance 157
Stalin, Joseph 302
Stamos, Theodoros 244
Stanton, Elizabeth Cady 29, 199
Stebbins, Emma 28, 29, 214,
 289–90, 306, 346
Stefaniuk, Olga 308
Steffeck, Carl 223
Steger, Lawrence 23
Steichen, Edward 344
Stein, Gertrude 24, 25, 26, 95,
 163, 167, 207, 219, 244,
 277–78, 329, 330
Stein, Leo 167
Steinberg, Leo 126
Sterck, Jacobus de 118
Stern, Robert A. M. 36
Stevenson, Robert Louis 280
Stewart, Susan 69, 115, 255–56,
 308
Stickley, Gustav 37
Stieglitz, Alexander, Baron 223
Stieglitz, Alfred 93, 95, 167, 344
Still, Clyfford 26
Stone, Alan B. 69
Stone, Lucy 28, 347
Stopes, Marie 231
Story, William Wetmore 28
Stout, John 269
Stowitts, Hubert Julian 17
Strachey, Julia 73–74
Strachey, Lytton 73, 74, 161, 278
Strand, Paul 344
Strauss, Richard 122
Stravinsky, Igor 122, 296
Streisand, Barbra 36
Stride, Ricky 231
Strozzi, Umberto 63
Sukenobu, Nishikawa 312, 316
Suleyman, Sultan 185
Sullivan, Louis H. 35, 37
Sullivan, Noel 46
Sumner, Clark 27, 29, 346, 347
Sundaram, Vivan 184
Sutcliffe, Frank Meadow 292
Suter, Gerardo 206

Sutherland, Graham 335
Swan, Rebecca 255, 307
Swanson, Claude A. 66
Swinburne, Algernon Charles 287,
 302
Symonds, John Addington x, 132,
 228, 288
Symons, Arthur 267

T

Tabarant, Alphonse 225
Tacitus 143
Taft, William H. 26
Tagame, Gengoroh 193
Tammen, Silke 125, 126
Tanguy, Yves 324
Tanner, Allen 329
Tardi, Carla 31
Tate, Gertrude Amelia 26, 39
Taylor, Elizabeth 273, 340
Taylor, Jocelyn 13, 33
Taylor, Valerie 265, 266
Taymor, Julie 198
Tchelitchew, Pavel 219, 229–30
Ter Brugghen, Hendrick 117
Terry, Ellen 159
Thadani, Giti 180
Thadani, Theresa 254
Thatcher, Margaret 55, 85
Theotokopoli, Jorge Manuel 108
Thibault, Jean-Thomas 244
Thomas, Dylan 158, 259
Thoreau, Henry David 173
Thorvaldsen, Bertel 128
Thucydides 302
Thurman, Wallace 46
Tice, Clara 307
Tichnor, George 219
Tiepolo, Giambattista 121
Tiffany, Louis Comfort 37
Tilmans, Wolfgang 250
Tim Rollins + K.O.S. 88
Tintoretto, Jacopo 107, 300, 321
Titian 107, 119, 136, 299, 300,
 318, 321
Tobin Lahusen, Kay 259
Todd, Ruthven 148
Toklas, Alice B. 24, 207, 219, 244,
 278, 330
Tolstoy, Leo 159
Tom of Finland (Touko Laaksonen)
 ix, 17, 87, 112–13, 294,
 312–13, 319, 320, 330–31
Tomlin, Stephen 73, 74

Tomory, Peter 148
Tonks, Henry 73
Tooker, George 65, 144
Torres, Patricia 203
Torres, Tereska 266
Toulouse-Lautrec, Henri de 34, 131, 132
Trefusis, Violette 210
Tress, Arthur 250, 331–32
Trexler, Richard 126
Triest, Antoine, Bishop of Ghent 100, 118
Trotsky, Leon 198
Troubridge, Una 25, 62
Tsarouchis, Yannis 332–33
Tsinhnahjinnie, Hulleah 32, 256
Tuaillon, Louis 224
Tuke, Henry Scott 133, 137, 333–34
Turner, Ellen 31
Turner, J. M. W. 131
Twombly, Robert 35
Tyler, Parker 330
Tyson, Mike 12
Tyson, Nicola 32
Tyson, Willie 53
Tzara, Tristan 261

U

Udé, Iké 12
Uelsmann, Jerry 345
Urbach, Henry 36
Utamaro, Kitagawa 316

V

Valderrama, Alberto 206
Valenciennes, Pierre-Henri de 129
Vanderbilt, Cornelius 56
van der Rohe, Mies 195
VanDerZee, James 16
Van Dyck, Anthony 100, 119
Van Vechten, Carl 17, 46, 63, 278
Vanita, Ruth 180, 182
Vasari, Giorgio 124, 134, 136, 228, 262, 286
Vaughan, Keith 139, 231, 335–36
Velázquez, Diego 20, 45, 318
Veli 331
Verlaine, Paul 47, 133, 325
Vermeer, Johannes 259
Veronese, Paolo 119, 121
Verrochio, Andrea del 211
Versace, Gianni 272
Vickers, Hugo 51

Victoria, Queen of England 56, 349
Vidal, Gore 44
Vilchis, Gerardo 202, 353, 354
Villaseñor, Elena 203
Virgil 143, 300
Viriato, Edilson 204
Visual AIDS Artists' Caucus 15
Vitaljic, Sandra 308
Vivien, Renée 258, 278, 307, 321
Voeller, Bruce 44, 282
Voigt, Jon 250, 273
Volkmann, Artur 224
Vouet, Aubin 295
Vuillard, Edward 326

W

W., Vincent Alan 12
Wagner, Richard 49
Wagstaff, Sam 222, 223
Walker, A'Lelia 3
Walker, Christian 12
Walker, Dame Ethel 137, 339–40
Walpole, Horace 120, 122, 123
Walpole, Sir Robert 122
Walsh, Johnny 336
Walton, Cecile 268
Wanzenberg, Alan 36
Ward, Violet 39
Warhol, Andy ix, 18, 30, 33, 36, 77, 84, 85, 99, 264, 265, 317, 340–41
Warren, Edward Perry 16
Washburn, Janey 31
Wätjen, Otto von 207
Watson, Edith S. 25, 257
Watteau, Antoine 120, 121, 130
Waugh, Thomas 251
Weatherby, Kate 163
Webb, Marilyn 165
Weber, Bruce 250, 342–43
Wegener, Einar (Lili Elbe) 109
Wegener, Gerda 109, 307
Weider, Joe 253
Weil, Susan 270
Weinberg, Jonathan 168
Weisinger, Jean 13, 30, 256
Weisman, Stefan 296
Weiss, Theodore 282
Welbon, Yvonne 13
Wellington, Hubert 268
Welty, Eudora 319
Wesselmann, Tom 264
Westcott, Glenway 144, 219

Westcott, Joseph 96
Weston, Brett 344
Weston, Edward 52, 258, 292, 344
Wheeler, Monroe 144, 219
Whistler, James McNeil 61, 267, 271
Whitacre, Aelred 268
White, Max 307
White, Minor 77, 252, 253, 343–46
Whitman, Walt 20, 106, 139, 171, 173, 226, 292, 312
Whitney, Anne 27, 28, 29, 177, 214, 306, 346–47
Whitney, David 195
Wilby, Thomas 173
Wilde, Oscar 49, 67, 68, 93, 95, 119, 130, 132, 133, 231, 251, 252, 267, 268, 271, 280, 325, 326, 327, 333
Wildmon, Donald 86, 88, 250, 348
Wilgefortis, St. 126
Wilhelm, Gale 265
Wilkin, Karen 48
Williams, Carla 13
Williams, Tennessee 219, 247
Williams, Vanessa 12
Willson, Mary Ann 27, 29
Wilson, Ann 31
Wilson, Kaia 33
Wilson, Millie 32
Winant, Fran 30, 31
Winckelmann, Johann Joachim 120, 121, 128, 130, 147, 290
Winn, Albert 24
Wittig, Monique 165
Wojnarowicz, David 22, 78, 88, 89, 250, 317, 336, 337, 347–48
Wolf, Sylvia 208
Wolfe, Elsie de 35, 50, 349–50
Wolfe, Susan 90
Wolfthal, Diane 126
Wolgemut, Michael 102
Wollstonecraft, Mary 148
Wolverton, Terry 31
Wong, Martin 23
Wong, Paul 69, 70
Wood, Debra Dianne 160
Wood, Thelma Ellen 2, 25, 350–51
Woodman, Donald 79
Woodruff, Thomas 24
Woodson, Jacqueline 32

Woolf, Leonard 73
Woolf, Virginia 73, 258, 259, 278
Word of Mouth 256
Wright, Frank Lloyd 37, 188
Wright, Lewis 174
Wyld, Evelyn 162, 163
Wyle, Florence 69, 306

X
Xerxes 302

Y
Yamaoka, Carrie 33
Yeats, W. B. 271
Yourcenar, Marguerite 258
Yow, Jensen 292

Z
Zane, Arnie 305
Zárraga, Angel 201
Zeffirelli, Franco 273, 294, 333
Zenil, Nahum B. 202, 203, 313,
 353–54
Zola, Émile 47
Zontal, Jorge 69